MICKEY MOUSE

MICKEY MOUSE

EMBLEM OF THE AMERICAN SPIRIT

GARRY APGAR

THE WALT DISNEY FAMILY FOUNDATION PRESS

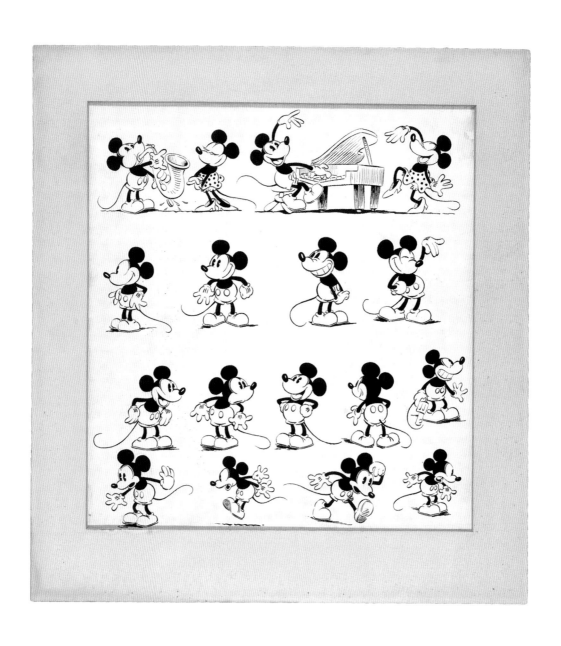

Walt Disney has been called everything from a genius to a philosopher—and denied that he is any of them. As a matter of fact when the English novelist, Aldous Huxley, praised the philosophy in the Mickey Mouse cartoons and asked Disney how he arrived at their underlying subtleties, the answer he is reputed to have received was: "Oh, we make pictures for entertainment, and after they are made the professors come along and tell us what we mean!"

"Mickey Mouse First Named 'Mortimer,'" *Irish Times*, November 26, 1945

God Help us put this thing over—we are sincere and deserve it.

Walt Disney, September 25, 1928, in a letter from New York, where he was supervising the recording of the soundtrack for *Steamboat Willie*, to his brother Roy Disney back in Hollywood

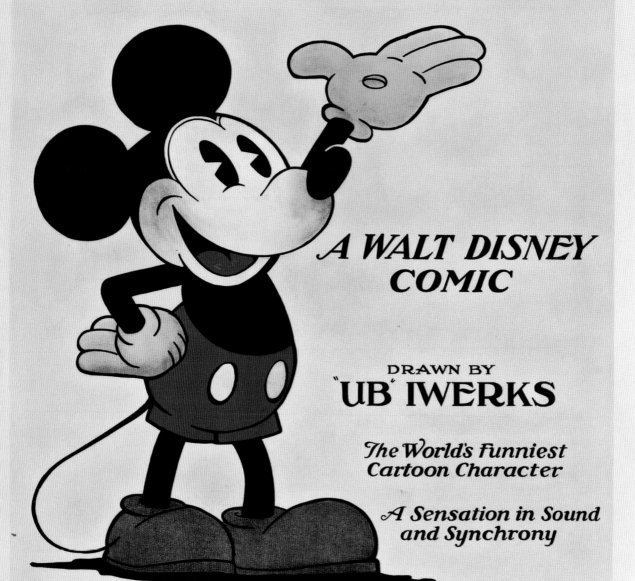

CONTENTS

INTRODUCTION

1. Walt Disney standing inside the Hyperion Avenue studio next to a shadow of Mickey, early 1930s, attributed to Tom Collins (active ca. 1930–35). A skilled polo player, Collins played at least twice with Walt on the same team in 1933. Walt's brother Roy, who also enjoyed the sport, purchased several polo ponies from Collins. The Walt Disney Archives, Burbank, California.

M ickey Mouse has been a part of our mental and emotional universe for over eight decades: as a font of mirth on film and in print, a plush doll or other consumer item, a corporate logo, and a cultural symbol. For a creature initially conceived—chiefly— as a means of keeping the Disney studio afloat after Walt had lost his contract to produce the Oswald the Lucky Rabbit series in March 1928, Mickey has had a long and remarkable run. Still, one may rightly wonder whether Disney's cartoon mouse—or, for that matter, any mass-market phenomenon, real or imagined—is all that important in the grand scheme of things.

In 1997, shortly before the release of a postage stamp featuring Bugs Bunny, one prominent philatelist complained that the U.S. Postal Service was "sinking to a new low in commercializing and trivializing its once high-minded stamp program." The Post Office had, however, already gone down that path four years earlier, in 1993, when it issued a glossy pink Elvis Presley commemorative. Since then, scores of figures in the realm of popular culture, from Charlie Chaplin, John Wayne, and Marilyn Monroe to Popeye, Superman, and Mickey, have joined the ranks of refined flesh-and-blood individuals—patriots, statesmen, scientists, and so on—for whom such dignities, as a rule, previously had been reserved. [1]

A Post Office spokesman defended its decision to honor Bugs Bunny by saying, "Bugs is an American icon." That succinct remark cuts to the heart of the matter. Popular entertainment has become a dominant gear in the clockwork of modern life. For better or worse, the darlings of secular culture are as precious today as the original icons—standardized wooden panels portraying Jesus, Mary, and the saints—were to Christians in the Middle Ages. [2]

But Mickey Mouse is no ordinary pop icon. Alone among his mass-cult brethren, he has been distinguished by the Postal Service no fewer than five times, starting in 2004, when he shared a stamp

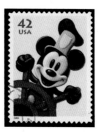

2. Mickey Mouse as Steamboat Willie, postage stamp designed by Terrence McCaffrey, Peter Emmerich, and Dave Pacheco. United States Postal Service, released August 7, 2008.

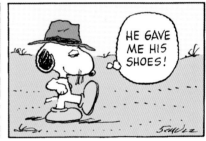

3. Charles M. Schulz (1922–2000), *Peanuts* Sunday comic strip, Oct. 13, 1996. United Feature Syndicate. The dog in this strip is Snoopy's desert-dwelling sibling, Spike. PEANUTS © 1996 Peanuts Worldwide LLC. Dist. By UNIVERSAL UCLICK. Reprinted with permission. All rights reserved.

with Goofy and Donald Duck, and, most recently, in 2008, by himself, in the lead role of his first animated sound cartoon, *Steamboat Willie* (1928) [2]. To a far greater degree than Bugs Bunny, or any other claimant to the status of "American icon," Mickey Mouse personifies both the fundamental qualities of the nation that begot him and its culture. To consider how Walt Disney's graphic invention came to be, and the complexities of its multiple meanings—which are the main goals of this book—is to better understand America and the wider world we all inhabit.[3]

In 1993, on the sixty-fifth anniversary of *Steamboat Willie*, a bronze statue was unveiled at Disneyland in Anaheim. It depicts Mickey standing atop a stone pedestal beside Walt, who gestures toward Main Street and the entrance to the park, remarking to his diminutive companion on "all the happy people who have come to visit us today." The sculptor, veteran studio employee Blaine Gibson, rendered his subjects as they looked in the mid 1950s, when the Magic Kingdom was inaugurated. The Mouse is rounder and heavier than he was in *Steamboat Willie*. Walt appears as the avuncular middle-aged man who had brought Disneyland into being and produced *Snow White and the Seven Dwarfs*, *Peter Pan*, and a raft of other memorable movies and characters in addition to Goofy, Donald, and Mickey. The monument thus conveys

a prosaic yet basic truth: almost from the beginning, Mickey Mouse has symbolized the aspirations and achievements of Walt Disney.[4]

At the core of their interlocking fortunes lies an intimate psychological bond [1] [4]. In his 2006 biography, *Walt Disney: The Triumph of the American Imagination,* Neal Gabler remarked that

> Mickey's intrepid optimism, his pluck, his naïveté that often got him
> into trouble, and his determination that usually got him out of it, even
> his self-regard, branded him as Walt's alter ego—the fullest expression of
> Walt Disney.

According to Mickey "himself," quoted in a French news magazine in 1978 on his fiftieth birthday, Disney might well have claimed, as Flaubert said of Madame Bovary: "Mickey, c'est moi."[5]

Cartoonists habitually identify with their handiwork. Charlie Brown, in Charles M. Schulz's *Peanuts* [3], famously reflects the trials, tribulations, and joys of the man who drew him. Chuck Jones, who helped to shape the vaunted Warner Brothers cartoon stable in

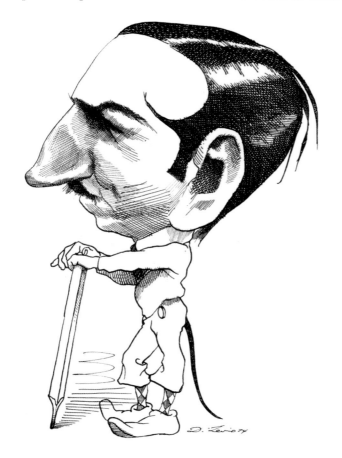

4. David Levine (1926–2009), caricature of Walt Disney with mouse tail, illustration for Robert Craft, "In the Mouse Trap," *New York Review of Books*, May 16, 1974. Pen and ink, 13½ x 11 in. Present location unknown.

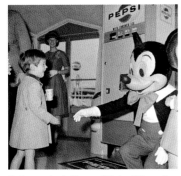

5. Four-and-a-half-year-old John F. Kennedy, Jr. (1961–99) about to shake hands with Mickey Mouse during a visit to the Pepsi-Cola/UNICEF Pavilion at the 1964/65 New York World's Fair, Flushing Meadows (Queens), New York City. Corbis Images/Bettman Collection.

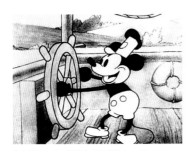

6. Ub Iwerks (1901–71), Mickey Mouse at the helm in *Steamboat Willie*, which premiered in New York on Nov. 18, 1928, and subsequently was distributed on a state-rights basis by Celebrity Productions. The Walt Disney Archives, Burbank, California.

the 1940s and '50s, Bugs Bunny included, confessed that the figure "with whom I most clearly associate" was Daffy Duck. Walt Disney made similar statements over the years, ranging from the disarmingly concise—"There's a lot of the Mouse in me," à la Flaubert—to longer, more explicit declarations:

> The life and ventures of Mickey Mouse have been closely bound up with my own personal and professional life. It is understandable that I should have a sentimental attachment for the little personage who played so big a part in the course of Disney Productions and has been so happily accepted as an amusing friend wherever films are shown around the world. He still speaks for me and I still speak for him.[6]

Mickey was indeed the fictional extension of Walt Disney, which is why this book is as much about him as it is the Mouse. For almost twenty years—until 1946—Disney found time amid the rigors of managing and building his animation empire, to record Mickey's screen voice and to mimic his squeaky speech for promotional purposes. Even Walt's family viewed man and Mouse as one. Nephew Roy E. Disney saw Mickey as "the naïve, trusting 'young feller' that represented the part of Walt who didn't ever want to grow up," and in 1973, seven years after Disney's passing, his widow, Lillian, recalled: "To this day Mickey can bring tears to my eyes. That's because Walt and Mickey were so 'simpatico,' they seemed almost like the same identity.[7]"

Disney's "little personage" bears a number of traits that attest to the youthful mindset of his maker: boundless energy, optimism, playfulness, independence, spunk, ingenuity, and a certain innocence. It is no coincidence, and undoubtedly is a key element in Mickey's abiding appeal, that these are among the traits that are most intrinsically and identifiably American.

Mickey was never just a one-dimensional cartoon mouse. He has enchanted children [5] and adults alike in myriad ways ever since *Steamboat Willie* [6] was first released in 1928, when, as John Updike later said, he "entered history as the most persistent and pervasive figment of American popular culture in this century."[8]

There has been a boom of late in Disney studies, including the Gabler biography; a sprawling exhibition in Paris, in 2006–07, *Il était une fois Walt Disney* ("Once Upon a Time Walt Disney"); and, in 2011, Timothy Susanin's monograph, *Walt before Mickey: Disney's Early Years, 1919–1928*. New information emerges constantly as more and more books, periodicals, and archival resources go online, original Disney art and artifacts are sold on eBay or at auction, and bloggers, scholars,

and Disney historians here and abroad—such as Michael Barrier, Didier Ghez, and Jim Korkis—share their insights and discoveries. Since October 2009, the Walt Disney Family Museum has filled ten galleries in a former barracks on the grounds of the Presidio in San Francisco with a rich and informative array of Disneyana. Nonetheless, as Barrier commented in his 2007 study, *The Animated Man: A Life of Walt Disney,* "If such a thing as a 'definitive' biography of Walt Disney is even possible, it will be decades before it can be written."[9]

So, too, with Mickey. Though much has been made of him over the past three quarters of a century, this book marks a first attempt at a comprehensive survey and analysis of his rise to cultural eminence. As such, it chronicles the confection, promotion, and many permutations of Walt's cheery alter ego. But what makes the book unique is the parallel tale it tells of how Mickey Mouse was received by the intellectual and artistic elite, and by the public at large, en route to becoming a ubiquitous planetary presence and a charged expression of the American spirit [7].[10]

As an emblem of America, its customs, vitality, and ideals, Mickey is—at times unfairly—freighted with the nation's perceived failings as well as its strengths. A British reporter, recounting a cruise-and-tour family vacation to Orlando and the Caribbean, observed that "Mickey Mouse and Minnie Mouse are king and queen in America, particularly in Walt Disney World, where young and old queue to meet them." But she sniffed, "Once the novelty has worn off, those of us Brits raised on Beatrix Potter find it all a bit over the top, particularly when charged £50 for a Mickey Mouse polo shirt. A week in the plastic world of Disney had me longing for bucket and spade holidays in Dorset."[11]

Mickey is featured by name in the sardonic lyrics of "Life on Mars?" by David Bowie (1971) as well as in Serge Gainsbourg's salacious French pop song "Mickey Maousse" (1981). The Blue Meanies in the Beatles' animated movie *Yellow Submarine* (1968) have Mouse ears. In the last sequence of Stanley Kubrick's *Full Metal Jacket* (1987), a platoon of Marines in Vietnam hikes off into the sunset chanting the Mickey Mouse Club March. Pop artist Claes Oldenburg, graphic satirist Saul Steinberg, West Coast painter Enrique Chagoya, and British sculptor Michael Sandle have, in their art, all been less than kind to the iconic rodent.

By and large, however, Mickey's reception in creative circles has been favorable. Soviet film director Sergei Eisenstein, the British sci-fi writer H. G. Wells, Steven Spielberg, and Kurt Cobain all were smitten by the Mouse. His image has been tucked, like a tiny truffle, into homegrown fiction such as Rex Stout's first Nero Wolfe mystery, *Fer-de-Lance,* Carson McCullers's *The Heart Is a Lonely Hunter,* John Updike's *Rabbit, Run,* and

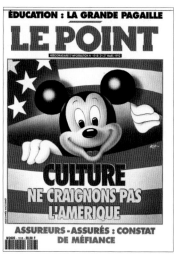

7. Laurent Melki (1960–), front cover of the French newsweekly *Le Point,* March 21–27, 1992, with the headline "Culture: Ne craignons pas l'Amérique" (Culture: Let's Not Be Afraid of America). Private collection.

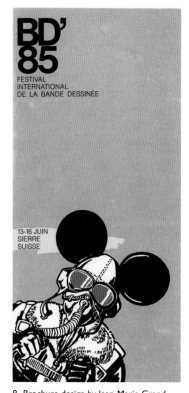

8. Brochure design by Jean-Marie Grand (1955–) for *BD '85/Festival international de la bande dessinée,* an international comics and cartoon and festival held in Sierre, Switzerland, June 13–16, 1985. Private collection.

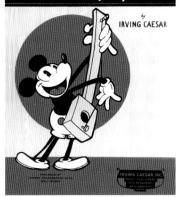

9. Irving Caesar (1895–1996), "What! No Mickey Mouse? (What Kind of a Party Is This?)," cover page to sheet music published in 1932 by Irving Caesar, Inc. This image of Mickey originated as a 1929 publicity drawing; starting in February 1930, it served as a logo for Mickey's German distributor Südfilm AG. Rob Richards Collection, Hollywood, California.

Dan Brown's page-turner *The Da Vinci Code*. E. M. Forster and Graham Greene were devotees, and his persona has cropped up in England in books as diverse as *The Luck of the Bodkins,* by P. G. Wodehouse, and *Goodbye, Mickey Mouse,* by Len Deighton. For the French littérateur Patrick Grainville, Mickey was a sort of monstre sacré.[12]

He has figured in a broad range of music, including his first official theme song, "Minnie's Yoo-Hoo" (1929), and a pop hit from 1932, "What! No Mickey Mouse? (What Kind of a Party Is This?)" by Irving Caesar [9]. He appears by name in Cole Porter's "You're the Top" and has inspired jazz (Chick Corea, "So Long Mickey Mouse"), punk (Subhumans, "Mickey Mouse Is Dead"), reggae, rap, mambo, folk, and at least one polka.

He had "bit parts" in Fritz Lang's film-noir masterpiece, *M*, and in Howard Hawks's screwball comedy, *Bringing Up Baby,* in which Cary Grant and Katharine Hepburn are mistaken for bank robbers and arrested. Ordered to identify their accomplices, Grant tartly retorts, "Mickey-the-Mouse and Donald-the-Duck." In the Preston Sturges movie *Sullivan's Travels,* an idealistic Hollywood director (Joel McCrea) is intent on making a ponderous social statement till he witnesses the salubrious effect of a Mickey Mouse cartoon on an audience of rural black churchgoers and their guests, a chain gang—mostly white— and its hard-boiled overseer. In *Crazy in Alabama,* the lead character (Melanie Griffith) explains how she was moved to kill and decapitate an abusive spouse by Mickey's desperate act, as the wizard's little helper, of hacking to bits the broom gone berserk in *Fantasia.*

10. Jack Ziegler (1942–), *New Yorker*, Oct. 10, 1988. The *New Yorker* has printed dozens of cartoons making light of Mickey over the years. Pen and ink. © Condé Nast.

LOS ANGELES, 1928:
MICKEY MOUSE EMERGES FROM THE PRIMORDIAL OOZE

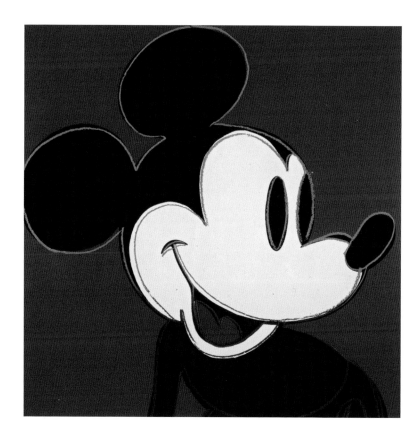

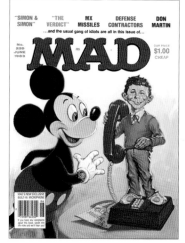

11. Andy Warhol (1926–87), *Mickey Mouse*, from the *Myths* portfolio, 1981. Acrylic and silkscreen ink on canvas, 60 x 60 in. Mugrabi collection. Image courtesy Ronald Feldman Fine Arts, New York, and The Andy Warhol Foundation, Pittsburgh, Pennsylvania.

12. Jack Rickard (1922–83), cover art for *Mad* magazine, no. 239, June 1983. MAD #239™ and © E.C. Publications, Inc. Used with permission.

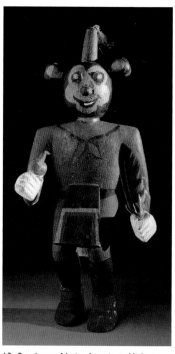

Countless cartoonists have inserted Mickey into their work [8]. As befits a *monstre sacré*, he has been vilified as Rat Fink, Mickey's "evil twin," by Ed "Big Daddy" Roth, teased in the pages of the *New Yorker* [10] and *Mad* magazine [12], parodied in a pastiche of *Steamboat Willie* on *The Simpsons*, mocked as the boss man of Disney Inc. on *South Park*, and reified in Native American folk art [13].[13]

Among the masters of twentieth-century figurative painting, Diego Rivera, George Grosz, Thomas Hart Benton, Roy Lichtenstein, and Andy Warhol all paid homage to the Mouse. In fact, I will argue in the conclusion of this book that Warhol's various iterations of Mickey [11] are the most satisfying visual formulation to date of what Edmund Burke, as far back as 1775, called the "American spirit." In the final chapter, I also examine the matter of what constitutes a genuinely "American" mode of art, and, scattered throughout these pages, I consider the kindred question of how Walt and Mickey have factored into the still unsettled debate in this country over the pros and cons of low versus high art.[14]

Chances are, Mickey will never regain the box office clout he enjoyed in the early and mid 1930s, when no other cartoon personality, or live actor, could match his hold on the popular imagination. However, based on his past-tense niche in motion picture history, in 1996 *Entertainment Weekly* rated the Mouse one of the "100 greatest

13. Southwest Native American, *Mickey Mouse Kachina*, after 1930. Carved and painted cottonwood sculpture, with feathers and string, 11¾ x 5⅜ x 4¾ in. Smithsonian American Art Museum, Washington, D. C.

film stars of all time." In 2002, *TV Guide* designated him the "ultimate pop-culture icon and multi-media star," and in 2005, *Variety* placed him in the top ten among one hundred media icons of the twentieth century (the Beatles were first). Like Marilyn Monroe, Elvis Presley, the Statue of Liberty, or a can of Coke, Mickey Mouse still looms large in our lives—but in ways more privileged and complex, and both negative and positive, than any other film or music legend, civic landmark, or omnipresent commercial item one can think of.[15]

The vast extent to which Mickey has permeated the fabric of society reflects the ascent in the twentieth century of three essentially plebeian forms of amusement—cartoons, popular music, and movies—that Jazz Age culture critic Gilbert Seldes, writing in the mid 1920s, numbered among what he dubbed the "lively arts." Fifty years later, in *The Culture of Narcissism,* historian Christopher Lasch declared that the media, "with their cult of celebrity and their attempt to surround it with glamour and excitement, have made Americans a nation of fans, moviegoers." By the end of the century, Neal Gabler would contend, in *Life the Movie: How Entertainment Conquered Reality,* that films and other popular diversions had come to represent "the primary value of American life." Nothing, said Gabler, weighs as heavily on our daily experience; mass entertainment has become "the most pervasive, powerful, and ineluctable force of our time—a force so overwhelming that it has finally metastasized into life." In other words: we've come to see ourselves through "showbiz"-tinted glasses.[16]

Aided and abetted by the press, itself a leading growth industry at the dawn of the twentieth century, show business, like amateur and professional athletics—exemplified by sports idols Babe Ruth and Jack Dempsey—became big business in the years around 1920, madly catering to an avid public with more disposable income and more free time than ever before. Among its shining attractions in that vernal epoch were stage and screen stars Charlie Chaplin, Al Jolson, and Mary Pickford, and three fledgling modes of mass communication: moving pictures, phonograph recordings, and radio. Near the end of this initial surge in the growth of modern mass-market entertainment, a tiny studio on the eastern fringe of Hollywood gave rise to a cartoon mouse with which, as Yale University professor William Lyon Phelps remarked in 1938, Walt Disney "conquers the whole world."[17]

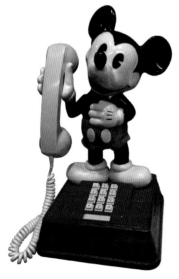

14. American Telecommunications Corp., "The Mickey Mouse Phone" Touch-Tone Design Line character telephone set, circa 1975–85. 14½ x 8 x 11 in. From the Dr. Ralph R. Chase West Texas Collection, Angelo State University, San Angelo, Texas.

Mickey Mouse has appeared in over a hundred cartoon shorts and thousands of comic strips and books, and has amused millions of people on television, video, and DVD. Human-scale Mickeys patrol Disney parks on three continents greeting visitors of all ages and nationalities. His likeness has been stamped on everything from coffee

mugs, designer jewelry, and disposable diapers to egg cups, milk bottles, bowling balls, and telephones [14]. During the Depression, sales of Mickey merchandise ushered in the now familiar strategy of year-round retailing of children's toys, and two companies, Ingersoll-Waterbury and Lionel Trains, were saved from bankruptcy thanks to unprecedented sales of, respectively, the Mickey Mouse wristwatch and Mickey-and-Minnie handcars. In the mid '30s, Mickey's films were used to promote the invention of television.

By then, according to Pulitzer Prize–winning journalist Alva Johnston, in a deft summation of Disney's early life and career—published in July 1934, five and a half years into Mickey's climb to fame and fortune—, the appeal of Mickey Mouse had reached "to and beyond the frontiers of civilization." Billed "as Miki Kuchi in Japan, Michel Souris in France, Miguel Ratoncito in Spain and Micky Maus in Germany," Johnston reported, Mickey had "received greater honors abroad than at home." Though he was banned, briefly, in Nazi Germany, Adolf Hitler secretly delighted in "Micky," whereas in Soviet Russia under Joseph Stalin, the Mouse was seen as a politically correct spoof of capitalism.[18]

In the 1950s, *The Mickey Mouse Club* broke fresh ground in juvenile television programming. In 1959, the first recognizable computer-generated image took the form of an abstracted head of one of Mickey's nephews. And, as reported a decade later in the *New York Times,* a cartoon-like sketch of *Geometric Mouse,* by Claes Oldenburg [15], was "said to have been clandestinely affixed to a leg of the lunar module Intrepid," which landed on the Moon in November 1969. This occurred at the height of the war in Vietnam, when Mickey's name became permanently attached to anything deemed dumb or trifling, a usage still current when the murky outcome of the 2000 presidential election prompted a London tabloid to display this bold-face, all-caps, page-one headline: "What a Mickey Mouse Way to Run a Country."[19]

"Though he belongs to the world," as the late pop-culture historian Marshall Fishwick said, "Mickey is the electronic embodiment of the American spirit and the know-how that has served us well in war and peace." He also remains, in all his many guises (electronic and otherwise), a source of pleasure and emotional reassurance for young and old, and a barbed cultural metaphor.[20]

In November 2000, after an eighteen-year hiatus, he returned as a forty-foot balloon in Macy's annual Thanksgiving Day Parade [16]. (He first appeared there in 1934.) In 2003, Kurt Vonnegut castigated the Bush administration for having seized control of the "federal government, and hence the world, by means of a Mickey Mouse coup d'etat," and, in 2007, the pseudo–Mickey Mouse host of a children's show aired on Palestinian TV urged his viewers to embrace terrorism.[21]

15. Robert Rauschenberg, Andy Warhol, Forrest Myers, John Chamberlain, Claes Oldenburg, and David Novros. Moon Museum, [1969]. Six drawings lithographed on a ceramic wafer, ½ x ¾ in., delivered to the moon on Nov. 14, 1969, (attached to the LEM-6 landing legs) as part of the Apollo 12 lunar mission. Photograph by Jade Dellinger. Courtesy of the Bob Rauschenberg Gallery, Edison State College, Ft. Myers, Florida.

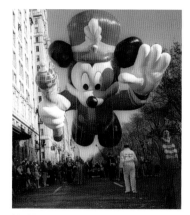

16. Mickey Mouse balloon in Macy's Thanksgiving Day Parade, Nov. 23, 2000. Getty Images.

Mickey is nothing if not iconic. To be authentically "iconic," however, entails an attribute greater, and more provocative, than garden-variety celebrity, notoriety, or excessive familiarity. Lest we forget, the term derives from a word, *ikon,* used to describe traditional sacred portraits in Eastern Orthodox religious art. Even today, properly applied, it denotes a being or thing touched by a vital spark, providing meaning, comfort, and connectedness across generational, ethnic, national, and class lines.

Anchored in what some might dismiss as trite or obsolete societal norms, no true icon will suit the values and taste of everyone. Any icon worth its salt invites ridicule or scorn [17] as well as approbation and devotion. This book, then, relates not just the story of how Mickey Mouse, one of the most widely circulated figures of modern times, was made, and how he has impacted and enriched our lives, but also how Walt Disney's cartoon creation has become a universal sign of guileless, childlike bliss and virtue, and the emblem of a people with a passion—all too often vulgar and self-indulgent—for personal fulfillment, individuality, and material as well as spiritual happiness.

17. William Joyce (1957–), cover for the *New Yorker,* Nov. 27, 1995. © Condé Nast Private collection.

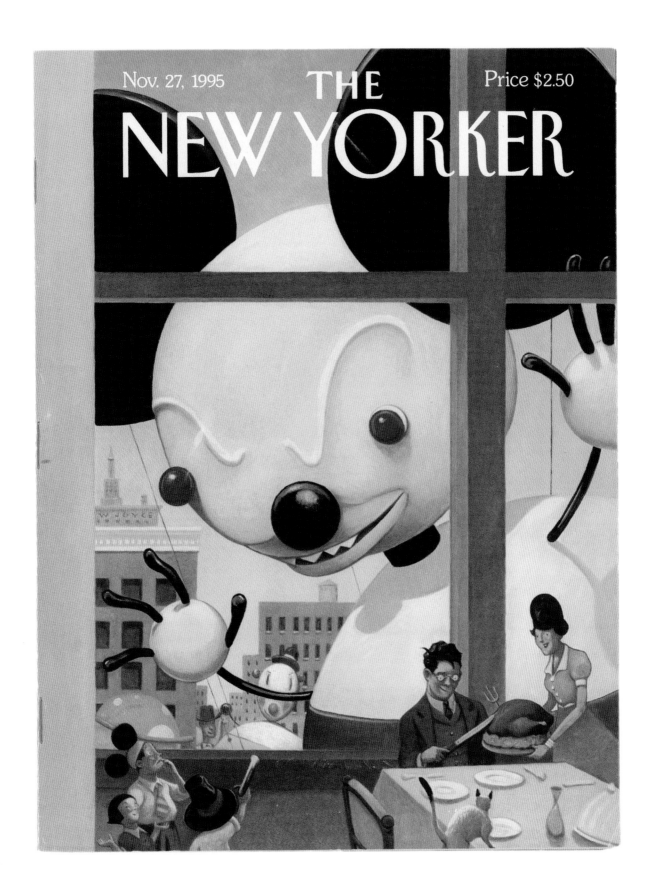

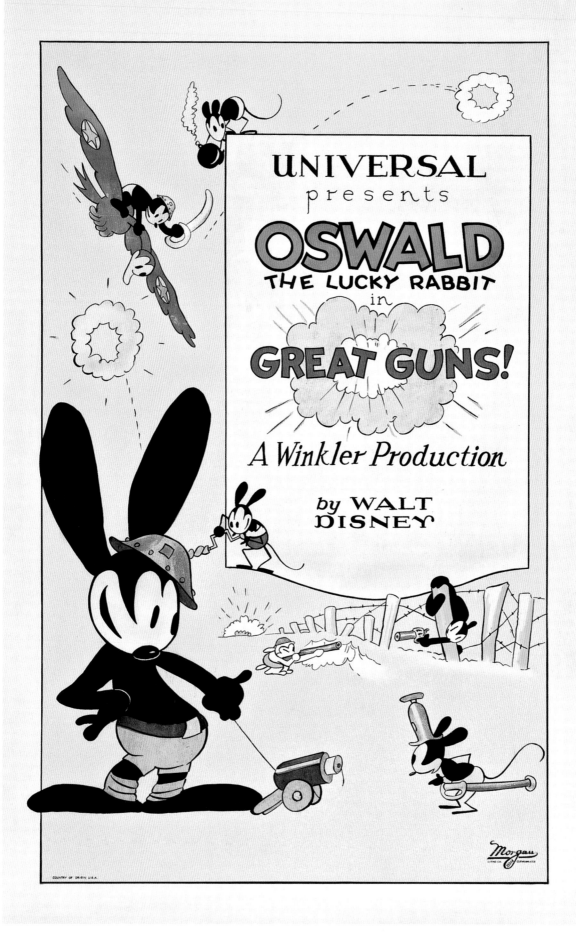

BEFORE MICKEY

W alt Disney did not set out to forge an "icon" with Mickey Mouse. Bringing Mickey to the screen was not the culmination of a long-cherished dream. Nor was Walt's future flagship character solely the product of artistic freedom and imagination. Mickey was primarily the circumstantial, fortuitous fruit of personal and professional necessity . . . and very much a reflection of the man who made him. This is why the creation and popularity of Mickey Mouse cannot be fully appreciated without taking into account the unique and distinctly American qualities of Disney himself.

In his often captious biography *The Disney Version: The Life, Times, Art and Commerce of Walt Disney* (1968), Richard Schickel, then a film critic at *Life* magazine, stressed his subject's "significance as a primary force in the expression and formulation of the American mass consciousness." Disney's artistic vision, Schickel said, had its failings: rank sentimentality, crass commercialism, comedic crudity. However, he declared, those flaws were the flaws of an entire country, and were well balanced by the virtues that Walt shared with his compatriots:

> [H]is individualism, his pragmatism, his will to survive, his appreciation of the possibilities inherent in technological progress, despite the bad odor it gives off today. [. . .] "The American mechanizes as freely as an old Greek sculpted, as the Venetian painted," a nineteenth-century observer of our life once said, and it is sheer attitudinizing not to see in our mechanized institutions one of the highest expressions of this particular genius of ours. These institutions may ultimately be our undoing, but it is being blind to history not to see that they were our making as well. It is culturally blind not to see that Disney was a forceful and, in his special way, imaginative worker in this, our only great tradition. [. . .] The industrial and entrepreneurial tradition that both moved and sheltered him was neither more nor less flawed than he was.[1]

18. Hugh Harman (1903–1982) and perhaps Carman Maxwell (1902–1987), poster for Walt Disney's first cartoon star, Oswald the Lucky Rabbit, in *Great Guns!*, released by Universal, Oct. 17, 1927. 27 x 41 in. Private collection.

Disney was born at a time when America's native genius for "mechanized institutions" was kicking into high gear, leading to life as we now know it—mostly urban or suburban, hectic, ever-changing, propelled by business and technology, focused more and more on pleasure and instant gratification. Theodore Roosevelt became president in September 1901, three months before Walt's birth, and determined to make the United States a global power. In 1903, Henry Ford, much admired by Disney, incorporated the company that would revolutionize manufacturing through the introduction of assembly-line mass-production methods, and Wilbur and Orville Wright made aviation history on a beach in North Carolina. Their innovations forever quickened the pace of human affairs, and laid the foundation for the nation's future economic and military might.[2]

In the realm of mass culture—the field in which Walt Disney eventually excelled—New York's Tin Pan Alley was, by 1900, home to a thriving popular music industry, and jazz, widely regarded as the only true American art form, was emerging. Three typically American genres of machine-age entertainment—comics, movies, and records (i.e., sound recording), all three vital to Walt's accomplishments—were taking hold as well. The first color comic star, the "Yellow Kid" (in *Hogan's Alley*), and the first daily comic strip of note, *Mutt and Jeff,* appeared in 1895 and 1909, respectively. In 1903, the landmark narrative motion picture *The Great Train Robbery* was filmed, and in 1904, Enrico Caruso began recording a historic series of 78-rpm discs for the Victor Talking Machine Company. It can be no coincidence that two other staples of America's modern mass-market "industrial and entrepreneurial tradition," fast food and spectator sports, also were coming into their own at the turn of the century. Coca-Cola was purveyed in bottles beginning in 1894, the first ice cream cones reportedly were served in 1896, and the first pizza parlor opened in New York City in 1905. In 1895, the first intercollegiate basketball and pro football games were played. In 1903, the country's swelling appetite for sports was further evidenced as Boston faced Pittsburgh in the first baseball World Series, and the storied career of Dan Patch, perhaps the greatest racehorse of all time, was launched.

Based on the premise that there are identifiable characteristics of specific age groups, William Strauss and Neil Howe, in their book *Generations: The History of America's Future, 1581 to 2069,* assigned Walt Disney to the "G.I. Generation," a cohort of individuals who battled the Great Depression and won World War II. Walt was a lifelong patriot who fits comfortably under that rubric. But, had he been born just a year earlier, in 1900, Strauss and Howe would have had to count him among the members of the "Lost Generation," many of whom were disillusioned by Woodrow Wilson's "war to end all wars."[3]

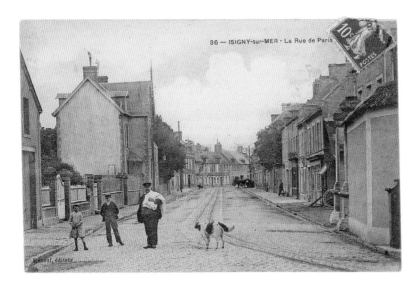

Disney could hardly be labeled a true rebel, disillusioned or otherwise. He was, nonetheless, as the *Saturday Evening Post* once put it, a "reckless" innovator, prone to bet his last dime on a dream. He gambled virtually everything he had to get Mickey Mouse off the ground, did the same in the mid '30s to fund *Snow White and the Seven Dwarfs,* and did it again in the 1950s to build Disneyland. It might be more fitting, therefore, to locate him on the cusp of the Lost and G.I. generations.[4]

Among Walt's gifted peers born in a seventeen-year period bracketing his birth, from 1893 to 1909, were Groucho Marx, Mary Pickford, Norman Rockwell, Jack Dempsey and Babe Ruth (the first superstars of sport), Henry Luce, (cofounder of Time Inc.), George Gershwin, Duke Ellington, Humphrey Bogart, Louis Armstrong, and Katharine Hepburn, whose names all appear again in the pages that follow. From the Midwest alone, where Disney grew up, his cultural coevals included humorist James Thurber, Buster Keaton, Ernest Hemingway, Charles Lindbergh, McDonald's mogul Ray Kroc, John Wayne, and Benny Goodman. Starting in the 1920s, and for decades to come, these talented individuals—coming along when they did, as the bandwagon of modern popular culture was getting underway—contributed more than their share to the maturation of the national "mass consciousness," and helped to realize America's rendezvous with its cultural destiny.

20. Lillian and Walt Disney on Disney Street, London, during a trip to England in the summer of 1965. In a letter to his sister Ruth Disney Beecher (Dec. 1, 1965), Walt said he'd learned that "a Disney Street and a Disney Place" got their names "in 1860 or thereabouts," but "that before they acquired the name of Disney, they had been known as Harrow's Dunghill!" The Walt Disney Family Foundation, San Francisco, California.

According to family lore, the Disney patronymic was originally "d'Isigny," meaning "of or from Isigny," a French town on the English Channel [19]. The first Disneys reputedly arrived in England in 1066 with William the Conqueror [20]. In the 1660s, Walt's paternal ancestors emigrated to Ireland, and, in the 1830s, his grandfather crossed the Atlantic to Canada. Walt's father, Elias Disney, came to the States in 1878, a date that is inscribed on the spine of a family album in the 1936 Mickey cartoon *Thru the Mirror* [21].[5]

After working on a farm in Kansas and as a railroad laborer in Colorado, among other jobs, Elias Disney married an Ohio-born

21. Mickey Mouse next to a family album dated 1878, in *Thru the Mirror,* released by United Artists, May 30, 1936. The Walt Disney Archives, Burbank, California.

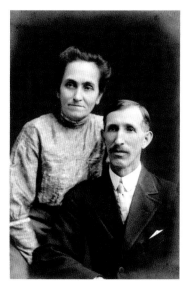

22. Flora Call Disney (1868–1938) and Elias Disney (1859–1941) in Kansas City, circa 1913. Walt Disney Family Foundation, San Francisco, California.

schoolteacher, Flora Call, on New Year's Day, 1888. Elias's ambitions were scattershot and not always prudent, and were usually ill fated. A hotel he managed with Flora failed, as did an orange-growing operation, both in Florida. In the spring of 1890, the couple moved to Chicago with their infant son Herbert, and Elias tried his hand in the construction trade. As an adult, Herb led a mundane existence as a postal carrier; a second boy, Raymond, sold insurance. Elias and Flora's third son, Roy O. Disney (1893–1971), was, of course, from 1923 till his death in 1971, chief financial officer of the Disney studio.[6]

Walter Elias Disney was the last of the four Disney boys. He was born on December 5, 1901, in the family home on North Tripp Avenue in Chicago. Elias had built the house himself, using plans conceived by Flora. Walt was named for Walter R. Parr, a Congregationalist preacher and friend of the elder Disney. A sister, Ruth, came along two years after Walt, almost to the day, on December 6, 1903.[7]

Flora and Elias Disney [22] were survivors: hard-working, thrifty, and willing to take risks. Walt inherited those qualities. Though Elias liked music (he played the violin), he was exceedingly sober and, by today's standards, a harsh disciplinarian. At his parents' golden wedding anniversary celebration, Walt kidded his father for having been "kind of ornery at times." Disney's penchant for pursuing his dreams and for building things, and his own occasionally ornery, driven temperament, came from his father. His artistic and theatrical talents, wit, and playfulness came from Flora. "My mother was the one with the humor," Walt recalled a half-century after his birth.[8]

In 1906, Elias decided to try his hand at farming and bought a spread in Marceline, Missouri, near a much larger property owned by his younger brother, Robert S. Disney. In his 1970 biography of Walt Disney, Bob Thomas said that this period in Walt's childhood left a greater mark on him than any other, so much so that, in 1950, when he built a barn to use as a workshop on his estate in the Holmby Hills section of Los Angeles, "it was an exact replica of the one he had known in Marceline." Hence, in part, the wisdom of an observation by Walt's daughter Diane Disney Miller that her father was "truly a Missourian."[9]

The tranquil formative interlude in Marceline was relatively short-lived. In 1911, the family set out once more after Elias acquired a newspaper distributorship in Kansas City, where, over the course of the next six years, Walt delivered papers for his father, morning and evening editions alike, seven days a week. At school, he was an indifferent student with a passion for drawing, and, in his teens, he decided to become a political cartoonist. He also had a gift for theatrics and vaudeville comedy, and was adept at impersonating Lincoln delivering the Gettysburg Address. Above all, like his British-

born teenage contemporaries Bob Hope and Laurence Olivier, Walt loved to imitate the Little Tramp character of Charlie Chaplin, whose motion picture comedies had by the latter part of 1914 made him an international sensation. Paired with a classmate, Walt Pfeiffer, he performed Chaplinesque skits for family and friends.[10]

In 1917, Elias Disney shifted careers yet again, taking a position at a jelly and fruit juice factory in which he was an investor, back in Chicago. After graduation from eighth grade, Walt remained in Kansas City for the summer to work as a news and candy butcher on the railroad, plying routes through Missouri, Kansas, and adjoining states. This experience gave him a wider glimpse of life beyond the relatively parochial bounds of Kansas City and rural Marceline, and it provided his first sense of real independence.[11]

That fall, he rejoined his parents in Chicago and began high school. After school, Walt worked at the factory where his father was employed and took cartooning classes at the Chicago Academy of Fine Arts, a school founded (in 1902) and operated by Carl Newland Werntz [23], a painter who'd had one-man shows in Paris and New York (where he met artists such as Man Ray). Werntz also had been exhibited at the Art Institute of Chicago, where he'd once been a student, and he published cartoons in the *Chicago Record*. Werntz wrote articles on cartooning as well. The academy's records indicate that Walt enrolled for one-month stints in October 1917 and January 1918. One course was taught by Lee Roy Gossett, a cartoonist at the *Chicago Herald* [24].[12]

During Disney's freshman year in high school, the United States entered World War I. Spurred by the example of *Chicago Tribune* political cartoonist Carey Orr [26], himself a former student at the Chicago Academy of Fine Arts, Walt contributed drawings to his school magazine, including cartoons in support of the war effort [27]. In the summer of 1918, he got hired as a postman by exaggerating his age. With his earnings, he took in movies and vaudeville shows, went on dates, bought a camera, and filmed himself doing his Chaplin routine.[13]

However, when brother Ray got drafted into the Army and brother Roy enlisted in the Navy, Walt itched to follow suit. Still a few months shy of seventeen, he was not yet old enough to serve in the military, but the American Red Cross Ambulance Corps had a minimum age of seventeen and was lax when it came to verification. Like fellow Illinoisans Hemingway and Ray Kroc, in September 1918 Walt Disney joined the Ambulance Corps, hoping to get into action through the back door. In his autobiography, *Grinding It Out,* Kroc recalled that he and Disney were both members of Company A at Camp King in Old Greenwich, Connecticut, prior to Walt's shipping out.[14]

Though the armistice effectively ending the war was signed in

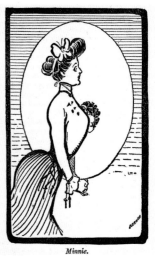

Minnie.

23. Carl Newland Werntz (1874–1944), "Minnie," illustration for "The Fable of the Veteran Club-Girl who had no Theories to Offer," in *The Girl Proposition: A Bunch of He and She Fables* by George Ade (New York, 1905), first published in 1902. Private collection.

24. Lee Roy Gossett (1877–1926), undated cartoon of a rooster examining a bullet (possibly related to the fighting in France in World War I). Billy Ireland Cartoon Library & Museum, The Ohio State University Libraries, Columbus, Ohio.

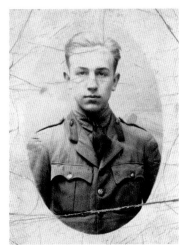

25. Photograph of Walt Disney in his Red Cross uniform, circa late 1918, sent home from Neufchâteau, France. The Walt Disney Archives, Burbank, California.

26. Tear-sheet of "The Tiny Tribune" by Carey Orr (1890–1967), published in the *Chicago Tribune*, May 28, 1918. Private collection. Carey Orr had been cartooning for the *Tribune* for no more than a year in May 1918. He remained with the paper until 1963 and received the Pulitzer Prize for editorial cartooning in 1961.

November 1918, Disney got his wish and left Camp King for overseas, arriving in December in Paris, where he experienced the City of Light still struggling under siege-like conditions. Initially, he chauffeured Army officers around town, then he became an ambulance driver, and, while based in Neufchâteau [25], in the Vosges region of eastern France, was assigned to drive a Red Cross canteen car.[15]

In April 1919, General John J. Pershing (who had grown up less than twenty miles from Marceline, Walt's boyhood home) sent his ten-year-old son and only child, Warren, to visit for a day. This was the result of Pershing's friendship with Walt's Red Cross boss, H. Alice Howell, who had met the general when she and Pershing, then a lowly first lieutenant, were instructors at the University of Nebraska in the early 1890s. Miss Howell and "Driver Disney," as Walt was called in his official orders for the trip, took Warren on an outing seventy miles north from Neufchâteau to Domrémy, birthplace of Joan of Arc. In a long personal letter to Miss Howell in 1931, Walt recalled the "wonderful picnic" they had, "with all sorts of good things to eat. And Boy! How good that fried chicken tasted!"[16]

During his tour of duty in France, Walt drew gag cartoons in his spare time that he submitted, unsuccessfully, to the American humor magazines *Judge* and *Life.* He also amassed a sizable nest egg from his salary, his winnings in a craps game, and his part of the profits from souvenirs he and a friend sold to troops bound for home. One of their tricks—an early sign of Walt's innate knack for salesmanship—was to take an abandoned German helmet, fire a shot at it, and, for a crowning touch, glue strands of hair to the rim of the bullet hole.[17]

After attending General Pershing's "farewell speech in Paris on the back of a truck," Walt was discharged and, in September 1919, was sent back to the States. During his ten months abroad, he had seen much of France, from Le Havre, Paris, and Strasbourg to Saint-Cyr, Marseilles, and Nice. He had grown both in maturity and physically, had honed

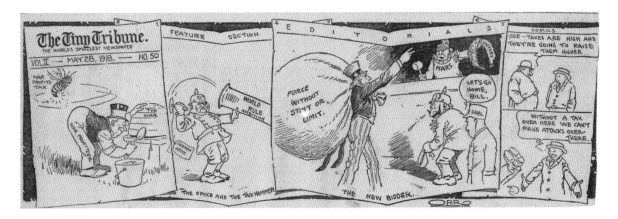

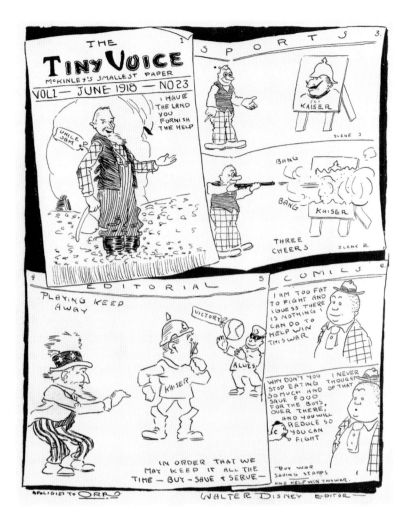

27. Walt Disney, "The Tiny Voice/McKinley's Smallest Paper," page of drawings in the McKinley High School (Chicago) student newspaper, *The Voice*, June 1918. As a boy, Walt clearly had the makings of a first-rate political cartoonist. This feature aped Orr's daily feature in the *Chicago Tribune*, "The Tiny Tribune/The World's Smallest Newspaper" [26], whose title played off the *Trib*'s once well-known motto "The World's Greatest Newspaper." The Walt Disney Family Foundation, San Francisco, California.

28. Detail of a photograph showing Walt Disney clowning around in Swope Park, the huge, wooded municipal park in Kansas City, March 12, 1922. Rudolf "Rudy" Ising probably took the photo. Ising and Hugh Harman, another of Walt's Kansas City pals, would go on to found both the Warner Bros. and the MGM animation studios in the 1930s. The Walt Disney Archives, Burbank, California.

his merchant skills, and, by American standards, had become a man of the world. When he reached Chicago, in mid October, the idea of completing high school seemed pointless. He likewise declined a position at Elias's factory, reportedly telling his father, "I want to be an artist."[18]

Walt decided instead to go back to Kansas City [28], where Roy Disney was clerking at the First National Bank. Uncle Robert had by then, for about a decade, resided in Kansas City as well. A canny wheeler-dealer (unlike Elias), Robert Disney was, as Walt later put it, the "real dandy of the family," and his avuncular presence in what was, in effect, Walt's hometown may have influenced Walt's decision to return to his old stomping ground. The aspiring artist applied for a job as editorial cartoonist—still his burning ambition at this stage in his life—with the *Kansas City Star*, where Ernest Hemingway had worked as a reporter before the war. Disney was rejected by both the *Star* and its competitor, the *Kansas City Journal*.[19]

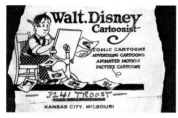

29. Walt Disney, caricature of himself printed on his business envelope, Kansas City, circa 1921. The address at the bottom, 3241 Troost, was handwritten above the original printed address, 3028 Bellefontaine, where Walt then resided. The Walt Disney Archives, Burbank, California.

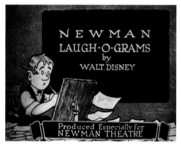

30. Walt Disney, title card with self-caricature for a "Newman Laugh-O-grams" sample reel, 1921.

When his career in art finally got going, in October 1919, it was on a far humbler level than that of a political cartoonist on a major newspaper. Thanks to a tip from Roy, who always had a soft spot for his kid brother, Walt became an apprentice with a commercial art studio run by two men, Lou Pesmen and Bill Rubin. It was there that he met a talented fellow apprentice of Dutch-German ancestry named Ubbe Iwwerks. After about a month and a half, however, as Pesmen-Rubin's pre-Christmas workload waned, Walt was let go, followed by Ubbe several weeks later. Using a portion of Walt's savings from France, the two newfound friends joined forces to open a shop of their own, Iwwerks-Disney Commercial Artists.[20]

It didn't last long. In late January 1920, Walt got hired by the Kansas City Slide Company and convinced his boss, A. V. Cauger, to employ Ubbe, too. The Kansas City Film Ad Service, as it was soon rechristened, made promotional shorts for local businesses, combining live action, animation, cut-out figures, and flash cards, that were shown in area movie theaters. These advertising spots were forerunners of modern-day television commercials and Web ads, and it was by helping to produce these films that Walt found his true calling. He quickly became hooked on the making of motion pictures—animation in particular— so much so that, soon after he commenced work at Kansas City Film Ad, he spurned what once would have been a dream come true, the post of political cartoonist on the *Kansas City Journal*.[21]

By early 1921, in his free time Walt was experimenting with animation and, while keeping his day job at Kansas City Film Ad, plunged into another side venture [29]. Working alone, he put together a string of cartoon shorts on local topics for a major theater chain in town. These "Newman Laugh-O-grams" were the first animations that Disney created entirely on his own. Heartened by their enthusiastic reception, he urged Cauger to extend the length of the Film Ad cartoons, but the suggestion was rebuffed. Forming yet another sideline operation, "Kaycee Studios" (in partnership with a Film Ad friend and colleague, Fred Harman), he provided newsreel footage to Pathé News and began working on an animated version of *Little Red Riding Hood* [31].[22]

In May 1922, Disney quit Kansas City Film Ad. Aided by Ubbe Iwwerks and other friends, he incorporated Laugh-O-gram Films [30], and, in June 1922, managed to catch the attention of *Film Daily,* a New York–based motion picture trade paper, which filed this brief report on Walt's budding operation:

> Kansas City, Mo.—Animated cartoons, to be known as "Laugh-O-Grams," will be produced by Laugh-O-Grams, Inc., which has just been organized. Walter E. Disney will draw the series which has been shown only at the Newman here for the last two years. Leslie B. Mace will take care of distributing.

Prompted perhaps by this engaging squib, a nontheatrical distributor in New York contracted with Walt in September 1922 for a set of fairy-tale spoofs to include *Little Red Riding Hood, Jack and the Beanstalk, Puss in Boots,* and *Cinderella.* The firm, however, went bankrupt and failed to pay for any of the finished product, and Laugh-O-gram's days were numbered. Its final income came from a tooth-care cartoon commissioned by a local dentist. Disney used the money on one last roll of the dice: a film about a modern-day Alice in Wonderland that united animation and live action. Max and Dave Fleischer had perfected this technique with their popular *Out of the Inkwell* series (Max went on to produce the Betty Boop franchise in the 1930s). Walt would approach the animation-and-live-action combo from a different angle.[23]

In the Fleischers' films, a cartoon clown named Koko popped out of an inkpot into real-world situations. Disney imagined the reverse: a live girl who entered a make-believe Cartoonland. In May 1923, he pitched the concept—"something new and clever in animated cartoons!"—in a letter to Margaret J. Winkler, a young woman who headed a releasing company in New York specializing in animated cartoons. M. J. Winkler had gotten her start in the business just a little over a year earlier by marketing *Felix the Cat.* She also handled the *Inkwell* series and, in 1925, assumed distribution of a revamped version of the Krazy Kat series, animated by Bill Nolan [32]. And she liked Walt's proposal.[24]

Unfortunately, just as Walt completed a sample reel for his new project, *Alice's Wonderland,* Laugh-O-gram ran out of cash. Crushed by debt and disappointment, he received a letter from Roy telling him, "Kid, I think you should get out of there. I don't think you can do any more for it." Several years earlier, Roy had been diagnosed with tuberculosis and was being treated at a Veterans Administration facility in West Los Angeles. Walt heeded his advice, and at the end of July 1923, with the pilot in hand, he bought a first-class rail ticket on the Santa Fe *California Limited* out of Kansas City to join his older brother in L.A.[25]

The premise of a pie-eyed mouse as cartoon star is rooted in the literary tradition of the fable, wherein animals act and speak like people. It is a genre, at once edifying and entertaining, that goes back to Aesop by way of Joel Chandler Harris, Hans Christian Andersen ("The Ugly Duckling"), and La Fontaine. Such venerable ancestry notwithstanding, there was little precedent for animals as heroes—serious or otherwise—in western art prior to the nineteenth century.

Historically speaking, cartooning itself, a necessary precursor of animation, is a fairly recent medium. Witty or satirical drawings destined for mass consumption came of age only in the eighteenth century, and animals did not factor significantly in graphic comic art until the late

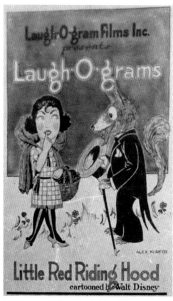

31. Poster for *Little Red Riding Hood,* Newman Laugh-O-grams, circa 1922. Detail from a photo provided by David Gerstein.

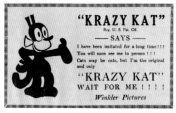

32. Advertisement for Winkler Pictures' Krazy Kat series, *Film Daily,* June 14, 1925. Image from *Film Daily.*

TYP. J. CLAYE.

33. Jean-Ignace-Isidore Gérard, pen
name J.-J. Grandville (1803–47), from
Métamorphoses du jour (Paris, 1847).
Private collection.

1820s. It was then, in magazines and in books such as *Metamorphoses of the Day* (1829), that the French caricaturist J.-J. Grandville began to conjure up the humanoid insects, fish, fowl, and other fauna for which he is now remembered [33].

Compared with the cartoons of today, the protagonists in Grandville's narratives were stiffly drawn. Because their humor lay primarily in the novelty of grafting animal heads onto fashionably clad human bodies and the droll situations in which his usually speechless cast was placed, Grandville's characters resembled mute mannequins in clever tableaux vivants more than actors in a comedic narrative. Circa 1827, Grandville's Swiss contemporary Rodolphe Töpffer developed a looser visual vernacular, but Töpffer, now regarded as the inventor of the comic strip, stocked his stories with human figures.

By the middle of the nineteenth century, Honoré Daumier, the first thoroughly modern cartoonist (he was the first to combine graphic political satire with an easeful, genuinely "cartoony" style), had begun lampooning French society and current events—though, again, like Töpffer, almost always without recourse to animals. In America, in 1895, Richard Outcault developed "the first great newspaper comic character," the Yellow Kid. It was not until 1910, however, that a significant comic-strip star in the form of an animal, George Herriman's Krazy Kat [34], was introduced. By the time Krazy Kat appeared in print, any filiation between him and Grandville's creatures was indiscernible.[26]

Grandville's impact was longer-lived in the field of children's book illustration. His fanciful figures have been cited as sources for Sir John Tenniel's drawings of the White Rabbit and the Cheshire Cat in Lewis

Carroll's *Alice in Wonderland* books. Grandville also influenced A. B. Frost's art for the Uncle Remus tales of Brer Rabbit, Brer Fox, and Brer Bear by Joel Chandler Harris, and the images of Toad, Rat, Mole, and friends in Kenneth Grahame's *The Wind in the Willows,* drawn by Arthur Rackham and Ernest H. Shepard [35].[27]

In 1930, one of Disney's artists showed him some stories illustrated by Rackham and N. C. Wyeth (father of Andrew Wyeth), saying, "Walt, wouldn't it be wonderful if we could make animation like these books?" Disney replied, "Maybe. Someday." By the mid 1930s he was doing just that. Veteran Disney animator Frank Thomas later recalled hearing that Rackham was asked to come over from England to work on *Snow White and the Seven Dwarfs,* and Thomas, along with a studio colleague, Ollie Johnston, surmised that the evil witch in the film was patterned after a hag drawn by Rackham for *Hansel and Gretel.* Disney scholar John Culhane also reported that Walt had his staff study Tenniel's and Shepard's work.[28]

In time, Walt would make cartoon adaptations of *Alice in Wonderland,* the Uncle Remus stories, *The Wind in the Willows,* and *Winnie-the-Pooh,* which had been illustrated by Ernest Shepard, as well. He did so (presumably) not so much because the art that accompanied the stories begged to be animated, but because they were compelling yarns. The pen-and-ink stylings of Tenniel, Frost, Rackham, and Shepard, like Grandville's, tended to be naturalistic. They provided invaluable frames of reference. But the leap to animation for such imagery required the far more relaxed and abstract, coloristic qualities that Disney and his men had mastered, qualities we've since come to expect from animated cartoons in general and cartoon characters in particular, in print or on film.

34. George Herriman (1878 1944). Detail from an original drawing for "Krazy Kat," 1922. Pen and ink, colored pencil, and graphite pencil on paper. Lawrence H. Bloedel Bequest, Whitney Museum of American Art, New York.

35. Ernest H. Shepard (1879–1976), illustration of Mr. Mole and Mr. Rat for Kenneth Grahame's *The Wind in the Willows* (London: Methuen & Co., 1931). In 1934, Lady Bridget Carlisle sent Disney a copy of this book from England. The Walt Disney Archives, Burbank, California.

With few exceptions (Krazy Kat, Pogo, Snoopy, Garfield, Shoe), the comic strip's predominant humorous figures have long been human: Mutt and Jeff, the Gumps, the Katzenjammer Kids, Popeye . . . Li'l Abner, Blondie, Charlie Brown, Beetle Bailey . . . Andy Capp, Michael J. Doonesbury, Dilbert. But in the domain of animation, over a forty-plus-year span—from the 1920s into the 1960s—animals predominated. Human leads in movie cartoons during that period (Farmer Al Falfa, Bosko, Betty Boop, and Mr. Magoo, for example) were far outnumbered by the likes of Felix the Cat, Oswald the Lucky Rabbit, Mickey, Donald Duck, Pluto . . . Daffy Duck, Bugs Bunny, Porky Pig, Mighty Mouse, Woody Woodpecker . . . Tom and Jerry, Tweety, Sylvester, the Road Runner, Wile E. Coyote, and the Pink Panther.

At first, animal protagonists were as rare on the big screen as they were in the comic pages, and almost always, as Donald Crafton, author of *Before Mickey: The Animated Film 1898–1928,* has pointed out, they

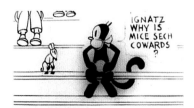

36. "Ignatz why is mice sech cowards?" Screen capture from *Krazy Kat and Ignatz Mouse at the Circus*, released by International Film Service, March 17, 1916.

37. By or after Johnny Gruelle (1880–1938), "The Quacky Doodles Family." *Moving Picture World*, Feb. 17, 1917.

were presented as "pets, sidekicks, or antagonists of the main characters." It was George Herriman's Krazy Kat who paved the way for animals as movie stars when he was converted to animation in 1916 [36]. Three years later, in 1919, a second feline, Felix the Cat [38], came along. Cartoonist Otto Messmer based Felix in part by on Krazy Kat and on Chaplin's Little Tramp, who, incidentally, had been featured in a series of animated shorts in 1916.[29]

The "Chaplin of cartoon characters," as Leonard Maltin called Felix, quickly rivaled the Little Tramp in popularity. (About 150 to 175 Felix the Cat one-reel shorts were made between 1919 and 1930.) The popularity of the Felix the Cat series, "the quintessential cartoon of the 1920s," Crafton observed, "encouraged other animators to develop their own animal heroes." Felix, Mickey Mouse, and other creatures that followed, Crafton added, "gradually redefined the animated genre as an artificial folkloric tradition."[30]

Redefining animation meant finding ways to adapt the ancient idiom of the fable to a newer, faster-paced mode of communication. In his memoirs, *Chuck Amuck: The Life and Times of an Animated Cartoonist*, Chuck Jones asked, "'Why do animated cartoonists use animals?' For the same reason that Aesop, La Fontaine, Kipling, Beatrix Potter, and Kenneth Grahame did: it is easier and more believable to humanize animals than it is to humanize humans."[31]

The use of animals as cartoon heroes was an inherently more amusing gambit as well. In a puff piece in 1917 about an animated cartoon duck and her family ("Quacky Doodles" [37]), created by Johnny Gruelle, the trade journal *Moving Picture World* commented, "Easily the characters that strike the average person as being funniest are birds and animals humanized." Walt Disney himself, in 1924, declared, "I believe that animals afford a bigger opportunity for laughs than people." In a more expansive discussion of the issue in *Chuck Amuck*, Chuck Jones formulated the choice between animals and people this way:

> In animated cartoons we do generally prefer animals to humans. First, if your story calls for human beings, use live action. It is cheaper, quicker, and more believable.[. . .] Second, as said, it is easier to humanize animals than it is to humanize humans. We are far too close to other human beings; we are subconsciously and consciously critical of other human beings according to how they deviate from our own behavior or from standards of behavior we approve of. Therefore, to many of us, everyone who looks like a cokehead *is* a cokehead. Everyone who looks like a bum *is* a bum.[. . .]
>
> It is in order to avoid these stereotypes that animators, as well as Aesop, Kipling, La Fontaine, E. B. White, Beatrix Potter, Felix Salten,

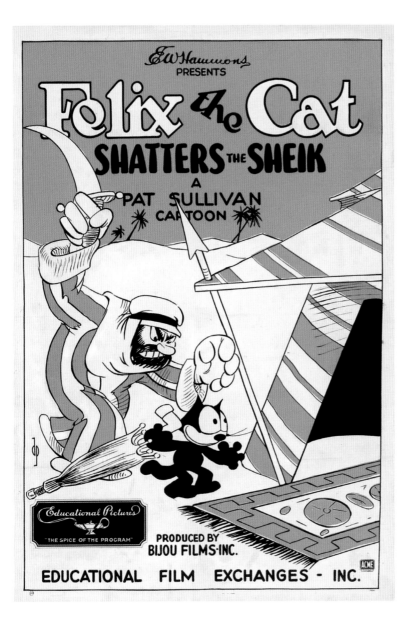

38. Dana Parker (1891–1933), poster for the cartoon *Felix the Cat Shatters the Sheik*, released by Educational Film Exchanges, Sept. 19, 1926. Collection of Mike Glad. Permission to use image provided courtesy of Don Oriolo and FTCP, Inc. © 2014 and ™ Felix the Cat Productions, Inc.

Walt Kelly, and countless other writers, turn to animals. People look at rabbits or ducks or bears as a class rather than as individuals, though it is true we stereotype those classes.[32]

Animation also has a more immediate, visceral appeal than comic strip art, not just because it moves—and on the motion picture screen, at least, is larger than life—but because, as a rule, it is less dependent on words. It is more completely visual, and, as Jones suggested, there is something about animals that liberates them, as characters, and the stories in which they appear from the stereotypical bonds of age, gender, nationality, and social class. This is why the unalloyed fantasy of animation and the time-honored, mythic power of fables were a perfect fit for each other.

It is the universality of the fable in all its forms, including animated

cartoons, that makes it a part of the cultural and moral glue that binds society together, preserving and passing customs, mores, and received wisdom on to posterity. After Disney's death in 1966, *New York Times* movie critic Bosley Crowther described him as "the most persistent and successful fantasist of our age." Crowther's comment was echoed in 1970 by the French film historian Maurice Bessy, who said that Walt was Grandville's "direct successor." In Bessy's estimation, Disney "stood out as the champion of gentility, or rather civility: a modern exemplar of the Fable, elevated by him to the dimension of motion through the magic of animation."[33]

Upon arriving in California in early August 1923, Walt rented a room from Robert Disney, who had moved west a few years before and bought a house on Kingswell Avenue in Hollywood. Working out of "the back end of a real estate office," a block or so from their uncle's house, over the next four years the Disney Bros. Studio—Walt and Roy Disney—would produce a total of fifty-six shorts known as the Alice Comedies [39].[34]

The springboard for the series was Walt's *Alice in Wonderland* film, which combined live action and animation. Though Hollywood was fast becoming the mecca for American movie-making, the financial and distribution end of the business was still anchored in Manhattan. So, on August 25, 1923, Walt renewed contact with the lady back in New York who'd been keen on the project a few months before. In October, Margaret Winkler sent him a contract, and the first Alice Comedy arrived in theaters in March 1924. Four months later, Disney received his first acknowledgment from a mainstream newspaper, the *Los Angeles Times:*

> In Hollywood a young cartoonist by the name of Walt Disney is making a series of twelve animated cartoon productions. Real people are seen acting with pen-and-ink actors. They are known as the "Alice" series and 5-year-old Virginia Davis, de luxe child dancer, has the big part. M. J. Winkler of New York is releasing the comedies.

The quality of the animation component of the films had by then been greatly reinforced by the arrival of Ubbe Iwwerks, who, heeding Disney's call, had come out from Kansas City and, by year's end, had simplified the spelling of his name to Ub Iwerks.[35]

Meanwhile, in November 1923, Margaret Winkler had wed Charles B. Mintz, a hard-nosed former booking agent for Warner Brothers, who immediately assumed operational control of Winkler Pictures. The Alice Comedies proved profitable enough for the Disney brothers

39. Poster for *Alice the Whaler,* released by Winkler Pictures, July 25, 1927. The Walt Disney Archives, Burbank, California.

the series you can book on pure faith, and our solemn word that they have the goods.

Film Daily, it should be noted, and its editor-president, Jack Alicoate—"a dandy fellow" (like Uncle Robert), as Walt would observe after meeting him in New York the following year—consistently supported the animator early in his career. Between 1922 and 1929, Disney was written up twelve times in the self-styled "Newspaper of Filmdom."[39]

With his contract for the series set to expire—and confident and proud of what he had accomplished with Oswald—Walt boarded a train to New York in February 1928, accompanied by Lillian, to ask for more money, only to be shocked when Mintz offered less than he was already getting. Disney was reminded that Universal, not he, owned the rights to the character. After that brutal fact failed to bring Walt to heel, Mintz is said to have threatened, "Either you come with me at my price, or I'll take your organization away from you. I have your key men signed up." Walt refused. After a futile appeal to the upper echelons of Universal, he abandoned his claim to Oswald and headed back to California. Before his departure from New York, on March 13, he sent a telegram to brother Roy:

LEAVING TONITE STOPPING OVER KC ARRIVE HOME SUNDAY MORNING SEVEN THIRTY DONT WORRY EVERYTHING OK WILL GIVE DETAILS WHEN ARRIVE=

WALT.[40]

44. Ub Iwerks, standard end title card for the Oswald cartoons released by Universal, 1927–1928. From a Walt Disney Archives 35-mm frame clipping, preserved 1971. Walt Disney Photo Library, Burbank, California.

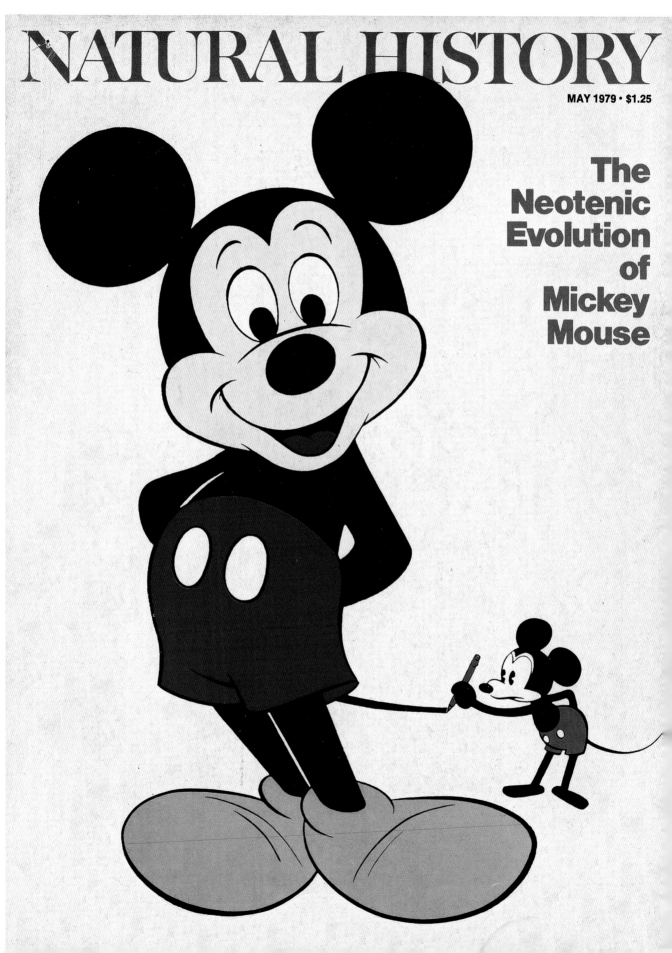

NATURAL HISTORY

MAY 1979 · $1.25

The Neotenic Evolution of Mickey Mouse

MAKING THE MOUSE

verything was not OK. And yet by the time Walt returned to California, whatever details he'd had in mind, however hazy, when he cabled Roy would—thanks to Mickey Mouse—lead to their salvation.

Those two words, "Mickey Mouse," trigger a mental picture almost anywhere on earth. Four basic elements affect our image of Mickey: our age, ethnic (or social) background, individual taste, and personal experience. Mickey's movie cartoons and newspaper comics of the 1930s were the chief frame of reference for the G.I. Generation; for Baby Boomers, it was the *Mickey Mouse Club* of the '50s; for youngsters in the 1990s, it was the hipped-up *Mouse Club* of Britney Spears, Christina Aguilera, and Justin Timberlake. But our perceptions are also a function of the verbal and visual references to Mickey that assail our senses almost every day, references refracted through the kaleidoscopic lenses of high and low culture and the media.

Suffice it to say, there has never been a definitive representation of Walt's disk-eared star. Variously different "Mickeys" have always jostled cheek by jowl. The little tyro discovered by picturegoers in 1928 was not the same fellow they would meet up with in 1935 or 1940. During the first ten to twelve years of its existence, the physiognomy of the character could shift, if only slightly, from cartoon to cartoon—and in some cases within the same film, depending on which animators were assigned to a specific sequence [46–47]. Nor did Mickey's on-screen persona necessarily fit the way he looked on title cards and lobby posters, as a toy, in comic strips and comic books, or any of his other commercial or promotional links.

There was, however, a trend to such herky-jerky changes. In a jovial disquisition published in 1979 in *Natural History* magazine, "Mickey Mouse Meets Konrad Lorenz" [45], Harvard scientist Stephen Jay Gould traced a pattern of "progressive juvenilization" [48] that produced the more genteel, childlike image of Mickey that has prevailed

45. *Natural History* magazine cover, featuring the story "Mickey Mouse Meets Konrad Lorenz," by Stephen Jay Gould, May 1979.

46. Johnny Cannon (1907–46), screen capture from *Mickey's Good Deed*, released by United Artists, Dec. 17, 1932. Here, as elsewhere in the book, screen captures from the animated cartoons are usually credited to the men who made the animation drawings that were transformed into cels by the Ink & Paint Department and photographed against watercolor or gouache backgrounds to create images like the ones seen on this page.

47. Tom Palmer (1902–72), screen capture from *Mickey's Good Deed*.

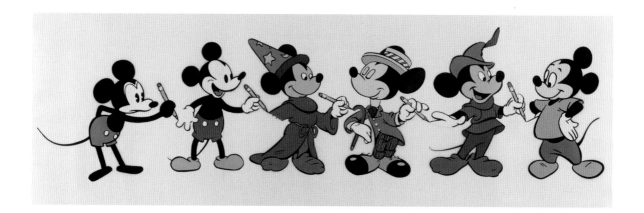

48. Three stages in Mickey's graphic development, illustration for Gould's article in *Natural History,* May 1979. Walt Disney Archives, Burbank, California.

over the past three quarters of a century. This reverse-developmental process, which began with the animated cartoons of the mid 1930s and intensified in the 1950s, is called neoteny. According to Gould, Mickey's neotenic conversion entailed modifications that gave him proportionately stubbier legs, a bigger, more rounded skull, and larger and more expressive eyes—in short, a more babyish countenance and figure. Citing the zoologist Konrad Lorenz's landmark tome *Studies in Animal and Human Behavior,* Gould explained that the juvenescent reconfiguration he described subliminally triggers a greater level of instinctive attachment in the eye (and heart) of the beholder than did the original Mouse.[1]

Paradoxically, this regressive transmutation was accompanied by a more calculated process that made him act more his age. Mickey's earliest roles were diverse, exotic, and exciting, the stuff of fantasy: he was a deckhand on a steamboat, a renegade of the pampas, a cowboy, a detective, etcetera. By the 1950s (he turned twenty-one in 1949), the adventurous side of Mickey was restricted to comic book stories. In films, newspaper strips, and other media, he had eased into a state of mellow, grown-up contentment, complete with house and virtual spouse and kids, without, let it be said, ever getting a steady job. (An iron law among "toons" seems to hold that *Homo sapiens* alone—a Fred Flintstone or a Homer Simpson—have actual careers.)

These characterological changes, played out more or less in tandem with his physical makeover, had unexpected consequences. Mickey's dip in the neotenic fountain of youth, described by Gould, yielded a softer personality and a more infantile look at odds with his "mature" bourgeois lifestyle as it evolved after World War II. The combined characterological and formal changes imposed on Mickey—again, paradoxically—also clashed with his more spirited image of circa 1928–1930. The resultant bastardy, a discordant mix of adult and child, helps explains why, after *Fantasia,* in 1940, the mouse came across as neither fish nor fowl nor frisky rodent, and was increasingly perceived as dull or bland.

Mickey's visual transformation parallels the standard textbook trajectory of ancient Greek statuary. In his first few years as a cartoon hero [50], his physical traits might be compared stylistically to those of

an Archaic kouros: youthful, primitive, radiating satisfaction and raw energy [49]. In films from the mid 1930s, like *Thru the Mirror* [52], Mickey's form, by then rendered in color—"rounder, sleeker, and far more human in appearance," as Richard Schickel put it—flirted with perfection. The antique analogue for this archetypal image is the Classical phase of Greek sculpture, which, as never before, combined naturalism with a refined sense of flawless human proportions [51].[2]

Within a few years, as in *The Pointer,* a more affective Mouse was developed [53]. Until then, his eyes had resembled two plump black olives. In the late 1930s, they began to look like true eyeballs, each orb set within a white oval outlined in black, thereby producing a more subtle range of emotive possibilities. The definitive formulation of the character at this stage in his evolution was as the young sprout in the "Sorcerer's Apprentice" segment of *Fantasia,* poised on the edge of a cliff [54]. This sublime image brings to mind Hellenistic-era goddesses in flowing drapery, personified by the *Winged Victory of Samothrace* [55] that crowns the main staircase of the Louvre in Paris. (The statue's original site was grander still: in a sanctuary on the Greek island of Samothrace, theatrically placed—like Mickey's apprentice on his rocky perch—on the sculptured prow of a ship, above pools of rippling, boulder-strewn water.)[3]

Finally, there is the "Decline-and-Fall" mode, as seen in children's books and comic strips drawn in the 1950s, '60s, and '70s [56], which cemented Mickey's degeneration into a fully clothed cartoon equivalent of a suburbanite dad in a postwar television sitcom. By the 1940s, though, it was already apparent that his cinematic vigor, like the brilliance of Hellenic culture two thousand years before, was dead or dying. Greece had been overwhelmed and subsumed by a more forceful civilization, that of the Romans. The new and improved Mouse, defanged and homogenized, would be shunted off center stage at the movies by hyperkinetic competitors such as Donald Duck, Popeye, Bugs Bunny, Tom and Jerry, and Woody Woodpecker, and by the benign neglect of Walt Disney, by then long preoccupied with feature-length projects such as *Snow White and the Seven Dwarfs, Pinocchio,* and *Bambi.*

What Mickey Mouse might look like ten or more years down the line, or whether he might even survive that long, were not, in March 1928, matters that entered Walt Disney's mind as he scrambled to develop Oswald's successor. He needed something fresh that would succeed immediately. With little time to ponder which particular qualities might make such a creation appealing, much less enduring, he had to improvise. In the end, much of what made Mickey "Mickey" came from within Disney himself. But Walt's comic wunderkind

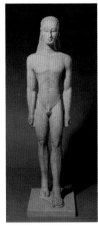
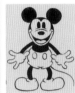

49. Archaic kouros from Attica, circa 590–80 BC, marble statue. © The Metropolitan Museum of Art. Image source: Art Resource, NY.

50. Figure from Mickey model sheet "No. 1," the first formalized animation model sheet, circa 1930. Walt Disney Archives, Burbank, California.

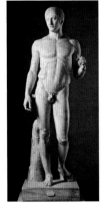
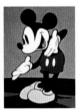

51. Roman marble copy after lost original by Polykleitos, *The Spear-Bearer,* circa 450–40 BC. Polykleitos is said to have invented the technique of contrapposto as a canonical means of representing the ideal human form. Museo Archeològico Nazionale, Naples.

52. Dick Lundy (1907–90), screen capture of Mickey in contrapposto pose in *Thru the Mirror,* released by United Artists, May 30, 1936. Walt Disney Archives, Burbank, California.

53. Frank Thomas (1912–2004), animation rough of Mickey Mouse for *The Pointer* (detail), released July 21, 1939. Graphite and red pencil on paper, 10 x 12 in. Andreas Deja collection.

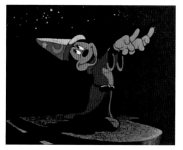

54. Screen capture of Mickey as the "Sorcerer's Apprentice" in *Fantasia*, released November 13, 1940. The animation of Mickey in this scene was supervised by Riley Thompson (1912–1960) and Cornett Wood (1905–1980). Walt Disney Archives, Burbank, California.

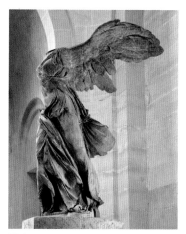

55. *Winged Victory of Samothrace*, circa 220–190 BC, marble statue. Musée du Louvre, Paris.

also was shaped by the intersecting spheres of Jazz Age animation, print cartoons, filmmaking, popular music, and other currents of contemporary popular culture.

In *The Story of Walt Disney* [86], published in 1957 and officially authored by Diane Disney Miller (albeit, she later candidly asserted, "wholly written" by veteran journalist Pete Martin)—an invaluable biographical account based on personal recollections from Walt and from Diane's uncle Roy—Charles Mintz was dismissively referred to as a nameless "Easterner who distributed the Disney films." Disney might have raised Oswald the Lucky Rabbit to a level of prosperity at least mildly comparable to what Mickey attained if the greedy Easterner had not muscled him out of the series. However, if that had happened, Mickey Mouse almost certainly would not have seen the light of day, and Walt might never have realized his full artistic and entrepreneurial potential.[4]

The history of Mickey's genesis is a tangled—often maddeningly tangled—knot of fact and fiction. Veteran entertainer and one-time child star Mickey Rooney, for example, insisted that the "Mickey" in "Mickey Mouse" was lifted from him. In his autobiography and in interviews, Rooney claimed that he met Disney at the age of five, on a lunch break at the Warner Bros. studio while shooting one of the *Mickey McGuire* comedies, a series of B pictures similar to the *Our Gang* films.

"Who are you?" I asked the guy working there. "My name is Walt Disney," he said. "Come over and sit on my lap." So I went over and sat on his lap, and there was a mouse he had drawn. "My gosh, that's a good-looking mouse, Mr. Disney." "It sure is, Mickey," he said, and he stopped and looked into space for a minute. "Mickey, Mickey," he said. "Tell me something, how would you like me to name this mouse after you?"

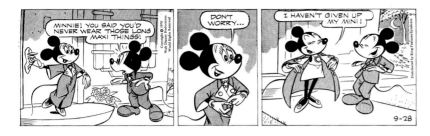

56. Del Connell (1918–2011), story, and Floyd Gottfredson (1905–86), art, *Mickey Mouse* comic strip, published September 28, 1970. Distributed by King Features Syndicate.

And I said, "I sure would like that, but right now I got to go get a tuna sandwich." And I jumped down.[5]

The name "Mickey Mouse" may well be related to the Mickey McGuire pictures, popular in the late 1920s, which, in turn, were based on a recurrent figure of that name in *Toonerville Folks,* a comic panel that had been running in the nation's newspapers for more than a decade by then. The names have a shared double-M consonance, and titles in the McGuire series, such as *Mickey's Pals, Mickey's Rivals,* or *Mickey the Detective,* presaged the titles typical of the Mouse cartoons. Nonetheless, "Mickey Rooney" could not have played a part in the naming of the Disney character. Until 1932, Rooney went by his real name, Joe Yule, Jr., and if, as he said, he was five when he met Walt Disney, that would place the event in 1925 or 1926 (Rooney was born in 1920). The Mickey McGuire films, which were not Warner Bros. productions, began in 1927, Mickey Mouse was spawned in 1928, Walt never worked at Warner Bros., and it is impossible to imagine him lolling about there anyway, sketching his as yet-unnamed-successor to Oswald. So Rooney's claim must be taken with a colossal grain of salt.[6]

As documented by Craig L. Andrews in his book *Broken Toy: A Man's Dream, a Company's Mystery* (1999), a more plausible namesake for Mickey was a wooden plaything patented in 1926 by Rene D. Grove for the Performo-Toy Co., Inc. [57–58]. Grove's product was widely marketed by Performo and, reputedly, also by the biggest toy distributor in America, the George Borgfeldt Co., for whom Performo also manufactured Felix the Cat toys. The features on the Performo plaything bear a certain if imperfect resemblance to those of Walt Disney's future Mouse, with (typically) an ebony body, arms, legs, and feet, a black-and-white cartoonish face, a red ball on the tip of its tail, black knobs for hands. What is most striking about the Performo toy is that it had a crimson badge on its chest inscribed "MICKY."[7]

Sources linked to Performo, according to Andrews, were convinced there had been a legal row with Disney. But he could not confirm their suspicions. Disney archivist Dave Smith, in a letter to Andrews, stated that he was "not aware of any legal dispute with the Performo Toy Company." Still, the similarities between "Mickey Mouse" and the earlier "Micky" are striking. Walt or Lillian Disney may have spotted the Performo toy in New York. They might also have seen it for sale on the train ride back to California or during a halt in the station at Harrisburg,

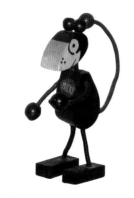

Aug. 17, 1926. Des. 70,840

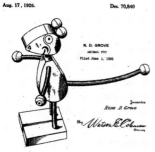

R. D. GROVE
ANIMAL TOY
Filed June 3, 1926

Inventor
Rene D. Grove
By Wilson E. Coleman
Attorney

57–58. "Micky Mouse" toy manufactured by the Performo-Toy Co., Inc., circa 1926. Painted wood and wire covered with fabric, 5 x 1 x 2½ in. Patent application #D70,840 submitted by Rene D. Grove and Performo was approved and issued on Aug. 17, 1926. Performo-Toy also manufactured a "Mickey McGuire" toy during the 1920s. Photograph of toy courtesy Bonnie and Joseph Stazewski, Middletown, Pennsylvania.

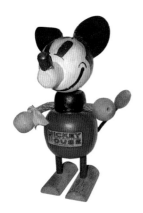

59. Mickey Mouse toy designed by Burt Gillett (1891–1971) and manufactured by the George Borgfeldt Co., 1930. Wood, leatherette, and rope. Note that the Borgfeldt "Mickey," like the Performo "Micky," has a bendable tail, arms, and legs made of what appear to be lengths of thick telephone cord wrapped in fabric. Carole Halstead, Santa Barbara, California.

Pennsylvania, near the Performo factory. Furthermore, if, as Andrews surmised, Performo felt Disney had copied its product, the Borgfeldt company was ideally positioned to block a potential court case. In 1930, Borgfeldt reached an agreement with the Disneys for a line of wares, including the first Mickey Mouse wooden toy [59]. Since Walt's rising star looked to be a more profitable property, Borgfeldt (hypothetically) could have warned Rene Grove that, should he sue, Performo's contracts with Borgfeldt for Felix and other toys would be canceled.[8]

Whether or not Grove considered legal action, we still must wonder: did Performo's Micky provide the name for Walt's mouse, thereby sowing the seed for the greatest entertainment enterprise in history? An unanswerable question, perhaps. However, even if Disney had in some way or other "copied" the Performo toy—and there is no proof that he did—the task of translating a rigid wooden figure into a commercially viable animated cartoon hero was by no means a slam-dunk proposition.

The knotted tale of the Making of the Mouse cannot be tied to any one specific source, much less compressed into a single ah-ha! moment of inspiration. It involves a welter of factors and circumstances, some of which, to one degree or another, may be forever shrouded in mystery.

A feeble first stab at a meaningful discussion of the matter was delivered by a top film critic of the day, Creighton Peet, in "Miraculous Mickey," a short piece published in a weekly magazine, the *Outlook and Independent,* in July 1930 [60]. But Peet was not drawn to how or why the character was created. He was attracted by Mickey's novelty as a screen sensation, by the freedom and artistry of the Disney studio's work in the Mouse cartoons, and, above all, by the Silly Symphonies, a line of animated one-reelers put into production in January–February 1929, each one constructed around a unique musical and narrative motif.

In his paean to Walt's talents, Peet wrote:

Should I ever visit Hollywood—that golden land where other people's ideas are used until they are threadbare and then patched a hundred times—there is but a single studio I should insist on visiting. This is the modest establishment which turns out the Walt Disney "Mickey Mouse" and "Silly Symphony" animated cartoons. These charming drawings, ingenious and often refreshingly original, are something of a high climax in the cinematic art—yes, art. They are "free" in the fullest and most intelligent sense of the term. [. . .] While even Charlie Chaplin must contend with a more or less material world, Mickey Mouse and his companions of the "Silly Symphonies" live in a

The success of Mickey Mouse is so great that it overshadows not only the competitors of Walt Disney in the field of animated comics, but Disney's own more interesting work, the "Silly Symphonies." Mickey Mouse is a movie comic of the first order, but I do not think its popularity depends entirely on its artistic merit; it has some of the element of a fad, where it joins the kewpie and the Teddy Bear, and I think because Mickey Mouse is a character, Disney finds himself forced occasionally to endow him with a verbal wit and to give him too much to say, which is against the spirit of the animated cartoon. The great satisfaction in the first animated cartoons was that they used sound properly—the sound was as unreal as the action; the eye and the ear were not at war with each other, one observing a fantasy, the other an actuality. The words of Mickey Mouse are still disguised as animal sounds, but the moment they are recognizable the perfection of the animated drawing is corrupted.[17]

Point taken. The Mouse was always more amusing for what he did, or stood for, than for what he said. All the same, Seldes was wrong when he claimed that Mickey had "some of the element of a fad." The Kewpie doll, likewise a hot-ticket item in the Borgfeldt inventory (based on elfin cartoon figures designed by Rose O'Neill), and, above all, cuddly Teddy Bears and Mickey Mouse, have, in one guise or another, remained with us for pretty much a century now, often collapsed into a single object, in the form of a plush Mickey doll.

One of the first accounts of how Mickey was created, by Harry Carr, a highly regarded journalist with the *Los Angeles Times,* was written for the March 1931 issue of *The American Magazine* [64–65], a little over two years into Mickey's rise to fame. After a curt allusion to Walt's breach with Mintz and Universal—Oswald "gave up the ghost as the result of a dispute between Disney and a motion picture releasing

64. Attributed to Les Clark (1907–79), with inking by Win Smith. These vignettes are from Harry Carr's March 1931 article in *American Magazine.* The piano-playing Mickey seen here appeared in print as early as December 1929 in a full-page ad in *Film Daily.*

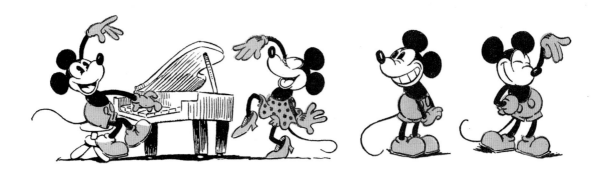

63. Clarence Sinclair Bull (1896–1979), photograph of Disney holding a cutout figure of Mickey designed by Ub Iwerks, inscribed "To Mother + Dad—from your Ornery Son and mischievous Grand son," published in *Silver Screen*, November 1932. The same image, minus the inscription, was used to illustrate Harry Carr's article "The Only Unpaid Movie Star," *American Magazine*, March 1931. Bull, a renowned and prolific stills photographer at MGM, is best known for his many publicity shots of Greta Garbo.

It is surely beside the point that [the] cartoon is not, and never can be, the highest form of expression in any medium. The cinema has not yet discovered its highest form of expression, but it has discovered, and perfected, the cartoon. I can imagine finer films than Mickey Mouse and the Silly Symphonies, but I cannot walk into a theatre and see them. Disney's work is here, and it is good; that somebody else's work must eventually be better, does not affect my pleasure in Disney to-day.[14]

Whether or not he had read Lejeune's critique—it's a safe bet that he did—Seldes finally acknowledged Mickey's widespread appeal in a profile of Disney, titled "Mickey-Mouse Maker," in the December 19, 1931, issue of the *New Yorker*: "In the current American mythology, Mickey Mouse is the imp, the benevolent dwarf of older fables, and like them he is far more popular than the important gods, heroes, and ogres." And yet, like Creighton Peet (and Lejeune), Seldes was unconcerned with how Disney's mythic "imp" came about, or its significance as a cultural phenomenon, probably because, as Seldes made clear near the end of "Mickey-Mouse Maker," he, too, preferred the Silly Symphonies to Mickey:

I have kept Mickey Mouse in the foreground because in general it is with Mickey that Disney is identified; but I belong to the heretical sect which considers the Silly Symphonies by far the greater of Disney's products. Although there is a theme in each one, Disney's imagination is freer to roam than it is in the more formal Mouse series. The Symphonies, moreover, are true sound pictures, without dialogue; the Mouse series has a tendency, lately, to run to verbal fun, which is a little out of place.[15]

The founder of the "heretical sect" to which Seldes said he belonged was Creighton Peet, who, in his 1930 article in *The Outlook and Independent*, had remarked: "It is in the 'Silly Symphonies' that the animated cartoon, now the musical cartoon, has achieved real triumphs." In the Silly Symphonies, Peet added, "Disney deals with ideas rather than characters," and does so "in perfect synchronism with the provocative" musical soundtracks of the films. Gilbert Seldes endorsed that rather elitist judgment. He also might have preferred the Symphonies because of the commercial exploitation of Mickey that was rampant by 1931 . . . or simply because he felt the imp was too "cute," a quality, it turns out, Walt Disney believed was essential.[16]

In a second article devoted to Walt and his cinematic artistry, "Disney and Others," appearing in *The New Republic* in June 1932, six months after his *New Yorker* profile, Seldes expanded on his initial tepid response:

62. Vignette from a *Film Daily* advertisement, May 13, 1929, used to illustrate "Mickey Mouse's Miraculous Movie Monkey-Shines," *Literary Digest*, August 9, 1930. This image also accompanied Walt's article "'Mickey Mouse': How He Was Born," *Windsor Magazine*, October 1931. (For another 1929 motif of Mickey playing the piano, see images 64 and 66.) Walt Disney Archives, Burbank, California.

slapstick and Chaplin), comic strips (*Krazy Kat* especially), musical comedy (George M. Cohan, George Gershwin), vaudeville (Eddie Cantor), burlesque, radio, popular music (ragtime, jazz, Irving Berlin, Jolson, Whiteman), café dancing, and the slang-riddled humor columns of "Mr. Dooley" and sportswriter Ring Lardner.

Motion pictures excepted, the "most despised" and "most popular" of these genres, Seldes argued, was the comic strip, which provided "a changing picture of the average American life" and "the freest American fantasy." Curiously, despite his affinity for movies and comics, affirmed at length in *The 7 Lively Arts*, Seldes regarded animated cartoons as a "good" but "irrelevant" form of filmmaking, on a par with newsreels, educational films, and travelogues.[12]

Seldes was not alone among his contemporaries in neglecting the rise of animation as a facet of modern life in America. In an engaging volume, *Only Yesterday: An Informal History of the 1920s* (1931), social historian and *Harper's* magazine editor Frederick Lewis Allen commented repeatedly on mass entertainment and popular "gods" such as Chaplin, Dempsey, Lindbergh, and Ruth, and noted in passing comic-strip characters such as Andy Gump. However, animation techniques were still comparatively crude in the 1920s, and nowhere in *Only Yesterday* did Allen refer to movie cartoons, Disney, or the historic first screening of *Steamboat Willie*. Five years later, in *The American Language* (1936 edition), the prolific journalist and essayist H. L. Mencken described "the comic-strip artist" as "a very diligent maker of terse and dramatic words," but Mencken never discussed comic art at any length, and he made no more than fleeting mention of Chaplin, Disney, or Mickey in his many writings or his private correspondence.[13]

During the 1930s, animated films increased in quality, invention, and, in intellectual circles, respectability, thanks primarily to Mickey Mouse and Walt Disney. In January 1930, Mickey rose a notch in critical esteem when he got his own syndicated feature in "the freest American fantasy" and the second "most popular" of Gilbert Seldes's lively arts: the comic strip. Eventually, some seven years after *The 7 Lively Arts* and eighteen months after Peet's article were published, Seldes chose to expound upon Walt and Mickey, spurred, we may suppose, by the opinion of Caroline A. Lejeune, a respected British movie reviewer, whose *Cinema: A Review of Thirty Years' Achievement* was written up in *Saturday Review* in October 1931. In this landmark early survey of the history of film, Lejeune wrote:

> Walt Disney's cartoons are, to my mind, the most imaginative, witty, and satisfying productions that can be found in the modern cinema.

Mickey Mouse, his lady love, a chaperon and the chickens go for a ride—(Drawn for the Outlook by the Walt Disney Studios).

special cosmos of their own in which the nature of matter changes from moment to moment. Mickey can play the great lover, the great hunter or the great toreador, after which he can reach inside the bull's mouth, pull out his teeth, and use them for castanets . . . he can lead a band or play violin solos . . . his ingenuity is limitless . . . he never fails . . . he is the perfect hero of all romance. He overcomes skyscrapers, mountains, oceans, or even the expanse of planets without so much as getting out of breath or singeing his whiskers.[9]

A month later, an anonymous writer in the *Literary Digest* declared [62]:

Reading Mr. Peet's eulogy of "Miraculous Mickey" in *The Outlook and Independent*, we realize that the funny little fellow at whom we have laughed so often, has met the same fate as many others who have set out to be merely amusing.

Like Krazy Kat, Charlie Chaplin, Joe Cook, Paul Whiteman, and detective stories, a few years ago, he is being "discovered" by the intelligentsia.[10]

This last remark alluded to the views of Gilbert Seldes [61] as expressed in *The 7 Lively Arts,* a collection of essays published in 1924 and devoted to Krazy Kat, Chaplin, vaudeville performer Joe Cook, and jazz bandleader Paul Whiteman, among other paragons—in Seldes's view—of early '20s pop culture. The cardinal thesis of the book, which established Seldes's reputation as a media maven, was the notion that the popular arts were more typically American and often qualitatively better than highbrow modes of expression. "Eighty per cent of the music heard" at the Metropolitan Opera, Seldes opined, "is trivial in comparison with either good jazz or good symphonic music," and a dramatic, game-winning home run by New York Yankees slugger Babe Ruth was proof that "the appreciation of aesthetic qualities is universal."[11]

The 7 Lively Arts was an idiosyncratic mélange of insightful reportage and personal opinion. Devoid (mercifully) of sustained conjecture on the merits of mass-market entertainment, the title of the book is, nonetheless, a tad disjointed. Seldes focused on nine—not seven—categories of entertainment: motion picture comedies (he loved

61. Carl Van Vechten (1880–1964), portrait of culture critic Gilbert Seldes (1893–1970), October 7, 1932. Library of Congress, Washington, D. C., Prints and Photographs Division, Carl Van Vechten Photograph Collection.

company"—Carr declared that it "was then that 'Mickey Mouse' was born." But, Carr wondered, how did it all happen?

> "I can't say just how the idea came," said Disney. "We wanted another animal. We had had a cat; a mouse naturally came to mind. We felt that the public—especially children—like animals that are 'cute' and little.
>
> "I think that we were rather indebted to Charlie Chaplin for the idea. We wanted something appealing, and we thought of a tiny bit of a mouse that would have something of the wistfulness of Chaplin . . . a little fellow trying to do the best he could."[18]

When journalist Dan Thomas, writing for a nationally syndicated Sunday supplement, *EveryWeek* (also March 1931), asked Walt why he chose a mouse, Walt said, "Principally because I needed a small animal."

> I couldn't use a rabbit because there already was a rabbit on the screen. So I decided upon a mouse, as I always have thought they were very interesting animals. At first I decided to call him Mortimer Mouse, but changed to Mickey as the name has a more friendly sound, and Mickey really is a friendly sort of character. We have become great pals. And I'm not fooling when I say that he is just as much a person to me as anyone I know. He actually is just like a child to me.

In preparing these contemporaneous stories, Carr and Thomas—together or separately—must have conferred with Walt or someone speaking on his behalf, possibly Harry Hammond Beall, who was described in July 1932 as "Mickey's chief press agent." The *EveryWeek* piece ("How They Make Animated Cartoons") by Dan Thomas is particularly noteworthy because he may have been the first person to reveal in print that Disney's preferred name for his hero—before settling on Mickey—had been Mortimer.[19]

Seven months after "How They Make Animated Cartoons" appeared,

65. Five more figures from Carr's article, all of which, in addition to the three vignettes opposite, appeared on a model sheet said to have been "created circa December 1929" and "used until the fall of 1931." See [66].

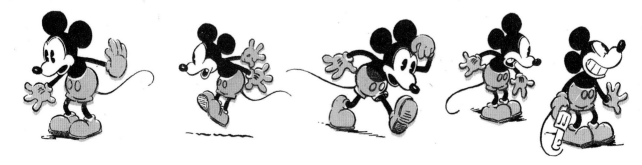

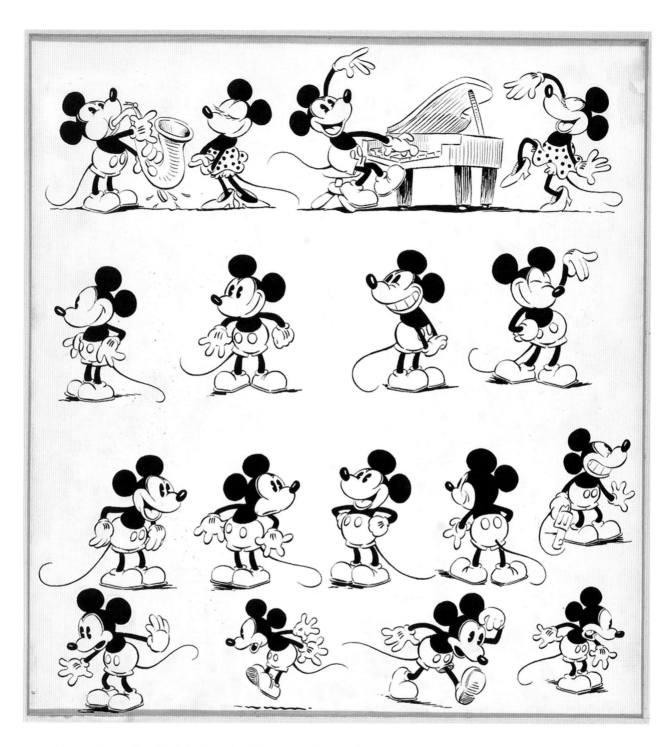

66. Attributed to Les Clark (drawing) and Win Smith (inking), original design for Mickey Mouse model sheet, dating from circa 1929, and used until the fall of 1931, courtesy Rev. Ed Bergen. The vignettes in the top row, plus four other Mickeys on the sheet, were used to illustrate the Dan Thomas article as seen in the *Ohio State Journal,* March 8, 1931.

Thomas's take on why Walt settled on Mickey was repeated virtually verbatim in "Mickey Mouse: How He Was Born," a text presented as having been written by Walt himself, in a middlebrow British monthly, the *Windsor Magazine:*

> Why did I choose a mouse for my principal character? Principally because
> I needed a small animal. I couldn't use a rabbit, because there already
> was a rabbit on the screen. So I decided upon a mouse, as I have always

thought they were very interesting little creatures. At first I decided to call him Mortimer Mouse, but changed his name to Mickey as the name has a more friendly sound, and Mickey really is a friendly sort of character.

These various statements, in the *Windsor Magazine* and in the reports filed by Harry Carr and Dan Thomas, hardly constitute a comprehensive explanation of how Mickey came about. But they do offer a fairly forthright response to the question. Together, as a unit, they form the first of four—ad hoc, at times inconsistent and overlapping—efforts, over a thirty-five-year period by Walt Disney, his family, publicity operatives, and an ever obliging press, both to satisfy popular curiosity with respect to how Mickey Mouse was born, and, from a business standpoint, to promote the studio's most prized property.[20]

The key points in these statements comprise what, in retrospect, may be termed "version 1.0" of the legend of the Making of the Mouse, to wit: after losing Oswald, Walt felt he had to create a new character along the lines of Oswald or Felix the Cat, with the "wistfulness" of Charlie Chaplin: a small, cute, friendly fellow, "trying to do the best he could," who, initially, was to bear the name "Mortimer." Nothing we've learned since regarding the circumstances of how Mickey came to be contradicts the "facts" contained in these three accounts.

In December 1931, "The True Story of Mickey Mouse," a less-than-factual hash of a piece, was published in the fan magazine *Movie Mirror*. Based in part (purportedly) on an interview with Mickey's creator, like the Carr and Thomas stories ("as Mr. Disney and I sipped our cool drinks"), the author, Sara Hamilton, made no mention of Chaplin or of Walt's belief that Oswald's successor needed to be cute. Instead—and here is where the legend of the Making of the Mouse gets a mite tangled—Hamilton claimed that after what she called the "Alice cartoons" caught on, "Walt conceived the idea of an animal for the chief character of the cartoons and someone chose a rabbit. And named it Oswald." That, of course, was not true. Hamilton likewise claimed that "in the back of Walt Disney's mind," while working on Alice, "lurked the tiny germ of an idea" that eventually led to Mickey. When she mentioned "Mortimer," she got that wrong too, saying, rather too colorfully, that Walt "soon decided on Mickey" because the earlier name spawned "spasms of Hollywood sarcasm."[21]

To her credit, Sara Hamilton did add three fresh and, no doubt, true—or substantially true—elements to the tale. The idea for a mouse, she reported, came to Walt en route back to L.A. from New York as the wheels of the train "turned to the tune" of "chug chug mouse," and the whistle screeched "A m-m-m owa-ouse." By the time he got home, she wrote, Disney "had dressed his dream mouse in a pair of red velvet pants

67. Undated photograph of Dorothy Grafly (1896–1980). The daughter of Charles Grafly, a sculptor and instructor at the Pennsylvania Academy of the Fine Arts, she was, at one time or another, an art critic for four Philadelphia newspapers and a contributing editor with *Art Digest*. Wichita State University Special Collections.

with two huge pearl buttons, had composed the first scenario, and was all set." This information, provided, perhaps, by Walt or a studio flack like Harry Hammond Beall, would resurface two years later, in January 1934, in Walt's second bylined piece for the *Windsor Magazine,* "The Life Story of Mickey Mouse."[22]

However, two months prior to the publication of "The Life Story of Mickey Mouse," in November 1933, at the height of the fifth-year celebration of Mickey's 1928 debut in *Steamboat Willie,* one more ingredient was thrown into the mix, as noted in an article, "He's Mickey Mouse's Voice and Master," written by Jack Grant for a second fan magazine, *Movie Classic:*

> There have been many stories of how *Mickey Mouse* originated. Some of these have Walt as an artist suffering various degrees of starvation in a garret, feeding a friendly mouse and having his great idea born from observation of the rodent. Intriguing though this romantic legend may be, unfortunately it is not true. Disney chose a mouse for his cartoons because he "wanted a little fellow."

According to Grant, stories about Walt the starving artist "feeding a friendly mouse," which had made their way into print as early as October 1932, were just that: "stories." Nevertheless, by December 1933, as the hoopla surrounding Mickey's fifth anniversary was winding down, the feeding-a-friendly-mouse meme had become a core component in "version 2.0" of the legend of how Mickey was born, promulgated over a fifteen-month period via an assortment of publications. Though the Making of the Mouse, per se, was a minor aspect in each instance, every text associated with this more romanticized version of the tale stressed Disney's special feeling for mice.[23]

The first significant elaboration of this revised account of the Making of the Mouse was authored by Dorothy Grafly, a Wellesley- and Harvard-educated art critic [67]. It appeared in the October 23, 1932, issue of the *Philadelphia Public Ledger* in conjunction with "Cartoons by Walt Disney," an exhibition at the Art Alliance of Philadelphia, as one of two unsigned sidebars to Grafly's review of the show. The other unsigned piece was a backgrounder on animation in which Walt was labeled as "one of the few creative minds working in an American idiom."[24]

In the first sidebar, a thumbnail sketch titled "An Artist of Our Time," Dorothy Grafly served up a brisk survey of Disney's life and career, undoubtedly derived from material furnished by United Artists, Walt's distributor. "It was not until 1928," she declared, that Disney

68. Vignette used to illustrate "Mickey Mouse's Miraculous Movie Monkey-Shines," in *Literary Digest*, Aug. 9, 1930, from a *Film Daily* advertisement, May 13, 1929. This image also accompanied Walt's article, "'Mickey Mouse' How He Was Born," *Windsor Magazine*, October 1931.

hit upon Mickey Mouse as star. Mickey was not born in a flash. His beginnings go back to the midnight hours that Disney spent in that Kansas City advertising concern, when he watched the antics of the office mice, and even trained one to sit on his drawing-board.[25]

Art Digest, in November 1932, reprinted Grafly's bit about Disney watching "the antics of the office mice," and, in a July 1933 article on animation in the *American Magazine of Art* [68], Grafly revisited the anecdote. "Working late into the night," she wrote, "he made friends with the office mice and taught one to sit on his drawing board, thus planting the creative seed that sprouted later in Mickey Mouse." Also in 1933, for a newspaper in Minnesota, Disney himself proffered a more detailed slant on the story:

> I first got the idea [for Mickey], I suppose, when I was working in an office in Kansas City. The girls used to put their lunches in wire waste baskets and every day the mice would scamper around in them after crumbs. I got interested and began collecting a family in an old box. They became very tame and by the time I was ready to turn them loose they were so friendly they just sat there on the floor looking at me. I had to shoo them away.[26]

In an analogous account in August 1933, journalist Edwin C. Hill, switched the locale from Walt's workplace to his personal workspace, where Mickey's future consort entered into the legend as well:

> Mickey was born in Kansas City. He was really a live mouse, playing unafraid over the drawing board of an ambitious art-crazy kid of 17, who was working in a five-dollar-a-month room over a garage in the Missouri city. That was how and where Walt Disney, Mickey's creator, got his inspiration, his model and his start. Perhaps one should say, really that there was actually a live Mickey and a live Minnie scampering over Walt Disney's drawing board as the young artist dreamed his dreams, for there were two mice that played about in Walt's room, and which he tamed and taught to pose for him. It's really a fascinating story.[27]

A sixth item, in the November 1933 issue of *Psychology* magazine, a forebear of *Psychology Today,* parroted the now established mythic line, including, again, the presence of a companion for Mickey:

> One evening as he [Disney] was bending over his drawing board, two little mice scampered across his table. Amused at their capers, he began to make friends with them. And presently they were serving as his models.

69. Photograph possibly by Cecil Beaton (1904–80), Eleanor Lambert (1903–2003), circa 1930. Courtesy of Bill Berkson and The Walt Disney Family Foundation, San Francisco, California.

70. Walt's niece, Dorothy Disney (1915–2007), circa 1923. The Walt Disney Archives, Burbank, California.

For hours they would sit on his drawing board, while he worked, combing their whiskers and licking their chops in true mouse fashion. And Walt would weave them into human situations and make them tell funny human stories.[28]

Established incrementally in magazine and newspaper stories like these, version 2.0 of the legend of how Mickey was born had, however, already reached its climax in the spring of 1933, with the most thorough packaging of the sequence of events up till then: a six-page booklet, *Notes on The Art of Mickey Mouse and his creator Walt Disney,* containing an essay by Eleanor Lambert [69], a press agent for several Manhattan art dealers and the Whitney Museum of American Art. Like Disney, Lambert was a Midwesterner (her Hoosier father had been an advance man for the Ringling Brothers, Barnum & Bailey Circus). She had been a student at the school of the Art Institute of Chicago and was in later years an early supporter of the Costume Institute at the Metropolitan Museum of Art (in 1962, she founded the Council of Fashion Designers of America).[29]

In April 1933, *Art News* magazine announced that the Kennedy Galleries in New York were presenting "Original drawings and watercolors by Walt Disney, creator of Mickey Mouse and the Silly Symphonies, sponsored by the United Artists' Corporation and the College Art Association." Elisabeth Luther Cary, art critic for the *New York Times*, reported that Disney had been invited by the association "to lend his original drawings to form a circuit exhibition for the leading museums and colleges throughout the United States." Lambert's *Notes on The Art of Mickey Mouse* was published by the College Art Association to be sold (at ten cents per copy) at the Kennedy Galleries and other venues on the tour, including its first major stop, in December 1933, at the Art Institute of Chicago. This is how her essay began:

> In a five dollar-a-month room over a garage which he proudly termed his "studio," a boy named Walt Disney used to sit at night and watch the antics of a pair of little mice. After weeks of patient persuasion, he had tamed them beyond the precincts of their hole in the base-board, across the floor and at last onto his drawing-board. There they sat up and nibbled bits of cheese in their paws or even ate from his hand. As he watched them, he sometimes wrote letters to his niece, aged six, daughter of his older brother who carried mail in Los Angeles. The letters described the activities of the mice and were sometimes illustrated with drawings of them, doing funny, fantastic human things.[30]

Lambert followed the studio talking points laid down over the preceding year, but added a new wrinkle to the story with her

71. Mickey and Minnie on skates, one of six illustrations in Eleanor Lambert's *Notes on the Art of Walt Disney*. Art attributed to Al Taliaferro; published contemporaneously in *Mickey and Minnie Mouse Coloring Book* (Saalfield, 1933). Walt Disney Archives, Burbank, California.

description of Disney corresponding about the mice with his niece. It is likely that this information came, one way or another, from Walt, although Lambert mistakenly said that the girl, the daughter of Walt's brother Herb, lived in Los Angeles. Dorothy Disney [70] and her parents resided in Oregon at that time and did not move to California until 1930.[31]

But there was more to Lambert's version of the legend. After a rundown of Disney's family background and artistic beginnings, including his previous employment as a commercial artist, she picked up the story leading to the birth of Mickey Mouse:

> The character of "Oswald the Rabbit" was his next creation. The success of this series was not by any means great, but this disappointment would probably not have driven the producer to summary action if it had not been simultaneous with the sudden introduction of sound and dialogue into picture, which completely demoralized the industry. Out of a job, he again found his brother (now, if anything, more confident in Walt than he was in himself) ready to back him on a new venture, one wholly new and completely his own, of synchronizing the actions of animated cartoon characters to music and dialogue. It was then, in the spring of 1928, that the idea of the mouse as a character recurred in Disney's mind. At first he was to be known as Mortimer Mouse but the name Mickey was soon introduced, and it stuck. The memory of the second little mouse who had nibbled the cheese so friendly back in Kansas City was realized in Minnie, Mickey's companion and leading lady [71]. Soon Mickey and Minnie were dancing in time to music, tripping off together on extravagant adventures, meeting the animals of the Missouri farm, who also danced and talked in perfect rhythm.[32]

Here again, Disney's relations with Mintz are only hinted at—and his loss of the Oswald series (which, as Alva Johnston observed, had in fact been "a great success") had nothing to do with the advent of sound. Nevertheless, by virtue of its verve and narrative sweep, *Notes on The Art of Mickey Mouse* was the mother of all future accounts of the birth of the Mouse, including one other variant of version 2.0, from a Georgia newspaper, that quoted extensively from a newsletter,

72. This is the only extant copy as of this writing of the earliest surviving full-color poster for the Mickey Mouse cartoon series, 40 x 26 in., 1929. Celebrity Productions, a Pat Powers company, later distributed Ub's Flip the Frog series. The poster sold at auction in December 2012 for $101,575. Mickey as seen here was drawn by Les Clark based on a motif created by Ub Iwerks. Walt Disney Archives, Burbank, California.

73. The same image of Mickey, was reworked for a general-use stock poster. Here the title of the film, *Wild Waves*, appears in a band of blank space near the top of the sheet, printed by Columbia Pictures, Mickey's distributor starting in March 1930. *Wild Waves* was first released by Pat Powers's Celebrity Productions, December 1929. Walt Disney Archives, Burbank, California.

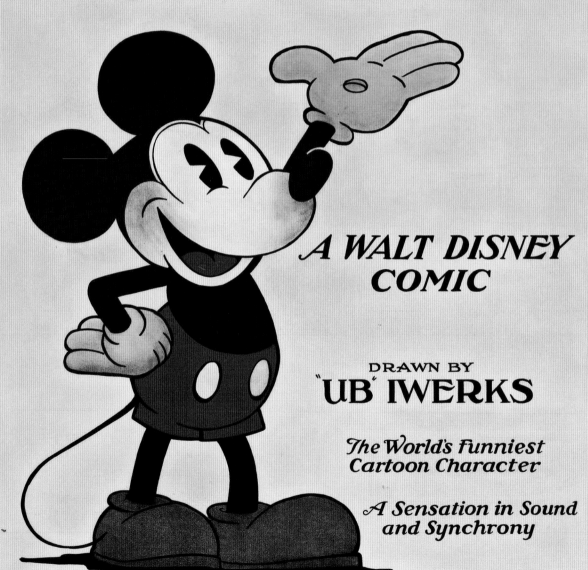

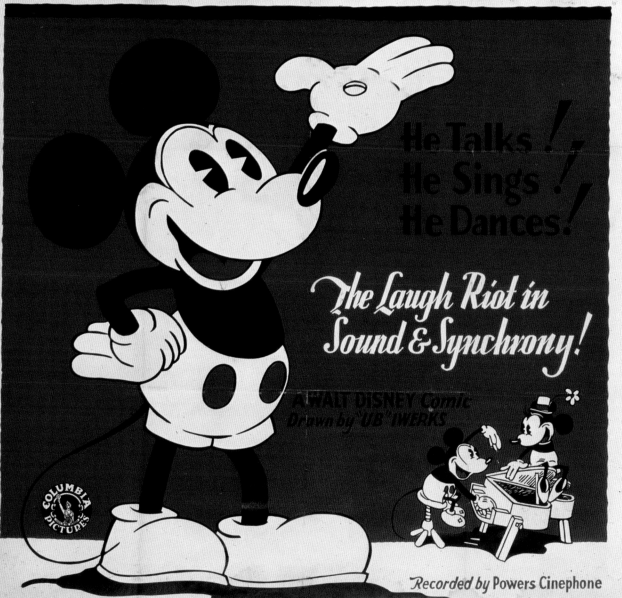

74. Bill Cottrell (1906–95) at the camera, with (on the wall behind him, far right) a variation on the waving Mickey motif seen on some of the earliest posters [72–73]. This photo dates from around the end of 1929. The Walt Disney Archives, Burbank, California.

based on Lambert's essay, circulated by the Art Institute of Chicago to publicize its hosting of the Disney show—though the paper further spoiled the bit about Walt writing to his niece, impossibly setting it in 1927, after he departed Kansas City. According to the *Athens* (Georgia) *Banner-Herald:*

> "It was Disney's brother's daughter, aged six, who was chiefly responsible for 'Mickey,'" its editor writes, "Six years ago Disney had a five-dollar a month studio over a garage where he sat at night and watched the antics of a pair of mice.
> "After weeks of patient persuasion, he tamed them so that they would climb upon his drawing board. There they sat up and nibbled bits of cheese in their paws and even ate from his hand. As he watched them, he occasionlly [*sic*] wrote letters to his niece. The letters described the activities of the mice and sometimes were illustrated with drawings of them doing funny, fantastic human things."[33]

Despite the odd misstatement or inconsistency, each of these stories published between October 1932 and December 1933 communicated a vision of Disney as, in the words of one writer, a sort of "St. Francis of the Silver Screen," befriending innocent creatures. As corny as it might seem in our more cynical day and age, there could be something to that kindly image. For who can say, with total assurance, that, as a struggling artist, Walt Disney had no empathy for mice, that a real-life Mickey and Minnie Mouse did not keep him company at night, and that he never considered turning them into cartoon characters?[34]

By January 1934, in Disney's story for the *Windsor Magazine*, a third version of the legend of the Making of the Mouse—version 3.0—had emerged. Although it appeared under Walt's name, it was based in part, as already noted (almost word for word in places) on information served up in Sara Hamilton's December 1931 *Movie Mirror* story, and was, no doubt, ghostwritten, like many others over the years, beginning with Walt's piece in the same publication from 1931. In this second *Windsor* article, "Mickey Mouse: How He Was Born," the Oswald fiasco was, once more, glossed over. Its principal thrust was on what passed through Disney's mind as he returned to California from New York:

> But was I downhearted? Not a bit! I was happy at heart. For out of the trouble and confusion stood a mocking, merry little figure. Vague and indefinite at first. But it grew and grew and grew. And finally arrived—a mouse. A romping, rollicking, little mouse.

The idea completely engulfed me. The wheels turned to the tune of it. "*Chug, chug, mouse, chug, chug, mouse*" the train seemed to say. The whistle screeched it. "*A m-m-mowa-ouse,*" it wailed.

By the time the train had reached the Middle West I had dressed my dream mouse in a pair of red velvet pants with two huge pearl buttons, had composed the first scenario and was all set.[35]

In June 1934, writing in the *New York Times Magazine,* Douglas W. Churchill put a less dramatic, though similar spin on the story:

When Oswald showed a profit, Disney, then in New York, asked for money with which to improve the picture. The distributors said no, so he parted with them. On the train back to Hollywood he tried to think of a new character. He recalled a mouse that he had once trained to sit on his desk while he drew—a mouse with a personality. He decided to take it to the screen. With Mrs. Disney, who had been one of his artists, he drafted the first scenario of the new series, and when he reached Hollywood he was ready for work.

They called the figure "Mortimer Mouse," but that didn't seem right. Finally they thought of Mickey. His inamorata they called Minnie.[36]

These two tales of Machine Age inspiration, like the timeworn yarn about Lincoln drafting the Gettysburg Address on the back of an envelope in a railway car, on his way to the site of the epochal battle, smack of mythmaking just as much as the legend propounded over the preceding fifteen-month period. Only here, a different image has been projected. In the *Times Magazine* piece, Disney's fondness for tiny creatures was de-emphasized and, in the *Windsor* article, scrapped altogether. He is revealed, instead, as one who, in the face of adversity, takes charge of his own destiny. This was the germ of observations such as John Culhane's remark, in 1978, that "Mickey began life as an expression of Walt Disney's innate optimism."[37]

Another intriguing aspect of the *Windsor* story is its reference to what Mickey wore when he was born. There is tangible support for the statement that he came dressed in "a pair of red velvet pants with two huge pearl buttons." The first known color poster for one of his cartoons, from 1929 [72][74], in a pose invented by Ub Iwerks, conforms to Walt's description. This figure, incidentally, was the basis for the first "classic" image of Mickey Mouse: right hand on hip, the other raised in a joyous gesture of greeting. (Ub was fond of this design: circa 1927 he had drawn Oswald the Lucky Rabbit, and would later depict his own uniquely personal creation, Flip the Frog, in the same attitude.) From

75. Earl Duvall (1898–1969) and Roy Nelson, (1905–56) artwork for *The Adventures of Mickey Mouse* (Book 1), David McKay Company, Philadelphia, 1931.

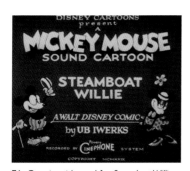

76. Opening title card for *Steamboat Willie*, distributed by Celebrity Productions. The Walt Disney Archives, Burbank, California.

77. Opening title, *Pioneer Days*, released by Columbia Pictures, Dec. 5, 1930.

1929 to 1933, this iconic stance was visible everywhere, in publicity shots [63] [83], and on book covers [152] and membership cards for the first Mickey Mouse Club [150], as well as on posters.

Red-shorted Mickeys were plentiful in the early 1930s as wooden toys [59] or stuffed dolls [158] and on the cover of the first full-color Mickey Mouse book [75], published by the David McKay Company of Philadelphia. But throughout the initial seven-year-run of Mickey's animations, his pants, and the buttons on them, bear no suggestion of color—for the simple reason that any shading in a black-and-white film intended to intimate a particular hue, such as red, would have diminished the contrasting tonal effect of the character's clothing against his black chest and legs.

That said, there were striking differences in Mickey's material trappings on title cards for the first black-and-white cartoons, even, in several instances, on the color posters and other objects that promoted them. The titles for the first three Mickey Mouse one-reelers, *Steamboat Willie, The Gallopin' Gaucho,* and *Plane Crazy,* show him in striped shorts with dark buttons, doffing a schoolboy's hat, leaning on a cane [86]. Closing cards for the same films have him hatless, in pale shorts with dark buttons. On title cards for cartoons from 1930 to 1932, the shorts are white with light gray buttons [77]. On promotional material from 1929 and 1931, Mickey's pants have a checkerboard or plaid pattern [78] [80], on a handful of posters—*Wild Waves,* for example, in 1929–30—the pants are white with red buttons [73], and on a pair from 1931–32 they're green [79] or pink.[38]

From this wild range of variations it is clear that, in the first years of Mickey's existence, at a time when he was still being animated in black and white, scant heed was paid to what his pants should look like. (Disney himself had little time to monitor promotional artwork, a task that probably fell, at the outset, to Ub Iwerks, until Columbia Pictures, which replaced Pat Powers as Walt's distributor in 1930, took over poster production for the Mouse cartoons.) As evidenced by the sequential record of the poster art, the now canonical scarlet hue of the character's shorts was not firmly established until about 1932 [82]. Thus, pants or no pants, striped, checked, red, or otherwise, we may conclude that, upon his return to Los Angeles, and for some while thereafter, Walt had a less than ironclad sense of what his hero should look like.

Walt was key to the making of Mickey from day one, and recorded his voice for years. But he never could draw him terribly well. It was Iwerks, Disney's top animator, and a much more gifted draftsman, who, as Dave Smith put it, "came to his salvation by helping" him with the design.[39]

WALT DISNEY'S **MICKEY MOUSE**

Terrific exploitation backs every
Mickey Mouse picture!

Nationally syndicated cartoon strips in the
largest newspapers—articles in the best mag-
azines—candy—toys—games—books and
scores of other tie-ups! Last but not least,
there's the "Mickey Mouse Club", a vast
alive organization of members whose great
interest in Mickey brings them to your theatre
every time he is on your screen!

The greatest cartoon character on
the World's Screen. Everybody
knows and loves him! His antics
brighten the tiny tot and the tot-
tering monarch! He has sold more
tickets than all the epic pictures
put together. He's in the news-
papers, the high-brow magazines
—and on the toy store shelf!
You couldn't get away from
Mickey if you wanted to—and
Gosh! who'd make a mistake
like that!

78. "Colorized" version of the Mickey in plaid shorts from a Columbia Pictures 1932–33 exhibitors' book. This figure of Mickey, originally drawn by Albert Barbelle, also appeared (in black and white) in the first *Mickey Mouse Book*, published in 1930 [152], and in the Feb. 16, 1931, edition of *Time*.

79. General-use poster for *The Moose Hunt*, released by Columbia Pictures, May 8, 1931, printed by the Morgan Litho Company. Walt Disney Archives, Burbank, California.

There is irrefutable proof of Ub's capital role in the delineation of the Mouse, notably the opening titles for the first fifteen cartoon shorts, from *Steamboat Willie* through *Wild Waves*, that identify them as "*A WALT DISNEY COMIC* by UB IWERKS," with Ub's name in bigger letters than Walt's. We have the 1929 poster [72] and an ad in a *Film Daily* yearbook [80], both emblazoned with the words "Produced by Walt Disney" and "Drawn by Ub Iwerks," plus two photographs: one, from 1929, showing Ub in shirtsleeves sketching Mickey [83], and a staff photo from around the same time, in which Iwerks is seen standing in the center of the group holding a cutout figure of the Mouse [84].

"Mickey Mouse" strips in some newspapers in 1930 were identified as "BY IWERKS," and five of the earliest discussions in print of the Mickey Mouse and Silly Symphony cartoon series, four of which were published in Europe—outside the studio's immediate public relations orbit—assigned Mickey's parentage to Ub. The first of these articles, "The Preposterous Rodent" (signed "Mercurius"), in the February 1930 issue of a British journal, *The Architectural Review*, described the Mouse cartoons

80. Advertisement from the *Film Daily* yearbook, 1929. Charles J. Giegerich (1880–1959) was a close associate of Pat Powers and eastern sales rep for the Powers company, which distributed Mickey cartoons from January 1929 into at least early 1930.

81. The Mickey vignette had been used in a Disney *Film Daily* advertisement, May 13, 1929. Walt Disney Archives, Burbank, California

82. Poster for *The Whoopee Party*, released by United Artists, September 17, 1932. Walt Disney Archives, Burbank, California.

83. Ub Iwerks sketching Mickey at his desk at the Hyperion Avenue studio, 1929. Mickey's pose as drawn here by Iwerks was the model for the figures on the two posters from 1929 illustrated on pp. 58–59 [72–73]. Walt Disney Archives, Burbank, California

as "Produced by" Disney and "Drawn by" Iwerks, exactly as they were identified in the *Film Daily* ad. A profile of Iwerks by Maurice Bessy in a leading French film magazine *Pour Vous* (March 1930), referred to Ub as "creator of Mickey." In May 1930, also in *Pour Vous,* Arsène Alexandre tagged Iwerks as "auteur des *Mickey*." In his July 1930 article, the American critic Creighton Peet claimed not to know who "the real genius back of these drawings" was, but said, "Until recently they appear to have been planned by a certain Ub Iwerks."[40]

In October of that year, for a piece titled "Avec Ub. Iwerks, père de Mickey Mouse," a correspondent for *Pour Vous*, A. E. Zischka, met Iwerks in Hollywood, nine months after Ub had ended his partnership with Walt. Zischka's interview produced this strange and fanciful account of how the two men met, and how their joint creation came about:

> "What was I before?" says Ub Iwerks when I met him in Hollywood, "a magazine cartoonist, which is to say I was in the boomerang business. Because for a long time ninety percent of my work never failed to come back to me.
>
> "Then, I made the acquaintance of Walter Disney who, way back, used to write ad copy, and sold suspenders and soap. He was in Hollywood at the time and had a little job in an office writing scripts. He drafted a few scripts for our little mouse Mickey, adapted the music for it; he did other things too."

Finally, in May 1934, in *Harper's* magazine, Arthur Mann stated that Iwerks, "who was then and still is the best animator in the film cartoon business," was "the artistic genius behind the early Disney animated cartoons, and his name appeared on the title flashes."[41]

In light of such overpowering evidence, a very important question must be asked: Why was Iwerks's name omitted in the various studio versions of the legend of how Mickey came to be?

The reasons are not hard to fathom. Ub had stuck with Disney after Charlie Mintz hired away most of Walt's key animators, and, in addition to his prominent on-screen credit, was financially rewarded for his loyalty. According to Arthur Mann, a "new partnership was drawn up," in which Iwerks "received about a fifth, and the Disneys divided the remainder equally." In January 1930, though, Ub fell out with Walt and started his own rival studio, surrendering his claim to a 20% share in the partnership (in exchange for a refund of $2,920 he had been paying the Disneys toward his interest in the business) as well as any proprietary claim on the Mouse. For years, Walt felt betrayed. The rift was repaired only after Ub's return to the fold, in 1940 (he stayed with the studio until his death in 1971, winning an Academy Award of Merit in 1965 for technical work

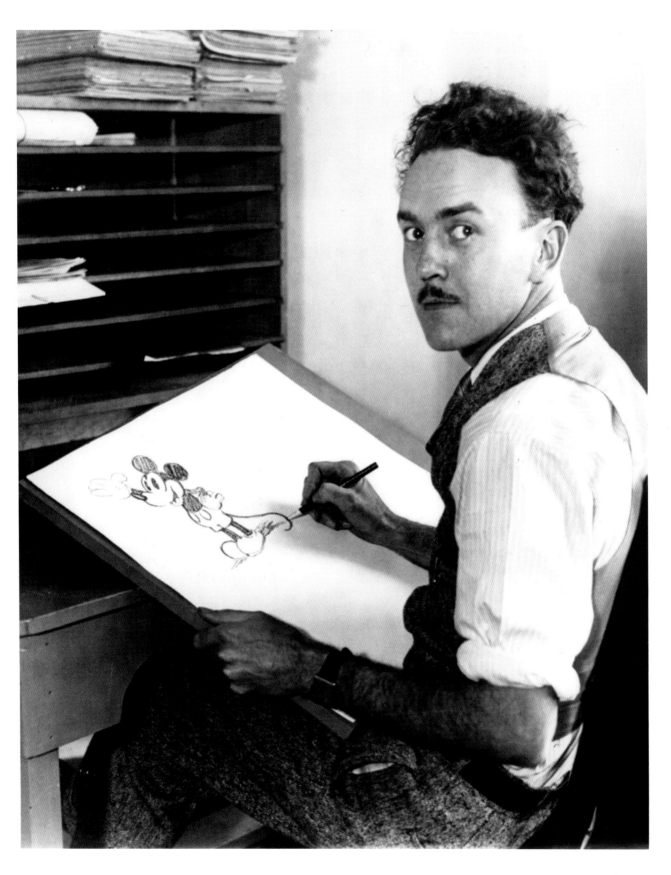

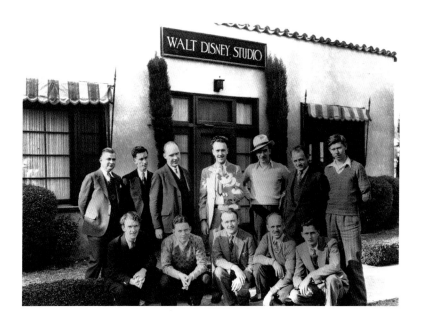

84. Walt Disney and members of his staff outside the main building at the Hyperion studio, with Iwerks (center, second row) holding a cutout of Mickey as he stands next to Walt, who is wearing a hat, circa 1929. Walt Disney Archives, Burbank, California.

on *Mary Poppins*). But Iwerks was on the outs in the 1930s as the mythic tale of Mickey's beginnings was, in fits and starts, cobbled together. Hence the silence with respect to Ub's pivotal role in the procreative process as related by Walt and the Disney studio for over three decades.[42]

It took that long for Ub to recover the credit he deserved. A publicity photo from around 1947, for example, showed Walt, pencil in hand, ostensibly finishing a sketch of Mickey as Steamboat Willie [85]. Sadly, Ub died before his rightful portion of the glory was restored. He was described in a wire service obituary in July 1971 as "Walt Disney's chief cartoonist and the man who helped create Mickey Mouse." In 1976, Disney biographer Bob Thomas said that "the real genesis of Mickey Mouse appears to have been an inspired collaboration between Walt Disney, who supplied the zestful personality and the voice for Mickey, and Ub Iwerks, who gave Mickey form and movement." In 1999, in his sumptuous art-book tribute to Mickey's life on film, Pierre Lambert observed that "Mickey Mouse was the product of the combined talents of Ub Iwerks and Walt Disney." Most conspicuously, in 2001, the centenary of Walt's birth, the Disney Company, propelled by Walt's nephew, Roy E. Disney, generously saluted its founder's longtime friend with a book and a documentary film, cowritten and produced, respectively, by Ub's granddaughter, Leslie Iwerks, both entitled *The Hand Behind the Mouse: The Ub Iwerks Story*.[43]

Disney's 1934 *Windsor* magazine piece, part of the third unofficial formulation of the Making of the Mouse—version 3.0—stressed Walt's singular, unaided talent, decisiveness, and resolve. The change it imposed on the original legend was, to some extent, surely calculated to strike a congenial Depression-era chord, much as version 2.0 had touted Walt's sympathy for the little guy. However, in a radio interview, probably in the late 1930s, Disney gave a primitive rendition of what

85. Walt Disney drawing a sketch of Mickey as Steamboat Willie, circa 1947–48. Walt Disney Archives, Burbank, California.

became the fourth and most definitive version of the legend issued in his lifetime. Here Walt seemed, ever so gently, to retreat from the brash claim that, as Marshall Fishwick later put it, the Mouse arose, "like Athena, full-blown from the brow of Zeus," fully formed from his imagination riding the rails home to California. In the interview, Disney declared:

> I was in New York at the time. I'd been producing a series of pictures for a company there. They were about a rabbit called Oswald. But I lost that. They took it away from me. So I was all alone and had nothing, and Mrs. Disney and I were coming back from New York on the train and I had to have something. I said, "By the time we get to Hollywood, I must have something, to . . . uh, I can't tell 'em I've lost Oswald." So I had this mouse in the back of my head because a mouse is a sort of a sympathetic character in spite of the fact that everyone is frightened of a mouse, including myself.[44]

In 1942, the key narrative threads from the preceding decade about how Mickey was born, including Walt's radio commentary, were rehashed, in summary fashion, by a defrocked assistant professor at Harvard, Robert D. Feild, in what, in retrospect, is a rather prosaic tome called *The Art of Walt Disney*. This first book-length study of Disney was published three years after Feild was chased from Harvard's Department of Fine Arts, an event that the student newspaper, the *Harvard Crimson,* said, "raised a storm of protest." According to the *Crimson,* Feild was the department's "most popular professor." Moreover, a mere six months earlier, Harvard had given Disney an honorary degree, hailing him as "a magician who has created a modern dwelling for the muses." In February and March 1939, concurrent with Feild's firing, Harvard's Fogg Museum of Art also mounted an exhibition, curated by Feild, devoted to Walt's work. Still, despite the honors showered upon Walt, and Professor Feild's popularity among his students, Feild was sacked by the university . . . evidently for the academic transgression of practicing "Mickey Mouse" art history, and the institutional sin of union-organizing.[45]

The "general purpose" of Feild's book was to promote the proposition that "the Art of Walt Disney" was "a growing force in our midst." Thinking a better grasp of the way Walt's cartoons were made would improve their critical standing, Feild, who had spent six weeks at the studio in 1938, stressed process—the mechanics of animation, how the business functioned—as opposed to historical, cultural, or esthetic considerations. He also favored the full-length features, *Snow White, Pinocchio, Fantasia, Dumbo,* and *Bambi,* over Mickey and Donald's one-reelers. Feild did, though, at the outset of his text, make the interesting

observation that the animated cartoon had been overlooked as art because it "did not require understanding to be enjoyed." Therefore, "we took it for granted or we ignored it."

> We have taken for granted even Mickey himself without questioning the source of his power.* We accepted Mickey so wholeheartedly that for years the idea never entered our heads that he was other than a fascinating cartoon character. We marveled at his antics and the ingenuity with which he went through his paces; we failed to realize the hypnotic power he was beginning to exert on us.
> * The reader will have to make up his own mind how to interpret the word "Mickey" in the following pages. It will be used indiscriminately with reference to Mickey himself or to the spirit of Walt Disney, either as a symbol of the art form or only a connecting link between two thoughts. What is Mickey anyway but an abstract idea in the process of becoming?[46]

It would have been nice had Feild addressed the matter of what that "abstract idea" was. Or explained in concrete terms what he meant by the "hypnotic power" of the Mouse and "the spirit of Walt Disney." Feild was mum on those points, and evinced no real curiosity about the circumstances surrounding the creation of Mickey. Instead, he merely recounted—vaguely—Walt's falling out with the proprietors of the Oswald series, and delivered a workmanlike story of what followed, in line with Disney's own statements and Dorothy Grafly and Eleanor Lambert's earlier reportage:

> Walt Disney boarded the train for Hollywood. What happened on his journey only Walt knows. But whatever may be hazarded now or in the future, we shall always believe that, in a railway coach journeying between New York and Hollywood, Mickey was given birth.
> The original mouse, the spiritual ancestor of Mickey, is reported to have made friends with Walt years before in the garage that served him as a workshop. He came to offer consolation during periods of despondency. Some say, even, that he trespassed on the master's drawing board, cleaning his whiskers with unconcern or hitching up his imaginary pants. The impression he left upon Walt's mind was such that it needed only a crisis for him to reappear in the form of a savior. Be this as it may, Walt had accepted a challenge, and he needed help. It was at this moment, on the train for Hollywood, that Mickey appeared before his mind's eye. Straightway he stretched out his gauntleted hand and said, "Put it there, pal," and a friendship was cemented for good and all.[47]

A little over a decade after Feild's book appeared, in the months leading up to the twenty-fifth anniversary of Mickey's debut in *Steamboat Willie*, versions 2.0 and 3.0 of the Mouse myth were combined, revised, and extended in a pair of articles for two mass-circulation magazines. The first of these, "I Live With a Genius," by Lillian Disney, in the February 1953 issue of *McCall's*, gave this explanation of how it all happened:

> [. . .] Stories have been printed about how Walt got interested in mice back on the farm in Marceline, Missouri, when he was a kid. Newspaper articles have told how Walt used to have a pet mouse named Mickey, which lived in his wastebasket during the free-lance cartoon days in Kansas City. Walt loves all animals—he won't even let the gardener and me put out traps for the little ones that are garden pests—but when he created Mickey Mouse there was no symbolism or background for the idea. He simply thought the mouse would make a cute character to animate.
>
> I'm getting ahead of my story, however, Roy and Walt were still working with Oswald the Rabbit when the New York distributor notified them that from now on he was cutting the price per picture almost in half. Walt went to New York to argue that they couldn't break even that way. I went along too, for a second honeymoon. It didn't turn out quite that way.
>
> Walt discovered that the distributor owned all the rights to Oswald and intended to go on making Oswald shorts without Walt if he refused to knuckle down to the cut price. Walt got mad and told the distributor what he thought of him. He came back to the hotel and announced that he was out of a job and glad, because he would never again work for anybody else. He never has, either.
>
> I know now how right his decision was, for to function, Walt has to be free. I didn't have the long-range viewpoint that day. I was scared to death. Walt didn't even tell Roy what had happened, but wired him that he was coming home with a great new idea. On the way back, on the train, he wrote a scenario for a cartoon short to be called *Plane Crazy* and starring a mouse named Mortimer.
>
> As for me, I was plain crazy. I sat watching the green of the Middle West change to sagebrush and desert. I remembered the early Hollywood days when Walt and Roy were so broke that they would go to a restaurant and order one dinner, splitting the courses between them. I knew I wouldn't care much for that. I couldn't believe that my husband meant to produce and distribute pictures himself, like the big companies. He and Roy had only a few thousand dollars between them. Pictures needed a lot of financing, even in 1927. And what if

86. Al Dempster (1911–2001) did the artwork for this paperback edition of Diane Disney Miller and Pete Martin's *The Story of Walt Disney* (New York: Dell, 1959). The first hardcover edition (Henry Holt and Company, 1957) used the same artwork. Private collection.

87. Cover of the *Saturday Evening Post*, November 17, 1956, by Gustaf Tenggren (1896–1970), who provided inspirational art for *Snow White and the Seven Dwarfs* and concept drawings for *Pinocchio*. The painting for the cover is in the collection of the Walt Disney Family Foundation. Mickey is actually the engineer on the train; Walt and friends are just along for the ride. Pete Martin's 1957 book *The Story of Walt Disney* first appeared in print in serialized form in the *Saturday Evening Post*, starting with this issue. In the book, for some reason, Martin had Diane refer to Walt as "Father," but in the *Post* articles, as in real life, he was "Dad." *The Saturday Evening Post* cover © SEPS licensed by Curtis Licensing, Indianapolis, Indiana. All rights reserved.

Walt failed? He had insulted his distributor and hadn't even looked for a new connection.

By the time Walt finished the scenario I was practically in a state of shock. He read it to me, and suddenly all my personal anguish focused on one violent objection to the script. "Mortimer is a horrible name for a mouse!" I exclaimed.

Walt argued—he can be very persuasive—but I stood firm. Finally, to placate his stubborn wife, Walt came up with a substitute: "Mickey Mouse." At this late date I have no idea whether it is a better name than "Mortimer." Nobody will ever know. I only feel a special affinity to Mickey because I helped name him. [. . .][48]

In late October 1953, eight months after *McCall's* published Lillian Disney's personal recollections, in the first installment of a two-part story, "The Amazing Story of Walt Disney," in the *Saturday Evening Post*, Jack Alexander told much the same tale:

Disney left the interview [in New York] in a state of shock. His little empire lay in ruins. Alice in Cartoonland had already run out its string. Oswald had been palmed, legally, by the hard-boiled distributor—who was soon to kill off the rabbit by trying to market an inferior imitation of it. Three thousand miles away, Disney's staff, which now numbered twenty-five members, would shortly have nothing to do but sit on their hands.

Afraid that morale would drop disastrously, Walt telegraphed Roy that everything had turned out great and added that he was bringing home a big new idea for an animal-cartoon series. All he had to do now was to come up with the big new idea on the train ride home.

From the time of departure Walt made trial sketches of practically every animal he had ever heard of, trying them in various poses in the hope of discovering a glitter of appeal in at least one. Neither he nor Mrs. Disney had detected any glitter by the time they reached Chicago and changed trains.

Walt resumed sketching as they whizzed westward out of Chicago. When he was ankle-deep in rejected drawings and getting mighty tired of it all, he began, for no explainable reason, to sketch mice. He found himself strangely amused as each new rodent figure took shape on his tablet. Suddenly, he shouted to his wife, who was dozing, "I've got him! Mortimer Mouse!"

Mrs. Disney was amused by the drawings, but she insisted—and even today cannot tell why—that Mickey Mouse was a better name. Walt, who was enjoying a happy creative delirium, accepted the suggestion.[49]

In 1957, for *The Story of Walt Disney* [86–87], Pete Martin crafted a crisp synthesis of the information in these two articles. After a painful review of Disney's dealings with Mintz, Martin has him saying to Lilly:

"[…] Let's get the first train out of here. I can't do any good in New York. I have to hire new artists and get a new series going. I can't sell a new series with talk. I've got to have it on film."

So they boarded a westbound train, and all the way across the continent Father tried to think up a cartoon built around a new character. Somewhere west of the Mississippi he decided upon a mouse.

Several stories have been told about Father's having had a mouse who lived in his desk during his Newman Laugh-O-Gram days in Kansas City. The thought back of this tale is that the mouse had given Father a special fondness for mice. "Unlike most of the stories that have been printed," Father told me, "that one is true. I do have a special feeling for mice. Mice gathered in my wastebasket when I worked late at night. I lifted them out and kept them in little cages on my desk. One of them was a particular friend. Then before I left Kansas City I carefully carried him out into a field and let him go."

Mice had been used in cartoons before, but until then they'd never been featured. "I think I've got something," Father told Mother. "It's a mouse. I'll call him Mortimer. Mortimer Mouse. I like that, don't you?"

Mother thought it over and shook her head. "I like the mouse idea," she said, "but Mortimer sounds wrong. Too sissy."

"What's wrong with it?" father asked. "Mortimer Mouse. Mortimer Mouse. It swings, Lilly."

But Mother didn't buy it. She couldn't explain why "Mortimer" grated on her. It just did.

"All right," Father said. How about Mickey? Mickey Mouse?"[50]

It is now commonly agreed that Lillian Disney [88] got Walt to drop the droll but prissy-sounding "Mortimer," though she has almost always been quoted as giving credit to her husband as the source of Mickey's name. "Mickey" was a smart choice for another reason: "Mortimer" basically mimicked the oddly comical moniker of Disney's ex-star and future competitor, Oswald. ("Felix" and "Julius" were not names of the average Joe either, hence Walt's rationale for "Mortimer.") Disney's new cartoon creation would be much more his own man, and a more regular guy, as plain old "Mickey."[51]

Nonetheless, Walt remained fiercely attached to "Mortimer." In September 1930, near the end of the first serialized Mickey Mouse comic strip story, "Mickey Mouse in Death Valley," Minnie and Mickey meet up with Minnie's rich Uncle Mortimer [89]. In a Sunday strip

88. Clarence Sinclair Bull, portrait of Lillian and Walt Disney and their pet chow in their house on Woking Way, Hollywood, circa 1933. Gelatin silver print, 9 x 7 in. Walt Disney Archives, Burbank, California

from October 1932, one of Mickey's nephews was presented to readers as Morty, . . . and in the 1936 color short, *Mickey's Rival,* Mickey had a slick antagonist named Mortimer [90–91].[52]

Mickey's name aside, what is significant about this last elaboration—version 4.0—of the legend of the Making of the Mouse, is that the main facets of the earlier versions—Walt's fondness for mice and his brave, solitary brainstorming—were fused with the fullest description yet of his dealings with Charles Mintz to form a relatively complete and accurate account of how it all happened. Of course, Walt's former partner, Ub, still has no place in this latest telling, which ignored another vital consideration, implied, a generation before, when Disney spoke of the public's liking for "animals that are 'cute' and little."

While sentiment, inspiration, and an affinity for the genus *mus* may have entered into the decision, at this make-or-break point in his career, Walt also had to really feel that by going with a mouse he was thinking with his head as well as his heart. As Robin Feild deduced, back in 1942, when he described Mickey manifesting himself before the "mind's eye" of the desperate young producer, "there was more to it than that."

> Spontaneous as Mickey's appearance may have been, the steps leading up to it had required much careful deliberation on Walt's part. He had been deprived of his rabbit, and almost all other animals and animatable creatures had been preempted upon the screen. What animal was left that offered the necessary human touch, the intimacy and playfulness, the power to appeal to one's sense of the ridiculous, and at the same time to inspire awe? There is no doubt that Walt, in his search, harked back to his little friend of earlier days. It was true, however, that Mickey's birth was to a large extent due to the process of elimination.[53]

That logical "process of elimination," which might have kicked in even before Walt and Lilly's departure from New York, would have to be finalized in concert with Roy Disney and Ub Iwerks after the couple got back to California, on Sunday morning, March 18, 1928. In 2011, Diane Disney Miller said that Roy once told Dave Smith that he

> picked them up at the train station. Dad said nothing about the loss of Oswald, etc. When Roy finally asked him, as they got home, "Well, what about the contract" . . . dad replied, almost casually "We don't have a contract."

Dave Smith, according to Diane, likewise learned from Roy that Walt "came in after his trip from NY very agitated, and said that they needed a new character, and four of them went into a room . . . Dad, Roy, Ubbe and Les Clark."[54]

89. This is the first panel in the last installment of the syndicated daily comic strip serial *Mickey Mouse in Death Valley,* published September 20, 1930, and penciled by Floyd Gottfredson and inked by Hardie Gramatky. The first installment appeared on April 1, 1930. Minnie is seen here shaking hands with her Uncle Mortimer, dressed in a checkered suit. Distributed by King Features.

90–91. Screen captures of Mortimer Mouse in *Mickey's Rival,* released June 20, 1936. With his sporty attire, jaunty chapeau, and whiskery mustache, Mortimer, as a would-be suitor to Minnie, was a thinly veiled caricature of Walt himself. Hamilton Luske (1903–68) supervised the animation of Mortimer in *Mickey's Rival* and may have personally animated the character in these two scenes.

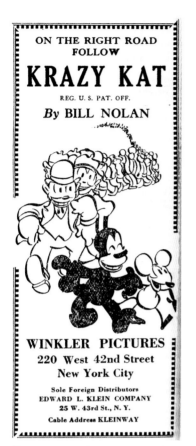

92. Advertisement for Winkler Pictures' "Krazy Kat" animated series, *Film Daily,* June 21, 1925.

93. Hugh Shields (active 1920s) and Paul Terry directed this Fables cartoon *Rats in His Garrett,* Pathé Exchange release, Dec. 11, 1927.

In an interview in 1970, more than forty years after the event, with Disney publications chief George Sherman, Iwerks said, "I don't recall any special meetings or discussions on how Mickey should look." Those words, however, contradict a previous statement in an interview in the mid 1950s, recorded in cursory shorthand fashion by Disney biographer Bob Thomas, in which what transpired during the critical conclave at Walt's home on March 18 was described by Ub this way:

> Walt came back discouraged to Hollywood—meeting with Ub and Roy—possibilities of a new character. tried some sketches of dogs and cats—too many cats (Krazy Kat)—Ub went through batch of magazines—a mouse there hadn't been any. In Life or Judge ran into cartoons of ~~Nofziger~~ Meeker—got an idea for a mouse. we weren't artists. almost none in the field. worked out character—Lilly gave it a name—then cooked up a story sitting around—Lindbergh a hero—kicked ideas around—no story boards at all.[55]

It "makes sense," Diane Miller recalled (in 2012), that this meeting took place at Walt and Lilly's place (on Lyric Avenue) since "Roy lived next door." It was imperative, too, that Walt, Roy, Ub—and Les Clark, if he was present—confer that very night. They needed to begin planning Oswald's successor immediately and be on the same page before the start of a new week when they would have to rub shoulders with the turncoats—the "key men" Mintz had signed up, who had not yet left the Disneys' employ to work for Winkler Pictures.[56]

Alas, we cannot take at full face value all that Iwerks was quoted as saying by Bob Thomas. First of all, it's not evident from Thomas's notes who it was that "got an idea for a mouse." Secondly, the "Lindbergh a hero" scenario had been exploited by Walt and Ub in the Oswald one-reeler, *The Ocean Hop.* So it was by no means an idea that was freshly "cooked up" that evening. Furthermore, we know that Ub prepared a primitive form of storyboards in the form of six pages of story sketches for *Plane Crazy* [111] [119]. (Full-fledged storyboards did not develop as a Disney studio practice until around 1933.)

Even more importantly, there *had* been animated mice before Mickey, although, as Pete Martin later said, "they'd never been featured." There was, in short, in Michael Barrier's words, "nothing particularly innovative" about Mickey: he was "a formulaic mouse of a kind that had long been plentiful in competitors' cartoons, and in some of Disney's own." Chief among the breed in 1920s animations were the zippy critters drawn by Bill Nolan, who, from 1925 to 1927, had tried to breathe new life into the Krazy Kat silent-film franchise [92], . . . and, most familiar of all, the bug-eyed, spindle-legged devils that tormented Farmer Al Falfa in Paul Terry's Aesop's Fables cartoon series all through the 1920s [93].

The Performo-Toy Co.'s "Micky Mouse" was itself the spitting image of Paul Terry's ratty little rodents.[57]

By 1928, mice had made their presence similarly felt in the public prints, as evidenced by *The Adventures of Johnny Mouse* [94], a comic strip written and drawn by Clifton Meek, the misnamed "Meeker" referenced by Ub, which was nationally syndicated from 1913 to 1915. Given to fits of pique, and at times sporting a twisted coat hanger of a tail, Johnny Mouse may have been inspired by Ignatz, the temperamental, wiry-tailed nemesis of Krazy Kat, created in 1910 by George Herriman. Around 1915, a second version of Johnny by Meek, plumper, furrier, fully clothed, with a graceful curly tail and saucer-rimmed ears—a look influenced by his friend and fellow cartoonist Johnny Gruelle—emerged in magazines such as *Life* (primarily) and *St. Nicholas,* a popular children's monthly. This second-generation Johnny must have been the one Ub was referring to. Walt, for his part, must have been aware of both versions of Johnny Mouse but, like Ub, had the second one in mind when he created Mickey.[58]

In the mid 1940s, Disney expressed his respect for Cliff Meek in an interview in which he described Meek as a man "who used to draw cute little mice and I grew up with those drawings. They were different mice from ours—but they had cute ears." The most solid testament to the impact of Johnny Mouse on Mickey, however, was provided by Floyd Gottfredson, who started working for Walt on December 19, 1929, shortly before Ub quit. In 1981, Gottfredson—the genius behind Mickey's splendid run in the daily and Sunday comics all through the 1930s—wrote a letter to Dave Smith remarking that he'd been "a big fan of Meek's mouse for years (even before I came to the Studio)." He went on:

> By coincidence, a couple of days after I received your letter, I ran across this page from the old *Life* humor magazine [95]. As you can see, the date is April 28 but unfortunately there is no year on either side of the original leaf and I only have the leaf, not the magazine. The mouse at the bottom of the page, drawn by Clifton Meek, was a very popular feature in Life for several years around this period. I'm sending this to you because early in 1930 I saw a couple of sketches that I'm quite sure were drawn by Walt of a mouse very similar to this one, on the conference table in the Music Room at Hyperion. Beside them were a couple of sketches by Ub of Mickey exactly as he appeared in Plane Crazy. I have always felt, but have never been able to confirm it, that Walt's sketches were his first concept of Mickey, but of course Ub's sketches being more appealing was the one adopted.

The Mickeys that Gottfredson recalled were, in all likelihood, the ones penciled on a single sheet of animation paper now at the Walt Disney Family Museum in San Francisco [100].[59]

94. Clifton Meek (1888–1973), "The Adventures of Johnny Mouse," *Des Moines Register,* July 31, 1913, NEA syndicate.

95. Meek, "Freddy Firefly, the Uninvited Guest, Gets All Lit Up," *Life*, April 28, 1921. The Walt Disney Family Foundation, San Francisco, California.

Ultimately, the prototype for all animated mice in the 1920s (perhaps Meek's original Johnny Mouse as well) was Ignatz [96], the fiery scamp with blocky, oblong feet and bold blots for eyes, who, with Krazy Kat, had a brief fling on film during Walt's teenage years and again, briefly, in the mid '20s. In a fact-filled essay for the first book-length survey of modern American comic art, *Cartoon Cavalcade* (1943), art critic and cartoon aficionado Thomas Craven allowed as how it was "more than probable that Walt Disney looked long and fondly at Ignatz Mouse before creating the insuperable Mickey Mouse." In a letter to Herriman's daughter Bobbie after her father's death in 1944, Walt expressed his high regard for Ignatz's progenitor: "His unique style of drawing and his amazing gallery of characters not only brought a new type of humor to the American public but made him a source of inspiration to thousands of artists." Walt's own debt to Herriman, implied here, is attested by a poster for his 1924 film *Alice the Peacemaker* [101], which depicts a mouse aiming a brick at Julius the Cat, just as Ignatz repeatedly did to Krazy Kat [34].[60]

Under the influence of Ignatz and the Paul Terry mice, and dating from before Ub joined Walt's burgeoning Hollywood operation, the Alice Comedies were amply stocked with what Donald Crafton has dubbed "proto-Mickeys." Iwerks himself (in his 1970 interview with George Sherman) remembered that it was Disney who conceived the Alice mice:

In 1925, for a publicity photo, Hugh Harman had redrawn the characters created by Walt and they had been photographed around him. A couple of small mice looked like Mickey. The only difference was the shape of the nose.

96. George Herriman, lower panel from the syndicated Krazy Kat comic strip published June 11, 1916. Brush and black ink. Comic Strip Library.

These Disney-generated proto-Mickeys (with longer, rattier snouts) were seen on film credits [97], on posters [18] [101], and in publicity shots for the Oswald series like the one mentioned by Ub Iwerks [102]. A pair of bear cubs in the Oswald short *Tall Timber* even have remarkably Mickey-like heads [98]. And then there is the visual testimony of a birthday card for Elias Disney from his "Hollywood kids," Roy and Walt, handmade in February 1926 by Walt (or by Ub or another studio artist at Walt's behest), dominated by three rambunctious mice [99]. Could so personal an item have been adorned in such adorable fashion if Walt Disney did not have a soft spot for the little critters?[61]

The sole object known to be directly linked to the birth of Mickey Mouse is the sheet of "sketches" presumably glimpsed by Floyd Gottfredson in 1930, now among the prize holdings of the Walt Disney Family Foundation. This extraordinary if esthetically unprepossessing artifact—which raises almost as many questions as it answers—came to light in 1989 or 1990, after having been secretly stored in a safe for a quarter-century at the offices of the Disney family corporation, Retlaw Enterprises ("Retlaw" = "Walter" backward). Its history before its discovery is rather a mystery.[62]

Most, if not all, of the imagery on this sheet [100] must date from immediately or almost immediately following Walt and Lillian Disney's return to California from New York City.

According to Diane Miller, longtime Disney intimate John Hench felt "that the figure in the center of the page was done by dad." Diane, too, was convinced that her father probably "did Mickey #1"—the one in the

97. Main title card for the pilot version of the Oswald the Lucky Rabbit cartoon *Poor Papa*, released by Universal, June 11, 1928. Walt Disney Archives, Burbank, California.

98. Oswald confronting a bear cub in *Tall Timber*, released by Universal, July 9, 1928. Hugh Harman and Rollin "Ham" Hamilton (1898–1951) did the animation on this cartoon. Walt Disney Archives, Burbank, California.

99. Birthday card for Elias Disney from Roy and Walt, drawn by Walt Disney (or by Ub Iwerks or another staff artist, with lettering at the bottom by Walt), inscribed, "Wishing you a happy birthday—Dad—your Hollywood Kids—," Feb. 1926. Walt Disney Archives, Burbank, California.

100. Attributed to Ub Iwerks, sketches for Mickey and Minnie Mouse, presumably circa March 18, 1928. Graphite on two-peghole animation sheet, approx. 9 x 12 in. The two mice circled in blue probably represent Walt's final first and second choices for how Mickey should look, with the one in the center emerging as the "winner." Lightly drawn on the lower right-hand side of the paper is a the fantail of a turkey, which Mickey used in *Plane Crazy* as the vertical stabilizer on his homemade aircraft. Walt Disney Family Foundation, San Francisco, California.

101. Poster for *Alice the Peacemaker*, released by Winkler Pictures, Aug. 1, 1924. Walt Disney Archives, Burbank, California.

middle of the paper—"in his home, and came into the studio with it," although "Dave Smith would say Ub drew it, 'with Walt standing over his shoulder,'" and, Diane added, "It's possible that it was the hand of Les Clark, with dad and Ub standing over his shoulder."[63]

We may never establish beyond a shadow of a doubt who drew Mickey #1 and the other mice on the sheet, or precisely when they were drawn. Still, based on what we now know and what can be deduced from the visual evidence of the object itself, it is hard to disagree with Dave Smith and not attribute the artwork entirely to Ub Iwerks . . . and, as a consequence, hard to believe that it does not date from March 18, 1928, or soon thereafter. By that stage, professionally, Walt Disney was an idea man, a salesman, and a manager. Ub Iwerks was his ace animator. The sheet is blocked off in six panels very much like Ub's story sketches, also penciled on animation paper, for *Plane Crazy* [111] [119]. And—most revealing of all—upon careful inspection, the way each of the figures was drawn almost perfectly matches Ub's dynamic and assured draftsmanship.

There are four rudimentary heads and six full-length mice on the sheet, one a close approximation of Minnie (bottom right). Nine of the

ALICE
THE
PEACEMAKER

A WALT DISNEY COMIC

M.J.WINKLER
DISTRIBUTOR, N.Y.

WINKLER PICTURES

102. Publicity photograph of Walt Disney surrounded by Alice Comedy characters, 1926. The cartoon figures reputedly were drawn by Hugh Harman based on sketches by Walt. There is a dramatic contrast between the seven mice in this image and the crudely drawn mouse on the *Alice* poster [101], produced in New York by Winkler Pictures. Also in the photo, note the fellow leaning against a prop tree behind Alice. He is Pegleg Pete, Walt's oldest character in continuous use, later recast in the 1940s in the Mickey Mouse comic books as Black Pete. The Walt Disney Archives, Burbank, California.

103–104. Attributed to Ub Iwerks, "Mortimer" figure and two mouse heads, details from [100]. Michael Barrier has also dubbed him "Little Lord Fauntleroy Mouse." The Walt Disney Family Foundation, San Francisco, California.

ten images seem to represent a range of options for how Mickey might look. The most refined and striking of the bunch, dressed in "Buster Brown" schoolboy attire (upper left corner), and a similar schoolboy figure, immediately below it, may be the sketches that Gottfredson felt "quite sure were drawn by Walt." Whether or not that was the case, they must, in one way or another, convey Walt's embryonic vision of the mouse he wanted to call "Mortimer," since the uppermost of the two is how "Walt Disney's original rendering of Mickey" was presented in print several times in the 1930s [107] [109–110].

This "Mortimer" (there are four full-length Mortimers on the sheet) most likely was drawn by Ub based on an image conceived by Walt, quite possibly en route back to California from New York. As Diane Miller said, "Knowing my dad, I could not imagine that, during that train ride from NY to LA, with a stop over in KC, he was not constantly thinking of the new character, and he always thought with paper and pen or pencil in hand."[64]

Prominently placed in the top-left panel of the sheet, the normal starting point for the sequential reading of any narrative graphic art, this schoolboy figure in black pants and floppy black tie [103] is a distant cousin to Clifton Meek's second-generation Johnny Mouse [105], as is one of the isolated heads with rimmed, saucer-like ears [104] facing "Mortimer"—whom Michael Barrier has called a "Johnny Gruelle version of Mickey." Gruelle, a forgotten master of American cartoon art (he fathered the Raggedy Ann and Raggedy Andy franchise), was a regular contributor to *Life* and *Judge*. In 1920 and 1921, a series by Gruelle, "Johnny Mouse and the Woozgoozle," ran in *Woman's World*, and his 1922 children's book, *Johnny Mouse and the Wishing Stick* [106], featured a character akin to Meek's primly garbed iteration of "Johnny." (Gruelle and Meek were pals and neighbors in the arts community of Silvermine, Connecticut, circa 1910 to 1920, so there was definitely some friendly "borrowing" going on here.) Walt and Ub had to have been as

familiar with Gruelle's work as they were with Cliff Meek's.[65]

"Mickey #1," the central motif on the page, instantly recognizable as Mickey Mouse, circa 1928, is nearly as polished as the Meek-like Mortimer. He alone amid the mice around him is barefoot and bare-chested. Gottfredson must have been thinking of Mickey #1 in particular when he said he'd seen "a couple of sketches by Ub of Mickey exactly as he appeared in *Plane Crazy*"—Mickey's first film, in which, in contrast to all his subsequent cartoons, he was shoeless. In stylistic terms as well, notably the knobby fists and vigorous shading on his torso, Mickey #1 [108] is strikingly similar to a pair of Mickeys in Ub's story sketches for *Plane Crazy*.

Like the most polished of the standing Mortimers [103], and the more faintly delineated full-length male mice on the sheet, Mickey #1 once had long pants, maybe shoes (all erased). But, since he's located close to the very middle of the paper, circled in blue, we may infer that during this larval stage in Mickey's creation, just as the name "Mortimer" was cast aside, Walt surrendered his frilly train-ride visualization of the Mouse. It requires no great leap of faith, based on these sketches, to conclude that, given a choice between "Mortimer" and Mickey #1 (the two most finished figures on the page), Disney settled on a character similar to the kind of cartoon mouse he and Ub Iwerks had been animating all along.

"Mortimer" [103] was, so far as we know, first published in November 1933, during Mickey's fifth anniversary year, in a syndicated feature, *Seein' Stars,* drawn by Feg Murray, a personal friend of Walt's, in the multipanel style of "Ripley's Believe It or Not!" [109], wherein a Mickey from the early '30s is taken aback by the sight of Walt's original vision of him. In 1934 [110] and again the following year, United Artists compiled press books containing drawings of "Mortimer" circulated to promote Mickey's seventh-birthday celebration in 1935. In 1935, U.A. distributed a simpler, two-figure publicity image that was a variant on the combo seen in Feg Murray's cartoon [107].[66]

The *Bridgeport Sunday Herald* was one newspaper that (in slightly modified form) used one of the promotional spreads put out by United Artists, which, as the caption states, presented "Mortimer Mouse Walt Disney's original rendering of Mickey." This was in late September 1935, on the eve of Mickey's official seventh birthday, as commemorated by the Disney studio throughout the 1930s.[67]

This exploitation of "Mortimer," tying him to a major anniversary, was, from a marketing angle, a clever and logical ploy. Even if one cannot help but wonder why this "original rendering" came to the fore and was privileged in 1933–1935 yet failed, for instance, to make the grade three years later, on the occasion of Mickey's tenth birthday in 1938. There may

105. Clifton Meek, detail of Johnny Mouse from [95]. The Walt Disney Family Foundation, San Francisco, California.

106. *Johnny Mouse and the Wishing Stick* (Bobbs-Merrill, 1922), a children's book written and illustrated by Johnny Gruelle (1880–1938). Billy Ireland Cartoon Library and Museum, The Ohio State University Libraries, Columbus, Ohio.

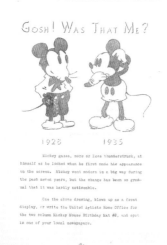

GOSH! WAS THAT ME?

1928 1935

Mickey gazes, more or less thunderstruck, at
himself as he looked when he first made his appearance
on the screen. Mickey went modern in a big way during
the past seven years, but the change has been so grad-
ual that it was hardly noticeable.

Use the above drawing, blown up as a front
display, or write the United Artists Home Office for
the two column Mickey Mouse Birthday Mat #3, and spot
in one of your local newspapers.

-6-

107. "Gosh! Was That Me?," promotional
image from a mimeographed press book
("On Sept. 28th, 1935") distributed
by United Artists, circa August 1935.
Dennis Books.

108. Attributed to Ub Iwerks, central figure
of Mickey, circled in blue, detail from [100].

why Iwerks's shoeless "Plane Crazy" mouse, the first *real* Mickey, was never part of any PR campaign. The mere act of publishing Mickey #1 [108], with or without Ub's name attached, might have prompted talk, in motion picture or animation circles anyway, about Ub's role in the Making of the Mouse. From the Disney perspective, because he'd jumped ship in January 1930, Ub Iwerks and his artistry could receive no play, no matter how minor or indirect, in studio-sanctioned publicity.

Conversely, we must assume that "Mortimer" would not have been widely publicized if he did not reflect Disney's original concept for Mickey. It would have been out of character for Walt to so blatantly claim paternity for this "original rendering" if the assertion was fundamentally untrue. (During the time when Iwerks and he were partners, Ub's name was prominently featured on screen credits and posters for having "drawn" the Mickey cartoons, so it's not like Walt was claiming that he actually animated the Mouse.)

A portion of the foregoing discussion amounts to little more than conjecture. But we must face the very real possibility that we will never possess incontrovertible proof of who drew the ten pencil sketches of Mortimer, Mickey, and Minnie. The preponderance of whatever relevant data that emerges in coming years may never be significantly more than circumstantial. In the end, where the authorship of "Mortimer," Mickey #1, and the other figures is concerned, we shall probably always have to rely to one extent or another on what in the art world, among Old Masters drawings experts especially, is termed connoisseurship: a practice—informed, scholarly *conjecture*—based largely on long-term, firsthand study of the comparative styles and techniques of individual artists, the materials they employ, and the subjects they favor.

Not nearly enough connoisseurial attention has yet been paid to Ub's handiwork —or Walt's. Thus it is not always easy to identify this or that sketch as having come from the hand of Iwerks, much less from Disney, whose body of firmly attributable drawings from the 1920s, which might provide a solid basis for comparison, is pitifully slim. Until we have a surer grip on the peculiar graphic characteristics of both men, we shall continue to puzzle over these sketches, and continue to ponder such further mysteries as the fact that the paper on which they were drawn was folded over on itself several times, "in a size that would fit into a shirt pocket," as Diane Miller put it. Folded, one may surmise, by Walt, as he walked about the studio, or by Ub, who might have pocketed it after the big Sunday confab to guide him in his clandestine, solo work on *Plane Crazy*.[68]

Once the men who jumped ship were gone, and animation on Plane Crazy was completed, this "Holy Grail" of Mickeyana must have casually lain about at the studio (where Floyd Gottfredson noticed it)

before winding up in Walt's office and eventually, after his death, being secured at Retlaw as a treasured relic of the process whereby Mickey, via Mortimer, came into being.

I t was so logical, Diane felt, for Walt "to have chosen a mouse as he'd been drawing them for years in the Alice series and Oswalds . . . I have to give my parents' story credibility. It just makes sense."[66]

It does make sense. Just as it is abundantly clear that Ub took Walt's idea for the Mouse, massaged and perfected it, and, in a very tangible way, brought Mickey to the screen—a signal achievement in its own right. Without the artistic prowess of Ub Iwerks, Mickey Mouse would not have looked or moved the way he did, and might well have failed to become the huge hit that he was.

However, when all is said and done, it is all but certain that Walt Disney, and he alone, had the germ of an idea, which, at his insistence and direction, led to Mickey. If only because, as suggested in Walt's *Windsor* magazine piece, it is well nigh impossible to imagine the boss and presiding genius of the studio returning from New York to face Roy and Ub empty-handed, with nary a clue as to what to do next. In some way, shape, or form, Mickey must have sprung from Walt's fertile and restless mind riding the rails home to California, as his keen awareness that people prefer "animals that are 'cute' and little" merged with what Pete Martin termed his "special feeling for mice."

110. Full-page "drawing" from a press book reproduced by ditto machine and distributed by United Artists. This set of images was traced from a promotional mat, UMM-252, supplied to newspapers by United Artists as part of a press kit for *Playful Pluto*, a Mickey one-reeler released March 3, 1934.

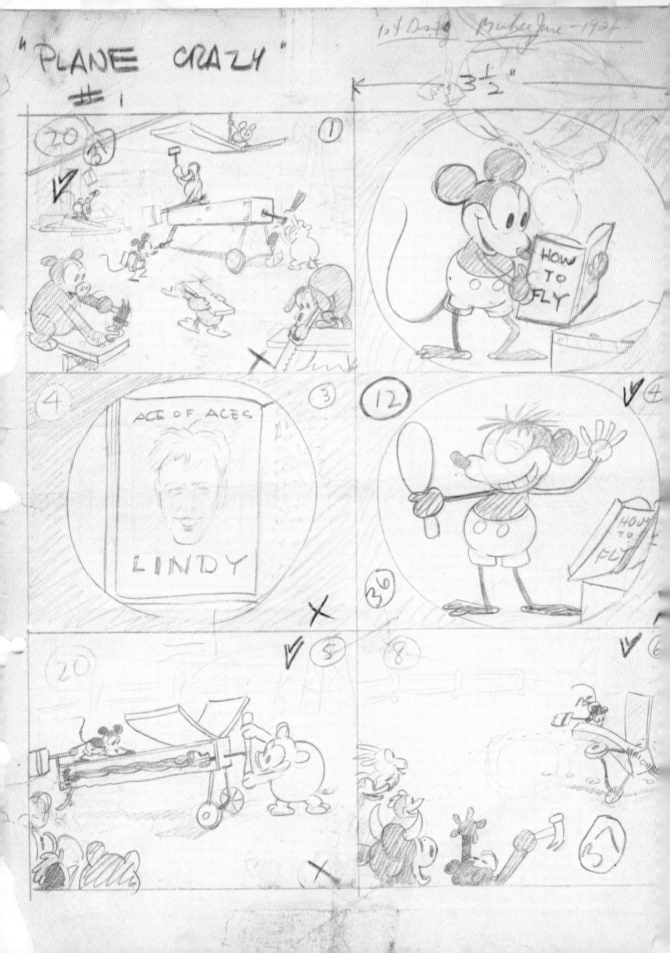

THE MOUSE TAKES OFF

Mickey's "career" fits into four basic phases. Phase one, which lasted from November 1928 until about 1940, culminating in *Fantasia,* was the basis for all that followed. In that twelve-year span, Mickey became one of the most revered and talked about figures on the American scene. Phase two, a two-decade-long period that started on the eve of World War II, as his screen stardom began to dim, saw a dramatic revival of his popularity with the opening of Disneyland (in the planning stages: "Mickey Mouse Park") and the debut of the *Mickey Mouse Club* TV series, both in 1955. During phase three, from the '60s through the Vietnam War and into the presidency of Ronald Reagan, Pop Art embraced the Mouse, and, by the 1980s, Mickey had assumed the mantle of a time-tested classic. Driven by nostalgia, marketing, and an often fractious political and social climate, at home and abroad, phase four, from the mid '80s to the present day, has seen the continued validation of Walt Disney's iconic invention as an integral part of American and global culture.[1]

As first brought to the screen by Walt and Ub Iwerks, Mickey was a graphic blend of preexisting cartoon mice, including Disney's own, and his most recent animated hero, "Felix the Cat with floppy ears," i.e., Oswald the Lucky Rabbit. Combining traits of the Little Tramp, Felix, and Ignatz, Krazy Kat's pugnacious adversary, the Mouse was peppy, free-spirited, amorous, and endearing, with a hefty dose of Walt's and Ub's buoyant Midwestern spirit. His alliterative name, Mickey (even "Mortimer") Mouse, if not lifted from the Performo-Toy Co. product, can be traced to Krazy Kat, Charlie Chaplin, or "Mickey McGuire." But these multiple sources knitted together as more than a patchwork of appropriation, pastiche, or parody. They took on a life of their own, exceeding the sum of their parts.

Chaplin—Disney's childhood idol—had by 1928 been the king of popular culture for more than a decade and was a natural source of

111. Ub Iwerks, sheet of story sketches for *Plane Crazy,* spring 1928 (released March 17, 1929). The sheet appears to be inscribed (presumably at a later date), "1st Draft Maybe June—1928." Graphite pencil and red and blue pencil, on two-hole animation paper, approx. 9 x 12 in., first of six sheets. Steve Geppi, Geppi Museum, Baltimore, Maryland.

112. Mickey Mouse imitating Charlie Chaplin's Little Tramp in *Mickey Plays Papa*, released by United Artists, Sept. 29, 1934. Animator Bob Wickersham (1911–62) was assigned to this scene. The Walt Disney Archives, Burbank, California.

113. Pegleg Pete and Mickey, animated by Ub Iwerks and Les Clark, in *Steamboat Willie*, released Nov. 18, 1928.

114. Mack Swain and Charlie Chaplin in *Pay Day*, released by United Artists, April 2, 1922. © Roy Export S.A.S.

inspiration for Mickey Mouse. In 1931, as we've seen, Walt described to Harry Carr the qualities he felt had been teased out of the Little Tramp's cinematic DNA: specifically, his "wistfulness" and the spirit of a little guy "trying to do the best he could." In October 1932, the editor of the *Motion Picture Herald*, Terry Ramsaye, would declare:

> Mickey Mouse is the crystalline, concentrated quintessence of that which is peculiarly the motion picture. . . . He is as simple as a dandelion and we do not know what makes it grow.
>
> Mickey is most humbly superhuman. He is an evolutionary product with everything that ever was made for the screen in his ancestry and with Charlie Chaplin as his closest human relative.
>
> The irrepressible Mickey. . . has in a very certain sense paid tribute to Mr. Chaplin by becoming his successor in certain considerable sectors of the world of the motion picture.

Ramsaye concluded by saying,

> Even as Chaplin was, Mickey Mouse is all things to all men. He is a gust of thoughtless fun to the casual, the lowbrow, the thoughtless. He is the voice and personification of the weltschmerz to the sophisticate and a blood brother to the philosopher.
>
> Mickey is more of a man than a mouse and in all humility, not irony, we must admit that it takes a mouse to be Everyman.[2]

In *Mickey Plays Papa* (1934), there is a visual salute to Chaplin: when Mickey discovers an infant mouse on his doorstep, he tries to amuse the foundling by mimicking the Tramp [112]. J. B. Kaufman has pointed out that *Alice's Orphan* (1925) was based on the same narrative premise, and that both films borrowed heavily from Chaplin's 1921 feature film, *The Kid*. As Kaufman further noted, this also was one of many instances in which plots or gags from the Alice Comedies and Oswald cartoons were repeated in animated Disney shorts and even in full-length cartoons such as *Fantasia* and *Dumbo*.[3]

In the first decade of his existence, Mickey, like Chaplin's Little Tramp, assumed a variety of movie roles. In *Steamboat Willie,* he has a brawny boss, similar to Chaplin's oppressive master in *Pay Day* [113–114]. His awkward turn on the dance floor with Minnie in *The Barn Dance* (1929) derives from a scene in *The Gold Rush* [115–116], whose plot and arctic locale likewise prefigured a 1932 Mickey cartoon, *The Klondike Kid*. Disney's leading "man," like Chaplin's Tramp, also was a soft touch for a damsel in distress—though the one damsel requiring his gallantry,

as in *The Gallopin' Gaucho* or *The Klondike Kid,* was always Minnie. The battle he waged for her affections with the oily lothario Mortimer in *Mickey's Rival* recalls various situations in which Charlie engaged, sometimes in vain, a brutish or more imposing romantic competitor.

Chaplin's influence did not stop there. The combination in his work (and in silent movies in general) of the two most universal of human languages, pictures and music, the latter supplied since the days of the nickelodeon by a house pianist, organist, or orchestra, may have prompted Disney to make melodic expression, not the spoken word, the chief audio component in his films. Dialogue in the early Mickey cartoons, as in the Chaplin comedies, was far less important than the action, music, and sound effects. Still, there were big differences between the two. Mickey Mouse generally got his girl, and his adventures were chock full of raucous gags. His character drew more from the robust burlesque, at times mischievous, strain in Chaplin's vagabond as opposed to his pathetic, loner tendencies. Moreover, as evidenced by his first three cartoons, the ones that framed his budding screen persona, he initially had three other influential models: Buster Keaton, one of Charlie's great comedic film rivals; Douglas Fairbanks, the most popular of Hollywood's swashbuckling actors (whom Ub Iwerks singled out as an inspiration); and a real-life hero, Charles A. Lindbergh.

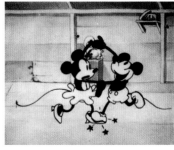

115. Mickey and Minnie Mouse on the dance floor in *The Barn Dance*, opened in New York, Feb. 9, 1929. Ub Iwerks and Les Clark animated this cartoon.

116. Charlie Chaplin and Georgia Hale in *The Gold Rush*, released by United Artists, June 26, 1925. © Roy Export S.A.S. Scan Courtesy Cineteca di Bologna.

The first Mickey Mouse adventure actually captured on film was *Plane Crazy.* Production on the seven-minute one-reeler began in March or April 1928. Iwerks accomplished the animation in record time, reputedly pumping out as many as 700 drawings a day (or more).[4]

Plane Crazy capitalized on America's boundless admiration for Charles Lindbergh, the clean-cut son of a Minnesota Congressman. When he landed his plane, the *Spirit of St. Louis,* in France in May 1927, Lindbergh became the first man to fly nonstop alone across the Atlantic, and the first "all-American hero." He was fêted in Paris, London, and the United States, where a dance step, the Lindy Hop, was named for him and he received a ticker-tape parade in New York. A flying tour that took him to every state in the union, touting the future of commercial aviation. and the release of Lindbergh's best-selling memoir of the flight kept him in the news. By year's end, Congress had awarded him the Medal of Honor and *Time* had made him its first "Man of the Year." Journalist Marquis Childs remarked that he had "become a demigod." Then, just as Walt, Ub, and Roy were considering how to script Mickey's first film, MGM released *40,000 Miles with Lindbergh* [117]—a short subject, heavily promoted in *Film Daily,* that gave a renewed boost to the flyer's fame. Since one Oswald film, *The Ocean Hop,* had already been based on Lindbergh's heroics, it

Metro-Goldwyn-Mayer presents

40,000 MILES WITH LINDBERGH

One sheet now available for three-reel special on Lindbergh.

117. Illustrated promotional material for the MGM three-reel documentary short *40,000 Miles with Lindbergh*, printed in *Film Daily*, March 4, 1928.

118. Mickey trying to make himself look like Lindbergh in *Plane Crazy*, animated by Ub Iwerks. Compare this screen capture and the image of "Lindy" above with the third and fourth panels in illus. 111, p. 84.

119. Iwerks, sheet of story sketches for *Plane Crazy*, March 1928. Graphite pencil, red and blue pencil on two-hole animation paper, approx. 9 x 12 in., sheet five of six sheets. Steve Geppi, Geppi Museum, Baltimore, Maryland.

must have seemed a no-brainer to recycle a time-tested plot yet again.[5]

The characters in the most-watched TV cartoons of recent years—*The Simpsons, South Park, King of the Hill, Family Guy*—typically inhabit suburban or small-town America, just as Mickey mirrored Walt's and Ub's hinterland origins. Unsurprisingly, therefore, *Plane Crazy*, opens on a farm where a swarm of ducks, pigs, mice, and a dachshund are madly rushing about, slapping together a contraption with a wooden crate for a body and a broom for a rudder, more like a soapbox derby racer than an airplane. While his barnyard friends complete their task, Mickey—barefoot, gloveless, in white shorts and white buttons—thumbs through a manual titled *How to Fly*. When he comes across a picture of "Lucky Lindy" (like one seen in *Film Daily*), he pulls out a mirror and fluffs up a thatch of fur to emulate the aviator's tousled hair [118].[6]

Once in his cartoon plane, Mickey fails to get off the ground and smashes into a tree. Undeterred, he builds a second plane, this time unassisted, turning an old jalopy into a flying machine by shaping the two flaps on either side of the car's hood into wings and stretching the body into an appropriate length. A fantail of feathers plucked from a turkey serves as a rudder. Before he can try another takeoff, Minnie Mouse, his female doppelganger and constant companion, appears.

Visually speaking, Minnie—named, it is said, after Minnie Cowles, the wife of one of Walt's benefactors in Kansas City—is Mickey with a skirt and eyelashes. (From the start, they were both rural or small-town folk as well.) Minnie presents him with a horseshoe for luck; to her delight, he gives it a big kiss and invites her to join him. Without a second's hesitation, she clambers aboard, with the cheeky pilot grabbing her panties to pull her in. The plane lurches across the barnyard and hits a rock, and Mickey is tossed to the ground. Minnie is now alone, trembling as the craft careens down a country road, buzzing a cow's udder with its propeller, a ribald comedy sequence displayed in all its full-screen glory. The cow is next seen desperately clinging to the tail of the machine, and, as Mickey scrambles back in, grasping its seemingly indestructible gland, he's sprayed with milk. The Mouse regains the cockpit, but the plane is still out of control, bouncing off telephone poles and nearly smashing into oncoming traffic.[7]

At last, he restores order and climbs to a safe altitude. As Minnie's fears subside, however, Mickey turns out to be neither as modest nor as "lucky" as Lindy. After he has her alone in the sky, he, like the sometimes-lecherous Tramp in the early Chaplin comedies, puts an unwanted move on the object of his affections that leads to his literal downfall. When Minnie spurns his advances, the randy flier stomps on the gas and roars into a loop-de-loop that flips her up and, momentarily, out of the plane. Thinking he has impressed her, he plants an unwanted kiss on

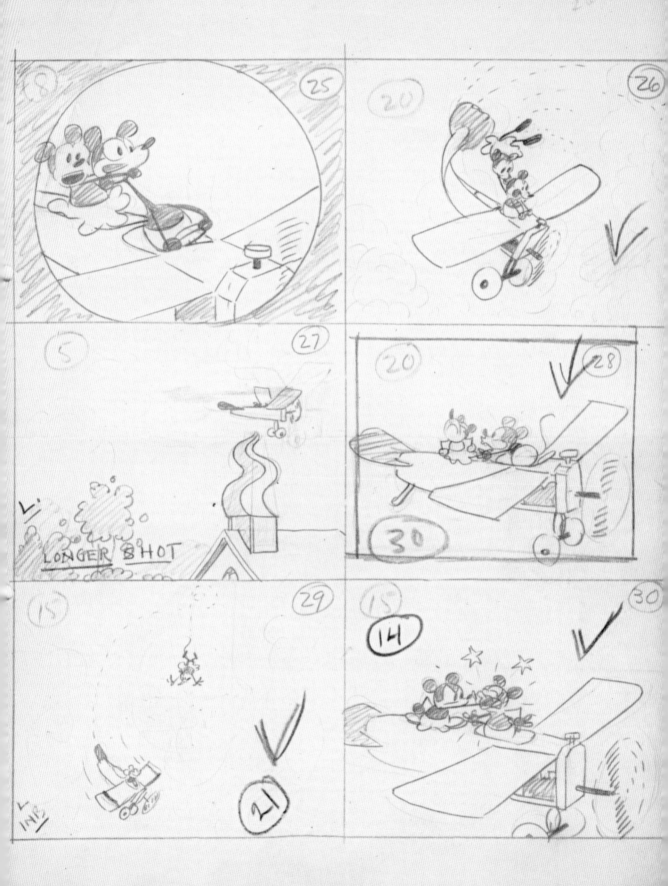

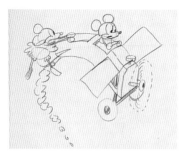

120. Iwerks, animation drawing for *Plane Crazy*, March 1928. Graphite pencil on two-hole animation paper. Walt Disney Family Foundation, San Francisco, California.

her lips; appalled and disgusted, she slaps him in the face and, in a sight gag resurrected from *The Ocean Hop,* bails out, using her panties as a parachute [119–120]. Mickey's libidinal distraction sends the plane into a tailspin and he crashes into a tree. As he hits the ground, the horseshoe plops down onto his skull. Minnie then lands beside him. He razzes her as she gathers up her voluminous, life-saving drawers and storms off in a huff. The frustrated flyer flings the "lucky" shoe away, and, in one last gag, it boomerangs back to whack him on the head a second time [121].

Plane Crazy was informally previewed on May 15, 1928, at a theater on Sunset Boulevard—perhaps the West Coast Hollywood Theatre (later the Oriental), at the corner of North Vista Street. Since this was the first public screening of a Mickey Mouse cartoon, May 15 can be considered Mickey's actual "birthday." On May 21, the brothers Disney applied to the United States Patent Office to register "Mickey Mouse" as a trademark, and in this way, one might say, recording his birth. The film was well enough received for Walt to put a second picture into production: *The Gallopin' Gaucho,* a take-off on *The Gaucho,* a recently released adventure film starring Douglas Fairbanks.[8]

The Gallopin' Gaucho opens with the Mouse in a poncho and flat-brimmed sombrero, riding across the pampas of Argentina on a rhea, the South American cousin to the ostrich. Unlike his character in *Plane Crazy,* Mickey now, and forevermore, wears shoes. Arriving at the Cantino Argentino, he swings with his tail up to a second-story window. Inside, Minnie Mouse is dancing a seductive cabaret number before an appreciative male audience. We also see a poster on the wall with Mickey's face on it, offering a reward for an outlaw called El Gaucho, the name of the lead character in the Fairbanks movie. Mickey is by then perched on a window ledge watching the show down below. He laughs, lights a cigarette with a bare foot, which he pulls out of his shoe, and blows an impressive set of smoke rings—again, à la Fairbanks [122].

The vampish Minnie is charmed by the mysterious stranger and responds by tucking a daisy between her teeth. El Gaucho, meanwhile,

121. Iwerks, for *Plane Crazy,* 1928, detail of last of six story sketch sheets. Steve Geppi, The Geppi Museum, Baltimore, Maryland.

has lifted up a mug of beer with his ever-useful tail and drains it in a single gulp, lustily licking the foam off his face with his tongue. Thus fortified, he leaps to the floor, where he and Minnie cut loose in a racy tango [123]. At this point appears the beefy, cat-like villain soon to be formally dubbed Pegleg Pete—Mickey's arch-enemy in his early cartoons—first seen in the Alice films, where he was known as Bootleg Pete. (Another alias, Black Pete, was not coined until 1942.) Here, in *The Gallopin' Gaucho,* Pete snatches Minnie in his hairy paw and carries her off on his donkey. The Mouse whistles for his mount, which, having entered the cantina by the side door, is now soused on beer, a gag previously employed in the Oswald cartoon *Harem Scarem.* Nonetheless, Minnie's would-be savior and the tipsy bird take off in pursuit across a landscape dotted with bizarre, vertically stacked piles of boulders [124], a visual homage to the surreal desert locale of *Krazy Kat* [34].[9]

Pete arrives at his lair with Mickey hot on his heels. Stretching his tail into a rope, the Mouse pulls himself up to a third-story window, much as he did at the cantino. He finds Minnie chained to a wall. Pete grabs a sword in order to fend off her knight-errant, who seizes a second blade, and a duel ensues [125] in which Mickey gets the better of his adversary until his weapon falls limp. In the end, though, he wins the day—and the girl—by tossing a chamber pot over Pete's head. On the way back to the saloon, carried by Mickey's feathered steed, this time it is Minnie, the seductress, who offers him a kiss, to which he responds with appropriate ardor. When the jolting gait of the bird impedes their smooching, the couple coil their tails like inner springs to level the ride. They start kissing madly [126] and soon disappear behind a clump of dark foliage in the foreground that fills the screen as the film fades to black.

The Gallopin' Gaucho was finished in August 1928 and, along with *Plane Crazy,* gave Walt two one-reelers in his sample kit. This inaugural pair of Mickeys was silent, despite the fact that a sound revolution was underway, ignited in October 1927 by the release of the part-talkie *The Jazz Singer,* starring Al Jolson. By mid 1928, with the release of several more crowd-pleasing talkies—capped, a few months later, by the hugely successful Jolson vehicle *The Singing Fool,* in September 1928—it was clear that talking pictures were here to stay. As theater owners scrambled to wire for sound—a costly undertaking—Disney could not find a distributor for his technologically passé project. In the end, this may have been a stroke of good luck, for, as Richard Schickel has observed, the Mouse might "have had a life no longer than many of his competitors" if his maker had been able to market his new silent-screen hero immediately.[10]

122. Ub Iwerks, Mickey Mouse blowing smoke rings in *The Gallopin' Gaucho,* opened in New York, Dec. 29, 1928.

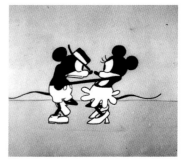

123. Iwerks, Mickey and Minnie Mouse doing a tango in *The Gallopin' Gaucho,* 1928.

124. Iwerks, Mickey riding across the pampas in *The Gallopin' Gaucho*, 1928.

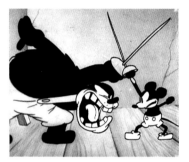

125. Iwerks, film still of Mickey dueling with Pegleg Pete in *The Gallopin' Gaucho*, 1928.

126. Iwerks, Mickey and Minnie Mouse kissing at the end of *The Gallopin' Gaucho*, 1928.

In any case, even before *The Gallopin' Gaucho* was a wrap, Walt—as ever, attuned to innovation, bent on producing quality work at any price—had been thinking about sound. Animator Wilfred Jackson recalled his boss saying at a staff meeting, in late May 1928, "that it might be possible to make cartoons with sound." By late June at the latest, Walt had written to the Powers Cinephone Corporation in New York, inquiring about recording costs, and announcing his intention to come East in the fall to discuss terms. He had decided to go the route of the new technology whether or not he managed to sell his latest series of cartoons as silents.[11]

When Disney made his move, he shunned the path of least resistance, i.e., regearing *Plane Crazy* or *The Gallopin' Gaucho* with words and music. Instead, he started from scratch with *Steamboat Willie*, in which Mickey, accompanied by Minnie, wreaks tuneful havoc aboard a riverboat captained by Pegleg Pete. Animation on this, the third Mickey short and the first Disney film with sound, must have begun by June 1928. The major conceits, thematic and musical, in *Steamboat Willie* came from two movies starring stone-faced Buster Keaton: *Steamboat Bill, Jr.* (1927) and *The Navigator* (1924). Walt's infatuation with Keaton, another on-screen jack-of-all-trades—like Chaplin's Tramp—is evident in both the Alice and the Oswald series, as Russell Merritt and J. B. Kaufman pointed out in their book, *Walt in Wonderland: The Silent Films of Walt Disney*. The loopy railroad effects in the 1929 animated short, *Mickey's Choo-Choo* also may have been inspired by two Keaton comedies, *Our Hospitality* (1923) and *The General* (1927).[12]

What made *Steamboat Willie* special was the melding of fast-paced comedy with familiar tunes, amusing sound effects, and the novel, irrepressible personality of Mickey Mouse. The action kicks off as an old-time side-wheeler chugs down a river among the rolling hills of a rural locale—not unlike the one in Keaton's *Steamboat Bill, Jr.* The boat's smokestacks bend, bulge, and bounce, puffing and tooting to the ragtime beat of a popular vaudeville number "Steamboat Bill." It was also the theme song of *Steamboat Bill, Jr.*, which had been released in May 1928 and was fresh in everyone's mind when *Steamboat Willie* debuted that November. In the cartoon, Mickey performs a variety of chores under the command of the burly bully Captain Pete, a relationship akin to the one in Keaton's film between Steamboat Bill and his son, Bill, Jr. (or Willie, as he was also called), a recent college grad, played by Buster.

We first glimpse Mickey in the wheelhouse. Sporting a captain's cap, he swings and sways at the helm, whistling the syncopated rhythms of "Steamboat Bill" [6] [127]. Tugging on a cord, he plays the smokestacks like the pipes on an oversize organ. His hijinks are cut short when the skipper boots him down to the main deck. A parrot hoots at him as he

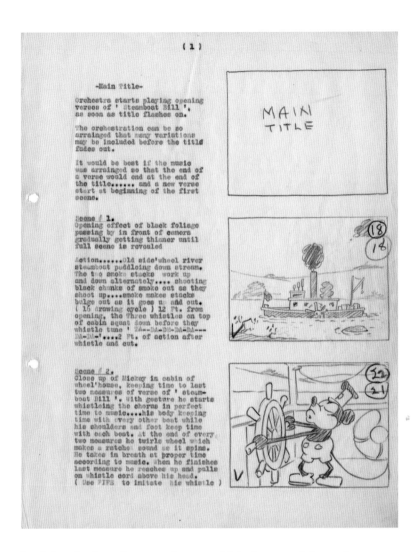

127. Ub Iwerks, illustrated script for *Steamboat Willie*, 1928. Graphite pencil and red and blue pencil on paper, sheet one of twelve sheets. Walt Disney Archives, Burbank, California.

lands in a bucket of soap and water, which the angry Mouse then tosses at the bird. Meanwhile, now at the wheel, Pete is enjoying a plug of chewing tobacco. Pete's skill in the art of spitting the stuff is imperfect, however, since one of his shots blows back in the wind to splatter him in the face. As the vessel arrives at "Podunk Landing," a cow, goat, goose, and two chickens await pickup. Naturally, as Mickey tries to bring the cow onboard, he gets squirted with milk from its udder. After the cargo is loaded, Minnie Mouse—whose name, though not yet spoken on screen, appears in a layout sheet for the cartoon—dashes onto the dock, ukulele in one hand, a bundle of sheet music in the other.

The boat shoves off before the provincial flapper can get aboard. Undeterred, she dashes after it along the riverbank; voiced by Disney himself, she shouts, "Yoo-hoo!" to get Mickey's attention. Thinking quickly, he employs a winch to snatch the last-minute arrival. The anthropomorphic hook on the end of the hoist daintily lifts her skirt before it clamps on to the waistband of her panties [128]. As Minnie is deposited safely on deck, the ukulele and sheet music for the old standby "Turkey in the Straw" fall from her hands and are gobbled

128. Ub Iwerks, Minnie hoisted onboard the boat by her panties in *Steamboat Willie*, 1928.

129. Charlie Chaplin in *The Tramp*, released by Essanay/General Film Company, April 12, 1915. © Roy Export S.A.S. Scan Courtesy Cineteca di Bologna.

130. Ub Iwerks, Mickey and Minnie Mouse in *Steamboat Willie*.

131. Ub Iwerks, Mickey Mouse playing a sow like an accordion in *Steamboat Willie*.

up by the goat. When the beast belches, musical notes pour out of his mouth, giving the Mouse an idea. To their great satisfaction, Mickey and Minnie crank the goat's tail as if it were the handle on a Victrola. The goat then begins playing the very song it had just eaten. Disney first used this gag in an Oswald cartoon, *Rival Romeos*, but the visual fantasy itself likely had its genesis in Chaplin's masterpiece, *The Tramp* (1915), where Charlie winds a cow's tail like the starter on a car [129–130].[13]

The melodious goat gets Mickey's juices flowing and, in a long virtuoso performance, he forces sounds from everything in sight. He drums on a wash barrel, a trash bin, and a set of pans, strums on a washboard, and bangs on his own skull, all to the tune of "Turkey in the Straw." He pumps the tail of a cat and, when that loses its charm, tosses it aside and picks up the goose, squeezing the fowl like a bagpipe and stretching its neck as if it were a trombone. Next, in the most hilarious sequence in the film, and still playing to the beat of "Turkey in the Straw," he pulls on the tails of six suckling piglets, then lifts up the sow, shakes and kicks the little ones loose, fingering her teats like the keys on an accordion [131]. The only visible audience for these musically driven shenanigans is the parrot, gleefully hopping about on its perch. In his final exploit, the Mouse plays the cow's teeth like a xylophone, closing the number with the old seven-beat standby known as "shave and a haircut, two bits." As the mayhem comes to an end, Pete intrudes and dumps Mickey in the galley, where, as punishment, he must peel a pile of potatoes. When the parrot appears at the porthole, taunting him once again, an exasperated Mickey hurls a spud at the raucous bird, knocking it into the water with a loud splash.

After a few sequences of the cartoon were done, Disney organized an informal trial screening of *Steamboat Willie* at the studio one summer evening in 1928 before a modest audience of friends and family. Walt performed the squeaky sounds made by Mickey and Minnie standing behind a bedsheet as the film was projected in front of him. Ub Iwerks and two other artists, Wilfred Jackson and Les Clark [132], used a washboard, harmonica, and whistles to play the music. The experiment confirmed Disney's belief that a synchronized union of sound with animation was feasible.[14]

Since Manhattan was still the technological as well as the financial hub of the film industry, Walt boarded an eastbound train in late August to record the sound track and find a distributor for *Willie*. He laid over in Kansas City to ask an old acquaintance and talented theater organist, Carl Stalling, to compose scores for *Plane Crazy* and *The Gallopin' Gaucho*. Just after Labor Day, he got to New York, settling

132. Group staff photo, late December 1929 or early January 1930. Standing, from left, Johnny Cannon, Wilfred Jackson, Les Clark, Jack Cutting. Kneeling, from left, Ub Iwerks, Walt Disney, and Carl Stalling. Walt Disney Archives, Burbank, California.

in for what turned into a marathon two-and-a-half-month stay at the Hotel Knickerbocker on West 45th Street off Broadway.[15]

In New York, Disney had a chance to catch one other animated cartoon that tried to adapt to the new technology: *Dinner Time,* the first sound short in Paul Terry's Aesop's Fables series. He was scornful of what he saw. In a letter to Roy and Ub, dated September 7th, Walt wrote:

> MY GOSH ----- TERRIBLE ----- A lot of racket and nothing else -----
> I was terribly disappointed ---- I realy *[sic]* expected to see something
> halfway decent ------ BUT HONESTLY --- it was noything *[sic]* but one
> of the rottenest fables I believe that I ever saw and I should know
> because I have seen almost all of them ----- It merely had an orchestra
> playing and adding some noises The talking part does not mean a
> thing It doesn't even match in ----- We sure have nothing to worry
> about from these quarters.[16]

Disney's correspondence with the Powers Cinephone Corporation brought him face to face with Patrick A. Powers [133], a magnetic Irish-born wheeler-dealer formerly associated with Carl Laemmle in the early years of the Universal studio, who now headed his own small independent distribution operation. Walt talked to three major sound-recording companies as well, including Fox Movietone and RCA Photophone, but settled on Powers, finding him more congenial and his offer more affordable. Negotiations ensued, but the strain of the quest took its toll. In a letter to Roy and Ub on September 11th, Walt vented his frustrations:

> Personally I am Sick of this picture ' Steamboat Willie ' every time time I
> see it the lousy print spoils everything Maybe it will be adifferent

133. Patrick A. Powers (1869–1948), circa 1920s. Walt Disney Archives, Burbank, California.

[sic] looking picture with the sound I sure hope so I am very nervous and upset and I guess that has a lot to do with my attitude in the matter This DAMN TOWN is enough to give anybody the the HEEBIE - JEEBIES ' I sure wish I was home.[17]

Despite his malaise, Disney struck a bargain in which, according to Arthur Mann, he and his new associate "entered into a ten-year recording agreement. Powers agreed to distribute the films, to promote the idea generally, and to lend money to Walt to finance the making of the pictures." Pat Powers also arranged for a recording session under the direction of Carl Edouarde, the retired long-time musical director of the Mark Strand Theatre, the first picture palace to boast its own symphony orchestra. Chaplin's film *The Gold Rush* had opened in New York during Edouarde's tenure at the Strand in 1925, and the first true talkie, *Lights of New York,* premiered there as well, although Edouarde had left by then.[18]

On the eve of the first recording session, which took place on September 15, Walt wrote to Roy and Ub: "We are using a Seventeen piece Orchestra and Three of the best Trap Drummers and Effect men in Town They get Ten Dollars an hour for this work It will take Three hours to do it plus the time the Effect men put on it on today." The work would, in fact, require a second go-round—and the percussionists Walt glowingly described turned out to be far from the best. On September 17, he cabled Roy: "ALL CONCERNED DESIRE BEST RESULTS OBTAINABLE THEREFORE ARE REMAKING IT USING DIFFERENT EFFECTS MEN." Edouarde's credentials and experience notwithstanding, the session had been a fiasco. He thought he could lead an orchestra in the studio much as he'd done at the theater, by watching the cartoon action flicker past on the screen. This was not the only problem Disney had to contend with. In a letter dated September 20, he complained to Roy and Ub, "BOY - these unions sure are tough on Movie Recordong *[sic]*. They are doing everything they can to discourage the Sound Film craze."[19]

Strapped for cash, the Disneys had to scramble to fund a second session, planned for the wee hours of September 30. (Roy—as always—found the money.) This time Walt got Edouarde to try a method for synchronizing music to images devised by Iwerks. It allowed Edouarde to successfully lead the players by following a device inscribed on the print of the film that the he alone could see, a "little BALL" that kept "time through out the entire picture." We cannot, incidentally, identify any of the men in the orchestra who made the soundtrack recording, but we know that the effects the second time around were supplied by the three named stars of the Green Brothers Novelty Band, George, Joe, and Lew Green

134. The Green Brothers Novelty Orchestra in a New York City recording studio, 1930–31. In front, on either side of the xylophone, are leader George Hamilton Green (1893–1970), left, and Joe Green (1892–1939), right. Behind George Green, holding a guitar, is the youngest of the three brothers, Lew Green (1909–92). Behind George Green to his left is sax player Jimmy Dorsey, brother of famed band leader Tommy Dorsey. Photo courtesy Lewis Green, Jr.

[134]. The brothers Green played the marimba, vibraphone, bells, chimes, and—most importantly, perhaps, for *Steamboat Willie*—the xylophone, which George Green helped popularize. George Green probably supplied the percussive sounds for the sequence where Mickey hammered a cow's teeth like the bars of a xylophone.[20]

In a letter to Roy and Ub, on September 23, Walt reported:

We have made arraingements with the Green Bros. Victor recording artists to handle the effects on this one They are supposed to be the best Effect men in the business Powers is arraingeing everything and will stand the expense . . . He is just as determined that this should be good as I am He is taking a very big interest in the whole affair

The Green Bros. did the effects on ' The Shadows ' and it is supposed to be wonderful They are very busy and we were not able to get them until next Tuesday They are going to rehearse the effects with a piano Powers is going to shoot a test and we will see it wednesday and make all the changes necessary and then call in the Orchestra Thursday and shoot Should have a finished print by Saturday This is the best we can do I am not worrying about it because I feel that it will be well worth while

These Green Bros. are familiar with what is necessary for recording . . . The trouble before was that the Drummers were familiar with what would sound good from an Orchestra pit and not familiar with how it would reproduce through the mike There is a lot of difference.

[. . . .]

135. Harry Reichenbach (1882–1931), press agent extraordinaire, circa 1920–25. Photo courtesy Michael Barrier.

The Green Bros. have Twenty Thousand Dollars worth of Special built effects for recording . .(They invented them their selves and hold the patents) They are going to use them on this picture They are experts at Recording Don't do anything else Have been doing this for about Fifteen years They should be good They are also Xylophone Recording Artists ~~also~~ . All the Victor Records that have effects in the music have been done by them [. . .]

The Green Brothers' ragtime recordings, including "Yes, We Have No Bananas," were huge hits in the 1920s. That, along with their musical genius, meant their talent did not come cheap. "Do you realize what Powers paid the Green Bros. for their work on our picture? (Get ready to faint.)," Walt wrote in a subsequent letter to Roy and Ub: 'SIX HUNDRED DOLLARS.' Because their services proved so costly, George, Joe, and Lew Green may have been hired for just one other Mickey cartoon, *The Opry House* (and the first Silly Symphony, *The Skeleton Dance*). But Walt instinctively appreciated and strove for quality whenever he could— and hang the expense. The Green Brothers were a perfect fit for the comic effects required in Mickey's film debut, and their snappy, syncopated sound left its musical mark on the early Mouse animations.[21]

On Sunday evening, September 30th, a weary but relieved Walt typed a long letter to the "gang" back in Hollywood, that began as follows:

Well - we finally recorded the picture this morning Everything went Great It worked like clock works . . . The Orchestra kept synchronization through out the entire picture. It didn't get off one beat. This was a big help to the Effect men and the result was they all hit on the dot. I am sure happy over the whole affair because it proves absolutely that it can be done [. . . .] That Ball keeping time through out the entire picture sure is a dandy idea It saved this picture .[22]

In Walt's mind, *Steamboat Willie* must have been ready to go at that point. Throughout the 1930s, the studio celebrated the anniversary of Mickey Mouse on or around September 30 [136]. Still, there was one last roadblock: neither Disney nor Pat Powers could find a theater willing to screen the film. At last, the Colony Theatre at Fifty-Third Street and Broadway, where several Oswald the Lucky Rabbit one-reelers had been exhibited, offered to run *Willie* for two weeks. The man behind this minor miracle was the legendary press agent Harry Reichenbach [135], who, as Walt remembered, some thirty years after the fact, approached him, saying, "I want to put that on." Disney also recalled Reichenbach as being the manager of the theater, a position, in reality, held by one David C. Werner. However, Harry Reichenbach was in the employ of Universal, the

136. Article from *Motion Picture Herald*, Oct. 1, 1932 (detail of page).

The text within the image reads:

42 MOTION PICTURE HERALD October 1, 1932

MICKEY MOUSE'S FOURTH BIRTHDAY FINDS ORGANIZATION WORLDWIDE

700 Clubs Meet on Saturday Mornings and New Units Form Overseas; Anniversary Is Observed in Series of Broadcasts

Mickey Mouse is a big boy now.

Since his birth on October 1, 1928, he has seen the growth of a production organization which for comprehensiveness has no parallel in the field of the screen cartoon. In those four years he has noted the development of a direct contact with the children of this and other countries until the numbers enrolled in Mickey Mouse Clubs are estimated as on the way to the million mark. And since midsummer, when he entered the United Artists household, has come a nationwide concentration of tieup connections with the makers of Mickey Mouse dolls, toys, wearing apparel and other articles.

The ramifications of active interest in the careers of Mickey and Minnie Mouse, as depicted by Walt Disney, are cited as follows:

Children members of more than 700 Mickey Mouse Clubs meet on Saturday mornings.

Approximately 15,000 exhibitors throughout the world show the cartoons at one time or another.

Publishers of 172 newspapers print a daily Mickey Mouse cartoon strip.

Fifty to sixty mercantile houses are engaged in the manufacture of Mickey Mouse novelties.

At the birthday party on the studio lawn. Walt Disney is holding the left hand of his Mickey. Roy O. Disney, brother and chief lieutenant of Walt's, is shown on the other side of him.

leaseholder on the Colony, and he must have seen a distinct advantage for his client in running the cartoon.[23]

Steamboat Willie had its debut Sunday, November 18, 1928, on an afternoon bill that featured Ben Bernie and His Famous Orchestra, live stage acts, and a Pathé newsreel with sound. The nominal highlight of the program was the premiere of a run-of-the-mill action picture, *Gang War,* starring Olive Borden and Jack Pickford, the younger brother of "America's Sweetheart," Mary Pickford. Walt's friend Carl Stalling had joined Disney in New York by then, arriving from Kansas City on October 26 bearing scores for *Plane Crazy* and *The Gallopin' Gaucho.* Years afterward, Stalling recalled the occasion with relish:

Walt . . . came through Kansas City on his way to New York to record the music for *Steamboat Willie.* . . . I didn't go with him, since he already had that all set up. I had nothing to do with that. I met Walt in New York to record that music and we shared the same hotel room; we both washed out our socks in the same bathroom sink. I was with Walt when *Steamboat Willie* was previewed at the Colony Theater, down on Broadway, and we got the audience reaction. The reaction was very good. We sat on almost the last row and heard laughs and snickers all around us.[24]

On Monday, November 19, *New York Times* movie reviewer Mordaunt Hall gave Mickey his first critical mention in print. While describing *Gang War* as "better than the majority of its ilk," he was infinitely more impressed by Disney's handiwork. In the last paragraph of his review, he noted:

On the same program is the first sound cartoon, produced by Walter Disney, creator of "Oswald the Rabbit." This current film is called

137. "No Interruption," page-one squib, *Film Daily*, Nov. 20, 1928.

"Steamboat Willie," and it introduces a new cartoon character, henceforth to be known as "Micky [*sic*] Mouse." It is an ingenious piece of work with a good deal of fun. It growls, whines, squeaks, and makes various other sounds that add to its mirthful quality.

Mordaunt Hall's mention of *Steamboat Willie* as "the first sound cartoon" reflected the film's billing by the Colony in its Sunday ad in the *Times*, as the "*FIRST and ONLY* Synchronized-sound animated cartoon comedy."[25]

The trade journals were equally enthusiastic. In its report on Tuesday, November 20, 1928, *Film Daily* stressed the reliability of the Powers Cinephone system: "Demonstrating interchangeability with Western Electric equipment," Disney's cartoon short "was shown five times Sunday and five times yesterday" [137]. In a squib devoted exclusively to *Willie* in the November 21 issue of *Variety*, the first solo review anywhere for Disney and Mickey, a staff writer declared:

> Not the first animated cartoon to be synchronized with sound effects but the first to attract favorable attention. This one represents a high order of cartoon ingenuity cleverly [*sic*] combined with sound effects. The union brought forth gags galore. Giggles came so fast at the Colony they were stumbling over each other.
>
> It's a peach of a synchronization job all the way, bright, snappy and fitting the situation perfectly. Cartoonist, Walter Disney.
>
> With most of the animated cartoons qualifying as a pain in the neck it's a signal tribute to this particular one. If the same combination of talent can turn out a series as good as "Steamboat Willie" they should find a wide market if interchangeability angle does not interfere.
>
> Recommended unreservedly for all wired houses.

Three days later *Moving Picture World* chimed in:

> Mechanical interchangeability was further demonstrated Sunday when the Colony Theater here exhibited a one reel cartoon subject drawn by Walter Disney and recorded by Powers Cinephone. It was shown on the Western Electric device. [. . .] The cartoon called *Steamboat Willie* is also said to be the first cartoon subject to be made specially for sound.[26]

On November 25, the one-week anniversary of Mickey's debut, the Colony's ad in the *New York Times* proclaimed its Sunday program on that date to be "the biggest and best show ever offered by a Broadway Film Theatre," one that featured Disney's "Synchronized Animated Cartoon Comedy," *Steamboat Willie*. Paul Terry and Max Fleischer had used sound before Disney, but Walt had a far better product and was

prepared to exploit it with a ready stock of one-reelers. Consequently, he got the glory for the breakthrough, which proved an immense advantage in selling his new series.[27]

Meanwhile, the accolades continued. On December 4, columnist T. O. Service in *Moving Picture World* called *Steamboat Willie* a "riot of mirth" that "knocked me out of my seat." A few weeks later, in January 1929, amid a review of the silent film *Synthetic Sin* at the Earle Theater in the nation's capital, *Washington Post* critic Nelson B. Bell said that he had

> learned that a cartoon comedy can be made devastatingly funny by convulsing commotions. Mickey Mouse as "Steamboat Willie" is an inspired example of sound-picture insanity!

Thus did the year 1928, which in March had seemed destined for disaster, end in triumph in December. Within a few short years, it would be apparent as well that an American icon had been spawned. As the *Washington Post* recalled on the occasion of the character's seventh birthday in 1935:

> Overnight Mickey became not only an authorized representative of the American people and the American scene, but an incentive to the laughter of nations.[28]

In a letter to Roy and Ub in late September 1928, Walt expressed the hope that Mickey's success "may mean the beginning of a big organization out of our little Dump." On October 20, he wrote to Lilly, "I really think our big chance is here." So it was. Mickey Mouse was born and the foundation laid for the most resilient, imaginative, and profitable of all the Hollywood studios. Among its achievements, Walt and Roy's "little Dump" would go on to make the first major, full-length animated color motion picture, *Snow White and the Seven Dwarfs,* to establish theme park operations in America, France, Japan, and China, and to acquire a vast media empire, including control of three television networks and ownership, in 2006 and 2012, respectively, of Pixar and of George Lucas's production company, Lucasfilm. As Walt remarked on the very first *Disneyland* TV show in October 1954:

> During the last few years we've ventured into a lot of different fields and we've had the opportunity to meet and work with a lot of wonderful people. I only hope that we never lose sight of one thing—that it was all started by a mouse.[29]

MICKEY MANIA

Before 1928 drew to a close, three new Mickey Mouse cartoons, *Plane Crazy* and *Gallopin' Gaucho*, both with sound added, plus *The Barn Dance*, had been completed, though none of the first Mickeys, *Steamboat Willie* included, were in circulation nationally as yet. Eleven more would be made and released in 1929, nine in 1930, twelve in 1931—at a rate of roughly one short per month during the first three years of Mickey's existence.

Music fired their popularity. As *Time* magazine noted in 1954, what was novel about the typical early Disney cartoon, "aside from its frenetic ingenuity, and what struck the public most, was the music. It hopped, it jangled, it twitched, it plankety-planked, and from that day forward was known as 'Mickey Mouse Music'—an exquisite melding of bad honky-tonk and good rattletrap." Leonard Maltin put it this way: "Some people will tell you that music was a key ingredient of Walt Disney's success. Don't you believe it. Music was the foundation of Walt Disney's success."[1]

Disney's merging of music and screen action was remarked on almost instantly. In December 1929 in the Parisian monthly *Jazz*, journalist Pierre Scize (aka Pierre-Joseph Piot) raved about the grand piano with a mind all its own in one of Mickey's most fun-filled productions, *The Opry House* [139]. For Scize, the cartoon was "a kind of *symphonie parodique* full of surprising sounds that never get tiresome because they're measured and strike just the right tone, with humor that is genuine and *profondément expressif.*"[2]

Sergei Eisenstein's friend, the English film aficionado, Ivor Montagu, let it be known that the renowned Soviet director "had already declared in Europe," prior to his arrival in America in 1930, that Disney "was the only man working in the United States who used sound properly." In an August 1930 article in *Close-Up* ("the fascinating international magazine of cinema-aesthetes," as Gilbert Seldes called it), Eisenstein

138. Edward Steichen (1879–1973), portrait of Walt Disney illustrating an unsigned squib, "Walt Disney and his children." Published in *Vanity Fair*, October 1933. Gelatin silver print, 9 5/8 x 7 3/4 in. © Condé Nast.

likewise claimed that the future of motion pictures lay not so much with "the all-talking film" as it did

> the sound film—that is to say, the film in which sound is not used naturalistically. The line of departure, in one direction, is indicated by the excellent Mickey Mouse films. In these, for example, a graceful movement of the foot is accompanied by appropriate music, which is, as it were, the audible expression of the mechanical action.[3]

In a monograph on the German animator Lotte Reiniger, published in 1931, by Leonard and Virginia Woolf's Hogarth Press, the Oxford-educated music critic Eric Walter White gave his opinion on the subject:

> The important discovery made by Walt Disney in his cartoon films concerns the unexpected relations that exist between visual and aural phenomena. For instance, when a stream of bubbles appears on the screen, Mickey will almost certainly prick them with a pin, and as they explode they will play a tune in which the frequency of the wave-vibration of each note will be inversely proportional to the size of the bubbles.

In 1936, Jerome Kern, "the founding father of the American musical," stated that Disney had "made the twentieth century's only important contribution to music. Disney has made use of music as language. In the synchronization of humorous episodes with humorous music, he has unquestionably given us the outstanding contribution of our time. In fact I would go so far as to say it is the only real contribution."[4]

According to *Time* magazine in 1952, Walt's innovation of having "the tempo coinciding with movement and speech" quickly became known in movie circles as "Mickey Mouse music," or, alternatively, "Mickey-Mousing," an expression attributed to David O. Selznick, signifying in both instances, in the words of one film scholar, "the exact, calculated dove-tailing of music and action." This terminology is still part of industry lingo. In an interview in 1990, composer John Barry said, "I've always called my Bond scores 'million-dollar Mickey Mouse music.'"[5]

The range of music in Mickey's cartoons was extensive. Until the mid '30s, when in-house compositions began to predominate, the orchestrations contained a cross-section of American popular music from traditional ballads and lullabies, patriotic anthems and minstrelsy to vaudeville, ragtime, jazz, pop tunes, and even classical. In a vaudeville show staged in *The Opry House* (1929), for instance, there are snatches of *Carmen* and, as played by Mickey, at the piano, the Hungarian

Rhapsody and Rachmaninoff's Prelude in C sharp minor. Rachmaninoff, not an easy man to please, reportedly told Disney, "I have heard my inescapable piece done marvelously by some of the best pianists, and murdered cruelly by amateurs, but never was I more stirred than by the performance of the great maestro Mouse." (*The Opry House* was also the first cartoon in which Mickey wore gloves.)[6]

In *Steamboat Willie,* Mickey's cinematic debut, music was a major component, although just two tunes were used: "Steamboat Bill" and "Turkey in the Straw." For *Plane Crazy* and *Gallopin' Gaucho,* a half-dozen familiar airs were worked into each soundtrack, some just once in snippets, others as repeating motifs. Among the old standards were "For He's a Jolly Good Fellow," "Goodnight, Ladies," "Auld Lang Syne," "Yankee Doodle," and "Cielito Lindo." More recent melodies included "Rock-a-by, Baby (In the Treetop)," from 1887, and "Hearts and Flowers" (1893).

Gradually the music got more varied—and daring—as in *Karnival Kid* (1928), the second Mickey Mouse film planned from the start with sound in mind. It was also in *Karnival Kid* that Mickey first spoke (as a vendor yelling out "Hot dog! Hot dog!"). In it there are riffs on old chestnuts such as "Where, Oh Where Has My Little Dog Gone?" and "My Bonnie Lies Over the Ocean," but its musical centerpiece is the turn-of-the-century gem of barbershop harmony "Sweet Adeline," with vocals by two alley cats. *Karnival Kid* also includes the comically suggestive strains of an air made famous by the 1893 Chicago World's Fair: often referred to as the "Hoochy Koochy Dance," sung by a barker outside a tent where "Minnie the Shimmy Dancer" struts her stuff [140]. (The title of the 1931 Cab Calloway hit "Minnie the Moocher"—with the lyric line "She was a red hot hoochie coocher"—may well have derived from this scene in *Karnival Kid.*)[7]

In *Mickey's Follies* (1929) there is no pretense at all of a plot, just a barnyard revue with a program that includes Stephen Foster's "Old Folks at Home," a rooster and hen performing a Parisian Apache dance, and an operatic sow singing "O Sole Mio." *Mickey's Follies* is noteworthy, too, because the cartoon's featured tune, sung and played on the piano by Mickey Mouse, introduced his theme song, "Minnie's Yoo-Hoo." In *The Gorilla Mystery* (1930), Minnie Mouse is the focus of the musical action, as she sings and plays (also on piano) a now tender, now wildly syncopated, rendition of the Irving Berlin–Hoagy Carmichael hit from 1924, "All Alone (By the Telephone)."

The Birthday Party (1931) was one of Disney's finest unions of animation and music. A surprise party for Mickey at Minnie's house, with Horace Horsecollar, Clarabelle Cow, and other guests in attendance,

139. Piano with a mind of its own in *The Opry House,* released by Celebrity Productions, March 28, 1929. Ub Iwerks was responsible for the bulk of the animation in this cartoon.

140. "Minnie the Shimmy Dancer" in *The Karnival Kid,* Celebrity Productions, opened in New York circa Aug. 9, 1929. Iwerks did most of the animation on this film.

141. Mickey and Minnie in a piano duet in *The Birthday Party,* released by Columbia Pictures, Jan. 7, 1931. Dave Hand (1900–86) was the lead animator for this production.

142. Mickey balancing a broom on his nose in *Mickey Steps Out,* released by Columbia Pictures, July 7, 1931. Dave Hand was the lead animator on this film.

is a flimsy excuse for nonstop song-and-dance. It all begins with the Mouse and Minnie performing a dueling-piano version of "I Can't Give You Anything But Love" [141], one of the most popular songs of the late '20s and into the '30s, which would resurface in 1938 as the title tune of *Bringing Up Baby*. Next, the twosome does the Charleston to the "Darktown Strutters Ball," which is followed by "Home Sweet Home," played on the xylophone by Mickey, and—in the fast-paced climax— another piano duet, to the tune of "Muskrat Ramble," in which the star tickles the ivories with his fanny.[8]

In Mickey Steps Out (also 1931) the Mouse prances over to Minnie's house, striking the planks of the wooden sidewalk with his feet like keys on yet another (this time giant) xylophone, to the beat of "When My Sugar Walks Down the Street" (1924). After he arrives, Minnie rags a keyboard version of "Sweet Georgia Brown"—famous today as the theme song of the Harlem Globetrotters—and Mickey trips the light fantastic with a broom [142], well before Gene Kelly partnered with one in the 1944 film *Thousand Cheer*. Thus was a pattern established: not infrequently, in Mickey's initial film appearances, a cartoon's story line provided only the barest of pretexts for tuneful merriment, with jazz a frequent element in the fun. They were the MTV or YouTube music videos of their generation.

A third animated short from 1931, *Blue Rhythm,* kicks off with Mickey at the piano in a large theater or concert hall. The opening chords are played in a dignified classical manner. However, he soon breaks into a ragtime treatment of the "St. Louis Blues," and Minnie comes on stage, singing (in dialect) and dancing to the W. C. Handy favorite. Mickey then leaves the piano and joins Minnie in her larking about, and near the end of the cartoon does an impression of jazzman Ted Lewis, battered top hat and all. Another one-reeler, *Mickey Cuts Up,* again, from 1931, starts with the Mouse rhythmically mowing the lawn to "Shine," which Louis Armstrong had recorded in 1924, and Dooley Wilson would perform in *Casablanca* (1942). *Mickey Cuts Up* also features Mickey and Minnie in a lively performance of the 1921 hit "Ain't We Got Fun?"

Music pulsed through Mickey's veins in the early days, as part of a persona that united multiple aspects of the nation's character and customs. He was a mock-heroic product, and emblem, of the "industrial and entrepreneurial tradition" cited in Schickel's analysis of what made Disney tick. Like Walt and Ub, Mickey was a child of the heartland, an all-American boy and, like Chaplin, Keaton, or Lindbergh, inclined to take a crack at whatever caught his fancy. He frolicked to the latest tunes and, at the outset, like Walt Disney, even smoked and enjoyed a brew. In their very first films, at least, Mickey and Minnie were as frisky as many another liberated adolescent—or adult—of the Jazz Age.

Jazz had been around since the turn of the century. The word entered the lexicon right around the time of World War I, but it was not until the early to mid 1920s that it became a part of everyday language. Writing in the *New York World* in 1923, the classical composer and music critic Deems Taylor called jazz "utterly American—the only utterly American music that I know." Two years later, a student writer in the *Harvard Crimson* observed that jazz, along with films, "another of the Things People Look Down On," had by then been "brought into the fold" by Seldes's book *The 7 Lively Arts.* Coming along just as talkies were replacing silents and jazz and motion pictures were winning mainstream acceptance, Disney's cartoon character profited from and encapsulated the dynamic traits of both mediums. In his early animations, such as *The Jazz Fool, Blue Rhythm,* and *Mickey Cuts Up,* the Mouse personified the Roaring Twenties. Those films, and others, in which Mickey and Minnie cavorted to tunes like "Sweet Georgia Brown" or "Shine," represent a merging of three uniquely American mass-cult artforms: the movies, popular music (jazz included), and cartoons.[9]

Among Mickey Mouse's initial enthusiasts were the queen and king of Hollywood royalty, Mary Pickford and Douglas Fairbanks. According to a frequent guest at Pickfair, the couple's grand estate in Beverly Hills, "the feature of the evening" one night around 1928 or 1929 was *Steamboat Willie.* In 1930, Pickford wrote to Walt, thanking him for a present of a toy Mickey, probably a stuffed doll, and urging him to make more Mouse cartoons. A photograph from that year shows her snuggling with a Mouse doll. Nonetheless, Pickford's letter—like Disney's gift—was surely not the product of utterly disinterested admiration; in December 1930, Walt Disney would sign a film distribution deal with United Artists, the company that Chaplin, D. W. Griffith, Pickford, and Fairbanks had incorporated in 1919.[10]

Overseas, in November 1929, the first institution in England (and one of the first in the world) formed in order to promote serious cinema, the London Film Society—an elite private club cofounded in 1925 by Ivor Montagu—hosted a program that included Eisenstein's *Battleship Potemkin, The Fall of the House of Usher,* and a Mickey Mouse cartoon, *The Barn Dance.* Aldous Huxley and Eisenstein himself were among the attendees. Mickey's popularity abroad was further consecrated, in 1930, by a novelty foxtrot from British songwriter Harry Carlton, "Mickey Mouse," that led to dozens of recordings in Europe and America. In the opening verse of Carlton's tune were these words:

Mickey, Mickey, tricky Mickey Mouse,
On the land and on the sea, he's a big celebrity.

143. David Low (1891–1963), "Thomas Cat and the Mickey Mice," editorial cartoon of Labour Secretary James Thomas as a cat being harassed by critics and colleagues, *London Evening Standard,* March 10, 1930. The British Cartoon Archive, University of Kent, Canterbury, Great Britain. © Solo Syndication / Associated Newspapers Ltd.

Later that year, the piano sequence in *The Opry House,* and perhaps illustrations related to it, like the one published in *Film Daily* [64], inspired an installation at Madame Tussaud's wax museum in London .[11]

In February 1930, Labour Prime Minister Ramsey MacDonald was caricatured by Sidney Strube as Mickey Mouse in the *Daily Express.* In March 1930, the *London Evening Standard* printed an editorial cartoon by David Low depicting a Labour cabinet secretary tormented by a swarm of "Mickey Mouse" party colleagues, including the future British Fascist leader Oswald Mosley, and assorted "left wing critics" [143]. Low's drawing signaled Mickey's official adoption as a visual cliché in the cartoonist's armory. He has appeared in graphic political satire countless times since, in Europe and in America. In 1980, for example, Pulitzer Prize laureate Mike Peters used Mickey to make light of artificial insemination [145], and as recently as 2013, two-time Pulitzer winner Michael Ramirez depicted Barack Obama leading a clueless tot in Mouse ears toward the Promised Land of "free stuff" [144].[12]

Across the Channel, in December 1929, one of the first published critiques of Mickey Mouse was ain the article in the French journal *Jazz* in which Pierre Scize applauded *The Opry House* and *The Jazz Fool* and called such cartoons—"la prodigieuse série des 'Mickey'"— one of three examples of talking pictures "d'un art parfait" then playing in Paris. (The other two, according to Scize, were a Hollywood production, *The Broadway Melody* and *Les Trois Masques,* the first French talking picture.) In 1930, three of Pierre Scize's fellow critics,

144. Michael Ramirez (1956–), "The State of the Union," editorial cartoon, *Investor's Business Daily,* Feb.14, 2013. The original is a digitally colored pen-and-ink drawing over pencil sketch on DuoShade paper, 13 x 18 in. (sheet). By permission of Michael Ramirez and Creators Syndicate, Inc.

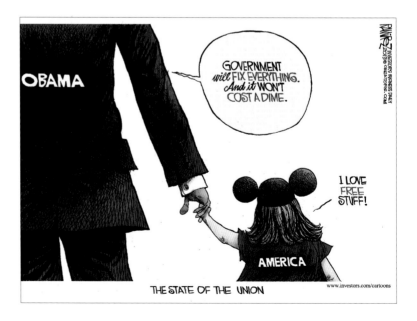

LOOK, LADY— YOU'RE THE ONE WHO ASKED FOR A FAMOUS MOVIE STAR WITH DARK HAIR, STRONG NOSE AND DEEP SET EYES...

Maurice Bessy, Alexandre Arnoux, and Anton Zischka, all contributed articles on Mickey Mouse and his co-creators, Walt Disney and Ub Iwerks, to the Parisian film magazine *Pour Vous*. In October 1930, the Mickey Mouse comic strip was picked up, in translation, by the daily newspaper *Le Petit Parisien*.[13]

When audiences in Germany first glimpsed the Mouse in *The Barn Dance* (January 1930), the house organ of Disney's German distributor, *Süd-Film-Magazin*, declared: "Micky ist das Beste vom Besten!" ("Mickey is the best of the best!"). In February, after the release of *The Jazz Fool*, the country's most prestigious motion picture daily, *Film-Kurier*, called him *ein Tonfilmwunder*, or "talking-picture wonder," a term that inspired a program of one-reelers at the Marmorhaus cinema, on the Kurfurstendamm, the Champs-Élysées of Berlin, billed as "Micky das Tonfilm-Wunder." In 1930, Harry Carlton's "Mickey Mouse" was covered by ten different bands in Germany, where, beginning that year, Micky-und-Minni toys, salt-and-pepper shakers, and Micky-Maus cigars went on sale. The character's popularity was such that a 1930 feature film, *Die vom Rummelplatz*, starring Anny Ondra (future wife of boxing champion Max Schmeling), was distributed in Austria as *Micky-Maus-Girl*, because, in one memorable scene, Ondra wore a Mickey Mouse costume [148]. Mickey would have "guest shots" or be mentioned in approximately twenty non-Disney feature films between 1930 and 1952, but *Die vom Rummelplatz* marks his first confirmed appearance in a film produced by another studio.[14]

On this side of the Atlantic, in September 1930, Sergei Eisenstein visited the Disney studio and posed for pictures with Walt and a cutout figure of Mickey. Eisenstein inscribed one of the photos for his wife, "To my best friend in U.S.S.R. together with my best friend in U.S.A." [146–147]. In February 1931, Eisenstein was quoted in *Time* as saying

146. Panel from a Mickey Mouse comic strip, Mar. 7, 1930, inscribed by Walt Disney to "my friend Sergei Eisenstein." S. M. Eisenstein Scientific-Memorial Cabinet (Museum of Cinema), Moscow.

147. Eisenstein with figure of Mickey alone at the Disney studio, signed, dated, and inscribed by Eisenstein to his wife, Pera Atasheva ("To my best friend in U.S.S.R. together with my best friend in U.S.A./ Hollywood IX–19–1930"), Sept. 1930. The Walt Disney Family Foundation, San Francisco, California.

148. Swedish poster for the Anny Ondra film *Die vom Rummelplatz*, released in Germany on August 14, 1930, and in America on January 1, 1932, as *Fair People*. Ondra's costar, Siegfried Arno, had a bit part in *Palm Beach Story* as Toto, an idiotic, simple-minded European hanger-on. The Walt Disney Family Foundation, San Francisco, California.

that Walt's animated cartoons "are America's most original contribution to culture."[15]

In January 1931, *The Nation* published its "Honor Roll for 1930" in which it saluted the makers of animated cartoons for the preceding year, "particularly as exemplified in the MICKY MOUSE and the SILLY SYMPHONY series." In March, a Columbus, Ohio, newspaper proclaimed Mickey "Movieland's most popular star!" And near the end of 1931, the Mexican muralist Diego Rivera, residing in the United States at the time, penned an article entitled "Mickey Mouse and American Art" for a New York literary and artistic journal, *Contact*.[16]

In 1932, the lyricist for George Gershwin's mega-hit "Swanee," Irving Caesar, authored "What! No Mickey Mouse? What Kind of a Party Is This?" [9], which was recorded by Ben Bernie & His Orchestra. Another 1932 Tin Pan Alley composition was "I'd Rather Stay Home with Mickey Mouse (Than Go Out with a Rat Like You)." In 1933, "What! No Mickey Mouse?" triggered a flurry of Mouse novelty tunes, including "Hot Cha House," "Mickey Mouse and Minnie's in Town" [151], recorded for Victor Records by the Frank Luther Orchestra, and "Mickey Mouse and the Turtle" (the Washboard Rhythm Kings).[17]

In December 1933, two programs of Mickey Mouse and Silly Symphony cartoons were presented at New York's Carnegie Hall "as a special holiday entertainment for children and adults alike." By then, as Mickey's first lustrum of existence drew near, "Mickey-mania" was in full bloom. Through December 1933, sixty-two animated shorts— more than half of all the Mickey Mouse cartoons ever made—were released. He also was being exhibited in museums and galleries all over the country and was omnipresent as a consumer item in the United States and Europe.[18]

Mickey Mouse was not the first film personality to be lionized by the American public. Mary Pickford, Felix the Cat, and Rudolf Valentino had had legions of fans, too. But neither Mary, Felix, nor the Sheik inspired an intensity in their followers to match that of Charlie Chaplin. Starting in 1915, there were toy dolls, playing cards, clothing

Anny Ondra

FLICKAN MED
MUSSE PIGG-
HUMÖRET

Siegfried
Arno
Margarete
Kupfer
Vidor
Schwanecke

VARIETÉNS
SKÄLMUNGE

Regi: Karl Lamac

149. Fox Dome Theatre, Ocean Park (Santa Monica), California, home of the first movie-theater Mickey Mouse Club. "Ocean Front Promenade," by Ansel Adams. Los Angeles Public Library Photo Collection.

150. Membership card for June Sullivan, Capitol Mickey Mouse Club (Miami, Florida), circa 1933–34. 2¼ × 3¾ in. Walt Disney Family Foundation, San Francisco, California.

151. Ann Ronell (1906–93), words and music, "Mickey Mouse and Minnie's in Town," sheet music (Irving Berlin, Inc., 1933). Rob Richards, Hollywood, California.

apparel, and other products bearing his likeness, plus popular songs such as "The Charlie Strut" and show tunes such as "Those Charlie Chaplin Feet," performed on Broadway by cane-wielding Ziegfeld Girls in baggy pants, derbys, and false mustaches. Charles McGuirk, a film trade observer, diagnosed the madness for all things Charlie as "Chaplinitis."[19]

Chaplinitis was just one phase in the life of a great twentieth-century cultural icon. Film scholar Charles J. Maland coined the term *star image* to describe how Chaplin attained that status. Chaplin's star image was the result of a quasi-organic process involving journalists, critics, and, most important, the public at large, in response to his films, studio publicity, and media coverage of him as an actor, a director, and a man with a notorious penchant for young women. Chaplin's reputation eventually suffered as the result of a paternity suit, tax problems, and accusations of being a Communist fellow traveler. In 1952, after a trip abroad, he was refused reentry to the United States, and was obliged to live out his days in Switzerland.[20]

The star image of Mickey Mouse would be more intense, variegated, lasting, and happier than Chaplin's, if only because, as a fictional figure, he was free of real-world woes and personal frailties. To a far greater extent than was true of the Little Tramp, his popularity also was tied to merchandising. An important aspect of his product appeal, as Richard deCordova revealed in his article "The Mickey in Macy's Window: Childhood, Consumerism, and Disney Animation," was the "sacred connection" that developed "between Mickey Mouse and idealized childhood." How this interlocking relationship among children, Mammon, and Mickey Mouse arose was the result of talent, hard work, and calculation by Walt and Roy Disney—as well as just plain luck.[21]

It all began in September 1929, when the first Mickey Mouse Club was formed at the Fox Dome Theatre, in Santa Monica, California [149]. The original Mouse Club (not to be confused with the TV show of the 1950s) was a regular event each Saturday that always included a Mickey cartoon. As articulated by Harry Woodin, the Fox Dome manager who came up with the idea, the primary aim of the club was that of "getting and holding the patronage of youngsters." The second goal was "through inspirational, patriotic, and character-building activities related to the Club, to aid children in learning good citizenship."[22]

Club meetings included the mass recitation of a creed (to "be a good American"), a pledge ("Mickey Mice do not SWEAR—SMOKE—CHEAT or LIE"), the salute to the flag, and singing of one verse of "My Country 'Tis of Thee." Next came games, stunts, or contests, the Mickey Mouse Club Yell, and the Mickey Mouse "Theme Song." The words of the "Theme Song" (alternate lyrics, actually, to "Minnie's Yoo Hoo")

MICKEY MOUSE AND MINNIE'S IN TOWN

BY ANN RONELL

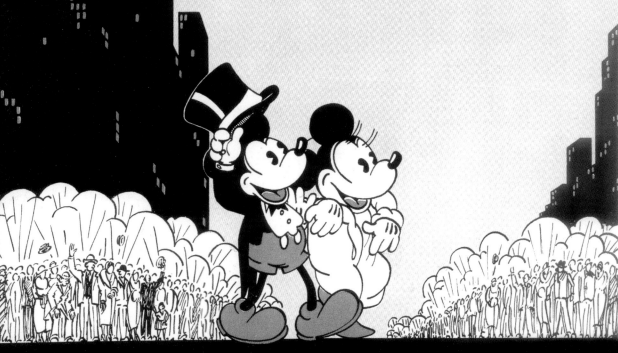

Irving Berlin, Inc.
MUSIC PUBLISHERS
1607 Broadway New York

MADE IN USA

152. *Mickey Mouse Book* (New York, Bibo and Lang), October 1930. Albert Barbelle (1887–1957), a New York–based freelance artist provided all of the art for the book, including the cover. The Walt Disney Family Foundation, San Francisco, California.

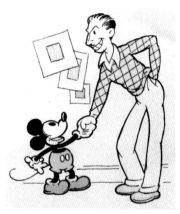

153. Barbelle, Mickey shaking hands with Walt Disney, illustration in the *Mickey Mouse Book*, October 1930. The Walt Disney Family Foundation, San Francisco, California.

flashed across the screen for everyone to follow, beginning with:

> We're the gang they call little Mickey Mice
> And we're always mighty nice
> Whether fat or skinny we're the Horse's whinny
> Reg'lar little Mickey Mice.

There was a club handshake, a secret password, and a membership card [150]. Officers wore a specially designed vest and fez. By the fall of 1932, according to a promotional spread in the *Motion Picture Herald*, over seven hundred chapters were active nationwide, with a total membership "that approximates that of the Boy Scouts of America and the Girl Scouts, combined."[23]

For the first several years of the clubs' existence, the studio encouraged their activities. Harry Woodin was hired to help organize new chapters and assist existing groups. In April 1930, he instituted a twice-monthly *Official Bulletin* for theater managers with functioning units. The clubs built up a clientele and culture all their own. According to the *Harvard Crimson,* in 1935, the manager of the University Theatre in Cambridge identified "three distinct groups" that comprised his customer base:

> the so-called common people, the professors and the Brattle Street element, and the undergraduates, not to mention the youthful audience at Saturday morning's Mickey Mouse Matinees. The kids, incidentally, may have been the least of the manager's problems. The undergrads, he said, "hiss newsreel shots of Roosevelt" (leading him to conclude that "the student body is fundamentally Republican"), "the townies return the compliment" with Hoover, and once "an efficient usher apprehended a Harvard professor who was hissing violently."[24]

Though the Mickey Mouse Clubs thrived, ultimately a decision was made to quit favoring theaters that hosted the events. The change in strategy was explained in a letter written in 1935 to a St. Louis cinema manager by the manager of the clubs at the studio, Lucille Allen Benedict (who was also Roy Disney's secretary):

> We found that granting exclusive rights to any theatre to call its junior matinee a Mickey Mouse Club in the long run caused us more trouble than it did good in the way of publicity. After all, all of the theatres are our potential customers, because if they don't buy one year they may the next. We ran into all kinds of difficulties and controversies and finally decided to do away with them. [. . .] The success of each Club always depended upon the resourcefulness of the theatre manager, at any rate,

and no matter how many suggestions we gave them from this end, the manager had to put it over in the long run. We also found that in the cases where the Club wasn't especially successful, the Managers felt "Mickey Mouse" was responsible and developed a resentment against the product in general.[25]

154. Floyd Gottfredson (1905–86) sketching Mickey Mouse at the Hyperion Avenue studio, Feb. 21, 1933. Corbis Images.

Ironically, in the fall of 1929, as the Mouse Club craze was taking off, trouble was brewing on the distribution end of the business. Walt and Roy felt they were not receiving a fair percentage of their films' gross from Pat Powers. When they confronted him, they discovered—shades of Charlie Mintz—that Powers had secretly signed Iwerks to an exclusive contract in a ploy to pressure the brothers to toe the line (this marked the start of Ub's ten-year divorce from Disney). They paid Powers $100,000 to buy out their contract, and in February 1930 they chose Columbia Pictures, which was already handling the Silly Symphonies, as their future outlet for the Mouse cartoons. Harry Cohn, the head of Columbia, was allegedly advised to do the deal by director Frank Capra, although the arrangement didn't last long: in 1932, United Artists began distributing the Disney cartoons.[26]

Meanwhile, Walt and Roy looked for other ways to build their business. In January 1930, the daily *Mickey Mouse* comic strip, initially drawn by Iwerks and, for a few weeks written by Walt, kicked off in the *New York Daily Mirror* [155], to be carried on, starting in May 1930 [157], by Floyd Gottfredson [154]. In October 1930, the first children's book appeared [152]; its contents included a "Mickey Mouse March," "Mickey Mouse Game," "Mickey Mouse song," and a four-page fantasy, "The Story of Mickey Mouse." This charming tale told how "mouse number thirteen" was booted out of a celestial "mouse fairyland" for "always playing tricks and cutting capers"—only to become a star when he fell in the lap of a Hollywood producer named Disney [153], who recognized his talent and christened him "Mickey." In 1931, a full-color storybook, *The Adventures of Mickey Mouse* [75], featuring Mickey and Minnie and their barnyard friends, was published.[27]

In February 1930, Walt and Roy signed an agreement with the preeminent toy importer and wholesaler Borgfeldt & Co. (whose most successful item to date had been Rose O'Neill's Kewpie doll) to merchandise "Figures and Toys of various materials embodying your design of comic Mice known as MINNIE & MICKEY MOUSE." In March, Borgfeldt made its first licensing deal with a European firm, Waldburger, Tanner & Co. of St. Gall, Switzerland, for the fabrication of Mickey and Minnie handkerchiefs. At about this time, too, a woman named Charlotte Clark approached the Disneys with a proposal to make stuffed Mouse dolls. The brothers were so pleased with the sample

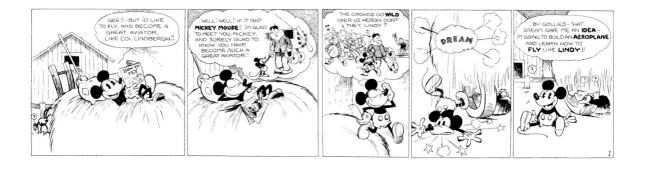

she presented that they set her up in a house near the studio, and a handful of other seamstresses were hired to assist her. Within a few months, in what became known as the "Doll House," Mrs. Clark and her helpers were spinning out as many as four hundred Mickeys per week, in two sizes. The standard model stood sixteen to eighteen inches high, while a larger model was about three feet tall [158]. The prototype for the Mickey doll, incidentally, was supposedly designed for Clark by Bob Clampett, later an animator and director at Warner's, who helped perfect Porky Pig, Bugs Bunny, Sylvester, and Tweety (Clampett is widely referred to as the dollmaker's teenage nephew, but no actual family ties have yet been established).[28]

Charlotte Clark could generate only so much merchandise working on an essentially artisanal basis. It was not until 1934, however, that the Disneys were satisfied with any mass-market doll: a design proposed by the Knickerbocker Toy Company of New York. After World War II, the Gund Manufacturing Company, also of New York, carried on the Disney tradition of high-quality stuffed characters. Meanwhile, in June 1930, London-based William Banks Levy had become Disney's merchandising rep in the United Kingdom. By September of that year, Levy's sales list included "dress fabrics, fountain pen clips, balloons, tablecloths, egg cups, toothbrushes, candles and calendars, nursery wallpaper, and a Mickey Mouse 'jazzer'—a small felt Mickey which, when attached to the arm of a phonograph, danced about on the revolving record." In a deal engineered by Levy, the first English-made Mouse plush toy, distinguished by a faintly malicious, toothy grin, came out in October 1930 [156]. The Disneys judged them inferior, though, and refused to permit their sale in America.[29]

In 1930, Mickey and Minnie Mouse toys became hot-ticket items in stores all over the United States. They were prominently displayed in such emporiums as Bloomingdale's and Lord and Taylor's (New York City), Kresge's (Newark, New Jersey), Gimbel's (Philadelphia), Stearn's (Cleveland), and Bullock's (Los Angeles). This outsized demand for Mickey Mouse products aimed at children was novel in more ways than one. As Gary Cross, author of *Kids' Stuff: Toys and the Changing World of American Childhood,* has shown, a broader approach to toy sales had begun at the end of the nineteenth century, when "the beliefs that children had a right to play and needed specially manufactured

objects for this purpose were still new." Thus, many commercial toys at the time, such as Lincoln Logs and Erector Sets, were designed to attract parents who wished to prepare their male offspring for stereotypical grown-up jobs such as construction work, engineering, or being handy around the house. Mickey Mouse toys broke with that tradition. They tended to be made for pure enjoyment. In addition, according to Cross, Walt and Roy developed "the marketing strategy that now dominates children's culture," linking the licensing of toys to the release of their films.[30]

Before Mickey, toy sales had been largely seasonal. The unprecedented demand for stock in his image coupled with a desire by retailers to sell

157. Floyd Gottfredson, comic strip ("Interrupted Message"), June 21, 1932. Gottfredson wrote and drew the strip and Al Taliaferro inked it The Walt Disney Archives, Burbank, California.

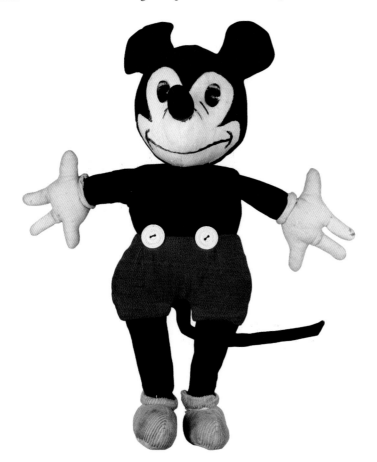

158. Charlotte Clark, Mickey doll, 44 in. high, circa 1930. Velveteen-covered body, felt ears, oilcloth eyes, string whiskers, and rubber tail. The Walt Disney Family Foundation, San Francisco, California.

159. *Mickey Mouse Magazine* under the imprimatur of the Matthews Frechtling Dairy (Cincinnati, Ohio), Sept. 1935. Walt Disney Family Foundation, San Francisco, California.

toys all year long, not just primarily during the run-up to Christmas. Richard deCordova characterized the Disneys' innovative approach this way: "By tying toys to movies, stores tied the consumption of toys to the everyday rituals of movie going, and a different kind of temporality. Mickey Mouse, as a regularly recurring character, was especially suited for this strategy."[31]

Mickey's popularity energized the sale of Disney-licensed products, which in turn heightened demand for Disney films, comic strips, and books. The process played out in two other ways as well, according to deCordova. Mickey dolls and toys were used by theaters as promotional giveaways or display items in their lobbies. Theaters that hosted the Mickey Mouse Club also found co-sponsors amongst local businesses like department stores, banks, newspapers, and dairies [159], all seeking to cultivate friendly connections to children. Other movie clubs that competed for the American youth market in the early 1930s, including a few that were associated with big-name filmmakers such as Warner's, were less successful than the Mouse Clubs in hitching their screen properties to the sale of toys, either because they had no stars as hot as Mickey or because they did not pursue their commodification as doggedly as Disney did.[32]

Commercial tie-ins to films, involving shifting alliances among Hollywood studios, television networks, toy makers, fast-food chains, and cereal and snack manufacturers, often on a multinational scale, are now commonplace. Motivated by the need to keep their modest animation operation afloat, it was Walt and Roy Disney, via Mickey Mouse, who pioneered this year-round exploitation of mass culture—the meshing of corporate synergy with the phenomenon Neal Gabler called "Life the Movie."

Before the first Mickey-inspired seed for kiddy consumerism was sown, Disney had inaugurated his second, higher-toned line of animated cartoons, the Silly Symphonies. The brainchild of studio music director Carl Stalling, the Silly Symphonies emphasized the marriage of music and imagery—as opposed to the star-driven doings of the Mickey Mouse comedies. The series kicked off in August 1929 with a black-and-white short, *The Skeleton Dance* [160]. Mickey was still the studio's flagship character, but Disney's commitment to the Silly Symphonies, mere months after the Mouse was launched, and his career-long obsession with fairy tales and quality storytelling overall, underscored the fact that he always had creative aspirations beyond the Mouse.

Within a year or so, the Silly Symphonies and Mickey Mouse were held in almost equal regard. In July 1930, Creighton Peet had saluted them both, and in November of that year, Harold W. Cohen, the film

critic at the *Pittsburgh Post-Gazette,* paid Walt the following compliment:

> Nothing is too difficult for Mr. Disney to tackle and the imagination
> he has so consistently displayed in making every one of his pictures just a
> little bit different is something not to be taken lightly. [...]
> Hard work, imagination, and a keen appreciation of audience
> psychology go into every one of these Mickey pictures and "Silly
> Symphonies" and if Mr. Disney isn't drawing down a salary as fat and
> juicy as that of any Hollywood Cinderella, then there is something
> radically wrong with this nation's economic system, particularly as it
> applies to the movie industry.[33]

160. Ub Iwerks, *The Skeleton Dance,*
released by Columbia, August 22, 1929.

As we know, in January 1931, *The Nation* commended the two
series, and in December 1931, Gilbert Seldes added his kudos. However,
the Mickey Mouse cartoons were not viewed with universal favor. The
devil-may-care jazz fests, parties, and other mischief in them rubbed
the sensibilities of at least some Americans the wrong way. And so a
preliminary skirmish in the nation's now seemingly interminable "culture
wars" broke out. In mid November 1930, the *New York Times* reported:

161. Attributed to Dave Hand, *The Shindig,*
Mickey Mouse cartoon, released by
Columbia, July 29, 1930.

> Although there is no morality clause in the contract of Mickey Mouse,
> that vivacious rodent of the animated screen cartoons must lead a model
> life on the screen to meet the approval of censorship boards all over
> the world. Mickey does not drink, smoke, or cut any suggestive capers.
> Walt Disney, his creator, must be hypercritical of his own work to avoid
> wounding various national dignities.

The *Times* also noted that a Mouse cartoon had recently been "banned
in Ohio because a cow, one of the rodent's playmates, was portrayed
reading" a mildly erotic best-seller by Elinor Glyn, *Three Weeks* [161].
Six years earlier (in 1924), Mrs. Glyn had adapted the book for the
screenplay of the film version.[34]

In January 1931 as well, an advocate of conventional bourgeois
morality sent a letter to an Atlantic City, New Jersey, newspaper
asserting that there "can be small doubt as to the harm done to our
rising generation through the present day lack of decency on both stage
and screen." In a cri de coeur of a sort voiced ad infinitum ever since, the
signatory of the letter, "A Child Lover," affirmed that

> Those concerned with child welfare lay much stress upon the proper
> home environment upon the child—and rightly. But are not the
> best of home influences neutralised and counteracted when children
> [...] are constantly having presented before them on the screen such

162. Army of cats in Prussian-style helmets in *The Barnyard Battle*, released by Cinephone, April 29, 1929. This cartoon was animated by Ub Iwerks and Les Clark.

163. Army of mice in French-style military caps, *The Barnyard Battle*, April 29, 1929.

subjects as easy divorce and remarriage, indecency in dress, dancing and suggestiveness? Even in such should-be innocent subjects as [. . .] Mickey Mouse comedies, they are beginning to inject these same undesirable qualities.[. . .][35]

By mid February 1931, according to *Time* magazine, concerns like the one expressed by the "Child Lover" from New Jersey had reached a head:

Motion Picture Producers & Distributors of America last week announced that, because of the complaints of many censor boards, the famed udder of the cow in Mickey Mouse cartoons was now banned. Cows in Mickey Mouse or other cartoon pictures in the future will have small or invisible udders quite unlike the gargantuan organ whose antics of late have shocked some and convulsed other of Mickey Mouse's patrons. In a recent picture the udder, besides flying violently to left and right or stretching far out behind when the cow was in motion, heaved with its panting when the cow stood still; it also stretched, when seized, in an exaggerated way.

This action by the forerunner of today's Motion Picture Association of America, in response to Disney's depiction of bovine private parts—a frequent bit of barnyard schtick in Walt's cartoons from day one—was unique. The so-called Hays Code, which, under intense lobbying pressure from Catholic organizations, had been adopted by the major studios in March 1930, was otherwise never enforced in the early '30s.[36]

A few days after the *Time* article appeared, out of admiration for Disney, a sense of solidarity in the face of blue-nosed prurience, or financial self-interest, Chaplin asked that his latest film, *City Lights*, "be accompanied wherever possible with a Mickey Mouse cartoon." A newspaper cartoonist in Oregon, George Corley, soon depicted the Little Tramp proffering a "floral tribute" to the Mouse. Ironically, in 1936, Chaplin, too, would be advised by the Hays Office to eliminate a "close-up shot of the udders of the cow" from a preliminary cut of *Modern Times*. Despite scattered howls like this from what H. L. Mencken called the "booboisie," Mickey's stock kept rising, as reflected in another cartoon of the day. A drawing by Gardner Rea in a March 1931 issue of *Life*, the pre-Luce humor magazine, to which Walt had submitted drawings a dozen years earlier, showed a set of sophisticates leaving a movie theater bemoaning the fact that the evening's program had included "No Mickey Mouse!"[37]

Overseas as well, Mickey's stock was on the rise once more. In February 1931, a candidate for the London County Council ran for office using a portable projection device to show Mickey Mouse

cartoons to passersby in the street. In March, students at the famed Paris art school the École des Beaux-Arts paraded through the Latin Quarter as part of their annual Mardi Gras revelry with Mickey daubed on the backs of their smocks. That summer, *Literary Digest* would report that Mickey Mouse was "really the Columbus of a new world of motion-picture expression, according to a number of 'highbrow' European critics."[38]

In Germany, Mickey's popularity was dubbed the "Micky-Maus-Boom" by cartoon specialist Carsten Laqua, though there was negative fallout from one cartoon, *The Barnyard Battle* [162–163], released in June 1930 as *Micky im Schützengraben* (Mickey in the Trenches), that depicted the Mouse as a soldier in a ratty army wearing French military–style caps. As the *New York Times* commented, the cartoon was considered "offensive to the national dignity," and it probably inspired, or helped inspire, a statute voted by the Reichstag requiring that non-German movies, including animated shorts, "be submitted to the approval of a special committee before being shown in Germany." According to the *Times,* the law was "intended to prevent the popularization of 'cheap, inferior foreign films' without barring desirable pictures."[39]

Micky im Schützengraben was the first victim of the new law. On July 14, the *London Times* reported:

> Those who follow the adventures of "Mickey Mouse" may be astonished to hear that the one adventure he was never expected to encounter has befallen him—he has been censored. This has happened on account of his trip to the trenches.
>
> His friends will remember that on this trip Mickey wore a *képi,* and that, with his usual ingenuity, he there outwitted at every turn a number of very dangerous-looking cats wearing steel helmets of the German pattern. The German Board of Film Censors says gravely that the "artist evidently aimed at a comic representation of an action in the War. While the victorious mouse is distinguished by the French *képi,* his enemies the cats are clearly recognizable as the German Army by their German steel helmets."
>
> The Board thinks that Mickey's trip to the trenches is calculated to "reawaken the latent anti-German feeling existing abroad since the War" and "to wound the patriotic feelings of German cinema-goers." The exhibition of the film has therefore been forbidden.

The liberal newspaper *Berliner Tageblatt* ran this headline over its contemptuous coverage of the incident: "Die verbotene Maus" (The Forbidden Mouse). (In February 1931, the Danish censor also banned the Silly Symphony *The Skeleton Dance* because it was "too macabre to be put on the screen.")[40]

Micky-Maus

(Karl Arnold)

„Unerhört, dieses Biest stellt unser aller Prominenz in den Schatten!"

The uproar in Germany over *Micky im Schützengraben* was to a certain extent understandable. In the summer of 1931, however, events took a nastier turn when a provincial Nazi organ, *Die Diktatur*, published a tirade ("Der Micky-Maus-Skandal!!!") addressed to "blonde, freethinking, urban German youth tied to the apron strings of Jewish finance." The venomous item reached a much wider audience after it was reprinted and disdainfully commented on in the July 28 issue of *Film-Kurier*. Several lines from the piece inspired the epigraph in volume 2 of Art Spiegelman's Pulitzer Prize–winning graphic novel *Maus: A Survivor's Tale* [165]:

> Mickey Mouse is the most miserable ideal ever revealed. . . . Healthy emotions tell every independent young man and every honorable youth that the dirty and filth-covered vermin, the greatest bacteria carrier in the animal kingdom, cannot be the ideal type of animal. . . . Away with Jewish brutalization of the people! Down with Mickey Mouse! Wear the Swastika Cross![41]

Disney, who could not forget the Great War against the Kaiser, which he had itched to get into, took as a badge of honor Mickey's hostile reception in Germany. In October 1947, Walt recalled that

Hitler was infuriated by him and forbade his people to wear the then popular Mickey Mouse lapel pin in place of the swastika. The little fellow's grin was too infectious for Nazism.

Too infectious for Nazism, perhaps, but not for weighty Freudian analysis. In December 1931, the *New York Times* disclosed that "Germany takes its Mickey Mouse sitting down—with a volume of abnormal psychology for ready reference." Quoting from a piece in a conservative journal, *Der Querschnitt,* the *Times* provided a wooden translation of a passage that is every bit as plodding in English as it is in the original German. The article in *Der Querschnitt,* "Micky Maus ist geisteskrank" (Mickey Mouse Is Crazy), began as follows:

> The chronic film picture of Mickey Mouse [i.e., the Mickey Mouse film series] shows unmistakable symptoms of a paranoidical dementia on the part of his creator. [. . .] A psychiatric observation of Mickey Mouse during several film presentations leaves no doubt that there exists in him a severe case of paraphreny, which [. . .] is related to the dementia paranoides. Mickey Mouse's world of comprehension, so plentifully supplied with fantastic and fabulous traits, is a borderline case of this group of insanity psychoses which often leads to lunacy.

The *Times* report also contained an extract from a piece in the Zurich newspaper, the *Neue Zürcher Zeitung,* which served up an only slightly more palatable slant on the Mouse:

> Mickey's celluloid existence awakes to real life only through the mystic blessing of music, about which one might write, with a twinkle in the eye, what Beethoven put over in the orchestration of his Pastoral Symphony: "More expression of emotion than painting."[42]

Despite Nazi opprobrium and mind-numbing psychobabble, the Mouse remained very much in favor among Hitler's countrymen. In 1931, his first German-language publication, *Micky Maus: Ein lustiges Filmbildbuch,* appeared, and the Margarete Steiff toy company, which marketed one of the earliest versions of the teddy bear (in 1902), began producing stuffed Mickeys for domestic consumption and export to the United States [166]. (The Steiff dolls resembled Charlotte Clark's handiwork but were distinguished from hers by their stringy black whiskers.)[43]

166. Mickey Mouse stuffed doll made in Germany by the Margarete Steiff toy company, 1931 or 1932. Velvet with mother of pearl buttons, 9 in. tall. Dennis Books, Seattle, Washington. A tag on Mickey's chest, bearing Steiff's trademark Teddy Bear logo, reads: "Steiff - Original - Marke," and "Mickey Mouse / Copyright / Walt Disney Company." Stamped on the bottom of one of the doll's feet is: "Walt Disney's Mickey Mouse / Design Patent 82802 / Margarete Steiff and Co, New York." Mickey and Minnie Mouse plush toys by Steiff—particularly, matched pairs—are quite rare. In May 2015, a six-inch-high model of Mickey in near-mint condition, with bright red shorts, was on sale on eBay for $9,900.

167. Christmas card prepared by the Walt Disney Studio, 1931. Ink and watercolor on card stock, 5 x 7 in. The Walt Disney Archives, Burbank, California. Mickey is depicted as Santa Claus holding a toy version of himself in this presumed copy or duplicate of a card sent to five-year-old Princess Elizabeth, future queen of the United Kingdom. A search in March–April 2015 of the holdings of the Royal Collection failed to locate an original.

A drawing from January 1931 by Karl Arnold, in the German satirical weekly *Simplicissimus*, shows Frederick the Great, Chaplin and other luminaries of the cinema outshone by a knee-high, spotlighted Mickey [164]. Arnold's cartoon prefigured a number of lively connections to German mass-market amusements that year. Also in January, Berlin's Odeon record label released two discs, each with original Mickey material on both sides. On the first of these were "Micky Maus beim Hochzeitsschmaus" and "Micky Maus auf Wanderchaft" ("Mickey Goes Travelling"). On the second disc were "Micky als Jazzkönig," perhaps inspired by *The Jazz Fool*, and "Micky Maus im Lunapark," a tune that might have inspired a scene in the movie *Werr nimmt denn schon die Liebe ernst* (Who Takes Love Seriously), in which two lovers watch a Mickey cartoon in a "Micky-Maus-Haus" at Berlin's equivalent of Coney Island, Luna-Park. In 1931 as well, in Fritz Lang's classic thriller *M*, about a serial child murderer (played by Peter Lorre), cardboard or paper display figures of the Mouse in a pastry shop are symbols of the innocent treats used by Lorre to entice his victim. And in the same year, the Berlin weekly *Film-Magazin* put a photo on its cover of the Russian-born film star Olga Tschechowa contemplating a toy Mickey. Thus did Mickey's star shine as brightly in the final months of the Weimar Republic as it did in England, France, and America.[44]

In November 1931, as Mickey's third busy year in the ring of popular culture wound down, the Prince of Wales (the future Edward VIII) bought "a Mickey Mouse nursery tray" at an exhibition of goods made by disabled veterans. Since the royal heir apparent was unmarried, the purchase must have been a Christmas gift for his five-year-old niece, Princess Elizabeth, who, in 1952, would become Queen Elizabeth II. Coincidentally, toward the end of 1931, Disney apparently ordered up from his staff a personalized, hand-colored Christmas card (presently

168. Eddie Pola (1907–95) and Franz Vienna, aka Franz Steininger (1906–74), "The Wedding of Mister Mickey Mouse," sheet music (London: Keith Prowse & Co., Ltd., 1935). Rob Richards, Hollywood, California.

169. Earl Duvall, first *Mickey Mouse* Sunday comic strip, January 10, 1932. Walt Disney Archives, Burbank, California.

unlocated) depicting Mickey as Santa Claus pulling a toy figure of himself out of his sack, which was sent to the future monarch [167].[45]

Nearly a year later, in October 1932, Mickey was still, as the *London Times* reported, "the most popular film star of the moment." In 1933, "The Wedding of Mister Mickey Mouse" [168] was a hit for the BBC Orchestra; that July, the *Times* headlined a critique of Walt's new color films as "The Art of Mr. Walt Disney"; and, in August, the *Times* published a letter from a man who declared:

No more fanciful creature ever came from Fairyland than Mickey Mouse. His antics delight all, young or old, simple or learned: they are stamped with the imagination of genius. Ought we not to treat this charming little rogue with greater respect? A cinema devoted entirely to

his cult would probably prove too much of a good thing. Nor do I say we should deposit his reels in the British Museum to amuse posterity or that the new Film Institute should award its first gold medal to Mr. Walt Disney, his creator—though why not? [. . .] To long-suffering adults Mickey gives a seasoning to programmes which enables them to digest any amount of "tripe" from Hollywood. Many would cross the town to see a new adventure, and who, even among his fans, can be sure he has seen them all? If the cinemas could be encouraged to mention these masterpieces in their advertisements, we should seldom have to sigh, "What? No Mickey Mouse!"

These wishes would, within a few months' time, be at least partially satisfied. In January 1934, Mickey's cartoons were listed in the *Times*—alongside the feature films they accompanied—on the bill at five

170. Floyd Gottfredson, for story and pencils, and Ted Thwaites (1886–1940), inks, Mickey Mouse Sunday comic strip, Sept. 18, 1932, featuring the first appearance of nephews Morty and Ferdie. Walt Disney Archives, Burbank, California.

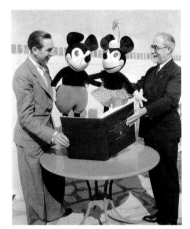

171. Walt honored for creating Mickey by the consul of Argentina in Los Angeles, Dr. Henry Niese, on behalf of the National Academy of Fine Arts of Buenos Aires, Nov. 20, 1933. Corbis Images.

172. Left to right: Walt Disney, studio attorney Gunther Lessing (1885–1965), Kay Kamen (1892–1949), and Roy Disney poolside at Walt's home on Woking Way, Hollywood, circa 1933–35. The Walt Disney Archives, Burbank, California.

173. "Well! What Mouse Be, Mouse Be!," full-page advertisement, *Variety*, November 15, 1932. Courtesy of MGM Holdings, Inc.

different London cinemas on the very same day. By then, the Tatler Theatre in Charing Cross Road was presenting entire programs of Silly Symphonies and Mickey Mouse shorts, and, in July 1934, the *Times* would report that the week's program at the Tatler consisted of three Silly Symphonies, plus a Mickey Mouse cartoon, *Playful Pluto*.[46]

Back in the Americas, in February 1933, Walt Disney was singled out "for his cinema creations 'Mickey Mouse' and the 'Silly Symphonies'" by the Cuban National Academy of Arts and Letters, and, in October, he was honored by the Academy of Fine Arts of Buenos Aires. In November, when he formally received his award from the consul of Argentina in Los Angeles, Disney posed for press photos with what by then was a standard prop, a large stuffed Mickey Mouse doll, and an equally large version of Minnie Mouse [171].[47]

In the United States, starting in January 1932, the first syndicated Mickey Mouse Sunday color comic strip appeared in the *New York Mirror* and other papers [169]. On July 30, a promotional shot was taken at the Los Angeles Coliseum of a large Mickey Mouse doll watching an event at the Olympics. In mid-September, nephews Morty and Ferdie joined the cast of Mickey's Sunday strip [170]. In October, Mickey and other Disney characters were showcased at the Philadelphia Art Alliance and membership in the Mickey Mouse Clubs passed the million mark. Beginning in November 1933, kids attending Saturday Mouse Club matinees would receive free copies of a slightly revamped version of the *Mickey Mouse Magazine*, launched ten months earlier by Disney licensing representative extraordinaire Herman "Kay" Kamen [172]. The smallish (7 x 5 in.) magazine contained tales of Mickey and Minnie, articles, jokes, games, poetry, and so on, and was sponsored by local dairies, whose names appeared on the cover [159]. This was the granddaddy of the far more familiar *Walt Disney's Comics and Stories*, featuring Mickey, Donald, and, starting in 1947, Uncle Scrooge (created and drawn by Carl Barks).[48]

On November 18, 1932, Disney received his first Academy Award for *Flowers and Trees*, the first color Silly Symphony, and a special Oscar for fathering the Mouse. For the occasion, he produced an animated short, projected at the awards banquet, in which Mickey made his first screen appearance in color [174]. Three days later, a full-page advertisement in *Variety* [173] read, "Well! What Mouse Be, Mouse Be! Santa Claus Has Asked Mickey Mouse to Help Make This the Merriest Christmas of All Time and Mickey's Gonna Do It!" A box within the ad stressed the fact that "200,000 stores sell Mickey Mouse articles."

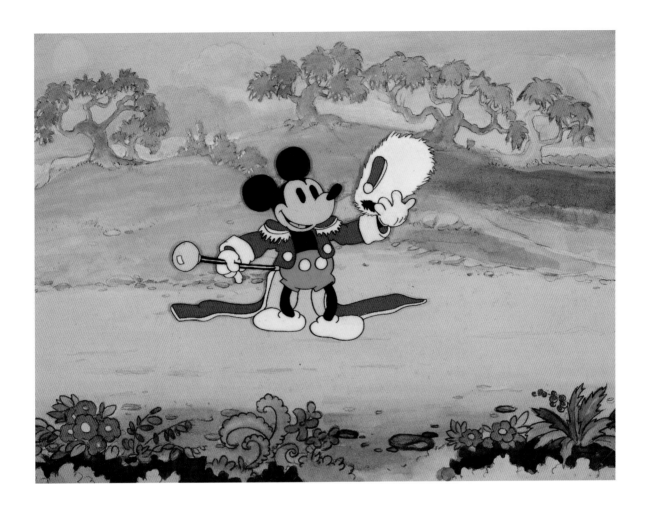

In 1933, a *Saturday Evening Post* cartoon showed an Indian brave carving traditional animal figures into a totem pole. A group of kids is looking on, one of whom says, "Hey, Pop—you forgot Mickey Mouse" [175]. A cartoon by Paolo Garretto in the August 1934 *Vanity Fair* would set Mickey's totemic cultural presence in a broader context. Titled "*Vanity Fair*'s Great American Waxworks: The Chamber of Heroes," the drawing spoofed a clutch of celebrities of the day, among them former President Herbert Hoover, Chief Justice Charles Evans Hughes, philanthropist John D. Rockefeller, Charles Lindbergh, bank robber John Dillinger, Babe Ruth, and entertainers Rudy Vallee, Katharine Hepburn, John and Ethel Barrymore, Jimmy Durante, and Mae West, the latter at the head of a staircase, with Mickey Mouse climbing up the steps, happy to see her [178].[49]

In 1933 as well, the freshman class at Princeton voted Mickey its favorite film actor, and Mary Pickford declared him to be her favorite star. Pickford's company, United Artists, was still Walt's distributor at this time (photos of Mary and Douglas Fairbanks are glimpsed in the 1932 Mouse cartoon *The Wayward Canary*), but Pickford's commendation may have been slightly disingenuous. By 1933 her career was as much on the skids as Disney's was on the rise. She wanted Walt to collaborate

174. Mickey Mouse in *Parade of the Award Nominees*, shown at the Nov. 18, 1932, Oscars banquet. Joe Grant (1908–2005) is credited with the animation on this short. Animation Research Library, Glendale, California.

175. Ludwig Bemelmans (1898–1962), "Hey, Pop—You Forgot Mickey Mouse," *Saturday Evening Post,* Oct. 21, 1933. *The Saturday Evening Post cartoon* © SEPS licensed by Curtis Licensing, Indianapolis, IN. All rights reserved.

DRAWN BY LUDWIG BEMELMANS

"Hey, Pop — You Forgot Mickey Mouse"

with her in the production of a combined cartoon and live-action color version of *Alice in Wonderland* (in which she'd be the star). Pickford made a screen test of herself, dressed as Alice in white stockings and a frock and holding hands with a stuffed Mickey, like the toy Walt had given her in 1930, but a deal was never consummated.[50]

At about this time it became known that Mickey had an even more prestigious friend in the newly elected president of the United States, Franklin D. Roosevelt, who had his cartoons screened in the White House. In 1934 or thereabouts, Walt gave a signed drawing of Mickey and other Disney characters to the daughter of FDR [176], and in 1936, the chief executive would present a Mickey doll to a twelve-year-old girl in Ohio. "My husband always loved Mickey Mouse," Eleanor Roosevelt later remarked, "and he always had to have the cartoon in the White House."[51]

It could even be said that, like the protagonists in Disney's *Three Little Pigs* (released in May 1933), who fought to keep the wolf away from their door, Mickey Mouse embodied FDR's words in his first inaugural address of March 1933: "We have nothing to fear but fear itself." As Edwin C. Hill, in August of that year, commented in the *Boston American* in his homage to Mickey's salt-of-the-earth qualities:

One thing is certain. Mickey will never "go Hollywood." He is too real for that—too genuine. His rise to popularity is one of the most amazing

stories of the times. This writer is certain that more people follow his doings and the doings of his little group than pay heed to the heavy sessions of economic conferences or the doings of legislatures.

Perhaps Mickey's celebrity is not so amazing, after all, when one remembers that he came to us at the time the country needed him most—at the beginning of the depression. He has helped us to laugh away our troubles, forget our creditors, and keep our chin up. And now that good times are returning, I think Mickey Mouse, as well as Franklin D. Roosevelt, his good friend and ardent admirer, is entitled to take a bow.

Though Hill didn't say so, he must have been aware of the fact that by the summer of 1933 the first Mickey Mouse wristwatches [177] and pocket watches were being marketed, helping to spare their Connecticut manufacturer, the Ingersoll-Waterbury Clock Company, from financial ruin. The Mouse's contribution to this minor, much-publicized commercial miracle only added to his renown.[52]

With the Yuletide approaching, Mickey gave even Father Christmas a run for his money. According to the *Boston Herald:*

> Santa Claus is not going to be left out in the cold nor is he going to
> compete with mice or men. [...] Through his spokesman [...] head Claus
> of the Association of S. C.'s, Santa has announced his displeasure with
> the competition which department stores are providing in the form of
> Mickey Mouse and the Three Little Pigs. These creatures, while doubtless
> possessed of a definite place in the hearts and affections of the young, have
> nothing to do with Christmas, Santa asserts. Therefore they must go.

Mickey Mouse (and the Three Little Pigs) was more welcome in Chicago. There in mid December 1933, the Art Institute rang in the holiday season with a Disney exhibition, preceded by a fancy reception hosted by two of the city's grandest dames, Mrs. Potter Palmer, Jr., and

176. Scamper the Rabbit being introduced by Mickey to Minnie, Pluto, and the Three Little Pigs, circa 1934. It is inscribed by Walt, "Best Wishes to/Anna Roosevelt Dall/and 'Scamper.'" Scamper was created by the president's daughter Anna for her 1934 book, *The Bunny Who Went to the White House.* Ink and watercolor on heavy wove paper, 12 13/16 x 24 5/8 in. Franklin D. Roosevelt Presidential Library & Museum, Hyde Park, New York.

177. First Mickey Mouse wristwatch, Ingersoll-Waterbury Clock Co., summer 1933. The Walt Disney Archives, Burbank, California.

178. Paolo Garretto (1903–89), "*Vanity Fair's* Great American Waxworks: The Chamber of Heroes," *Vanity Fair,* August 1933. The figure mounting the stairs behind Mickey is John D. Rockefeller. The "Forgotten Man" on the far left is former President Herbert Hoover. © Condé Nast.

LINDY

THE FORGOTTEN MAN

DILLINGER

INSULL

THE BABE

VANITY FAIR'S
GREAT AMERICAN
WAXWORKS
THE CHAMBER
OF HEROES

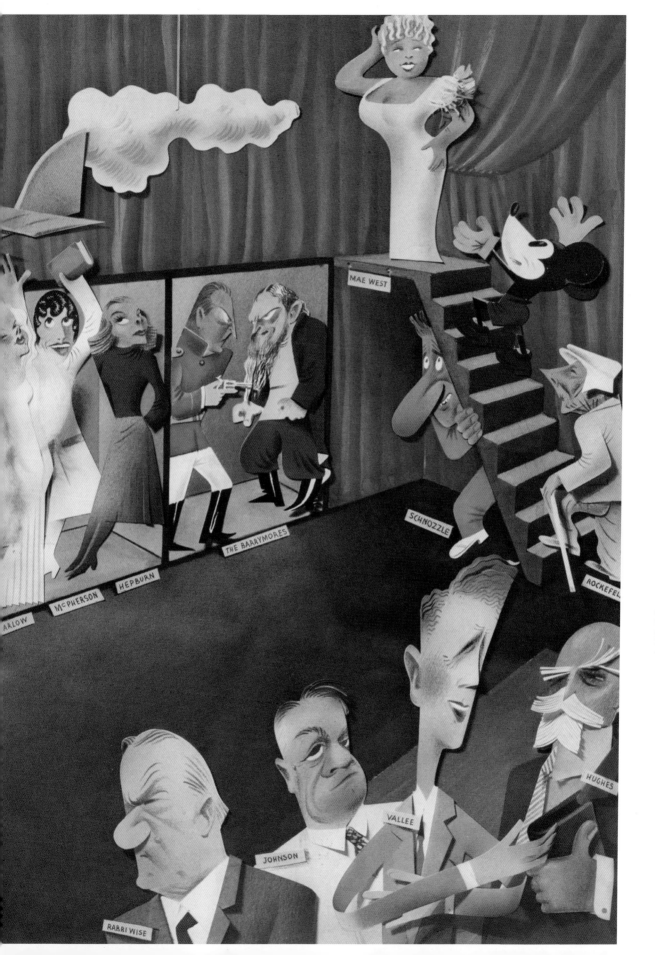

179. Mickey surrounded by (clockwise from top left) Maurice Chevalier, George Arliss, Edward G. Robinson, Wallace Beery, and William Powell, animation drawing for *Mickey's Gala Premier*, released July 1, 1933. Pencil and colored pencil on paper, 9½ × 12 in. National Portrait Gallery, Smithsonian Institution, Washington, D.C., gift of Miriam and Stuart Reisbond. Joe Grant created the caricatures of all the Hollywood stars amiably made fun of in this cartoon.

McCormick, an affair that led the *New York Times* to say that "Mickey Mouse has been admitted to full citizenship in the domain of art."[53]

The grumpy Saint Nicks in Boston might have bemoaned Mickey's intrusion on Christmas, but Mordaunt Hall, the *Times* critic who had given him his first review in 1928, asserted that the Mouse was "never too tired to brighten the lives of those who feel a little gloomy." Indeed, after the repeal of Prohibition, in the fall of 1933, more than one gloomy soul must have lofted a glass in his honor when an adult cocktail similar to the bloody Mary—the un–Shirley Temple—was named for him.[54]

Walt Disney bore his protégé's fame, and his own, modestly—making light of it in two cartoon shorts released in 1933. In *Mickey's Gala Premier*, the Oscar-winning celebrity dreams of appearing at a grand opening night at Grauman's Chinese Theater, where he is worshiped by Hollywood legends like Chaplin, Keaton, Greta Garbo, and the Marx Brothers, among others [179]. A second one-reeler from 1933, *The Mad Doctor*, parodied the nation's fascination with horror films such as *Frankenstein*, starring Boris Karloff. It also subliminally spoofed the extraordinary popularity of Mickey himself in a nightmare Mickey has about an evil scientist who nearly slices him in two [180]. Like Frankenstein's monster, Mickey Mouse had taken on a life of his own.

180. *The Mad Doctor*, released January 21, 1933. Lithographic poster, 41 × 27 in. Walt Disney Archives, Burbank, California.

JOSEPH M. SCHENCK
· PRESENTS ·
WALT DISNEY'S
MICKEY MOUSE
"THE MAD DOCTOR"

UNITED
ARTISTS PICTURE

"HE IS NOT A MOUSE AT ALL"

As much as their fame had grown in 1933, the following twelve-month period was a virtual *annus mirabilis* for Disney and the Mouse. In January 1934, the *New York Times* reported that the Poor Richard Achievement Medal was given "to Walt Disney, creator of Mickey Mouse," at the annual celebration of Benjamin Franklin's birthday, in Philadelphia. That same week, a cartoon appeared in the *New Yorker* [182] showing an urbane fellow at a cocktail party exclaiming to a lady friend: "All you hear is Mickey Mouse, Mickey Mouse, Mickey Mouse! It's as though Chaplin had never lived."[1]

181. Poster art for *The Band Concert*, released by United Artists, Feb. 23, 1935 (originally in black and white), colored for a lithograph included with *Mickey Mouse in Living Color* (Walt Disney Home Video, 2001). The Walt Disney Archives, Burbank, California.

"All you hear is Mickey Mouse, Mickey Mouse, Mickey Mouse! It's as though Chaplin had never lived."

182. Alain. a.k.a. Daniel Brustlein (1904–96). *New Yorker*, Jan. 20, 1934. © Condé Nast.

In 1934, Mickey made his inaugural appearance in a work of literature: Rex Stout's first Nero Wolfe detective adventure, *Fer-de-Lance*, in which wise-guy private investigator Archie Goodwin, the novel's narrator, ponders what will happen if he and his corpulent boss were to bungle their current case: "everybody from the D.A. down to a Bath Beach flatfoot would be saving twenty cents by staying home and laughing at us instead of going to a movie to see Mickey Mouse."[2]

In 1934 as well, Cartier offered diamond-studded Mickey Mouse pins to their clientele, and Mickey was immortalized in the lyrics of Cole Porter's "You're the Top" when the musical *Anything Goes* opened on Broadway the day before Thanksgiving. The tune, which *New York Times* theater critic Brooks Atkinson called "one of the most congenial songs Mr. Porter has written," was a hit both for the star of the production, Ethel Merman, and, in a separate recording, for the Paul Whiteman Orchestra. Among its many ingenious rhymes, the most memorable are these, from the opening verse:

> You're the top!
> You're the Coliseum.
> You're the top!
> You're the Louvre Museum.
> You're a melody from a symphony by Strauss,
> You're a Bendel bonnet,
> A Shakespeare sonnet,
> You're Mickey Mouse.

The Yale-educated composer-lyricist was quite the fan. According to John Culhane, when one of Mickey's films arrived at New York City's Radio City Music Hall, Porter "would bring his dinner guests there just to see the cartoon." And, in the 1936 Metro-Goldwyn-Mayer musical *Born to Dance*, Eleanor Powell introduced another Porter number, "Rap Tap on Wood," which contained the lines,

> If you want to roll and roll those lucky dice,
> If you want to spend your journey's end with sweet music and love,
> If you want to lick this world of men and Mickey Mice,
> Take my advice,
> When you sit down, one day,
> Look over yourself and say,
> "You're very good,"
> Ra-ap-tap on wood.[3]

In May 1934, in the depths of the Depression, the Lionel Train Corporation faced financial ruin. Like Ingersoll-Waterbury the year

before, Lionel averted bankruptcy by marketing a toy Mickey-and-Minnie Mouse handcar [183], orders for which totaled 253,000 by Christmas. As the *New York Daily Mirror* reported:

> Those joy-bringers of the films and the Daily and Sunday Mirror comic sections—Mickey and Minnie Mouse—got recognition yesterday in a Federal court which is stepping high even for Mickey and Minnie.
>
> Federal Judge Guy L. Fake called attention of the world to their good deed for the Lionel Corp., makers of toys, when he discharged that concern from receivership, "probably the most successful in the history of the Newark, N.J., court" and gave the bulk of the credit to the comic characters.

183. Mickey–and–Minnie Mouse toy hand car, Lionel Train Corp., May 1934. Sacramento Railroad Museum, Sacramento, California.

Thus was Mickey's aura as a "real-life" hero, a kind of Good Samaritan of commerce, further burnished. Almost simultaneously, in November 1934, he joined the Macy's Thanksgiving Day parade as a fifty-foot balloon built by the Goodyear Blimp Company [184].[4]

In England, a Mickey Mouse toffee candy was introduced, and, in July 1934, the *New York Times* reported that the "most significant news item of the week was the announcement that Mickey Mouse had crashed the Encyclopædia Britannica." (As late as 1952, alone among fellow animators, Disney was singled out in the Britannica, where a dozen of his cartoon stars, Mickey included, were illustrated in color.) As already noted, Walt's first-person account, "Mickey Mouse How He Was Born," was published in the *Windsor Magazine* in January 1934, and in April, one could read in the *Times* of London that "Mr. Walt Disney, the creator of Mickey Mouse and the Silly Symphony films, has been elected an honorary member of the Art Workers' Guild," joining such distinguished company as George Bernard Shaw and the architect Sir Edward Luytens. Shortly thereafter, John Betjeman, future Poet Laureate of Great Britain, and future honorary Guild member as well, in a squib accompanying his regular movie column in the *London Evening Standard,* declared that the "Silly Symphonies and Mickey Mouse are still, in spite of everything, the best entertainment the cinema provides."[5]

184. Mickey Mouse inflatable balloon built by the Goodyear Blimp Company, lying on its back in a warehouse as a man refreshes the color on its face, ca. Nov. 29, 1934. British Pathé, London, England.

The honor of the first artful analysis of the Mouse goes to England at this time as well. In an article titled "Mickey and Minnie," in the January 19, 1934 issue of *The Spectator,* the novelist and essayist E. M. Forster extolled "a scandalous element" in the Disney character that "I find most restful." Forster was especially fond of Mickey's roles in films like *Wild Waves* (1929), *The Beach Party* (1931), and *Mickey in Arabia* (1932). Above all, Forster said,

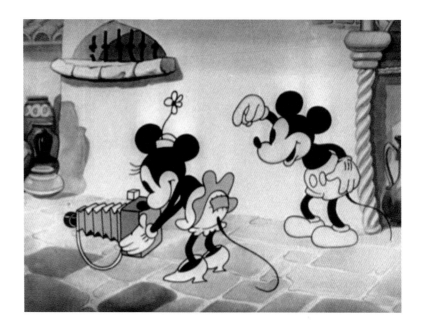

185. Screen capture of Mickey and Minnie in *Mickey in Arabia*, released by Columbia, July 18, 1932. The Walt Disney Archives, Burbank, California. Dave Hand was the chief animator on the film.

I like him as a lover most, and rather regret these later and more elaborate efforts, for the reason that they keep him too much from Minnie. Minnie is his all, his meinie, his moon. Perhaps even the introduction of Pluto was a mistake. Have you forgotten that day when he and she strolled with their kodaks through an oriental bazaar [185], snapping this and that, while their camel drank beer and galloped off on both its humps across the desert? Have you forgotten *Wild Waves?* Mickey's great moments are moments of heroism, and when he carries Minnie out of the harem as a pot-plant or rescues her as she falls in foam, herself its fairest flower, he reaches heights impossible for the *entrepreneur.* I would not even have the couple sing. The duets in which they increasingly indulge are distracting. Let them confine themselves to raptures appropriate for mice, and let them play their piano less.

The author saw Mickey Mouse as a sort of miniature, skirt-chasing Greek god. Like Zeus, who might transform himself into a bull or a cloud in order to bed a nymph that had caught his eye, Mickey appeared in many forms, in the early films, before the love of his life, of whom Forster observed:

About Minnie too little has been said, and her name at the top of this article is an act of homage which ought to have been paid long ago. Nor do we know anything about her family. When discovered alone, she appears to be of independent means, and to own a small house in the midst of unattractive scenery, where, with no servant and little furniture, she busies herself about trifles until Mickey comes. For he is her Rajah, her Sun. Without him, her character shines not. As he enters she

expands, she becomes simple, tender, brave and strong, and her coquetry is of the delightful type which never conceals its object. Ah, that squeak of greeting! As you will have guessed from it, her only fault is hysteria.

Forster continued:

It is possible that, like most of us, she is deteriorating. To be approached so often by Mickey, and always for the first time, must make any mouse mechanical. Perhaps sometimes she worries whether she has ever been married or not, and her doubts are not easy to allay, and the wedding chimes in *Mickey's Nightmare* [186] are no guide or a sinister one. Still, it seems likely that they have married one another, since it is unlikely that they have married anyone else, since there is nobody else for them to marry.

What of their future? At present Mickey is everybody's god, so that even members of the Film Society cease despising their fellow members when he appears. But gods are not immortal. There was an Egyptian called Bes, who was once quite as gay, and Brer Rabbit and Felix the Cat have been forgotten too, and Ganesh is being forgotten. Perhaps he and Minnie will follow them into oblivion. I do not care two hoots. I am all for the human race. But how fortunate that it should have been accompanied, down the ages, by so many cheerful animals, and how lucky that the cinema has managed to catch the last of them in its questionable reels.[6]

Forster's glum assessment of Mickey's future as a "heroic" lover was prescient. In 1930, "everybody's god" had acquired a canine companion, officially named, a year later, "Pluto," in the cartoon, *The Moose Hunt* (after the recently discovered, since tenuously demoted, planet). Pluto was a true pet, not an anthropomorphic peer like Donald Duck or Goofy (who, as "Dippy Dawg," first came on the scene in 1932, in *Mickey's Revue*). Forster felt that the addition of Pluto might have been "a mistake." He must have been similarly distressed, a few months after his *Spectator* article was published, when Mickey's life got even more prosaic, as Morty and Ferdie made their film debut in *Mickey's Steam Roller* [187] . . . though it would be the nephews' sole screen role prior to *Mickey's Christmas Carol* (1983). In 1935, in an essay ("Does Culture Matter?"), Forster voiced an opinion on contemporary mass culture that reflected his unease with what Mickey had become, and still applies to stars who use celebrity as a soapbox: "Crooners, best-sellers, electrical-organists, funny-faces, dream-girls, and mickey mice are all right when they don't take themselves seriously. But when they begin to talk big and claim the front row of the dress circle, and even get into it, something is wrong."[7]

186. Still of Mickey and Minnie Mouse in *Mickey's Nightmare,* released by United Artists, Aug. 13, 1932. Tom Palmer animated this scene.

187. Screen capture of Morty and Ferdie in *Mickey's Steam Roller*, United Artists, June 16, 1934. Johnny Cannon or Les Clark was responsible for animating this scene.

The Harvard biologist Stephen Jay Gould (like Forster) wryly spoke of Mickey's "unresolved relationship with Minnie and the status of Morty and Ferdie." In *Mickey's Steam Roller,* for instance, Minnie Mouse is seen, dressed like a nanny, pushing the nephews about in a baby carriage. Their putative mother, officially known only as "Mrs. Fieldmouse," had brought the twins to Mickey's home for their first appearance in the Sunday Mickey Mouse comic strip [170], published in September 1932 (Mrs. Fieldmouse appeared in several much later comic book series, but never on film, nor again in an American strip). For all intents and purposes, Mickey Mouse was the boys' father, just as, for Forster, Minnie was effectively Mickey's spouse. As a result, the one-time carefree bachelor found himself in the clutches of bourgeois domesticity—a decidedly *unheroic* paterfamilias, saddled with a lover-cum-wife, dog, and dependents. These changes, at least on the surface, reflected Walt Disney's personal growth and life experience. In December 1933, he became a father for the first time when Diane was born (a second girl, Sharon, was adopted in 1936).[8]

The taming of the Mouse, it also must be said, was propelled by his role in juvenile consumerism. By year's end, 1934, the *New York Sun* would issue this lament:

> Consider the evidence. Look at the recent Mickey Mouse cartoons and see how they are failing in invention beside the increasing richness and fertility of the Symphonies. Mickey is too valuable a trade-mark—has too many sidelines, too many gadgets—for Disney to be allowed to dispense with him altogether. But there seems to be a reasonable case for thinking that Mickey, the barnyard mouse, the sweetheart of Minnie, is becoming more and more a figure of the newspaper strip cartoon, while Disney himself is concentrating all his screen invention on the more impersonal and far wider field of the Silly Symphonies.[9]

"Failing in invention" or not, in 1934 the Disney "trade-mark" got his own magazine in France, with *Le Journal de Mickey* [188], and, on the other side of the Pyrenees in that year, a publishing house in Barcelona produced the first of three albums of *Aventuras Mickey* [189]. The outbreak of the Spanish Civil War in July 1936 appears to have brought a halt to the series. Elsewhere in the world in 1935, Mickey was declared the leading American hero by an Indian potentate, a Mickey Mouse watch was worn by the Emperor of Japan, and King George V insisted that a Mouse cartoon accompany any movie shown to the British royal family. In 1935, too, P. G. Wodehouse, creator of Jeeves and Wooster, authored a droll novel of upper-class English manners, *The Luck of the Bodkins,* in which one Monty Bodkin purchases a "brown

188. First numbered issue of *Le Journal de Mickey,* Oct. 21, 1934. Courtesy Pierre Lambert. *The Silly Symphony* (top) was written by Ted Osborne and drawn by Al Taliaferro. "Mickey" was written by Osborne, penciled by Floyd Gottfredson, and inked by Ted Thwaites. Both strips first appeared in American Sunday newspapers on March 11, 1934.

LE JOURNAL DE MICKEY

L'HEBDOMADAIRE DES JEUNES
RÉDACTION - ADMINISTRATION
68, CHAUSSÉE D'ANTIN, PARIS Tél.: Plg. 94-61

PUBLICITÉ : Sté Nlle de Publicité, 11, boul. des Italiens
PARIS (2e). Téléphone : Richelieu 67-90

1re ANNÉE. — N° 1 LE NUMÉRO : **30** centimes 21 OCTOBRE 1934

MICKEY

189. Covers of the complete *Biblioteca de Aventuras Mickey* series, published in Barcelona, Spain, by Editorial Alas: *Mickey y su Jazz / Mickey Bombero* (1934), *Mickey Calzador / Mickey Taxista* (1935), and *Mickey y los Indios / Mickey Caballista* (1935). Each 28-page album contains two complete stories. Courtesy Didier Ghez.

plush Mickey Mouse with pink coral eyes" in the barber shop of a transatlantic ocean liner as a gift for his fiancée. The object becomes a repeated element in the story—the MacGuffin, as Hitchcock would say—a prized item that a half-dozen characters, variously motivated, vie to get hold of.[10]

In July 1935, the man who invented all-electronic television, Philo T. Farnsworth, presented the first wireless transmission of the nascent medium at his lab in Chestnut Hill, outside Philadelphia. A "group of chorus girls, an orchestra, and Mickey Mouse" were on the program, according to the *New York Times,* which reported that "Mickey Mouse's voice and antics, as well as the dancing of the chorus," were "from a sound movie film." Fittingly, Disney's breakthrough comic, *Steamboat Willie,* was one of the segments that went out on these pioneering broadcasts. In 1935 as well, Farnsworth engineered "a fashion show, a horse show, a boxing match, and *Steamboat Willie,* televised from ten miles away," as part of a wireless program at the Crystal Palace in London. (This was not a first for Mickey, however: a Mickey Mouse toy had been seen on a Christmas season broadcast on BBC television in December 1933, and Farnsworth had used *Steamboat Willie* in test broadcasts as far back as late 1929 or early 1930.)[11]

Mickey's popularity also got a big boost when his first Technicolor short, *The Band Concert,* was released in February 1935 [181]. In the cartoon, Mickey Mouse conducts Goofy (aka Dippy), Horace Horsecollar, Clarabelle Cow, Gideon Goat, Peter Pig, and the smaller Paddy Pig, in a spirited outdoor program of classical music. Disney's unparalleled use of color is visible throughout. The rich, saturated hues of the band's costumes likewise stand in vivid contrast to the softly rendered, pastoral background art [190]. And the crisp black-and-white purity of Mickey's face and gloves contrast superbly with his baggy adult crimson suit, festooned with lush green trim, gold braid, and buttons.

Donald Duck, in a frenetic, irruptive turn that made him an overnight star, appears in *The Band Concert* as a vendor peddling ice cream and other snacks. When the musicians tackle the *William Tell Overture,* the irascible bird decides to steal the show. He pulls out a fife and, as Robert Feild pointed out, plays "Turkey in the Straw" [191], Mickey's big number in *Steamboat Willie*—underscoring, as the English art critic Christopher Finch later remarked, that by the mid '30s Donald had taken over Mickey's former "role of mischief-maker." Of course, the Mouse perseveres, leading the players and fending off Donald by snatching and breaking his fife in two, though the Duck has a boundless stock of them up his sleeve. Matters are further complicated as the band battles a bee, causing Mickey to quicken the musical pace and Horace

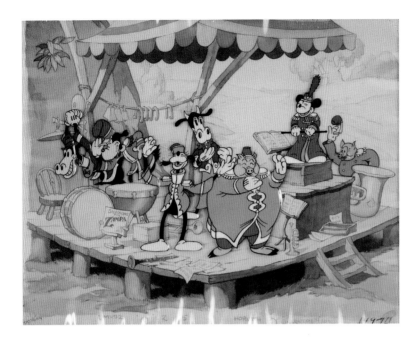

190. Ferdinand Horvath, *The Band Concert*, 1935. Cels on watercolor and gouache production background. Heritage Auctions.

to slam his cymbals madly and (all without skipping a beat) bang a sledgehammer on Goofy's head in an effort to nail the pesky bug.[12]

As the players plow into the "Storm" movement, a real storm—a tornado—bursts on the scene and the crowd runs for shelter. Forging ahead in perfect tempo, oblivious to the chaos surrounding it, the band is picked up and transported acrobatically through an aerial obstacle course of chairs, a farmhouse, and assorted debris [192]. Amazingly, Mickey's music stand remains before him till one and all are deposited safely back on terra firma, most of them dangling like ornaments on the branches of a Christmas tree. In a visual pun on the childhood lullaby, "Rock-a-bye Baby," Clarabelle lands in a stroller suspended from one of the boughs [193]. Alas, no one remains to appreciate the band's tenacity, and Donald Duck has the final laugh when he plucks one last fife from the bell of a battered tuba and pipes a few notes of "Turkey in the Straw."

The Band Concert received the Venice Film Festival Gold Medal for Best Animation in 1935. Several years later, a French-born artist, muralist, and illustrator of children's books (and friend of Diego Rivera), Jean Charlot, raved about it in the pages of the *American Scholar* magazine:

> Just as a painter composes with physical volumes, an animator composes mainly with diagrams based on motion. [...] Who has not thrilled at the spiral into space evoked by the gyrating musicians caught by the cyclone in "Mickey's Band Concert"? No one would be more delighted by it than Hogarth; for here at last, in its three-dimensional reality, has been realized that Line of Beauty, the S shape which, with the imperfect techniques of the painter, Hogarth strove to wind into space by coiling it around a superfluous cone [192]. That spiral, which the painter can only hint at and the sculptor can only freeze, animation brings to life.

191. Screen capture of Mickey and Donald in *The Band Concert*, 1935. Gilles "Frenchy" de Trémaudan (1909–88) and Dick Huemer (1898–1979) were the principal animators assigned to this scene.

192. Screen capture of Mickey's band spiraling though the air in *The Band Concert*, 1935. Note the "flying saucer," bottom right. Cy Young (1900–64) was the lead animator for this scene.

193. Clarabelle Cow in a baby carriage, at rest on a tree limb in *The Band Concert*, 1935. Louis ("Louie") Schmitt (1908–93) may have been responsible for the animation in this scene.

This was an unusual observation, since William Hogarth's eccentric Line-of-Beauty theorizing cannot have been awfully well known in America. In 1934, a writer in *Art Digest* also had referred to the great English graphic satirist when he described Disney's cartoons as "genuine works of art" that create "a saga which will mark this era as vividly as Hogarth's engravings stamped the eighteenth century." But Charlot's point was more incisive. The spatially complex aerial sequence in *The Band Concert* did mark an important advance from the essentially flat, planar action typical of animation in the 1920s and 1930s, including Walt's.[13]

One of the unhappy few apparently unmoved by *The Band Concert* was journalist Graham Greene, later the author of *The Quiet American* and other novels. A fan of the early black-and-white Mouse—like his fellow Brit and colleague at *The Spectator*, E. M. Forster—Greene began a review of the 1936 RKO musical *Follow the Fleet* by describing the star of the picture, Fred Astaire, as

> the nearest we are ever likely to get to a human Mickey, near enough for many critics to have noted the resemblance. If one needs to assign human qualities to this light, quick, humorous cartoon [the Astaire film], they are the same as the early Mickey's: a touch of pathos, the sense of a courageous and impromptu intelligence, a capacity for getting into awkward situations. Something has to be done, and Mickey without a moment's hesitation will fling his own tail across an abyss and tread the furry unattached tightrope with superb insouciance. Something has to be done, and Mr Astaire bursts into a dance which in its speed and unselfconsciousness seems equally to break the laws of nature. They are both defending Minnie, though Ginger Rogers will never attain Minnie's significance (she is too brazen and self-sufficing for the part), and there is no villain type, no huge black Pasha cat, continually to threaten her with ravishment: the plots of Mr. Astaire's films are more everyday; one might say more decent, more "family."

Then Greene let fly with this parting shot at the colorized Mouse:

> Mr Astaire dressed in a seaman's inhuman uniform does drop one more terrestrial envelope, comes nearer to soaring in those regions where once Mickey soared. Alas! Where he soars no longer. Mickey in his Technicolor days has been refined out of all knowledge; no longer does Minnie struggle on the edge of the great cat's couch, and the very capable Fleischer cartoon *The Little Stranger*, in the same programme as *Follow the Fleet*, should be a warning to Mr Disney that if he relies only on agreeable colour, on pictorial prettiness, there will soon be others to equal him.

If, as it seems, Graham Greene held *The Band Concert* in low esteem, he was virtually alone. Even Gilbert Seldes loved and lauded it wholeheartedly. In the September 1937 issue of *Esquire* magazine, Seldes wrote:

> I am afraid there are still two or three of Disney's works which I have missed, but I think I have seen all of the great ones and after two years it is still my judgment that the *Band Concert* is Disney's greatest single work and I doubt very much whether half a dozen works produced in America at the same time in all the other arts can stand comparison with this one. What Mr. Henry James might have called the "dazzling, damning apparition" of Donald Duck in this picture is only a small part of its glory. I know of no other Mickey Mouse in which all the elements are so miraculously blended.[14]

In his encyclopedic and indispensable compendium, *The Disney Films*, Leonard Maltin called *The Band Concert* "the pinnacle of Mickey's career as a short-subject star, and a harbinger of things to come." however, as "the 1930s wore on," Maltin added, the Mouse "played a progressively less important role in the proceedings" of Disney cartoon shorts. [15]

By the mid 1930s, at the height of Mickey's imperium, his raison d'être was fast becoming one of providing non-comic relief to the more animated doings of Pluto, Donald, and Goofy. Gone was the rascally whelp Forster and Greene were so fond of, who once played a cow's teeth like a xylophone and never failed to free Minnie Mouse from the clutches of the villainous Pete.

A month after *The Band Concert* was released, in March 1935, a remarkable examination of the character's rise to stardom by freelance writer L. H. Robbins appeared in the *New York Times Magazine*. (Throughout Mickey Mouse's first decade of existence, the *Times* was truly the "newspaper of record" where he was concerned, and one of his biggest boosters.) "How," Robbins asked in his article, "has an imaginary creature only 6 years old, going on 7, captured the interest of almost every tribe on this terrestrial ball?"

> Crowds of ambitious folk looking for ideas and fortune would like to know, to say nothing of people trying to interpret day-to-day phenomena for the press, psychologists who must somehow account for human behavior, and historians who will have to record this age for posterity's eye. Mickey Mouse is Public Question No. 1 to a lot of people.
>
> Sages in great argument try to explain Mickey Mouse, and, in the

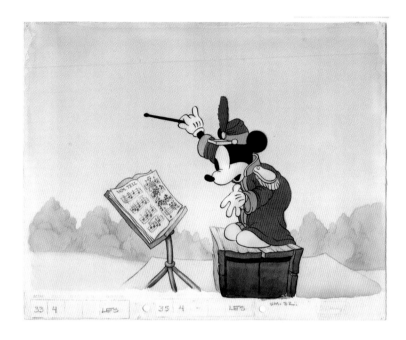

194. Cel set-up from *The Band Concert*, 1935. Ink and gouache on celluloid, 9¾ x 12½ in. Walt Disney Family Foundation, San Francisco, California. Les Clark was in charge of animating this scene in the film.

fashion of the blind men of Hindustan who went to see the elephant, they reason variously, each according to his feeling. To the timid among us, Mickey represents mankind beset by grim circumstances and escaping whole and right-side up through luck. To them he is that dearest figure in fiction, the ill-used, defenseless, well-deserving Cinderella in disguise. To the aggressive and the predatory among us, on the other hand, he symbolizes cleverness and resource. He is "little, but oh my!" He outsmarts even Behemoth.

Again, world-weary philosophers find in Mickey's antics "a release from the tyranny of things." He declares a nine-minute moratorium on the debt we owe to the iron facts of life. [. . .]

The wise men, Robbins continued, believe

there is in human nature a streak of rebellion [. . .] even at the cost of a headache and an unpleasant taste in the cold gray dawn of the morning after. This craving of ours [for] Mickey, with his absurdities, his defiance of reason and his accomplishments of the impossible, gratifies for us vicariously.

We see Mickey, the bandmaster [194] drawing dulcet strains out of the bell of the big brass tuba with his hands. We see him render the storm movement of the overture so convincingly that he brings on a tornado; and an umbrella is blown through the duck's flute, and the orchestra runs for cover, and the benches run, too; and at the last the musicians, high in the tree tops, go on playing, loyal to their dauntless leader, while the branches to which they hang beat time to the music.

After that excursion into the fantastic, the philosophers tell us, we are cured of our revolt. We leave the theatre calmed and stabilized to take up the humdrum of life in the right spirit again. Maybe so.

Robbins concluded by saying:

> It sounds a bit highbrow to those who have most to do with Mickey's career. So does the explanation of educators who recall that folk tales have always been popular and fables of talking animals beloved [...] and conclude that Mickey's creator has merely applied the old, tested method of Aesop.
>
> There would seem to be more to Mickey Mouse than that, and besides, he is not an animal; he is a personality, along with Uncle Sam, John Bull, Mr. Dooley, and the Tammany Tiger. He is not a mouse at all; he is Mickey Mouse. In one way or another, since there is a bit of Mickey's helplessness, shrewdness, madness, and mischief in the best of us, he is an approach, the nearest one in our day, to that mythical and ubiquitous fellow, Everyman.
>
> All these piecemeal explanations help in explaining Mickey Mouse, but they ignore the two obvious ones—that Mickey is superlatively funny, and that he is simple. The world, in all its continents and islands, wants to laugh, and never more than now. Mickey makes it laugh till the roof shakes.[16]

Disney's Everyman was by this time riding high. In October 1935, Graham Greene, anticipating his commentary six months later, praised Fred Astaire's performance in *Top Hat* as "the nearest approach we are ever likely to have to a human Mickey Mouse." Astaire, Greene enthused, "might have been drawn by Mr Walt Disney, with his quick physical wit, his incredible agility. He belongs to a fantasy world almost as free as Mickey's from the law of gravity."[17]

Secure financially, professionally, and individually, thanks to the success of Mickey and the Silly Symphonies, and with production of *Snow White* getting underway, Walt was persuaded by Roy to take their wives on a grand and, it turned out, much to their amazement, triumphal tour of Europe. Walt was being treated for a thyroid deficiency, and Roy felt that getting his brother away from work for an extended period would do more good than the injections he was getting. (He was right.) Another reason to go: it was the tenth anniversary year for both couples.[18]

They left New York for England on June 7, 1935, aboard the first eastbound run of the luxury liner *Normandie*. In a joint diary kept by Edna and Roy, it was recorded that at dinner one evening they sat "next to Baron Rothschild who is very hard of hearing," and that Walt sketched

195. Walt and Lillian Disney, with a stuffed Mickey Mouse doll, on the roof of their London hotel, Grosvenor House, June 12, 1935, the day they reached London. Corbis Images.

196. Vignettes from a *reportage,* "Mickey à Paris," *Le Figaro,* June 23, 1935. The captions read: "Ces Parisiens me reçoivent comme s'ils me connaissaient déjà" (These Parisians greet me as if they already knew me) and "Chic, je suis tombé en pleine saison de Paris" (Great, I've arrived in the peak season for Paris). During their stay in Paris, the Disneys made an excursion to Versailles. In Didier Ghez's *Disney's Grand Tour,* there is a still of Roy posing in the huge forecourt of the château taken from one of the home movies the brothers made during their European vacation.

197. Ernest Shepard (1879–1976), "Public Benefactor No. 1 (With Mr. Punch's salutations to Mr. Walt Disney, who has arrived in England 'in person')," *Punch,* June 19, 1935. Private collection.

Mickey on a menu for the wife of the president of France, Mme. Albert Lebrun. Arriving on the twelfth, Walt and Lillian posed for publicity shots with a stuffed Mouse [195] and checked into their hotel in London, the posh Grosvenor House. The party spent twelve days in the United Kingdom, visiting Eton, Oxford, Ascot, Carlisle, Edinburgh, and the Scottish Highlands, as well as London, where Walt met the political cartoonist David Low over lunch at the home of H. G. Wells. Disney's presence in Britain inspired a cartoon in the satirical weekly *Punch* by Ernest Shepard, depicting the imperial British lion shaking Mickey's hand, to the prancing delight of Minnie, Pluto, and the Three Little Pigs [197].[19]

On June 25, Walt, Roy, Lilly, and Edna flew to Le Bourget airport, outside Paris, where Lindbergh had set down eight years earlier. They stayed at the Hôtel de Crillon, on the Place de la Concorde. Walt's return to France was exciting in and of itself—he had been posted there sixteen years earlier, mainly in the Lorraine region—but he could not have imagined the greeting in store for him in the French capital.

His impending arrival had been headline news for several days in *Le Figaro,* Paris's oldest and most prestigious daily newspaper, which accorded him a full-page advance spread, complete with photos and a sequence of droll cartoon vignettes titled "Mickey à Paris" [196]. An elegant reception in Walt's honor on the 26th, hosted by the *Comité International pour la Diffusion Artistique et Littéraire par le Cinématographe* (C.I.D.A.L.C.), was attended by the U.S. ambassador and by the legendary movie pioneer Louis Lumière. (The *Comité* claimed an affiliation with the League of Nations—a polite fiction, really.) The high point of the Paris sojourn, however, was a glorious happening under the patronage of Mme. Lebrun, organized and touted by *Le Figaro* as a "Gala Mickey-Mouse," which took place on the 27th at Paris's most magnificent *cinéma,* the Gaumont-Palace. In her diary, Edna noted that at 11 o'clock they all went "to a large theatre where Walt was presented with a League of Nations medal. There were 4,000 school children present." On the program for the event: two Mickey cartoons, the *Three Little Pigs,* three other Silly Symphonies, several musical numbers, a "Ballet de Mickey," performed by children from the Théâtre du Petit-Monde, a poem recited by the troupe's girl star, Gaby Triquet, as well as the medal presented to Walt by the president of the C.I.D.A.L.C., Elena Văcărescu, for his "original and distinctive work" with the Mouse and Silly Symphonies series, and in recognition of Mickey as "a symbol of international goodwill."[20]

From Paris, the Disneys motored through eastern France to inspect battlefields and more of Walt's old haunts from the war. Then it was on to Reims, Strasbourg, Baden-Baden, Munich, Lindau, Lucerne, and, via the St. Gotthard Pass, over the Alps to Italy, where Mickey's first foreign

PUBLIC BENEFACTOR NO. 1

(*With Mr. Punch's salutations to Mr. WALT DISNEY, who has arrived in England "in person"*).

198. First issue of *Topolino,* Dec. 31, 1932.
Artwork by Giove Toppi (1888–1942).
Photo courtesy David Gerstein.

199. Vol. I, no. I, of the British publication,
Mickey Mouse Weekly, Feb. 8, 1936.
Wilfred Haughton (1894–1980)
furnished the artwork. The Walt Disney
Archives, Burbank, California.

kids' magazine, *Topolino,* had been launched two and a half years earlier [198]. On the itinerary in Italy: Lake Como, Milan, Venice, and, as Roy Disney's biographer, Bob Thomas, noted, a "clamorous" reception in Rome. (Despite reports to the contrary, Walt specifically told a writer for the *New York Daily Mirror* that he'd met neither Mussolini nor the Pope during his stay in Italy.) The couples took rooms at the Hotel Excelsior and, according to Thomas, dined at Alfredo's, where "Alfredo himself mixed the pasta with a gold spoon and fork given to him by Mary Pickford and Douglas Fairbanks." After Rome, they visited Pompeii and Naples, and returned home, "prima classe," on the crown jewel of the Italian steamship line, the *Rex.*[21]

In 1936, Mickey appeared to maintain his popularity. In January, in one of nine mini-plays rotated into Noël Coward's London stage production *To-Night at 8:30,* an actor urges everyone to hurry to the cinema, or "We'll miss the Mickey." According to a report in the *New York Times,* also in January, the "red ribbon of the French Legion of Honor arrived today for Walt Disney, producer of 'Mickey Mouse.'" In February, the British children's magazine *Mickey Mouse Weekly* was created [199], and that fall, the Mouse topped a student poll at Virginia Tech. One of the hit tunes for the year was "Mickey Mouse's Birthday Party," by Wayne King, the "Waltz King." Nevertheless, it was at about this time that Mickey Mouse eased into his downward slide as a movie property. Around 1935 his physiognomy had started to get more rounded and softer. A pinkish or pale ochre facial tone was introduced in cartoons like *Brave Little Tailor* and *Lonesome Ghosts* [200]. As Stephen Jay Gould demonstrated, these changes made him appear more human. But such changes masked the fact that he was becoming less interesting, mainly, as Disney noted in 1947, because his fame had carried him to "the stage where we had to be very careful about what we permitted him to do." Mickey, Walt added, "could never be a rat."[22]

In 1937, the year *Lonesome Ghosts* was released, Mickey's preeminence was diminished when, as Leonard Maltin pointed out, "Disney stopped calling his shorts 'Mickey Mouse Cartoons,' identifying each production by its star character instead." Following the release of *Fantasia* in 1940, Mickey's film work slacked off markedly and his screen presence languished in mild-mannered vapidity, exemplified by *The Simple Things* (1953), his last animation for thirty years, in which he literally went fishing and left all the comedy action to Pluto [201].[23]

A parallel fate had already befallen the Marx Brothers. Groucho, Chico, Harpo, and Zeppo Marx, like Disney and Chaplin, were unique in Hollywood among their contemporaries for their ability to please both a broad public and the cultural elite. Among their admirers were Winston Churchill, George Bernard Shaw, T. S. Eliot, and Salvador

200. Screen capture from the Mickey Mouse cartoon *Lonesome Ghosts*, released by RKO Radio Pictures, Dec. 24, 1937. Rex Cox (1911–90) was the principal animator on this scene. Walt Disney Archives, Burbank, California.

201. Mickey and Pluto in *The Simple Things*, released by RKO, April 18, 1953. Marvin Woodward (1905–71) was in charge of animating this scene.

202. Screen capture from *Mickey's Gala Premier*, released by United Artists, July 1, 1933. Top left to bottom: Zeppo, Groucho, Chico and Harpo Marx. Fred Moore was the lead animator in this scene.

203. Book jacket for Gilbert Seldes's *The Movies Come from America* (New York: Charles Scribner's Sons, 1937). Private collection.

Dalí. Disney paid homage to them on three occasions in the 1930s. All four Brothers appeared as caricatures of themselves in *Mickey's Gala Premier* [202]. A cartoon Harpo was seen in *Mickey's Polo Team* and a cartoon Groucho (along with Laurel and Hardy, Hepburn, and W. C. Fields) had a cameo role in the non-Mickey animated short, *Mother Goose Goes Hollywood.*

Cocoanuts, Animal Crackers, Monkey Business, and *Horse Feathers,* the Marx Brothers' finest comedies (all from 1929–1932), had been characterized by "warp-speed wisecracks and wordplay seasoned with music and old-school slapstick." After *Duck Soup* fizzled at the box office in 1933, Metro-Goldwyn-Mayer chief Irving Thalberg toned down their aggressive madcap personalities and resuscitated their career with *A Night at the Opera* (1935). Still, by 1940, when Mickey was handed his last great role in *Fantasia,* their glory days as film stars were behind them.[24]

The Marx Brothers were never masters of their own cinematic destiny, and for that reason perhaps never scaled the heights reached by Chaplin and Disney, who, as H. G. Wells remarked in January 1936, "do the only thing in film work today that remains interesting." Wells was not alone in that opinion. In March 1936, playwright Thornton Wilder told an interviewer: "The two presiding geniuses of the movies are Walt Disney and Charlie Chaplin," and, Gilbert Seldes, in his 1937 book, *The Movies Come from America* [203], declared,

> I can say with absolute confidence that any picture made by Walt Disney
> is worth seeing, his rare failures being more attractive than the successes
> of most others; I can say the same about Charlie Chaplin. And the reason
> is that these two artists either create or closely control the creation of
> their own work.

All three of these statements, it should be noted, were made before the release of Disney's feature-length tour de force, *Snow White.*[25]

Though the term "auteur" was not yet used in critical circles, several days after H. G. Wells's words appeared in the *Times*, the French director, René Clair, endorsed the *auteur* status implicitly granted to Disney and Chaplin: "they have no outside interference. They act as their own producer, director, and even attend to their own stories and musical scores. Their artistry is sublime." Clair knew whereof he spoke; as did his peers in the motion picture business. Germany had led the way in working the iconic Mouse into the action in three films in the early 1930s. U.S. moviemakers were slower out of the gate in that

THE
MOVIES
COME
FROM
AMERICA

GILBERT
SELDES

With a
Foreword by

CHARLES
CHAPLIN

THE MOVIES

COME

FROM

AMERICA

By
GILBERT
SELDES

With a Foreword by
CHARLES CHAPLIN

Walt Disney

regard. However, by the end of 1936 Mickey had in various ways, over a nearly four-year period (with or without contractual permission from the Disney studio), been injected by Warner's, MGM, and other studios into at least ten non-Disney Hollywood productions, including six musicals.[26]

The first of these, released in November 1933, was *My Lips Betray* (Fox), a romantic comedy whose opening scene included a clip of Mickey from *Ye Olden Days* flashed on a futuristic TV screen. *My Lips Betray* was followed, a month later, by *Lady Killer,* a comedic Warner Brothers gangster-drama, wherein James Cagney, as a brash young usher at a New York City movie theater, has this sarcastic exchange with a pair of tough customers:

—Hey, is there a Mickey Mouse on the bill today?
—No, not today.
—What, no Mickey Mouse?
—No, no Mickey Mouse.
—Why?
—Because he's making a personal appearance in Jersey City.

Closing out the year was *Roman Scandals* (Goldwyn/United Artists), in which Eddie Cantor makes a wry reference to Mickey and Minnie.[27]

In 1934, Disney loaned his star out to David O. Selznick for an animated cartoon cameo in *Hollywood Party*, an MGM comedy-and-songfest starring Jimmy Durante and Lupe Velez, in which Laurel and Hardy and the Three Stooges, among others, likewise briefly appeared. A week or so before Christmas of that year, a Laurel and Hardy version of the Victor Herbert operetta, *Babes in Toyland* (also MGM), was released, with a small monkey, dressed as the Mouse, bounding through several scenes.[28]

Mickey's most amusing outside role in 1934, though, was completely nonvisual: in the Astaire-Rogers RKO musical *The Gay Divorcée,* which premiered in October. In the film's big comic song-and-dance sequence, the Mouse helped seventeen-year-old Betty Grable make the most of her one-shot turn as a gold-digger working a seaside resort in Brighton, England. Grable decides to charm a prissy, middle-aged stranger (Edward Everett Horton), whom she has spotted in the lobby, absorbed in a book, and springs into action with a number, "Let's K-nock K-nees," that minces no words:

You're my type of a shy type of a beau, dear.
So let's do things, I'll teach you a few things.

Horton meekly mutters, "Oh, no, no—I'm reading." Undeterred, Grable forges on:

> Now, who said just what you said, for I know dear.
> I'm not bashful, I'm "mashful" and "pashful."
> When you're near, I feel so "let's-play-housey."
> Oh, you make me feel so Mickey Mousey.

To her mark's embarrassement and delight, Grable then brazenly marches her fingers up his neck and tickles him in the ear. September 1935 saw the release of a third MGM musical in which, as in *The Gay Divorcee*, Mickey Mouse was a part of the tuneful goings-on; *Broadway Melody of 1936*, with Robert Taylor and Eleanor Powell in the leading roles.[29]

Unlike *The Gay Divorcee*, the comedy-relief number in *Broadway Melody* features Mickey in solely visual terms—as he was seen on lobby cards whenever one of his cartoons was on the bill—stitched onto a sweatshirt worn by Buddy Ebsen. The sequence unfolds on the roof of a New York apartment building, where Powell, as an aspiring actress, and two unemployed dancers, played by Ebsen and his real-life sister Vilma, live. In an online Q&A session in 2001, Ebsen said that the idea to use Mickey as a prop came from the director Roy Del Ruth, who felt that Ebsen's plain, unpatterned garment needed spicing up (MGM's previous ties to Mickey must have factored in too). Ebsen's re-fashioned sweatshirt reflected an emerging cultural trend taken for granted today: the mass-marketing of adult and children's clothing bearing the faces of pop icons of every sort, from Mickey Mouse and Betty Boop to Kurt Cobain and Che Guevara.[30]

Mickey's "moonlighting" for other studios peaked in 1936 with three more films. In *Modern Times,* the Little Tramp's final movie appearance, he falls for a homeless waif played by Paulette Goddard. After he gets a job as a night watchman at a department store, Charlie sneaks Goddard in with him; with the place to themselves, the love-struck pair makes a beeline to the toy section where she hugs a stuffed Mickey doll [204]. In *The Princess Comes Across,* Carole Lombard plays a Brooklyn showgirl posing as a Swedish blueblood, who, upon arriving in America, informs reporters that her favorite film star is "Meeky Moose," and, in *Born to Dance,* Eleanor Powell sings Cole Porter's tune about licking "this world of men and Mickey Mice."[31]

In 1937, in *Night Must Fall,* an MGM murder mystery situated in England, when asked (by actor Robert Montgomery) if her mistress is really an invalid, a maid responds, "If she's an invalid, I'm Mickey

204. Chaplin and Paulette Goddard in *Modern Times,* released by United Artists Feb. 5, 1936. A plush Mickey doll sits on the counter behind Chaplin. © Roy Export S.A.S. Scan Courtesy Cineteca di Bologna.

Mouse." This line must have inspired a similar exchange in *Indiana Jones and the Last Crusade* (1989), directed by Disney admirer Steven Spielberg, set in roughly the same period (1938). Convinced that his father is held captive in a German castle, Jones (Harrison Ford) tries to bluff his way inside by masquerading as a Scottish nobleman who wishes "to view the tapestries." The butler who opens the door haughtily tells the intruder: "This is a castle and we have many tapestries, and if you are a Scottish lord, I'm Mickey Mouse."[32]

Cary Grant and Katharine Hepburn, in Howard Hawks's comedy classic *Bringing Up Baby* (1938), run amok in the wilds of exurban Connecticut chasing a leopard named "Baby" and an errant dinosaur bone that Grant, in the role of a nerdy paleontologist, must retrieve for the museum in New York where he works. Cary and his scatterbrained companion (Hepburn) wind up being mistaken for bank robbers and tossed behind bars. In the movie's farcical dénouement, a bumbling constable asks Grant, "Who was with you last month in Rockdale on that mail-truck job?" At his wit's end, Cary blurts out: "Mickey-the-Mouse and Donald-the-Duck."[33]

This may well have been Mickey's final presence in a non-Disney, Depression-era film. And aptly so. The coupling of mild-mannered Mickey in the same breath with his choleric friend—mirroring the personality clash between the Grant and Hepburn characters—

underscores the fact that by 1938 the Duck had equaled if not surpassed the Mouse in popularity.

But the insertion of their names into the script probably signifies more than respect for Mickey and Donald's bipolar, mass-cult resonance. RKO, which released *Bringing Up Baby*, had begun distributing the Disney cartoons in 1937, and thus had a vested interest in advancing Walt's fortunes. Mendacity aside, Grant's exasperated rejoinder is one of the great lines in motion picture history, and the parts played by Cary and Kate were models for the roles filled by Barbra Streisand and Ryan O'Neal in *What's Up Doc?* (1972), Peter Bogdanovich's avowed tribute to Hawks's film, for which Streisand sang the picture's title song, "You're the Top" ("... you're Mickey Mouse").[34]

Bringing Up Baby also may have reverberated in the American version of John Woo's made-in-Hong-Kong feature, *The Killer*. In a key scene in *The Killer*, as seen in the States (1991), the hero, a hit man named Jeffrey, is confronted by a tenacious policeman who has come to regard him as an honorable man. The two adversaries meet in the presence of Jennie, a temporarily blind young woman whom Jeffrey has befriended. Unseen by Jennie, they have their guns pointed at each other. For her sake, they pretend to be old friends, who "used to hang around in the same neighborhood," the cop explains. In the original Chinese-language version (1989), he tells Jennie that their nicknames for each other were "Shrimp" and "Little Brother." However, the American audience heard the cop say: "He was Mickey Mouse. I'm Dumbo."[35]

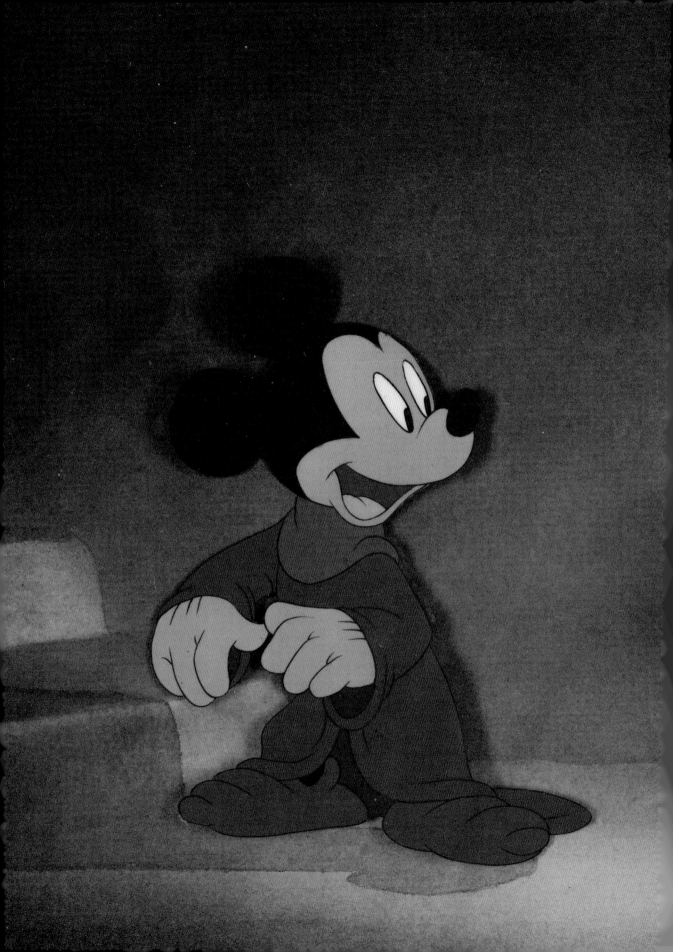

FROM *FANTASIA* TO MOUSE CLUB

Despite the critical and box-office success of Mickey's first color cartoon, *The Band Concert*, Walt Disney's creative passion for the character had by then peaked. It was hard to dispute the view, voiced at the time by the *New York Sun*, that Disney was "concentrating all his screen invention on the more impersonal and far wider field of the Silly Symphonies." Disney had, in fact, set a new course as far back as 1932–1933, with Oscar-winning color shorts like *Flowers and Trees* and *Three Little Pigs*. In 1934, he plunged into totally uncharted territory as work began on his first full-length animation, *Snow White and the Seven Dwarfs*.

Following the glittering premiere in Los Angeles, in December 1937, of *Snow White*, which he'd seen no fewer than three times, the film critic for the *New York Herald Tribune*, Howard Barnes, said that "it belongs with the few great masterpieces of the screen." It is, Barnes declared, "more than a completely satisfying entertainment, more than a perfect moving picture, in the full sense of that term. It offers one a memorable and deeply enriching experience." In the *New York Times*, Frank S. Nugent called *Snow White* "a classic, as important cinematically as *The Birth of a Nation* or the birth of Mickey Mouse. Nothing quite like it has been done before." And, in a long reflection on Walt's œuvre after his death in 1966, a later *Times* movie critic, Bosley Crowther, remarked that, as "we now look back upon it," *Snow White* stands as "the Continental Divide in Mr. Disney's creative career." Crowther was right. After the release of *Snow White and the Seven Dwarfs*, feature films—animated and, in due course, live-action—would forever supplant cartoon shorts as the artistic and financial mainspring of Disney studio activity.[1]

Like *Pinocchio, Dumbo, Bambi,* and subsequent Disney motion pictures, *Snow White* deals with a theme too complex for a one-reeler: growing up. Snow White, a girl on the brink of maturity, must experience the oedipal ordeal of her evil stepmother's demise before she can ride

205. Detail of a cel set-up of Mickey as the sorcerer's apprentice in *Fantasia*, released Nov. 13, 1940. Ink and gouache on celluloid taped to watercolor background drawing on paper, 10⅔ x 12⅔ in. (sheet).
Art Wood Collection, Library of Congress, Washington, D.C. Riley Thomson (1912–60) was the artist in charge of animating Mickey in this scene.

off with Prince Charming. Pinocchio becomes a "real" boy—a young man, really—when he masters the concept of personal responsibility. Dumbo, already fatherless, and separated from his mother, must learn to navigate through life on his own. Bambi grows up before our very eyes as time and first love assuage the loss of his parents. Such themes were incompatible with any Mickey Mouse scenario, short or feature-length. As Michiko Kakutani observed (in 1998) in the *New York Times Magazine*, Mickey and Donald "never developed or changed in a movie . . . They were still points in a topsy-turvy world."[2]

Despite the progressive maturation imposed on him in the 1930s, Mickey has always represented the permanent child in Everyman, living and delighting in the here and now, and in the latter part of the 1930s his many fans maintained their reverence for him. The *New York Times*, in July 1937, reported that

> Mickey Mouse, the naive movie and comic strip character, whose saucy antics and strange assortment of friends have made millions of children and grown-ups chuckle, has been placed on the recommended reading list of New York City's elementary schools for the coming year, Dr. Harold G. Campbell, Superintendent of Schools, revealed yesterday.
>
> The Superintendent's decision was supported by the school system's chief medical examiner, Dr. Emil Altman, who felt that "Mickey Mouse is 'very good' for children because it helps to stimulate the imagination." Dr. Altman said that kids "should recognize fantastic, unreal situations as being unreal and not confuse phantasy with realism."[3]

Superintendent Altman was convinced that Mickey Mouse would help children distinguish one from the other. Occasionally, though, Mickey's "saucy antics" caused adults to confuse fact and "phantasy." In December 1937, the "censor for art, literature, and drama" in Yugoslavia obliged the newspaper *Politika* to hand over "for destruction" some comic strips in which the Mouse, "in the guise of a 'Prince,'" was part of a "conspiracy to overthrow a young king," a story line taken by the government as a reference to fourteen-year-old Peter II, son of the recently assassinated King Alexander.[4]

In "L'Affaire Mickey Mouse," a *New York Times Magazine* article accompanied by three cartoons by Al Hirschfeld, published the day after Christmas 1937, freelance writer Herbert Russell offered this gloss on Mickey's global impact:

> Now that that unreconstructed international rebel, Mickey Mouse, has been thrown out of Yugoslavia for conspiring against the throne— he together with the newspaper correspondent who rashly reported

the plot—the expulsions from foreign countries of this arch-enemy of nations have risen to two. Hitler once barred him from Germany because Mickey was accompanied by a brigade of animals wearing Uhlan helmets, which was a reflection on the honor of the German Army and too serious to be passed over. Of course, Mickey was eventually pardoned, because not even dictators are completely immune to his spell; Mussolini loves him.

The incident in Yugoslavia serves again to emphasize the international character of Mickey's activities, the boring within by means of which he is winning the populations of a good part of the world to his cause. He is apparently without principles and can be all things to all men. While Yugoslavia suspects him of communistic and revolutionary designs, the Soviet thinks he represents the meekness and mildness of the masses under capitalism, and has countered by creating a Russian Mickey, known as Yozh, or the Porcupine, an animal favorite.

Russell was right about Mussolini. Although briefly banned in Italy (in November 1938) for undermining the regime's program of raising "children in the firm and imperialist spirit of the Fascist revolution," Il Duce, himself, was hooked on Mickey Mouse.[5]

Back in the United States, on January 2, 1938, the NBC radio network launched the *Mickey Mouse Theatre of the Air,* broadcast every Sunday evening opposite two popular series: a mystery, *The Shadow,* and a musical program starring Guy Lombardo and his Royal Canadians. In June 1938, Disney got well-publicized recognition from three of America's top institutions of higher learning when the University of Southern California, Yale University, and Harvard [206] conferred honorary degrees on him. At Yale, a revered professor emeritus of English, William Lyon Phelps, began his citation of Disney's accomplishments as follows:

> In every way an American of the 20th century. Born in Chicago, educated in the high schools of Kansas City and Chicago, he became a commercial artist at the age of 17, and at 18 began his career in animated cartoons. He has the originality characteristic of genius, creating the demand as well as the supply. He has achieved the impossible. He has proved that popular proverbs can be paradoxes—for he labored like a mountain and brought forth a mouse! With this mouse he conquers the whole world."[6]

Mickey Mouse was nearing his tenth anniversary at this time, and, in late September 1938, the *New York Times* filed this story on the event:

206. Walt holding five toy dolls in his lap—Dopey, Donald Duck, Minnie, Mickey, and another of the Seven Dwarfs, Sleepy—on June 23, 1938, the day he received an honorary master's degree at Harvard. Corbis Images.

The week's big news, of course, was Mickey's tenth birthday celebration, due this Tuesday. [. . .] Besides radio "salutes" from various maestri and the showing of Disney shorts by 4,000 theatres, "thousands of telegrams will be sent to Mickey to the Hollywood studio from all over the world, as they have in the past," the announcement stated, "including one from President Roosevelt." (Aside to Mr. Stephen Early, the President's secretary: You'd better investigate that leak.)[7]

Alas, as the 1930s grew to a close, fewer and fewer Mickey Mouse cartoons were being made. A caricature in the June 1937 issue of *Vogue*, by Miguel Covarrubias, who would include Mickey and Donald among a hundred radio all-stars in a caricature published in *Fortune* in 1938 [207], reflects Mickey's shrinking presence on the big screen. The caption in the *Vogue* cartoon reads: "Walt Disney has made a brilliant acting unit out of about as irresponsible, undependable, unstable a crew as ever trod the boards" [209]. What is interesting is that Mickey and Minnie, Disney's now-virtuous couple, were each reduced by Covarrubias to the rank of second mate on this fanciful ship of fools, overshadowed by Walt, of course, and also by Pluto, Goofy, and Mickey's splenetic pal, Donald. By 1940, the Duck was the studio's biggest draw, and, after World War II, Mickey was eclipsed as well at the box office by more manic cartoon competitors, like Bugs Bunny. Profits from *Snow White*, however, ensured that lesser studio vehicles were unaffected, at least for the present, by budgetary constraints. (The movie "would have made twice as much," Mae West joked, "if they had let me play Snow White.") Thus, thanks to *Snow White*, production values in the Mickeys of the late 1930s were finer than ever, resulting in the second and third of only six Oscar nominations the Mouse ever got, for *Brave Little Tailor*, in 1938, and *The Pointer*, in 1939.[8]

As the 1930s came to an end, most of Mickey's iconic Jazz Age contemporaries had faded to black or drifted into the twilight of their careers. Babe Ruth retired in 1935, George Gershwin died in 1937, and, by the end of the decade, Lindbergh's dalliance with Nazi Germany had tarred his once pristine image. In 1940, Chaplin would star in his first talkie, *The Great Dictator*, but made just four films thereafter; in 1941, Jolson virtually quit performing altogether and the Marx Brothers stopped making movies. Still, after a decade at the top of the heap, Mickey Mouse was not quite ready to be consigned to celluloid oblivion.

In 1937, Disney laid plans for another Silly Symphony, set to the music of *L'Apprenti-sorcier* by the French composer Paul Dukas, which had itself been inspired by an ancient Greek tale, as reworked by the German poet Goethe, in the ballad *Der Zauberlehrling* ("The Apprentice Magician"). At first, someone suggested that the apprentice be "played"

by Dopey, but Walt was always reluctant to use a character from *Snow White* in a cartoon short. Instead, Mickey was tapped for the part and animator Fred Moore, the house expert on the Mouse, prepped him for his turn as the *Sorcerer's Apprentice.* Moore improved Mickey's expressiveness by adding pupils to his eyes and, as indicated on a model sheet for fellow animators, turning the black crown of his head into the graphic equivalent of eyebrows [208].[9]

In the end, it was decided that *The Sorcerer's Apprentice* would be included in a feature-length motion picture, *Fantasia,* to be composed of eight Silly Symphony–type sequences all pegged to classical music. Among other highlights in *Fantasia* were Chinese mushrooms shuffling about to the "Nutcracker Suite"; an Art Deco vision of Bacchus, centaurs, and winged horses cavorting to Beethoven's "Pastoral Symphony"; and a hippo and alligator in a pas de deux from Ponchielli's "Dance of the Hours." Mickey Mouse was the only stock Disney character in the movie, and, underscoring his primacy, he appears on screen in silhouette immediately after the *Apprentice* sequence to greet Leopold Stokowski and confer his star power upon the distinguished conductor.

Fantasia showcased what turned out to be Mickey's last cinematic triumph. Thanks to the film's periodic re-release in theaters and ready availability on video or DVD, it has rarely been out of the public eye. (The *Apprentice* itself was spruced up electronically and reprised as part of the cartoon feature *Fantasia 2000.*) When the Disney Feature Animation Building at Burbank, designed by architect Robert A. M. Stern, opened in 1994, the entrance was topped by a monumental three-story version of Mickey's sorcerer's hat [211]. Inside the building, the hat doubled as the ceremonial second-floor office of Walt's nephew, Roy E. Disney, then

207. Miguel Covarrubias (1904–57), "Radio Talent," original art for a double-page spread in the May 1938 issue of *Fortune* magazine. Mickey and Donald Duck are depicted in the lower left corner, beneath Dick Tracy and Little Orphan Annie and to the left of Guy Lombardo (who bears a slightly Disneyesque brow). Among the other figures seen here are FDR, Rudy Vallee, Bing Crosby, W. C. Fields, and Shakespeare, grouped clockwise in the lower right above the microphone. Watercolor on illustration board, 15¾ x 24¼ in. National Portrait Gallery, Smithsonian Institution, Washington, D.C.

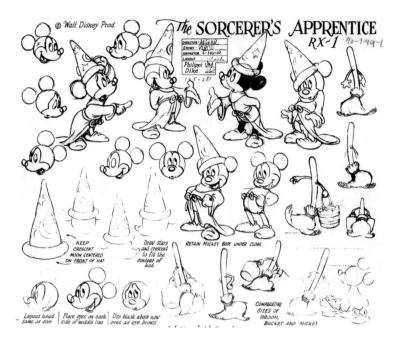

The SORCERER'S APPRENTICE
RX-1

DIRECTOR - ALGAR
STORY - V.P.G.
ANIMATOR - F. Moore
LAYOUT - Ty Wheel
Philippi Ink
Dike
1.15 - 2.87

KEEP
CRESCENT
MOON CENTERED
ON FRONT OF HAT

Draw stars
and crescent
to fit the
contour of
hat.

RETAIN MICKEY BODY UNDER CLOAK

COMPARATIVE
SIZES OF
BROOM,
BUCKET AND MICKEY

Layout head | Place eyes on each | Use black above new
Same as ever | side of middle line | eyes as eye brows.

208. Fred Moore (1911–52), model sheet for "The Sorcerer's Apprentice" segment of *Fantasia* (1940), circa 1938. Courtesy Michael Sporn Animation, Inc., New York. Note in particular the second Mouse head from the top left and the third one in at the bottom, where Moore specifically instructs animators to use the "black" of the stylized crown of Mickey's facial fur "as eye brows." The brows in these two instances are used to express either dread or worry.

209. Covarrubias, "Disney's Light-hearted Ark, Afloat in a Wild World," caricature of Walt Disney with Mickey and other characters, used to illustrate Lydia E. Sherwood, "The Eternal Road Company," *Vogue*, June 15, 1937. Gouache on paper, 13 × 11 in. Library of Congress, Washington, D. C. On the port side of Walt's Ark, behind Pluto are (left to right): Goofy, Clara Cluck, Peter Pig, Horace Horsecollar, and Clarabelle Cow. Used with the permission of María Elena Rico Covarrubias.

president of Disney Feature Animation, who masterminded the making of *Fantasia 2000*. The hat motif was repeated for a structure erected in 2001 at Walt Disney World for the centennial commemoration of Walt's birth [210].[10]

Literally and figuratively, *The Sorcerer's Apprentice* gave Mickey Mouse his most fabulous role [205]. The story boasts a splendid if tiny supporting cast: a glowering Raymond Massey look-alike as the Merlinesque wizard and the self-replicating broom that springs to life through Mickey's misplaced magic. Yet it succeeds mainly because it operates on the universal level of a fable. Mickey's medieval togs, as in *Brave Little Tailor*, give him a timeless premodern look. He utters not a word, and the range of color in the sequence is relatively limited—compared, for instance, to the pastel palette of *The Pastoral Symphony*. All of the action, as in *The Band Concert*, unfolds against a potent musical backdrop. The Mouse also appears with none of the middle-class possessions that had burdened him of late: a house, a pooch, and pesky nephews. He is entirely a kid again, without even Minnie Mouse to distract him.

In "The Sorcerer's Apprentice," Mickey plays a boy whose tasks are simple enough: to fill a cistern with pails of water [212] or sweep dust in the wizard's laboratory. One day, however, he dons the hat of his absent master and pulls off a cool, seemingly harmless trick: commanding the broom to haul the buckets for him. Content in his easy triumph, the apprentice falls asleep, dreaming of more worlds to conquer as he directs the stars, the clouds, and the sea in a grand, cosmic symphony. When he awakes, the cauldron is overflowing and the room is awash in water. The broom no longer bends to his will, so he hacks it apart with an ax [213]. That just multiplies the madness. A horde of new brooms springs to life from the shattered original. Like faceless Storm Troopers, they

210. Structure erected at Walt Disney World for the centenary celebration of Walt's birth, 2001. Image © Barrie Brewer, Barrie Brewer Photography.

211. Robert A. M. Stern (1939–), Disney Feature Animation Building, Burbank, California, inaugurated December 1994. Erected as the Feature Animation Building in Burbank, this structure was re-dedicated in 2010 as the Roy E. Disney Feature Animation Building. Walt Disney Archives, Burbank, California.

descend repeatedly into the submerged chamber, pouring water upon water [214], and the young helper winds up clinging to the sorcerer's book of magic in a swirling vortex of water [215]. Only the return of the sorcerer brings a halt to the mayhem.

The biblical overtones of the story are self-evident. After he puts on the magic cap (Before the Flood, as it were) Mickey tastes from the forbidden Tree of Knowledge, a metaphor implied, perhaps, by the wooden broomsticks. The sorcerer, who parts the waters, then dissipates them completely, resembles an Old Testament God . . . or the prophet Moses. The apprentice might be seen as a sexually innocent, solitary Adam. But, in reality, he is a callow fool, motivated by sloth and fantasies of unlimited, "adult" power, not a full-fledged sinner. In the end, Mickey is neither cast out of Eden nor into the desert. His sole rebuke, as he sheepishly scurries off, à la Chaplin, is a swat on the behind with a broom—a blow to Mickey's self-esteem cushioned for the viewer by a faint smile from the wizard. The moral is clear: know your limitations (or place), and don't mess with stuff you don't fully comprehend.

The lesson is brought home by the terrifying effect of the cloned bucket brigade, the emotional wallop of which undergirds the climactic scene of the 1999 movie directed by Antonio Banderas, *Crazy in Alabama*, which might otherwise seem contrived or frivolous. In that compelling dramatic sequence, the lead character, Lucille (Melanie Griffith), explains in court why she murdered her abusive husband Chester, cut his head off, and took it with her in a hatbox on her picaresque, cross-country travels:

> Well, 'member *Fantasia*, that movie, when Mickey Mouse chops the little . . . the wicked little broom into splinters, and then those splinters they turn into hunerds and hunerds and hunerds of brooms? I was afraid that Chester was going to pull some kind of stunt like that.

Many a child and, like Lucille, not a few adults, must have had a similarly emotional experience viewing *The Sorcerer's Apprentice*.[11]

Mickey's battle with the broom had even grander implications for John Culhane, who, in his monograph on *Fantasia*, proposed a parallel with World War II and the advent of atomic power:

> Like a conflict in some Promethean myth, that war ended with the beginning of the nuclear age—the age in which man, like the Sorcerer's Apprentice, set in motion forces that can be as helpful or destructive as the animated brooms, and, like the brooms, may escape our control. [...] It now seems that *The Sorcerer's Apprentice,* which most people know in the Disney version, is the truest folklore of the nuclear age.[12]

The apprentice in *Fantasia,* as Culhane suggested, is a Promethean over-reacher (much like Faust, Goethe's most famous literary creation), in whose hands knowledge and power unleash a seemingly infinite destructive force. As Mickey, in his reverie, stands on the rocky peak, it is tempting to see him as representative of a nation, still green in many ways, set to take command in a global struggle that would not cease until the genie of atomic energy was released from its terrible lamp.

To Culhane, the *Apprentice* segment in the film suggested one further parallel:

> the Mickey in *The Sorcerer's Apprentice* is Walt Disney at the time of *Fantasia,* having risen in just a few years from conducting a few associates in *The Band Concert* to *becoming* the dreamer on a mountaintop, conducting the stars.

212. Fred Moore (1911–52), rough animation drawing of Mickey as the sorcerer's apprentice in *Fantasia* (detail). Graphite and red pencil on paper, 10 x 12 in. Andreas Deja collection.

213. Storyboard drawing of Mickey chopping the broom to pieces in *Fantasia.* Watercolor on paper, airbrush on celluloid. The Walt Disney Company.

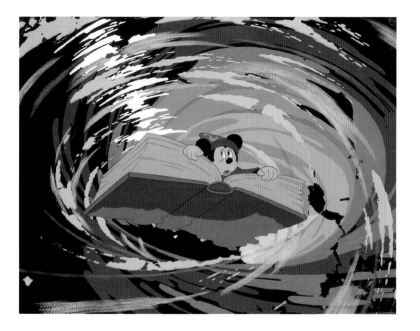

214. Army of brooms pouring water into water in *Fantasia.* The Walt Disney Archives, Burbank, California.

215. Mickey in *Fantasia* clinging to the wizard's book of tricks in a whirlpool of water. The Walt Disney Archives, Burbank, California.

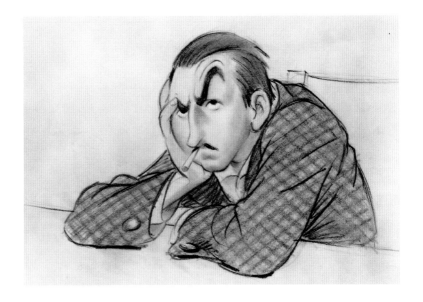

216. Caricature of Walt Disney, circa 1940, attributed to T. Hee. This image was first published in *Walt Disney Presents Fantasia*, a 28-page program for the film, where the caption reads: "The obviously anonymous artist who drew this sketch of the Boss titled it 'I don't like it!' Walt Disney's facial expression is one that his staff frequently sees when he confronts something that is good, but not good enough." Walt Disney Archives, Burbank, California.

217. The sorcerer in *Fantasia*, 1940. Watercolor storyboard panel. Disney Animation Research Library, Glendale, California. Since Bill Tytla (1904–68) was responsible for animating the sorcerer in this scene he might have created this image. It also may have been drawn by Joe Grant or Martin Provensen in the studio's Character Model Department.

So, just as America identified with Mickey Mouse, and the world identified Mickey with America, so Walt Disney's identity was being given "complete control of the earth and its elements"—a dream that resulted in Disneyland, Walt Disney World, and Epcot Center.

Walt's plans, circa 1940, were no doubt grand if not grandiose, but it could be a bit of a stretch to liken him to Mickey in the *Fantasia* dream sequence, directing the stars. After hitting the jackpot with *Snow White*, Disney was regarded by peers and underlings alike as the indomitable chief who, by dint of his own genius, wit, and nerve, built a quality Hollywood studio from scratch, led it through near-death crises, and was expected to guide it to ever greater prosperity in years to come. He might, in fact, more aptly be compared, in the late 1930s, to Mickey's wizardly superior in *The Sorcerer's Apprentice* [219], tellingly named, in comics and merchandising, Yen Sid (a reverse anagram for "Disney"). Indeed, elsewhere in his book on *Fantasia*, Culhane explained that animator Bill Tytla "gave the Sorcerer Walt's raised eyebrow of disapproval when he takes back his magic hat at the end—an expression Walt himself called 'that dirty Disney look.'" A caricature printed in the program for the film [216] captured the arched-brow Disney look that inspired the kindred expression on *Fantasia*'s Yen Sid [217].[13]

*F*antasia opened in New York on, November 13, 1940, at the same Colony Theatre, renamed the Broadway, where *Steamboat Willie* had debuted twelve years earlier, almost exactly to the day. This was fitting for another reason. As Walt noted in an essay published in the *Journal of the Society of Motion Picture Engineers* (January 1941), "The span of twelve years between *Steamboat Willie*, the first Mickey with sound, and *Fantasia*, is the bridge between primitive and modern animated pictures."[14]

In his review in the *New York Times*, the day after the film's premiere,

Bosley Crowther wrote:

> the vital report this morning is that Mr. Disney and his troop of little
> men, together with Leopold Stokowski and the Philadelphia Orchestra
> and a corps of sound engineers, have fashioned with music and color
> and animated figures on a screen a creation so thoroughly delightful
> and exciting in its novelty that one's senses are captivated by it, one's
> imagination is deliciously inspired. In the same fresh, lighthearted spirit
> which has marked all their previous cartoons, Mr. Disney and the boys
> have gone aromping in somewhat more esoteric fields; they have taken
> eight symphonic numbers which are generally reserved for the concert
> halls, let Mr. Stokowski's band record them on multiple soundtracks, and
> have then given them visual accompaniments of vast and spellbinding
> range. In brief, they have merged high-toned music with Disney's
> fantastic imagery.[15]

In January 1942, in an article titled "Leonardo da Disney," in the *New
Republic,* the British political cartoonist Sir David Low (he was knighted
in 1962) said that *Fantasia* "lifts the art of drawing movement right out of
the 'comics' and essays for the first time serious studies of a higher plane."
The film was generally well received by other critics and by the audiences
that saw it (it ran for eleven months at the Broadway Theatre). Despite the
plaudits, however, the costly sound set-up required to create a wrap-around
musical effect, a forerunner of today's stereophonic theater systems, sorely
limited the number of houses able to exhibit the film. And, though the film
made its way to London, in July 1941, most foreign markets—then, as now,
a major revenue source for Disney—were cut off after the Japanese attack
on Pearl Harbor, and *Fantasia* did not turn a profit for a full generation.[16]

As World War II began—and, with it, phase two in Mickey's progress
as a cultural icon—Disney's personal stature remained high. Thomas
Craven, in *Cartoon Cavalcade* (1943), singled out just one master of
animation, "the most famous of living humorists, or the most famous
of living artists, if I may be allowed the expression, Walt Disney." But
Fantasia's unhappy fate, in the immediate, did presage a decline in the
studio's fortunes through the late 1940s, and Mickey's permanent eclipse
at the box office. In 1939 and 1940, five Mouse shorts were produced, as
opposed to fourteen in 1932, during his pre-color heyday. (From 1939
to 1942, eight Duck cartoons were released per year.) Between 1947
and 1953, Disney made just eight Mickeys. From around 1940 until the
Mickey Mouse Club TV show was launched, in 1955, public exposure to
Walt's one-time breadwinner was reduced to performances in a handful
of new cartoons, theatrical reruns of old ones, and an ongoing presence
in newspaper strips, comic books, and merchandising.[17]

218. Screen capture of Pluto being outwitted by a sheet of flypaper in *Playful Pluto*. Norm Ferguson (1902–57) animated Mickey's faithful hound in this scene, which—as evidenced by its inclusion in *Sullivan's Travels*—has been widely hailed as a masterpiece of classic 1930s animation.

This might have sounded the death knell for other Hollywood players. But, for a while at least, Mickey's star still burned bright. In the 1941 Preston Sturges movie, *Sullivan's Travels,* for example, Joel McCrea plays a youthful motion picture director, John L. Sullivan, who is well bred, talented, high-minded. Tired of churning out facile box-office hits, "Sully" decides to use film to examine an issue of "social significance": the suffering of the Common Man. He hits the road disguised as a hobo, seeking real-world experience. After a string of droll misadventures, his quest spirals madly out of control: he's caught hitching a ride on a freight train and is knocked on the head by a guard, giving him amnesia. Unable to say who he is, the young genius is sentenced to hard labor on a chain gang, where, in a swampy purgatory, he's struck by the divine light of Mickey Mouse.

One evening, in a rare respite from their torment, the convicts (mostly white, like Sullivan) are allowed to watch a movie as guests in the church of a rural black congregation. Before the main feature begins, a brilliant, sunburst face of Mickey flashes on the screen, announcing one of his cartoons. Next, we see a hilarious sequence in which Pluto is outwitted by a chest of drawers and some pesky sheets of flypaper [218]. Everyone in the audience, including the prisoners' inflexible overseer, is reduced to gales of laughter. The lesson Sully learns here—an epiphany, really— is delivered at the end of the picture, after his identity is discovered, and he's been freed. In a private plane flying back to California, the director tells his studio bosses and entourage: "There's a lot to be said for making people laugh . . . did you know that's all some people have? It isn't much, but it's better than nothing in this cockeyed caravan—Boy!"[18]

Sullivan's Travels has been compared to the satirical novella *Candide* (each, as *Life* commented in 1942, being "the adventure yarn of a young idealist"). Like Voltaire's eponymous protagonist, Sullivan is good-natured and naïve, but sincere, morally upright, and intellectually curious. In *Candide,* Voltaire's parting wisdom is that one should "cultivate one's garden" and forego grandiloquent metaphysical or theological postulations. The wisdom absorbed from Sullivan's travails is equally direct and commonsensical, though the moral Sully articulates is as much about the medium, the mass appeal of motion pictures, as it is the message, the cathartic power of humor on the bumpy, winding road of life.[19]

It is interesting that the Disney animated short chosen by Sturges to make his point, like *Sullivan's Travels* itself, was in black and white. The cartoon, *Playful Pluto,* dates from 1934, when hopes for many were low and Mickey's appeal was still sky-high. In 1941, when the action in *Sullivan's Travels* takes place, the Second World War would soon push the Depression to the back burner, and Mickey, entering phase two of his iconic saga, was seemingly bound for mass-cult extinction.

219. Gerald Scarfe (1936–), illustration for Anthony Lane's article "Wonderful World," *New Yorker,* Dec. 11, 2006.

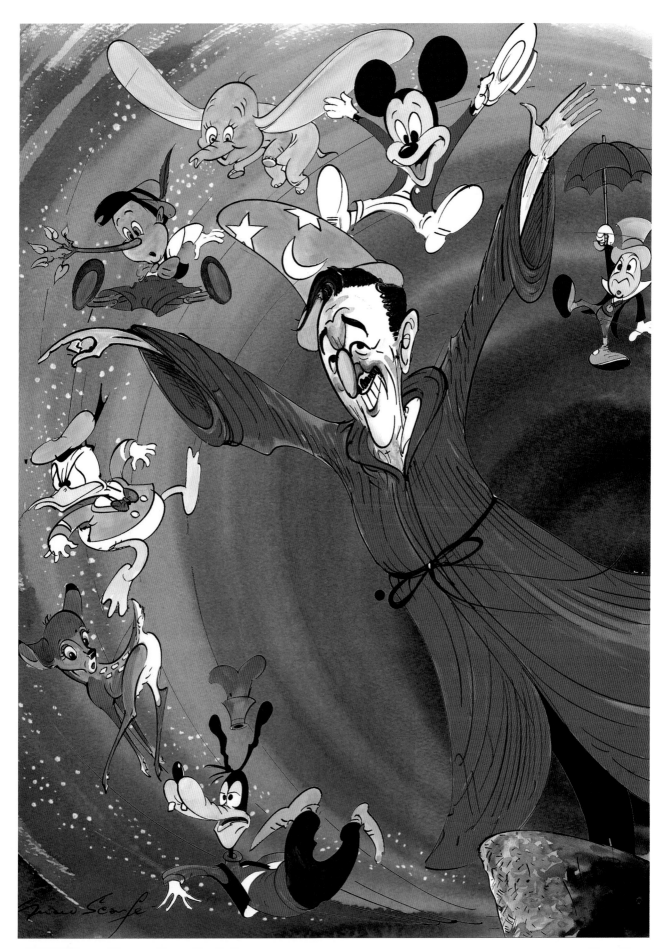

220. British Lancaster Mk III bomber (nicknamed "Mickey the Moocher") with sketch of Mickey Mouse painted on the nose of the craft, painted circa 1940. Courtesy of Ad Vercruijsse.

221. Mickey Mouse on the nose of "Mickey the Moocher," with bombs drawn to indicate the number of missions flown. Courtesy of Ad Vercruijsse.

222. Constantin Alajalov (1900–87) drew the cover art for this Jan. 9, 1943 issue of the *New Yorker*. © Condé Nast.

In the context of Sturges's morality tale, the pre-color Mickey Mouse short *Playful Pluto* inserted in *Sullivan's Travels* is wistful and timeless, a tribute to the ongoing presence of two time-honored friends, Mickey and Pluto . . . and the soothing balm of laughter.[20]

A goodly number of the spectators assembled inside the church in *Sullivan's Travels* had grown up with Mickey Mouse, whose lasting appeal would, for them and the rest of the planet, be proven— or reinforced—in the bloody struggle waged over the next four years by men of Sully's age: the "G.I. Generation." As in the Preston Sturges movie, that attraction might crop up in the least expected of places. For example: a 1943 *New Yorker* cover by Constantin Alajalov, published during the U.S. military campaign in North Africa [222], depicts two off-duty G.I.s, probably in French Morocco, standing before a movie theater plastered with posters for Hollywood films starring the likes of Hopalong Cassidy and Veronica Lake. But the object in this bazaar of American cultural plenty that draws their quizzical attention is a lobby card in Arabic touting the beloved, classic, black-and-white Mickey Mouse, with chipped-button eyes.

Mickey's star image was summoned up in a myriad of ways during World War II, starting in Great Britain, where he and other Disney characters helped boost morale among civilians and servicemen alike. In strictly military terms, as the *New York Times* reported, in April 1941, "This war is producing a new batch of army slang." Royal Navy Motor Minesweepers (MMS) were nicknamed "Mickey Mice," "Mickey Mouses," or "Mickeys." A pattern of black circles against an olive or khaki drab background on British and, later, American military vehicles was "Mickey Mouse ear" camouflage.[21]

In the Royal Air Force, the electrical bomb-release mechanism on certain bomber aircraft was referred to as "a Mickey Mouse" because "it strongly resembles the intricate machinery portrayed in Walt Disney's cartoons." The men who flew one British-built Lancaster Mk III bomber christened it "Mickey the Moocher" (after Cab Calloway's "Minnie the Moocher"). On the plane's nose, a portly Mouse was depicted marching past a signpost pointed toward "3 Reich" and "Berlin," towing a bomb on a trolley; beside the artwork, slash marks in the form of bombs, totaling more than one hundred, announced the number of missions craft and crew had flown [220–221]. Mickey made himself felt in the Pacific theater too. A latter-day governor of Tokyo, whose "anti-American politics were formed" during the war, Shintaro Ishihara, "remembers being strafed 'for fun' by US planes 'with pictures of naked women and Mickey Mouse painted on the fuselage.'"[22]

After Pearl Harbor, and America's formal entry into the war, Mickey

223. Helen McKie (1889–1957), *News Theatre*, Waterloo, 1942. Watercolor on paper, 14¾ x 20¾ in. (sight size). National Railway Museum, York, England. Mickey and Donald Duck are perched atop the ticket booth for a small cinema at one end of the main concourse of the Waterloo train station, which served Southern Railway lines in and out of London. The station had recently reopened after being bombed during the Blitz. This drawing was one of several works by McKie showing Waterloo's main-line train platforms during the war.

and other Disney figures appeared on Civil Defense posters [224] and were adopted—Mickey far less frequently than his fellows—as mascots by U.S. and Allied units. Studio artists generated over a thousand insignia for the several service branches over the course of the war. Walt's characters were stamped on aircraft and vessels much as a pilot or crewman might carry a religious medal to ward off harm. The first request for a Disney design came from an air squadron on the USS *Wasp* in June 1939. But the use of cartoons as American military insignia actually began in the First World War, when a bomber squadron in France asked George McManus for a drawing of Jiggs, the henpecked husband in his comic strip *Bringing Up Father*. In 1930, Oswald the Lucky Rabbit was picked as a logo for a naval air unit . . . and, prompted perhaps by Mickey's role as an amateur aviator in *Plane Crazy,* the first Mickey Mouse—or true Disney— military emblem appeared around October 1931, "probably created by an enterprising airman" at the U.S. Naval Air Reserve Base at Floyd Bennett Field in Brooklyn. Mickey was portrayed on the patch astride a diving goose seen wearing a pilot's cap and goggles, with a trident propped (like a lance) under one wing and a bomb clasped in its webbed feet. Silhouetted behind the flying figures is the Statue of Liberty, which stood across New York harbor from Floyd Bennett Field.[23]

In the 1930s, during the Spanish Civil War, a fighter group in the

German Kondor Legion was called the "Mickey Mouse" squadron because its leader, Nazi air ace Adolph Galland, had adopted Disney's Übermaus as his personal seal and had it emblazoned on each plane in the unit. As a Luftwaffe pilot in World War II, Galland also had the Mouse painted on his Messerschmidt. His Teutonic Mickey boasted a long snout and bowling-ball belly, and brandished a cigar, pistol, and hatchet. Galland's identification with the character likely helped inspire the British writer Len Deighton's novel *Goodbye Mickey Mouse* (1982), about a fictional American Fighter Group based in England during the war. Deighton's title character was an untidy little pilot from Arizona, Mickey Morse, "who'd grown so used to being called Mickey Mouse, or MM, that he'd painted the cartoon on his plane."[24]

Toward the end of the war, in October 1944, Hitler's favorite commando, Otto "Scarface" Skorzeny, mounted "Operation Mickey Mouse," in which Miklós "Miki" Horthy, Jr., son of the regent of Hungary, was kidnapped in a bid to keep the regent from delivering his country to the Soviets. The ultimate tribute to Mickey's wartime exploits, though, did not surface until almost a decade later, eight years after the Nazi regime had been defeated. It was propelled primarily by a passing remark during an hour-long tribute to Disney in February 1953 on the Ed Sullivan television show *Toast of the Town,* followed roughly six months later by a fleeting mention in the *New York Times Magazine,* where it was stated that "'Mickey Mouse' was the password for the troops landing on the Normandy beaches on D-Day." Repeated numerous times over the years, this nifty factoid may be traceable to Walt himself. In a 1947 radio broadcast, Disney declared how "pleased" he was with "the high compliment bestowed" when Mickey's name was selected as "the password for the invasion of France."[25]

Mickey's verifiable ties to D-Day, while less rousing than this, are still extraordinary. A line in Walt's *New York Times* obituary came nearer to the truth of his story from a generation earlier: "On D-Day during World War II Mickey Mouse was the password of Allied Supreme Headquarters in Europe." Before the Normandy invasion, Supreme Headquarters Allied Expeditionary Force, commanded by Eisenhower, established itself outside Portsmouth, in close proximity to where Mickey's most glorious involvement with D-Day occurred. The facts are these, as filed on June 7, 1944, one day after the Allied landings in France, by United Press, published by the *New York Herald Tribune* on June 8:

> LONDON, June 7 (UP)—"Mickey Mouse" played a part in the invasion of northern France, it was revealed today. Naval officers gathering for invasion briefing at [a] southern port approached the sentry at the

224. Walt Disney Studio, "Thousands of Eyes in the Dark/Keep Your Eyes Open, circa 1941–44. Mickey is depicted in this undated poster as a member of the Aircraft Warning Service, a volunteer civilian organization set up in May 1941 under the aegis of the United States Army Ground Observer Corps. Mickey appeared in five other AWS poster according to David Lesjak (*Service With Character*, p. 85). Walt Disney Archives, Burbank, California.

door and furtively whispered into his ear the password of admission: "Mickey Mouse."

The high-ranking officers in question must have gathered at a major Royal Navy base such as Portsmouth—or Plymouth, where United States invasion forces were headquartered—perhaps on May 30, on which date naval support commanders for Canadian army troops on the Isle of Wight were briefed. (British invasion forces were headquartered in Portsmouth and Southampton.)[26]

The United Press dispatch appeared in a number of papers nationwide, including the *Los Angeles Times,* where it had to have caught Walt's attention. A mention of the D-Day report in the *New York Post* in late June, by a writer who interviewed Disney (as he sipped "a scotch-and-soda at '21'"), all but proves that he'd read the story. During a postwar visit to England—Walt and Lillian arrived in Southampton in November 1946—Walt also may have learned of another Mickey

connection to D-Day, involving maps published and issued shortly before the invasion by the Allied naval commander-in-chief, charting "routes to be followed by all outward-bound groups, convoys, and other units." The words "Mickey Mouse Diagrams" actually appear in print on these maps [225]. Like the RAF bomb-release gizmos, to the casual eye they were almost surreally complex.[27]

Obviously, by 1947, three years later, Walt had forgotten some details of the UP wire service story. However, Mickey's several links to what General Eisenhower, on June 2, 1941, called this "great crusade," and the fact that Omaha and Utah Beaches, where the American army landed in Normandy, lay less than ten miles from Isigny, source of the Disney family name, must have profoundly affected Walt. We might add here, too, that Walt and Lillian's house on Woking Way, near the Hyperion Avenue studio, had been designed in the French Normandy style.

Mickey's ties to D-Day likewise illuminate a bittersweet scene in *Saving Private Ryan,* Steven Spielberg's searing film about the assault on Omaha Beach and the days immediately afterward. In the movie, a fearful German soldier, captured by an Army patrol led by Lt. Miller (Tom Hanks), tries to prove his goodwill by telling the Yanks: "I like Americans—'Steamboat Willie'—toot, toot!" Spielberg is known for his love of Disney cartoons (in addition to the Mickey reference in *Indiana Jones and the Last Crusade,* the opening sequence with the giant boulder in *Raiders of the Lost Ark* was inspired by not one but two Scrooge McDuck comics). It is perhaps no coincidence, then, that 1998, the year in which *Private Ryan* was released, was the seventieth anniversary of *Steamboat Willie.*[28]

After the war, the drastic drop in production of Mouse cartoons— with none being made for thirty years after 1953—ought, in E. M. Forster's words, to have doomed him "to oblivion." Adding insult to injury, a name once honored in weekly pledges by tens of thousands of Mickey Mouse Club members in the early '30s, became, in post-war parlance, an insult laced with sarcasm, generally designating, as the *Supplement to the Oxford English Dictionary* put it, "something, small, insignificant, or worthless." Subbing, in 1992, for William Safire as the author of Safire's weekly "On Language" column in the *New York Times Magazine,* Jack Rosenthal mistakenly said that all negative implications of "Mickey Mouse" derive from the "cheap, tacky, schlocky" Mickey Mouse watches of the 1930s. The pejorative use of "Mickey Mouse" in fact originated in the jargon of jazz musicians. In 1958, jazzman-turned-academic Maurice Crane noted that expressions like "a *mickey* or *Mickey Mouse* band" were applied, in the '50s, and earlier, to "the kind of pop band that sounds as if it is playing background for an animated cartoon. Listen to Lawrence Welk, if you will, and discover how apt the

Operation "NEPTUNE" - NAVAL ORDERS.
(SHORT TITLE - ON.)
ON 20. Mickey Mouse Diagrams.
DIAGRAM No. 9

TOP SECRET. CHART Nº N.H.2

Situation at 0600 D + I.

225. "ON 20. Mickey Mouse Diagrams / Diagram No. 9," one of twenty-four charts for Operation Neptune, mapping the routes and planned progress of Allied military convoys crossing the Channel on June 6, 1944, issued by Admiral Sir Bertram Ramsay, Commander in Chief of the Allied Naval Expeditionary Force. At the bottom of the map, very near the coastline, is Isigny, said to be the source of the Disney family name. Isigny is equidistant from the beaches where American troops landed. Portsmouth City Museum, Portsmouth, England.

expression is." These expressions, Crane correctly stated, had "been around almost as long as Mickey Mouse himself." By November 1930, a "Mickey Mouse Orchestra" was providing entertainment at a Dublin department store during the Christmas season. In Dublin again, in 1936, at the Theatre Royal, "many tuneful and humorous items" were performed at a Saturday Mickey Mouse Club matinee by a "Chief Mickey Mouse and his Orchestra," where, behind the players, the sun-ray Mouse face that served as the opening title for all United Artists–released Mouse cartoons starting with *Mickey's Nightmare* in August 1932 could be seen in all its glory.[29]

In the United States at least, the epithet "Mickey Mouse band" was, in all likelihood, a play on the film-industry expression "Mickey Mouse music." The use of the words "Mickey Mouse" as a put-down for unhip musical fare was recorded in the first lexicon of jazz slang published in the jazz monthly *Down Beat* in November 1935. Three years later, in 1938, *Down Beat* further reported that "a strictly 'Mickey Mouse band' is still box office." In 1945, again in *Down Beat,* "Mickey Mouse music" was described as "the tripe" musicians might have to play in order to get a gig.[30]

In 1967, George T. Simon, an editor and critic at *Metronome,* devoted several pages in his book *The Big Bands* to the "Mickey-Mouse Bands," popular from the mid 1930s to the 1950s, that, Simon said, "phrased in an old-fashioned way and blazed few new trails." Among the leaders

of these slightly corny, sweet-sounding bands, were Jan Garber, Horace Heidt, and Harry Friedland, known onstage as Blue Barron. According to Simon, Blue Barron began his career booking the "numerous mickey-mouse bands that infested the Midwest," but "soon posed a serious threat for the Master Mouse title." Blue Barron, for his part, relished the appellation and jested that he was "competing for the title of 'King of the Mickey Mouse bands.'" On a TV show in 1980, Benny Goodman went so far as to label Paul Whiteman "Mickey Mouse."[31]

In an interview with Dave Smith, retired Disney executive Carl Nater said that he first heard the term "Mickey Mouse" used in a negative way during World War II, when an Army auditor (formerly in the movie business) called the studio's bookkeeping "the darnedest system of Mickey Mouse accounting I've ever heard of." During the Korean War, as in the global conflagration preceding it, Mickey's name was generally used in a good-natured way. Puffy, insulated footwear for winter combat, for example, were called "Mickey Mouse boots." But, when a San Francisco newspaper headlined the phrase "Mickey Mouse Army" to describe American troops in Korea that were short on equipment, it was a rather definite sign that the unfavorable connotation of "Mickey Mouse" was spreading from the province of music to that of the armed services, where, by the 1960s, it would be firmly entrenched as a staple of informal speech among soldiers, sailors, and Marines.[32]

Though still a source of fond memories for those who had known him as kids, a generation before, by the 1950s Mickey was in cultural free-fall, reduced to little more than a joke among musicians, hipsters, active-duty military, and veterans. His classic color cartoons of the 1930s and '40s were from time to time still projected as lead-ins to first-run feature films, but he no longer figured significantly in the financial viability of the Disney company. Ironically, it was at almost precisely this point that Walt and Roy severed their fifteen-year connection with RKO, established their own distribution operation, Buena Vista, and, as Edward Jay Epstein said, in *The Big Picture: The New Logic of Money and Power in Hollywood*, "finally became a full-service studio."[33]

In the mid to late 1930s, some critics wondered when the Mouse would fall from grace. In the 1950s, critics began to debate when and why it had happened. In July 1954, in *Saturday Review*, Marshall Fishwick described the early Mickey as a comedic counterpart to Frankenstein's terrible creature:

Big, unwieldy, humorless, destructive, the Monster served as a warning that man might fabricate things that would wrest control from their makers. Mickey, on the other hand, is tiny, agile, funny, and full of

226–227. Screen captures from the opening sequence of the *Mickey Mouse Club*, 1955. Walt Disney Archives, Burbank, California.

compassion. He releases us from the tyranny of things, and from the fear of the very intricacy and impersonality that makes him possible.

Fishwick believed that the "use of Technicolor, a stream-lined torso, and perspective damaged rather than helped" the character, citing a claim in *Life* (the Luce publication, not the humor magazine) that Walt now had "little time for Mickey Mouse who is judged too sweet-tempered for current tastes." Fishwick's line about our release, thanks to Mickey, "from the tyranny of things," was, of course, borrowed from the 1935 *New York Times* essay by L. H. Robbins cited in the preceding chapter. In his *Saturday Review* piece, Fishwick also picked up on Robbins's comparison of the Mouse to the national emblems of America and England when he (Fishwick) declared that

> neither Walt nor anyone else can deprive us of Mickey. Like Uncle Sam or John Bull, the Mouse now has a separate existence off the drawing board. He belongs to those of us who accept him, as well as those who create him; he is public property.[34]

In the summer of 1954, that "separate existence" dwelt primarily in the memories of adults aged twenty-five or older. However, fate soon intervened again, favorably, on Mickey's behalf. In the fall of 1955, the year in which Ray Kroc opened his first McDonald's franchise (in Des Plaines, Illinois), ABC television aired the first one-hour *Mickey Mouse Club* program. The show began with the Club's symbol, a Mickey Mouse happy face inside a circle [226], set against a nocturnal Manhattan skyline, with powerful beacons beaming up toward the heavens. An off-screen voice announced: "Walt Disney and Mickey Mouse present the Mickey Mouse Club," and three junior Mickey look-alikes (modeled after the kids in cartoons like *Orphans' Benefit*) with horns, dressed as circus heralds [227], blew the opening notes of the Mickey Mouse Club march that began with these unforgettable words:

> Who's the leader of the club
> That's made for you and me?
> M-I-C K-E-Y M-O-U-S-E!

In varying attire—changing, based on the day of the week, from cowboy to sorcerer to 1890s dandy in striped jacket, straw boater, and cane—the leader appeared on stage and greeted viewers with a chirpy "Hi, Mouseketeers!" After Mickey's intro came the main body of the program: a potpourri of live-action serial adventures, vintage Disney cartoons, travelogues, newsreels, reports on Disneyland or other studio projects,

and musical byplay among adult hosts Jimmie Dodd and Roy Williams and a dozen juvenile Mouseketeers. Much of the Club's success, though, had nothing to do with Mickey: a big factor was perky Annette Funicello, the most popular, and (for some) appealing, of the Mouseketeers [229].[35]

Like the 1930s Saturday matinee phenomenon, the televised *Mickey Mouse Club* fueled tons of collateral merchandising, from school supplies and Mouse-ear hats to toy guitars . . . all bearing Mickey's imprimatur. Revived and revamped for the television age, the 1950s *Mickey Mouse Club* was, as one writer has since remarked, "a celebration of the upbeat side of postwar America: contemporary optimism and economic abundance infused with Disney's nostalgia for the mythical good-old days." The *Club* remained on the air through September 1959, giving Mickey a new lease on life with a younger generation.[36]

The broader impact of Mickey's resurrection was illustrated in February 1959, when a significant breakthrough in computer science was announced. Since 1956, a twenty-something engineer, Douglas T. Ross, had led a research group at the Electronic Systems Laboratory of the Massachusetts Institute of Technology, whose mission was the creation of a computer code for the Air Force that could describe "how parts are to be produced by a numerically controlled machine tool"—in other words, a code for the computerized, precision manufacture of three-dimensional objects. Ross and colleagues called the language they were asked to develop "APT," for "Automatically Programmed Tools." APT is one of the most important programs in the history of computer technology and one of a select few of the earliest ones still in use (antedated chiefly by FORTRAN). The first item successfully produced using APT was an aluminum ashtray. As an added kicker for the public unveiling of APT, the Air Force asked Ross to write a second computer program for demonstration purposes. APT, the ashtray, and the new program were to be presented at a televised press conference on February 25, 1959.[37]

As he racked his brain to devise a new, readily recognizable design for the demo, Ross turned to a two-dollar Mattel Mousegetar-Jr. belonging to one of his preteen daughters that was "well beat up because it was well loved." Mickey's face, the logo of the Mickey Mouse Club, appeared on the top of the guitar's body, his round black ears jutting up and out from either side of the neck of the instrument [228]. Farther down on the soundboard was a smaller picture of Mickey, baton in hand, leading his two nephews and Pluto in song. Ross passed on the more dominant face of Mickey in favor of one of the nephews ("the profile was better!" he said). Ross's program, based on this image, defined by a set of seven overlapping circles, became a standard test for the APT system. Thus, Mickey Mouse and his nephew(s) helped publicize the earliest computer-generated objet

228. Mattel Mousegetar-Jr., 1955. 14 inches high. Hakes Americana, York, Pennsylvania.

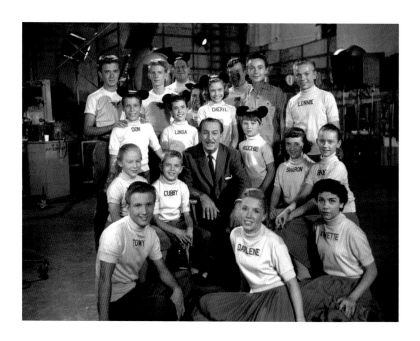

229. Walt with the original Mouseketeers, 1955. Annette Funicello is seated in the foreground, on the far right. Walt Disney Archives, Burbank, California.

d'art and APT, a program that was a forerunner of Adobe Illustrator and other graphic software we now take for granted.[38]

It is ironic that a technological breakthrough of this magnitude was so intimately connected to a TV show which, like its emblem, the kinder, gentler Mickey of circa 1940–1950, was often perceived as borderline bland. The audience for the *Mickey Mouse Club* was composed chiefly of white, middle-class preteens and teenagers. Many of the boys who watched the show would, of course, grow up to volunteer or be drafted to serve in Vietnam. In his book *The Long Gray Line: The American Journey of West Point's Class of 1966,* Pulitzer Prize–winning journalist Rick Atkinson noted that the shavetail lieutenants commissioned at the Academy that year were "sons of the 1950s." "Had they been asked," Atkinson added, "they collectively could have belted out the theme songs to the *Mickey Mouse Club* or the *Davy Crockett* show." The *Mouse Club* was fixed in the minds of enlisted men in the Vietnam era, too. "Mickey Mouse," as we shall see, was a vivid and repeated motif in *The Short-Timers* (1979), a searing first novel by Gustav Hasford, who'd been a writer for the military newspaper *Stars and Stripes* and a grunt with the First Marine Division, headquartered in Danang.[39]

The expression "Mickey Mouse," current since at least 1935 as a put-down in the world of jazz, had occasionally also been used to suggest things that were fanciful, unreal, or evil, as in a letter by George Orwell from 1936, warning against moving "away from the ordinary world into a sort of Mickey Mouse universe where things and people don't have to obey the rules of space and time."[40]

In his 1935 novel, *It Can't Happen Here* [230], Sinclair Lewis vented his fear of a fascist take-over of the country, enabled by the dullness of John Q. Public and the babbittry of institutions like the Rotary Club in

fictional Fort Beulah, Vermont, the locale for most of the book's action. Lewis's tale begins at a Club's Ladies' Night Dinner where the tables "were bright with candles, cut-glass dishes of candy and slightly tough almonds, figurines of Mickey Mouse, brass Rotary wheels, and small silk American flags stuck in gilded hard-boiled eggs." There is, of course, a coup d'état, carried out by home-grown Storm Troopers called Minute Men or M.M.s, mockingly referred to as "Mickey Mouses" or "Minnies" by their liberal and leftist adversaries, including the novel's hero, Fort Beulah's resident curmudgeon and newspaper editor, Doremus Jessup.[41]

In the late 1950s and into the '60s and '70s, the pejorative use of "Mickey Mouse" became commonplace. In 1963, any assignment "regarded as foolish and a waste of time" by students at University of Kansas was derided as "a *Mickey Mouse*." In 1958, a Michigan State professor noted that a "'Mickey Mouse course' means a *snap* course, or what Princeton undergraduates in my day called a gut course"; at Berkeley in the 1970s, "easy classes were condescendingly labeled 'micks.'" And in 1966, Mrs. Lyndon (Lady Bird) Johnson pooh-poohed an event she'd been obliged to attend as First Lady as "Mickey Mouse," or "not quite the sophisticated thing to do any more."[42]

In the epic 1968 football game in which Harvard battled Yale to a miraculous, come-from-behind tie, the Yale band razzed its rival at half-time with the "Mickey Mouse Club March." But it was in the Vietnam period, especially among the young adults who'd grown up with the *Mickey Mouse Club*, that the expression "Mickey Mouse" took on a widespread negative connotation. (That particular usage may be going the way of the Edsel, in America anyway, where the offspring of the Boomer generation now belittle things their parents might call "Mickey Mouse" with language like "lame" and "sucks.")[43]

Though it had been a derogatory term in the military for a while, it was not until well into the Vietnam war that someone in authority tackled the root cause of that which was "Mickey Mouse." In 1970, the chief of naval operations, Admiral Elmo R. Zumwalt, promulgated one of his patented, service-wide memos known as "Z-Grams," aimed at loosening the petty, uptight restrictions that undermined morale of sailors and Marines. Paragraph one of Z-Gram #57, initially titled "Elimination of Mickey Mouse," but officially circulated as "Elimination of Demeaning or Abrasive Regulations," read:

> Those demeaning or abrasive regulations generally referred to in the Fleet as "Mickey Mouse" or "Chicken" regs have, in my judgment done almost as much to cause dissatisfaction among our personnel as have extended family separation and low pay scales.[44]

230. Federal Theater Division, Works Progress Administration, poster for a theatrical version of the Sinclair Lewis novel *It Can't Happen Here* staged in Iowa, 1936. Library of Congress, Washington, D.C.

231. New Jersey Devils fans taunting Edmonton Oilers star Wayne Gretzky, East Rutherford, New Jersey, Jan. 15, 1984. AP Images.

In an op-ed piece written for the *New York Times* several years later, Zumwalt recalled the circumstances and results of his directive:

> To many Navy men, the term "Mickey Mouse" sometimes means laughter—but not at a cartoon character. Sometimes it isn't a laughing matter. Who doesn't know that unnecessary or demeaning regulations are "Mickey Mouse"?

"Navy's Mickey Mouse," Zumwalt went on to say,

> was very impressive before World War II. [...] But the war nearly killed the creature. Millions of citizen-soldiers [...] disregarded the cheese—or was it cheesiness?—that fed the beast: they used common sense. By 1945, Mickey Mouse had deteriorated from dragon to—well, insect-size.
>
> Then, slowly, over the years Mickey Mouse recovered. His basic rations—excessive regulations—proliferated. By 1970, sailors were leaving the naval service in ever-increasing numbers at the end of their first four-year cruise; almost as much as the very unpopular Vietnam War, Mickey Mouse contributed to 1970's all-time historic low in re-enlistments—9.5 percent.
>
> Like Navy knights before me, I set out in 1970 with a mighty sword and a worthy following to slay Mickey Mouse. A memorandum was fashioned, in all its beauty, proclaiming throughout Navy's Camelot an intention to do battle with the dragon-sized rodent and declaring it unwanted. [...] We smote the foe hearty blows! Mickey Mouse, wounded, retreated. But no doubt he still lives somewhere. Hidden.[45]

"Mickey Mouse" mentalities and rules do still abound. As a mode of derision, the term has been used countless times over the last thirty years or so. In 1974, an acerbic critique of the Disney company in *Playboy* by D. Keith Mano was titled "A Real Mickey Mouse Operation." In Francis Ford Coppola's film *The Godfather II,* also 1974, the weakest of Don Corleone's three sons, Fredo (played by John Cazale), tells brother Michael (Al Pacino), the family's boss, why he had betrayed him to a rival Mafia clan. He did so, Fredo explains, because he was never allowed to do much more than "take care of some Mickey Mouse nightclub somewhere." In 1984, hockey great Wayne Gretzky, of the Edmonton Oilers, belittled the New Jersey Devils as a "Mickey Mouse Operation on ice," drawing howls from the team's loyal supporters [231], and in 1988, in a speech before an American Legion convention in Kentucky, President Reagan rhetorically asked:

> After eight hard years rebuilding America's strength do we really want to

return to a Disneyland defense policy—with Mickey Mouse treatment of our men and women in uniform; Goofy strategic plans; and Donald Duck–like lecturers telling us that whatever goes wrong is our own blankety-blank fault?[46]

From the 1960s into the 1980s, references like these played off mental images of Mickey's association with the *Mickey Mouse Club*, the clean-cut kids who were his acolytes (the Mouseketeers), and the preternaturally pleasant, trash-free zone that is Disneyland. The Mouse of yore, the lively star of *Steamboat Willie*, the *Brave Little Tailor*, and *The Sorcerer's Apprentice*, had by then been all but forgotten.

All too often, Mickey has served as a facile trope—a happy-faced, G-rated obscenity—to describe people, places, and institutions as boring or uncool. The downward arc leading to this point in his "career" was described by John Updike, who, as a teenager, aspired to work for Walt as a cartoonist. "To the movie audiences of the early Thirties," Updike observed in 1991, Mickey had been

> a piping-voiced live wire, the latest thing in entertainment; by the time of the Sorcerer's Apprentice episode of *Fantasia* he was already a somewhat sentimental figure, welcomed back. *The Mickey Mouse Club,* with its slightly melancholy pack-leader Jimmie Dodd, created a Mickey more removed and marginal than in his first incarnation. The generation that watched it grew up into the rebels of the Sixties, to whom Mickey became camp, a symbol of U.S. cultural fast food, with a touch of the old rodent raffishness.

The Mouse, Updike further noted, "remains one of the Thirties proletariat, not uncomfortable in the cartoon-rickety, cheerfully verminous crash pads of the counterculture." However, in Updike's view, Mickey was in grave danger of a more dire form of marginalization:

> At the Florida [232] and California theme parks, Mickey manifests himself as a short real person wearing an awkward giant head, costumed as a ringmaster; he is in a danger, in these Nineties, of seeming not merely venerable kitsch but part of the great trash problem, one more piece of visual litter being moved back and forth by the bulldozers of consumerism.[47]

In short, Mickey risked—and, truth be told, still runs the risk of—drowning in the mile-high pile of cultural clutter that he and his master, Walt Disney, unwittingly, helped create: a peculiarly American breed of mass entertainment wedded to the stultifying demands of marketing.[48]

232. Mickey and Minnie in front of Cinderella Castle at Walt Disney World, Orlando, Florida. © Barrie Brewer, Barrie Brewer Photography.

Maurice Sendak '78

IN THE TEMPLE
OF HIGH ART

The "piping-voiced" prole cherished as a boy by John Updike also appealed to Maurice Sendak, author-illustrator of the well-known children's book *Where the Wild Things Are,* whose adventurous and mischievous central character, Max, was partially inspired by the spunky disposition of Mickey Mouse. Like Mickey, Sendak was born in 1928 and, on the occasion of their shared fiftieth birthday, he wrote an article for *TV Guide,* "Growing Up With Mickey," accompanied by a drawing in which he portrayed himself waving into a full-length mirror at his coeval, who waves back from the spot in the glass where Sendak's reflection ought to be [233]. "Though I wasn't aware of it at the time," Sendak confessed:

> I now know that a good deal of my pleasure in Mickey—a rich, sensual pleasure—had to do with his bizarre but gratifying proportions, the great rounded head extended still farther by those black saucer ears, the black trunk fitting snugly into ballooning red shorts, the tiny legs stuffed into delicious doughy yellow shoes. The giant white gloves, yellow buttons, pie-cut eyes, and bewitching grin were the delectable finishing touches. I am describing, of course, the Mickey of early color cartoons (his first being "The Band Concert" of 1935). The black-and-white Mickey of the late '20s and early '30s had a wilder, rattier look. The golden age of Mickey for me is that of the middle '30s. An ingenious shape, fashioned primarily to facilitate the needs of the animator, he exuded a wonderful sense of physical satisfaction and pleasure—a piece of art that powerfully affected and stimulated the imagination.

The esthete in Sendak savored the red-and-yellow-accented Mouse—in his classic, color-cartoon incarnation—as a sensually "gratifying" form. However, it was the "wilder, rattier" Mickey Mouse in black and white,

233. Maurice Sendak (1928–2012), self-portrait waving at Mickey Mouse in a mirror, September or October, 1978. Illustration for Sendak's article "Growing Up with Mickey," *TV Guide,* Nov. 11, 1978. Tempera and brush, 6 x 4½ in. Private collection.

234. Diego Rivera (1886–1957), first page of manuscript, "Mickey Mouse and American Art," on Barbizon-Plaza stationery, circa January 1932. © 2013 Banco de México Diego Rivera Frida Kahlo Museums Trust, Mexico, D.F. / Artists Rights Society (ARS), New York. Walt Disney Family Foundation, San Francisco, California.

rated by Creighton Peet in 1931 as "something of a high climax in the cinematic art—yes, art," that was first esteemed in the sphere of high art.[1]

In February 1932, the internationally acclaimed Mexican mural painter, and dedicated Marxist, Diego Rivera published a 600-word essay, "Mickey Mouse and American Art" [234], in a cultural quarterly, *Contact,* edited by the poet William Carlos Williams. "If we look at the characteristics of the animated cartoons which are shown in the movies," Rivera wrote, "we find them to be of the purest and most definitive graphic style, of the greatest efficacy as social products, drawings joyous and simple that make the masses of tired men and women rest, make the children laugh till they are weary and ready for sleep, and will let the grown-ups rest undisturbed." In the concluding lines of his brief text, Rivera predicted that if the sum total of current motion picture production ("which according to Mr. Eisenstein is the only art of today!") were preserved for future generations, the

> masses which will have realized by then the genuine revolution, will not interest themselves greatly in the "revolutionary films" of today. And all that, together with the pictures and statues and poetry and prose which may have survived the general cleansing of the world, will be looked at with compassionate curiosity. But probably the animated cartoons will divert the adults then as now and make the children die laughing.
>
> And the esthetes of that day will find that MICKEY MOUSE was one of the genuine heroes of American art in the first half of the 20th Century, in the calendar anterior to the world revolution.[2]

Supposing Rivera's spirit could be channeled from the great beyond, he would, presumably, be gratified to learn that his prediction held true. Movies and their littler siblings, television and video (in its many guises), are, if not "the only art of today," the dominant artforms in the twenty-first century. And the masses could care less about Depression-era "revolutionary films." Diego might be pleased, as well, to learn that "one of the genuine heroes of American art" remains a monarch of pop culture—even if, from a collectivist perspective, he'd likely lament that Mickey had been co-opted by a profit-centered corporate world.

Rivera's article ends abruptly, with no real discussion of the character. We may never know what else, if anything, he might have had to say about "Mickey Mouse and American Art," or, for that matter, Walt Disney, with whom Diego was seen at the opening of a chic Mexico City nightclub in 1942, in the company of Mexican-born film star Dolores

235. Press photo of Diego Rivera and
Dolores del Rio (1905–83) conversing with
Walt Disney at the opening in Mexico City
of Ciro's, a nightclub in the Hotel Reforma,
December 1942. Courtesy Michael Barrier.

del Rio [235]. Still, something was in the air, circa 1932, in terms of
interest in Mickey and his creator amongst progressives, leftists, and
cognoscenti in the U.S. and Europe.[3]

It all may have begun in Germany, where, as we know, Mickey had
figured as a sign of popular taste in three motion pictures in 1930–1931.
In Berlin in 1931, after a three-way conversation that included Kurt
Weill, composer of the *Three-Penny Opera,* the Marxist philosopher
and analyst of material culture, Walter Benjamin, jotted down these
reflections in his notebook:

> Mickey Mouse proves that a creature can still survive even when it has
> thrown off all resemblance to a human being. [...]
>
> [...] All Mickey Mouse films are founded on the motif of leaving
> home in order to learn what fear is.
>
> So the explanation for the huge popularity of these films is not
> mechanization, their form; nor is it a misunderstanding. It is simply the
> fact that the public recognizes its own life in them.

In the original draft of his influential essay "The Work of Art in the Age
of Mechanical Reproduction," Benjamin included a brief section, titled
"Micky-Maus," which was eliminated when the essay was first published
in 1936. In the passage that was dropped (written in 1933), Benjamin
said that Mickey's cartoons were "full of miracles—miracles that not
only surpass the wonders of technology, but make fun of them." Those
words are of a piece with contemporaneous statements by Diego Rivera,
that cartoons were diversions that "make the masses of tired men
and women rest," and Disney himself (in far plainer language) in his
interview with Harry Carr, that Mickey Mouse was just "a little fellow
trying to do the best he could."[4]

In February 1931, at about the time Walter Benjamin first recorded
his thoughts about Mickey, the Soviet film director, Sergei Eisenstein—
whom Benjamin, like Rivera, admired—was quoted by *Time* magazine

(and, ten months later, by Gilbert Seldes) as saying that Walt's cartoons were "America's most original contribution to culture." Remarks like these, from Benjamin and Eisenstein, surely reflect a convergent sentiment regarding Disney among avant-garde European intellectuals during the early stages of the Depression.[5]

Meanwhile, back in the United States, where Diego, the muralist, was trying to establish himself, the buzz intensified, as the world of High Art opened its doors to Disney and Mickey. In a squib in its November 1, 1932, issue, *Art Digest,* Walt's most potent advocate in serious art circles, drew attention to an exhibit then underway in the City of Brotherly Love:

> Walt Disney, creator of the internationally known "Mickey Mouse,"
> is receiving his first recognition from an art organization at the Art
> Alliance in Philadelphia, where drawings from his "Silly Symphonies"
> and the antics of "Mickey Mouse" are being shown until November 6.

Citing commentary from an article in the *Philadelphia Public Ledger* by Dorothy Grafly, *Art Digest* reported that her take on Mickey echoed that of the radical German painter and graphic satirist Georg Grosz, then a guest instructor at the Art Students League in New York. Seconding the opinions of Eisenstein and Rivera, Grosz declared Mickey to be "art in every sense." Grafly, in the excerpt of her article reprinted by *Art Digest,* took that statement a step further:

> Whimsy, so largely lacking in the too-serious selfconscious art of the
> day, is given back to us through the medium of the animated cartoon.
> Perhaps because the cartoon was not considered art, it was free to chart
> its own course; to flit where fancy might lead it. As a result we have
> witnessed the birth of an American art, something that has yet to be
> given us in the realm of paint.

Such talk, deliberately or not, conformed with Seldes' belief that popular culture can be a dynamic, praiseworthy expression of our national character.[6]

In December 1932, Mickey made his physical debut in a work of so-called High Art when he appeared as a detail in one of eight mural paintings in a cycle called *The Arts of Life in America* by Thomas Hart Benton. The murals were commissioned to decorate the walls of the reading room of the Whitney Museum of American Art at its original home in lower Manhattan. Mickey's inclusion in this series of eight canvases indicates that Benton, soon to be hailed as the head of a nascent American Regionalist school, was on the same page with Diego Rivera

and Dorothy Grafly in viewing Mickey Mouse as an artistic extension of the American spirit.[7]

The Whitney murals were unveiled a month after the Disney show in Philadelphia closed. Custom-fitted to the dimensions of the library, the panels vary greatly in shape and scale. The four largest ones represent pastimes associated with the South, the West, a Great Plains Indian camp, and a big city. The most imposing of the four, *Arts of the City* [236], filled the irregular area around the only windows in the room, and was flanked on the adjoining walls by *Arts of the South* and *Arts of the West*. A frieze of three lesser panels ran beneath the ceiling in the narrow band of space above these three designs. The fourth of the larger tableaux, *Indian Arts*, faced the *Arts of the City* from the side of the room where the door was located. *Indian Arts* was crowned by the eighth and last panel in the cycle: a lunette that, at first blush, seems totally at odds with the others. This is *Political Business and Intellectual Ballyhoo* [237], a satirical scene in which Mickey Mouse, the personification of the new "American art," animation, and of cartoon art in general, plus four familiar comic-strip figures from the nation's newspapers, all play a role.[8]

In a brochure published by the Whitney, Benton described what he felt he'd accomplished in *Arts of Life in America*:

> The subject-matter of this Whitney Museum wall painting is named "The Arts of Life in America" in contrast to those specialized arts which the museum harbors and which are the outcome of special conditioning and professional direction. [. . .] The Arts of Life are the popular arts and are generally undisciplined. They run into pure unreflective play. People indulge in personal display, they drink, sing, dance, pitch horse shoes, get religion, and even set up opinions as the spirit moves them.
>
> These popular outpourings have a sort of pulse, a go and come, a rhythm and all are expressions—indirectly, assertions of value. They are undisciplined, uncritical, and generally deficient in technical means, but they are Arts just the same. They fit the definition of Art as "objectification of emotion" quite as well as more cultivated forms.[9]

236. Benton, *Arts of the City*, panel in the mural series *The Arts of Life in America*, 1932. Egg tempera with oil glaze on canvas. © T. H. Benton and R. P. Benton Testamentary Trusts, UMB Bank Trustee. New Britain Museum of American Art, New Britain, Connecticut.

The phrase "objectification of emotion," used by Benton as a defining term for "Art," enjoyed a certain vogue in elitist discourse of the first decades of the century. Here it is tinged with irony or sarcasm since among the "popular outpourings" visualized in *Arts of the City*—the centerpiece of the cycle—deemed by Benton as worthy as anything "the museum harbors," are images of boys reading the funnies, couples dancing to jazz in a nightclub, a musical radio broadcast, and at least one lady of easy virtue.[10]

Tom Benton's subject matter is, in short, anything but elitist. The four larger panels, and the blatantly satirical *Political Business and Intellectual Ballyhoo*, are essentially Realist, egalitarian, uncouth . . . in tune with Gilbert Seldes's assessment, expressed in *The 7 Lively Arts*, that the "simple practitioners and simple admirers" of the minor arts were preserving "a sure instinct for what is artistic in America." In rather

more caustic language, *New York Sun* art critic Henry McBride called the *Arts of Life in America* cycle "pure 'tabloid,'" adding that it would "rejoice the souls of those restless illiterates who 'march on Washington,' bomb judges, and otherwise annoy the government."[11]

Benton may even have lifted one word in the title of *Political Business and Intellectual Ballyhoo* from the name of a recently launched, rowdy publication called *Ballyhoo,* which, according to Thomas Craven, produced more "belly laughs" than "any other magazine of the time." Craven's comment appeared in his book *Cartoon Cavalcade* (1943), in which he affirmed that "in the growth of the American spirit, and its richest concomitant—a sense of humor—the quality of irreverence has played a conspicuous role." Humor and irreverence, Craven said, were traits also found "in our best painters," most especially his longtime friend Benton, "who thumbs his nose at cheesecloth goddesses and classical heroics."[12]

What sets *Political Business and Intellectual Ballyhoo* apart from the other Whitney panels is its derisive content. It is a kind of cartoon in paint that makes light of arbiters of political, social, and cultural values with little or no feel for what Seldes termed the "lively," and Benton, the "popular," arts. The chief "political" element of *Political Business and Intellectual Ballyhoo* is a broomstick/scarecrow in a top hat, posed on a base inscribed with burlesque ad lingo: "DON'T BE A TRILIUM / THEY CALL IT HALITOSIS / 5 OUT OF 6 HAVE IT!" Next to the broom, a symbol of reform (as in "sweep the rascals out!"), are two phrases, "We the Representatives of the People" and "We nominate Ed." A rainbow behind the broom evokes the gaudy promises of politicians.

The "intellectual" element involves caricatures of three men spouting bromides like "The hour is at hand" and "You don't know the half of it, dearie." They are, from right to left, Bruce Bliven and Oswald Garrison Villard, editors of *The New Republic* and *The Nation,* and Mike Gold, editor of *The New Masses,* a now-defunct Communist monthly. All three were respected journals in political circles that Benton frequented in New York and among progressive provincials like the fictional protagonist in Sinclair Lewis's novel *It Can't Happen Here,* Doremus Jessup, who subscribed to them all and was personally acquainted with Villard and Gold.[13]

From a megaphone clutched in its talons, the American eagle pours a stream of golden "ballyhoo" down on the political straw man and the posturing intellectuals . . . like an avenging angel dumping their own blather back on their heads. At the bottom of the panel is a seemingly innocuous phrase "Oh, the eagles they fly high in Mo-bile," from a bawdy World War I era song, which included the line (not in the picture) "And they shit right in your eye" (which is what, metaphorically speaking, the eagle is doing to these self-important editors).[14]

Beneath the winged emblem of liberty are five familiar faces from the domain of mass culture: Mutt and Jeff, the Captain from *The Captain and the Kids* (and its parent strip, *The Katzenjammer Kids,* which continued to run until 1949), Andy Gump, and Mickey Mouse. *Mutt and Jeff* was the longest-running comic strip in the country in 1932. The Captain, a hapless foil to the devilish Kids, had been a beloved figure in the comics for three decades, and Andy Gump of *The Gumps* had been a popular comic page fixture since 1919. Mickey was a relative newcomer to this cartoon constellation, but, by 1932, he, too, had his own syndicated newspaper strip.[15]

Henry Adams, the leading Thomas Hart Benton scholar, has observed that Benton found in Mickey Mouse and his comic-strip cousins a direct connection to the average person. Tom Craven struck a similar chord in

Cartoon Cavalcade when, with Disney and the nation's print cartoonists in mind, he said:

> Their work has this in common with art—any art, all art, high or low; it is the natural outgrowth of a living culture; as native to the U.S.A. as corn liquor and Coca-Cola, just as Italian art was as native to the peninsula as red wine and spaghetti.

Craven likewise remarked in *Cartoon Cavalcade* that Mutt and Jeff in particular

> never do anything decent or edifying; they have all the instincts of knaves and none of the talent—yet they are more widely known than Sherlock Holmes, and have almost as many followers as Mickey Mouse. [...] Whatever else the two rogues may be, they are characters, perhaps the most completely realized individuals in the crowded world of native comedy. They run true to form, and hold their public not by any single act of low-lived audacity, but by the constant pressure of their humorous personalities. In this they resemble Charlie Chaplin, or the Chaplin of the old days, before he was burdened with a social message.

Thomas Craven also felt that comic-strip masters like Bud Fisher, who created Mutt and Jeff, George Herriman (*Krazy Kat*), and Rudolph Dirks *(The Captain and the Kids)* all fashioned "an art of and for the people."[16]

Half a century later, in his book *Comics as Culture,* M. Thomas Inge said of Andy Gump, one of the five cartoon characters represented in *Political Business and Intellectual Ballyhoo,* that Andy and the Gump family, drawn by Sidney Smith, inhabited a "safe Midwestern world." The Midwest—the nation's heartland—was, as the famed sociologists Robert and Helen Lynd put it in 1929, in their now-classic tome *Middletown: A Study in Modern American Culture,* the "common-denominator of America."[17]

Like Walt Disney, all three men who drew the strips featured in *Political Business and Intellectual Ballyhoo* had ties to the heartland, often viewed as the seat of bedrock societal values—and to Illinois specifically. Dirks and Fisher were from Chicago, Sidney Smith was born in Bloomington. This had to have appealed to Benton, a proud son of the Show-Me State, who would win renown in the mid '30s, along with his fellows of the "Regionalist Triumvirate": Grant Wood from Iowa, whose iconic image of dour, "straight-laced" Midwesterners, *American Gothic,* has been touted as "the best known American painting," and

238–239. John Steuart Curry (1897–1946), *Tragedy* and *Comedy*, 1934. Egg tempera fresco, 180 × 90 in. each. Kings Highway Elementary School, Westport, Conn. Perched on the railing in the balcony on the upper right in *Comedy* is a kewpie doll next to its creator, Rose O'Neill, a Westport neighbor and friend of Curry and his wife. Courtesy of Westport Schools Permanent Art Collection, photograph by George Adams.

Two small oil sketches for *Tragedy* and *Comedy* were bequeathed by Curry's widow to the Marianna Kistler Beach Museum of Art at Kansas State University. Mickey's head in *Comedy* was surely inspired by the large relief figure of the Mouse in Edward Steichen's photograph of Disney reproduced on p. 102 in this book. The photo was published in *Vanity Fair* in October 1933, less than a year before Curry began work on this project.

John Steuart Curry, a Kansan who, two years after Benton first did so, put Mickey Mouse and other cartoon figures into a mural of his own.[18]

In 1934, Curry painted two frescoes, *Tragedy* and *Comedy*, on the walls of a school auditorium in his adopted hometown, Westport, Connecticut. *Tragedy* [238] depicts a theater stage packed with fabled figures like Lady Macbeth, Hamlet (embodied by John Barrymore), Uncle Tom and Pagliacci, both grieving as Little Eva (from *Uncle Tom's Cabin*) ascends to heaven. High above the other performers, a trapeze artist, falling to her death, evokes the fate of Lillian Leitzel, a renowned aerialist.[19]

The action in *Comedy* [239] is set in a movie house where an image of Chaplin's Little Tramp flashes on the screen. In the audience are Peter Rabbit, Mutt and Jeff, Olive Oyl and Popeye, and a Kewpie doll, perched in a loge next to its creator, Rose O'Neill. Beneath Chaplin's flickering form we see the comedy teams of Olsen and Johnson and Amos 'n Andy, dance duo Irene and Vernon Castle, and a line of Ziegfeld girls. Lower down, closer to the eye of the beholder are Will Rogers, Nick Bottom from *Midsummer Night's Dream*, and a trio of circus clowns. With pride of place, Mickey Mouse strides across the stage at the base of the mural, capturing the attention of Curry and his spouse, standing at the edges of the drawn curtains.[20]

John Steuart Curry and Thomas Hart Benton first crossed paths in 1926, and remained friends till Curry's death in 1946. His passing prompted Benton to pen an essay in which he remembered their initial meeting, at a time, Benton said, when

> painting in and around New York was a scrambling imitation of the new schools of Paris. Everybody was trying to swallow the "modernism" of the boulevards.
>
> I found that John was as dissatisfied with that as I had come to be. [...] I found that John's Middle Western Americanism coincided with my own outlook. He was offended by the satellite condition of American painting and by the denial of value to the particularities of American experience and expression which followed therefrom.

"We admired," Benton added

> the new Mexican school rising then into the public notice. Its indigenous flavor made us jealous of our own land. We found ourselves sharing a suspicion about the new Russian phase of man's ancient utopian dream some of the new Mexicans advocated and which was also much agitated among left-wing artists in New York. [...][21]

Mrs. Brooke Peters Church, of the committee that supervised Curry's

Westport commission, described *Comedy* and *Tragedy* as seemingly "trite and commonplace subjects, from which no new changes could be" wrung. John Curry skirted the mundane by adapting his subjects to "the particularities," in Benton's words, "of American experience and expression," and by giving them a personal touch. In *Tragedy,* for example, the artist and Mrs. Curry were (as in *Comedy*) inserted into the picture, and Little Eva bears the features of his wife's daughter by a previous marriage.[22]

Some of the locals in Westport must have found this terribly self-indulgent. Mrs. Church, however, who had authored articles on Michelangelo, Leonardo, and Rembrandt, praised Curry on cultural and esthetic grounds:

> Glowing with color, rhythmic as music, with a sweeping unity of design, they give meaning to the auditorium and center all eyes on the stage. Much of the town has never seen them, and of those who came to look, many went away to criticize. Why Charley [*sic*] Chaplin? Why Mickey Mouse? Uncle Tom's Cabin is melodrama, not tragedy. How can anyone keep his attention on serious matters, like concerts or town or school meetings, with such frivolity before his eyes.

"What did the public want?" Church asked rhetorically. "Greek masques, or Shakespearean figures?" Comedy and tragedy, she declared, "did not end with the classics."

> It is not for us to judge whether Uncle Tom's Cabin is worthy of a place beside Hamlet. The typical tragedy of modern times, as it is seen in the moving pictures is melodrama. [...] And who is the world's most popular star today?—Why Mickey Mouse, of course. Why insist on Touchstone, or Rosalind, or the clowns of The Midsummer Night's Dream? Mickey Mouse gets the laughs now. He is as familiar a figure of fun to our children as Punch and Judy were to our parents. To perpetuate him in a school fresco is a recognition of the fact that we perpetuate him in the children's memories. Typical modern comedy is much of it grotesque farce, and to leave this element out of the picture would be to falsify the facts.

The public in Westport, Connecticut may not have known what it wanted, but John Curry's artistry garnered outside praise of the highest order. In December 1934, a now-famous *Time* magazine cover story thrust the American regionalists into the national spotlight. Thomas Hart Benton was the main focus of the piece (he appeared on the cover). But Curry, too, was applauded. The anonymous writer

for *Time* called Curry's art "simple and dramatic," drawing attention to the "two-panel mural" in Westport, where Curry "gaily jumbled" Charlie Chaplin with Mickey Mouse and other characters. While some of the personages in the fresco are obscure today, Hamlet and Uncle Tom, Popeye, the Little Tramp, and Mickey have withstood the test of time, and Mickey still embodies, as he did in 1934, along with Chaplin, the pop culture–friendly impulse of Depression-era America.[23]

Comedy is unique among the works of John Steuart Curry, who is best known for his images of life in Kansas and its history—first and foremost, his mural of the fiery abolitionist John Brown in the state capitol building in Topeka. Without Tom Benton's example as a muralist—in various ways, general and specific—neither *Comedy* nor *Tragedy* would have turned out as it did. That is especially true with respect to Mickey, thanks to Benton's satirical panel *Political Business and Intellectual Ballyhoo.*[24]

The burlesque lunette by Benton and Curry's *Comedy* both reflect the down-to-earth, irrepressible fondness of Middle America for cartoons, as underscored by Gilbert Seldes in *The 7 Lively Arts:*

> Certainly there is a great deal of monotonous stupidity in the comic strip, a cheap jocosity, a life-of-the-party humour, which is extraordinarily dreary. There is also a quantity of bad drawing and the intellectual level, if that matters, is sometimes not high. Yet we are not actually a dull people; we take our fun where we find it, and we have an exceptional capacity for liking the things which show us off in ridiculous postures—a counterpart to our inveterate passion for seeing ourselves in stained-glass attitudes. And the fact that we care for the comic strip—that Jiggs and Mutt-and-Jeff and Skinnay [a character in a strip called *In the Days of Real Sport*] and the Gumps have entered into our existence as definitely as Roosevelt and more deeply than Pickwick—ought to make them worth looking at, for once.

There is, nevertheless, a distinction between Curry and Benton's designs. Mickey Mouse, for Curry, was a testament to the average American's fondness for lively, unpretentious entertainment. For Benton, the mass appeal of Mickey was but one facet of a more complex message. The buoyant, often brash, brio of the fourth estate, including the comic-strip stalwarts depicted in the Whitney lunette, is a thematic thread absent from Curry's fresco. Above and beyond their significance as emblems of popular taste, Benton assigned prominent roles in the Whitney lunette to Mickey, Mutt and Jeff, Andy Gump, and the Captain because

of what he perceived to be their comically subversive socio-political ramifications.[25]

But there is more to it than that. In *Political Business and Intellectual Ballyhoo,* Mutt wields a sign inscribed "Literary Playboys League for Social Consciousness," which may be a subtle dig at one of the nation's earliest academic public intellectuals, Columbia University professor emeritus John Dewey. In his book *Art as Experience,* published barely a year after the Whitney cycle was unveiled, Dewey would invoke the highbrow concept of "objectification of emotion" mocked by Benton in his brochure on the *Arts of Life in America.* Moreover, Dewey headed the socialist People's Lobby, was a leader of the League for Independent Political Action, which tried to launch a leftist third party in the early 1930s, and was a contributor to *The New Republic,* where the first uniformly hostile review of Benton's Whitney murals would appear in April 1933.[26]

Next to Mutt and Jeff, a copy of the *New York Post* (with its lurid tabloid headline, "Love Nest Murder") screens Mickey and his cartoon pals from the egghead journalists and the bombastic scarecrow politico. Behind the Mouse is a placard that reads "From the Writings of the Founders," a reference, no doubt, to the Constitution, the Declaration of Independence and its concise credo, "life, liberty and the pursuit of happiness," and, perhaps, the Federalist Papers, coauthored by Alexander Hamilton, who, in 1801, established the *New York Evening-Post.* By putting Mickey next to this placard, beneath the sheltering wings of the American eagle—and bearing in mind Eisenstein, Rivera, and Grafly's views on the Mouse and what he stood for—Benton may have meant for Mickey to stand as a droll exemplar of the Founders' noble aspirations. This supposition is supported by Benton's location of the *Political Business and Intellectual Ballyhoo* lunette above the *Indian Arts* panel, which implied a correlation between the lofty ideals signified by the national bird and both the mythic primitive purity of the first Americans and the vox-pop qualities of that American artform par excellence, the cartoon.

In addition, because *Political Business and Intellectual Ballyhoo* was placed on the wall directly opposite *Arts of the City,* Benton may have intended to stress the fact that the three publications he was mocking were edited by an urban elite, whose effete sensibilities were incapable of appreciating the taste of the common man. Mickey Mouse may (again) come into symbolic play here both as a cunning reminder that *The Nation* had put his cartoons on its "Honor Roll for 1930," and as a shaft aimed at Seldes for his remark, in *The New Republic* (June 1932), that Mickey had "some of the element of a fad." The anti-intellectual raillery in the *Arts of Life* panel and the ruckus it caused after it was unveiled, including charges of racism and anti-Semitism from Benton's erstwhile comrades on the left, must have been rooted as well in

240. Stuart Davis (1892–1964), *Lucky Strike*, 1924. Oil on canvas, 18 x 24 in. Hirshhorn Museum and Sculpture Garden, Smithsonian Institution, Washington, D. C.

ideological or private animus (one of the editors caricatured by Benton, Mike Gold, was Jewish). Benton might not have planned it that way when the project began, but the barbed message of *Political Business and Intellectual Ballyhoo* turned out to be his personal Declaration of Independence from the more hard-line radical politics espoused by much of the *Nation–New Republic–New Masses* crowd.[27]

Politics aside, there is one other factor to consider about the *Arts of the City* panels. As a young man, one of Benton's first jobs, in 1906, had been as a cartoonist on the *Joplin American*. As an art student in Chicago (1907–1909), Benton "assured a friend that his paintings would one day be as important as the funny papers." In 1940, he visited the Disney studio and, after World War II, spent a few weeks in Burbank exploring a possible collaboration with Walt. *Time* art critic Robert Hughes once pointed to the "rhythmical distortion of bone and muscular structure" in Benton's art that "made his human figures weirdly overdetermined, like lanky dummies with cartoon faces." Benton's trains, Hughes also observed, "lean forward like Walt Disney's as they stream along." If Tom Benton chose to include Mickey Mouse, Andy Gump, and company in the Whitney murals, it was to some extent simply because, as a former cartoonist, he liked them.[28]

Henry Adams has said that "art historians today recognize this lunette as the most original panel in the series, for it directly introduced cartoon characters into large-scale painting, demolishing the usual barriers between 'high' and 'popular' art. The effect looks forward to 1960s Pop Art, in which cartoon figures were used by Andy Warhol and Roy Lichtenstein." Benton was not, however, the first to blur the line separating High from Low by putting a cartoon motif in a painting. In 1874, Pissarro painted a portrait of Cézanne with a satirical political print of Courbet pinned to the wall behind him; more recently (in 1924), Benton's contemporary, Stuart Davis, had painted a post-Cubist

241. This cel set-up was reproduced in Eleanor Lambert's "Notes on The Art of Mickey Mouse and his creator Walt Disney" (1933), where it was captioned: "'Minnie the Fair, Minnie the Beautiful' from Ye Olden Days." It almost certainly was one of the objects exhibited at the Kennedy Galleries in the spring of 1933. Dick Lundy (1907–90) was the chief animator for this scene from *Ye Olden Days*, released by United Artists, Apr. 8, 1933 (it was offered at auction at Christie's East on Nov. 19, 1989). Ink and gouache on celluloid over a watercolor and gouache production background, 7 ½ by 9 ½ in. Private collection.

still-life, *Lucky Strike*, whose focal point was a simulation of a sports cartoon in the *New York Evening Journal* [240]. Davis's preoccupation in the 1920s with everyday commercial objects (cartoony, flattened against the picture plane), one could argue, makes him a precursor of Pop Art, though Lichtenstein and Warhol probably found Benton's rejection of "the 'modernism' of the boulevards" more to their liking. Tom Benton, Henry Adams also remarked, "believed that modern subject matter would give rise to modern forms." Benton's satirical panel and Curry's *Comedy* may not have actually portended Pop Art's fascination with the Mouse—they were certainly unrelated to the formal innovations of Lichtenstein, Oldenburg, and Warhol. But the witty irreverence and seditious vitality in *Political Business and Intellectual Ballyhoo* and *Comedy* were very much in the spirit of Pop.[29]

n January 1933, several weeks after Benton's panels were installed in the Whitney Museum library, *Art News*, another of the country's premier art magazines, had this to say:

> The cinema with its wealth of pictorial possibilities appears to have reached a point in its development when a new art form of special significance may be said to have received its inception. The animated cartoon, that inventive though humble agent of the screen which brought Mickey Mouse and his host of cut-up cousins into such world-wide acclaim, has taken on new life with the advent of color, and the past few weeks have seen the first of a new series of these features [the Silly Symphonies] all aglow with rainbow hues that argue endless delights to come [. . .]. It is not difficult to imagine the screen made thrilling with scenes from *Moby Dick* drawn by Rockwell Kent and worked out as to detail by the various technicians such as Mr. Disney has at his command. Then think of *Alice in Wonderland* with all the Teniel [sic] fixings coming into new life on the screen, or any of a host of pictorial characters that

242. Cel set-up from *Mickey's Mellerdrammer Days*, released by United Artists, March 18, 1933, as reproduced in Dorothy Grafly's "America's Youngest Art," July 1933. Like the set-up on p. 204, it was offered at auction at Christie's East on Nov. 19, 1989. Eddie Donnelly (active circa 1930–60) was the chief animator for this scene.

have rested so far on the printed page. [...] The possibilities are indeed endless and the vistas thus opened up alluring to say the least. Mr. Disney has started a new art that is destined to go a long way.[30]

In a similarly alluring, if slightly tongue-in-cheek vein in *The Nation*, a year later (March 1934), James Thurber confessed his distaste for Homer's *Odyssey* ("too many dreary hours between this rosy-fingered dawn and that rosy-fingered dawn"), then expressed his "conviction that the right 'Odyssey' has yet to be done, and to name as the man to do it no less a genius than Walt Disney . . . A year or two ago," the humorist and sometime cartoonist declared, "Mr. Disney made a Silly Symphony, as he too lightly called this masterpiece, entitled 'Neptune.' Those who missed seeing it missed a lusty, fearsome, beautiful thing." Thurber concluded by saying that a Disney version of *The Odyssey* "can be, I am sure, a far, far greater thing than even his epic of the three little pigs. Let's all write to him about it, or to Roosevelt."[31]

Commendations like these, high-minded or fanciful, surely bolstered Disney's instinctual ambition to move on from Mickey and the Silly Symphonies, toward *Snow White and the Seven Dwarfs*, *Fantasia*, and beyond. Meanwhile, concurrent with Benton's inclusion of the Mouse in his Whitney mural cycle, the idea that production work from Disney animation should be considered as true art, heralded by the Art Alliance exhibition in Philadelphia, began to catch on. In May 1933, as previously noted, New York's Kennedy Galleries put on display fifty pieces of production work from the Mickey Mouse and Silly Symphony cartoon series. The show received this glowing notice from *Art News*:

> An amazing and amusing interlude is to be found in the present exhibition at the galleries of Kennedy & Co., where the fabulous conceptions of Minnie and Mickey Mouse, done in water color as well as pen drawing, by Walt Disney, are now holding forth. The water colors consist of stills from the "King Neptune" and "Flowers and Trees" reels of the "Silly Symphony" series. The drawings, also stills, are concerned with the popular pair's activities in "Ye Olden Days" [241–242], "The Nightmare," and "Mickey's Mellerdrammer," with a few extemporaneous subjects thrown in for good measure.
>
> Aside from the artistry contained in the studies, Mr. Disney may be likened to a Hollywood director, for it is he who is responsible for the emotions registered by his protégés, and in this latter category his triumph becomes complete.[32]

The event was a hit with the hoi polloi as well. According to the *New York Morning Telegraph*,

School children went to the exhibition by thousands, but grown-ups augmented the crowds to such an extent that throngs have been turned away for several days. Now the exhibition has been extended indefinitely. The catch in the whole thing is that two weeks is the usual period of an art exhibition at the larger galleries.

Upon viewing the show, the *New York Sun*'s Henry McBride, a leading champion of modernist art, called Disney "the people's genius." Elisabeth Luther Cary, the first permanent art critic at the *New York Times,* declared: "Down goes the Ivory Tower at last under the impact of what has been accurately described as 'the embodiment of a new art, an art in motion, and an art in rhythm, the keynote of a new epoch in the history of aesthetics.'" Without naming her source, Cary was quoting from a companion publication to the Kennedy Galleries exhibition, Eleanor Lambert's "Notes on the Art of Mickey Mouse." In Cary's own opinion, it also seemed that it was "quite necessary to give these drawings at least this much of the kind of serious notice which breaks out among the historians of art."[33]

That summer, in a long essay for the *American Magazine of Art*, titled "America's Youngest Art," Dorothy Grafly [242], who had lauded the Disney show in Philadelphia one year earlier, professed her faith in the future of animation:

> While art on canvas or in clay has grown more and more subjective and more and more incomprehensible to the general public, the animated cartoon, devised for entertainment, keeps alive the tradition of whimsy and imagination. It is, to a great extent, the folk art of a sophisticated century. Let those who sing the praises of the primitive and extol child art consider what is being accomplished, without benefit of recognition by the art fraternity, in satisfying a poignant adult nostalgia for the world of make-believe. Until its recent experiment with egocentric psychology, art itself spread the magic carpet of escape.
>
> [. . .] While artists have been burrowing more and more within themselves, the film has gone its own way, and, in the art of Walt Disney, has at last given the world what should have come through established art channels—the creative exploit of the animated cartoon in color, probably the first genuinely American art since that of the indigenous Indian.

A little deeper into the piece, Grafly added:

> The Mickey Mouse films are the last word in the animated comic

strip; the Silly Symphonies are the triumph of a new art. In these, with the brush stroke of his imagination, Walt Disney paints a sequence of movements and resulting emotional episodes that do for art what the orchestra does for music. They make possible not one scene, as on canvas, but the interrelation of many scenes that together produce a new emotional experience.

In August 1933, the decidedly lowbrow periodical, *Screenland*, mocked the rising regard for Disney among sophisticates when it issued its own take on "The Art of Mickey Mouse," which carried this subhead: "'I'm the Mous-solini of Geniuses,' Cries Modest Mickey as High Art Claims Him for Her Own." In the article, the writer reports having bumped into Mickey admiring images of himself displayed on the walls of the Kennedy Galleries exhibition and saying, "I truly appear to have joined the company of the immortal great. There is Rubens' Wife, there is Whistler's Mother—and now there is Disney's Mouse."[34]

Disney's cartoons were now perceived as a distinct cut above the usual run of mass-market entertainment. And yet, in spite of their worldwide popularity,

> no one was more surprised than Mr. Disney when the College Art Association invited him to lend a collection of his original Mickey Mouse and Silly Symphonies drawings to form a circuit exhibition of leading museums and colleges throughout the United States. He has been too busy to realize that his engaging, lovable little adventurer, has become the embodiment of a new art, an art in motion and an art in rhythm, the keynote of a new epoch in the history of aesthetics.

These words appeared in Lambert's *Notes on The Art of Mickey Mouse*, published by the College Art Association, the national organization of art historians, curators, and studio instructors that organized the exhibit at the Kennedy Galleries in New York City in the spring of 1933.[35]

The New York show was just the first stop in this ambitious traveling exhibition. The Art Institute of Chicago would be the next (and most prestigious) of some forty-five venues planned for a tour that ultimately included, among other host institutions, the Albright Gallery (Buffalo), the Evansville (Indiana) Temple of Fine Arts, Currier Gallery in Manchester, New Hampshire, the Milwaukee Art Institute, Portland (Oregon) Museum, Toledo Museum of Art, Brooks Memorial Art Gallery (Memphis), and the Washington County Museum of Fine Arts (Hagerstown, Maryland).[36]

Actually, as *Newsweek* reported, there were two separate, constantly evolving shows operating simultaneously, each consisting "of 50 black

243. Alfredo Herculano (b. 1903), statuette of Mickey Mouse riding a tortoise, 1934. Bronze, 13¼ x 10½ x 7¾ in. Walt Disney Family Foundation, San Francisco, California.

and white Mickey cartoons and 50 water colors." This description of the number of pieces shipped to each venue jibes with information in a letter to the Toledo museum, dated May 24, 1933, in which the director of traveling exhibitions with the College Art Association, Audrey McMahon, stated:

> The Mickey Mouse exhibition consists of 100 mounts, fifty devoted to Mickey Mouse and 50 to the Silly Symphonies. These are all original works by Walt Disney. The enclosed booklet by Eleanor Lambert will give you some scope of the exhibition. No list catalogue accompanies the exhibition as each mount is fully captioned.

A second reason why there was no formal catalogue was that the two exhibits, running in parallel with one another, kept changing. According to *Newsweek*, "every four months," Disney "supplies 40 new items from his current movie releases" for the shows, which were so popular that "the association's director of exhibits believes it will be necessary to keep one show available 'till kingdom come.'" None of the art, incidentally, was for sale. Disney, *Newsweek* said, "is a rare artist in more ways than one. He

refuses to sell any of his pictures. College Art borrows them and sends them to museums throughout the country, charging only for transportation."[37]

When the exhibition opened at the Art Institute, it was a social register must, as the *Chicago Tribune* made clear:

> No matter what else is on her engagement pad for this afternoon, every "lady of fashion" will find time to visit the Art Institute between 3 and 5:30 o'clock to view the re-arranged painting galleries and the temporary exhibition of paintings and lithographs of Greenland by Rockwell Kent, contemporary French paintings lent by the Fleming museum, drawings for "Mickey Mouse" and "Silly Symphonies" by Walt Disney, paintings by Eugene Berman, paintings by Paul Kleinschmidt lent by Erich Cohn, photographs of Mohammedan architecture, and illustrations for Dostoevsky's "The Brothers Karamazov" by Boris Grigoriev.[38]

But this commingling of high and low fell immediate prey to a wire service story that took a swipe at high-class culture in general and non-native artists in particular:

> The antics of Mickey Mouse and fantasies from Silly Symphonies ascended to the stately walls of the Chicago Art Museum today for the winter exhibits of the Art Institute.
>
> Beside the grim Russian morbidities of Boris Grigoriev, Walt Disney's big, bad wolf squared off for a good huff and puff at the house of straw and the little piggies wiggled their way under the bed.
>
> Grigoriev's "Theodore Karamazov" squinted with a leer trying to watch Minnie Mouse chase Pluto, the dog, just across the gallery.
>
> Sandwiched between Rockwell Kent's austere paintings of Greenland ice fields and the classically conceived cows from the brush of the young Frenchman, Eugene Berman, were four rats from Disney's Pied Piper of Hamlin.
>
> The rats, perched on a high molding, craned forward and down, their little tongues protruding in a whole-souled gesture of "giving the bird" to the goodly burghers of Hamlin town. That was before the piper came along.
>
> Thus Mr. Disney returned to the Chicago Art Institute, where a few years ago instructors told him there was no future for him as an artist. Sadly, Mr. Disney laid down his palette and brush, at that time, and turned to newspaper cartooning.[39]

Of course, Walt had studied at the Chicago Academy of Fine Arts, not the school of the Art Institute—the alma mater of Benton, Curry, and Lambert—and he was never a newspaper cartoonist, though that had once

244. François Rude (1784–1855), *Neapolitan Fisherboy Playing with a Tortoise*, 1831–33. Marble, 32.3 × 34.6 × 19 in. Musée du Louvre, Paris.

245. Pierre Hébert (1804–69), *Boy Playing with a Tortoise*, circa 1858. Marble, 41 × 25.6 × 36 in. Musée du Louvre, Paris.

been his dream (such factual niceties would have spoiled the fun for the ink-stained wretches of the Fourth Estate). Two days after the wire story came out, an editorial writer at the *Columbus Dispatch* took the persiflage a step further: "We, for one, are sorry to see Mickey Mouse elevated to the plane of high art. Once he was amusing. Now he is significant and at the mercy of every high-browed critic in the nation."[40]

Over the coming months Mickey would remain on that high plane. Following the lead of Thomas Hart Benton, in 1934, Klir Beck, a now obscure landscape artist, designed two stained-glass windows for the small mammal house at the National Zoo in Washington, D.C., in which "Mickey and Minnie were to be the central motif" (the commission was scrapped when the federal agency in charge, the Public Works of Art Project, went out of business).[41]

On August 30, 1934, the *New York Sun* reported that "a tribute to Walt Disney in the form of a bronze statuette of Mickey Mouse straddling a turtle" [243] had been brought to the United States by "a delegation of forty-one prominent Brazilians," headed by Dr. Marcondes Alves de Souza, Jr. The statuette, modeled by de Souza's compatriot, Alfredo Herculano, may have been inspired by a pair of sculptures in the Louvre, depicting naked ragazzi playing with a captive tortoise [244–245], both likewise inspired by a lighthearted subset of Greek statuary focused on boys with pet animals, like the Roman copy of a Hellenistic original, also in the Louvre, of a *Boy Wrestling with a Goose*.[42]

During the spring of 1934, as the Disney show sponsored by the College Art Association continued its national tour, the American Art Dealers Association gave a gold medal to the "creator of Mickey Mouse." And, in July 1934, in the *Woman's Home Companion,* Alva Johnston reiterated the ironic lament in the *Columbus Dispatch.* "Poor Mickey is in the hands of the dilettantes," Johnston said. "After escaping hundreds of other dreadful perils, he is now in the most desperate fight of his career."[43]

The "desperate fight" continued. In December 1934, the Associated Press reported that Disney's Mouse, and a number of other cartoons figures, had paid a repeat visit to Chicago:

> A strange company trooped into the Art Institute today.
> Mickey Mouse, the Three Little Pigs, the Katzenjammer Kids, Jiggs and Maggie, Mutt and Jeff, and others of their ilk took their places alongside austere and venerable canvasses that grace its walls. The exhibit is part of a salon of American humorists which will open to the general public tomorrow.
> Cartoonists from the Revolutionary period until the presen[t] day are represented in the exhibition, which marks the first occasion

the cartoon has been exhibited as an art form, except for one or two individual shows in the past.[44]

With an assist from Walt's distributor, United Artists, Disney production art was soon being seen and appreciated abroad as well. A variant of the 1933 College Art exhibition, *Walt Disney and His Animated Cartoons: Original Working Drawings* [246], opened in mid February 1935 at London's Leicester Galleries. It included photographs illustrating the working methods at the studio, original drawings, "cels" (images on transparent sheets of cellulose nitrate—or later—plastic—each one contributing to a single frame of film footage), plus background art from the Mickey Mouse cartoon *The Klondike Kid* and a "Ten-Picture Cycle of Mickey Mouse Drawings Showing How Continuity of Action Is Achieved." (Novelist Irving Wallace would say of the event that Mickey had been "stuck on the wall between a Picasso and an Epstein sculpture," but this was poetic license on Wallace's part.) In the spring and summer, the exhibit traveled to the Harris Museum and Art Gallery, Lancashire, and the City of Manchester Art Gallery. In October, it opened at the City of Belfast Museum & Art Gallery, in Northern Ireland.[45]

Until the late 1930s, the sale of original Disney art by commercial galleries, or dealers, was exceedingly rare. Usually such items were given away. "Walt was very generous," longtime studio employee and "Disney Legend" Ruthie Tompson recalled. "He gave an awful lot of setups away, of *Snow White* and of Mickey and of Donald Duck and Dumbo, all of 'em." That all changed thanks to *Snow White and the Seven Dwarfs*. The concerted commercialization of Disney production art kicked off a few months before the release of Walt's first full-length feature, when the studio made an exclusive deal with a San Francisco gallery owner, Guthrie Courvoisier, to market original works suitable for framing. The objects purveyed by Courvoisier, as listed on an inventory dated March 7, 1939, came mainly from Disney's two current Academy Award–winning pictures: *Snow White* and *Ferdinand the Bull*. But Courvoisier mounted and sold cels from other cartoon shorts, notably *Donald's Penguin* and two Mickey cartoons, *Brave Little Tailor* and *The Pointer,* like the magnificent set-up that Walt gave to President Franklin D. Roosevelt for his birthday in 1940 [247].[46]

In a letter in April 1938 to Kay Kamen, making his pitch to represent the studio, Courvoisier boasted,

Through my own business I have come to know many museum directors, most of the important art dealers in America and a great host of collectors and people interested in art. They have not only been amused by the Walt Disney animated cartoons, but have often expressed

246. Front cover of the eight-page catalogue *Walt Disney and His Animated Cartoons: Exhibition of the Original Working Drawings* (London: Leicester Galleries, February 1935).

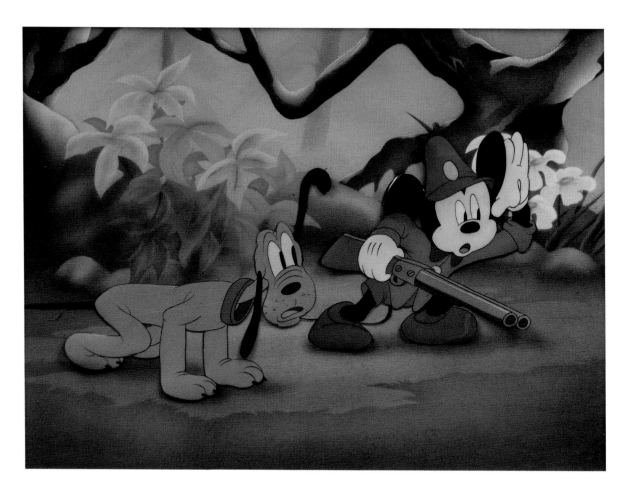

247. Mickey and Pluto in *The Pointer*, released by RKO Radio Pictures, July 21, 1939. Courvoisier animation cel set-up sent to Franklin Roosevelt by Walt Disney for the President's fifty-eighth birthday in January 1940. Black ink, tempera, and watercolor on celluloid and board, 17 ¾ x 20 in. framed, Franklin D. Roosevelt Presidential Library, Hyde Park, N.Y. Norm Ferguson and John Lounsbery (1911–76) were responsible for s animating this scene.

In a letter dated Mar. 4, 1940, FDR thanked Walt "for that original drawing of Mickey Mouse," adding "I am glad to have it and appreciate your friendly thought in sending it to me." Walt Disney Archives, Burbank, California.

a great respect for Mr. Disney as an artist of profound ability in the same sense as a great painter or composer. Proof of this may be found in the recent scheduling of the exhibition of celluloids at the Museum of Modern Art in New York. This was official recognition that Mr. Disney has actually created a new and distinct artistic expression which will rank his name with the great artists of this age.[47]

In the spring of 1936, four cel set-ups from a *Three Little Pigs* sequel, *Three Little Wolves*, had been featured in *Fantastic Art, Dada, Surrealism*, an exhibition at the Museum of Modern Art organized by founding director Alfred H. Barr. Also in 1936, MoMA included *Steamboat Willie*, with such films as *The Jazz Singer* and *All Quiet on the Western Front*, in a program "illustrating the development of cinematography," conceived by the newly named head of the museum's film library, Iris Barry, a former movie critic for *The Spectator* and the *Daily Mail*, and cofounder (with Ivor Montagu) of the Film Society in London. In an article, "On Movies," published in June 1936, the distinguished art historian Erwin Panofsky, a member of the advisory committee of the film department at MoMA (who would give a talk at the Metropolitan Museum of Art five months later on the same subject), referred approvingly to Felix the Cat's "prodigious offspring, Mickey Mouse."[48]

Disney was now primed to take center stage at MoMA. In January 1938, the museum announced that an exhibition was "in preparation" for the 1938 season titled "Walt Disney—original drawings," no doubt a version of a national traveling show of art from *Snow White* then in the works. But for some reason, the stop at America's premier gallery of modern art never materialized. Walt did not get his solo show at MoMA, although he was elected a museum trustee in November 1943.[49]

Another indication of Disney's reputation at this time in High-Art circles came from Salvador Dalí, who, in February or March 1937, sent a postcard from California to fellow Surrealist André Breton, in Paris, in which Dalí announced (in French): "I'm in Hollywood where I've made contact with the three American surrealists, Harpo Marx, Disney, and Cecil B. DeMille. I believe I've intoxicated them suitably and hope that the possibilities for surrealism here will become a reality." Though surely flattered by such attention, Walt must have been perplexed (and amused) as well. He was, moreover, ill-equipped—and temperamentally disinclined—to enter into intellectual discourse about his craft as "art." When, as *Time* magazine reported, in December 1937,

> no less a savant than Aldous Huxley tried to find out just what made Walt Disney do the kind of work he does [. . .] Mr. Disney was not much help. "Hell, Doc," was all he could say in response, "I don't know. We just try to make a good picture. And then the professors come along and tell us what we do."[50]

n 1938, in his book *The History of American Graphic Humor,* published on behalf of the Whitney Museum, William H. Murrell hailed Walt as the "creator of the world-famous Mickey Mouse," who "has had more honors bestowed on him than any living person in the world." In June of that year, Mickey's maker received his honorary degrees from USC, Yale, and Harvard, and in September, Guthrie Courvoisier announced that cels from *Snow White and the Seven Dwarfs* would "go on sale this month [. . .] through one gallery in each of the large cities here and abroad." In January 1939, Walt reached another milestone when, again in the words of *Time,* the "dignified old matriarch of U.S. museums, Manhattan's Metropolitan, bestowed a grandmotherly kiss on the forehead of art's guttersnipe youngster, Walter Elias Disney," whom the Met called "a great historical figure in the development of American art."[51]

The *New York Times* could not resist commenting:

> Walt Disney has entered the Valhalla to which all American artists, good and bad, hope to go, preferably before they die.
> This goal is the Metropolitan Museum of Art, America's greatest art

248. Two vultures tracking the fall to her doom of the evil queen in *Snow White and the Seven Dwarfs*, which premiered in Hollywood, Dec. 21, 1937, and was released nationally by RKO Radio Pictures. Animation cel set-up, black ink and tempera on celluloid and board, 10 x 9 in. (sheet), circa 1937. Ward Kimball (1914–2002) was assigned to animate the vultures in this sequence. Metropolitan Museum of Art, New York.

museum and one of the major institutions of its kind in the world. Most of the American artists who are not represented in the museum would give their last paint brush to get in.

The coveted honor of having a picture accepted by the Metropolitan has come to the creator of Mickey Mouse, the Three Little Pigs, and Donald Duck. Visitors at the museum next month will see in its room of recent accessions one of the original water-colors for "Snow White and the Seven Dwarfs."

The "water-color" in question, in reality, a cel set-up (a cel laid down over a watercolor background), representing two vultures watching the old hag fall to her doom at the climactic conclusion of the film [248], came to the museum in 1938 as a "gift of the artist," possibly at the suggestion, or through the good offices, of Julien Levy, whose Manhattan gallery then handled Disney art—and works by Dalí as well.[52]

Animation art from *Snow White* was exhibited commercially in the fall of 1938 at the Julien Levy Gallery in New York, the Charles Sessler Galleries (in Philadelphia), Albert Roullier Art Galleries (Chicago), Leicester Galleries (London), and the Phillips Memorial Gallery (Washington, D.C.). By September 1940, Courvoisier could report to Walt and Roy that twenty-five institutions had acquired Disney art during the two preceding years. Among them were some of the most respected in the nation: the Cleveland, Toledo, Vassar College, and Dallas museums, in addition to MoMA and the Met. Other institutions, not mentioned by Courvoisier, as well as individuals, must have purchased drawings or set-ups through dealers like Levy or Sessler, who had established commercial relationships with the studio prior to Courvoisier's exclusive arrangement.[53]

Pinocchio ignited further commercial interest in Disney art. In May 1940, the Roullier Galleries, then presenting "an exhibition of the Walt Disney original celluloids" from the film, informed the director of the Toledo museum that "Disney's agent," presumably Courvoisier, "is wondering if you would like to show a large number of them in your Museum." The offer was accepted, and, in late September 1940, Toledo was shipped "112 Disney originals consisting of 68 celluloids, 15 celluloids on master backgrounds, 2 special celluloid setups, 17 animation drawings, and 10 story sketches," from "a wide range of Disney films, beginning with Snow White and the Seven Dwarfs and ending with Pinocchio, and include[s] items from various short subjects such as Little Hiawatha, Ferdinand the Bull, etc." This was a sales exhibition. Prices ranged from $5, for the least expensive cel, to $185 for one celluloid on a master background from *Snow White.* Two cels from the Mickey Mouse cartoon, *The Pointer* went for $15 apiece, a third for $25.[54]

On November 30, 1940, Disney's climb into the empyrean of high

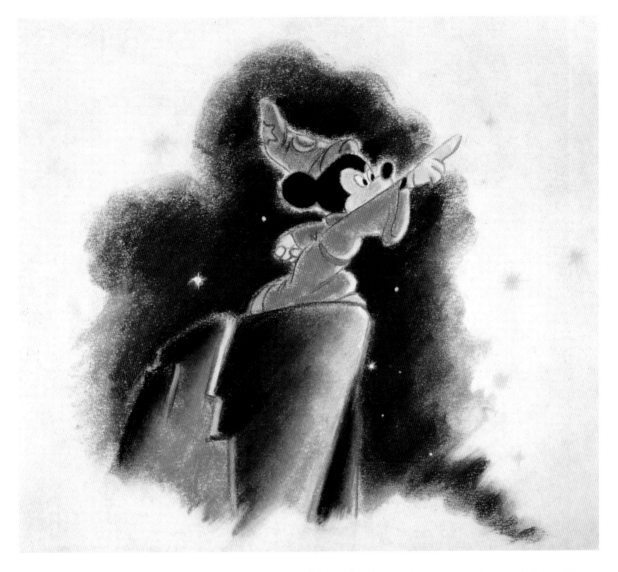

art reached its peak when a *Retrospective Exhibition of the Walt Disney Medium* opened at the Los Angeles County Museum [249]. The month-long show—encyclopedic in its breadth—was based on the premise that Walt, in the words of the museum's director, had single-handedly "elevated animated pictures from a crude form of entertainment to the dignity of a true art." A museum newsletter distributed to the press before the show opened described it as follows:

> Called "A Retrospective of the Disney Medium," this exhibit will present its material in a manner never before attempted. While Disney's pictures have for some years been attracting the attention of art lovers, and while some museums have sponsored exhibits of individual celluloid cartoons, no attempt has ever been made to present in review not only all the steps involved in the filming of the Disney pictures, but a history of the progress made in developing the medium.
>
> All phases of all contributions to annimation [*sic*] will be presented,

249. Mickey Mouse as the Sorcerer's Apprentice, from *Fantasia,* a lavishly illustrated volume with an interpretative text by Deems Taylor and foreword by Leopold Stokowski (New York: Simon and Schuster, 1940), touted by the publisher as "the first Disney book designed for adults." This same image also appeared in the catalogue for the L.A. County Museum exhibition in November–December 1940. Walt Disney Archives, Burbank, California.

with original material from all the pictures, arranged in chronological order. Beginning with the "Skeleton Dance" (1915–1916), earliest silent, the exhibit will progress through the advent of sound—which factor contributed highly to this art's success—in "Steamboat Willie," and on through "Snow White," "Pinocchio," and the latest—still unreleased in Los Angeles—"Fantasia."

Occupying three galleries devoted to original designs, the observer can trace the development of the media which has gone hand-in-hand with technical developments in motion picture production. He can also trace the interesting steps by which Mickey Mouse and others have developed and crystalized their characters. Shown in detail will be the evolution of a natural cricket into the engaging Jiminy.[55]

Midway through the run of the exhibition, *Art Digest* reported:

Though Walt Disney is not at all interested in producing art, he has, in his incessant effort to perfect his own particular medium, done just that. He has tried only for superb entertainment; critics have insisted for several years that he has achieved art. Reinforcing this appraisal, directors of important American museums have added to their permanent collections the watercolors and drawings created by Disney artists.

Quoting verbatim a passage in the LACM newsletter, the magazine went on to say that Disney "remains a master artist by every definition. Superbly creative, a virtuoso of his complicated tools, he strives fiercely for perfection and the continuous evolution of his medium."[56]

The *Retrospective Exhibition of the Walt Disney Medium* closed out what the *San Bernardino Sun* declared to have been "the most successful year in the history of the Los Angeles County Museum." During its first three weeks, more than 17,000 visitors streamed through the museum's galleries—a remarkable total in an era before today's heavily hyped blockbusters. Walt must have been especially elated, since it all happened in his own backyard, a short drive from the Disney studio.[57]

As indicated in the LACM newsletter, from 1932 to 1940, shows devoted to Disney cartoon art were presented in dozens of cities across the United States, from Philadelphia and New York to Chicago and Los Angeles. Another third of a century would pass before such honors again came—albeit posthumously—Walt's way: a retrospective commemorating the start of his career in Hollywood, at Lincoln Center in New York in 1973, and three events in 1978, the year in which Mickey Mouse got his star on the Hollywood Boulevard Walk of Fame. The first of these was a film festival at the Museum of Modern Art, celebrating

Mickey's fiftieth birthday; the second was a show at the Library of Congress, in Washington, D.C., curated by Michael Barrier, *Building a Better Mouse: Fifty Years of Animation* [250]; the third, an exhibition of Mickey art and collectibles at the Bowers Museum in Santa Ana, California. There was another *événement* as well in 1978, at one of Paris's leading department stores: *Mickey Fête Ses 50 Ans au Printemps* [252], composed of a continuous projection of Mickey cartoons, a "Boutique Mickey," with toys on sale from around the world, and a display from a private collection of classic Mouse playthings and other "antiquités."[58]

250. Cover of catalogue for the exhibition curated by Michael Barrier, *Building a Better Mouse: Fifty Years of Animation*, Library of Congress, Washington, D.C., 1978. Private collection.

Just ten years after the L.A. County Museum exhibition, Mickey Mouse would be a spent force, creatively and culturally. In 1950, a prediction like Diego Rivera's, from 1932, that Mickey was destined to be "one of the genuine heroes of American Art in the first half of the 20th century," would have been dismissed as preposterous. But in the fullness of time Mickey did, in fact, go back to the future and reclaim his title as the most iconic American artistic creation ever. Only this time, when he re-entered the temple of High Art, in the 1960s, '70s, and '80s, it was through his association with the practitioners of Pop Art, not by engraved invitation from critics, curators, or scholars, as had been the case in the 1930s.

The year 1940 had been pivotal for Mickey and Walt. It saw the completion of *Fantasia,* which closed out Mickey's thirteen-year reign as a screen star of the first magnitude—phase one of his place in American life. It also gave rise to the LACM *Retrospective* that ended Disney's ten-year run in the sun of serious art circles. At almost precisely this time, an egalitarian vision of combining elite cultural modes with popular idioms of amusement, widely embraced during the Depression, likewise began to lose its potency.

Although the parameters and depth of that vision have yet to be fully explored, it may have had its roots in what is now a national institution, the outdoor concerts offered since 1885 by the Boston Symphony Orchestra—officially dubbed, in 1900, the Boston "Pops." As stated at their inception, the Pops "Promenade Concerts" were "made up largely of light music of the best class," tunes composed by Victor Herbert, marches by Sousa, musical theater numbers, and novelty songs. Gilbert Seldes, a Harvard graduate, must have attended or at least heard or read about the Pops performances. Whether or not the taste underlying the Promenade Concerts affected his thinking is hard to say. But, as noted in *The 7 Lively Arts,* Seldes did believe that, "except in a period when the major arts flourish with exceptional vigour, the lively arts are likely to be the most intelligent phenomena of their day," and, as we recall, he likewise felt that the bulk of the music at the Metropolitan Opera was "trivial in

251. Screen capture from the Silly Symphony, *Music Land*, released by United Artists, Oct. 5, 1935.

comparison with either good jazz or good symphonic music."[59]

One early attempt at mating major and minor artforms that Seldes is known to have appreciated was a jazz ballet-pantomime, *Krazy Kat,* by John Alden Carpenter, another Harvard man (and, like Disney, a native Chicagoan), that had its maiden performance in 1922. It was termed by Seldes "a notable effort," but "foredoomed to failure" because it lacked the irony of the original and because "it isn't Russian ballet Krazy requires; it is American dance." In Seldes's opinion, just one man could have pulled off such a trick: Chaplin. (Also in 1922, incidentally, *Vanity Fair* ran a comparative poll of 210 cultural figures, ranging from Homer and Shakespeare to William Randolph Hearst, Babe Ruth, and Krazy Kat—rated by H. L. Mencken, Henry McBride, Edmund Wilson, and seven other "Modern Critics of America"—which could not have escaped Seldes's attention.)[60]

A vastly more successful marriage of high and low than Carpenter's *Krazy Kat* ballet was the legendary Paul Whiteman concert in 1924 at New York's Aeolian Hall, which was probably being spoofed, at least indirectly, in the Mickey Mouse cartoon *Blue Rhythm* [253]. On the program were Elgar's "Pomp and Circumstance," a suite by Victor Herbert, and, specially commissioned for the event, George Gershwin's "Rhapsody in Blue." In 1930, when, for the first time, Arthur Fiedler, the newly appointed Boston Pops conductor, mingled classical and popular fare with "symphonic jazz," Gershwin's "Strike Up the Band" was on the bill.

The 1930s, Michael Barrier has noted, were "one of those rare periods when artistic quality and broad public acceptance coincided much more closely than usual." The dream of allying high and low musical forms gained such currency during this period that, as we've seen, there was a program of music-laden Disney cartoons at Carnegie Hall in 1933. In 1935, one of Walt's finest Silly Symphonies, *Music Land* [251], pitted the Land of Symphony in cartoon battle against the Isle of Jazz, with musical instruments as weapons of mass destruction. (The hostilities concluded with a Bridge of Harmony built to connect the two erstwhile enemies.) In April 1936, the Rodgers and Hart musical *On Your Toes* (also a film, starring Eddie Albert, from 1939) was one of the first Broadway shows to integrate ballet into the plot, with "Slaughter on Tenth Avenue," choreographed by George Balanchine.[61]

The ultimate high-low combo at this time, terpsichorean or otherwise, emerged in the form of the man Graham Greene had termed the closest thing to a "human Mickey": Fred Astaire, who, in a string of nine motion pictures from 1933 to 1939, joined casual top-hat flair with witty insouciance . . . all in the ivory arms of Ginger Rogers. Benny Goodman's historic 1938 Carnegie Hall concert, with guest players from the Count Basie and Duke Ellington bands, crowned the forty-

252. Promotional material for the exhibition *Mickey Fête Ses 50 Ans au Printemps* ("La plus grande 'Star' de tous les temps" / "The greatest 'Star' of all time"), 1978, Paris. Private collection.

year march of jazz to respectability. But the program was comprised solely of jazz (including the inevitable "Shine"), with nary a hint of anything classical, despite its prestigious setting. Goodman's tour de force foreshadowed the gradual collapse of the dream of uniting serious and popular musical idioms, and the separation, for decades to come, of high and low in other areas, too.

In retrospect, *Fantasia* marked not just the end of Mickey Mouse's Golden Age. The collaborative conjoining by Stokowski and Disney of "high-toned music" and "fantastic imagery," as Bosley Crowther put it, also signified the beginning of the end of an intense interwar impulse to set mass-cult forms of native artistic expression, like jazz and cartoons, on a par with Old World high culture.

In *Hollywood Flatlands* (2002), Esther Leslie voiced her "frustration at the phoney war" in contemporary academic milieux pitting "high culture and popular or low or mass culture" against one another. A burning belief among present-day cutting-edge artists and theorists, Leslie wrote, insists that high and low

> have been—for so long—enemies. To declare an intimacy between modernism and mass culture is too far-fetched for the professionals of popular culture (just as it is for the proponents of a sealed-off lofty culture by the privileged for the privileged). From such a perspective, it is impossible to imagine the personal and critical rendezvous between Eisenstein and Disney, or to acknowledge that [intellectuals like] Walter Benjamin sat amongst cartoon audiences and developed their thoughts on representation, utopia, and revolution to Disney or Fleischer output, or to entertain the idea that the flattening of surfaces and the denial of perspective troubled simultaneously New York art critics, and *New Yorker* cartoonists, not to mention myopic Mister Magoo.
>
> Modernist theorists and artists were fascinated by cartoons. And those who took cartoons most seriously were political revolutionaries. As such they were anxious to develop new vocabularies for cultural and social forms within a totality that also contained possibility. They were modernists, not 'high modernists' and all that implies, but proponents of a demotic modernism that was open to base impulses and ever curious about the shadow side, the mass market of industrialized cartoons.[62]

Diego Rivera, Thomas Hart Benton, and John Steuart Curry fit the description of modernist as defined by Leslie. Their interest in the Disney character as an emblem of art in the broadest sense, and of American art in particular, earned them a place in the ranks of those

who rejected a "sealed-off," "high-modernist," Eurocentric esthetic. Until around 1940, as we have seen, a respectable minority of museum curators, art critics and writers subscribed to that view of Mickey. After the Second World War, the populist strain in high art exemplified by the Regionalist Triumvirate all but disappeared. By 1946, Grant Wood and Curry were dead, abstraction was king. Benton survived into the age of Pop (he died in 1975), but whatever postwar prestige he enjoyed in elitist eyes stemmed from the belief that "his teaching and example," as one scholar noted, contributed to "the evolution of Jackson Pollock, abstract expressionism's original golden boy."[63]

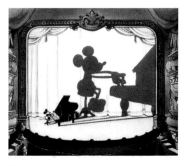

253. Mickey Mouse at the piano in *Blue Rhythm*, released by Columbia, Aug. 18, 1931. Cel on production background, ink, watercolor, and gouache. Joe D'Igalo (1898–1987) was the animator assigned to this scene. Walt Disney Archives, Burbank, California.

In 1990, *Fantasia* was released once again as a theatrical feature. *Washington Post* film critic Henry Allen facetiously called it "Disney's glorious monument to midcentury middlebrowism," adding: "No doubt dutiful, reverent, forward-thinking, nostalgic, self-improving parents will be hauling children to it by the Volvo load." Why? Because: "You know you are supposed to like 'Fantasia' the way you are supposed to like 'Tom Sawyer,' or the Mormon Tabernacle Choir, or Bob Hope, or the recent PBS series about the Civil War—cozy icons you're obliged to enjoy as if they stand for something higher." Allen nevertheless assured his readers that *Fantasia* "is still glorious." Reflecting, perhaps, a familiarity with Richard Schickel's book, *The Disney Version*, he declared:

> Disney, let us not forget, was a genius whose medium was the American psyche—its fascination with technology along with its yearning for old Europe, its cultural inferiority complex along with its democratic desire, back [. . .] when so much seemed possible, to make new art in a new land by putting high and low culture together. Gershwin had done it with "Rhapsody in Blue." Thomas Hart Benton returned from Paris to paint murals of farms and industry. Pete Seeger dropped out of Harvard to invent a new "folk music." Thornton Wilder wrote "Our Town."
> Disney came up with "Fantasia."

By 1990, when these words were written, it was, Henry Allen said, "difficult to keep faith in the uplifting power of high culture as the American arts community sinks ever further into a sullen sump of self-reference and grantsmanship, notable less for civilizing genius than for self-righteousness, obscurity, obscenity, and the boondoggles of academia." *Fantasia* has endured, Allen concluded, and become "part of the Disney gospel as Disney himself became a prophet and saint of the American way", even as "the American way became a joke among the higher-educated classes in the 1960s."[64]

"POP" GOES
THE MOUSE

Ever the perfectionist, Walt Disney instituted weekly life-drawing classes for his staff on the sound stage of the Hyperion Avenue studio. In an eight-page memorandum to Donald Graham, a gifted instructor at the Chouinard School of Art in Los Angeles, dated December 1935, Walt outlined his ambitious program to "work out a very systematic training course for young animators" and articulated what he believed was job one in animation:

> I am convinced that there is a scientific approach to this business, and I think we shouldn't give up until we have found out all we can about how to teach these young fellows the business. The first duty of the cartoon is not to picture or duplicate real action or things as they actually happen—but to give a caricature of life and action—to picture on the screen things that have run thru the imagination of the audience to bring to life dream fantasies and imaginative fancies that we have all thought of during our lives or have pictured to us in various forms during our lives. Also to caricature things of life as it is today—or make fantasies of things we think of today.

As Disney further explained, "the true interpretation of caricature is the exaggeration of an illusion of the actual; or the sensation of the actual put into action."[1]

Walt was determined to apply his core belief that animation involves "caricature"—the deliberate, meaningful, illusionistic distortion of reality—to filmmaking of ever greater quality on an increasingly ambitious scale. Toward that end, he hired three men with Continental, though hardly high-art, credentials, starting with Swiss-born Albert Hurter and Hungarian Ferdinand Horváth, in 1932 and 1934, respectively, to provide background and concept drawings for the Silly Symphonies. Joined in 1936 by a Swede, Gustav Tenggren, these men's European origins would

254. Eduardo Paolozzi (1924–2005), *Real Gold*, 1950. © 2013 Trustees of the Paolozzi Foundation, Licensed by DACS / Artists Rights Society (ARS), New York Mixed media collage mounted on card support, 14 x 9¼ in. Tate Gallery, London.

ultimately help assure authenticity of visual detail and a truer overall tone for feature-length Old World tales like *Snow White and the Seven Dwarfs* and *Pinocchio* that Disney meant to produce.[2]

Walt Disney never met Piet Mondrian, another perfectionist of the first order and one of the most estimable figures in modern art. The cool, reductionist grid of black, white, red-yellow-and-blue that typifies Mondrian's mature style might seem wildly opposed to the emotional cascade of music, color, and images in *Snow White*. But Mondrian was enthralled by the film. After moving from Paris to London in 1938, he mailed to his brother and sister-in-law back in his native Holland a dozen or so picture postcards (including some he drew himself) embellished with characters from *Snow White*. In March 1940, he saw *Pinocchio*, which disappointed him ("a mixture of good and bad and an archaic moral"). As the Blitz got underway, Mondrian left for New York (where he died in 1944), arriving a little over five weeks before the premiere of *Fantasia*, in November 1940, though there is no indication that he ever viewed the lushest fruit born of Walt's aspiration to combine the popular visual medium of animation with concert-hall music.[3]

Two of America's foremost figurative painters did put their seal of approval on the project. Several studio publicity shots show Thomas Hart Benton and Grant Wood, among a group of fellow artists, looking appreciatively at painted character models for the "Pastoral Symphony" sequence of *Fantasia*. Other photos show dancer-choreographer George Balanchine and his Russian compatriot, composer Igor Stravinsky, inspecting figurines for the "Dance of the Hours" segment. As we know, the political cartoonist David Low also had enormous respect for Disney. In remarks before the English-Speaking Union at Grosvenor House, London, six months after they met during Walt's 1935 visit to England, Low said that "Mickey Mouse is the only public figure in the world today who is universally loved." And of course, in 1942, in his piece for Benton's old enemy, the *New Republic,* Low would, with *Fantasia* and *Bambi* in mind, describe Disney as "the most significant figure in graphic art since Leonardo."[4]

Low's opinion of *Fantasia* was not shared by his fellow Brit Graham Greene, who said that "the world of Disney is a world of children's storybooks." "It was no doubt," Greene added, "a mistake to want to connect such a world with the mature imaginations of Bach and Beethoven." But Low's praise was in sync with that of Bosley Crowther, chief film critic for the *New York Times,* who, in his review of *Fantasia,* wrote:

> At the risk of being utterly obvious and just a bit stodgy, perhaps,
> let us begin by noting that motion picture history was made at the

Broadway Theatre last night with the spectacular world premiere of Walt Disney's long-awaited "Fantasia." Let us agree, as did almost everyone present on the occasion, that the sly and whimsical papa of Mickey Mouse, Snow White, Pinocchio, and a host of other cartoon darlings has this time come forth with something which really dumps conventional formulas overboard and boldly reveals the scope of films for imaginative excursion. Let us temperately admit that "Fantasia" is simply terrific—as terrific as anything that has ever happened on a screen. And then let's get on from there.

In his review, Crowther also anticipated the fuss that soon erupted from elitist precincts over the film:

What the music experts and the art critics will think of it we don't know. Probably there will be much controversy, and maybe some long hair will be pulled. Artistic innovations never breed content. But for this corner's money—and, we reckon, for the money of anyone who takes it in the blithe and wondrous spirit in which it is offered—"Fantasia" is enchanting entertainment.[5]

Much long hair indeed was pulled because of *Fantasia*. As Russell Lynes observed, in his book *The Lively Audience: A Social History of the Visual and Performing Arts in America, 1890–1950*, "Dedicated music lovers were distressed by the cheapening, as they saw it, of serious art. Intellectual devotees of animation and Mickey Mouse considered it pretentious nonsense." Otis Ferguson, the *New Republic*'s regular film reviewer, emboldened perhaps by Graham Greene's critique, agreed that Disney was mistaken when he tried to combine serious music with fantasy. In his take on *Fantasia*, in November 1940, Ferguson stated:

In a general or show-business way, I think Mr. Walt Disney has made his first mistake. Someone told him about the capital letter in Music, or more specifically someone introduced him to Dr. Leopold Stokowski. This is a wrong-foot start for describing "Fantasia," . . . but I do wish that people who are simply swell in their own right would stop discovering about art and stuff and going swish. First Chaplin learns about the class struggle; now Disney meets the Performing Pole. And it's worse in Disney's case, because his studio has always turned out the most original sound-track in films.[6]

Writing in *Art News,* a then-fashionable, now-forgotten painter, I. J. Belmont, was "saddened to see the great Stokowski stoop to conduct that heavenly 6th Symphony of Beethoven as conceived by Disney." And, in a

piece for *Theatre Arts* magazine, Harvard-educated writer-painter-architect Christopher La Farge called *Fantasia* "another example of the failure of taste and of analyzed conception [that] succeeded in proving beyond further necessity of proof that to illustrate music with drawing is impossible and useless; but that music can be used magnificently as an adjunct to drawing."[7]

In 1947, two of Walter Benjamin's one-time colleagues at the Institute for Social Research at the University of Frankfurt-am-Main (the Frankfurt School), Max Horkheimer and Theodor W. Adorno, published a bleak Marxist critique of modernity, *Dialektik der Aufklärung* (Dialectic of the Enlightenment), in which they said, "Cartoons were once exponents of fantasy as opposed to rationalism," but had become instruments that "confirm the victory of technological reason over truth." By cartoons, they meant Walt Disney . . . and, more specifically, Mickey's successor as king of the fast-paced Disney one-reeler, Donald Duck, who, like "the unfortunate in real life," they wrote, gets his "thrashing so that the audience can learn to take their own punishment."[8]

Horkheimer and Adorno did not comment on *Fantasia*, and the first English edition of their opus did not appear for a quarter-century. However, prior to its translation, their sober slant on Disney must have penetrated the minds of leftist intellectuals in Europe and the United States where, by the 1960s, postmodernist doctrine had begun its ascent to academic prominence. Meanwhile, from the 1940s into the '60s, the views that prevailed in elitist American circles with respect to *Fantasia* and Disney's artistic ambitions remained those expressed, circa 1940, by Graham Greene, Otis Ferguson, I. J. Belmont, and Christopher La Farge. In 1958, those views were pared to their bare-bones essentials by the esteemed Vienna-born British art historian Ernst Gombrich, who stated that, by "prematurely trivializing" the marriage of "music and pure shapes" in *Fantasia*, Disney had discredited the experimental union of different artforms.[9]

Despite *Fantasia*'s failure to turn a profit and its rejection by refined tastemakers, Disney continued to envision films that combined animation and artistry of a higher order. In 1946, Tom Benton worked up an outline for a Davy Crockett "musical production" that might have figured in such a project, but was never made. At one point, plans for a follow-up to Walt's two Latin and South American features, *Saludos Amigos* and *The Three Caballeros,* involved a six-minute segment called *Destino,* combining song, live-action dance, and Surrealist animation conjured up by Salvador Dalí. In 1946, while in Hollywood collaborating on Alfred Hitchcock's *Spellbound,* Dalí was engaged by Disney to develop ideas for *Destino* [255]. A test clip was made, but, for financial reasons, both *Destino* and the package feature were scrapped. It was not until fifty-seven years

later that, under the aegis of Walt's nephew Roy E. Disney, utilizing Dalí's original art and storyboard work, *Destino* was completed and publicly screened for the first time at the Annecy Film Festival in France, in 2003.[10]

Other artists of Rivera's, Benton's, Mondrian's, and Dalí's stature may have admired Disney. If so, after about 1940, and certainly by 1950, it was not wise to let it be known. In the 1930s, Walt had been honored by the left, his studio perceived as a model of machine-age, artistic collaboration, generating top-notch visual fantasy for all levels of society. In Frank Capra's Depression-era comedy, *You Can't Take It with You* (1938), Disney's production methods were represented as embodying the antithesis of dehumanizing materialism. In the film, Jean Arthur plays a young woman who lives with a large extended family of eccentrics. Early in the action, five members of the household are seen in a basement workshop, engaged in their individual oddball projects, to the tune of "Whistle While You Work" from *Snow White.* After Arthur's beau, James Stewart, meets the quirky crew, he tells her, "I was just thinking about that family of yours. Living with them must be like living in a world that Walt Disney might've thought of. See, everybody just does as he pleases, doesn't he?"[11]

255. Salvador Dalí (1904–89), *Pyramid Reflected in a Pool,* preliminary study for *Destino,* 1946. Watercolor. Salvador Dalí, Fundació Gala-Salvador Dalí, Artists Rights Society (ARS). Disney Animation Research Library, Glendale, California.

256. Ronald Reagan, Bob Cummings, and Art Linkletter, cohosts of the live ABC-TV broadcast of the grand opening of Disneyland, July 17, 1955. Walt Disney Archives, Burbank, California.

That rosy image of Disney changed in 1941 when he became embroiled in a bitter labor dispute with striking studio employees. By the 1960s, he was an avid supporter of two prominent conservative politicians, Senator Barry Goldwater, the Republican presidential nominee in 1964, and Walt's fellow Californian (and fellow Illinoisan) Ronald Reagan, the fading film star and corporate spokesman for General Electric, who cohosted the televised first-day festivities at Disneyland in 1955 [256] and had become an outspoken anti-Communist in the late 1940s and early 1950s.

To the extent that art-world movers and shakers were conscious of Disney's politics, his undisguised conservative bent could only confirm their disdain for romantic froth like *Cinderella* (1950) or the feeble postwar Mouse animations. Au courant postwar artists, patrons, dealers, curators, critics, and academics were committed to the *style du jour:* nonrepresentational art, whose chill existentialist ethos spelled poison for a cartoon character as a player on the flattened field of modern art. Chances were slim at best that a flip figural motif like Mickey Mouse would fire the imagination of an Abstract Expressionist like Jackson Pollock (despite his ties to Benton) or Willem de Kooning, much less one of their more ascetic heirs, Hard Edge or Color Field painters such as Josef Albers and Ellsworth Kelly.

Pop Art, the greatest twentieth-century revival of figural expression, and the most mass cult–friendly artistic movement since Cubism, would, on the other hand, draw Mickey Mouse to its bosom. In a *Time* magazine review of a 1999 Whitney Museum retrospective of modern American art, Steven Henry Madoff wrote:

> It is hard to imagine a more explosive, splintered era in art making than the past 50 years in America. The roll call is dizzying—happenings, body art, minimalism, earthworks, conceptualism, neo-Expressionism, installations—to name just a few of the schools that have swum vigorously or otherwise through public waters. [...]
>
> Yet for all that, there have arguably been just two moments of final consequence to art's mainstream in the past half-century: Abstract Expressionism, with its reinvention of the spiritual; and its brazen opposite, Pop, whose smart, smirking celebrations of Brillo boxes, billboards, and Mickey Mouse smiled into the heart of postwar America and found it made of chrome.[12]

Ironically, the return of Mickey Mouse to the good graces of art with a capital "A" may have come about as a result of his role in *Fantasia,* which was re-released in 1963 and again in 1969. In an essay in *Time* in 1973, in an article titled "Disney: Mousebrow to Highbrow," Robert Hughes regarded *Fantasia* as of seminal importance for Pop Art. Taking

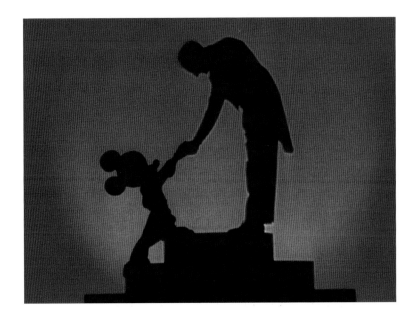

257. Mickey Mouse shaking hands with Leopold Stokowski in *Fantasia* 1940. The Walt Disney Archives, Burbank, California.

a contrary tack from Gombrich's pre-Pop negativity—and, apparently, unaware of Disney's links in the 1930s to Rivera, Benton, and Curry—Hughes declared:

> The point at which the flow reversed and Disney's iconography began affecting high art can be identified almost to the frame it happened when, in *Fantasia,* Mickey Mouse clambered up on the (real) podium and shook hands with the (real) conductor Leopold Stokowski [257]. High and low art collapsed into one another. It was inevitably Mickey who made Stokowski more of a star by the handshake, not the other way round. The gesture made Pop Art possible and, after a gestation of nearly 20 years, it arrived in a flurry of mice.[13]

For his 1980 television series about modern art, *The Shock of the New,* Hughes expanded on this remark:

> The hostility with which American defenders of *le beau et le bien* viewed the products of mass culture in the fifties was given its special edge by their sense of isolation and embattlement: their frail precincts, the universities, small magazines, and art schools, were threatened by McCarthy as well as by philistinism. [...] The first glimmer of another attitude perhaps came as early as 1940, in Walt Disney's *Fantasia,* when Mickey Mouse was seen to mount the podium and shake hands with Leopold Stokowski; but for most serious writers, composers, and especially painters and sculptors, there could be no *rapprochement* between the imagery, let alone the values of high and low art. Indeed, there was no low art as such. There was only kitsch, foisted upon a dumb manipulated public by flacks, sellouts, and moguls; and from that, art had nothing to learn.[14]

The pangs of fear planted in elitist hearts by the prospect of a high-low *rapprochement* were not unfounded. It originated in Europe in 1947 when the German Dadaist Kurt Schwitters incorporated a print cartoon into a tiny, unassuming collage, *For Käte.* In Paris, the following year, English artist Eduardo Paolozzi made an even more dramatic leap. Between 1948 and 1952, the year in which he co-founded the avant-garde Independent Group, Paolozzi pasted together a series of ten small collages called *BUNK*, a thematic rubric inspired by Henry Ford's words of vintage American know-nothing wisdom: "History is more or less bunk. It's tradition. We don't want tradition. We want to live in the present and the only history that is worth a tinker's damn [*sic*] is the history we make today."[15]

Meet the People [258], from 1948, one of the first works in the *BUNK* series, was a proto-Pop stab at middle-class culture. It features Minnie Mouse primping with face powder, surrounded by clichéd emblemata of domesticity plucked from the popular prints: a plate of fruit, glass of juice, and can of tuna fish. Another key component of the collage is a publicity shot of Lucille Ball (from pre–*I Love Lucy* days) for a run-of-the-mill soufflé of romance, music, patriotism, and comedy from MGM, *Meet the People*—hence the populist-tinged title of the work. In 1950, Paolozzi made a de facto pendant to *Meet the People.* This second collage, *Real Gold* [254], has as its main elements a print ad for "Real Gold

Pure California Lemon Juice" and a clipping of an impish, 1930s-era Mickey Mouse, glued to the rump of a starlet in a two-piece swimsuit. The scantily clad pin-up fills the cover of a pulp fiction magazine, *Breezy Stories,* which provides the ground for the collage. Slugged at the top, "BETTER THAN EVER," the magazine's feature story, headlined above Mickey's head, is "Novelet of Hollywood."[16]

Independent Group members like Paolozzi, as Kirk Varnedoe and Adam Gopnik have said, were "fascinated by the more colorful, sexier, and gaudier exotica of consumer life" in postwar America that came to Europe via magazines and other media. The IG's fascination, though, was tinged with repugnance as well as curiosity. In Paolozzi's two collages, the pungent tastes we associate with lemon juice and tuna fish empathically reinforce his jabs at bourgeois consumerism and pop-cult entertainment. By the late 1940s, Mickey and Minnie Mouse were, by Henry Ford's lights, "history," trapped in the amber of cultural "tradition." Paolozzi's focus on the cartoon couple in these works also reflects at least a jot of bemused affection—or nostalgia. That ambiguous message recurred in 1967 when Paolozzi again turned to the Mouse of old for the design of a sprightly tapestry [259]. Mickey had been a paragon of contemporary mass culture for Benton. By snipping and pasting prewar imagery of the peppy rodent couple, Paolozzi gave an intentionally musty, ironic edge to his critique of

259. Eduardo Paolozzi and Archie Brennan, director of weaving, *The Whitworth Tapestry,* 1967. Tapestry, 60 x 68 in. The Whitworth Art Gallery, University of Manchester, England. © 2013 Trustees of the Paolozzi Foundation. Licensed by DACS / Artists Rights Society.

260. Peter Saul (1934–), 1962. Oil on canvas, 59 x 71 in. Copyright Peter Saul, courtesy Mary Boone Gallery, New York.

imposing on the postwar world. So it was that these two collages, plus Paolozzi's fixation on Mickey as a motif in his tapestry, not Benton's Whitney mural from the early 1930s, more properly anticipated every Pop and postmodern treatment of Mickey Mouse to come.[17]

In her book *Attached to the Mouse: Disney and Contemporary Art*, Holly Crawford inventoried some 130 postwar American and European artists, starting with Paolozzi, who "used Disney" in their work. The best known of these appropriations, needless to say, were by the leading lights of Pop Art: Roy Lichtenstein, Claes Oldenburg, and Andy Warhol, who, like Paolozzi, Updike, and Sendak, all were born in the 1920s and grew up with Mickey. One of the first bona fide Pop pictures, Lichtenstein's 1961 canvas *Look Mickey (I've Hooked a Big One!)* [262] ushered in stage three of Mickey's career, the phase that gave him a truly mythic dimension. The genesis of *Look Mickey,* an affectionate pastiche of a Disney children's book of the period, was intimately connected to the painter's coming of age, during his Abstract Expressionist period in the late 1950s. As Lichtenstein once explained, "I began putting hidden comic images into those paintings, such as Mickey Mouse, Donald Duck and Bugs Bunny. At the same time I was drawing little Mickey Mouses and things for my children and working from bubble gum wrappers." "Mickey's Son and Daughter," from 1967, a retro rendition of a tune from 1935, by the Monty Python–ish British mock-pop group the Bonzo Dog Doo-Dah Band, represents a faux formulation of the same spirit of gaiety and childlike innocence:

> All the world is so delighted.
> And the kids are so excited.
> 'Cause the stork has brought a son and daughter
> For Mr. and Mrs. Mickey Mouse.[18]

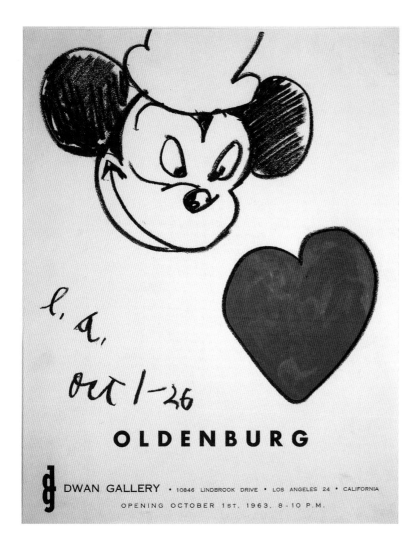

261. Claes Oldenburg, poster for his one-man show at the Dwan Gallery in Los Angeles, October 1963. Color offset, 22 × 17 in. Walt Disney Family Foundation, San Francisco, California. A study by Oldenburg for this poster (wax crayon and watercolor on paper, measuring 16 5/8 × 13 3/4 in. and inscribed "C.O./63"), was gifted to the Whitney Museum of American Art in 2002 by The American Contemporary Art Foundation, Inc., Leonard A. Lauder, President.

Yale-educated Claes Oldenburg—"the thinking person's Walt Disney," as Robert Hughes called him—had a darker, more convoluted relationship with Mickey Mouse than did Lichtenstein or Warhol. The son of a Swedish diplomat, Oldenburg came to America in 1936 at the age of seven. Influenced initially, perhaps, by Lichtenstein and by "the errant breed of Pop" of Californian Peter Saul, whose *Mickey Mouse vs. the Japs* was painted in 1962 [260], Oldenburg's Mickey-themed projects, which continued into the 1990s, originated with a poster for a one-man show in Los Angeles in 1963 [261].[19]

Within two years' time, Oldenburg transformed that first Mickey, which he termed "soft, curvy, and humanized," into a "simple schematic form" that led to a horde of like-minded objects and images, including a mask for a New York performance called *Moveyhouse* and a letterhead motif for an exhibition in Stockholm. The latter design, *Geometric Mouse*, is a witty, Rorschach-like splattered-ink drawing in which circular ears and a square skull double as the reels and body of an old-fashioned movie camera from Mickey's salad days, circa 1928–30. Oldenburg also

262. Roy Lichtenstein (1923–97), *Look Mickey*, 1961. Oil on canvas, 48 × 69 in. Gift of the artist, in Honor of the 50th Anniversary of the National Gallery of Art © Board of Trustees, National Gallery of Art, Washington, D.C.

remembers, in 1965, making "drawings for a building in the shape of the geometric mouse head to house my 'museum of popular art,' that was to become the *Mouse Museum*."[20]

Lichtenstein's appropriations of cartoon characters, like Doug Ross's Mousegetar-inspired computer program, were partly spurred by paternal devotion. Oldenburg's take on Mickey Mouse is anything but kid-friendly. "Both Lichtenstein and Oldenburg," Varnedoe and Gopnik remarked in their catalogue for the MoMA exhibition *High & Low*, shared the "dream of finding a modern mythology in the comic strip." But, they said, Lichtenstein's mythology

> was still paradisiacal: an imaginary folk culture, a coherent world
> of stereotyped action that seemed at once to echo and second the
> apparently sophisticated world of avant-garde gestures. Oldenburg's
> pop mythology is, by comparison, almost Hindu in its multiplicity,
> and sinister in its effect. His Mickey is, by turns, lecherous,
> benevolent, frightening, and distant, the benevolent overseeing
> presence in the temple of shopping and the hard, impassive, sacrifice-
> demanding deity of the museum—a mouse whose three circles
> suggest a thousand faces.[21]

In 1978, Oldenburg established the definitive inventory of the Mouse Museum, a collection of hundreds of pieces of pop effluvia he had found or made over the years. A small-scale sculptural abstraction of Mickey's head, likewise called *Geometric Mouse*, which was adapted as a logo for his 1969 show at the Museum of Modern Art in New York, had begun as an architectural design for the Mouse Museum. Eventually, starting in 1969 and carrying on into the 1970s, seven large-scale versions of *Geometric Mouse* joined Oldenburg's output of crowd-pleasing public-art installations like Chicago's *Batcolumn* and *Clothespin* in Philadelphia.* The biggest of the seven *Geometric Mouse* pieces, in bright red with nine-foot ears, now sits in front of the downtown Houston Public Library in Texas. Smaller nine-foot-tall models, in blue and yellow respectively, are sited outside museums in Stockholm and Minneapolis. There is also a white *Geometric Mouse* on view, on a rotating basis, in the sculpture garden at MoMA, with black versions on the Mall at the New York state capitol in Albany, at Southern Methodist University in Dallas; and in the Hirshhorn Museum and Sculpture Garden in Washington.[22]

Oldenburg's *Mouse* works are, in Varnedoe and Gopnik's words, "benevolent," not "frightening." The substitution of one canonical geometric shape (the square) for another (the circle), combined with the rectangular flapdoor eyes and slanting, slammed-to-the-ground positioning of the pieces, is a clever deflation of Mickey's normally

* Regrettably, Mr. Oldenburg refused to grant me permission to publish even one of his *Geometric Mouse* images, saying in an e-mail, "I just don't think it belongs in a book called Mickey Mouse."

jolly, well-rounded persona. But a decidedly "frightening" side to Oldenburg's reconstructive mythologization of the Mouse was evident in an appendage to the Mouse Museum dubbed "the Ray Gun Wing." In the late 1980s, Coosje van Bruggen, Oldenburg's spouse and artistic partner, explained why Oldenburg chose to relate Mickey to guns, other gun-shaped objects, and a second cartoon character we already know:

> The release of violence is transformed into an energizing force, as it is in George Herriman's *Krazy Kat* comic strip when Ignatz the mouse throws his bricks at the Kat. [...] When the brick bounces off Krazy Kat's head, a little heart spirals off it as well, symbolizing gratitude to the mouse for paying attention. Oldenburg prefers Ignatz, who in his ingenious wickedness is described as "a malignant little tangle of barbed wire" to the well adjusted, conformist Mickey Mouse.[23]

Oldenburg's rejection of the "well adjusted, conformist Mickey Mouse" in favor of Ignatz's "ingenious wickedness" suggests a personal dimension to his 1967 poster design [261], wherein a demonic Mouse, as the sorcerer's apprentice, glowers at a dark red heart floating in space. Indeed, van Bruggen's statement must be read in light of a seemingly contradictory remark by Oldenburg, who once said, "I'm the Mouse," adding, "In other words, the *Mouse is a* state of mind." Comments like these, in the context of Oldenburg's almost obsessive-compulsive reiteration of Mickey's image, over a span of some three decades, further suggest a love-hate relationship not unlike Krazy Kat's masochistic response to Ignatz's brickbats.[24]

Oldenburg's *Geometric Mouse* installations, like his more colossal, impersonal, and less problematic public commissions in Chicago or Philadelphia, tickle the fancy of most everyone. They exude ironic subtextual scents as well that are pleasing to intellectuals and esthetes. Much the same can be said of Andy Warhol, though Oldenburg wrought his magic from within the friendly confines of High Art, whereas Warhol, the quintessential outsider, as Dave Hickey has said, employed his "Pop images to mount an all-out assault upon the elite citadel of American high culture," which, in the early 1960s, "couldn't have been less ready to destroy the boundaries between 'real' art and 'commercial' art." Warhol's productions, furthermore, represented a clear-cut positive response to the gloomy mindset prevalent among postwar intellectuals and artists, typified by Jackson Pollock, who, as Hickey remarked, were in

despair over America—over American television, American business, American movies, American cars, American music, and American

263. Keith Haring (1958–90), *Andy Mouse,* 1986. Silkscreen print, 38 × 38 in. © The Keith Haring Foundation. Keith Haring Studio, New York.

suburbia and its tacky interior design. Entire careers, like those of Lewis Mumford, Dwight McDonald, and Clement Greenberg, were built upon articulation of this despair.

The Barbarians were at the gate: Elvis was in Memphis, Buddy Holly was in Lubbock, Marilyn was in Hollywood, and Jack Kerouac was on the road between them. The Hucksters of Madison Avenue were using "hidden persuaders" to sell us things we weren't supposed to want, and *all* the young artists were worried about "selling out"—accidentally or on purpose.

Warhol was not worried about selling out. On the contrary, in the final two decades of his life, he wanted nothing more than to cash in. "The industrial and entrepreneurial tradition" that, in Schickel's words, "both moved and sheltered" Walt Disney, was one that Andy, in his unique way, wanted to be a part of.[25]

Oldenburg's stance with respect to that tradition, like his stance vis-à-vis the Mouse, was conflicted. Warhol's Mouse art came straight from the heart (like Sendak and Mickey, he was born in 1928). It is tempting to dismiss Warhol as a purveyor of pseudo-chic, commercial schlock. But, as Susan Sontag, à la Gilbert Seldes, wrote in her 1964 essay "Notes on 'Camp,'"

> The experiences of Camp are based on the great discovery that the sensibility of high culture has no monopoly on refinement. Camp asserts that good taste is not simply good taste; that there exists, indeed, a good taste of bad taste.[26]

Whether or not Sontag's gloss on taste applies to Warhol's affinity for Camp-grounded content and his predilection for the more marketable medium of silkscreen over painting, Andy certainly wore his affection and admiration for Disney on his sleeve. Once, when asked to name an artist from the past that he would want to paint his portrait, he replied, "Walt Disney. He'd make me like a duck." Walt's accomplishments also furnished a career template for Warhol. According to Bruce D. Kurtz, Disney's far-flung endeavors inspired Andy "with empire-building ambitions of his own in painting, printmaking, photography, films, and publishing." Warhol is best known for his larger-than-life silkscreened effigies of Mickey, Marilyn, Mao, Jacqueline Kennedy Onassis, Campbell's Soup cans, and Brillo boxes. However, there was more to Andy than that. He made and produced motion pictures, ran a sound-and-light nightclub, was a cofounder of Lou Reed's rock group the Velvet Underground, and launched a celebrity fan magazine called *Interview.* Even the name given informally by Warhol to his

collaborative operations in the early or mid 1960s, "The Factory," evokes the longstanding nickname of the Disney studio, "the Mouse Factory."[27]

Warhol might have imagined himself as a bespectacled, fright-wigged cousin (or nephew?) to Donald Duck, but it was as Mickey Mouse that he was lampooned in a clever parody of one of his self-portraits by Mark Caywood. And that was how, at least a half dozen times, his friend and protégé Keith Haring portrayed him. In 1986, Haring created a portfolio of silkscreen prints called *Andy Mouse* [263] and a drawing, "Money Magazine 'Andy Mouse Bill,'" about which Haring said:

> It's like treating him [Warhol] like he was part of American culture, like Mickey Mouse was. That he himself had become a symbol, a sign for something completely, universally understandable. He sort of made this niche for himself in the culture. As much as Mickey Mouse had . . . putting him on a dollar bill was just making him even more like an icon or part of the American dream.[28]

Dave Hickey has surmised that Warhol's soup cans "reminded him of his mother, his *mother,* for heaven sake, and of quiet afternoons in Pittsburgh," where Andy grew up, "and New York, when she would heat him up a can of Campbell's." The industrial sameness of Campbell's soup, like Proust's madeleine, was comfort food that triggered warm memories of things past, as did Mickey Mouse, on an esthetic level. The artist's brother, John Warhola, has recalled that:

> When Andy was about eight he wanted a movie projector. My dad couldn't afford to buy it so my mother would do some housework one

264. Andy Warhol, *Myths Portfolio*, 1981. Ensemble of ten screenprints, each 38 × 38 in. The "mythic" figures represented, running clockwise from the top left, are Mickey, Howdy Doody, Santa Claus, Greta Garbo, Dracula, a self-portrait of Warhol as the Shadow, Mammy (Aunt Jemima), the Wicked Witch of the West, Uncle Sam, and Superman. The Andy Warhol Foundation for the Visual Arts, Inc. / Artists Rights Society (ARS), New York.

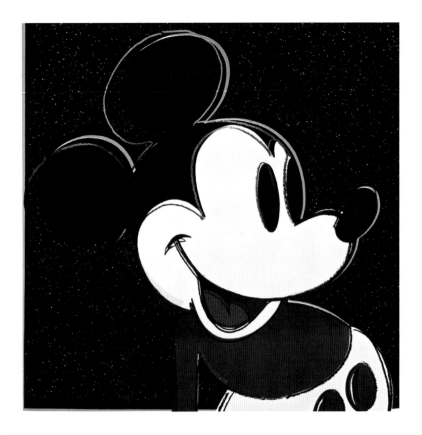

265. Warhol, *Mickey Mouse,* from the *Myths Portfolio,* 1981. Silkscreen print with diamond dust, 38 × 38 in. Private collection, California.

or two days a week. I remember she got a dollar a day, and this projector was around ten dollars, so she saved the money up and got it for Andy. He'd buy a film of Mickey Mouse or something like that and show it on the wall over and over again.

Warhol's Mickey was conceived as part of his 1981 ten-piece silkscreen project, *Myths Portfolio* [265], an ensemble that must be laden with childhood memories. Nine of the subjects were mainstays of pre- and postwar popular culture: Uncle Sam, Santa Claus, Greta Garbo, Mickey, Superman, Dracula, the Wicked Witch of the West (from *The Wizard of Oz*), Aunt Jemima, and Howdy Doody. The tenth panel is a portrait of Warhol himself, presented as the crime-busting vigilante hero of a radio series, *The Shadow,* that aired in the 1930s. Here at last, Andy, who'd long aspired to the status of pop idol, carved a niche for himself in his own personal, modern-day Temple of Fame.[29]

Of all the figures in the *Myths* series, Mickey Mouse [264] was the one most often repeated by Warhol, the one he seems to have been most attached to (or, perhaps, could make the most money from). His simple yet powerful effigy assumes added weight if we remember this statement by John Culhane: "Mickey's face is a trinity of wafers—and the circular symbol, as C. G. Jung has told us, 'always points to the single most vital aspect of life—its ultimate wholeness.'" But the Warhol Mouse is composed of ovals, not circles—in the ears, eyes, muzzle, and cheeks. Ovals are squashed circles. Their formal compression adds subliminal

energy to the basic spherical wholeness of Andy's totemic design, an image that can be seen to have capped the widespread popular and critical comeback for the Disney character that had commenced in the 1960s. In its various versions, it is arguably the single most iconic of Mickey's many masks.[30]

Over the last thirty years or so, Mickey Mouse has inspired numerous non-, post-, or crypto-Pop American and European artists working in every imaginable medium, from traditional painting to sculptures to installation pieces in some of the world's most prestigious museums. An impressive array of artists working in the United States can be included in this group, including Les Krims, Saul Steinberg, Keith Haring, Llyn Foulkes, Joyce Pensato, Wayne Thiebaud, Peter Saul, Philip Pearlstein, and Robert Anderson. In the rest of the world, we can look to Michael Sandle and John Keane in the United Kingdom, to Otto Künzli in Switzerland [279], to the Dutch artist Rob Birza, whose *Mickey of the Blind (Sea of Lights)*, made in 1989–90, is a visual metaphor about AIDS [266], and, in France, to the sculptors César [267] and Philippe Parrot Lagarenne, whose gaminelike "Miquettes" offer a piquant amalgam of a slimmed-down Minnie and a Japanese geisha girl.

The conceptualist photography of Les Krims might be tagged "Son of Dada meets *National Lampoon*." Krims's fanciful social satire, spiked with naked ladies, is typified by *The Static Electric Effect of Minnie Mouse on Mickey Mouse Balloons* (1968), in which a comely nude in a Mouse mask is posed in front of intersecting rows of Mickey-headed toy balloons that form a cross [269].

A generation later, the artist-composer Llyn Foulkes may have had Krims's *Static Electric Effect of Minnie Mouse* in mind when he decried the rage for product branding that has "gotten into everybody so much that it's almost like a religion and that's why Mickey Mouse is the cross." "He's the Crucifixion," Foulkes said. "He's the thing that they are worshiping." Thus Krims's photograph functions on three levels: as a hit on Christianity, on conventional high-art genres like

266. Rob Birza (1962–), *Mickey of the Blind (Sea of Lights)*, 1989–90. Painting. Artists Rights Society (ARS) New York / PICTORIGHT Amsterdam. Collection Stedelijk Museum, Amsterdam.

267. César, aka César Baldaccini (1921–98), *Mickey*, 1986. Etching, 11 x 15 in., no. 70 in a signed print run of 80. Galerie Champetier, Cannes (France). © 2013 Artists Rights Society (ARS), New York / ADAGP, Paris. A similar image was published as a New Year's greeting for kids in the Paris daily *Le Figaro*, Jan. 1, 1986.

268. John Keane (1954–), *Mickey Mouse at the Front*, 1991. Oil on canvas, 68 x 78 in. Imperial War Museums, London.

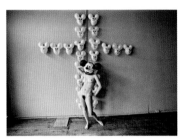

269. Les Krims (1942–), *The Static Electric Effect of Minnie Mouse on Mickey Mouse Balloons*, 1968. Photograph, gelatin silver print transferred with selenium, 8 x 10 in. © Les Krims. Collection of the artist.

the nude and Crucifixion scenes, and, as Foulkes would have it, on unbridled consumerism.[32]

Arguably the the most sinister of the Mouse works of the past three or four decades is Michael Sandle's bronze installation *A Twentieth Century Memorial,* begun in 1971 and completed in 1978. This piece plays off of Oldenburg's Ray-Gun imagery as well as referencing his trademark preoccupation with monumentality. Following in the footsteps of Oldenburg and Sandle, in 1992, John Keane exhibited a painting in a one-man show at London's Imperial War Museum, entitled *Mickey Mouse at the Front* [268].[33]

From the mid-1970s through the early 1990s, Saul Steinberg's use of a stumpy, minuscule Mouse in a clutch of *New Yorker* cover drawings put Mickey in a select repertoire of the cartoonist's stock characters, including a Thanksgiving turkey and Uncle Sam, as satanic emblems of "Amerika"—emblems, in Steinberg's mind, of the dark side of the national psyche [273]. In an essay for an exhibition catalogue of Steinberg's work, John Updike explained that Steinberg's use of Mickey Mouse came about as he tried "to depict the racially mixed reality of New York streets for the supersensitive and race-blind *New Yorker* of the Sixties and Seventies." Steinberg "hit upon scribbling numerous Mickeys," Updike wrote, as a means of depicting "what was jaunty and scruffily and unignorably there."[34]

Steinberg's Mickeys have a spiritual bond with Oldenburg's, Sandle's, Keane's, and Haring's graffiti images of the Mouse, too. It's been said that Haring's work is like a three-legged stool with one leg in the world of fine art, the second in pop culture, and the third in the demi-monde of graffiti counterculture. That countercultural edge is absent in Warhol's Mickeys. Still, Haring told a friend that he viewed both Warhol and Walt as heroes. In one of his earliest renderings of the character [270], Haring, like Warhol [271], exalts the Mouse, albeit in a rougher, campier way than his friend and mentor. In an interview in 1981 in *Arts Magazine,* Haring described the creative origins of this particular picture, which he had made earlier that year:

> The Mickey Mouse figure came out of drawing Mickey Mouse a lot when I was little. I've appreciated this anew because the drawings I'm doing now have more to do with what I drew in high school than anything I did in art school. I did it partly because I could draw it so well and partly because it's such a loaded image. It's ultimately a symbol of America more than anything else.[35]

Although he says nothing here of the figure in the *Myths Portfolio,* also created in 1981, Haring's early Mickey imagery must somehow relate to

Warhol's project. Like the Mouse in the *Myths* series, Haring's drawing is a throwback to the character from a half-century before, not the one typically seen in the mid 1970s, during Haring's high school years. Such retro-iconography was easy to come by. In 1973, Lincoln Center staged its festival of classic Disney cartoons. A profusely illustrated, much publicized volume by Christopher Finch, *The Art of Walt Disney,* appeared in 1973 as well, and the 1978 MoMA program of Disney films occurred even nearer to when Haring and Warhol were making their first Mickeys. That said, Haring's smaller-scale, crudely scrawled renditions lack the grandeur of Andy's designs, which are virtually devoid of irony. Any irony we might attach to them—or, for that matter, to Warhol's Brillo boxes or Campbell's soup cans—comes primarily from the subjects' conceptual opposition to an elitist view of how art should be defined. They represent a triumph of earthbound form, content, and joy over formalist cant.

Californian Llyn Foulkes, whose father-in-law at the time was Ward Kimball, one of the "Nine Old Men" of Disney animation, began using Mickey Mouse in his art in 1983. *Made in Hollywood* and *The Last Outpost* are examples of Foulkes's "relief paintings," mongrel offspring of

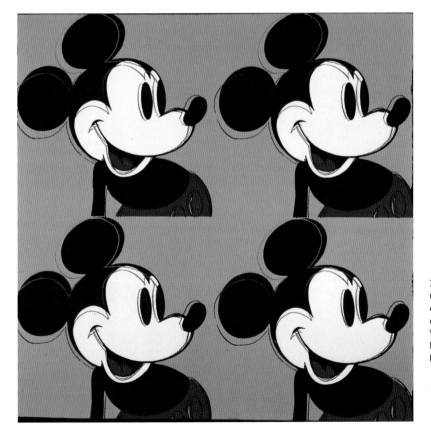

270. Keith Haring, *untitled (Mickey Mouse),* 1981. Black ink on paper, 38¼ x 50 in. © The Keith Haring Foundation, Keith Haring Studio, New York.

271. Andy Warhol, *Mickey Mouse,* from the *Myths Portfolio,* 1981. Silkscreen ink over synthetic polymer paint on canvas, 60 x 60 in. © 2013 The Andy Warhol Foundation for the Visual Arts, Inc. / Artists Rights Society (ARS),. Ronald Feldman Gallery, New York.

trompe-l'œil still-life, Surrealist wit, and the boxed assemblages of Joseph Cornell. In *Made in Hollywood,* a toy handgun fixed to a wall appears to be aimed at a snapshot of Foulkes's own kids. Beneath the gun is a page with guidelines for the original Mickey Mouse Club from the 1930s, among them the precept "I will be a square shooter in my home, in school, on the playground, wherever I may be." *The Last Outpost* [272], titled after an old Hollywood B-picture starring Ronald Reagan (elected president three years earlier), represents a rough-hewn stage set in which the Lone Ranger lies on a wooden floor, grinning insanely (literally "dying of laughter"), having been shot by a boy standing hundreds of feet away, out in the desert. Off to one side, leaning on a classical column, stands a prim-and-proper frontierswoman—a silent witness to the Ranger's death—with a shrunken Mouse head for a skull. One false myth, Foulkes seems to say, that of the straight-shooting values of the Old West, has been done in by another: Mickey Mouse, the "squeaky-clean symbol" who, according to one critic, is visual shorthand here for our "national soullessness."[36]

For an oral history project undertaken by the Archives of American Art at the Smithsonian Institution, Foulkes was asked, "Why do you choose Mickey Mouse?" His response:

Because I have feelings about Mickey Mouse. Mickey Mouse represents America to me. I mean[,] my God, you don't see tourists with American

272. Llyn Foulkes (1934–), *The Last Outpost,* 1983. Assemblage, 81 x 108 x 5 in. Palm Springs Art Museum, Palm Springs, California.

273. Saul Steinberg (1914–99), cover for the *New Yorker,* Nov. 22, 1975. Magazine cover, private collection. © Condé Nast.

flags on their T-shirts, do you? No. You see Mickey Mouse on their T-shirts, and Mickey Mouse represents America, and the good, happy, friendly, passion side of America as opposed to a mean, evil American flag[,] which is really crazy because if you really think about it, it's like everybody's got this backwards. The American flag [...] represents a government which tries to help the people even though they've got corrupted politicians also. It tries to help people.[...] Corporations don't do that.[37]

Made in Hollywood and *The Last Outpost* were the first of dozens of Mouse-themed pieces by Foulkes over the next two decades, confected in part because they were marketable. As he told the Smithsonian interviewer, "the only two paintings that I sold out of my last show both had Mickey Mouse in them." Among his productions in the mid 1990s were a savage hit on Los Angeles as an architectural wasteland, *Welcome to Mauschwitz,* and *To Ub Iwerks,* "a gruesome yet sympathetic portrait of Walt Disney" who "seems wasted by the demonic dominance" of the Mouse that "literally springs from his brain." In a work painted in 2004–05, Foulkes stuck Mickey's pie-slice eyes and bulbous snout on a faceless skull and called it *Portrait of Walt Disney*; in 2006, in *Mr. President,* he gave George Washington a similar treatment [274].[38]

In the 1980s and '90s, as the fourth and still current phase of Mickey's iconic existence kicked in, two other American artists, Terry Allen, a graduate of the Chouinard Art Institute, and Joyce Pensato, adopted a less polished approach than that of Warhol (or Oldenburg), but one that was more directly, and formally, focused on Mickey Mouse than was the case with Foulkes. Allen's cartoony painting *The Red Letter,* from 1986, depicts Mickey Mouse in his role as host at the Disney parks, four-fingered hand raised high to greet a visitor, though his eerie facial expression, suggests that this may *not* be the leader of the club that's truly made for you and me.

Joyce Pensato started out painting Abstract Expressionist landscapes. But by the early 1990s she found her true love: rough-cut abstractions of figures like Mickey, Minnie, Donald Duck, and Bart Simpson that are, stylistically, even cartoonier than Terry Allen's Mickey. She approaches them all—stain-like streams of enamel dribbling down the surfaces of the pictures—with the ferocity of Pollock, de Kooning, or Franz Kline. Mickey Mouse, her target of preference, is generally rendered as a stubby schlub, with a rubber-duck belly and diabolical smirk [275]. Nonetheless, despite their repeated instances of lèse-majesté with respect to the Mouse, neither Foulkes nor Pensato ever incurred outright opposition from the Walt Disney Company. Dennis Oppenheim has. In 1992, *Virus,* a ten-foot-high set of thirty-four fiberglass toy figures of Mickey and Donald,

274. Foulkes, *Mr. President,* 2006. Mixed media, 40 × 40 in. Santa Barbara Museum of Art, Santa Barbara, California. The pasted-on head of Mickey was penciled by Floyd Gottfredson and inked by Al Taliaferro for a 1931 marketing model sheet.

275. Joyce Pensato (1941–), 2007. Charcoal and pastel on paper, 67 x 60 in. Courtesy of the artist and Petzel, New York. Collection of Jeff and Laura Schaffer.

skewered by intersecting rods, was installed in a mall in Santa Monica. The design was uninspired, but the siting was very public, and since Oppenheim failed to reach a licensing agreement with Disney, as Warhol did and Wayne Thiebaud has done, he was sued for unauthorized use and the work was removed by the developer that owned it and the plaza.[39]

Mickey's relationship with race is a subject that deserves further exploration. His association with jazz, in the early films, provides one connection to black culture, and, like jazz, he seems to be beloved by African- and Euro-Americans alike. Jasmin Lucas, a junior at Penn State in 2003, was a case in point: her webpage announced her dream to go on to law school at Georgetown University or NYU. Her display name was "J1LUVMICKEY," because, she explained, "my first initial is 'J' I am his number '1' fan and I 'LuvMickey.'" Her room, she added, "is basically a shrine dedicated to him."[40]

As much as Jasmin adored the Mouse, his greatest African-American idolater was Michael Jackson, whose favorite Disney character, reputedly, was Peter Pan (hence the name of his Neverland Ranch property). But Jackson owned, among other objets d'art, a crystal- and pearl-studded Mouse brooch and a glass-domed case containing figures of himself, ET, Peter Pan, Jiminy Cricket, Goofy, and Mickey (as Chaplin), all, like Jackson, wearing a single glove. The singer's fondness for the character was likewise evidenced by a report, in 2005, of him shocking a maid at London's Dorchester Hotel when Jackson opened the door to his suite dressed as Mickey; he explained that he and his three children were having a party (the kids were costumed as Peter Pan, Tinker Bell, and Captain Hook). Michael also contributed a drawing of Mickey in a leather jacket titled *Bad*, which *is* truly "bad," to *The Art of Mickey Mouse*, the 1992 compendium of works by over ninety artists, cartoonists, and illustrators, for which John Updike's essay on Mickey Mouse, first published in *Art & Antiques,* served as an introduction. Among the book's other contributors: Paolozzi, Warhol, Haring, Thiebaud, Sendak, Charles Schulz, R. Crumb, Robert Grossman, and the French cartoonist Mœbius [276].[41]

Disney's mythic character appears in more elevated contemporary African-American art as well. In Michael Ray Charles's painting *Forever Free, Beware,* exhibited at the Albright-Knox Gallery in 1997, a pseudo-primitive "pickaninny" (a caricature of a caricature, as it were) whistles his way across the picture plane in bright red Mickey shorts, right above the boldly lettered word BEWARE [277]. Another painting, *Hello, I'm Your New Neighbor* [278], displayed in 1999 at the Katonah Museum of Art, was described on the gallery's Internet site as a "provocative work"

LE PETIT MICKEY
QUI N'A PAS PEUR DES GROS
AVRIL 1974 • 2 de nos Francs Actuels
SPÉCIAL MINI-RÉCIT
n° 7

MŒBIUS 74

276. Mœbius, cover for *Le Petit Mickey qui n'a pas peur des gros*, April 1974. From an original pen and ink drawing. Private collection.

that "confronts us with the menacing face of a black man with a coin-slot on top of his head and a devilishly wide grin of watermelon-seed speckled teeth. His skull is placed against crossbones and set beneath two black and white Mickey-Mouse arms in mock neighborly handshake." The curator of the show, *Re/Righting History: Counternarratives in African-American Art,* was quoted as asking, "Imagine if you've just bought a house and this man moves in next door and says, 'Hey, I'm your new neighbor.' What goes through your mind?"[42]

John Updike, too, had a view on Mickey's relationship with race. In his essay "The Mystery of Mickey Mouse," he wrote, "Like America, Mickey has a lot of black blood." It was in this context that he cited the scruffy figures scribbled by Saul Steinberg as emblems of the Mean Streets of New York. Updike then went on to say:

277. Michael Ray Charles (1967–), *(Forever Free) Beware*, 1994. Acrylic latex, stain, and copper penny on paper, 60¼ × 36 in. Private collection.

278. Charles, *(Forever Free) Hello, I'm Your New Neighbor*, 1997. Acrylic latex and stain on paper, 60 × 36 in. Courtesy Tony Shafrazi Gallery, NY.

From just the way Mickey swings along in his classic, trademark pose, one three-fingered gloved hand held on high, he is jiving. Along with round black ears and yellow shoes, Mickey has a soul. Looking back to such early animations as the early Looney Tunes' Bosko and Honey series (1930–36) and the Arab figures in Disney's own *Mickey in Arabia* of 1932, we see that blacks were drawn much like the cartoon animals, with round button noses and great white eyes creating the double arch of the curious peaked scullcaps. Cartoon characters' rubberiness, their jazziness, their cheerful buoyance and idleness, all chimed with popular images of African Americans, earlier embodied in minstrel shows and in Joel Chandler Harris's tales of Uncle Remus, which Disney was to make into an animated feature, *Song of the South,* in 1946.[43]

Updike's commentary was echoed in Howard and Judith Sacks's 1993 book, *Way Up North in Dixie: A Black Family's Claim to the Confederate Anthem,* in which they declare:

Of the many examples of minstrelsy's enduring legacy in popular culture [. . .] surely Mickey Mouse is the most graphic offspring of blackface minstrels' portrayals of the plantation slave. Black, wild-eyed, childlike, falsetto-voiced, and ever the clown, Mickey Mouse even takes his costuming from the burnt-cork brotherhood: see the oversized white gloves, the suspender buttons (minus suspenders), big feet, coy stance.

But the writers offer no foundation for this statement, and seem ignorant of the realities of cartoon production. Mickey's design, like that of Felix the Cat or Oswald, was dictated largely by the limitations of pre-color animation. A character's features, clothing and other accoutrements had to be simple and clear-cut in order to stand out on screen; hence the white gloves, shoes, and pants on a black body, and black eyeballs and ears on a white face. As seen in the *Plane Crazy* sketches, the very first Mickey had neither "big feet" nor "oversized white gloves." Adding the gloves made it easier to define the fingers, making his gestures more legible and expressive. The buttons on his pants visually rhymed with his eyes, giving him a greater formal unity. None of this had to do with race.[44]

More recently, in a nearly seven-hour documentary jab at postwar American culture, *Star Spangled to Death* (2004), avant-garde filmmaker Ken Jacobs used a clip of Mickey in blackface from an early Disney one-reeler to highlight the ongoing problem of race in the United States. The springboard for "Is Mickey Mouse African American?" and *Star Spangled to Death,* presumably, was Updike's observation that "Mickey has a lot of black blood." But Updike's point was more nuanced than merely equating Mickey with negritude or racial bigotry. There is, he wrote,

279. Otto Künzli (1948–), black Mickey Mouse brooch, 1991. Hard foam, lacquer, steel, 4 in. wide. Powerhouse Museum, Sydney, Australia.

a sense in which all animated cartoon characters are more or less black. Steven Spielberg's hectic tribute to animation, *Who Framed Roger Rabbit,* has them all, from the singing trees of Silly Symphonies to Daffy Duck and Woody Woodpecker, living in a Los Angeles ghetto [Toontown]. As blacks were second-class citizens with entertaining qualities, so the animated shorts were second-class movies, with unreal actors, who mocked and illuminated from underneath the real world, the live-actor cinema. Of course, even in a ghetto there are class distinctions. Porky Pig and Bugs Bunny have homes that they tend and defend, whereas Mickey started out, like those other raffish stick figures and dancing blots from the Twenties, as a free spirit, a wanderer. As Richard Schickel has pointed out, "The locales of his adventures throughout the 1930s ranged from the South Seas to the Alps to the deserts of Africa. He was, at various times, a gaucho, teamster, explorer, swimmer, cowboy, fireman, convict, pioneer, taxi driver, castaway, fisherman, cyclist, Arab, football player, inventor, jockey, storekeeper, camper, sailor, Gulliver, boxer" and so forth. He was, in short, a rootless vaudevillian who would play any part that the bosses at Disney Studios assigned him. And though the comic strip, which still persists, has fitted him with all of a white man's household comforts and headaches, it is as an unencumbered drifter whistling along on the road of hard knocks, ready for whatever adventure waits at the next turning, that he lives in our minds.

If Updike is correct on at least one point, one could say that Mickey's "unencumbered drifter" quality, like his anthropomorphized humanity, actually detaches him from any ethnic or other specificity. "Unrootedness," moreover, "is, and always has been, part and parcel of being American," according to biographer Arnold Rampersad. "It is the flip side of perhaps the defining aspect of Americanness, the capacity of its citizens to reinvent themselves." The archetypal freedom of the early Mickey Mouse goes far in explaining the broad-based appeal of this putative "second-class citizen"– cum– "rootless vaudevillian."[45]

In the present, fourth phase of his iconic "career," Mickey Mouse remains a major element of the American cultural imprint. Since the mid 1980s, the perception of Walt's happy-go-lucky character as a reflection of the American Way typifies numerous artistic appropriations. That is true of the Swiss-born goldsmith and designer Otto Künzli, the Californian painters Wayne Thiebaud and Peter Saul, and the New Jersey–based "pulp western" artist Robert Anderson.

Among the Mickey Mouse–themed items of jewelry by Künzli exhibited at Wesleyan University in 1992 was a gold brooch that a *New*

280. Peter Saul, *I Paint Faster Than Jackson Pollock*, painting of Mickey as a French painter, 2006. © Peter Saul. Courtesy Mary Boone Gallery, New York.

York Times reviewer called "a hybrid of the familiar round ears on a Darth Vader helmet." Just as menacing was a sleek black brooch with Mouse ears rising from a faceless, heart-shaped skull [279]. A recent picture by Peter Saul, *I Paint Faster Than Jackson Pollock* [280], depicting the character as a beret-wearing *artiste*, painted specially for a show, *Mickey dans tous ses états* ("Mickey all worked up," or, literally, "in all his states") at the Paris auction house Artcurial in 2006, is closer in spirit to the sugary renderings of cakes and pastries for which Wayne Thiebaud is best known. Though loosely associated with Pop Art in the 1960s, Thiebaud (like Peter Saul) did not start dealing with Disney figures in his art until about two decades. In 1988, he produced a standing figure, *Toy Mickey* [282], and, also in 1988, he fancifully made Walt's star the icing on his *Mickey Mouse Cake* [281].[46]

Yet another work of recent vintage, *How the West Was Won* (2000),

by the late Robert Anderson, is a tribute to pulp-fiction artwork from the years during and after World War II, in which a ray gun–wielding female space ranger clutches a 1930s Knickerbocker Mickey Mouse doll in sheepskin chaps. Warhol's Mickeys are more iconic. But Künzli, Saul, Thiebaud, and Anderson fabricated images that, in many ways, are truer to the sometimes friendly, sometimes mischievous Mickey Mouse that was the order of the day from the late 1920s through the mid 1930s.[47]

Thiebaud 1988

282. Thiebaud, *Toy Mickey*, 1988.
Oil on wood panel, 12 x 12 in.
Private collection. © Wayne Thiebaud.
Licensed by VAGA, New York, NY.

EMBLEM OF THE AMERICAN SPIRIT

I n 1981, the year in which Ronald Reagan took office as president and Andy Warhol executed his *Myths* series, Robert Hughes published an essay in *Time,* "Farewell to the Future That Was," in which he declared that "all the isms were wasms." Every movement of the 1960s, Pop Art included, and the century-long "cultural bedrock of Europe and America," Modernism itself, Hughes said, had expired,

> and, by 1976 "avant-garde" was a useless concept: social reality and actual behavior had rendered it obsolete. The ideal—social renewal by cultural challenge—had lasted 100 years, and its vanishing marked the end of an entire relationship, eagerly sought but not attained, of art to life.

Thus, according to Hughes, "painting and sculpture have ceased to act with the urgency that was once part of the modernist contract."[1]

A big difference between Claes Oldenburg and other practitioners of Pop, Warhol especially, is that Oldenburg maintained a certain Modernist contempt for Mickey. Warhol, who rejected theoretical posturing, may have been the first major postmodern artist, much as Reagan, "who blurred history and the movies," has been termed "our first postmodern President." Like any true icon, Mickey Mouse resides in the spheres of both fantasy and reality, making him a perfect mate for the charismatic then-governor of California in a 1967 caricature by Robert Grossman, *Ronald Rodent* [283]. In Grossman's drawing, an ebullient Reagan is depicted in the white gloves, red shorts, yellow dinner-roll shoes, jet-black mouse ears, bare chest, and tubular legs of the classic Mickey—rich and sensual—that Maurice Sendak loved. Reagan, Grossman remarked (in 1996), "seemed to me to have the cuteness of Mickey and he managed to maintain it the whole time he was in public view. I think it was the secret of his success: that he managed to embody a certain 'lovable' quality."[2]

283. Robert Grossman (1940–), *Ronald Rodent,* 1967. Watercolor applied with an airbrush, 17 x 11 in. (sheet). Prints and Photographs Division, Library of Congress, Washington, D.C. According to the entry for this drawing in the Division's records, it was published in the September 25, 1967 edition of the men's magazine *Cavalier,* but that was not the case (for one thing, *Cavalier* was a monthly, not a weekly).

284. Harvey Kurtzman (1924–93) and Will Elder (1921–2008), "Mickey Rodent," *Mad* magazine, January 1955. MAD #239™ and © E.C. Publications, Inc. Used with Permission. E.C. Publications, New York.

Grossman's caricature is a compound image of American idealism that plays off the ironic but engaging baggage of Disney's character, which is what makes any great homage or pastiche, including Warhol's, succeed. *Ronald Rodent* was not meant as a valentine to either party. Yet, in light of his friendship with Walt Disney, we can suppose that Reagan would not have minded the match-up. Like Ronald Reagan, Mickey Mouse may, to some, signify the lockstep march of bourgeois values and a shallow optimism, bereft of self-doubt or weighty intellectual curiosity. Like Reagan, however, Mickey Mouse also personifies the energy and can-do spirit at the heart of the American Dream. There is a jolly quality in the image as well, inherent in Grossman's style, that transcends its intended message. In the end, no matter how we feel about Mickey or the Gipper, Grossman's conflation of the two is an inspired graphic union.

John Updike put his finger on one reason why Walt's Mouse continues to seize our attention when he wrote: "The America that is not symbolized by the imperial Yankee Uncle Sam is symbolized by Mickey Mouse. He is America as it feels itself—plucky, put-on, inventive, resilient, good-natured, game." Needless to say, the traits enumerated by Updike are not universally viewed as representative of the national character. Nor has Mickey always been to everyone's liking.[3]

Prior to the 1960s, he had been hit with japes that were, upon occasion, sophomoric—like the ribbing he took, with "Darnold Duck," in a "superbly scurrilous" (for its time) 1955 *Mad* comic book parody by Harvey Kurtzman and Will Elder entitled "Mickey Rodent" [284]. Incidentally, the most "superbly scurrilous" image of Mickey Mouse from this or any period sprang from the inkpot of another *Mad* man, Wallace Wood, in the form of a cartoon centerfold in the May 1967 issue of *The Realist,* commissioned by the magazine's publisher, Paul Krassner, shortly after Walt Disney's death. (But, the less said about that, the better.)[4]

In the 1960s and '70s, a decided edginess crept into the raillery. Circa 1963, Mickey was transformed by Ed "Big Daddy" Roth into his "evil twin," "Rat Fink." Rat Fink was one of several hot-rod characters developed by Roth, a familiar figure in the Southern California counterculture scene. Roth's work would have been known to the premier poster artist of the psychedelic era, and the cocreator of the Grateful Dead's skull-and-roses emblem, Stanley Miller. As a boy, Miller was so fond of drawing Mickey that schoolmates called him "Stanley Mouse," a cognomen he adopted professionally and incorporated into his personal logo [285]. (A self-portrait, posted on his website, was described by one writer as an image of "Mickey Mouse's seedy sibling.") Miller later painted a "portrait" of Mickey [286] in a rumpled suit, bow tie, and white gloves, seated uneasily in an armchair in front of a bowl of fruit and a chintzy landscape painting, which may well be the forebear of Terry Allen and Joyce Pensato's Mickeys.[5]

As the national debate about Vietnam and social issues, notably race, intensified in the late 1960s, Mickey's formerly sunny, oft-times dull image was commandeered as a way to fault everything critics found objectionable about America. Saul Steinberg's Mouse-related *New Yorker* cover art [273] was part of that cultural sea change. Possibly the most influential verbal blast ever fired at Disney's creation came at this time, too, in an expansive piece by novelist James Michener in the August 1968 *New York Times Magazine.* In the essay, "The Revolution in Middle-Class Values," Michener wrote:

One of the most disastrous cultural influences ever to hit America was Walt Disney's Mickey Mouse, that idiot optimist who each week

marched forth in Technicolor against a battalion of cats, invariably humiliating them with one clever trick after another. I suppose the damage done to the American psyche by this foolish mouse will not be specified for another 50 years, but even now I place much of the blame for Vietnam on the bland attitudes sponsored by our cartoons.[6]

When *The Disney Version,* Richard Schickel's animadversion on Walt's life and work, was published in 1968, Leonard Maltin called it "a cruel book which is a study in propaganda." Leftist art historian David Kunzle, however, lauded it as "the first breach into the Disney part" of the "myth of U.S. political 'innocence,'" even though the "Great American Dream of cultural innocence," Kunzle said, "still holds a global imagination in thrall," and Schickel's tome,

> penetrating and caustic as it is, in many respects remains prey to
> the illusion that Disney productions, even at their worst, are somehow
> redeemed by the fact that, made in "innocent fun," they are
> socially harmless.

This dire pronouncement was offered up in Kunzle's introduction to *How to Read Donald Duck: Imperialist Ideology in the Disney Comic,* the English translation of a Marxist tract, in the manner of Horkheimer and Adorno, coauthored by the Chilean academic and cultural advisor to Chile's Communist president, Salvador Allende, Ariel Dorfman (later a professor at Duke University), and Armand Mattelart, a Belgian sociologist.[7]

Kunzle called the book, published in its original Spanish edition in 1971, two years before the coup that toppled Allende, "the first thoroughgoing analysis of the Disney ideology." In *How to Read Donald Duck,* Dorfman and Mattelart staked out a two-pronged mission: to unmask Disney's cartoon characters as pawns in the promotion of a benign image of the United States in places like Chile, and to encourage "the whole process of the potential Chilean and Latin American revolution."[8]

To support their thesis, they turned to Mickey's blustery buddy, Donald—plus his three nephews (Huey, Dewey, Louie) and Uncle Scrooge—because "we Latin Americans tend to identify more readily with Donald at the mercy of fate or superior authority, than with Mickey, the boss in this world." Basing their opinion on his then-current incarnation in Chilean editions of the Mickey Mouse comic books, Dorfman and Mattelart condemned Donald as a figure through whom "the power of repression dissolves into daily fact of life" "He is," they said, "at once law and big stick, church lottery, and intelligence agency." This was a significant shift from the view of fellow leftist Walter Benjamin, expressed in the early 1930s, that Mickey's animated

cartoons were "full of miracles" and that "the public recognizes its own life in them." For Dorfman and Mattelart, Mickey Mouse "turns the unusual, abnormal, arbitrariness of external power, into a commonplace phenomenon which partakes of the natural order. His extraordinary occult powers appear ordinary, and therefore, natural and eternal."[9]

The American edition of *How to Read Donald Duck* appeared in 1975, as the Vietnam war, the longest, most tragic campaign of America's forty-year struggle with Communism, was wending to its end. At around the same time, in 1974, Richard Schickel sent a letter to *Playboy* complimenting D. Keith Mano's indictment, in a previous issue, of the Disney corporate mentality. Schickel closed his letter by saying:

> I was pleased to see that my book was obviously of service to him in
> preparing the article. What I didn't say there that I would like to say here is:
> If fascism ever comes to America, it will probably be wearing mouse ears.

(Similarly, in 2005, George Carlin told fellow satirist Bill Maher that when "fascism comes to America, it will not be in brown and black shirts, it will not be with jack-boots, it will be Nike sneakers and smiley shirts.")[10]

Such utterances have lost much of their sting. Waiting for "fascism" to arrive in Mouse ears is rather like waiting for Godot. Michener's comment in the *Times Magazine,* in 1968, decrying the "foolish mouse" as one "of the most disastrous cultural influences ever to hit America," now rings a mite hollow. It was, however, part of an extensive and sober analysis of what Michener feared was a deep spiritual crisis afflicting young people in the late 1960s, in which he commented further on Mickey's symbolic connection with what, he believed, ailed the nation:

> I expected more trouble over Korea than what developed, but we
> were lucky. We got away with what was essentially an immoral operation,
> but in Vietnam it caught up with us. We are now paying a terrible
> price in alienation.
> I blame our middle-class values for this catastrophe. We mouthed
> platitudes and refused to face up to actualities. Fed on the optimistic
> pablum of Mickey Mouse, we believed that the good guys always won,
> no matter how precariously situated nor how faulty their motivations.
> We wanted to continue making money—more accumulation—while
> participating in a major war without public acceptance and with an
> insufficient number of men arbitrarily assigned to do our dirty work.
> [. . .] Now we see that the Vietnam impasse serves as an excuse for the
> young to question the middle-class values which produced it.[11]

The figure stigmatized by Michener as a mark of arrant materialism and militarism wasn't the scrappy star of Updike's and Sendak's Depression-era childhood that saved Lionel trains and lit up a church for an interracial audience in *Sullivan's Travels.* Michener's bête noire more closely resembled the Mickey Mouse familiar to kids who grew up in the 1960s: the gentler creature they had seen in comic strips, on kiddie merchandise, as a peripatetic host at Disneyland, and on the *Mickey Mouse Club* show, looking as he did on a T-shirt worn, no doubt as a droll contra-bourgeois fashion statement, at Woodstock in 1969 by Doug Clifford, the drummer for Creedence Clearwater Revival. Updike's and Sendak's Mickey Mouse was, by then, culturally kaput for the Baby Boom generation.

Michener's essay was issued in paperback in 1969 as *America vs. America: The Revolution in Middle-Class Values.* Since it had also run in the *New York Times Magazine,* his juxtaposition of Vietnam with the "optimistic pablum of Mickey Mouse" was bound to register on one level or other with many thoughtful readers, including, perchance, Gus Hasford as he labored on his Vietnam book, *The Short-Timers.* (Hasford was discharged in 1968; a voracious consumer of literature, he likely read Michener's Korean War novella, *The Bridges at Toko-Ri,* as well.)[12]

"Mickey Mouse shit," a salty phrase sprinkled a half-dozen times throughout *The Short-Timers* in dialogue spoken by officers and enlisted alike, adds humor, color, and realism to the tale, and helps build a cumulative power crucial to Hasford's narrative. The first third of *The Short-Timers,* one of three long chapters in the book, is set in Marine boot camp at Parris Island. The protagonist, Joker, and his fellow recruits are under the thumb of a tough-as-nails drill instructor, Gunnery Sergeant Gerheim.

At the conclusion of this stateside overture to the main action, Joker finds himself alone with his bunkmate, a doltish redneck that Sgt. Gerheim has dubbed "Pyle," after Gomer Pyle, the goofy Jarhead with a southern drawl in a 1960s sitcom. It is late on the final night of their training, during which time the sergeant had relentlessly bullied Pyle. The other young men are asleep in their bunks. Pyle has survived the ordeal—superbly—ranking first in his class, but the strain has pushed him over the edge. Gerheim confronts the two men: "WHAT'S THIS MICKEY MOUSE SHIT?" the Gunny yells at the top of his lungs. Pyle has a loaded M-14 in his hands. He levels the rifle, fires point-blank at Gerheim's heart, killing him instantly, then, with a mad smile, puts the barrel of the weapon in his mouth and blows himself away.[13]

The other instances of Mickey Mouse imagery in *The Short-Timers* come after Joker arrives in Vietnam. They include the chanting of the Mickey Mouse Club March as Joker and his comrades bury some rats

they've trapped and killed, and a scene during the Tết offensive in February 1968, where a Marine sings the Mouse Club March as machine guns on both sides shoot at one another. Finally, at the siege of Khe Sanh, near the conclusion of the novel, Joker describes the scorched skull of "Sorry Charlie,"

> an enemy grunt who got napalmed outside our wire. Sorry Charlie is still wearing my old black felt Mousketeer ears, which are getting a little moldy. I wired the ears onto Sorry Charlie for a joke. As we hump by, I stare into the hollow eye sockets. . . . The dark, clean face of death smiles at us with his charred teeth, his inflexible ivory grin.

Placed in the jarring context of Vietnam, the mystique of Mickey Mouse and the Mickey Mouse Club is admirably suited to Hasford's overarching theme of innocence lost in the crucible of brutish militarism and war. Once one has read the book, the epigraph on page 1 of the prologue from *Dispatches,* a much-praised compilation of Vietnam reportage by Michael Herr, assumes an even more bittersweet meaning: "I think that Vietnam was what we had instead of happy childhoods." Interestingly, Herr, who assisted Stanley Kubrick in adapting *The Short-Timers* for the director's 1987 film, *Full Metal Jacket,* may also have brought the book to Kubrick's attention soon after it was published, in 1980.[14]

The first third of *Full Metal Jacket* cleaves to Hasford's text as it chronicles the transformative experience of Joker's training platoon, culminating in the deaths of the drill instructor and Pyle. Just before he's shot, we see the sergeant storm in on Joker and Pyle in the lavatory (or "head," in Marine Corps lingo) adjacent to the recruits' squad bay, and, in words pulled almost verbatim from the novel, demand: "What is this Mickey Mouse shit? What in the name of Jesus H. Christ are you animals doing in my head?"[15]

Eliminating Hasford's concluding chapter set in Khe Sanh, the last two-thirds of *Full Metal Jacket* focuses on Joker's stint as a writer for *Stars and Stripes,* the military newspaper, and his participation as a grunt in the Battle of Hue, where most of his mates are killed. The film's final scene involves a brilliant appropriation of the Mouse inspired by, though not drawn directly from, the book. Having "nailed our names in the pages of history enough for today," Joker says in a voiceover, he and his platoon move out from Hue, after the battle, stoutly singing:

> Who's the leader of the club that's made for you and me?
> M-I-C-K-E-Y M-O-U-S-E.
> Hey there. Hi there. Ho there. You're as welcome as can be.
> M-I-C-K-E-Y M-O-U-S-E. . . .

As the platoon continues its song, Joker, remarks, again offscreen: "I am so happy that I am alive, in one piece and short. I'm in a world of shit . . . yes. But I am alive. And I am not afraid." The singing picks up again as the men hike off into the distance, and the screen fades to black:

> Come along and sing this song and join our family.
> M-I-C-K-E-Y M-O-U-S-E
> Who's the leader of the club that's made for you and me?
> M-I-C-K-E-Y M-O-U-S-E
> Hey there! Hi there! Ho there! You're as welcome as can be. . . .

Clearly, the sergeant's fatal query, culled from Hasford's text ("What is this Mickey Mouse shit?"), prompted Kubrick's comic-opera dénouement, which gives thematic unity to the movie and underscores its sardonic message about America's involvement in Vietnam.

Kubrick also took the correlation of Marine Corps and Mouse Club, implicit in *The Short-Timers,* as well as the bleak realization on Joker's part, likewise implied in the book, that Mickey Mouse "shit" happens, and forged them into the primary trope of the film. Hence one more cinematic detail—in the spirit of the novel, though not actually in it—glimpsed as a press officer reviews the work of the military reporters under his command. On a shelf behind Joker are three Mickey Mouse toys, a subtle salute to Fritz Lang and the scene in *M* where three figures of Mickey appeared in the background of a Berlin snack shop.

We must assume, in light of Kubrick's notoriously slavish attention to detail, that once he decided to make a film based on Hasford's book he was on the alert for cultural allusions to Disney's enfabled Mouse. If not before.

In Kubrick's horror film from 1980, *The Shining,* the little boy (played by Danny Lloyd) wears a sweater with an old-fashioned Mickey on it, and there are decals of the Mouse and other cartoon characters, including Snoopy and Dopey, on the wall of his bedroom as well. From the late 1960s on, there had been a plethora of barbed references to Mickey in the print media, cartoons, pop music, movies, and high art. If, for instance, Kubrick regularly perused the *New York Times,* he could have read what Michener said about the character and Admiral Zumwalt's take on Mickey Mouse regulations, and learned about Mouseketeer Doreen Tracey being greeted by troops singing the "Mickey Mouse Club March" during a USO tour in Vietnam. If he chanced to thumb through the right issue of *Playboy,* he might also have come across Richard Schickel's speculative comment about Mouse-eared fascism marching across America.[16]

287. George Harrison (right) and Ringo Starr posing with two actors costumed as Blue Meanies in a promotional photo for the Beatles film *Yellow Submarine*, July 8, 1968. © Bettmann/Corbis. The cartoon portions of *Yellow Submarine* were made using a cost-cutting style known as "limited animation," which was the antithesis of the glorious, labor-intensive craftsmanship that characterized the Golden Age of Disney cartoon production in the 1930s, 1940s, and into the 1950s.

Elsewhere in the whirl of pop culture in those years, the Mouse was helping inspire cutting-edge music and lyrics. In David Bowie's 1971 hit "Life on Mars," Mickey took an hallucinogenic hit. And he was roughed up, verbally, in John Lennon's 1974 song "Steel and Glass" and in "Mickey Mouse Is Dead" (1982) by the punk rock group Subhumans.[17]

Closer to home, in Kubrick's own professional bailiwick, there had been several films in which Mickey was hoist on the petard of satire. In the psychedelic animation *Yellow Submarine* (1968), the Beatles' nemeses, the Blue Meanies, have black Mouse ears [287]. In Cheech and Chong's *Up in Smoke* (1978), Cheech's pothead character sports a pink tank top with tasseled red pasties, a tutu, white stockings, a rhinestone mask, and Mouse ears while performing in a battle-of-the-bands competition. The burlesque Mouse-ear conceit also figured in the Monty Python movie *The Meaning of Life* (1983). And while there is no exact, tit-for-tat equivalence, then as now, "Mickey Mouse," "Disney," and "Disneyland" often are used interchangeably to describe things regarded as unreal, dumb, or trifling. In Francis Ford Coppola's antiwar film, *Apocalypse Now* (1979), for example, a soldier in 'Nam gets a letter from his girlfriend back home: "I was on a trip to Disneyland," she wrote. "There can never be a place like Disneyland, or could there?" Offscreen, the jaded lead character (Martin Sheen) comments, "Disneyland. Fuck, man, this is better than Disneyland."[18]

For more than two generations, Mickey Mouse has served as verbal and visual bait, tossed on the waters by countless writers, reporters, comedians, cartoonists, and illustrators who know that any image or mention of the Mouse ensures rapt reader, listener, or viewer attention [289]. Even among devotees of high culture. In 1992, the New York City Ballet staged a version of Mozart's 31st symphony in which the soloist wore Mouse ears and the troupe danced to the lyrics from the Mouse Club March.[19]

In more polemical terms, seventeen months after the terror attacks of September 11, Kurt Vonnegut lashed the Bush administration

288. Jul, aka Julien Berjeaut (1974–), political cartoon of Carla Bruni and her husband, French President Nicolas Sarkozy, with Mickey Mouse ears, at Paris Disneyland ("You like my purchasing power?"), on the front page of the French daily *Libération*, Feb. 4, 2008. Private collection.

289. Robert Grossman, "Disney's Dilemma." Watercolor applied with an airbrush. From *Newsweek*, Sept. 5, 1994. Private collection.

as "those who have taken over our federal government, and hence the world, by means of a Mickey Mouse coup d'etat, and who have disconnected all the burglar alarms prescribed by the Constitution, which is to say the House and Senate and the Supreme Court and We the People" In France, where Disney, Coca-Cola, and McDonald's are often reviled as symbols of American cultural decadence, in February 2008 the newspaper *Libération* printed a page-one cartoon mocking the nation's pro-American president, Nicolas Sarkozy, depicted in Mouse ears, holding a toy balloon, as he visits the Paris Disneyland with Carla Bruni, his newly-wed trophy wife in tow [288].[20]

France, as should by now be evident, has long had a thing for Mickey Mouse, and Walt Disney. The slang term *petits miquets,* since at least the early 1960s, has been synonymous in French with comics or comic strips [276] [290]. Beginning in the early 1930s, play centers for small children called "Clubs de Plage Mickey" have operated, in association with *Le Journal de Mickey,* at summer resorts nationwide; by 1937, there were almost one hundred Clubs Mickey [291]. In 1966, the magazine *Paris-Match* announced Disney's passing with a teary-eyed Mouse on its cover [292], and, in 1980, Goofy was the official mascot of the French Olympic tennis team. Coupled with the Gallic origin of Walt's family name, his World War I service on French soil, his taste for Gitanes cigarettes, and the fact that he'd had the Legion of Honor pinned on his chest, is it any wonder France was selected by his corporate successors over Spain as the site for the Euro Disney park?[21]

Censorious or emotionally over-the-top appropriations of Mickey Mouse, in France as in America, usually emanate from the left side of the political spectrum as blasts against the right, American "militarism," "cultural imperialism," and, since the 1980s, the explosive growth of the Disney conglomerate [293] and "Disneyfication" of life in general.

Most pop-culture references to Mickey Mouse, though, are not political. The hero in Dan Brown's pre–*Da Vinci Code* bestseller, *Angels & Demons* (2000), Harvard professor of religious symbology Robert Langdon, wears a "collector's edition Mickey Mouse watch," a "childhood gift from his parents." Whenever students ask about it, he says he keeps "Mickey as a daily reminder to remain young at heart." A seemingly offhand detail, it went unnoticed amidst the hoopla surrounding *The Da Vinci Code* (2003) that there may be a corollary message woven into the book that reveals what our true take should be on Brown's fantasy conspiracy surrounding Christ's temporal blood line.[22]

In *The Da Vinci Code,* we're told that Disney cartoons were Langdon's "first introduction to the magic of form and color." Deeper into the novel, in a perversion of David Low's novel personal slant on Walt's genius in his article "Leonardo da Disney," Professor Langdon declares to Paris policewoman Sophie Neveu that "Disney had made it his quiet life's work

to pass on the Grail story to future generations. Throughout his entire life, Walt had been hailed as 'the Modern-Day Leonardo da Vinci.'"

> Both men were generations ahead of their times, uniquely gifted artists, members of secret societies, and, most notably, avid pranksters. Like Leonardo, Walt Disney loved infusing hidden messages and symbolism in his art. For the trained symbologist, watching an early Disney movie was like being barraged by an avalanche of allusion and metaphor.

"Most of Disney's hidden messages," Langdon also explains, "dealt with religion, pagan myth, and stories of the subjugated goddess," and "the incarceration of the sacred feminine," in films like *Cinderella, Sleeping Beauty,* and *Snow White and the Seven Dwarfs.*

> Nor did one need a background in symbolism to understand that Snow White—a princess who fell from grace after partaking of a poisoned apple—was a clear allusion to the downfall of Eve in the Garden of Eden. Or that Sleeping Beauty's princess Aurora—code-named "Rose" and hidden deep in the forest to protect her from the clutches of the evil witch—was the Grail story for children.

According to Langdon, *The Little Mermaid* was "a ninety-minute collage of blatant symbolic references to the lost sanctity of Isis, Eve, Pisces the fish goddess, and, repeatedly, Mary Magdalene."[23]

This is all really rather nonsensical. For one thing, Walt Disney's "quiet life's work" was long done by the time his studio, under Michael Eisner, produced *The Little Mermaid.* As for Snow White, how can her life prior to tasting of the poisoned apple be considered Edenic? She suffered at the hands of an evil stepmother, was led alone—without the carnal equivalent of Eve's biblical companion, Adam—into the forest to be killed, and wound up sharing a cottage with seven stunted old miners. This was not exactly prelapsarian heaven on earth. In a *Wall Street Journal* column, Daniel Henninger called The *Da Vinci Code* a fraud, saying the "final clue to the hoax arrives" when Langdon tells Sophie that Disney had made it his mission to tell posterity about the Grail story. "I'll bet that line," Henninger cracked, "isn't in the movie." It wasn't. Nor did Tom Hanks's onscreen ProfessorLangdon wear a Mickey Mouse timepiece, although, in director Ron Howard's sequel, *Angels & Demons,* he does. But Henninger's witty critique may be truer than he thought. It may be that, by having a Mickey Mouse watch strapped to the wrist of his tenured sleuth, Dan Brown was flashing a wink to readers that they shouldn't take *The Da Vinci Code* so goshdarn seriously.[24]

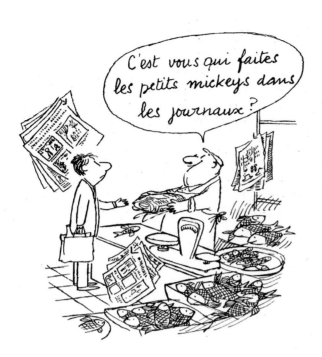

290. Jean-Jacques Sempé (1932–), *C'est vous qui faites les petits mickeys dans les journaux?* ("You're the one who does the cartoons in the papers?"), from a piece by Sempé, "La vie atroce d'un humoriste," published in *Paris-Match*, March 31, 1962. Private collection.

Mickey Mouse still resounds in our cultural consciousness, and what's been called our "cultural unconscious," because, no matter how weird or normal they might become as adults, innumerable children, like Andy Warhol or the fictional Robert Langdon, through nature or nurture, have found him, and other Disney characters, irresistible. Fashion designer Paloma Picasso, Pablo's daughter, recalled that, as a girl, she had "copied a Matisse, a Picasso, and, I think, a Walt Disney figure" (she didn't say which one). A highlight of Kurt Cobain's youth was a Mickey Mouse drum set his mother gave him. At the age of six, he could also draw Goofy, Donald, and the Mouse from memory. His sister Kimberly had a gift for mimicry and was so adept at imitating Mickey and Donald that their mother dreamed "that Kurt and I would end up at Disneyland, both of us working there, with him drawing and me doing voices."[25]

In 1987, Madonna posed with Minnie Mouse ears in a photograph by Herb Ritts for *Rolling Stone*, as she, evoking Marilyn Monroe, clutched a bedsheet to her breast [294]. Beneath its cheeky surface irony, Ritts's photo sums up Mickey and Minnie's hold on Boomers, like Madonna, and on subsequent generations, like Gen X-er Cobain. Almost from the second they were born, Madonna and Kurt, like millions of other girls and boys, were exposed to Mickey Mouse paraphernalia—diapers, rattles, mobiles over their cribs—and, in due course, books, videos, and costumed Mickeys greeting them when they visited the twin Lourdes of modern American life, the Disney parks in Anaheim or Orlando. When they became mothers and fathers they heaped Mickey- and Disneyana on their offspring to an extent unimaginable to their parents' generation. Hence the proliferation, starting in the mid 1980s, of Disney in-store and

291. Map marking locations of 89 Clubs de Plage Mickey in France, from the July 4, 1937, issue of *Le Journal de Mickey*. Private collection.

mail-order merchandising which could not have come about without a latent consumer demand.

In June 1985, J. G. Hook, the Philadelphia-based clothier, proclaimed the opening of Mickey & Co. at the South Street Seaport in lower Manhattan. The event was timed to coincide with a "combination feature film/live stage show" at Radio City Music Hall, *The Disney Summer Magic Show*. A press release declared: "This unique concept, which is the first of its kind to pay tribute to the beloved *MICKEY MOUSE* and his friends, will house the whimsical *MICKEY & CO.* sportswear collection exclusively." The concept was the doing of the board chairman of J. G. Hook and its newly minted Mickey & Co. subsidiary, Max Raab, who had observed a revival of the classic Mickey in Europe (which, in turn, may have been inspired by Warhol's Mickeys). Following the lead of Continental designers like Fiorucci, Raab used images from the early 1930s on shirts, sweaters, jackets, and so forth. "Ours is pure—," said Raab, "the antique Mickey." Mickey & Co. items were soon stocked in 350 stores nationwide. The *Philadelphia Inquirer* reported that they were "most likely to appeal

PARIS **MATCH** — ADIEU A WALT DISNEY

Le soir même de la disparition de Walt Disney un de ses proches collaborateurs a réalisé pour « Paris-Match » ce dessin qui est l'adieu de Mickey à son papa.

292. Pierre Nicolas (1929–), *Paris-Match* magazine cover, Dec. 24, 1966. Private collection. *Paris-Match* was reportedly the first magazine to honor Disney after his death with an homage on its cover. This issue would have gone on sale just four or five days after Walt passed away in Burbank on December 15, 1966.

to the baby boomer who still remembers all the words from the fan-club theme song," but Raab's gear was also aimed at the college-age progeny of the Boomer generation.[26]

In March 1987, two years after the launch of Mickey & Co., the first Disney Store opened in Glendale, California. In England, Princess Diana was soon seen in a Mickey Mouse sweatshirt, watching husband Charles play at polo as Prince Harry clung to her back. Coincidentally, perhaps, the first foreign franchise opened in London that fall, and by 1995 over 400 Disney Stores were operating in the U.S. and in eight foreign countries (the flagship store in France, on the Champs-Élysées in Paris, opened in 1993). At their peak, there were 522 Disney Store outlets in North America, though a downturn in sales led to the liquidation of many of them from 2002 to 2004.[27]

Mickey Mouse, like many other corporate emblems or pop icons, has been in style ever since Max Raab put him on the fashion map. "Licensed merchandise drove Disney's growth" in the 1980s and 1990s, Richard Verrier reported in the *Los Angeles Times,* as "a string of animated hits

293. Steve Brodner (1954–), illustration for Neal Gabler, "Revenge of the Studio System," *New York Times,* Aug. 22, 1995. Private collection.

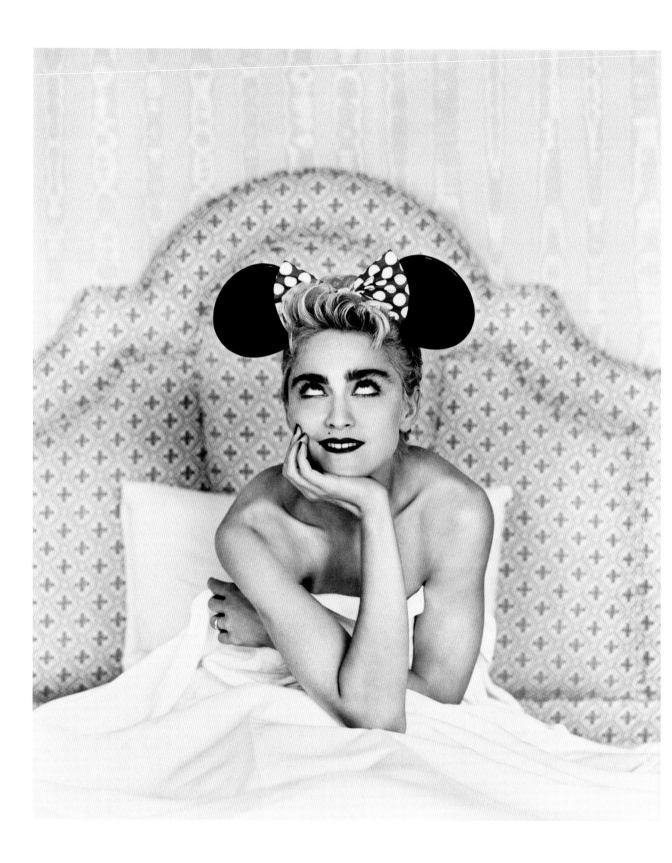

including 'Beauty and the Beast' and 'The Lion King' sparked huge demand for toys, clothes, and scores of other items." By the year 2000, however, sales were down, despite a major ad campaign on the theme of "Why do we love the Mouse," and, in 2003, when Verrier filed his story, Disney began "planting Mickey's vintage visage in some hip new places and planning to roll out the mouse in an aggressive marketing campaign centered on his 75th birthday." The effort was spearheaded by Andrew Mooney, head of corporate merchandising, who borrowed a fashion-industry trick known as "seeding" to get Sarah Jessica Parker into a "snug" classic Mickey tee for an episode of the HBO series, *Sex and the City*. Meanwhile, Verrier wrote, "at trendy Fred Segal in Santa Monica, shoppers are paying top dollar for silk pants (costing $250), belt buckles, and purses adorned with Mickey's retro image from the 1920s and '30s. It was enough to make Katie Couric, the host of NBC's *Today Show*, ask, "'Is it true . . . that Mickey is the new black?' while interviewing the style editor of *People* magazine this month."[28]

Mickey's turn-of-the-new-century retro look resulted mainly from the Disney Company's sudden discovery that boutiques in Hollywood were purveying, at hefty markups, Mouse T-shirts from the 1970s—the same garments, predating Fiorucci and Raab, originally sold as modest souvenirs at Disneyland or Walt Disney World. It must have been at about this time, too, that rocker Lenny Kravitz was spotted in a photo in *Rolling Stone* wearing an old-fashioned Mickey tee. According to a Disney vice president for global apparel, the photo "hit us like a two-by-four over the head." Thus, armed with an in-house line of old-style Mickey Mouse gear, by 2003 the company was ready for some heavy hitting of its own. In Verrier's words, "Disney doled out retro T-shirts to stars at events such as last week's ESPY awards hosted by Disney-owned ESPN, as well as to publicists, fashion editors, and designers. Before long, trendsetters—from actress Jennifer Aniston to musician Avril Lavigne—were wearing the T-shirts at events and magazine shoots."[29]

In the *Washington Post*'s coverage of the grand kick-off (in Glendale) for the Disney Company's year-long celebration of the character's diamond jubilee in 2003, reporter Frank Ahrens wrote: "If you thought Mickey Mouse was already ubiquitous, you ain't seen nothing yet." On Wednesday at a theater in this Los Angeles suburb, Disney Chairman Michael D. Eisner led a parade of company executives in a rally of hundreds of employees to reinforce that message. The "message" was communicated even more pointedly by Drew Carey, who emceed the affair, titled "This Is Your Life, Mickey Mouse." The comedian told the audience: "It's Mickey's 75th anniversary in show business—and we have a lot of stuff to sell."[30]

294. Herb Ritts (1952–2002), *Madonna, Tokyo*, 1987. Gelatin silver print, 17 7/8 x 15 1/16 in. (image), published as illustration for "The Madonna Mystique," *Rolling Stone*, Sept. 10, 1987. Department of Prints, Drawings, and Photographs, © Museum of Fine Arts, Boston, gift of Herb Ritts, 2000.

Over the past quarter-century, Disney has tried mightily to resuscitate the career of its aging star. The 1983 animation *Mickey's Christmas Carol* [295] ended a thirty-year drought of Mouse cartoons (the last one to be released had been *The Simple Things,* in 1953). In the 1980s and '90s, the studio also was motivated to enhance his onscreen viability after magazine and consumer polls showed Bugs Bunny outpacing the Mouse in popularity, driven chiefly by Bugs's greater visibility on TV at that time. Hence, in part, the decision to launch *MMC, a* variety program that debuted in 1989 on the Disney Channel. An earlier stab at reviving the original *Mickey Mouse Club* TV series in the late 1970s lasted just two years. This version ran till 1996, although, as Dave Smith has said, "the Mickey Mouse element was no longer emphasized, the cast no longer wore mouse-ear hats, and the show was aimed at a slightly older group." It was significant primarily as the show that, from 1993 to 1995, launched the very un-Mickey- and un-Minnie-like careers of Christina Aguilera, Justin Timberlake, Britney Spears, and Ryan Gosling.[31]

Mickey's Christmas Carol, based on the timeless Dickens tale, with the Mouse as Bob Cratchit, Goofy as Jacob Marley's ghost, and Uncle Scrooge as his namesake, Ebenezer Scrooge, was substantial enough to be nominated for an Academy Award. The twenty-five-minute film would have been ideal as the pièce de résistance in a *Fantasia*-length, Christmas-themed cartoon medley, and might have been even more successful had the characters been crafted with the same skill as the ones in *Fantasia.* The 1990 mini-feature *The Prince and the Pauper* [296], a feeble follow-up effort to reconnect Mickey to classic children's stories, was even less amusing. Mickey's only actual feature-film role in this period came in a memorable but brief (thirty-second) joint appearance with his Warner Brothers rival and confrère, Bugs Bunny, in *Who Framed Roger Rabbit* (1988).[32]

Runaway Brain, in 1995, which, stylistically, harkened back to Mickey cartoons from the early 1940s like *The Little Whirlwind*, came closer to reviving the original spirit of the Mouse. A loose remake of the black-and-white one-reeler *The Mad Doctor* (1933), its plot involves a demented scientist (voiced by Kelsey Grammer) who, in a clever turn on the Frankenstein story line, switches the brains of Mickey Mouse and the monster [297]. In 1999, a direct-to-video feature, *Mickey's Once Upon a Christmas,* was released. This heavily sentimental project, highlighting Mickey himself in only one of several unrelated segments, did little to burnish his reputation. Persistence, product development, and PR were, nonetheless, starting to pay off. In 1996, Bugs Bunny barely surpassed the Mouse with a Q-Score rating of 60 to Mickey's 59 in a survey of the ten most popular cartoon characters among youngsters aged six to eleven. By 2003, in the context of the VH1 miniseries *The 200 Greatest Pop Culture Icons* [298], Mickey Mouse came in at number 16, besting

Bugs, who placed much further back. In October 2005, he made the top ten in a *Variety* ranking of 100 media icons of the twentieth century. Bugs Bunny did not.[33]

Mickey's comeback was the culmination of a sustained effort tied to his seventy-fifth anniversary in 2003, when the Postal Service publicized its intention to issue several Disney stamps the next year, including a Mickey-Donald-Goofy commemorative [300]. In 2004, a renewed animation campaign yielded a pair of direct-to-video, full-length films: *Mickey, Donald, Goofy: The Three Musketeers* and *Mickey's Twice Upon a Christmas,* the latter in 3-D. The fast-paced *Musketeers*, with Mickey Mouse and his companions doing battle to save Princess Minnie from Pegleg Pete, the nefarious captain of the guard, and the underutilized Beagle Boys, was yet another honorable undertaking. But *Twice Upon a Christmas*, a compendium of five original two-reelers, whose plots, to their credit, were reminiscent of Disney's golden age in the late 1930s and 1940s, came a cropper, in part because the film's computer-generated 3-D characters looked like candied figurines [299]. These spotty attempts at reanimating Mickey's onscreen persona and "his role as chief greeter at Disney's theme parks" aside, Mickey's "only other major gig" in recent years, as Richard Verrier said in 2003, was "on the Saturday morning television cartoon 'MouseWorks.'" Then, as now, Mickey has averted consignment to comic-character obscurity: however, he is still a long way from the time when his star image was such that a movie audience felt cheated if a Mouse film was not on the bill.[34]

T hough woefully overused, the term *icon* has been ingrained in everyday speech as shorthand for social phenomena—persons or things—that are exceedingly familiar, no matter how long their popularity, celebrity, or notoriety is likely to last. We have political, sports, and cultural icons of every stripe, including those mythic Hollywood beings variously referred to, over the years, as screen idols, legends, gods and goddesses, stars, starlets, and, since the 1960s, superstars.

Fame has long been slave to publicity—and hyperbole. Voltaire, possibly the first "superstar" of modernity, was hailed in Paris, before he

295. Opening title from *Mickey's Christmas Carol*, released in the U.S. on Dec. 16, 1983. Walt Disney Archives, Burbank, California.

296. Mickey in *The Prince and the Pauper*, released Nov. 16, 1990. Walt Disney Archives, Burbank, California.

297. Mickey Mouse in *Runaway Brain*, released on August 11, 1995 with the feature film "A Kid in King Arthur's Court". Walt Disney Archives, Burbank, California.

298. Robert Risko (1956–), illustration for "Mickey Mouse: Animated Ambassador of America," in VH1's *200 Greatest Pop Culture Icons*, July 2003. Risko, Inc., New York.

died, as *le roi Voltaire* ("King Voltaire"). In Voltaire's case, the hype was justified. Over the course of his sixty-year career, the sharp-witted French *Philosophe* amassed a vaunted and voluminous body of writing. In old age, he was revered as an apostle of tolerance and human freedom, and was the first non-royal to achieve iconic status in his own lifetime. As with Mickey, Voltaire's fame was amplified via a dazzling array of objects depicting his prismatic persona and accomplishments, many of them produced by mechanical means: prints, bronze medallions, and casts of portrait busts such as the plaster head-and-shoulders by Houdon that Thomas Jefferson put on display in his home at Monticello.[35]

This was before the invention of photographic modes of reproduction. In the twentieth century, the democratization of political and social institutions, a rising expendable income, the liberation of ordinary people from the yoke of six-day-a-week labor, plus the advent of truly mass media and "machine-age" or electronic diversions like film, television, and the Internet, made possible the cult of celebrity we've come to know. In his book *The Image: Or, What Happened to the American Dream* (1961), Daniel J. Boorstin said that "celebrity in the distinctive modern sense could not have existed in any earlier age, or in America before" the middle of the nineteenth century. A celebrity, Boorstin observed, "is a person who is known for his well-knownness," and celebrities' biggest claim "to fame is their fame itself." Print and broadcast giants have, more recently, openly thrown in with the entertainment industry (think Time-Warner, News Corp., Disney/Cap Cities, etc.) further feeding a seemingly insatiable hunger for the latest scoop on the rich and famous.[36]

Years before the modern-day reign of excess set in, Boorstin warned:

> Celebrity-worship and hero-worship should not be confused. Yet we confuse them every day, and by doing so we come dangerously close to depriving ourselves of all real models. We lose sight of the men and women who do not simply seem great because they are famous but are famous because they are great. We come closer and closer to degrading all fame into notoriety.

According to Boorstin,

> The hero was distinguished by his achievement; the celebrity by his image or trademark. The hero created himself; the celebrity is created by the media. The hero was a big man; the celebrity is a big name.[37]

Boorstin's point with respect to celebrity-worship versus hero-worship is hard to refute. However, it fails to address the question of

299. DisneyToon studios' cartoon *Mickey's Twice Upon A Christmas*, 2004, Walt Disney Pictures.

300. David Pacheco, Peter Emmerich, and Terrence McCaffrey. Goofy, Mickey Mouse, and Donald Duck, on a commemorative stamp created by the United States Postal Service and released July 1, 2005.

what to think of make-believe figures like Mickey. In his 1988 survey of Warner Bros. animation, Steve Schneider wrote:

> The criteria for greatness in animated cartoons are several. Bugs Bunny easily meets them all: He was the star of his own long-running series of shorts, in this case numbering more than 160; he became the internationally recognized symbol of an animation studio; he has won more popularity polls than anyone cares to count; hit recordings, sheet music, comic books, newspaper strips, and feature films have carried his name; his image embellishes merchandise ranging from jewelry to toothpaste; he has not been absent from television for one day in more than 30 years; his mention brings a pleasant tension to the corners of the mouth.

Naturally, Schneider admits, "a few other cartoon characters can support such claims. "But," he said, "Bugs rises above the pack: Perhaps more so than any other cartoon creation, Bugs is the character whom, if he were to come to life, you would want to spend time with. There would be much to say."[38]

Bugs Bunny is the raucous cartoon equivalent of Groucho Marx, whose quip in *Duck Soup*, "Of course, you know this means war," became one of Bugs's catchphrases (a carrot being his prop counterpart to Groucho's cigar). Like Groucho Marx, though, Bugs is self-absorbed, perhaps a bit too quick with a wisecrack. Mickey recalls the earnest, spunky amiability of a Jimmy Stewart or Tom Hanks. Updike cited "his 'gawshes' and Gary Cooper-like gawkiness." Once his roguish side, showcased in *Plane Crazy* and *Gallopin' Gaucho,* was reined in, Mickey became a sort of cartoon analogue of good-guy actors like Cooper, Stewart, and Hanks.[39]

As these comparisons suggest, it is tempting to draw a parallel between Mickey Mouse and human icons of the big screen. "Every great star is a walking idea," Neal Gabler has written. "Cary Grant," for instance, "demonstrated the force of charm and quick-wittedness." Marilyn Monroe, as Michael Barrier said of Betty Boop, was "a travesty of compliant femininity." John Wayne was the gruff, solitary man's man, with a heart of gold he strove to hold in check; Bogart: a slim, sexier, more cynical—and vulnerable—version of the same.[40]

All movie legends can be reduced to similarly succinct, one-dimensional "ideas." Mickey, not so easily. Critic Robert Sklar has observed that, "in the culture of the later 1930s," he "was a creature of many masks, expressing what we all like to think are the best traits of our humanity: sweet sentiment, unfeigned pleasure, saucy impudence." The Mouse is, however, more than a set of masks that flatter our sense of well-being, and is not

merely famous for being famous. The hero may be self-made, the celebrity a media invention, but real-world heroes and film legends, as well as fictional folk like Mickey, who attain the status of cultural icon, have that status thrust upon them. They rise to that mystical condition only after they've become a quasi-organic, permanent part of cultural reality—and the cultural unconscious. Hollywood legends, in Gabler's words, "tend to create a longstanding emotional identification with their audience"; they incorporate ideas that seize our imagination, and, "the more powerful the theme a star" projects, the greater the stardom. Mickey Mouse's star image has always been intensely associated with feelings of joy, good cheer—and pluck. And yet, in a sense, he's also a "self-made man," having generated a sociocultural genome, in the aggregate more tangible, intricate, resonant, and heroic—remember Lionel trains, and Mickey's war-time "service"—than anything attained by Marilyn Monroe, Bogart, Bugs Bunny, or John Wayne.[41]

Robert W. Brockway, in his article "The Masks of Mickey Mouse," stressed Mickey's connection to what a fellow academic called the "most primitive, archaic level of the human mind." Because of the "various metamorphoses in the course of his development," Brockway found the Mouse to be "much more complex than the other animated figures" of his day, "none of which progressed past the slapstick stage." Neither Bugs Bunny nor, certainly, any other cartoon mouse, from Jerry of "Tom and Jerry" [301] to Mighty Mouse to *Pinky and the Brain* [302], has achieved a comparable breadth and depth of meaning.[42]

"If anything is more irresistible than Jesus," humorist Carl Hiaasen joked, in his essay-length book *Team Rodent (1998)*, "it's Mickey." Irresistible, although compared to the Depression-era population, the public today has relatively little idea what the early Mouse was like (despite the fact that the entire series of Mickey animated shorts is now available on DVD and, unofficially, online). Wearing a Mickey tee-shirt may be the principal point of contact with the character for most people in the new millennium. Much the same can be said of Jesus, the most iconic figure in Western history and, for the faithful, the supreme hero. The name and image of the Son of God long ago lost the hold over mind and heart they had when the monumental cathedrals of medieval Europe were going up. Like a plastic Jesus on a car dashboard or "Jesus Saves" on a bumper sticker, Mickey has been almost totally abstracted from the context of his original cult in the 1930s. Yet, Christ and the Mouse are reminders that a yearning for virtue is eternal.[43]

"America is dominating the world," filmmaker Spike Lee once told an audience in Singapore, "because of culture—movies, television, Levi's, Coca-Cola, Disney, rock and roll, hip-hop." Like Jesus, Disney and Mickey Mouse are irresistible where polemics are concerned. Walt's

best-known creation has become the metaphor of choice in rhetorical assaults on American global dominance [303].[44]

The positive, inverse side of the Mouse, on the other hand, can be seen even in the war-torn Middle East. In 2007, a Hamas children's television show urged its young viewership to do violence against Israel and America, via a rip-off Mickey character called Farfour [304], which Diane Disney Miller denounced as "pure evil." Almost simultaneously, however, two Palestinian boys were photographed standing before a huge picture of Mickey Mouse painted on the wall of a school. One way or another, it seems, Mickey's face still serves, as it did when it was affixed to the side of Dr. Paul Dooley's hospital ship off the coast of Vietnam in the 1950s, to promote juvenile well-being or healing through the symbolic expression of joy.[45]

301. *Tom and Jerry* cartoon title card, circa 1950, for the series created, directed, and produced by William Hanna and Joseph Barbera for MGM, 1940–57. Warner Brothers Entertainment.

302. *Pinky and the Brain*, 1995, from the TV cartoon series created by Tom Ruegger for Warner Bros. Animation, 1995–98. Warner Brothers Entertainment.

To many people outside the United States, Mickey Mouse signifies happiness, the spirit of adventure, and, above all, liberty. In an article published in 1991 in *New Perspectives Quarterly,* Michael Eisner declared:

> For viewers around the world, America is the place where the individual has a chance to make a better life, and to have political and economic freedom.
>
> Diversity of individual opportunity, individual choice, and individual expression is what American entertainment imparts—and that is what people everywhere want.

"The Berlin Wall," Eisner went on to say,

> was destroyed not by the force of Western arms, but by the force of Western ideas.
>
> And what was the delivery system for those ideas? It has to be admitted that to an important degree it was by American entertainment. Inherent in the best and the worst of our movies and TV shows, books and records is a sense of individual freedom and the kind of life liberty can bring. [...][46]

Michael Eisner may have had no specific event in mind when he made that statement, but his point had been vividly illustrated just two years before—with Mickey Mouse, Disney's corporate ambassador to the world, a key player in the drama. On the day after the Berlin Wall was breached, November 10, 1989, a young American physicist, James Le, who was studying in Germany at the time, spray-painted Mickey's features on the barrier near Checkpoint Charlie, one of the most chilling

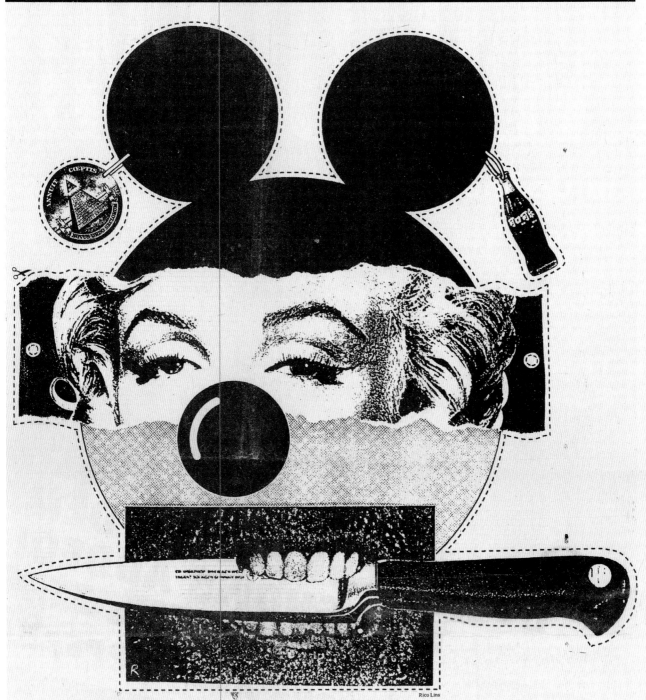

Rico Lins

World Leaders: Mickey, et al.

ceed in paving over the profuse variety of global cultures.

304. Suhaib Salem, Palestinian children watch an afternoon children's program on Al-Aqsa television, May 13, 2007. Reuters.

symbols of the Cold War. The picture bore the caption "Willkommen in ~~Ost~~ Berlin" [305].[47]

The next day, with James Le's Mouse looming over his shoulder, the Russian émigré Mstislav Rostropovich celebrated the historic happening with an impromptu performance of Bach's Suites for Cello, culminating in the solemn fourth movement or Sarabande from Suite No. 2 [306]. Chances are the renowned cellist delighted in the company of Walt Disney's cheery exemplar of freedom (he could easily have moved his chair if he didn't want to be seated near Mickey). Further proof of the maestro's affection for America came just three months later. In February 1990, he was invited to conduct concerts in Moscow and Leningrad. The program at the Moscow venue was "filled with sad music, including Shostakovich's anguished Fifth Symphony, which was written at the height of the Stalinist purges in 1937." For Rostropovich's "final encore, he chose an American classic, John Philip Sousa's rousing 'Stars and Stripes Forever,' the traditional finale of the National Symphony's annual Fourth of July concert on the West Lawn of the Capitol in Washington." The Moscow audience responded with a standing ovation. Later, amidst bear hugs and vodka toasts at a postconcert reception at the U.S. Embassy, Rostropovich was asked why he'd picked the "Stars and Stripes Forever." The idea, he said, came "from the heart."[48]

Eight years after Rostropovich's triumphal concert, in May 1998, a freelance writer for the *Washington Post,* Stephen Benz, spent three days in Communist Cuba. His assignment: to research an article "on what to do and where to go in Havana." But a totally unexpected incident, also sprung from the heart, "put a completely different spin on my visit to the city." A Cuban mailman named Eddie, "wearing a New York Yankees shirt," latched onto Benz and insisted on taking him on his rounds.

It was soon clear that Eddie was showing me off. In building after building, he introduced me to the tenants. "This is my friend," Eddie said. "An American." Everyone seemed unduly impressed. [. . .] Entire extended families gathered at the threshold to stare and ask questions.

In one dark passage, an impossibly old man heard Eddie's boast, then grabbed my arm and pulled me into his flat. [. . .] He led me to a corner where candles burned before the blackened statue of a saint. [. . .] With great panache, the old man reached behind the statue and drew forth a small paper rectangle. He handed it to me. In the candlelight I saw it was a postcard, a much-handled postcard of—I squinted—Cinderella's castle in Disneyland. Mickey Mouse waved from the foreground.

The old man rummaged through a wooden cigar box until he produced a stubby pencil. His speech was animated and constant. I

303. Rico Lins (circa 1955–), illustration for Todd Gitlin, "World Leader: Mickey, et al.," *New York Times,* May 3, 1992. Private collection.

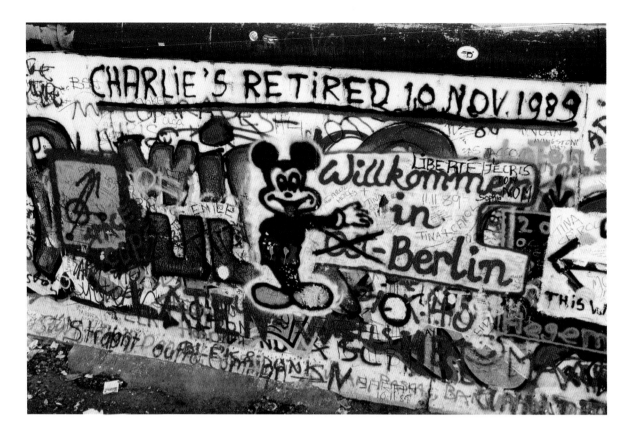

305. Photograph by Bruno Barbey. "Willkommen in Ost Berlin" (Welcome to East Berlin), photograph of the Berlin Wall with spray-paint drawing of Mickey Mouse and various graffiti, circa November 11, 1989. "Charlie's retired 10 Nov. 1989" refers to the location of this section of the wall: at Checkpoint Charlie, the most famous of the transit points between East and West Berlin during the Cold War. Magnum Photos.

306. Mstislav Rostropovich (1927–2007) playing Bach in front of the Berlin Wall at Checkpoint Charlie, Berlin, Nov. 11, 1989. Corbis Images.

looked to the mailman for interpretation. "He wants you to sign the picture," Eddie said.

The request baffled me. I couldn't think of any reason why he would want my autograph on the postcard. But I couldn't very well refuse. The old man rattled off another long sentence and tapped the card to indicate where I should sign. When I had done so, he snatched the card, cackled, and returned it to the altar.[49]

In the United States, Mickey waves at us incessantly, mostly as the front man for the many-faceted operations of the Walt Disney Company. Because we expend much of our time and energy coping with the stresses of daily life, we tend, unlike the "impossibly old man" in Cuba, to take what is good about the character, and what he means, for granted. Familiarity can breed ignorance or indifference as well as contempt.

Mickey is so deeply embedded in our cultural DNA that he fits into paintings like those of Wayne Thiebaud, Lawrence Faden [307], or Philip Pearlstein [308] as unremarkably as a copper pot in a still-life by Chardin or scraps of newsprint in a Cubist collage. Yet there is nothing casual about his role in a large canvas by Pearlstein, *Mickey Mouse Puppet Theater, Jumbo Jet, and Kiddie Tractor with Two Models* [309], one of several of the artist's works in which the Mouse appears. In the late 1940s, Pearlstein majored in art at what is now Carnegie Mellon University in Pittsburgh; he and Warhol were classmates and, after graduation, flat-mates in New York City. Pearlstein shared Andy's distaste for nonfigural abstraction as well, and, in 1952, nearly three decades before Warhol, in "a sign of Pop

307. Lawrence Faden (1942–), *Hearts for Michelangelo*, 1990. Oil on canvas, 38 × 44 in. Collection of the artist.

art to come," as Robert Hughes put it, he painted a muscular, Abstract Expressionist image of Superman (Museum of Modern Art, New York).[50]

Every aspect of Pearlstein's *Mickey Mouse Puppet Theater* is an artificial construct. The major focus is on two nude "models," one male, one female, surrounded by playthings, obviously, like the couple, thoughtfully selected and arranged by the artist. The woman sits on a toy tractor. A Mickey Mouse doll on a prepackaged cardboard stage is positioned next to the man, while a toy "Jumbo Jet" plunges, nose downward, between him and his companion. Writing in the *New York Times,* Michael Kimmelman wondered:

> Is the descending plane a 9/11 allusion, with the tractor and Mickey
> and the sleepy figures, like Adam and Eve, oblivious and innocent:
> the American heartland and American commercial culture with a
> somnolent populace on the verge of catastrophe? 'I see it but I prefer not
> to,' Mr. Pearlstein says.[51]

Well, it does allude to 9/11, although the couple might better be described as dejected or pensive than "sleepy." (The way the woman is posed is typical of images of the repentant Magdalene in Baroque art.) Pearlstein straddled an ambiguous line between opposing reactions to the horror of September 11. One can see the painting as a depiction of innocence lost, precipitated by a cruel, unexpected intrusion upon the American Way of Life, but it may also be construed as an allegory of divine retribution: a materialistic, imperialistic Mickey Mouse culture punished for its sins by a device of its own making, the "Jumbo Jet."

Hardly anyone still living can recall, as could the late John Updike, a powerful personal experience from Mickey's heyday. In Updike's case, he remembered winning, as a schoolboy before World War II,

Mouse piggy bank in a spelling bee ("my first intellectual triumph"). Though prior efforts fizzled, the brass at Disney might yet rekindle Mickey's mass-cult magic by aping the more feral Tom Sawyer antics and syncopated, Jazz Age merriment of his early one-reelers. As Max Raab learned in the field of fashion, a committed return to Mickey's roots could make him the "new black" in cartoons. *The Mickey Mouse Works* along with the *Disney's House of Mouse* TV cartoons of 1999-2002 marked a tentative step in that direction. A cluster of recent Mickey Mouse films, beginning with *Croissant de Triomphe* [311], and especially *Get a Horse!* [312], the first original Mickey theatrical short since *Runaway Brain*, released in 2013 as a lead-in to the animated feature *Frozen*, were more deliberate moves in the same direction.[52]

One could envision a revivified Mouse in any number of ways: as in *Epic Mickey* [310], for instance, a video game series launched in November 2010, that recast the character in an edgier, darker light. Or, in the realm of animation proper, a completely reworked version of *Plane Crazy*, in a deliberately antique or classic mid-'30s mode—drawn by hand, along the lines of *Get a Horse!* Another possibility: a Fourth-

308. Philip Pearlstein (1924–), *Model with Neon Mickey and Bouncy Duck*, 2007. Oil on canvas, 48 x 36 in. Courtesy of the artist and the Betty Cuningham Gallery, New York.

309. Pearlstein, *Mickey Mouse Puppet Theater, Jumbo Jet and Kiddie Tractor with Two Models*, 2002. Oil on canvas, 60 x 60 in. Courtesy of the artist and the Betty Cuningham Gallery, New York.

310. Box cover art for the *Disney Epic Mickey* platform video game designed by Warren Spector, released November 2010. Oswald the Lucky Rabbit is depicted in the upper right, just below the title. The Animation Research Library, Glendale, California.

311. Screen capture from *Croissant de Triomphe*, Paul Rudisch, dir., released June 28, 2013. The sketchy backgrounds in *Croissant de Triomphe* recall the "Cartoon Modern" style of the 1961 version of *101 Dalmatians*. The Animation Research Library, Glendale, California.

of-July Band Concert with Goofy, Horace Horsecollar and Clarabelle Cow, under Mickey's baton, tackling Sousa's "Stars and Stripes Forever," sticking to their guns despite hurricane winds or hectoring from Pegleg Pete—with, for good measure, Donald Duck squawking a few bars of "Be Kind to Your Web-Footed Friends."[53]

Like the rickety aircraft in *Plane Crazy,* Mickey Mouse entered this world the makeshift savior of Disney's fledgling entrepreneurial and artistic independence. His fortunes as an emblem of the American spirit began with a decade of affection from adults, children, esthetes, and swells, for whom he was energy, ingenuity, fidelity, and fun incarnate. Qualities, one and all, evidenced in this early, widely circulated depiction of Mickey [313], cocked back on one heel, hands politely parked behind his back. A twentieth-century counterpart to William Blake's Romantic-era etching *Glad Day* [314], it is the figural epitome of Yankee joie de vivre.

A second representation, the radiant Mouse face glimpsed in *Sullivan's Travels,* blasted moviegoers in the eye as it announced each Disney cartoon from 1932 into the 1950s, first in black and white, then, after 1935, in color [315]. Art historian Mia Fineman has said of Grant Wood's contemporaneous painting *American Gothic* [317] that "the stark frontality of the figures" "directly facing the viewer—just like the flatly frontal images of saints in medieval Christian icons," invests the flinty couple in the picture "with both authority and immediacy." But, truth be told, the subjects in *American Gothic* avoid direct eye contact with the beholder, whereas Mickey's mien, in the sunray design, is unambiguously straight-on in its frontality.[54]

It was the Mouse behind iconic effigies such as these that led Sergei Eisenstein, Diego Rivera, and Dorothy Grafly, among others, to embrace him as the great black-and-white hope for a universal, truly modern pictorial vernacular: the harbinger of an authentic, home-grown medium, the animated cartoon. That Mickey Mouse, Walt Disney, and Disney's cartoon empire, once the darlings of the left, have become signs of oppressive corporatism, consumerism, and cultural imperialism is a reversal of fortune unwittingly reflected in one of the most widely disseminated images of Mickey from the postwar period, a pale imitation of the exhilarating Technicolor face: the Mickey Mouse Club logo [316].

In 1968, two years after Walt died, he was, as previously noted, characterized by Richard Schickel as having been "a primary force in the expression and formulation of the American mass consciousness." Neal Gabler, in 2006, seconded that opinion, calling the cartoonist-producer-impresario "an architect of the American consciousness." Disney, Gabler suggested, was one of those individuals "who, if we understand

313. United Artists general-use lobby poster, circa 1933, 27⅜ x 40½ in., printed by Tooker-Moore Lithograph Co., Inc. The Walt Disney Family Foundation, San Francisco, California. The Mickey seen here originated as an animation pose in the Mickey Mouse cartoon *Puppy Love,* released Sept. 2, 1933.

them and how their minds work, and how they interact with American culture, will then help us understand America itself." Understanding—and appraising—the genius of Walt Disney requires, at the very least, thoughtful attention to Mickey Mouse, his fictional alter ego, whose durable cultural presence factored immensely in Walt's shaping of our consciousness as a people, and how we are perceived abroad.[55]

Soon after Mickey was loosed onto the screen, a now hackneyed staple of political discourse, closely tied to our national sense of self, entered the language: "the American Dream," an expression almost certainly coined by James Truslow Adams in 1931 in his best-selling historical study, *The Epic of America.* One purpose of the book (written during the bleak early days of the Depression), Adams said, was to try

> to trace the beginnings at their several points of entry of such American concepts as "bigger and better," . . . of our attitude toward

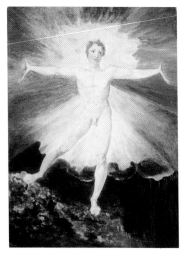

314. William Blake (1737–1827), *Glad Day* (also called *Albion Rose*), circa 1796. Color printed etching with hand-drawn additions in ink and watercolor, 10⅜ x 7⅜ in. The British Museum, London.

315. Sunburst Mickey, opening screen shot for all Mickey Mouse color cartoons starting in 1935. The Walt Disney Company, Burbank, California.

316. Logo for the *Mickey Mouse Club* television show, fall 1955.

business, of many characteristics which are generally considered as being "typically American," and, in especial, of that American dream of a better, richer, and happier life for all our citizens of every rank, which is the greatest contribution we have as yet made to the thought and welfare of the world. That dream or hope has been present from the start. Ever since we became an independent nation, each generation has seen an uprising of ordinary Americans to save that dream from the forces which appeared to be overwhelming and dispelling it. Possibly the greatest of these struggles lies just ahead of us at this present time—not a struggle of revolutionists against established order, but of the ordinary man to hold fast to those rights to "life, liberty, and the pursuit of happiness" which were vouchsafed to us in the past in vision and on parchment.[56]

In a pithy rejiggering of Adams's take on the "American dream," marketing guru Clotaire Rapaille has asserted that "America is not a place. It is a dream." Put another way, by Jeffrey Lord: "To be an American is exactly to be a dreamer." According to Lord, dreams "are the tell-tale cultural code of America that link the Founding Fathers to the pioneers and the astronauts, that connects Ben Franklin to Walt Disney and Walt Disney to Steven Spielberg."[57]

Dreams and dreaming compose a powerful thematic thread common to almost every one of the Disney full-length animated cartoons, voiced, no doubt most memorably, in the theme song from *Cinderella* [318]:

A dream is a wish your heart makes,
When you're fast asleep.

It is a theme sounded musically in *Snow White and the Seven Dwarfs* [319], *Pinocchio, Peter Pan, Sleeping Beauty,* even *Mary Poppins,* Walt's valedictory motion picture masterpiece, in which Mr. Banks (played by David Tomlinson), after being fired by the Dawes, Tomes, Mousley, Grubbs Fidelity Fiduciary Bank, wistfully intones: "A man has dreams of walking with giants." The action in each of these movies, as in *Cinderella,* unfolds in the Old World, but the notion of clinging to, and expecting to achieve, one's personal dream is pure Disney, and thoroughly American.

Jim Cullen, in his book *The American Dream: A Short History of an Idea That Shaped a Nation,* claimed that the phrase "American Dream" communicates what

seems like the most lofty as well as the most immediate component of an American identity, a birthright far more meaningful and compelling than terms like "democracy," "Constitution," or even "the United States."

Nonetheless, Cullen added, "there is no *one* American Dream"; there are, rather, "many American *Dreams*, their appeal simultaneously resting on their variety and their specificity." Actor Dennis Hopper scored the same point, more colorfully, in a TV commercial for the online brokerage firm Ameritrade:

> The American Dream . . . a white picket fence, 2.4 kids, and a nice puppy dog? No-o-o! The American Dream is that each one of us gets our own dreams. Big dreams, small dreams, *cra-zy* dreams. But here's the thing: it's not just about where your dreams take you, it's where you take your dreams. Ha-ha-aa![58]

317. Grant Wood (1891–1942), *American Gothic*, 1930. Oil on beaverboard, 30¾ x 25¾ in. Art Institute of Chicago; art © Figge Art Museum, successors to the estate of Nan Wood Graham. Licensed by VAGA, New York.

If Jefferson's immortal words in the Declaration of Independence, referenced by James Truslow Adams, "Life, Liberty, and the pursuit of Happiness," are the axiomatic articulation of the American Dream, one could say that the "American Spirit," the subhead of this volume, is the spark that fires our individual and collective aspirations. It is a trait that, as Adams also said, "has been present" going back to our infancy as a nation. In a parliamentary speech, in 1775, on conciliation with His Majesty's colonies, Edmund Burke famously marveled at "the American spirit [. . .] the spirit that has made the country," and "this spirit of American liberty." When asked, over two centuries later, in an interview, "What makes America great?" comedian Jeff Foxworthy replied: "The spirit of its people."[59]

Historians Charles and Mary Beard, in *The American Spirit, a Study of the Idea of Civilization in the United States* (1942), had this to say about the subject of their book:

> Out of our studies extending over many years we have reached the conviction that no idea, such as democracy, liberty, or society, or the American way of life, expresses the American spirit so coherently, comprehensively, and systematically as the idea of civilization.

If this is correct, the question becomes one of how we define the idea of "civilization," which, for the Beards, appears to have been synonymous with "culture." For Walt Disney, however, "culture" was a word that "seems to have an un-American look to me—sort of snobbish and affected," he once said. Many Americans would agree (in part at least). Keepers of the elitist flame tend—willfully, at times—not to see that popular culture *is* culture, or fail to understand, as Thomas Craven put it, that "any art, all art, high or low," including Disney's, "is the natural outgrowth of a living culture." And many still would exclude the American Regionalists (Benton, Wood, Curry), Norman Rockwell

318. Jaq the mouse, entranced by Cinderella singing "A Dream Is a Wish Your Heart Makes," in *Cinderella* (1950). Walt Disney Company, Burbank, California.

319. Snow White singing "I'm Wishing" in *Snow White and the Seven Dwarfs* (1937). Walt Disney Company, Burbank, California.

[320], Warhol, even Andrew Wyeth, from the pantheon of our most gifted painters. They will not admit what the late Arthur Danto, like Seldes and Susan Sontag before him, held (in an essay in *The Nation* in 1999) as self-evident: that the "distinction between good and bad art cuts across the distinction between Art and Culture."[60]

Thomas Hart Benton, in projects like his *Arts of America* cycle, and Rockwell, in the broader totality of his work, came nearer than any other artists to capturing the diversity of twentieth-century American culture. In a critique (1985) of a catalogue raisonné of Rockwell's œuvre, in language that Diego Rivera and Sergei Eisenstein might well have endorsed, and which applies equally to Walt Disney, Danto observed that Rockwell "was paradigmatically the artist of the age of mechanical reproduction," and, since his

> work was addressed to the common man so exclusively, he should be acknowledged as "revolutionary" in the definition of the famous essay by Walter Benjamin "The Work of Art and the Age of Mechanical Reproduction."

Rockwell, Danto further mused,

> seems to remain an intelligence test for theoreticians who are capable of explaining easily why a bottle rack or urinal can be not only a work of art but a great one but who are reduced to impotence in explaining why Rockwell's is not very good art and may not be art at all.[61]

In a *New York Times* review of a Norman Rockwell retrospective, *Times* art critic Michael Kimmelman commented that Rockwell "obviously" was "the most popular American artist of the century," despite having "defied the fundamental credo of modernism that good art should be difficult if not (better yet) discomforting." His "identification with his audience was the source of his popularity even more than folksy humor or fool-the-eye realism, and it remains the basis of his continuing appeal." Unfortunately, Kimmelman lamented, Rockwell practiced his profession "in a culture that, out of insecurity or mistaken priorities or simple snobbism, continues to divide a taste for high art from a taste for low art as if they were mutually exclusive."[62]

Kimmelman's review elicited a letter to the editor in which two *Times* readers declared, "Significant art is a result of the interaction among the artist, the subject, and those who experience the final work." Painter David Hockney, in another letter, disputed Kimmelman's take on Rockwell: "surely America's most popular artist this century was Walt

Disney," whose productions, were "more universal than Rockwell's—an excellent genre artist."[63]

In the end, should "significant art" be interpreted as any imagery, whatever the medium, that, over time, a substantial portion of society finds meaningful or fulfilling, then (like Rockwell) Walt Disney and his legion of animators, background artists, inkers, painters, and inbetweeners crafted some of the finest art ever made—as evidenced by contemporary French artist Serge Dutfoy's *hommage* to Mickey's maker [322].

In the course of his career, Norman Rockwell illustrated a virtual chapbook of native mores. There is much that is prototypically American in Rockwell's *Rosie the Riveter* or the *Four Freedoms,* from World War II, and his multilayered *Triple Self-Portrait* [320], which inspired a clever pastiche of Walt limning his inner self as Mickey [321]. And yet, if one had to select a single image to express the American ethos, none of Rockwell's "excellent genre" scenes or other compositions by themselves fill the bill.

A prime candidate as a visual summation of our character as a people is Grant Wood's *American Gothic* [317]. Steven Biel, in a superb monograph on the painting, has claimed that it "not only reflected but helped create American identity," and "personifies the nation: gives it white faces, locates it in the 'middle' both geographically and socioeconomically," and "establishes that middle as *the* national identity." And yet, *American Gothic* is really too parochial (rural Midwestern), grim, and racially restrictive to simulate who we are as a country in the twenty-first century. It is the visual inverse of John Updike's aphoristic remark that "America is a vast conspiracy to make you happy." The time-worn rustics in Wood's painting do not, as Updike said of Mickey Mouse, denote "America as it feels itself," nor can they be tagged as "all things to all men," as Mickey was described by Terry Ramsaye. From either of the latter, "more universal" perspectives (as David Hockney put it), any one of Andy Warhol's three-quarter views of Disney's cartoon Everyman provides an infinitely better choice as an emblem of the American spirit.[64]

Warhol's museum-grade refashioning of the classic standing figure of the early 1930s [323] gave Mickey renewed oomph, and blazed the way for the retro-tinged popularity he enjoys today. As one of a suite of pop icons [264], including Superman, Santa Claus, and Uncle Sam, Warhol's Mouse, despite its outward simplicity, it is contextually complex. At the junction of high and low culture, of art and commerce, Andy's various Mickeys are a compelling distillation of contemporary American civilization. What makes them an especially satisfying specimen of the national spirit is the image they project of a being, like America, at its best: guileless, energetic, at ease, eternally young

320. Norman Rockwell, *Triple Self-Portrait,* on the cover of the *Saturday Evening Post,* February 13, 1960. The original (oil on canvas, 44½ x 34¾ in.) is at the Norman Rockwell Museum, Stockbridge, Massachusetts.

. . . an all-encompassing image of an individual blissfully living the American Dream.

English art historian Bevis Hillier, a student of Mickey's progress, felt that "perhaps the previous literary character with whom" the Mouse "has most in common is Voltaire's Candide, with his boundless optimism and his conviction that all's for the best in the best of all possible worlds." In the end, though, Candide discovered that life can be tedious and brutal as well as pleasurable. His ultimate response to this immutable truth was the realization that gaining even a modicum of happiness in this world entails fruitful labor: "We must cultivate our garden." That pragmatic, action-based adage conveyed the sage thinking of Candide's creator, a philosophy arguably more Anglo-Saxon, indeed, more characteristically American, than French.[65]

Ray Bradbury once called WED Enterprises (formed in 1952 to plan the construction of Disneyland), Walt's "Idea Factory." Voltaire, Bradbury added, "would have filed it with proper delight in his *Philosophical*

Dictionary." Voltaire's own personal "Idea Factory," his rural estate at Ferney, near Geneva, was, for E. M. Forster, the embodiment of "Civilisation. Humanity. Enjoyment." The Disney theme parks, past, present and future—Walt's last great legacy—, represent, in their less sophisticated, New-World patois, a kindred set of ideals.

They function as secular, latter-day Gardens of Eden in which Mickey Mouse reigns as the supreme seraph. They are picture-perfect, people-friendly environments wherein persons of every color and ethnicity, rich or poor, gather to celebrate fundamental virtues, like devotion to kith and kin, and to revel in the rejuvenescent powers of imagination and good clean fun. They remind us, as William F. Buckley said of Walt Disney World in Orlando, "that the best pleasures are innocent." [66]

And they have always been associated with Mickey. Immediately after Disney's death in 1966, Bosley Crowther, writing in the *New York Times*, described Walt's mindset in the early 1950s, during the planning and development stage of Disneyland, as one of "joyously gestating another Mouse." [67]

322. Serge Dutfoy (1942–), The creative geniuses depicted here, from left to right and top to bottom, are Albrecht Dürer, Johann Sebastian Bach, French cartoonist Mœbius [276], Belgian comic book artist Hergé, creator of Tintin, Pablo Picasso, composer Maurice Ravel, Duke Ellington, Mondrian, and Disney. The man on his knees, holding the white flag of surrender inscribed "me," is Dutfoy himself. Photoshop, 2011. Digital print on paper. Courtesy Serge Dutfoy, Saint-Quentin, France.

Family treks to any of the Disney parks, with obligatory, Kodak-moment hugs from Mickey or Minnie, exemplify a generational process whereby adults pass deeply-felt affinities on to children, grandchildren, nieces and nephews. Like mom's apple pie or allegiance to dad's sports teams, shared experiences like these are among the familial and societal ties that bind. Like Mickey, the Magic Kingdoms, which attract visitors from all over the globe, are also proof positive that an urge to remain young and to live in the moment is not a solely American impulse, it is inherently human.

Mickey Mouse is a protean expression of the qualities, values, and dreams of the man and country that spawned him. He may not get another shot at motion picture stardom. However, as long as infants are seduced by his beaming face, or a toddler is moved to trace his rounded contours, he is bound to stir the popular and the creative mind. So long as the quest for happiness and a dedication to freedom—bolstered by faith in a force larger than self—endure, Walt Disney's cartoon Everyman will continue to connect and to prosper.

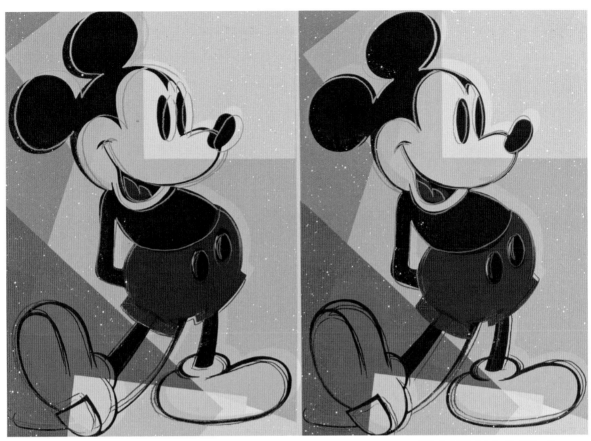

323. Andy Warhol, *Double Mickey Mouse,*
from the *Myths Portfolio,* 1981. Silkscreen
ink over synthetic polymer paint on canvas,
30½ x 43 in. VAGA / Ronald Feldman Fine
Arts, New York.

NOTES

INTRODUCTION

1. Gersh Kuntzman, "New Bunny Stamp," *New York Post*, p. 4.

2. Idem. ("Bugs is an American icon").

3. Mickey-Donald-Goofy and Mickey-Pluto commemoratives were issued on June 23, 2004 and June 30, 2005, respectively. Mickey and Minnie Mouse were paired on a stamp issued Apr. 22, 2006. Mickey appeared by himself as the Sorcerer's Apprentice in *Fantasia* and as "Steamboat Willie" on stamps released on Aug. 16, 2007 and Aug. 7, 2008.

4. In 1993, Blaine Gibson told Jim Korkis that his statue was meant to represent Disney "pointing down Main Street and saying to Mickey at his side, 'Look at all the happy people who have come to visit us today.'" See Korkis, "The History of the Partners Statue: Part 1 One" (www.mouseplanet.com/9766/The_History_of_the_Partners_Statue_Part_One).

 For more on Gibson and the statue, see: Dave Smith, *Disney A to Z* (2006), pp. 281, 522; Russell Schroeder, *Disney's Mickey Mouse*, 62; Floyd Norman, "Toon Tuesday" (jimhillmedia.com/blogs/floyd_norman/archive/2008/06/24/toon-tuesday-getting-a-head-in-the-game-with-blaine-gibson.aspx); and Korkis, "Partners Statue," in Korkis, *The Book of Mouse*, pp. 257-258.

5. Gabler, *Walt Disney: The Triumph of the American Imagination*, p. 154; Robert Benayoun, "La Souris qui a accouché d'une montagne," *Le Point*, p. 143.

6. Chuck Jones, *Chuck Amuck: The Life and Times of An Animated Cartoonist*, p. 238 (Jones's identification with Daffy Duck); Bosley Crowther, "Dream Merchant," *New York Times*, p. 40 ("there's a lot of the Mouse in me"). Disney's lengthier comment, from an eleven-minute recording made on Oct. 13, 1947 (Robert Tieman, *Disney Treasures*, CD insert, track 2), was the apparent basis for an account by Walt published as "What Mickey Means To Me" in *Who's Who in Hollywood* (Apr.-June 1948), pp. 50-51, reprinted in G. Apgar, ed., *A Mickey Mouse Reader*.

7. Roy E. Disney (1930-2009) was the son of Walt's brother and partner, Roy O. Disney; for his comment on his uncle, see his preface to Pierre Lambert, *Mickey Mouse*, p. 11. For Lillian Disney's remark, see Bob Thomas's interview with her published in Didier Ghez, ed., *Walt's People*, vol. 10 (2011), p. 36.

 For Walt mimicking in public the voice of Mickey, see Korkis, *The Vault of Walt*, p. 150 ("Song of the South Premiere"); for footage of Walt recording the voice: *The Hand Behind the Mouse: The Ub Iwerks Story*, Leslie Iwerks, prod. and dir., Walt Disney Video, VHS (also on disc two of *The Adventures of Oswald the Lucky Rabbit*, Walt Disney Video, DVD).

8. Updike, "The Mystery of Mickey Mouse," p. 234, in Apgar, *A Mickey Mouse Reader*, where the essay appears in its entirety. First published in *Art & Antiques* (November 1991), Updike's essay has also been reprinted in Susan Sontag, ed., *The Best of American Essays*, and Robert McQuade and Robert Atwan, eds., *Popular Writing in America*. In 1992, an expanded version of the text served as the "Introduction" to Craig Yoe's and Janet Morra-Yoe's *The Art of Mickey Mouse*.

9. The Paris exhibition *Il était une fois Walt Disney: Aux sources de l'art des Studios Disney*, which traveled in 2007 to Montreal, focused on European sources in fine art and book illustration for animated features like *Snow White and the Seven Dwarfs*. Since most of the catalogue was originally written in English, the English-language edition, *Once Upon a Time Walt Disney*, is the more useful of the two. The show also went to Munich (2008-2009), as *Walt Disneys wunderbare Welt und ihre Wurzeln in der europäischen Kunst* ("Walt Disney's Wonderful World and its Roots in European Art"), and to Helsinki, as *Walt Disney ja Euroopan taide* ("Walt Disney and European Art"), in 2009.

Among the most useful Internet sites relating to Disney and Mickey Mouse, in addition to MichaelBarrier.com (subtitle, "Exploring the World of Animated Films and Comic Art"), are: The Walt Disney Company website (www.Disney.com); Didier Ghez, *Disney History* (disneybooks.blogspot.com); JimHillMedia.com; the regular postings by Jim Korkis (a.k.a., "Wade Sampson") at *MousePlanet* (www. MousePlanet.com); David Lesjak, *Toons At War* (toonsatwar.blogspot.com); and *The Walt Disney Family Museum* (www.waltdisney.org). For Barrier's comment on a "definitive biography" of Walt Disney, see Barrier, *The Animated Man: A Life of Walt Disney*, p. xii. For a concise take on Disney and his accomplishments, see Neal Gabler, "Walt: Man or Mouse?" pp. 6-9; for an essay on the burgeoning field of "Disney studies," see Thomas Doherty, "The Wonderful World of Disney Studies," *The Chronicle Review*, p. B10.

10. Through mid-year 2015, nine noteworthy books (in English) will have been devoted to Mickey Mouse, not counting the present volume:

 • David Bain and Bruce Harris, *Mickey Mouse: Fifty Happy Years* (Harmony Books, 1977).
 • Richard Holliss and Brian Sibley, *Walt Disney's Mickey Mouse: His Life and Times* (Harper & Row, 1986).
 • Bevis Hillier and Bernard C. Shine, *Walt Disney's Mickey Mouse Memorabilia* (Abrams, 1986), with, in Hillier's introduction, a useful survey of the character's critical fortunes.
 • Russell Schroeder, *Walt Disney's Mickey Mouse* (Disney Press, 1997), a 64-page "first-person narrative" of Mickey's "career."
 • Pierre Lambert, *Mickey Mouse* (Hyperion, 1998), a lavish compilation of superb images (also published in a French edition as Mickey).
 • Robert Heide, John Gilman, Monique Peterson, and Patrick White, *Mickey Mouse: The Evolution, the Legend, the Phenomenon!* (Disney Editions, 2001), a lively visual and textual potpourri of Mickey's presence in American and world culture.
 • Robert Tieman, *The Mickey Mouse Treasures* (Disney Editions, 2007), a profusion of photos and facsimile reproductions covering a wide range of material.
 • Jim Korkis, *The Book of Mouse: A Celebration of Walt Disney's Mickey Mouse* (Theme Park Press, 2013).
 • Garry Apgar, *A Mickey Mouse Reader* (University Press of Mississippi, 2014), an anthology of sixty-nine articles, essays, and news squibs from 1928 to 2012, by Diego Rivera, E. M. Forster, Maurice Sendak, Stephen Jay Gould, John Canemaker, and John Updike, among others.

 John Updike's essay, "Mystery of Mickey Mouse," represents the most sensitive writing to date on Mickey. Other key articles are: E. M. Forster, "Mickey and Minnie," *The Spectator* (1934), also in Forster's anthology, *Abinger Harvest*; Irving Wallace, "Mickey Mouse and How He Grew," *Collier's* (1949); Richard Schickel, "Bringing Forth the Mouse," *American Heritage* (1968); Robert W. Brockway, "The Masks of Mickey Mouse" (1989); G. Apgar, "The Meaning of Mickey Mouse," *Visual Resources* (1999), Apgar, "Mickey Mouse at Seventy-Five," *Weekly Standard* (2003); and M. Thomas Inge, "Mickey Mouse," in *American Icons: An Encyclopedia of the People, Places and Things That Have Shaped Our Culture* (2006). All of these articles, except "Bringing Forth the Mouse" and "Mickey Mouse at Seventy-Five," are reprinted in the *A Mickey Mouse Reader* anthology.

 There is much useful information as well on Mickey in these books: Pete Martin and Diane Disney Miller, *The Story of Walt Disney: An Intimate Biography by His Daughter Diane Disney Miller as Told to Pete Martin*, esp. pp. 90-113; Bob Thomas, *Walt Disney: An American Original*, pp. 88-110; Steven Watts, *The Magic Kingdom: Walt Disney and the American Way of Life*, esp. "Young Man Disney and Mickey Mouse," pp. 24-41; Barrier, *Hollywood Cartoons: American Animation In Its Golden Age*, esp. ch. 1-2; Dave Smith and Steven B. Clark, *Disney: The First 100 Years*; Gabler, *Walt Disney*, ch. 4-5 ("The Mouse" and "The Cult"); and Barrier, *The Animated Man*, esp. ch. 3.

11. Emma Mahony, "And Mickey Came Too," *London Times*, p. 25. In *The Independent* in 2006, art critic Charles Darwent (another Brit) said that Mickey had become, for some artists, "a sneery metonym of American culture" (Darwent, "Hey Mickey, You're So Fine," *The Independent*, p. 7).

12. Grainville, "Mickey Monstre," *Les Nouvelles littéraires*, p. 1.

13. For Rat Fink, see: Douglas Martin, "Edward Roth," *New York Times*, p. B6; "Ed 'Big Daddy' Roth Dies," *Washington Post*, p. B7. Mickey has appeared in drawings by many *New Yorker* artists, including Alain, Saul Steinberg, and Jack Ziegler, all illustrated in this book. For a catalogue of Mouse-themed pictures published in the *New Yorker*, see its website: www.cartoonbank.com. The classic Simpsons spoof of Steamboat Willie, "Steamboat Itchy," first aired on Nov. 3, 1992. Mickey as "Mr. Mouse," "the boss of the Disney Company," first aired on the Disney Channel, Mar. 11, 2009, in an episode called "The Ring." For more on "Steamboat Itchy," see Ray Richmond and Antonia Coffman, *The Simpsons*, p. 98.

14. In an historic speech on "Conciliation with the Colonies," delivered in the British Parliament, Mar. 22, 1775, during the early stages of the American Revolution, Edmund Burke declared: "I do not choose wholly to break the American spirit, because it is the spirit that has made the country." See: *The Works of Edmund Burke*, vol. 2, p. 32.

15. Steve Daly, "Mickey Mouse: The Mighty Mite," *Entertainment Weekly*, p. 108; "50 Greatest Cartoon Characters of All Time," *TV Guide*, Aug. 3-9, 2002, p. 23 (the magazine rated Mickey just 19th in its all-time list; Bugs Bunny came in first); "Mickey Mouse," in "100 Icons of the Century," *Variety* (online).

16. Christopher Lasch, *The Culture of Narcissism*, p. 55; Gabler, *Life the Movie*, pp. 9-10. Gilbert Seldes argued the merits of popular culture in *The 7 Lively Arts* (1924); his views on Disney and Mickey are discussed in ch. 2 of this book.

17. For the text of Phelps's remarks, see "Eleven Notables Awarded Honorary Degrees," *New Haven Evening Register*, p. 13 (my thanks to Michael Barrier for providing a copy of this article).

18. Alva Johnston, "Mickey Mouse," *Woman's Home Companion*, p. 12, and p. 106 in the reprint of this article in *A Mickey Mouse Reader*. Johnston's roll of foreign names for Mickey may have been cribbed from a list published in "Profound Mouse," *Time*, May 1933, or a similar list in Arthur Mann's article, "Mickey Mouse's Financial Career," in the May 1934 issue of *Harper's*. Both of these texts also are reprinted in the *Mickey Mouse Reader*.

 "Michel Souris," the French name for Mickey cited by Alva Johnston, it should be noted, is a literal translation of "Michael Mouse" that has never been used by the French themselves. In France, Mickey Mouse is simply referred to as "Mickey."

19. Grace Glueck, "New York Sculptor Says Intrepid Put Art on Moon," *New York Times*, p. 19; Sarah Chalmers, "What a Mickey Mouse Way to Run a Country," *London Daily Mail*, p. 1.

20. Marshall Fishwick, "Mickey, A Mouse of Influence Around the World," *Orlando Sentinel*, p. D3, and in the reprint of that article in *A Mickey Mouse Reader*, p. 243.

21. For Mickey's return to the Macy's Thanksgiving Day Parade, see "Holiday Brings Turkey, Mouse," *Washington Post*, p. A27, and "Day of Giving," *Los Angeles Times*, p. A45. For Kurt Vonnegut's verbal

assault on George W. Bush in response to a reader, see "Dear Mr. Vonnegut" on Vonnegut's website, *In These Times* (inthesetimes.com). For the Palestinian TV show, see Bill Hutchinson, "Mock of Mickey Is Pure Evil," *New York Daily News*, p. 3, reprinted in Apgar, *A Mickey Mouse Reader*, pp. 348-349.

1: BEFORE MICKEY

1. Schickel, *The Disney Version: The Life, Times, Art and Commerce of Walt Disney*, pp. 360-362. The source (omitted in Schickel's book) of the phrase, "The American mechanizes as freely as an old Greek sculpted," is an 1878 article in the *Times of London*: "The American Mechanical Display in Paris," reprinted in *Reports of the United States Commissioners to the Paris Universal Exposition*, 1878, vol. 1, pp. 447-452.

2. For Walt's admiration for Henry Ford, see: Walter Wagner, *You Must Remember This*, p. 268 (interview with Disney animator Ward Kimball). See also Barrier, *The Animated Man*, p. 212, for the impact of Ford's collection of historical buildings and other artifacts at Greenfield Village, near Dearborn, Mich., on Walt's earliest post-war conceptualization of Disneyland. Much like the Magic Kingdom, Greenfield Village is served by horse-drawn passenger wagons and circled by a vintage steam engine.

3. William Strauss and Neil Howe, *Generations: The History of America's Future, 1584 to 2069*, pp. 261-278 ("G. I. Generation") and pp. 247-260 ("Lost Generation").

4. Jack Alexander, "The Amazing Story of Walt Disney," *Saturday Evening Post*, p. 84 (Walt as "reckless" inventor).

5. For the Disney family history, including its reputed Norman origins, see: Elias Disney, "Biography of the Disney Family in Canada," written by Elias in 1939, published posthumously in 1957 (www.michael barrier.com/Essays/Elias%20Disney/DisneyFamily InCanada.html); Martin and Miller, *The Story of Walt Disney*, pp. 6-7; Thomas, *Walt Disney: An American Original* (,, p. 21; Thomas, *Building a Company: Roy O. Disney and the Creation of an Entertainment Empire*, p. 7; Gabler, *Walt Disney*, p. 4; Barrier, *The Animated Man*, p. 12. On the 1918 passport application Walt signed in order to join the Red Cross Ambulance Corps, "1878" was given in answer to the question of when his father immigrated to the United States (see Marc Eliot, *Walt Disney: Hollywood's Dark Prince*, unnumbered plate following p. 104).

6. For Elias and Flora Disney, before and after their marriage, through the birth of Roy O. Disney, see: Martin and Miller, *The Story of Walt Disney*, pp. 6-10; Thomas, *Walt Disney*, pp. 21-24; Thomas, *Building a Company*, pp. 7-8, 10-11; Gabler, *Walt Disney*, pp. 4-8; Barrier, *The Animated Man*, pp. 12-15.

7. On Walt's birth, see: Martin and Miller, *Story of Walt Disney*, p. 6; Thomas, *Walt Disney*, pp. 23-24; Thomas, *Building a Company*, pp. 13-14; Gabler, *Walt Disney*, pp. 8-9; Barrier, *The Animated Man*, pp. 10, 13. For Ruth F. Disney (Beecher), see the entry on her in Smith, *Disney A to Z* (2006), p. 172. The house in which Walt was born, as noted by Gabler, was located at 1249 Tripp Ave.; in 1909, it became 2156 North Tripp. For a report on a latter-day owner of the home, see Ana Mendieta, "Birthplace of a Magic Kingdom," *Chicago Sun-Times*, p. 47.

8. Disney's comment about his father was captured on audiotape at Walt's house during a party celebrating his parents' anniversary (Watts, *The Magic Kingdom*, p. 16). His remark about his mother's sense of humor was recorded on a series of interviews in 1956 taped by journalist Pete Martin for the Diane Miller/Pete Martin biography of Walt (Watts, *The Magic Kingdom*, p. 14).

9. On Walt's life in Marceline, see: Disney, "The Marceline I Knew," p. 1 (repr. as "Walt Disney Recalls Some Pleasant Childhood Memories"); Martin and Miller, *The Story of Walt Disney*, pp. 10-18; Thomas, *Walt Disney*, pp. 25-32 (32, for Walt's replica of the Marceline barn); Gabler, *Walt Disney Story of*, pp. 9-19; Barrier, *The Animated Man*, pp. 9-12, 15-17; Timothy Susanin, *Walt Before Mickey: Disney's Early Years, 1919-1928*, p. 3 ("truly a Missourian").

10. On the Disney family's move to Kansas City and Walt's

experience as a paperboy, see: Martin and Miller, *The Story of Walt Disney*, pp. 18-33; Thomas, *Walt Disney*, pp. 31-34; Gabler, *Walt Disney*, pp. 9-22; Barrier, *The Animated Man*, pp. 9-12. For Walt's school years: Martin and Miller, *The Story of Walt Disney*, pp. 29-30; Thomas, *Walt Disney*, pp. 36-39; Holliss and Sibley, *The Disney Studio Story*, p. 8; Gabler, *Walt Disney*, 25-30; Barrier, *The Animated Man*, pp. 17, 20-21. On Olivier's imitation of Chaplin, and Chaplin's appearances in Chicago, of which Walt must have been aware, see: Kenneth S. Lynn, *Chaplin and His Times*, pp. 14, 97, 100, 176; for Hope and Chaplin: William Robert Faith, *Bob Hope*, p. 115.

11. For Elias Disney's jelly factory venture, see: Martin and Miller, *The Story of Walt Disney*, pp. 32, 35; Thomas, *Walt Disney*, p. 40; Gabler, *Walt Disney*, pp. 30, 32; Barrier, *The Animated Man*, pp. 20-21.

12. On Werntz see: "Carl M. Werntz, Arts Academy Founder, Dies," *Chicago Tribune*, p. 12; "Carl N. Werntz, Artist, Teacher," *New York Times*, p. 15; Esther Sparks, "Dictionary of Painters and Sculptors in Illinois," pp. 668-669. I am grateful for the latter reference to Dr. Wendy Greenhouse, a specialist in the history of art in Chicago.

The Illinois State Board of Education in Springfield is the repository for microfilm copies of the records of the Chicago Academy of Fine Arts (C.A.F.A.). According to a note inscribed on the front of the roughly 4-by-6 (ruled, pre-printed) card that served as his file, Disney phoned the school on July 21, 1933 during a trip to Chicago and "asked about" a "Mr. De Vos" and "Mr. Gorsett," obviously Lee Roy Gossett. (Who "De Vos" might be is a mystery.) My thanks to Bart H. Ryckbosch, Archivist at the Art Institute of Chicago, who put me on the trail of Walt's file, and to Sue Davsko, Program Specialist, Alternative Partnership Learning Division, at the State Board of Education, for providing photocopies of both sides of the card.

Here is a portion of Pete Martin's 1956 audio interview with Disney, transcribed and kindly provided by David Lesjak, in which Walt spoke about his studies at the C.A.F.A.:

> when I went to Chicago I went to the Academy of Fine Arts which, ah, was a sort of a private school there, run by Carl Werntz, and, ah, they were in the Willoughby Building. I went at nights, three nights a week, while I was going to high school. We worked from plaster [casts?]. In Kansas City [during Saturday morning classes at the Kansas City Art Institute] I got all the cast work and all of that and then when I went to, ah, Chicago, I worked from life and then after I'd been there a while I went into technique and I studied cartoon technique under—ah, you know, all the, ah, cross hatching and all of that stuff and techniques and things—under, ah, a fellow by the name of LeRoy Gosset [sic] who was a cartoonist on the, on the Record, the Chicago Record, which later on went out of business. G-O-S-S-E-T, LeRoy Gosset. He was a front page, you know, editorial cartoonist, and he died. And then Carey Orr used to teach there. [...] We had a kind of a connection where we could go, I remember, I went to the Herald, ah, the Tribune, we used to go up there, and be able to go up there in the art department and fool around and things, you know, and, ah, they had a pretty good school, the life classes, and things like that.

There is no known record of who taught what (or when) at the Academy, but Disney clearly recalled having studied under Gossett. In the Bob Thomas biography (pp. 42-43), based in part on his own interviews with Walt, Thomas said that among "his teachers were Carey Orr, cartoonist for the *Chicago Tribune*, and Leroy Gossitt [sic], of the *Herald*." In the Martin tape quoted above, however, Walt does not say that he studied under Orr and, in fact, the words "And then Carey Orr used to teach there" imply that Orr joined the faculty after Disney was no longer enrolled at the school.

If, as Disney's file indicates, he took just two classes at the C.A.F.A., the muralist and portrait painter Louis Grell, who taught at the school from 1916 to 1922,

may have been another of his instructors. That is what his great-nephew, Richard Grell, believes—a belief grounded in family lore passed down from the artist's sister. There is at present no further evidence to support this claim, but the traditional fine-arts training in one of the classes described by Disney—drawing "from life"—was just the sort of thing Grell might have taught.

For the possible Grell-Disney connection, see: "About Louis Grell," Louis Grell Foundation (www. louisgrell.com/about-2/about). For obituaries for Gossett and Orr, see: "Lee Roy Gossett, Cartoonist, Is Dead." *The Chicago Evening Post Magazine of the Art World*, p. 15; "Carey Orr," *Chicago Tribune*, p. 20. Regarding Disney and the Chicago Academy of Fine Arts, see also: Gabler, *Walt Disney*, pp. 33-34; Barrier, *The Animated Man*, pp. 21, 333 (n. 59); and David Lesjak's forthcoming book, *In the Service of the Red Cross: Walt Disney's Early Adventures 1918-1919*. The Martin audio interview was the basis for brief mentions of Walt's instruction at the C.A.F.A. in Martin and Miller, "Hard Times in Kansas City," p. 78, and Martin and Miller, *The Story of Walt Disney*, p. 36.

13. For Walt's cartooning in high school and his after-school work and other activities, see: Martin and Miller, *The Story of Walt Disney*, p. 37; Thomas, *Walt Disney*, pp. 42-45; Gabler, *Walt Disney*, pp. 32-36; Barrier, *The Animated Man*, p. 22; Lesjak, *In the Service of the Red Cross* (forthcoming).

14. For Walt's enlistment in the Red Cross, see: Martin and Miller, *The Story of Walt Disney*, pp. 37-41; Thomas, *Walt Disney*, pp. 45-46; Gabler, *Walt Disney*, pp. 35-37; Barrier, *The Animated Man*, p. 22, and Lesjak, *In the Service of the Red Cross* (forthcoming). For Ray Kroc's recollections, see: Kroc, *Grinding It Out*, pp. 18-19, and more on Kroc and Disney: Eric Schlosser, *Fast Food Nation*, pp. 35-36.

15. For an article published in 1934 in which Disney's boss during part of his service in the Red Cross in France, reminisced about their time together, see Robert Mossholder, "Alice Howell Recalls War Days," p. CD-3 (I found this reference on David Lesjak's website, *Vintage Disney Collectibles*, and am grateful to Scott Clark, Reference Services, Lincoln City Libraries, for a photocopy of the article). For more on Walt's service in France, see: Martin and Miller, *The Story of Walt Disney*, pp. 40-50; Thomas, *Walt Disney*, pp. 48-52; Gabler, *Walt Disney*, pp. 37-40; Barrier, *The Animated Man*, pp. 22-23, and, above all, Lesjak's forthcoming book, *In the Service of the Red Cross*.

16. For Walt's day trip with Alice Howell and young Warren Pershing, see Mossholder, "Alice Howell Recalls War Days," *Lincoln Sunday Journal and Star*, p. CD-3; Thomas, *Walt Disney*, pp. 50-51; Gabler, *Walt Disney*, p. 39; and Lesjak, *In the Service of the Red Cross*. A carbon copy of Walt's two-page typed letter to Alice Howell, dated Dec. 29, 1931, is in the Walt Disney Archives, Burbank.

17. Martin and Miller, *The Story of Walt Disney*, pp. 45-47; Thomas, *Walt Disney*, pp. 49-50; Gabler, *Walt Disney*, p. 40; Barrier, *The Animated Man*, p. 23.

18. The "farewell speech," recalled by Walt some years later (Martin and Miller, *Story of Walt Disney*, 50; Thomas, *Walt Disney*, p. 104), may refer to Pershing's ceremonial review in the Bois de Vincennes, July 19, 1919, of a special "Composite Battalion" that had represented American expeditionary forces in Paris's Bastille Day parade and in the Empire Day victory parade in London (Associated Press, "Pershing Tells Final Plans," *Chicago Tribune*, p. 3). For Walt's return home to Chicago, see: Martin and Miller, *The Story of Walt Disney*, pp. 50, 51 ("I want to be an artist"); Thomas, *Walt Disney*, pp. 52-54; Gabler, *Walt Disney*, pp. 40-42; Barrier, *The Animated Man*, p. 23.

19. For Disney's return to Kansas City, see: Martin and Miller, *Story of Walt Disney*, pp. 51-60; Thomas, *Walt Disney*, pp. 54-56; Thomas, *Building a Company*, p. 39; Leslie Iwerks amd John Kenworthy, *The Hand Behind the Mouse: An Intimate Biography of the Man Walt Disney Called "The Greatest Animator in the World,"* pp. 4-5; Gabler, *Walt Disney*, p. 7 (Robert Disney, "the real dandy in the family"), p. 44; Barrier, *The Animated Man*, p. 24; Susanin, *Walt Before Mickey*, p. 3.

20. For Walt's start in commercial art, and his meeting up with Ubbe Iwwerks see: Martin and Miller, *The Story of Walt Disney*, pp. 53-57; Thomas, *Walt Disney*, pp. 55-56; Thomas, *Building a Company*, pp. 39, 42; Iwerks and Kenworthy, *The Hand Behind the Mouse*, pp. 4-5; Gabler, *Walt Disney*, pp. 44-47; Barrier, *The Animated Man*, pp. 24-25; Susanin, *Walt Before Mickey*, pp. 3-10 ("captive studio," p. 4).

21. Martin and Miller, *The Story of Walt Disney*, pp. 57-59, 64-65; Thomas, *Walt Disney*, pp. 56-59 (Kansas City Journal job offer, made by a man named Lawrence Dickey, p. 57); Thomas, *Building a Company*, p. 39; Iwerks and Kenworthy, *The Hand Behind the Mouse*, pp. 6-9; Gabler, *Walt Disney*, pp. 48-52; Barrier, *The Animated Man*, pp. 25-27; Susanin, *Walt Before Mickey*, pp. 9-16.

22. Fred Harman, "New Tracks in Old Trails," *True West*, pp. 10-11; Martin and Miller, *The Story of Walt Disney*, pp. 61-65; Thomas, *Walt Disney*, 59-60; Merritt and Kaufman, *Walt in Wonderland*, pp. 38-39; Barrier, *Hollywood Cartoons*, pp. 36-37. On the Newman theater chain and its owner: Donald Crafton, *Before Mickey: the Animated Film 1898-1928*, p. 204; Russell Merritt and J. B. Kaufman, *Walt in Wonderland: The Silent Films of Walt Disney*, p. 38; Iwerks and Kenworthy, *The Hand Behind the Mouse*, pp. 11-14; Gabler, *Walt Disney*, pp. 56-60; Barrier, *The Animated Man*, pp. 27-31; Susanin, *Walt Before Mickey*, pp. 16-33.

23. For the Laugh-O-gram period, see: "Will Produce Animated Cartoons," *Film Daily*, p. 2; Martin and Miller, *The Story of Walt Disney*, pp. 65-66; Thomas, *Walt Disney*, pp. 60-65; Merritt and Kaufman, *Walt in Wonderland*, pp. 39-52, 125-126 (Laugh-O-gram filmography); Barrier, *Hollywood Cartoons*, pp. 37-38; Thomas, *Building a Company*, pp. 42-43; Iwerks and Kenworthy, *The Hand Behind the Mouse*, pp. 15-20, 23; Gabler, *Walt Disney*, pp. 59-74, 79; Barrier, *The Animated Man*, pp. 31-38; Susanin, *Walt Before Mickey*, pp. 34-75 (chapter titled, "Laugh-O-gram Films, Inc., 1922-1923").

24. For Disney's letter to Winkler, dated May 14, 1923, see: Richard Holliss and Brian Sibley, *The Disney Studio Story*, p. 12; Iwerks and Kenworthy, *The Hand Behind the Mouse*, p. 23 (a copy of the letter is in the Walt Disney Archives). On Winkler herself see: Carol A. Hayes, "Cartoon Producer Recalls Early Days," *New York Times*, p. WC24, and her obituary in the *Los Angeles Times*, "Margaret Winkler Mintz," p. 34.

25. Martin and Miller, *The Story of Walt Disney*, pp. 73-74; Thomas, *Walt Disney*, p. 66; Thomas, *Building a Company*, p. 43; Gabler, *Walt Disney*, pp. 72-75; Barrier, *The Animated Man*, pp. 35, 39; Susanin, *Walt Before Mickey*, pp. 72-75, 79.

26. For a rare instance of an anthropomorphized animal in a Daumier cartoon ("Emigration," 1856), see Robin Allan, *Disney and Europe: European Influences on the Animated Feature Films of Walt Disney*, pp. 20-21 (illus.); for the Yellow Kid, see John Canemaker, "The Kid From Hogan's Alley: How an Artist Named R. F. Outcault and an Urchin Named Mickey Dugan Invented the Comic Strip," *New York Times Book Review*, p. 10.

27. Regarding Grandville's influence on Tenniel, see: Ralph Shikes, *The Indignant Eye: The Artist as Social Critic in Prints and Drawings from the Fifteenth Century to Picasso*, p. 154, and John Harthan, *History of the Illustrated Book*, p. 194.

28. The staffer who spoke with Disney about animating on a level comparable to the art of Rackham and Shepard was Jack Cutting (Robin Allan, "The Fairest Film of All: *Snow White* Reassessed," p. 20). Frank Thomas heard about Rackham's invitation to join the Disney operation from the studio's art teacher, Don Graham (Martin Krause and Linda Witkowski, *Walt Disney's Snow White and the Seven Dwarfs: An Art in Its Making*, pp. 26, 52, n. 58). For Rackham's possible influence on the design of the witch in *Snow White*, see Frank Thomas and Ollie Johnston, *Disney Animation: The Illusion of Life*, p. 105; for Walt's wish that his men study Tenniel and Shepard: John Culhane, *Walt Disney's Fantasia*, p. 168.

29. Crafton, *Before Mickey*, p. 287; Patrick McDonnell, Karen O'Connell, and Georgia Riley de Havenon, *Krazy Kat: the Comic Art of George Herriman Krazy Kat*, p. 65; Canemaker, *Felix: The Twisted Tale of the World's Most Famous Cat*, p. 56; Esther Leslie, *Hollywood Flatlands: Animation, Critical Theory and the Avant-Garde*, p. 14.

30. Leonard Maltin, *Of Mice and Magic: A History of American Animated Cartoons*, p. 24 ("Chaplin of cartoon characters"); Canemaker, *Felix*, p. 169 (for the number of Felix cartoons made between 1919 and 1930); Crafton, *Before Mickey*, pp. 301, 321.

31. Chuck Jones, *Chuck Amuck*, p. 13.

32. "Quacky Doodles Hooks Up With Paramount," *Moving Picture World*, p. 1050 (repr. in Patricia Hall, *Raggedy Ann and More: Johnny Gruelle's Dolls and Merchandise* p. 48); Jones, *Chuck Amuck*, p. 227. Walt made the remark about animated animals in reference to Oswald the Lucky Rabbit, the character he created for Charles Mintz and Margaret Winkler, in a letter to Mintz, Dec. 2, 1924, quoted in Susanin, *Walt Before Mickey* (p. 117), from a carbon copy at The Walt Disney Archives.

33. Bosley Crowther, "Dream Merchant," p. 40; Maurice Bessy, *Walt Disney*, pp. 8-9. In the original French text, Bessy wrote:

> D'abord dessinateur, caricaturiste, puis reporter cinéaste, enfin réalisateur de dessins animés, Disney—successeur direct de Granville [sic] et de Benjamin Rabier—se signale assez vite comme le champion de la gentillesse, ou plutôt de la civilité: personnalité moderne de la Fable aggrandie par lui aux dimensions du mouvement par la magie de l'animation.

Benjamin Rabier (1869-1939) created a number of popular cartoon animal stories in album form for children around 1917, and collaborated with the pioneering French animator Émile Cohl in the production of two animated shorts (Crafton, *Before Mickey*, pp. 247-248).

34. For Walt's start in Hollywood, and the Alice series, see: Martin and Miller, *The Story of Walt Disney*, pp. 73-78, 84-85, 90; Thomas, *Walt Disney*, pp. 66, 71-76, 78-83; Holliss and Sibley, *The Disney Studio Story*, pp. 12-13; Merritt and Kaufman, *Walt in Wonderland*, pp. 50-85 (in the chapter, "Alice Comedies"); Smith, *Disney A to Z* (2006), p. 381 (entry on "Kingswell Avenue"); Thomas, *Building a Company*, pp. 44-50, 54-55; Gabler, *Walt Disney*, pp. 77, 83-91, 95-102; Barrier, *The Animated Man*, pp. 40-42, 47-51; Susanin, *Walt Before Mickey*, pp. 79-138 (chapter titled, "Disney Brothers Studio, 1926-1928"). For titles, cast, and other technical information relating to the Alice Comedies, see *Walt in Wonderland*, pp. 127-150.

A total of ten Alice films are available on five Walt Disney Video double-disc DVD sets. The first Alice Comedy, *Alice's Wonderland* (1923), is included as bonus material in *Alice in Wonderland: The Masterpiece Edition*, *Alice in Wonderland: Special Un-Anniversary Edition* and *Alice in Wonderland: 60th Anniversary Edition*. *Disney Rarities: Celebrated Shorts: 1920s-1960s* also includes *Alice's Wonderland* plus *Alice's Wild West Show*, *Alice Gets in Dutch*, *Alice's Egg Plant*, *Alice in the Jungle*, *Alice's Mysterious Mystery* and *Alice the Whaler*. Disc two of *The Adventures of Oswald the Lucky Rabbit* contains *Alice Gets Stung*, *Alice's Balloon Race* and *Alice in the Wooly West* as bonus material.

35. Thomas, *Walt Disney*, pp. 71-75; Merritt and Kaufman, *Walt in Wonderland*, pp. 53, 63-64; Barrier, *Hollywood Cartoons*, pp. 38-40; Iwerks and Kenworthy, *Man Behind the Mouse*, pp. 26-30; Gabler, *Walt Disney*, pp. 79-80, 85-86; Barrier, *The Animated Man*, 40, 42-43; Susanin, *Walt Before Mickey*, pp. 81-83, 110-112. For Disney's write-up in the *Los Angeles Times*, see "Actors Mix with Cartoons," p. B31.

36. For Winkler and Mintz, see Susanin, *Walt Before Mickey*, pp. 83-84, 90, 93; For Mintz's obituary, "C.B. Mintz, Producer of Films, Dead at 50," *New York Times*, p. 22.

On the Winkler, Roy and Walt Disney weddings, see: Christopher Finch, *The Art of Walt Disney* (1973), p. 44; Thomas, *Walt Disney*, pp. 76-78, 80; Thomas, *Building a Company*, pp. 50-52; Barrier, *The Animated Man*, 43, 45, Susanin, *Walt Before Mickey*, pp. 93,

122-123. On the Disney brothers' facilities at Hyperion Avenue and their homes on Lyric Avenue, see: Thomas, *Building a Company*, pp. 52-54; Gabler, *Walt Disney*, pp. 88-89, 92, 95, 104-105; Barrier, *The Animated Man*, pp. 48-49; Susanin, *Walt Before Mickey*, pp. 125, 138-141, 145-146, 148. For Walt's listing among the "Biographies of Important Directors," see "Walt Disney ...," *Film Daily*, p. 73.

37. For Disney's involvement with Oswald, see: Thomas, *Walt Disney*, pp. 78-87; Susanin, *Walt Before Mickey*, pp. 153-154. Bob Thomas (p. 83), relying on Walt's recollections, said it was Mintz who "named Oswald the Lucky Rabbit." According to the earliest published source on the subject, Arthur Mann ("Mickey Mouse's Financial Career," p. 715) said: "P. D. Cochrane, a Universal official, named the animal." Probably based on this story, Merritt and Kaufman (*Walt in Wonderland*, p. 86) said that Cochrane "reportedly" was responsible for naming Oswald.

38. On Walt urging Messmer to join his studio, see Crafton, *Before Mickey*, p. 319 (based, apparently, on Crafton's conversations with Messmer). For "Felix the Cat with floppy ears," see Crafton, *Before Mickey*, p. 292. Julius, the cartoon cat in Disney's Alice series, incidentally, may have owed his name to Krazy Kat, who once referred to himself as "a heppy, heppy 'Julius'" (McDonnell, et al., *Krazy Kat*, pp. 26-27). For proof of how easy it was to go from Oswald to Mickey, see the sketch by ex-Disney hand Leo Salkin in Eliot's *Walt Disney*, unnumbered plate following p. 104.

39. On Oswald and his theatrical success, see: "Short Subjects," *Film Daily*, p. 20; Crafton, *Before Mickey*, pp. 208-209; Merritt and Kaufman, *Walt in Wonderland*, p. 150; Iwerks and Kenworthy, *The Man Behind the Mouse*, p. 45 (where the Harold Lloyd-*Trolley Troubles* connection is cited); Susanin, *Walt Before Mickey*, pp. 156-164. Just fourteen of the twenty-six Oswald films are known to have survived; thirteen of them are available on *The Adventures of Oswald the Lucky Rabbit* ("Disney Treasures," Disney DVD). For the locations of prints and other technical information for ten of the thirteen, see Merritt and Kaufman, *Walt in Wonderland*, pp. 150-159. As reported in the *Daily Telegraph*, Nov. 28, 2011 ("Lost Disney Cartoon Shows How Mickey Mouse was Originally Oswald the Lucky Rabbit," online only), a 16 mm. print of the Oswald short *Hungry Hoboes* was rediscovered in England in the Huntley Film Archives; it was acquired by the Walt Disney Company at auction for $31,250 and has since been restored. *Hungry Hoboes*— perhaps the most outrageously funny film Disney ever made—had its premiere in May 1928, two months after Walt's break with Mintz.

For Jack Alicoate (1889-1960) and Walt's relations with him, see: "John Alicoate Dead," *New York Times*, p. 35; Gabler, *Walt Disney*, p. 107, p. 666 (n.); Susanin, *Walt Before Mickey*, pp. 166-167, 186. Walt mentioned Alicoate ("a real dandy") in a letter, Feb. 21, 1928, to Roy Disney back in Hollywood (Walt Disney Archives).

40. On Mintz's threat, see Thomas, *Walt Disney*, p. 86; Susanin, *Walt Before Mickey*, p. 170. On Disney's unsuccessful negotiations with Mintz and Universal over Oswald, see also Gabler, *Walt Disney*, pp. 106-110; Barrier, *The Animated Man*, pp. 55-56; Susanin, *Walt Before Mickey*, pp. 167-177. Walt's telegram to Roy (Walt Disney Archives, Burbank) was sent and received Mar. 13, 1928; see, Bob Thomas, *Disney's Art of Animation: From Mickey Mouse to Beauty and the Beast*, p. 11 (illus.); Susanin *Walt Before Mickey*, p. 176.

Incidentally, despite his bitter break with Mintz, until at least the following fall, as Walt was trying to launch his new Mickey Mouse series, it seems there still was a chance Universal might renew its contract with Disney to produce the Oswald films. In a letter from New York, dated Sept. 25, 1928, to brother Roy in Hollywood (also intended to read by Ub Iwerks), Walt wrote:

> I have not forgotten OSWALD. . . . I think it would be better to make a hit with the Sound stuff first Maybe we will be able to sell Fifty Two of them

'MAYBE'? If we can I think it would be better than having two different series Of course if we can't I think it would be good to try for the OSWALDs But I think Universal would have more respect for us if we made a good showing with this Sound Picture What do you Guys think ?
This typewritten letter is in the Walt Disney Archives; as elsewhere in this book, Walt's idiosyncratic use of ellipses is reproduced here as they appear in the original letter.

2: MAKING THE MOUSE

1. Stephen Jay Gould, "Mickey Mouse Meets Konrad Lorenz," *Natural History*, esp. pp. 32, 34 (repr. in Apgar, *A Mickey Mouse Reader*, pp. 208-214); "Part and Parcel in Animal and Human Societies," in Lorenz, *Studies in Animal and Human Behavior*, vol. 2, pp. 115-195.
2. Schickel, "Bringing Forth the Mouse," *American Heritage*, p. 96.
3. Christine Mitchell Havelock, "Victory of Samothrace," *Hellenistic Art: The Art of the Classical World from the Death of Alexander the Great to the Battle of Actium*, p. 136.
4. Martin and Miller, *The Story of Walt Disney*, p. 90. In her prefatory note to the 2005 republication of her biography (n.p.), Diane Disney Miller wrote: "First, I must announce that I did not write this book. Though it bears my name before the 'as told to Pete Martin,' the book was wholly written by Mr. Martin, based on hours of taped interviews with my dad, Walt Disney."
5. The version of Rooney's baseless story cited here was delivered at a Pacific Pioneer Broadcasters luncheon in his honor, May 21, 2004, as reported by Jim Korkis, who said he thought it had first been recounted in Rooney's autobiography, *Life Is Too Short* (p. 36). See Korkis (as "Wade Sampson"), "The Myth of Mickey Rooney & Mickey Mouse," at JimHillMedia.com, May 26, 2004, and, in print form, "The Mickey Rooney Myth," in Korkis, *Who's Afraid of The Song of the South?*, p. 176.
6. Korkis ["Sampson"], "The Myth of Mickey Rooney," and Korkis, *Who's Afraid of The Song of the South?*, pp. 177-178.
7. Craig L. Andrews, *Broken Toy: A Man's Dream, A Company's Mystery*, pp. 72, 79-83, 86-89, 92, 109. See also: Grace Grove, *Who Was First? The True Story of the Man Who Really Created Micky* (1984), pp. 39-41, 87-89. For the "Micky Mouse" patent, see the "Performo Toy Company" page at Wikipedia.com.
8. Andrews, *Broken Toy*, 159-172, 181-190, 215-222, esp. pp. 159, 181-187, 217-218, and (for Dave Smith's letter to Andrews, Nov. 24, 1999), p. 222. There was, apparently, at least one other pre-Mickey "Micky" on the juvenile market in the mid 1920s. In their book, *Cartoon Collectibles: Fifty Years of Dime-Store Memorabilia* (p. 130), Robert Heide and John Gilman published a photograph of a child's desk with a simulated wooden top from 1925 bearing an image of a "nile-green" mouse named "Micky," holding an umbrella and walking along beside a duck. I'm grateful to David Gerstein for bringing this object to my attention.
9. Creighton Peet, "Miraculous Mickey," *Outlook and Independent*, p. 472 (repr. in Apgar, *A Mickey Mouse Reader*, p. 17). Peet's passage on Mickey's life "in a special cosmos" and his ability to "reach inside the bull's mouth, pull out his teeth and use them for castanets," was cribbed almost six months later, almost word for word, by *Time* in its article "Regulated Rodent," p. 21 (also in *A Mickey Mouse Reader*, p. 23). For an expert book-length study of the Silly Symphonies that Peet admired so much, see Russell Merritt and J. B. Kaufman, *Walt Disney's Silly Symphonies: A Companion to the Classic Cartoon Series* (2006), now out of print, but scheduled to appear in a revised edition in late October 2015.
10. "Mickey Mouse's Monkey-shines," *Literary Digest*, p. 36.
11. Seldes, *The 7 Lively Arts*, p. 313 (the Metropolitan Opera), 351 (Babe Ruth), in both the original and a 2001 facsimilé edition. In 1957, the book was republished with a new preface by Seldes, and added critical commentary, but minus some of the original appendices. The 1924 text is available online at

xroads.virginia.edu/~HYPER/SELDES/toc.html.
12. *The 7 Lively Arts*, pp. 8 (animated cartoons), pp. 213-214 (the comic strip). The section in Seldes's book, "The 'Vulgar' Comic Strip" (pp. 213-228), was reprinted in Jeet Heer and Kent Worcester, *A Comics Studies Reader* (2009), pp. 46-52. For Seldes's critical appreciation of Krazy Kat, the comic-strip creation of George Herriman, see "The Krazy Kat That Walks by Himself" in *The 7 Lively Arts*, pp. 231-245; repr. in Heer and Worcester, *Arguing Comics Literary Masters on a Popular Medium* (2004), pp. 22-29.
13. In *Since Yesterday: the 1930s in America* (1940, p. 19), a sequel to *Only Yesterday*, Frederick Lewis Allen evoked Disney several times, starting with this, his only reference to Mickey in an early section of the book: "Does Walt Disney, who, after years of adversity, is at last finding a public for his Mickey Mouse pictures and has just brought out his first Silly Symphony, foresee his fame and fortune as the creator of 'Three Little Pigs' and 'Snow White'?" H. L. Mencken spoke of "the comic-strip artist" in *The American Language* (1936, p. 184).
 Incidentally, it is rather shocking—but also revealing—that three-quarters of a century later, in Professor Morris Dickstein's *Dancing in the Dark: A Cultural History of the Great Depression* (2009), Mickey is mentioned just once, and then, only obliquely, in connection with the clip from *Playful Pluto* glimpsed in the 1942 film, *Sullivan's Travels*. In fact, the subtitle of *Dancing in the Dark* is bogus. It is much more of an academic and literary than a universal cultural history of the 1930s. In a comment for *Bookmarks* magazine (November-December 2009) a critic named "Jon" called Dickstein's "insights" of "inevitable scattershot quality," adding: "Walt Disney, perhaps the most famous artist and visionary to come out of the period, doesn't figure at all in the book" (www.bookmarksmagazine.com/book-review/dancing-dark-cultural-history-great-depression/morris-dickstein).
14. C. A. Lejeune, "Disney's Cartoons," in Lejeune, *Cinema: A Review of Thirty Years' Achievement*, p. 83; Mark Forrest, "The Film To-Day," p. 467.
15. Seldes, "Mickey-Mouse Maker," *New Yorker*, pp. 23, 26.
16. Peet, "Miraculous Mickey," p. 472.
17. Seldes, "Disney and Others," *New Republic*, p. 101; repr. in Lewis Jacobs, *Introduction to the Art of the Movies*, p. 170.
18. Harry Carr, "The Only Unpaid Movie Star," *American Magazine*, p. 57.
19. Dan Thomas, "How They Make Animated Cartoons," *EveryWeek*, p. 4. Harry Hammond Beall (1889-1953), the first publicist known to have worked for Disney, was tabbed "Mickey's chief press agent" in a July 1932 newspaper column (Kaspar Monahan, "Mickey Mouse," *Pittsburgh Post*, p. 11).
 In promotional material in both the June 20, 1931 issue of *Motion Picture Daily* (p. 8) and the Oct. 1, 1932 *Motion Picture Herald*, (p. 47), Beall was identified as "Director of Publicity" for the Disney studio. For his obituary in the *Los Angeles Times* see: "Harry H. Beall, Publicist, Found Dead in Home," p. 6, and, for more biographical information, "Advertising and Publicity Representatives," *Motion Picture Almanac*, p. 85. A fanciful piece by Beall, "Mad Moments of Mickey Mouse," was published in the *Milwaukee Sentinel* (June 28, 1931, p. E5).
 An indication that Harry Carr may not not have interviewed Walt personally for his 1931 story, "The Only Unpaid Movie Star," comes from Carr himself. In one of his daily newspaper columns in 1935, he said he'd just "met a young man whom I dimly remembered to have seen somewhere. [. . . .] Was my face red when I discovered that I had been talking to Walt Disney!" See Carr, "The Lancer," *Los Angeles Times*, p. 1.
20. Walt Disney, "Mickey Mouse: How He Was Born," *The Windsor Magazine*, p. 642. Clearly, someone other than Disney wrote this article. In addition to the cribbing from Dan Thomas's "How They Make Animated Cartoons" (March 1931), one line in the *Windsor* piece was lifted almost verbatim from an unsigned text in *Motion Picture Daily* ("The Evolution

of Mickey Mouse," June 20, 1931, p. 7): "While returning from New York he plotted out the first story which was to be later released to the public as 'Plane Crazy.'" In *The Windsor Magazine* the sentence read: "While returning from a visit to New York, I plotted out the first story, which was to be later released to the public as 'Plane Crazy.'"
21. Sara Hamilton, "The True Story of Mickey Mouse," *Movie Mirror*, pp. 100-101, 122.
22. Ibid., p. 122. In an article, "Mickey and Minnie" (*Motion Picture* magazine, May 1931, p. 45), based perhaps on the physical appearance of the stuffed Mickey Mouse dolls being marketed by then, Hamilton also described Mickey as having "two huge pearl buttons on his velvet pants." However, her statement in December 1931 that Mickey was conjured up as Disney rode the rails home must have come from Walt, a studio PR rep (Harry Hammond Beall?), or an earlier newspaper or magazine account that has not yet surfaced. The anonymous June 20, 1931 piece in *Motion Picture Daily*, "The Evolution of Mickey Mouse" (p. 7), stated that while "returning from New York" Walt "plotted out the first story which was to be later released to the public as 'Plane Crazy'," but no specific mention was made of a train in the article.
 "The Evolution of Mickey Mouse" appeared above an open letter signed by Disney, placed and presumably paid for by the studio, in which he expressed his appreciation to his "loyal staff of associates" and his "gratitude to the millions of film fans all over the universe who have taken to their hearts 'Mickey Mouse' and welcomed 'Silly Symphonies' with their applause." Both the article and letter were part of a package that occupied eleven of sixteen pages in a special issue of *Motion Picture Daily*. More than a third of the space in those eleven pages was filled with display ads from Columbia Pictures (Walt's distributor), George Borgfeldt & Co., the Hall Brothers greeting card company, the David McKay Company, Saalfield Publishing, and the Powers Paper Company.
 Presented by editor Maurice Kann, under the heading "Hi, Mickey!" (p. 3), the package began: "We doff our straw hat in your direction." Kann concluded by saying, "you've given us more fun in digging up the facts that follow about you than we've had since the bears shooed the bulls out of Wall Street and that's a long, long time." Thus, while it is possible that "The Evolution of Mickey Mouse," like the open letter from Walt, was prepared for publication by the studio, it seems just as likely that it was researched and composed by one or more freelance or staff writers assigned to work on this special salute to Mickey.
 Finally, further proof that by June 1931 promotional activity on behalf of the studio had taken a professional turn, appears on p. 8 in the same package, in a boxed text labeled "Congratulations to Walt Disney from the Studio Personnel." Prominently listed among eight members of top-level staff was Harry Hammond Beall, "Director of Publicity." For more on Beall, see note 19 immediately above.
23. Jack Grant, "He's Mickey Mouse's Voice and Master," *Movie Classic*, p. 80.
24. Dorothy Grafly [unsigned], "Disney Has Debut In Art Circles: His Cartoons Given First Recognition by Art Body," *Philadelphia Public Ledger*, p. 12. "Cartoons by Walt Disney" was listed in a calendar of "Current Exhibitions" in the *Public Ledger*, Oct. 26, 1932, p. 7. In Nov. 1932 the show traveled to the Syracuse Museum of Fine Arts, as noted by its director, Anna Wetherill Olmsted, in a letter to *Time* (May 29, 1933, p. 2). Maggie Kruesi, Manuscripts Cataloguer, University of Pennsylvania, and Ian Graham, Assistant Archivist, Wellesley College, supplied much useful information on Grafly.
25. Grafly, "An Artist of Our Time," *Philadelphia Public Ledger*, p. 12.
26. "Comedy Relief," *Art Digest*, p. 10; Grafly, "America's Youngest Art," *American Magazine of Art*, p. 338. For the unspecified Minnesota newspaper account, see: Hillier, *Mickey Mouse Memorabilia*, p. 18, and Holliss, Sibley, *Disney's Mickey Mouse*, 13.

27. Edwin C. Hill, "Mickey Mouse Goes to Hollywood," *Boston Evening American*, p. 26. Henry F. Scannell, Curator of Microtext and Newspapers, Boston Public Library, kindly provided copies of Edwin C. Hill's article in the *Boston Evening American* and another story, subsequently cited, "Picking on Santa," from the *Boston Herald*.

28. G.M.K. [presumably Grace M. Keeffe], "Personalities," *Psychology: Psychology: Health, Happiness, Success*, pp. 24-25. I am grateful to Dr. Ludy T. Benjamin, Jr. for providing the presumed name of "G.M.K." (email, Aug. 15, 2011). For information on popular magazines like *Psychology*, see his article, "A History of Popular Psychology Magazines in America."

29. On Eleanor Lambert see: Cathy Horyn, "Still Groovy After All These Years," *New York Times Magazine*, pp. 94-100 (sidebar by Marjorie Rosen, "Footnotes," p. 100); Amy Fine Collins, "The Lady, the List, the Legacy," *Vanity Fair*, pp. 260-275, 328-333.

30. "Calendar of Exhibitions," *Art News*, p. 13; Elisabeth Luther Cary, "Mickey Mouse and the Comic Spirit," *New York Times*, p. X8 (repr. in David Manning White, *Popular Culture*, p. 386); Eleanor Lambert, *Notes on the Art of Mickey Mouse*, p. 1 (n.p.). For a scan of a copy of this booklet at the Art Institute of Chicago, see: www.artic.edu/sites/default/files/libraries/pubs/1934/AIC1934Disney_comb.pdf.

31. On Herbert Disney and his daughter Dorothy Disney (Puder), see: Gabler, *Walt Disney*, pp. 31, 51-52, 59, 61, and Dorothy's obituary, "Dorothy Puder," *Napa Valley Register*, Oct. 4, 2007, p. B2 (www.napavalleyregister.com/articles/2007/10/04/obituaries/obituaries/doc4704837064ac6284377757.txt).

32. Lambert, *Notes on The Art of Mickey Mouse*, third page (n.p.).

33. Johnston, "Mickey Mouse," p. 12; "Origin of Mickey Mouse," *Athens Banner-Herald*, p. 4.

34. Edward G. Smith, "St. Francis of the Silver Screen," *Progress Today*, p. 44.

35. Disney, "The Life Story of Mickey Mouse," *Windsor Magazine*, p. 261. In *The Disney Version* (p. 115), Richard Schickel noted that "it is doubtful that" Walt "did more than glance at the draft his publicity department prepared for him" of this article. The text was, in fact, as already noted, partly stitched together from passages in at least one previously published story, either by a studio PR man, an editor at *Windsor Magazine*, or some combination of the two.
 The three paragraphs quoted here, albeit refashioned somewhat, were lifted from Sara Hamilton's *Movie Mirror* story (Dec. 1931, pp. 101, 122), notably this passage:
 So with no contract signed, and just six months to go on the old one, Walt Disney boarded a train for home.
 Heart full of rejoicing.
 For a out of the trouble and confusion stood a mocking, taunting little figure. Vague and indefinite at first. But it grew and grew and grew. And finally arrived—a mouse.
 Born, like Ivan Lebedeff over in Budapest, on a train. A little romping, rollicking mouse.
 The idea completely engulfed him.
 The wheels turned to the tune of it.
 "Chug chug mouse, chug chug mouse, chug chug mouse" they seemed to say. The whistle screeched it. "A m-m-m owa- ouse," it wailed.
 To date I have identified thirty-two articles published over the years under Walt's name. There must be more. However, the October 1931 Windsor piece seems to have been the first.

36. Douglas W. Churchill, "Now Mickey Enters Art's Temple," *New York Times Magazine*, p. 12 (repr. in White, *Popular Culture*, p. 144).

37. John Culhane, "A Mouse for All Seasons," *Saturday Review*, p. 50 (repr. in Apgar, *A Mickey Mouse Reader*).

38. Another poster from 1929-1930, promoting *The Barn Dance*, shows the Mouse in white pants (see Thierry Steff, *Bon Anniversaire, Mickey!*, p. 61, illus.). As noted in the caption for [78], in its Feb. 16, 1931 issue, *Time* published a black-and-white version of the image of Mickey in plaid shorts that would appear in color in the Columbia Pictures exhibitor's book for 1932-33

39. Smith, *Disney A to Z*, p. 320 (Walt's voice work), 356 (Ub "helping" design the Mouse).

40. Mercurius, "Preposterous Rodent," *The Architectural Review*, p. 98; Maurice Bessy, "Un langage international," *Pour Vous*, p. 11 (repr. in Apgar, *A Mickey Mouse Reader*, p. 15); Alexandre Arnoux, "Ub Iwerks, Maître de ballet des dessins animés sonores," *Pour Vous*, p. 11; pp. 8-9; Peet, "Miraculous Mickey," p. 472. My thanks to Hollie Jenkins, at the Harry Ransom Center, The University of Texas at Austin, for providing a copy of the Mercurius article.
 The serialized comic strip story, "Mickey Mouse in Death Valley" (Apr. 1-Sept. 20, 1930), was published in at least one newspaper as drawn "BY IWERKS." It was reprinted in 2011 in a compilation of Floyd Gottfredson's earliest Mickey strips (David Gerstein and Gary Groth, eds.), *Walt Disney's Mickey Mouse: Race to Death Valley*, in The Floyd Gottfredson Library, vol. 1, pp. 21-70.

41. Zischka, "Avec Ub Iwerks," *Pour Vous*, p. 2; Mann, "Mickey Mouse's Financial Career," p. 715. Zischa's story bore the dateline, "Hollywood, octobre 1930." Here is the original text, in French, of the passage cited and translated by me:
 —Ce que j'étais avant? dit Ub. Iwerks quand je l'ai rencontré à Hollywood, dessinateur humoriste pour magazines, c'est-à-dire fabricant de boomerangs. Car quatre-vingt-dix pour cent de mes travaux ne manquèrent pas, pendant longtemps, de me revenir. "Après, je fis la connaissance de Walter Disney qui, autrefois, écrivait des textes de réclame, vendait des bretelles et des savonettes. Il était alors à Hollywood et occupait un petit emploi dans un bureau de scénario. Il esquissa quelques scénarios pour notre petite souris Mickey, y adapta la musique; il faisait d'autres choses encore."

42. On Ub Iwerks's partnership with Walt, first mentioned in print by Mann, in "Mickey Mouse's Financial Career," p. 715, see: Gabler, *Walt Disney*, p. 143; Barrier, *The Animated Man*, pp. 75-76. For Ub's break with the Disneys: Mann, p. 717; Thomas, *Walt Disney*, pp. 100-101, 192-193; Smith, *Disney A to Z* (2006), p. 356; Barrier, *Hollywood Cartoons*, pp. 63-64, 66-67; Gabler, pp. 143-144; Barrier, *The Animated Man*, pp. 75-77; *Hollywood Auction 44: Saturday and Sunday May 14-15, 2011*, pp. 44, 103 (for Ub's copy of the signed agreement dissolving his partnership with Walt and Roy Disney, lot 448, sold at auction, May 14, 2011, for $10,000).
 For a second obituary, see "Ub Iwerks Artist With Disney, Dead," *New York Times*, p. 26. For Iwerks generally, see: Dave Smith, "Ub Iwerks, 1901-1971," *Funnyworld: The World of Film Animation and Comic Art*, pp. 32-37, 47; Peter Adamakos, "Ub Iwerks," *Mindrot*, pp. 48-50; and Iwerks and Kenworthy, *The Hand Behind the Mouse*.

43. Thomas, *Walt Disney*, p. 88, and Pierre Lambert, *Mickey Mouse*, p. 16. For Ub's wire service obit, see: Associated Press, "Ub Iwerks Artist with Disney," p. 26 (Walt's "chief cartoonist"). The book by Iwerks and Kenworthy was published by Disney Editions; the film, written, produced, and directed by Leslie Iwerks, was distributed by Walt Disney Home Video and later released as a special feature on the Disney DVD package, *The Adventures of Oswald the Lucky Rabbit*.

44. Marshall Fishwick, "Aesop in Hollywood," *Saturday Review*, p. 38; for Walt's radio interview, see the introductory segment in the video anthology, *Donald*, Walt Disney Cartoon Classics Limited Gold Edition, 1984, VHS.

45. On the show organized by Robert D. Feild at Harvard's Fogg Museum (Feb. 15-Mar. 18, 1939), "The Art of Walt Disney—Explanatory Material," plus the series of four related lectures Feild gave at the museum, and his firing, see: "Disney Exhibit at Fogg," *Harvard Crimson*, p. 1; "A Tale of Six," *Harvard Crimson*, p. 2; "Art of Walt Disney; Exhibition and Lectures," *Bulletin of the Fogg Art Museum*, p. 58; "Prof. Feild Is Out," *New York Times*, p. 20; "Walt & the Professors," *Time*, p. 58.
 According to *Time* in 1942 ("Teacher Disney,"

pp. 49-50), Feild had been "dropped by Harvard's conservative art department because of too much enthusiasm for modern art, particularly Disney's." After Walt learned that Feild had been sacked, he sent a telegram stating, "Robin Feild is held in high esteem by our staff of over 300 practical artists. I don't know of a better recommendation, and can only say Harvard's loss will be someone's gain" ("Disney Lauds Feild," *Harvard Crimson*, Feb. 10, 1939, p. 1).

46. Feild, *The Art of Walt Disney*, xiii, 2. According to Frank S. Nugent ("Disney Is Now Art—But He Wonders," *New York Times Magazine*, p. 4): "Dr. Robert D. Feild, the Harvard Professor of Fine Arts whose recent dismissal has Cambridge in a dither, spent six weeks at his [Disney's] studio last Spring and returned convinced the animated cartoon 'is perhaps the only universal art form.'"

47. Feild, *The Art of Walt Disney*, p. 31.

48. Lillian Disney, "I Live With A Genius," *McCall's*, p. 104.

49. Alexander, "Amazing Story of Walt Disney," *Saturday Evening Post*, p. 92.

50. Martin and Miller, *The Story of Walt Disney*, pp. 91-92.

51. Lillian was credited with helping establish Mickey's name by Jack Alexander, Pete Martin and Diane Disney Miller, by Bob Thomas (*Walt Disney*, p. 88), and Ub Iwerks, who, in a July 1970 interview with George Sherman (Walt Disney Archives) said that "Lilly—Walt's wife—baptized him" (Lambert, *Mickey Mouse*, p. 20). The entertainment industry evidently shared Walt's conviction that the name "Mortimer" was funny. A dim-witted character created by ventriloquist Edgar Bergen in the late 1930s was "Mortimer Snerd," and the easily flustered character played by Cary Grant in the 1944 madcap comedy, *Arsenic and Old Lace*, was named "Mortimer Brewster."

52. Minnie's Uncle Mortimer in the comic strip story, "Mickey Mouse in Death Valley," was a rich cattleman (see Floyd Gottfredson, *Walt Disney's Mickey Mouse*, pp. 68-70).

53. Feild, *The Art of Walt Disney*, pp. 31-32.

54. Email to the author from Diane Disney Miller, Nov. 6, 2011.

55. For Ub's comment in his interview with George Sherman and a scan of part of Bob Thomas's typescript record of his interview with Ub, also in the Walt Disney Archives, see Barrier, "The Mysterious Mouse, Cont'd," July 7, 2010 (www.michaelbarrier.com/Home%20Page/WhatsNewArchivesJuly10.htm#mysteriousmousecontd). As Barrier points out, "Thomas's notes referred originally to 'Nofziger'—presumably Ed Nofziger, a magazine and newspaper cartoonist who specialized in animals—but that reference was corrected by someone—I can't identify the handwriting—to 'Meeker.' […] there seems to be no question that Iwerks was thinking of Clifton Meek, who drew mouse cartoons in the teens and twenties."

56. Email to the author from Diane Miller, Dec. 15, 2012.

57. Martin and Miller, *The Story of Walt Disney*, p. 92; Barrier, *Hollywood Cartoons*, p. 49. For Mickey's cartoon-mouse antecedents on celluloid, see: Holliss and Sibley, *The Disney Studio Story*, p. 15; Crafton, *Before Mickey*, pp. 295, 297 (illus.); Barrier, *Hollywood Cartoons*, p. 49 ("nothing particularly innovative") and p. 50.

58. For a discussion of the "Johnny Mouse" characters by Cliff Meek and Johnny Gruelle, see Barrier, "The Mysterious Mouse, Cont'd." For more on Meek and Gruelle's mice, see Gunnar Andreassen's post, May 13, 2010, on Didier Ghez's website, *Disney History* (disneybooks.blogspot.com/2010/05/this-just-in-from-gunnar-andreassen-i.html). For a death notice for Meek, see "Clifton Meek," *Bridgeport Post*, Aug. 1, 1973, p. 49.

59. For Walt's comment on Meek ("who used to draw …"), see Mary Braggiotti, "Mickey Mouse's Dearest Friend," *New York Post*, p. 17 (my thanks to Michael Barrier for a copy of this article). Floyd Gottfredson's July 21, 1981 letter to Dave Smith and a copy of Dave's response are in the Walt Disney Archives, Burbank. I am indebted to David Gerstein for bringing them to my attention.

60. Craven, *Cartoon Cavalcade*, p. 16; for Walt's letter of condolence to Mabel Herriman, see McDonnell, *Krazy*

Kat, p. 26 (a carbon copy of the original letter, dated May 6, 1944, is in the Walt Disney Archives).

61. Crafton, *Before Mickey,* p. 295 ("proto-Mickeys"); Pierre Lambert, *Mickey Mouse,* p. 20 (the publicity photo, mentioned in Ub's interview with George Sherman). The birthday card for Elias was first published in Leonard Mosley, *Disney's World,* in the photo section after p. 172. There is no year on the calendar, but since Elias' birthday, Feb. 6th, fell on a Sunday as inscribed on the card, it must date from 1926.

62. There are, in fact, two Mickey-Mortimer drawings at the Walt Disney Family Museum, one a virtually exact tracing of the other. My discussion pertains to what is almost certainly the true original of the pair; that is the sheet illustrated in the main body of this book. In a July 31, 2009 email to Gunnar Andreassen, posted by Michael Barrier ("Curious Case of Mortimer Mouse," Sept. 3, 2009), Disney Archivist Dave Smith wrote:

> The only thing I know about those drawings is that they were found in a safe at Retlaw Enterprises, the Disney family corporation. In a 1993 letter to me, the vice president of Retlaw [Benjamin W. Tucker, Jr.] stated that they had been in the safe for 25 years, in a folder labeled "Mickey Mouse Original Drawings," and he asked my opinion as to whether they really were original drawings or what the source of them might have been. I was unable to provide any information to him. There is absolutely no factual history or provenance associated with the drawings, so everything is speculation.

In an email to me (Nov. 6, 2011), Diane Disney Miller shared her personal recollection of how the drawings came to light, saying in part:

> I forget just when it was that I got a call from Paul Villadolid, who was a producer of special programs at the Studio. It had to have been late 1980's. He wanted to do a biopic of my dad, and felt that he had found the right man to do, Bill Couturié. Bill had won an Emmy for his film *Dear America: Letters Home from Vietnam.* Paul brought Bill up to Napa to meet Ron and me. I have always been unwilling for something like this to be done. There have been so many biographies that have done dad a disservice, and I really dread seeing someone else portraying him on stage or screen. But I did like Paul, and I realized then that something like this was inevitable. We gave our blessing to the project, and suggested to Bill that he go to the Retlaw offices [in North Hollywood], to see what they could provide him with. Bill called me after he'd been there, and told me about his discovery of the Mickey drawing… he was very excited. At this point in time Bill Cottrell [Retlaw's President] had passed away, and [Retlaw Treasurer] Mickey Clark was retired. Jeff Kaye was the Controller, and he had led Bill [Couturié] into a small office with a safe, which he opened. A smaller safe was inside, which he also opened, and brought out an aged manila envelope labeled "original Mickey drawing" . . or "first Mickey Mouse drawing." I did see that envelope, but can't recall the exact words. I was astounded. I got the story from Jeff, then called Mickey, whose recall was rather dim. Evidently, according to Mickey, Bill [Cottrell] had come in one day very excited and handed the envelope to someone… Mickey, maybe, with the instructions to put it in the safe. I can't even get a time period for it.

"Mickey" or Royal Clark, incidentally, was a younger brother of Disney animator Les Clark, and the son of veteran Disney security guard "Pop" Clark. Bill Cottrell, President of Retlaw from 1964 to 1982, joined the studio in 1929 as a cameraman (he was a sequence director on *Snow White*) and was Diane Miller's uncle, having married Hazel Bounds Sewell, Lillian Disney's sister.

"If the drawings were in that Retlaw safe for twenty-five years," Michael Barrier has said (based on what Dave Smith told Gunnar Andreassen), "that would have been since roughly 1968, two years after Walt's death." David Gerstein has suggested that perhaps they were put there after the central figure on the two sheets was used in "a staged recreation" of how Mickey was created for "The Mickey Mouse

Anniversary Show," broadcast on Dec. 22, 1968 as part of the *NBC Walt Disney's Wonderful World of Color* television series. See: Barrier, "Curious Case," Sept. 3, 2009, and Barrier, "Curiouser and Curiouser," Sept. 4, 2009.

Kevin Coffey made the following comment with respect to the Disney Family Museum drawings on MichaelBarrier.com ("And the Mystery Mouse," Sept. 30, 2009):

> There are two sheets of two-hole animation paper on display as a matching set of Mickey's first drawings. There is the original folded and circled sheet that you have reproduced in your writings, and directly below that is displayed another sheet featuring most of the same drawings as the first, folded sheet. I didn't take notes, but the second sheet is described as a "copy," or a tracing, made near the time of the original.
>
> I have been an animator for many years, and have studied closely other animators' work—I believe the tracing (it is clearly a tracing) was done by the same artist that did the original drawings. It's beautifully done, using (in my guess) similar pencils with a similar pressure on a similar sheet. As if someone was happy with the original folded sheet and wanted a cleaned up copy. Knowing when to stop is certainly an important part of the creative process! [….]

63. Email to the author from Diane Miller, Nov. 6, 2011.

64. Email from Diane Miller, Dec. 15, 2012.

65. On Gruelle's "Johnny Mouse," see Barrier, "The Curious Case of Mortimer Mouse," Sept. 3, 2009. For a biography of Gruelle, see: Patricia Hall, *Johnny Gruelle, Creator of Raggedy Ann and Andy* (1993). Meek and Gruelle were friends; both at one time resided in Silvermine, a rustic art colony straddling portions of Norwalk, New Canaan, and Wilton, Connecticut. After Walt died, Meek published "A Tribute to the Late Walt Disney" in the *Norwalk Hour* (Feb. 23, 1967, p. 23).

66. There is a collection of Feg Murray Papers in the Department of Special Collections and University Archives at Murray's alma mater, Stanford University (collection no. M0946). Photostats or lithographic copies of many of Murray's drawings, and a number of originals, are among his Papers. The one illustrated in this book is not among them.

67. For the *Bridgeport Sunday Herald* feature published Sept. 25, 1935, see Cholly Wood, "Mickey Mouse Is 7 Years Old Today," p. 3; both the article and the artwork were reprinted in Apgar, *A Mickey Mouse Reader,* pp. 128-130. The same spread of line art must have appeared in other American papers, but so far I've seen just one other instance, the Sept. 23, 1935 issue of a Bombay newspaper (Walt Disney Archives album 1934-35).

Altogether—among various postings dated Sept. 3, 4, 10 and 30, 2009—Michael Barrier "published" about half a dozen images relating to the "original" drawing at The Walt Disney Family Museum, including the "Mortimer" figure as it appeared in promotional material from United Artists ("Join Mickey Mouse in his Lucky Seventh Birthday Party September 28th 1935")—sent to Barrier by Hans Perk—and as it appeared in two French books: Joseph-Marie Lo Duca, *Le Dessin Animé* (1948, p. 32), and Robert Benayoun, *Le Dessin animé après Walt Disney* (1961, p. 12). In 1979, "Mortimer" also popped up near the end of a four-part comic-book history of how Mickey was created in the French children's magazine, *Le Journal de Mickey.* In 2011, Barrier posted the page containing the "Mortimer" image, along with a note by Didier Ghez, who reported that the comic was based on the Martin-Miller biography of Walt. See: Michel Mandry and Carlo Marcello, "Et tout a commencé par une souris!" *Le Journal de Mickey,* p. 27; Stéphane Beaujean, "Véritable histoire de Mickey Mouse," *BeauxArts,* p. 17 (illus.); Barrier, "Catching Up," MichaelBarrier.com, Jan. 11, 2011.

In addition to Barrier's own analysis in his four September 2009 postings, my thinking about the sheet at the Disney Family Museum was especially influenced by comments posted on those dates by various individuals, particularly Gunnar Andreassen,

Dan Briney, Kevin Coffey, and Peter Hale.

68. Email from Diane Disney Miller, Nov. 6, 2011.

3: THE MOUSE TAKES OFF

1. On "Mickey Mouse Park," see: Thomas, *Walt Disney,* pp. 218-219, and Barrier, *The Animated Man,* p. 233.

2. Carr, "The Only Unpaid Movie Star," *American Magazine,* p. 57; Ramsaye, "Mickey Mouse: He Stays on the Job," *Motion Picture Herald,* p. 41.

3. J.B. Kaufman, "The Shadow of the Mouse," *Film Comment,* pp. 68-69, 71.

4. Nearly thirty years after the fact, Iwerks told Bob Thomas:

> I did all the animation for Plane Crazy: 700 drawings in one day. I've always had a competitive nature. I had heard that Bill Nolan, who was doing Krazy Kat, had done 500 or 600 drawings a day, so I really extended myself. Five thousand drawings for a picture took four weeks to complete.

See "Ub Iwerks (1901-1971): Interviewed by Bob Thomas around 1956," in Ghez, ed. *Walt's People,* vol 10, p. 43. See also: Iwerks and Kenworthy, *The Hand Behind the Mouse,* p. 55, and Korkis, "Secrets of Steamboat Willie," p. 57 (repr. in Apgar, *A Mickey Mouse Reader,* p. 321).

Incidentally, some of Ub's animation sheets for *Steamboat Willie* have fetched well over $1,000 apiece at auction. If, in fact, he produced 5,000 drawings for that cartoon, the totality of his handiwork might, theoretically, be worth nearly $10,000,000 today!

5. Lindbergh appeared on the Jan. 2, 1928 cover of *Time.* For the Lindbergh phenomenon, see: A. Scott Berg, *Lindbergh,* pp. 150-151, 161-170, 173, 175; and Strauss and Howe, *Generations* ("first 'all-American hero'"), p. 261.

6. The dachshund in *Plane Crazy,* as noted by Kaufman ("The Shadow of the Mouse," p. 69), had appeared in Alice and Oswald films, including *Alice Stage Struck, Alice the Collegiate,* and *The Ocean Hop.* He also would appear in *Mickey's Choo-Choo* (1929), among other Mouse cartoons (*Touchdown Mickey, The Whoopee Party*), and in various comics as a character named "Weinie," a name given to him by Walt Disney himself as the daily Mickey Mouse strip's initial writer.

7. Minnie Cowles was the wife of a wealthy, politically-connected Kansas City physician, Dr. John V. Cowles, who helped bankroll Walt's Laugh-O-gram productions (Gabler, *Walt Disney,* 116). It might be noted here that an installment in a series of children's stories, "The Dwarfies," written and drawn by Johnny Gruelle, featured a character, Mrs. Minnie Mouse, and her two small sons, Mickie and Maurice (www.michaelbarrier.com/Home%20Page/Dwarfies.htm). Gruelle's characters appeared in an April 1921 issue of *Good Housekeeping.*

8. For the preview of *Gallopin' Gaucho,* see Holliss and Sibley, *Disney's Mickey Mouse,* p. 16; Korkis, "Secrets of Steamboat Willie," in *Hogan's Alley,* p. 59 (also Apgar, *A Mickey Mouse Reader,* p. 322). For the registration of Mickey's name, see *Cartoon & Comic Art Including Archival Material From the International Museum of Cartoon Art,* p. 58 ("The Original Storyboard for Plane Crazy …The First Animated Film Featuring Mickey Mouse").

9. For Bootleg Pete and the reference to *Harem Scarem,* see Kaufman, "The Shadow of the Mouse," p. 69.

10. Schickel, *The Disney Version,* p. 118.

11. Wilfred Jackson, who began working at the Disney studio on Apr. 16, 1928, later recalled a meeting at which "Walt brought up the idea that it might be possible to make cartoons with sound." According to Michael Barrier, the meeting "almost certainly took place" on 29 May. On June 27, 1928, Walt wrote to the Powers Cinephone Equipment Corporation asking how much it would cost to produce synchronized sound cartoons. See: Barrier, *Hollywood Cartoons,* p. 50, Barrier, *The Animated Man,* pp. 58-59 and Gabler, *Walt Disney,* pp. 116-117.

12. For more on Keaton's influence on Disney's Oswald and Mickey films, see, above all: Merritt and Kaufman, *Walt in Wonderland,* pp. 22, 24-25, 29, but also: Thomas, *Walt Disney,* p. 90, Holliss and Sibley, *The Disney Studio Story,* p. 16, and Crafton, *Before Mickey,* pp. 295, 297.

For a comprehensive analysis of *Steamboat Willie*, see Korkis, "Secrets of Steamboat Willie" and "Secrets of Steamboat Willie," both reprinted in *A Mickey Mouse Reader*.

13. For the parallels between the musical antics in *Steamboat Willie* and the Oswald cartoon, *Rival Romeos*, see Kaufman, "The Shadow of the Mouse," p. 71, with a further reference to a sequence in *Alice Gets Stung* (1924) featuring a bear drumming on "an ensemble of other animals," just as Mickey does in *Steamboat Willie*.

14. Thomas, *Walt Disney*, pp. 90-91; Barrier, *Hollywood Cartoons*, pp. 51-52 (with a recollection by Wilfred Jackson); Gabler, *Walt Disney*, pp. 118-119. According to Merritt and Kaufman, *Steamboat Willie* was in production during July-August 1928 (*Walt in Wonderland*, p. 159).

15. For Walt's arrival in New York, see: Thomas, *Walt Disney*, p. 91; Mosley, *Disney's World*, pp. 106, 116, 118; Barrier, *The Animated Man*, p. 61; Susanin, *Walt Before Mickey*, p. 166.

The Hotel Knickerbocker, built in 1925, was located at 120-128 West 45th Street, roughly one block east of Broadway and four blocks from the site of the almost identically named but far more famous Knickerbocker Hotel on Times Square. The Hotel Knickerbocker on West 45th is no longing standing. According to the stationery used by Walt in March 1928, it boasted 400 rooms and 400 baths. A display ad in the Lewiston Daily Sun, Dec. 19, 1925 (p. 10), gave its rates as "$3 to $5 per Day." See: "Hotel Purchased on West 45th St." New York Times, p. 27; Christopher Gray, "Beaux-Arts Facade and 'Old King Cole' in the Bar," p. R7; Elizabeth Bradley, Knickerbocker: The Myth Behind New York, pp. 119-120, 172 (n.).

16. News of Paul Terry's achievement, using RCA Photophone technology, was reported in *Moving Picture World*, in its Aug. 18 and Nov. 17, 1928 editions (Crafton, *Before Mickey*, pp. 211, 363, n. 49). Iwerks and Kenworthy say that Terry's *Dinner Time* premiered on Sept. 1st, and that Disney saw a preview of the cartoon (*The Hand Behind the Mouse*, p. 65). Gabler (*Walt Disney*, p. 121) believes Walt saw the Terry cartoon when he met with RCA in New York to discuss using its sound system. The first animation with a synchronized soundtrack, however, was neither *Dinner Time* nor *Steamboat Willie*. As early as 1924 Max and Richard Fleischer started making sound cartoons, among them, *My Old Kentucky Home*, released in 1926. For Disney's reaction to *Dinner Time*, see: Barrier, *Hollywood Cartoons*, p. 55; Thomas, *Walt Disney*, pp. 92-93; Gabler, *Walt Disney*, pp. 121, 668 (n.).

Walt's Sept. 7, 1928 letter to Roy and Ub is at the Walt Disney Archives. I have respected here, as elsewhere in this chapter and the book in general, Walt's idiosyncratic spacing, use of capitalization (or lack thereof), and occasional misspellings in his typed correspondence.

17. The Sept. 11, 1928 letter to Roy and Ub is also at the Disney Archives. For Walt's initial dealings with Pat Powers, see: Barrier, *Hollywood Cartoons*, pp. 50, 53; Iwerks and Kenworthy, *The Hand Behind the Mouse*, p. 65; Gabler, *Walt Disney*, pp. 120-121; Barrier, *The Animated Man*, pp. 61-64. For more on Powers see his obituary in the *New York Times*, "Patrick A. Powers, Film Official, Dead," p. 57, and Richard Koszarski, *Hollywood on the Hudson*, pp. 231-234, 256. Excerpts from Walt's "HEEBIE JEEBIES" letter have been published in: Thomas, *Walt Disney*, p. 93; Barrier, *Hollywood Cartoons*, pp. 50, 581 (n.); Watts, *The Magic Kingdom*, pp. 153, 471 (n. 23); Iwerks and Kenworthy, *The Hand Behind the Mouse*, p. 67.

18. For Disney's deal with Powers, see Mann, "Mickey Mouse's Financial Career," *Harper's*, p. 716. Carl Edouarde's obituary in the *New York Times* (Dec. 9, 1932, p. 28) makes no mention of his part in recording the soundtrack for *Steamboat Willie*, though it states that in 1929 he "synchronized one of 'Aesop's Fables,' one of the first screen cartoon comics with sound." For an informative piece on Edouarde's pioneering work as orchestra conductor

for New York's first great movie palace, the Strand Theatre, see: Gordon Whyte, "Carl Edouarde" *The Metronome*, Feb. 1928, pp. 27, 42-43.

19. Walt's letter dated Sept. 14, 1928 is partially quoted in Thomas, *Walt Disney*, p. 93, and Iwerks and Kenworthy, *The Hand Behind the Mouse*, p. 67. For Walt's Sept. 17th cable to Roy, see: Thomas, *Walt Disney*, p. 94, and Mosley, *Disney's World*, p. 114. For his Sept. 20 letter to Roy and Ub, see: Watts, *The Magic Kingdom*, p. 220; Iwerks and Kenworthy, *The Hand Behind the Mouse*, p. 67; Koszarski, *Hollywood on the Hudson*, p. 401. All three documents are in the Walt Disney Archives.

20. For the two recording sessions, see: Thomas, *Walt Disney*, pp. 93-95; Mosley, *Disney's World*, pp. 112-114; Barrier, *Hollywood Cartoons*, pp. 53-54; Iwerks and Kenworthy, *The Hand Behind the Mouse*, pp. 66-67; Gabler, *Walt Disney*, pp. 122-123; Barrier, *The Animated Man*, pp. 61-63; Koszarski, *Hollywood on the Hudson*, p. 232. Thomas mistakenly said that the first session took place on Sept. 17th; Gabler concurred with Barrier (*Hollywood Cartoons*, p. 53) that it happened "on a late Saturday night, 15 September."

For the Green Brothers' contribution to the sound track recording for *Steamboat Willie*, see: Tim Gracyk and Frank W. Hoffmann, *Popular American Recording Pioneers: 1895-1925*, pp. 147-150, and especially Ryan C. Lewis, "Much More Than Ragtime: The Musical Life of George Hamilton Green (1893-1970)." PhD diss., pp. 150-154. My thanks to Dave Smith for the latter reference and to Ryan Lewis for furnishing additional information based on his research.

For the description of the "Little BALL" devised by Ub Iwerks, see Walt's letters from New York to Roy, Ub, and "the gang," dated Sept. 30 and Oct. 6, 1928 (Walt Disney Archives).

21. Walt's letters cited here, dated Sept. 23 and Oct. 6, 1928 ("Get ready to faint"), are in the Walt Disney Archives. The Sept. 23 letter was published in part in: Barrier, *Hollywood Cartoons*, pp. 53, 582 (n. 150); Barrier, *The Animated Man*, pp. 62, 340 (n. 107, n. 110); Lewis, "Much More Than Ragtime: The Musical Life of George Hamilton Green (1893-1970)," PhD diss., p. 151. The Oct. 6 letter was partially published in Barrier, *The Animated Man*, 63, 340 (n. 116), and Lewis, "Much More Than Ragtime," p. 152.

According to Leonard Mosley, who must have seen Walt's Sept. 14th letter in the Disney Archives (cited above, n. 21, and partially quoted in Iwerks and Kenworthy, *The Hand Behind the Mouse*, p. 67), it cost $20 per hour for Edouarde's services, $10 per sound-effects specialist, and $7 per hour for orchestra members. In a radio broadcast in 1947, Walt recalled paying $10 an hour per man for thirty musicians. That may represent a lapse of memory: in his Sept. 14, 1928 letter regarding the anticipated first recording session he mentioned employing just seventeen players. See Disney, "Story of Mickey Mouse," track 2 of the CD included with Tieman, *Disney Treasures*, and Mosley, *Disney's World*, pp. 113-114.

22. Letter dated Sept. 30, 1928 (Walt Disney Archives), published in part in Lewis, "Much More Than Ragtime," p. 152.

23. The studio held a second birthday party for the Mouse on Oct. 4, 1930, at the Ambassador Hotel in downtown Los Angeles ("Ambassador Archive," www.ambassadorarchive.com/hotel.html"). Mickey's fourth birthday was fêted on the studio lawn (*Moving Picture World*, Oct. 1, 1932, p. 42). The fifth birthday, as noted by Jim Korkis, was celebrated Sept. 30, 1933, "with a Hollywood testimonial party where the speakers included Charlie Chaplin, Mary Pickford, and Will Rogers." *Time* saluted Mickey on his sixth anniversary in its Oct. 8, 1934 issue, ("Milestones," p. 40), and the *New York Times* ("Screen Notes," Sept. 28, 1935, p. 13) said that his seventh birthday would be marked on that date at a New York City theater with an "all-Walt Disney program of Mickey Mouse and Silly Symphony cartoons." The *London Times*, Sept. 25, 1936 ("Mickey Mouse's Eighth Birthday," p. 12), reported that the event would be honored (in England at least) on the 28th, and Mickey's tenth

birthday festivities were commented on by the *New York Times* on Sept. 25, 1938 ("Digest of an Indigestible Week," p. 5). For information gathered by Korkis, see Korkis [a.k.a., Wade Sampson], "Walt Disney Celebrates Mickey's Birthday" (www.mouseplanet.com/articles.php?art=ww061115ws).

On Mickey's debut at the Colony Theatre, see: Martin and Miller, *The Story of Walt Disney*, pp. 103-104; Thomas, *Walt Disney*, pp. 95-96; Mosley, *Disney's World*, pp. 115-116; Iwerks and Kenworthy, *The Hand Behind the Mouse*, p. 68; Gabler, *Walt Disney*, p. 126; Barrier, *The Animated Man*, p. 64; and, for Werner's position as manager: Abel Green ["Abel"], "Colony (Wired)," *Variety*, Nov. 28, 1928, p. 38. According to Thomas and Gabler, Disney recalled Harry Reichenbach offering him $1,000 for a two-week run. Barrier (*Hollywood Cartoons*, p. 54) argues that "it seems at least as likely" that Walt "let the Colony run it free of charge." For Reichenbach's relationship with Universal and the Colony Theatre, see "Reichenbach's Year" (p. 10), a squib in the Nov. 14, 1928 issue of *Variety*, posted July 3, 2007 at MichaelBarrier.com. For two obituaries, see: "H. L. Reichenbach, Press Agent, Dead," *New York Times*, p. 8, and "Barnum's Publicity Man Dies," *Los Angeles Times*, p. 3.

24. Barrier, Milton Gray, and Bill Spicer, "An Interview with Carl Stalling," recorded Nov. 25, 1969, published in *Funnyworld*, no. 13, spring 1971, p. 22; repr. in Daniel Goldmark and Yuval Taylor, *Cartoon Music Book*, pp. 38-39.

25. Mordaunt Hall, "The Screen," *New York Times*, p. 16. For a roughly contemporaneous profile of Ben Bernie, see: Land, "Ben Bernie Orchestra," p. 58, and a Sunday ad in the *New York Times*, Nov. 18, 1928, p. IX5.

26. Land (Robert Landry), "'Steamboat Willie'," *Variety*, p. 13 (repr. in Apgar, *A Mickey Mouse Reader*, p. 6); in the same issue of *Variety*, in a review of the Colony's stage program, starring Benny Rubin ("Colony Wired." p. 42), Landry said of *Steamboat Willie*: "It was a laugh. Sure fire." For the *Moving Picture World* commentary, see Crafton, *Before Mickey*, pp. 214, 363, n. 54.

27. *New York Times*, Nov. 25, 1928, p. X6 (Colony Theatre ad).

28. T.O. Service, "Service Talks" (subhead, "'Steamboat Willie'"), *Moving Picture World*, p. 59; Bell, "The New Week's Bills," *Washington Post*, p. 14; "Master Mickey Celebrates an Epochal Event," *Washington Post*, p. SA3.

29. The line about "our little Dump" from Walt's late September 1928 letter to Roy and Ub was first quoted in Thomas, *Walt Disney*, p. 94 (and from that source by Charles Solomon, "Mickey Mouse's Birth Was One of Desperation," p. 10), in each case without the specific date (it was September 23rd). That letter and Walt's October 20th letter to Lillian are in the Disney Archives. Walt's remark ("it was all started by a mouse") was made on "The Disneyland Story," the first program in the *Disneyland* TV series on ABC, aired Oct. 27, 1954. The entire show may be seen on *Disneyland USA* ("Walt Disney Treasures," Disney DVD, 2001), disc 1.

4: MICKEY MANIA

1. "The Mouse That Walt Built," *Time*, p. 45; Leonard Maltin's quote appeared in "For the Record: A Concise History of Walt Disney Records," formerly posted at the official Walt Disney Company website (disney.go.com/DisneyRecords/history).

2. Pierre Scize, "Le Cinéma," *Jazz*, p. 548. The passage roughly translated here is taken from a longer sentence: "Toutes ces folies soutenues par des bruiteurs et un orchestre admirablement appropriés, déroulent en même temps à notre oreille une espèce de symphonie parodique pleine de sons inattendus et qu'on ne peut se lasser d'entendre tant ils demeurent à leur place, dans *leur ton*, tant ils participent d'un humour vrai, profondément expressif." For Scize's commentary in its entirety in the original French, see Apgar, *A Mickey Mouse Reader*, pp. 355-357 (and in English translation, pp. 12-14).

3. Ivor Montagu, *With Eisenstein in Hollywood*, p. 82; Sergei Eisenstein, "The Future of the Film" (interview with

Mark Segal, repr. in *Close-Up*, vol. 7, p. 143; Seldes, *The Movies and The Talkies*, p. 116.

4. Eric Walter White, *Walking Shadows: An Essay* on Lotte Reiniger's Silhouette Films, p. 30 (cited at length in Leslie, *Hollywood Flatlands*, pp. 30, 303, n. 37); Jerome Kern was quoted in the *New York Journal*, May 25, 1936 (as cited by Finch, *The Art of Walt Disney*, p. 124). Popular music aficionado Mark Steyn called Kern the "founding father of the American musical" in his article "Centenary Special: Dorothy Fields Song of the Day," SteynOnline, July 2005, a tribute to Fields, a lyricist and collaborator with Kern (www.steynonline.com/index2.cfm?edit_id=65).

5. For "Mickey-Mousing," see: "Goblin Music?" *Time*, p. 44; Roger Manvell and John Huntley, *Technique of Film Music*, p. 38; Stephen Handzo, "A Narrative Glossary of Film Sound Technology," in Elizabeth Weis and John Belton, eds., *Film Sound*, p. 409; J.P. Telotte, *The Mouse Machine: Disney and Technology*, p. 29 (the Selznick reference). For the John Barry quote, see Stephen Holden, "Dances With Wolves," *New York Times*, p. C20.

6. Rachmaninoff must have met Disney around June 1942, after settling in Hollywood; this anecdote was apparently supplied by his friend, Vladimir Horowitz. See: Sergei Bertensson and Jay Leyda, *Sergei Rachmaninoff*, p. 372 (and the caption to a photo of Rachmaninoff, Disney, and Horowitz, after p. 216). For Rachmaninoff and Horowitz in Hollywood in 1942, see Glenn Plaskin, *Horowitz*, pp. 222-223.

7. There were various versions of the "Hoochy Koochy" dance, the most famous of which, by James Thornton, was published as "Streets of Cairo or The Poor Little Country Maid" (1895). The music and dance were major factors in the popularity of "A Street In Cairo," a main attraction at the 1893 Chicago World's Fair, formally known as the Columbian Exposition. See Lynn Parramore, *Reading the Sphinx*, pp. 40-41. The Willie Dixon song "Hoochie Coochie Man," by Muddy Waters, was written and recorded in the early 1950s.

8. In his book *Since Yesterday* (p. 132), Frederick Lewis Allen remarked that "'I Can't Give You Anything But Love, Baby' dated from 1928, but it might well have been the theme-song of the nineteen-thirties."

9. Deems Taylor, "And tomorrow...," *New York World*, Nov. 4, 1923, quoted in Taylor, *Selected Writings*, p. 78. For the *Harvard Crimson* comment, see "The Comic Strip," June 9, 1925, p. 2. Jazz did not conquer all until the end of the 1920s. As reported in another *Crimson* article, as late as 1929 Harvard students still wanted recordings of such old chestnuts as "When You and I Were Young, Maggie" and "Silver Threads Among the Gold," which they were finally letting go of, in droves in that year, through an exchange program mounted by the Victor company; see "'That Baboon Baby Dance' Traded for Modern Jazz Record as Concerted Attack on Evolutionary Theory Gets Under Way," p. 6.

10. The Pickfair guest was actor William Bakewell. On Mickey and Pickford, see: Scott Eyman, *Mary Pickford*, pp. 165, 231; Kenneth S. Lynn, *Chaplin and His Times*, p. 253; Eileen Whitfield, *Pickford*, p. 271; Barrier, *Hollywood Cartoons*, p. 80.

For Disney's partnership with United Artists, see: "That Rodent Now Rates a Top Ranking," *Washington Post*, p. A4; "Mickey Mouse Full-Fledged Producer," *Washington Post*, p. A1; "Mickey Mouse's New Affiliation," *New York Times*, p. X3; "Short of the Week," *Time*, p. 40; Mann, "Mickey Mouse's Financial Career," p. 718; Schickel, *The Disney Version*, pp. 150-151; Thomas, *Walt Disney*, pp. 113-114; Barrier, *Hollywood Cartoons*, pp. 80, 584 (n. 58); Thomas, *Building a Company*, pp. 72-73, 104-105; Gabler, *Walt Disney*, pp. 159-161; Barrier, *The Animated Man*, p. 89.

11. According to the printed program for the London Film Society event, which took place on Nov. 10, 1929: "The personality of Felix is no doubt more individual than are those of the protagonists of 'Mickey Mouse,' but the drawings of the latter series are superior in fertility of invention." See: "The Barn Dance 1929 / Draughtsman...Walt Disney," *The Film Society Programme*, p. 130 (repr. in Apgar, *A Mickey Mouse Reader*, p. 8).

The Carlton tune and the Tussaud installation in London are cited in Holliss and Sibley, *Disney's Mickey Mouse*, p. 23; according to Gabler (*Walt Disney*, p. 674), Tussaud's Mickey was reported on in the *Boston Herald*, Nov. 13, 1930. Carlton's song was recorded in 1933 by the BBC orchestra. For "The Wedding Party of Mickey Mouse," see: Heide, et al., *Mickey Mouse: The Evolution, the Legend, the Phenomenon!*, p. 54; Sam de Vincent Collection of Illustrated American Sheet Music, National Museum of American History, Smithsonian Institution, Washington (#300, Series 7).

12. Strube's editorial cartoon of Labour Prime Minister MacDonald as "The Westminster Mickey Mouse" was published "with apologies to the famous film mouse" in the Feb. 1, 1930 issue of the *Daily Express* (p. 8). In the Feb. 28, 1934 edition of the *Evening Standard* (p. 10), the Austrian Chancellor Dollfus, widely regarded as the puppet of Mussolini, was depicted by Low as Mickey, threatened by a snarling striped cat with Hitler's face and labeled "Germany." (Dollfus was later murdered by Austrian Nazis.) The Low cartoon was reprinted in *The Nation*, Mar. 28, 1934, p. 350, and in Colin Seymour-Ure and Jim Schoff, *David Low*, p. 66.

13. Scize, "Le Cinéma," pp. 547-548, also repr. in Bessy, *Walt Disney*, pp. 105-107, erroneously titled "Éloge de Mickey." For the three articles published in 1930 in *Pour Vous*, see: Bessy, "Un langage international, le dessin animé," p. 11; Alexandre Arnoux, "Ub Iwerks, Maître de ballet des dessins animés sonores," pp. 8-9; Zischka, "Avec Ub Iwerks," p. 2. Bessy's piece, "Un langage international," like Scize's "Le Cinéma," is repr. in the original and in English translation in *A Mickey Mouse Reader*.

14. For Mickey's reception in Germany at this time, see Carsten Laqua, *Wie Micky Unter die Nazis Fiel*, pp. 18-19, 21-23, 26-37, 33, 224, 234, 243.

15. On Eisenstein, his high opinion of Disney, and his visit to the Disney studio, see: "Regulated Rodent," *Time*, p. 21; Montagu, *With Eisenstein in Hollywood*, p. 82; Leslie, *Hollywood Flatlands*, pp. 219-220, 229-232. Gilbert Seldes paraphrased Eisenstein's comment on Walt in his 1931 article, "Mickey-Mouse Maker," p. 23.

16. Regarding *The Nation*'s salute to Mickey and the Silly Symphonies, see "*The Nation*'s Honor Roll for 1930," p. 8. For the Columbus, Ohio, article see Thomas, "How They Make Cartoons," p. 4; for Diego Rivera's article, see p. 190 in the chapter titled "In the Temple of High Art."

17. The Washboard Rhythm Kings recording was re-released (June 24, 1997) as a CD by Storyville (a Danish label) on *Washboard Rhythm Kings, vol. 4: 1933*.

18. "Animated Cartoons for Christmas Week," *New York Times*, p. 29.

19. Lynn, *Chaplin and His Times*, pp. 14-16. The term "Chaplinitis" was coined by Charles J. McGuirk in a two-part article entitled "Chaplinitis," in the July and Aug. 1915 issues of *Motion Picture Magazine*, pp. 85-89, 121-124.

20. Charles J. Maland, *Chaplin and American Culture*, p. xiv ("star image").

21. Richard DeCordova, "The Mickey in Macy's Window," in Eric Smoodin, ed., *Disney Discourse: Producing the Magic Kingdom*, p. 203; repr. in Apgar, *A Mickey Mouse Reader*, pp. 245-260.

22. Holliss and Sibley, *Disney's Mickey Mouse*, p. 80.

23. "Mickey Mouse's Fourth Birthday Fest Organization Worldwide," *Motion Picture Herald*, pp. 42-43; Lorraine Santoli, *The Official Mickey Mouse Club Book*, p. xix. The first Mouse Club "Theme Song" was a variation on "Minnie's Yoo-Hoo," a tune written by Carl Stalling with words by Walt Disney. In 1930, "Minnie's Yoo-Hoo," first heard in the animated short, "Mickey's Follies," became the first Disney song released in the form of sheet music (Smith, *Disney A to Z*, p. 457; Pierre Lambert, *Mickey Mouse*, p. 291).

24. On the Official Bulletin, see Santoli, *Official Mickey Mouse Club Book*, xvii. For the incidents at Harvard, see "Harvard Professors as Well as Students Are Guilty of Hissing," *Harvard Crimson*, p. 1.

25. For the letter from Lucille Allen Benedict, dated Dec. 4, 1935, see Cecil Munsey, *Disneyana*, p. 102.

26. The Disneys secretly signed with United Artists in

December 1930. For the confrontation with Powers, and Walt and Roy's dealings with Columbia and United Artists, see: Mann, "Mickey Mouse's Financial Career," pp. 716-718, 720; Schickel, *The Disney Version*, pp. 134-136, 138-139, 150-151; Thomas, *Walt Disney*, pp. 100-103, 113; Thomas, *Building a Company*, pp. 64-66, 72; Barrier, *Hollywood Cartoons*, pp. 63-64, 80, 584 (n. 58); Gabler, *Walt Disney*, pp. 137-138, 142-149, 158-161; Barrier, *The Animated Man*, pp. 75-79, 89.

Frank Capra, in his 1971 autobiography (widely regarded as notoriously unreliable), claimed to have touted Disney and his work to Harry Cohn after seeing a Mickey cartoon screened for him by Walt. Disney was described by Capra as a "scrawny, nondescript, hungry-looking young man, wearing two days' growth of beard and a slouch hat." See Capra, *The Name Above the Title*, pp. 104-105. Neal Gabler (pp. 137-138) repeated and referenced Capra's claim.

According to Bob Thomas, the veteran Hollywood reporter, in his 1967 biography *King Cohn* (p. 64), which preceded Capra's memoir by two years, "Capra induced Cohn to see *Steamboat Willie*, and Cohn was properly impressed." In his 1976 biography of Walt (p. 102) Thomas said that Capra "advised" Cohn "to make a deal with the brilliant young cartoon maker." Thomas gave no source for either assertion, however. In his 1968 monograph *The Disney Version* (pp. 138-139), also unsourced, but presumably based on the Bob Thomas bio of Cohn, Richard Schickel repeated the same perhaps apocryphal tale.

27. For the first Mickey Mouse comic strip, see: Floyd Gottfredson, "Introduction," *Walt Disney: Mickey Mouse*, p. 11; Munsey, *Disneyana*, pp. 16-17, 21 (illus.); Holliss and Sibley, *Disney's Mickey Mouse*, p. 77; Holliss and Sibley, *The Disney Studio Story*, p. 19; Smith, *Disney A to Z* (2006), p. 294; Gabler, *Walt Disney*, pp. 140-141; Barrier, *The Animated Man*, p. 83.

Art for the 1930 *Mickey Mouse Book* was provided by the Disney studio. Regarding it, and other vintage Mickey books, see: Holliss and Sibley, *Disney's Mickey Mouse*, p. 79; Hillier and Shine, *Mickey Mouse Memorabilia*, pp. 130, 145 (illus), 146 (illus.). For a facsimilé reproduction of the "Story of Mickey Mouse," see Bain and Harris, *Mickey Mouse*, pp. 160-164.

28. Regarding Rose O'Neill, see Shelley Armitage, *Kewpies and Beyond*. For the Borgfeldt contract, see: Munsey, *Disneyana*, p. 39; Thomas, *Walt Disney*, p. 106; Thomas, *Building a Company*, p. 69; Gabler, *Walt Disney*, pp. 141, 195-197; Barrier, *The Animated Man*, p. 83. On Charlotte Clark (1884-1960), her dolls, and Bob Clampett's contribution to their creation, see: Munsey, *Disneyana*, pp. 31-32, 36, 39-42, 151; Holliss and Sibley, *Disney's Mickey Mouse*, pp. 72-73; Hillier and Shine, *Mickey Mouse Memorabilia*, pp. 78-79, 80; Marian Peterson Guiver, "Charlotte Clark Dolls," *Tomart's Disneyana Update*, pp. 10, 31; Gabler, *Walt Disney*, pp. 195-196. For Clampett's career at Warner Brothers, see: Steve Schneider, *That's All Folks! The Art of Warners Bros. Animation*, pp. 78-88, and Barrier, *Hollywood Cartoons*, p. 343ff. My thanks to Didier Ghez and Joe Campana, in particular, for providing valuable information and references on Charlotte Clark.

29. For the Knickerbocker and Gund companies' dolls, see: Munsey, *Disneyana*, pp. 41-42; Holliss and Sibley, *Disney's Mickey Mouse*, p. 74; Hillier and Shine, *Mickey Mouse Memorabilia*, pp. 78-79. For Levy's sales list: Holliss and Sibley, *Disney's Mickey Mouse*, pp. 73-74. For the English dolls made by Dean's Rag Book Company: Munsey, *Disneyana*, p. 40; Holliss and Sibley, *Disney's Mickey Mouse*, p. 74; Hillier and Shine, *Mickey Mouse Memorabilia*, pp. 78, 82-85.

30. DeCordova, "The Mickey in Macy's Window," pp. 205-206; Gary Cross, *Kids' Stuff: Toys and the Changing World of American Childhood*, p. 12.

31. Cross, *Kids' Stuff*, pp. 106-107; DeCordova, "The Mickey in Macy's Window," pp. 206-207.

32. DeCordova, "The Mickey in Macy's Window," p. 208.

33. Cohen, "An Appreciation of the Disney Works," *Pittsburgh Post-Gazette*, p. 13.

34. "The Censor!," *New York Times*, p. X5.

35. A Child Lover, "Movies Harmful to Kiddies," *Atlantic*

City Press, p. 9.

36. "Regulated Rodent," *Time*, p. 21.

37. The Gardner Rea cartoon appeared in the March 20, 1931 issue of *Life*. Chaplin's request that a Mickey cartoon be on the bill whenever *City Lights* was exhibited was reported in the *Motion Picture Record*, published in Seattle, Feb. 28, 1931 (cited in Hillier, *Mickey Mouse Memorabilia*, p. 15). In his book *Comics as Culture* (p. 63), M. Thomas Inge said that "in 1931 when the popular Disney shorts threatened to undermine the market for live-action comedy shorts, Chaplin decided to maneuver Mickey to his side," which is why he "announced that theaters should accompany all showings of his film with a Mickey Mouse cartoon. For the Hays Office's suggestion that Chaplin eliminate a "close-up shot of the udders of the cow," see Lynn, *Charlie Chaplin*, p. 370.

38. "Europe's Highbrows Hail 'Mickey Mouse,'" *Literary Digest*, p. 19. For a photo of a Mickey Mouse cartoon used to promote the election in 1931 of two London County Council candidates, see Getty Images (an-lcc-election-campaign-run-by-sir-w-ray-mickey-news-photo/3434058). For an Acme wire photo of the École des Beaux-Arts student parade, captioned "A Film Character Invades the Latin Quarter," see the *New York Herald Tribune*, Mar. 8, 1931, Gravure Section (section IX, pt. I), p. 5.

39. Laqua, *Wie Micky Unter die Nazis Fiel*, p. 31; "The Censor!," *New York Times*, p. X5; Associated Press, "Reich Acts to Curb Foreign Films," *New York Times*, p. 7. For an informative survey of Mickey's fortunes in Germany at this time, see Laqua, pp. 28-31, 224, 243.

40. "'Mickey Mouse' in Trouble: German Censorship," *London Times*, p. 12; "Die verbotene Maus," in the *Lichtspiel Rundschau* supplement to the *Berliner Tageblatt*, July 13, 1930, p. 7; "Danes Ban 'Mickey Mouse': Censor Calls the Film Creation of Disney Too Macabre," *New York Times*, p. 11. The *Berliner Tageblatt* was edited at this time by Theodor Wolff, who was of Jewish ancestry; he was sacked in 1933, and the publication was finally closed down by the Nazis in 1939 ("Berliner Tageblatt," en.wikipedia.org/wiki/Berliner_Tageblatt).

41. "Der Micky-Maus-Skandal!!!" which was published in a regional (Pomeranian) National Socialist publication, *Die Diktatur*, was reprinted as "Sie sehen Micky Mäuse tanzen …" on p. 1 of the July 28, 1931 issue of *Film-Kurier*. For both the original German text and an English translation, see Apgar, *A Mickey Mouse Reader*. The opening words in German are: "Blonde, freisinnige, deutsche Stadtjugend am Gängelbande des Finanzjuden." The lines quoted in English by Spiegelman in *Maus: A Survivor's Tale: II And Here My Troubles Began* are, in the original German: "Die Micky Maus ist das schäbigste, elendste Ideal, das je erfunden wurde. [. . .] der große Bakterienüberträger im Tierreich, nicht zum idealen Tiertypus gemacht werden kann. [. . .] Hinweg mit der jüdischen Volksverdummung! Hinaus mit dem Ungeziefer! Herunter mit der Micky Maus, steckt Hakenkreuze auf!"

42. For Walt's comment on Mickey and Hitler in 1947, see Disney, "Story of Mickey Mouse," on the CD in Tieman, *Disney Treasures*. For the piece in *Der Querschnitt*, see "Mickey Mouse in Germany," *New York Times*, p. 95 (the article in question, by Walther Schneider, was "Micky Maus ist geisteskrank"; for the German text and bibliographical details relative to it, see Laqua, *Micky unter die Nazis Fiel*, pp. 35-36).

43. *Micky Maus: Ein lustiges Filmbildbuch* was published in Berlin (Laqua, *Micky unter die Nazis Fiel*, pp. 37-38, 243). The Steiff dolls were imported into the United States by the Borgfeldt Corp. (Hillier and Shine, *Mickey Mouse Memorabilia*, pp. 78-79, 85).

44. For the Mickey Mouse music on the Odeon label, see Laqua, *Micky unter die Nazis Fiel*, pp. 39-40, 234. The disc of "The Wedding Party of Mickey Mouse" (by Robert Bagar, Milton Coleman, and James Cavanaugh) and "Micky Maus auf Wanderschaft" was recorded in Berlin in November 1930; "Micky Maus im Lunapark"/"Micky als Jazzkönig" was recorded in December 1930. For Fritz Lang and Mickey's connections to German films in 1931, see Laqua,

Micky unter die Nazis Fiel, pp. 31-33. The motion picture *M* was released in Germany on May 11, 1931, and in the U.S. on Apr. 2, 1933 (prod. Seymour Nebenzal, dir. Fritz Lang, Criterion, DVD). *Werr nimmt denn schon die Liebe ernst* (prod. Curt Melnitz, dir. Erich Engel, Terra-Filmkunst) was released in Germany, Sept. 28, 1931, and Feb. 9, 1936 in the U.S. On a purely speculative note, one has to wonder whether Lang's inclusion of Mickey Mouse (initials M. M.) in *M* was not, at least in part, a punning play on the title of the movie.

45. "The Prince of Wales," *London Times*, p. 15. An image of the Christmas card purportedly sent to Princess Elizabeth was published in Hillier and Shine's *Mickey Mouse Memorabilia* (p. 159), reproduced from a duplicate or copy (measuring 5 x 7 in.) in a Walt Disney Archives scrapbook containing clippings from circa 1931. The original, however, is at present either lost or unlocated. According to Sally Goodsir, Assistant Curator of Decorative Arts, Royal Collection Trust, there is no record of such a card in the databases of the royal collections or at the Royal Archives (email dated April 8, 2015).

46. "The England of Hollywood: Work on Film of 'Cavalcade,'" *London Times*, p. 10 ("the most popular film star of the moment"); "The Art of Mr. Walt Disney," *London Times*, p. 10; H. P. Garwood, "Ridiculus Mus," *London Times*, p. 11 ("To the Editor of the Times"); "New Films in London," *London Times*, p. 10. On "The Wedding of Mr. Mickey Mouse," by Eddie Pola and Franz Vienna, see: Heide, et al., *Mickey Mouse: The Evolution, the Legend, the Phenomenon!*, p. 54.

47. "Mr. Walt Disney Has Been Awarded a Diploma by the Academy of Fine Arts of Buenos Aires" (untitled news squib), *London Times*, p. 15 (also mentions the Cuban National Academy honor).

48. On Herman "Kay" Kamen, who died in an air crash in the Azores, see: "Merchandising: The Mighty Mouse," *Time*, pp. 96, 98; Associated Press, "48 Killed in Azores Crash as Plane for U.S. Hits Peak; Cerdan, Boxer, Is a Victim," *New York Times*, pp. 1, 3; "Sketches Of Dead From U.S. in Crash," *New York Times*, p. 3; "Air Liner Crash in Azores Kills 48," *Los Angeles Times*, pp. 1, 6 (Los Angeles Olympics); Robert Heide and John Gilman, "King of Character Merchandise, Kay Kamen," *Collector's Showcase*, pp. 18-20, 22, 28, 30; Didier Ghez, "The Man with the Golden Touch," *Disney twenty-three*, pp. 22-26. For the Mickey Mouse Sunday comic strips, see Floyd Gottfredson (Gerstein and Groth, eds.), *Walt Disney's Mickey Mouse: Color Sundays*, vol. 1, pp. 19, 58.

49. In light of the caricature in *Vanity Fair*, it is amusing to note a gag line published in December 1933 in the *New London Day* ("Observations of The Day's Philosopher," 6): "A theatre owner's idea of heaven: A film in which Mickey Mouse plays opposite Mae West."

50. For the Princeton students' taste for Mickey, see "Vote for Mickey Mouse," *New York Times*, p. 17. Pickford's interest in working with Walt in a film version of *Alice in Wonderland* was reported in the *New York Times* ("Mary Pickford Back from Europe," p. 22). See also: Eyman, *Mary Pickford*, p. 232; Whitfield, *Pickford*, pp. 280-281. For her claim that Mickey was her favorite star, see Fishwick, "Aesop in Hollywood," p. 39. A photo of Pickford seated alongside a plush Mickey doll on the lawn at Pickfair is reproduced in Finch, *Walt Disney*, p. 123; it may date from 1933, or perhaps 1930, when Disney appears to have given her the toy.

51. Associated Press, "President Confers Valor Medal on Girl, 12," *New York Times*, p. N12; Culhane, "A Mouse for All Seasons," p. 50 (Eleanor Roosevelt, "My husband always loved Mickey").

52. Hill, "Mickey Mouse Goes to Hollywood," p. 26. For the Ingersoll-Waterbury Mouse watches, see: Hillier and Shine, *Mickey Mouse Memorabilia*, pp. 11, 98; Holliss and Sibley, *Disney's Mickey Mouse*, p. 76; Thomas, *Building a Company*, p. 70.

53. For the angry Santas, see: "Picking on Santa," *Boston Herald*, p. 28; for the Art Institute reception: "Very Popular Art," *New York Times*, p. 14.

54. Mordaunt Hall, "The Outstanding Pictorial Features of

1933," *New York Times*, p. IX5; and, for the Mickey Mouse cocktail: *New York Financial World*, Dec. 13, 1933, cited in Hillier, "Introduction," *Mickey Mouse Memorabilia*, pp. 12, 27 (n. 5).

5: "HE IS NOT A MOUSE AT ALL"

1. "Roosevelt Observes Franklin's Birthday," *New York Times*, p. 15.

2. Rex Stout, *Fer-de-Lance* (1992 edition), p. 60 (ch. 5).

3. For the Mickey Mouse jewelry by Cartier, see: Finch, *The Art of Walt Disney*, p. 125; Holliss and Sibley, *Disney's Mickey Mouse*, p. 76. Cole Porter wrote both the words and music for "You're the Top," performed by William Gaxton and Ethel Merman in the original Broadway production of *Anything Goes* that opened at the Alvin Theatre, Nov. 21, 1934, and "Rap Tap on Wood," for the film *Born to Dance*, released Nov. 27, 1936. For the music, see Kimball, *Complete Lyrics of Cole Porter*, pp. 119-121 ("You're the Top") and pp. 140-141 ("Rap Tap On Wood"). For the *New York Times* review of *Anything Goes*, see Brooks Atkinson, "'Anything Goes' as Long as Victor Moore, Ethel Merman . . . Are Present," *New York Times*, p. 26. For Porter's fondness for Mickey: Culhane, "A Mouse for All Seasons," p. 50 (and Apgar, *A Mickey Mouse Reader*, p. 195).

4. "Mickey Mouse Saves Jersey Toy Concern; Carries It Back to Solvency on His Railway," *New York Times*, p. 21; "Mickey Mouse With Minnie's Aid Saved Toy Firm," *New York Daily Mirror*, p. 14. For more on Mickey, Minnie, and the Lionel Corporation, see: Hillier, "Introduction," *Mickey Mouse Memorabilia*, pp. 12-13, 27 (n. 6), 34-35, and Holliss and Sibley, *Disney's Mickey Mouse*, p. 76.

On Mickey and the Macy's Thanksgiving Day parade in general: Munsey, *Disneyana*, pp. 127-128; Holliss and Sibley, *Disney's Mickey Mouse*, p. 25; Hillier, "Introduction," *Mickey Mouse Memorabilia*, p. 15; Korkis, "Disney Goes to Macy's," in Korkis, *The Vault of Walt*, pp. 397-404.

5. Munsey, *Disneyana*, p. 128 (English toffee); "Mickey Mouse Makes the Britannica," *New York Times*, p. X2; "Motion Pictures," in *Encyclopaedia Britannica* (1952), vol. 15, p. 879, and pl. xviii, facing p. 871; "Mr. Walt Disney: Election to Art Workers' Guild," *London Times*, p. 12; John Betjeman, "Stars to See To-night," *London Evening Standard*, p. 9 (sidebar to his regular column, "London After Dark").

6. E. M. Forster, "Mickey and Minnie," *The Spectator*, pp. 81-82. The essay was published in Forster's 1936 anthology *Abinger Harvest* (repr. 1964), pp. 50-54 and reprinted in full in *A Mickey Mouse Reader*, pp. 89-92.

7. Forster, "Does Culture Matter?" *Time and Tide*, pp. 1657-1658; repr. in Forster, *Two Cheers for Democracy*, pp. 101-102.

8. Gould, "Mickey Mouse Meets Konrad Lorenz," p. 30, and *A Mickey Mouse Reader*, p. 208.

9. The *New York Sun* quote appears in Hillier, "Introduction," *Mickey Mouse Memorabilia*, p. 23.

10. Publication of *Le Journal de Mickey* was halted in 1944, but revived in 1952 and it is still published today (a color facsimilé of page one of the first issue was printed in the Aug. 15, 1971 edition of *Le Journal de Mickey*, pp. 40-41). On George VI and the Emperor of Japan, see: "Mickey Mouse Makes the Britannica," p. X2; "Master Mickey Celebrates an Epochal Event," *Washington Post*, p. SA3.

For P. G. Wodehouse, see Wodehouse, *The Luck of the Bodkins* (1935 and 1954), p. 61. The misadventures with a stuffed Mickey doll are also referred to in a book about the same characters called *Pearls, Girls and Monty Bodkin* (1972); a similar use of the object by different characters occurs in a short story, "Life with Freddie," in the Wodehouse collection *Plum Pie* (1966). Tony Ring, editor of *Wooster Sauce*, the P. G. Wodehouse Society's quarterly journal, kindly brought these references to my attention.

11. On Philo Farnsworth: "Gain in Television Is Demonstrated," *New York Times*, p. 15; "Television," *Time*, pp. 76-81; Daniel Stashower, *The Boy Genius and the Mogul*, p. 190; "Round the Shops: Clothes as Gifts," *London Times*, p. 13. A Scottish pioneer in television, J. L. Baird, also used a 1932 Mickey cartoon, *Musical*

Farmer, on a broadcast in the United Kingdom in 1935. See: "A Professor Abroad. Europe's 'Tramping Men,'" West Australian (Perth), p. 12; "Films in Home by Television," Barrier Miner (New South Wales), p. 7; Oswald Anderson, "This New Wonder—Television," Australian Women's Weekly, p. 14 (I'm grateful to Didier Ghez for these three references).

Mickey Mouse was not the first cartoon character to appear on television. In 1929, an early hard-wire transmission featured a Felix the Cat doll. Chad Grothkopf's now forgotten Willie the Worm was the first animated series to be regularly broadcast on TV, beginning in April 1938 on NBC, the network owned and operated by Robert Sarnoff, Farnsworth's arch-rival in the development of the medium in America. See: "50 Greatest Cartoon Characters of All Times," TV Guide, Aug. 3-9, 2002, p. 26; Jeff Lenburg, The Encyclopedia of Animated Cartoons, p. 695.

12. Feild, The Art of Walt Disney, p. 47; Finch, The Art of Walt Disney (1973), p. 120. Finch shortened and modified the wording of his original text relating to The Band Concert in the 1995 edition of his book. The first edition, cited here, also has a richer selection of illustrations relating to The Band Concert (pp. 120-121) and other early Disney films, plus a bibliography section cut from the newer edition.

13. See Jean Charlot, "But Is It Art? A Disney Disquisition," The American Scholar, p. 267, and "Walt Disney and Hogarth," Art Digest, p. 8. "But Is It Art?" was published in the summer of 1939 and formed the final chapter in Charlot's book, Art from the Mayans to Disney, which went on sale about Dec. 1, 1939. He was born in France, but spent nearly a decade in Mexico City before settling in the United States in 1928. From April 12 to June 7, 1938 Charlot gave eight lectures on composition and design at the Disney studio, which were published in mimeograph form by the studio as Pictures and Picture Making: A Series of Lectures for distribution among the artists on staff.

14. Greene's review of Follow the Fleet appeared in The Spectator, Apr. 24, 1936, p. 744; repr. in David Parkinson, ed., The Graham Greene Film Reader: Reviews, Essays, Interviews & Film Stories, pp. 94-96. The Fleischer Studios cartoon, The Little Stranger, mentioned by Greene, was released March 13, 1936. For Gilbert Seldes's take on The Band Concert, see his article "No Art, Mr. Disney?" in Esquire, pp. 91, 171 (the phrase "dazzling, damning apparition" is from the preface to Henry James's novel, The Wings of the Dove, 1902).

15. Leonard Maltin, The Disney Films (2000), p. 365.

16. L. H. Robbins, "Mickey Mouse Emerges as Economist," New York Times Magazine, pp. 8, 22 (repr. in toto in A Mickey Mouse Reader, pp. 119-125).

17. Greene compared Astaire to Mickey in his review of Top Hat in The Spectator, Oct. 25, 1935, (Parkinson, ed., The Graham Greene Film Reader, p. 40).

18. For the reasons behind the Disney brothers' trip to Europe, see: Thomas, Walt Disney, p. 131; Thomas, Building a Company, p. 99; Gabler, Walt Disney, p. 222.

19. For the Disneys' trans-Atlantic voyage on the Normandie and their stay in London, see: Edna and Roy Disney, "Europe Trip—1935," pp. 1-4; "Ocean Travelers," New York Times, p. 14; "Normandie Sails for a New Record," New York Times, p. 17; "Mr. and Mrs. Walt Disney with a Mickey Mouse at Paddington Station on their arrival yesterday" (photo caption), London Times, June 13, 1935, p. 10; "British Crowd Mobs Disneys," Los Angeles Times, p. 1; Thomas, Walt Disney, pp. 131-132; Thomas, Building a Company, pp. 100-101; Gabler, Walt Disney, pp. 222-223; Rebecca Cline, "Adventure of a Lifetime," Disney twenty-three, pp. 31-32. For Walt, David Low, and H. G. Wells, see Low's Autobiography (p. 213), where he said that he "met Walt Disney over H G Wells's lunch-table in the early 'thirties," but that date is impossible.

20. For Walt's impending arrival in Paris and sojourn there with Roy Disney and their wives, see: "Le Père de 'Mickey Mouse' à Paris," June 22 and June 23, 1935, both p. 1 in Le Figaro; Jean Laury, "Mickey-Mouse et les Silly Symphonies," Le Figaro, p. 8; Laury, "La Vie Aventureuse de Walt Disney," Le Figaro, p. 8; Edna

and Roy Disney, "Europe Trip—1935," pp. 4-6; Thomas, Walt Disney, pp. 131-132; Thomas, Building a Company, p. 101; Gabler, Walt Disney, p. 223; Cline, "Adventure of a Lifetime," p. 32.

Regarding the C.I.D.A.L.C. award, see: Edna and Roy Disney, "Europe Trip—1935," pp. 1-4; "League of Nations Medal For Mr. Disney," London Times, p. 18; "Gala Mickey Mouse," June 25, p. 1; Laury, "Mickey Mouse au Gaumont-Palace," Le Figaro, p. 1 (also, in both English and the original French, in A Mickey Mouse Reader, pp. 126-127, 364); "Gold Medal for Walt Disney," New York Herald Tribune, July 2, 1935, p. 12; "Disney Awarded Medal," Motion Picture Herald, p. 43; "A Creative Confab," Box Office, p. 29; Laury, "Le Cinéma," Le Figaro, p. 8; "Outstanding in the Week's News," Box Office, p. 11; Disney, "What Mickey Means To Me," p. 51; Thomas, Walt Disney, pp. 131-132; and Cline, "Adventure of a Lifetime," p. 32.

According to the London Times ("League of Nations Medal," p. 18): "In a letter to Mr. Disney's representative in Paris, M. [Nicolae] Pillat, the permanent secretary of the committee, says that the award is to be considered an exceptional honour in recognition of the original and distinctive work done by Mr. Disney." The medal was presented to Walt by the president of the C.I.D.A.L.C., the aristocratic, Romanian-born poet, Elena Va ca rescu (Hélène Vacaresco), co-founder of the committee in 1930. Presumably it was at her instigation that Walt received the award, which is on display at the Walt Disney Family Museum in San Francisco. (Another C.I.D.A.L.C. co-founder, Francis de Croisset, was the grandfather of Philippe de Montebello, director of the Metropolitan Museum of Art from 1997-2008.) For the League of Nations episode in secondary literature, see: Martin and Miller, The Story of Walt Disney, pp. 133-135; Thomas, Walt Disney, p. 132; Thomas, Building a Company, p. 101; Gabler, Walt Disney, p. 223; Barrier, The Animated Man, p. 113.

For the event at the Gaumont Palace: "La Gala Mickey Mouse," Le Figaro, June 25, 1935, p. 1, and June 26, 1935, p. 5; Laury and Roy Disney, "Europe Trip - 1935," p. 5; Laury, "Mickey Mouse au Gaumont Palace," Le Figaro, p. 1 (also in A Mickey Mouse Reader, pp. 126-127, 364); "Le Gala Mickey-Mouse" (five-piece photo spread), June 28, Le Figaro, p. 6, where it was reported that 5,000 children were in attendance, though Le Petit Parisien gave the number as 3,000 ("Fêtes et réunions," p. 3); Laury, "Le Cinéma," Le Figaro, p. 8. Gaby Triquet, the girl who recited the poem, was a child star in the French cinema as well.

21. Edna and Roy Disney, "Europe Trip - 1935," pp. 6-15 (the source for the Alfredo anecdote); George Buchanan, "Radio Phone Boards Ship," New York Daily Mirror, pp. 2, 7; Thomas, Walt Disney, p. 132; Thomas, Building a Company, p. 103; Gabler, Walt Disney, p. 223; Cline, "Adventure of a Lifetime," pp. 32, 34.

In a story filed from Rome, July 23, 1935 ("Walt Disney Honored," Edwardsville Intelligencer, p. 7), it was reported that Walt "was tendered an autographed photograph of Premier Benito Mussolini" at a reception "under the auspices of the [Italian] propaganda ministry." The photo, dated July 21, 1935, is at the Walt Disney Archives. Mussolini was out of town on the day Walt received it. In his book, Disney's Grand Tour, Didier Ghez definitively puts to rest the false story that Walt and Mussolini met, though the Disneys did meet his son-in-law, Count Galeazzo Ciano. Diane Miller, for her part, has long maintained that such a meeting never happened. In an email to Didier (June 1, 2013) she wrote: "As I have related to you and others, my mother talked about meeting Count Ciano and his wife.. said he was very handsome. They apologized for the fact that il Duce was unable to be there."

22. "Mickey Mouse," in R.W. Burchfield, Supplement to the OED, p. 925 (for Noël Coward's To-night at 8:30); Associated Press, "French Honor Disney's Work," New York Times, p. 25; "Mickey Mouse Scores in Virginia Tech Poll," Washington Post, p. X13; Holliss and Sibley, Disney's Mickey Mouse, p. 78 (for the Mickey Mouse Weekly); "Top Hits of 1936," Lyrics World (ntl.matrix.com.br/pfilho/html/top40/1936.

html); Disney, "The Life Story of Mickey Mouse," Windsor Magazine, p. 50 ("Mickey could never be a rat"), repr. in Apgar, A Mickey Mouse Reader, p. 164.

23. Maltin, The Disney Films (2000), p. 365.

24. Ben Wattenberg, "Groucho Marx: The Hard Work of Making It Look Easy," Weekly Standard, p. 31 ("warp-speed wisecracks"); David E. Chinitz, T. S. Eliot and the Cultural Divide, pp. 188-189 (Eliot's affection for the brothers Marx).

25. Gilbert Seldes, Movies Come From America, pp. 6-7; Curt L. Heymann, "In Which He Answers a Few Questions," New York Times, p. 4 (Wells on Chaplin and Disney); Maxine Barrus, "Disney, Chaplin Top Movie Geniuses, Wilder Declares," Tulsa Tribune, p. 12. Thornton Wilder and Disney had met at least once by the time Wilder made this comment. From Hollywood, Sept. 8, 1934, he wired his mother in New Haven, saying he had "ROLLER SKATED WITH WALT DISNEY" (Wilder, Selected Letters, p. 282). My thanks to Ellen Cummings, Research Center Manager, Tulsa City-County Library, for locating the Barrus article.

26. For the René Clair quote (New York Journal, Jan. 16, 1936), see Finch, The Art of Walt Disney, p. 85. Clair, incidentally, had incorporated cartoon sequences into two of his films from the mid 1920s, Paris qui dort and Entr'acte (Leslie, Hollywood Flatlands, p. 19).

27. Lady Killer, prod. Henry Blanke, dir. Roy Del Ruth, in Warner Gangsters Collection, vol. 3, Warner Home Video, DVD (the scene involving Mickey appears in Leslie Iwerks's documentary, The Hand Behind the Mouse).

28. Hollywood Party, prod. Lewis Lewyn, Harry Rapf, dir. Richard Boleslawski, and others; Babes in Toyland, prod. Hal Roach, dir. Gus Meins and Charley Rogers, Good Times Video, DVD.

29. The Gay Divorcee, prod. Pandro S. Berman, dir. Mark Sandrich, Warner Home Video, DVD. In Tinker Belles and Evil Queens (pp. 48-49), Sean Griffin writes about "Mickey Mouse" and the prehistory of the term "gay" in the 1930s. Griffin posits a "sly double meaning" for the Mickey reference in Grable's song, and makes a similar claim for the insertion of "Mickey Mouse" into the lyric of "You're the Top" by closet homosexual Cole Porter. However, "gay" (as in "having a gay time," "Gay Paree") ... and The Gay Divorcee) maintained its overwhelmingly standard connotation as a synonym for "joyful" or "chipper," devoid of discomfiting double-entendre, until the 1960s. In The Gay Divorcee, Grable plays an outrageously transparent gold digger; the song's lyricist, Mack Gordon, also wrote the words and music for "It's the Animal in You," with its line about Mickey and Minnie living "on love and cheese." The raciness in the Divorcee lyric, like its use in the Cole Porter and Mack Gordon tunes, has to do with Mickey's image as a ladies' man, admired as such, among others, by E. M. Forster, himself a homosexual. Any "sly" or secret artistic "gay"-ness with respect to Mickey—highly unlikely at best— would have amounted to an extremely inside, very closeted joke in the 1930s.

30. The Big Broadcast of 1936, prod. Benjamin Glazer, dir. Norman Taurog, Paramount; Broadway Melody of 1936, prod. Jack Cummings, dir. Roy Del Bluth, on disc two of two-disc set, Classic Musicals from the Dream Factory, vol. 3, Warner Home Video, DVD. The tune in Broadway Melody that Ebsen sang and danced to, was "Sing before Breakfast" by Arthur Freed and Nacio Herb Brown. For Ebsen's Q&A, see: "The Real Beverly Hillbilly: With Buddy Ebsen, Actor, Painter, Author," Washingtonpost.com, Sept. 1, 2001 (formerly at: discuss.washingtonpost.com/wp-srv/zforum/01/entertainment_ebsen090701.htm).

31. Modern Times, prod. and dir. Charles Chaplin, Warner Home Video, DVD; The Princess Comes Across, prod. Arthur Hornblow, Jr., dir. William K. Howard, Universal, 1936, DVD (on disc two of two-disc set).

32. Night Must Fall, prod. Hunt Stromberg, dir. Richard Thorpe, MGM/UA Home Video, VHS; Indiana Jones and the Last Crusade, prod. George Lucas, et al., dir. Steven Spielberg, Paramount, DVD.

33. Bringing Up Baby, prod. and dir. by Howard Hawks, Turner Home Entertainment, DVD. Dudley Nichols and Hagar Wilde wrote the screenplay for Bringing Up

Baby, based on a story by Wilde, with additional uncredited dialogue by Robert McGowan and Gertrude Purcell (Gerald Mast, *Bringing Up Baby*, pp. 29, 180). In 1940, two years after playing Constable Slocum in *Bringing Up Baby*, Walter Catlett provided the voice for the nefarious fox, J. Worthington Foulfellow, in *Pinocchio*; and in 1956, Catlett had a small role in the Disney live-action film, *Davy Crockett and the River Pirates*.

34. *What's Up Doc?*, prod. and dir. Peter Bogdanovich, Warner Home Video, DVD. For Disney's contractual relationship with RKO in the mid to late 1930s, see: B. R. Crisler, "Film Gossip of the Week," *New York Times*, p. X7; Smith, *Disney A to Z* (2006), p. 558; Thomas, *Building a Company*, p. 105; Barrier, *The Animated Man*, p. 136.

35. *The Killer*, prod. Tsui Hark, dir. John Woo, Criterion, DVD; the original made-in-Hong Kong version of *The Killer* was titled *Dip Huet Seung Hung*.

6: FROM *FANTASIA* TO MOUSE CLUB

1. Maltin, *The Disney Films* (2000), p. 31 (for the Howard Barnes quote; no source given); Frank S. Nugent, "The Music Hall Presents Walt Disney's Delightful Fantasy, 'Snow White and the Seven Dwarfs'—Other New Films at Capitol and Criterion," *New York Times*, p. 21 ("The Screen in Review"); Crowther, "Dream Merchant," *New York Times*, p. 40.

2. Michiko Kakutani, "This Mouse Once Roared," *New York Times Magazine*, p. 8.

3. "Mickey Mouse Gets Schools' Backing," *New York Times*, p. 21.

4. "Mickey Mouse as a 'Revolutionary,'" *London Times*, p. 15; United Press, "Yugoslavia Bans Mickey Mouse," *New York Herald Tribune*, p. 1.

5. Herbert Russell, "L'Affaire Mickey Mouse," *New York Times Magazine*, p. 4. See also: "The Banning of Mouse," *New York Times*, p. 15; "Mickey Mouse Reprieved," *London Times*, p. 12; James M. Minific, "American Comics Making Young Italians Sissies," *Washington Post*, p. X1.

In Nazi Germany on Dec. 20, 1937, six days before Herbert Russell's story was published, Propaganda Minister Joseph Goebbels noted in his personal diary that he'd given Hitler "18 Mickey Mouse films" for Christmas. "He was very pleased with this. Is very happy with this treasure that will hopefully provide him much joy and relief." Ironically, according to Sinclair Lewis, in his novel, *It Can't Happen Here* (1935, p. 86), the scrawny, slightly built Goebbels, was "privily known throughout Germany as '"Wotan's Mickey Mouse.'" Lewis probably got this phrase from a news report like Madelin Blitzstein's "Illegal Laughs from Germany's Bootlegged Anti-Nazi Humor," *Washington Post*, Aug. 18, 1935, p. SM4.

Playing off this epithet, a Soviet propaganda poster from 1941, published in English and Russian versions, depicts Goebbels as Mickey—the tip of his tail forming a jagged swastika—and bears the words: "WHAT IS AN ARYAN? HE IS HANDSOME AS GOEBBELS" (a copy of the English-language version of this poster is at the Stanford University Library and Archives, Palo Alto, Calif.). For Goebbels' diary entry, see Mario Dreßler and J. P. Storm, *Im Reiche der Micky-Maus*, p. 8. The entry quoted here in English is from Leslie, *Hollywood Flatlands*, pp. 152, 312 (n. 7).

6. *The Mickey Mouse Theater of the Air*, conceived as a thirteen-week series, was so popular that it ran until May 15, 1938; see: Smith, *Disney A to Z* (2006), p. 558; Korkis, *The Vault of Walt*, pp. 375-387. The full text of Phelps's citation honoring Walt, and the shorter remarks of Yale President Charles Seymour, were printed in the *New Haven Evening Register*, "Eleven Notables Awarded Honorary Degrees," p. 13. Phelps's colorful phrase, "With this mouse he conquers the world" (often misquoted as "he conquered the world"), may have been inspired by a satirical image created by Miguel Covarrubias titled "This Mountain Labored and Brought Forth a Mickey Mouse," published in the

September 1934 of *Vanity Fair* (see note 8 below).

For national coverage of Walt's honorary degrees, see "Walt Disney, M.S., M.A.," *Art Digest*, p. 17, and these four articles, all in the *New York Times*: "Says Harvard Will Honor Disney," p. 21; "Honor Where Due," p. 18; W.A. MacDonald, "Yale Throng Pays Tweedsmuir Honor," p. 25; B. R. Crisler, "Gossip, of Pictures and People," p. 99.

7. B. R. Crisler, "Digest of an Indigestible Week," *New York Times*, section IX, p. 5.

8. For the Mae West quote see Donald King Dunaway, *Huxley in Hollywood*, p. 96. The multi-talented Mexican artist Miguel Covarrubias caricatured Walt, Mickey, and other Disney characters at least four times in the mid to late 1930s. Two of those images are reproduced in this book: *Disney's Light-hearted Ark* [209] and *Radio All-Stars* [207], from the June 15, 1937 and May 1938 issues of *Vogue* and *Fortune* (pp. 41 and 256-257, respectively). Walt, Donald Duck, and Pluto appeared in another *Vogue* drawing ("Our Changing Tastes in . . . 1938," May 15, 1938, p. 66) in the company of Benny Goodman, Salvador Dalí, Orson Welles, Fred Astaire, Ginger Rogers, and six other pop culture figures. In a spread in the September 1934 issue of *Vanity Fair* ("Mountains into Men," p. 40), Mickey was caricatured by Covarrubias with an immense upturned snout in a kind of low-relief sculpture titled "This Mountain Labored and Brought Forth a Mickey Mouse."

9. For the *Sorcerer's Apprentice*, including Mickey's make-over by Fred Moore, see Culhane, *Walt Disney's Fantasia*, pp. 12, 25-26, 80-81.

10. For the Stern building, see Herbert Muschamp, "Playful, Even Goofy, but What Else? It's Disney," *New York Times*, p. H34; for the Disney World structure: "Walt Disney World Resort Will Host a Celebration Commemorating the Legacy of Walt Disney," *The Connecticut Traveler*, p. 15.

11. *Crazy in Alabama*, prod. Jim Dyer, dir. Antonio Banderas, Columbia Tristar, DVD.

12. Culhane, *Disney's Fantasia*, p. 100.

13. Ibid., pp. 100, 104, 200 (illus. and caption).

14. Walt Disney, "Growing Pains," *Journal of the Society of Motion Picture Engineers*, p. 30.

15. Bosley Crowther, "Fantasia," *New York Times*, p. 28.

16. David Low, "Leonardo da Disney," *The New Republic*, p. 18; for *Fantasia* in London, see "'Fantasia': Mr. Disney's New Full-Length Film," *London Times*, p. 6.

17. Craven, *Cartoon Cavalcade*, p. 247. In *Cartoon Cavalcade* (pp. 248, 250-251, 346-348, 408-409, 437-439), Craven reproduced sixteen cels or preparatory sketches from *Three Little Pigs*, *The Pointer* (Mickey and Pluto), *Dumbo*, *Pluto at the Zoo*, *The Ugly Duckling*, *Bambi*, *The Village Smithy* (Donald Duck), *Pinocchio*, *Saludos Amigos* (Donald), plus line drawings of Walt's two biggest stars, Mickey and Donald.

18. *Sullivan's Travels*, prod. Buddy G. DeSylva, dir. Preston Sturges, Criterion, DVD. For a brief commentary on this scene, see Peter Bogdanovich, *Who the Hell's in It?*, p. 36. See also: Sturges, *Five Screenplays*, pp. 511-683, esp. p. 683; Diane Jacobs, *Christmas in July: The Life and Art of Preston Sturges*, pp. 248-265, esp. p. 257 (Sturges initially planned to use a clip from a Chaplin film in the church scene rather than *Playful Pluto*); Watts, *Magic Kingdom*, pp. 69-70.

19. "Movie of the Week: *Sullivan's Travels*: It Stamps Sturges an Ace Director," *Life*, p. 51.

20. This appearance was not, incidentally, the first instance in which a major Hollywood film that was not affiliated with the Disney Company had included footage from one of Walt's cartoons as an integral part of the story. In fact, in Alfred Hitchcock's *Sabotage*, a dazed, hysterical wife, played by Sylvia Sidney, is seated in the movie theater operated by her husband, when she realizes he is a saboteur. As this truth dawns on her, the 1935 Silly Symphony *Who Killed Cock Robin?*, with its parody of Mae West, parades

across the screen. See *Sabotage*, prod. Michael Balcon, dir. Alfred Hitchcock, MGM, DVD.

21. "New British Army Slang," *New York Times*, April 6, 1941, p. 30 (cited in the entry "Mickey Mouse," in Burchfield, *Supplement to the OED*, p. 925); Terry Wise, *D-Day to Berlin: Armour Camouflage and Markings of the United States, British, and German Armies, June 1944 to May 1945* (1993), pp. 46, 50, 55 (photos, pp. 39, 41, 44, 46); Michael J. Melvin, *Minesweeper, The Role of the Motor Minesweeper in World War II*, pp. 29, 73.

22. "New British Army Slang," p. 30; "Royal Air Force: Battle of Britain Memorial Flight 50" (www.bbmf.co.uk/bomber.html); Ishihara is quoted in David McNeill, "Shifting Sands of Iwo Jima," *New Zealand Herald*, p. B12.

23. For the Jiggs and Oswald insignia, see Walton Rawls, *Disney Dons Dogtags: The Best of Disney Military Insignia From World War II*, pp. 10-15. With Charles Lindbergh in attendance, Floyd Bennett Field was dedicated on May 23, 1931; an official Navy photograph dates the Mickey Mouse air unit emblem to October 1931 (DisneyDave [David Lesjak], "1st Disney Character Combat Insignia," toonsatwar.blogspot.com/search?q=1931). For more on the Naval Air Reserve unit emblem, see Lesjak, *Service With Character: The Disney Studio & World War II*, pp. 109-111.

24. Raymond F. Toliver and Trevor J. Constable, *Fighter General*, pp. 45, 48-51; Rawls, *Disney Dons Dogtags*, p. 14; Len Deighton, *Goodbye Mickey Mouse*, p. 26.

25. For "Operation Mickey Mouse," see: Rob Vest, "Otto Skorzeny" (homepages.ius.edu/RVEST/SkorzenyDr2.htm); Toland, "Living History"; Laura-Louise Veress, *Clear the Line: Hungary's Attempt to Leave the Axis During the Second World War*, p. 276. For mentions of the purported "Mickey Mouse" password on the Ed Sullivan show and in the *New York Times*, see: Larry Wolters, "Fabulous Story," *Chicago Daily Tribune*, p. B9, and Barbara Berch Jamison, "Of Mouse and Man, or Mickey Reaches 25," *New York Times Magazine*, p. 26. Walt's eleven-minute radio broadcast, on Oct. 13, 1947, in which he mentioned the password on D-Day, is part of a CD bonus insert included in Tieman, *Disney Treasures*; a very similar text, with the same D-Day reference, appeared under Walt's byline in "What Mickey Means To Me," *Who's Who in Hollywood*, pp. 50-51, reproduced in Apgar, *A Mickey Mouse Reader*, along with Jamison's article.

26. "Walt Disney, 65, Dies on Coast," *New York Times*, p. 40; United Press, "'Mickey Mouse,' the Password," *New York Herald Tribune*, p. 381 On June 11, 1944, the *Johannesburg Sunday Times* printed a longer and more fact-filled version of the June 8th United Press squib ("'Mickey Mouse' Was Invasion Password," p. 1), in which it was reported that the pre-D-Day briefing for "nearly 200" "senior naval officers" took place at "a naval cinema." My thanks to Dave Smith for the Johannesburg reference, and to Keith K. Apgar for retrieving a copy of the article at the British Library. The text and an image of this longer report are reprinted in Apgar, *A Mickey Mouse Reader*.

On SHAEF's "battle headquarters on the Portsdown Hill just behind Portsmouth," and on the Allied forces' points of assembly on the southern coast of England, see: Commander U.S. Naval Forces in Europe, *Administrative History of U.S. Naval Forces in Europe, 1940-1946*, p. 388 (also: www.history.navy.mil/library/online/comnaveu/comnaveu-6.htm). In his war memoirs, Winston Churchill noted that on May 28, two days before what I believe may have been the date of the "Mickey Mouse" briefing described in the United Press dispatch, "subordinate commanders were informed that D-Day would be June 5," although poor weather ultimately delayed the invasion till the 6th (Churchill, *Second World War*, volume

5, p. 618). I am grateful to Andrew Whitmarsh, Military History Curator at the D-Day Museum, Portsmouth (Hampshire), England, for the reference to the photo of the May 30 briefing on the Isle of Wight in the Imperial War Museum, and for responding to various inquiries about the "Mickey Mouse" briefing.

27. See Heide, et al., Mickey Mouse: The Evolution, the Legend, the Phenomenon! (p. 81), for one of many books and articles over the years stating that "Mickey Mouse" was the "password for the Allies who stormed the beach at Normandy." The United Press item about the password that Walt probably saw was "Mickey Mouse Has Invasion Role," Los Angeles Times, p. 6. For the interview all but proving his awareness of the report, see Mary Braggiotti, "Mickey Mouse's Dearest Friend," New York Post, p. 17. Michael Barrier located variants of the United Press item in the Charleston Daily Mail (W.Va.), Piqua Daily Call (Ohio), and Statesville Daily Record (N.C.); see www.michaelbarrier.com/Home%20Page/WhatsNewArchivesMay10.htm#mickeymouseanddday and www.michaelbarrier.com/Home Page/WhatsNewArchivesJuly10.htm.

For the Disneys' trip to England (and Ireland) in November 1946, see: Gabler, Walt Disney, p. 439; Barrier, The Animated Man, photo between pp. 140–141, and pp. 199, 360 (n. 124). For the "Mickey Mouse diagrams," see: Maj. J. R. Martin, 147 / Historical Section Canadian Military Headquarters … , p. 101 ("routes to be followed"); Samuel Eliot Morison, Invasion of France and Germany 1944–1945, pp. 84–85 (illus.); Robert Hendrickson, Dictionary of Eponyms, p. 218. The D-Day Museum, Portsmouth, has an almost complete set of the twenty-four original invasion charts.

28. Saving Private Ryan, prod. Ian Bryce, dir. Steven Spielberg, Universal/DreamWorks, DVD. The opening sequence of Raiders of the Lost Ark (1981), in which Indiana Jones outruns a huge boulder, was modeled on the Scrooge McDuck comic book story, "The Seven Cities of Cibola," written and drawn by Carl Barks (1954); another Uncle Scrooge story by Barks that helped inspire Raiders of the Lost Ark is "The Prize of Pizarro" (1959). Spielberg, like George Lucas, co-producer of Raiders, is also a collector of Barks artwork, including original oil paintings (Barks, Carl Barks: Conversations, p. xii).

29. "Mickey Mouse," in Burchfield, Supplement to the OED, p. 925; Jack Rosenthal, "Mickey Mousing," New York Times Magazine, p. 12; Maurice A. Crane, "Miscellany (Vox Bop)," in American Speech, p. 225 (also: A Mickey Mouse Reader, p. 185); "Mickey Mouse Matinee Attraction," Irish Times, p. 4 (Theatre Royal, Dublin).

30. For the 1935 lexicon in Down Beat, see Carl Cons, "The Slanguage of Swing: The Terms the 'Cats' Use," Down Beat, pp. 1, 8 (discussed in McRae, "'What is Hip?' and Other Inquiries in Jazz Slang Lexicography," pp. 577–578); for the 1938 reference, see Down Beat, April 1938, p. 25; for 1945: Down Beat, September 1945, p. 15 (from "Mickey Mouse," in Burchfield, Supplement to the OED, p. 925). In 1949 Arnold Shaw claimed that terms like "Mickey Mouse" had been confected by song pluggers to refer to bands that were "corny," but it is unlikely they actually invented the expression (Shaw, "The Vocabulary of Tin-Pan Alley Explained," Notes, pp. 34, 42).

31. George T. Simon, The Big Bands (1981), pp. 491–492. For Blue Barron's comment see: "Jazz Royalty," Wikipedia (www.answers.com/topic/jazz-royalty). For more on Blue Barron, see Christopher Popa, "Blue Barron: The Music History of Yesterday and Today'" (www.bigbandlibrary.com/bluebarron.html). For Goodman on Whiteman: 78-L-Digest (www.78online.com/forum/read.php?f=3&i=2221&t=2221&v=t) and a discussion group post by "Dan K.," Sept. 3, 2004.

32. Hendrickson, Dictionary of Eponyms, p. 218 ("Mickey Mouse boots"); "40th Division. Troops Lack Equipment. Woes of 'Mickey Mouse Army,'" San Francisco Examiner, p. 1. In a taped recollection of comments he'd made in a memo to Disney executive Marty Sklar, Carl Nater described for Dave Smith the circumstances of the Army auditor calling the Disney system of bookkeeping "the darndest system of Mickey Mouse accounting I've

ever heard of" (Carl Nater, "Interviewed by Dave Smith on October 7, 1972," in Ghez, Walt's People, vol. 11, p. 147.

33. Edward J. Epstein, "Walt Disney: the Genius of the New System," in Epstein, The Big Picture, p. 33.

34. Fishwick, "Aesop in Hollywood," pp. 39–40 (for the quote from Life, see "Silver Anniversary for Walt and Mickey," p. 83).

35. For the most complete history of the show, see Lorraine Santoli, Official Mickey Mouse Club Book, esp. pp. xix, 17.

36. Barbara J. Coleman, "Through the Years We'll All Be Friends: The 'Mickey Mouse Club,' Consumerism, and the Cultural Consensus," Visual Resources: An International Journal of Documentation, p. 299 (repr. in Apgar, A Mickey Mouse Reader, p. 291).

37. Douglas T. Ross, "Origins of the APT Language," in Richard L. Wexelblat, ed., History of Programming Languages, pp. 280, 285, 288, (appendix summary of APT), from the proceedings of a meeting held in Los Angeles, June 1–3, 1978; and p. 338 for remarks by John Goodenough, chair of the APT session at the conference. On other early programming languages, see: Sammet, "Organization of the Conference," pp. xvii, xix, in the same proceedings (History of Programming Languages). FORTRAN began to be developed in 1953, and another language, LISP, ca. 1957 (Capt. Grace Murray Hopper, "Keynote Address," and John McCarthy, "History of LISP," both in History of Programming Languages, pp. 15, 173, 182). A report in the San Francisco Chronicle about the unveiling of APT was picked up, with a humorous aside, by the New Yorker in its Mar. 28, 1959 issue (Ross, "Origins of the APT Language," pp. 279, 332).

38. Ross, "Origins of the APT Language," pp. 363 (frame 44), 364 (frames 45–46), 365. For the fourteen-inch Mousegetar-Jr., with a wind-up music box that played the Club's march song, see: Heide and Gilman, Disneyana, pp. 187, 295, 299; Bain and Harris, Mickey Mouse: Fifty Happy Years, pp. 222, 223. On TV, Mickey Mouse Club co-host Jimmie Dodd played a full-size "Mousegatar," similar to the 23-inch model that sold for $4.00. Mr. Ross made the comment about the head of Mickey's nephew ("the profile was better!") in an email message to me, Aug. 6, 2002.

39. Rick Atkinson, Long Gray Line: The American Journey of West Point's Class of 1966, p. 14. For a rave review of Gustav Hasford's novel, The Short-Timers, see Walter Clemons, "Killing Ground," Newsweek, p. 60.

40. George Orwell, letter of Aug. 26, 1936, in Orwell, Collected Essays, vol. 1, p. 228.

41. Sinclair Lewis, It Can't Happen Here, pp. 2, 113.

42. Alan Dundes and Manuel R. Schonhorn, "Kansas University Slang: A New Generation," in American Speech, p. 176; Crane, "Miscellany (Vox Bop)," p. 226; Lady Bird Johnson, White House Diary, p. 387 (June 4, 1966 entry). Berkeley alumnus Roland De Wolk shared the "micks" anecdote in an email, Nov. 23, 2011.

43. Harvard Beats Yale 29–29, prod. Kevin Rafferty, dir. Kevin Rafferty, Kino International, DVD.

44. Elmo R. Zumwalt, Jr., "Z-gram #57" ("Elimination of demeaning or Abrasive Regulations"), Nov. 10, 1970 (www.history.navy.mil/faqs/faq93-57.htm). For more on Zumwalt and his battle against "Mickey Mouse" regs in the Navy, see: Dana Adams Schmidt, "Navy Will Allow Beer and Beards," New York Times, pp. 1, 11, and Richard Goldstein, "Elmo R. Zumwalt Jr., Admiral Who Modernized the Navy, Is Dead at 79," New York Times, p. A17.

45. Zumwalt, "… on the Navy," New York Times, p. 23 (repr. in Apgar, A Mickey Mouse Reader, pp. 186–187).

46. D. Keith Mano, "Real Mickey Mouse Operation," Playboy, pp. 199, 322ff.; The Godfather II, prod. Francis Ford Coppola, Gray Frederickson, dir. Francis Ford Coppola, Paramount, DVD; Andrew Rosenthal, "Reagan Asserts Democrats Would Hinder U.S. Defense," New York Times, p. A28.

47. Updike, "The Mystery of Mickey Mouse," p. 239 (in Apgar, A Mickey Mouse Reader). For Updike's boyhood dream of working for Walt Disney, see Jack De Bellis, The John Updike Encyclopedia, pp. 138–139, 175.

48. Updike, "The Mystery of Mickey Mouse," p. 240 (A Mickey Mouse Reader).

7: IN THE TEMPLE OF HIGH ART

1. Jesse Green, "Can Disney Build a Better Mickey Mouse?," New York Times, p. AR1 (for Sendak's Max being inspired by Mickey); Sendak, "Growing Up With Mickey," p. 17. Both articles are reprinted in Apgar, A Mickey Mouse Reader, where these references appear on p. 312 and p. 192, respectively.

For more on Sendak's 1978 drawing of Mickey and himself, including a preliminary pencil sketch for the TV Guide illustration (dated Aug. 28, 1978), see Justin C. Schiller and Dennis M. V. David (Leonard S. Marcus, ed.), Maurice Sendak: A Celebration of His Work, pp. 168-69.

2. Rivera, "Mickey Mouse and American Art," Contact ("An American Quarterly Review"), pp. 37-39 (repr., with commentary, in A Mickey Mouse Reader, pp. 53-55). A photocopy of Rivera's original manuscript is in the Rivera Collection (shelf number NR8224. M47 R58 1933), Rosenberg Archives, Rosenberg Library, City College of San Francisco, San Francisco, Calif. Rivera's article, which was probably drafted in November or December 1931, was mentioned in the New York Times, Feb. 6, 1932, p. 15 ("Book Notes"). According to two other Times stories, Rivera arrived in Manhattan on Nov. 13, 1931; his one-man show at the Museum of Modern Art opened on December 22nd ("Rivera Here," p. 31; "Rivera on the Horizon," p. X10).

3. Michael Barrier, "Walt and Dolores—and Diego," and "More on Walt, Dolores, and Diego," MichaelBarrier.com (www.michaelbarrier.com/#waltanddolores and www.michaelbarrier.com/#moreonwaltanddolores).

4. For Benjamin's 1931 notebook entry (in English), "On Mickey Mouse," see: Bullock and Jennings, eds., Walter Benjamin: Selected Writings, vol. II, p. 346; for the original text in German (Zu Micky-Maus) see: Benjamin, Gesammelte Schriften, vol. VI, p. 145. Both texts, in English and in German, are reprinted, with commentary, in A Mickey Mouse Reader, pp. 20-21, 360). The 1933 version of Benjamin's essay, The Work of Art in the Age of Mechanical Reproduction, was titled Experience and Poverty (Erfahrung und Armut). For that text, in English and in German, see Walter Benjamin: Selected Writings, vol. II, p. 732, and Gesammelte Schriften, vol. II.I, pp. 218-219.

Benjamin's theorizing can be exceedingly hard to follow. A density inherent in his writing, in both the original German and in translation, is compounded by an often less-than-compelling Marxist-Freudian intellectual approach. For Esther Leslie's helpful take on Benjamin and the Mouse, see Leslie, Hollywood Flatlands, pp. 81-83, 102. See also: Michael North, Machine-Age Comedy, esp. pp. 57-59 (ch. 2, "Mickey's Mechanical Man"); Miriam Hansen, "Of Mice and Ducks: Benjamin and Adorno on Disney," South Atlantic Quarterly, pp. 27-61, esp. pp. 29-30; and "Micky-Maus," a revised version of the same article, published as ch. 6 in Hansen's book, Cinema and Experience: Siegfried Kracauer, Walter Benjamin and Theodor Adorno.

5. "Regulated Rodent," Time, p. 21; Seldes, "Mickey-Mouse Maker," p. 23 (and A Mickey Mouse Reader, p. 43).

6. "Comedy Relief," Art Digest, p. 10 (the opening of the show was announced in the Oct. 15, 1931 issue of Art Digest, "Great Calendar of U.S. and Canadian Exhibitions," p. 25); Grafly, "Animated Cartoon Gives the World An American Art: Slips Into Being Without Benefit of the Orthodox," Philadelphia Public Ledger, p. 12 (for the two other pieces, both unsigned, see Grafly, "Disney Has Debut In Art Circles" and "An Artist of Our Time," the latter reprinted, with commentary, in Apgar, A Mickey Mouse Reader, pp. 58-60).

7. Robert Neuman brought the Benton murals to my attention. The best analysis to date of the Arts of Life in America series is the chapter titled "The Whitney Mural," in Henry Adams, Thomas Hart Benton: An American Original, pp. 176-191. When the Whitney Museum moved uptown in the 1950s, the bulk of the Benton murals was sold to the New Britain Museum of American Art in Connecticut where it remains today.

8. According to the critic Edward Alden Jewell, the Whitney Museum site was awkward and relatively small, "only some twenty-five feet square, with a complicated sloped and broken ceiling"; Jewell also reported that a "private showing for invited architects and patrons" was held on Dec. 5, 1932, and that, after a brief public viewing period, the murals might "be seen by special appointment" (Jewell, "Arts of Life in America Are Portrayed in Murals of New Library at the Whitney Museum," *New York Times*, p. 24). The imminent completion of the project was announced in another *Times* article, "Mural for Whitney Museum," p. 23.

9. Benton, "The Arts of Life in America," in *Arts of Life in America: A Series of Murals by Thomas Benton*, p. 4.

10. Kate Gordon, professor of psychology at Bryn Mawr, employed the words "objectification of emotion" repeatedly in an essay, "Pragmatism in Aesthetics," published in 1908 in George Stuart Fullerton, *Essays Philosophical and Psychological in Honor of William James*, pp. 464-465, 467. The language may be rooted in Kantian rhetoric, but the concept likely originated with Wordsworth's characterization of poetry as "emotion recollected in tranquility."

11. Seldes, *The 7 Lively Arts*, p. 349; McBride, "Whitney Museum Decorations Still a Subject for Debate," *New York Sun*, p. 22.

12. Craven, *Cartoon Cavalcade*, p. 242; Benton and fellow Midwesterner Craven were roommates in Greenwich Village in the early 1910s (Adams, *Thomas Hart Benton*, p. 65). *Ballyhoo* was one of the first magazines in the Dell Publishing Co. stable, founded in 1921 by George T. Delacorte, Jr. (for years, Dell published the Disney comic books). In its April 1934 issue, *Ballyhoo* published a parody of Mickey Mouse, Mutt and Jeff, and other comic strips. For more on *Ballyhoo*, see: www.dellmagazines.com/about/company.shtml. For Craven's comments on American humor and Benton (and also Mark Twain), see *Cartoon Cavalcade*, p. 6.

13. "The hour is at hand" were Christ's words when he awakened his disciples after praying in the garden of Gethsemane (Matthew 26:30). "You don't know the half of it, dearie," seems to have originated as a catchphrase used by vaudevillian Bert Savoy ("Notes," *Time*, p. 16). The line also appears in F. Scott Fitzgerald's novel, *Tales of the Jazz Age* (1922), and in a George and Ira Gershwin song "The Half of It, Dearie Blues" from *Lady Be Good* (1924). For the fictional character, Doremus Jessup, and his relations with Villard and Gold, see Lewis, *It Can't Happen Here*, pp. 11, 243. For more on the die-hard Marxist Mike Gold, see pp. 19-52, and elsewhere, in Morris Dickstein's *Dancing in the Dark: A Cultural History of the Great Depression*.

14. "The Eagles They Fly High in Mobile" was recorded (as "Zamboanga") in 1960 by folk singer Oscar Brand on his album *Every Inch A Sailor*, Elektra EKL 169/EKS 7169.

15. For bibliographical information on these strips and profiles of the men who drew them, see Judith O'Sullivan, *The Great American Comic Strip*, pp. 159, 163, 187. On *The Gumps*, see also George Perry and Alan Aldridge, *The Penguin Book of Comics*, p. 96.

16. Adams, *Thomas Hart Benton*, pp. 188-189; Craven, *Cartoon Cavalcade*, pp. 16, 101, 240.

17. Inge, *Comics as Culture*, p. 5 (the Gumps, inhabitants of a "safe Midwestern world"); for the line about the Midwest as "that common-denominator of America," see the Lynds' *Middletown*, p. 8. According to Steven Biel, *American Gothic: A Life of America's Most Famous Painting* (pp. 108-109), "There is no way to date precisely when the Midwest came to represent 'America,' but the rhetoric and iconography of the Depression—and *American Gothic* in particular—certainly helped consolidate the association. As a term for the region …'Middle West' entered into popular usage around 1910."

18. Biel, *American Gothic*, p. 44 (for the claim, by Biel, that *American Gothic* is "the best known American painting") and p. 45 (Grant Wood's own description of the man and woman in the picture as "straight-laced").

19. *Tragedy* and *Comedy* were painted on the walls in the auditorium of Bedford Junior High School; completed by early fall 1934, they remain in situ. The building, renamed in 1958 the Kings Highway Elementary School, has sometimes been mistakenly referred to as "Westport High School," notably by Alexander Eliot, "U.S. Scene," *Time*, p. 24, and Laurence E. Schmeckebier, in his 1943 monograph, *John Steuart Curry's Pageant of America*. As noted in the caption on p. 198 in this book, small oil sketches by Curry for *Tragedy* and *Comedy* (on a single canvas) are at the Marianna Kistler Beach Museum of Art at Kansas State University (accession no. 2002.1532). I am grateful to Kathie Bennewitz for bringing these sketches to my attention.

The two main references on Curry's project are: Schmeckebier, *John Steuart Curry's Pageant of America*, pp. 273, 276-277, 282-283; M. Sue Kendall, "Alien Corn: An Artist on the Middle Border," in Junker, et al., *John Steuart Curry*, pp. 170-172, 180 (n. 47-53, 58-59). See also: "November First Set as Tentative Date for Formal Unveiling of Curry Murals at Bedford Jr. High," *Westporter-Herald*, p. 1; Edward Alden Jewell, "American Murals on Display Here," *New York Times*, p. 17; Brooke Peters Church, "John Curry, Artist …," *The Town Crier*, pp. 10-11 (n.p.).

20. For the identities of the figures in Curry's compositions, see: "Late Political Rumor Causes Sensation: Curry's Frescoes Receive Enthusiastic Comment Among Westport Artists: Famous Artist Finishing One of Two Frescoes," *Westporter-Herald*, p. 5; Eliot, "U.S. Scene," pp. 24; Church, "John Curry, Artist," pp. 10-11 (n.p.); Schmeckebier, *John Steuart Curry's Pageant*, p. 277; Vivien Testa, "The Curry Frescoes," p. 2 (n.p.); Joanna Foster, "The Way Westport Was: John Curry's Murals," *Westport News*, 12-13; Thane Grauel, "Expert Restores Frescoes," *Westport Minuteman*, p. 10; Kendall, "Alien Corn," pp. 170-172, 180 (n. 50). As reported in her obituary in the *New York Times*, the Currys' friend Rose O'Neill was known for keeping "open house for artists and the *literati*" at her Westport home, "Carabas Castle" ("Miss Rose O'Neill, Creator of Kewpie," *New York Times*, p. 19).

21. Thomas Hart Benton, "John Curry," *University of Kansas City Review*, winter 1946, pp. 87-90; repr. in Junker, *Curry: Inventing the Middle West*, pp. 74-76 (p. 74, for the part of the essay cited here).

22. Church, "John Curry, Artist" p. 10 (n.p.). On the circumstances of the commission, see also: Donald Munson, "Westport Artist, John Stuart [sic] Curry, Wins Acclaim," *Bridgeport Post*, p. 5; Testa, "Curry Frescoes," p. 2. On Kathleen Curry's daughter, who posed for Little Eva, see: Foster, "The Way Westport Was," p. 13. On Kathleen Shepherd Curry herself, see: Steven Slosberg, "Uncasville's Brush With Fame," *The Day*, p. 4.

23. Church, "John Curry, Artist," p. 11, and, for the *Time* article, Eliot, "U.S. Scene," p. 24. For the Curry frescoes' reception locally, see: "November First Set as Tentative Date," p. 1, and Munson, "Westport Artist," p. 5.

In February 1935, the frescoes were reproduced in the magazine *Survey Graphic*, and mentioned by *New York Times* critic Edward Alden Jewell, who saw enlarged photographs of them at the Grand Central Galleries and said they appeared to be "highly effective" ("Tragedy, Comedy," *Survey Graphic*, pp. 58-59; Jewell, "American Murals on Display Here," p. 17). It is not impossible, incidentally, that Disney admirer Eleanor Lambert helped promote Curry's art in the press at this time as she was then his publicist (Collins, "The Lady, the List, the Legacy," p. 267).

24. In addition to Mickey's presence in *Comedy*, a second motif in Curry's 1934 Westport commission had an antecedent in Benton's work. As in the *Tragedy* fresco, a female aerialist figures prominently in *City Activities with Dance Hall*, one of ten panels in Benton's first important mural series, *America Today* (1930-1931), painted for the New School for Social Research (acquired in 2013 by the Metropolitan Museum of Art). Curry's portrayal of family, friends and himself in the Westport frescoes also was something Benton had done in *City Activities with*

Dance Hall (illustrated in Adams, *Thomas Hart Benton*, p. 167).

25. Seldes, *The 7 Lively Arts*, p. 213.

26. John Dewey, *Art as Experience*, p. 69 ("objectification of emotion"); Paul Rosenfeld, "Ex-Reading Room," *New Republic*, pp. 245-246 (hostile review of the Whitney murals). For Dewey's political activism, see George Dykhuizen, *The Life and Mind of John Dewey*, pp. 251, 254. *The Nation* apparently was not offended by its inclusion in the *Political Business and Intellectual Ballyhoo* satire, since Benton was named to the magazine's "Honor Roll" for 1932 in its Jan. 4, 1933 issue.

Benton recalled having been introduced, around 1916, to the writings of Marx, Freud, William James, and Dewey by Dr. John Weichsel, founder and director of the People's Art Guild (Benton, *An Artist in America*, pp. 41-42). In 1930-31, while he was painting the *America Today* murals for the New School for Social Research, co-founded by Dewey in 1919, several of Benton's friends were protégés of Dewey (Emily Braun, "Thomas Hart Benton & Progressive Liberalism," in Braun and Branchick, *Thomas Hart Benton*, p. 25). In Henry Adams's *Thomas Hart Benton* (pp. 184, 191, 348, n.), Adams quoted a line from a passage in Dewey's *Art as Experience* (pp. 5-6) that parallels rather strikingly the ideas expressed two years earlier by Benton in his Whitney Museum essay, and, visually, in the Whitney library project. Here is a portion of that passage:

> The arts which today have most vitality for the average person are things he does not take to be arts: for instance, the movie, jazzed music, the comic strip, and too frequently, newspaper accounts of love nests, murders, and exploits of bandits. For when what he knows as art is relegated to the museum and gallery, the unconquerable impulse towards experiences enjoyable in themselves finds such outlet as the daily environment allows. [. . .] When, because of their remoteness, the objects acknowledged to be works of fine art by the cultivated seem anemic to the mass of people, esthetic hunger is likely to seek the cheap and the vulgar.

Eight months after *Art as Experience* was published, Benton reiterated his central thesis in language that, in almost circular fashion, echoes Dewey's "Bentonian" phraseology. According to the *New York World*, Benton said that the Whitney murals reflected "the color and tempo of the jazz age as represented by racketeers, fast women, gunmen, boozehounds, and so on." "My subjects, he added, "portray American life in the 20th century realistically." Clearly, some degree of ideational interpenetration was at work here.

27. On Benton's politics, see Matthew Baigell, "Thomas Hart Benton and the Left," in R. Douglas Hurt and Mary K. Dains, *Thomas Hart Benton: Artist, Writer and Intellectual*, pp. 1-33.

28. Adams, *Thomas Hart Benton*, pp. 18, 20 (cartooning for the Joplin American); Hughes, *Nothing if Not Critical: Selected Essays on Art and Artists*, p. 194 (Benton's cartoony, Disney-like style). Benton's boast about his art one day being "as important as the funny papers," is part of the narration on the documentary film *Thomas Hart Benton*, prod. Ken Burns, Julie Dunphey, dir. Ken Burns, PBS Home Video, DVD.

29. Adams, *Thomas Hart Benton*, pp. 175, 188.

30. "A New Art in the Making," *Art News*, p. 221.

31. Thurber, "The 'Odyssey' of Disney," *The Nation*, p. 363.

32. R. E. S., "The Art of Mickey Mouse," *Art News*, p. 6 (the correct title of the Mickey cartoon short mentioned in the *Art News, The Nightmare*, is *Mickey's Nightmare* from 1932).

33. "Mickey Mouse Art Show Extended," *New York Morning Telegraph*, p. 2; Henry McBride (Daniel Catton Rich, ed.), *The Flow of Art: Essays and Criticisms*, p. 307 (in a reprint of McBride's *New York Sun* review); Cary, "Mickey Mouse and the Comic Spirit," *New York Times*, p. X8.

34. Grafly, "America's Youngest Art," pp. 336-338; Mortimer Franklin, "The Art of Mickey Mouse," *Screenland*, p. 27.

35. Lambert, *Notes on The Art of Mickey Mouse*, page 5 (n.p.).

36. The *Evansville Courier Journal* ("Mickey Mouse Exhibit," p. 9) reported that the show at Evansville was comprised of fifty pieces in black and white, "while forty-five are in water color and the remaining five are rolls." The Toledo stop was mentioned in an *Art Digest* report ("Walt Disney and Hogarth," p. 8), in local news stories, and in museum records. An article describing the Milwaukee show, "The Art of Mickey Mouse," in the *Bulletin of the Milwaukee Art Institute*, borrowed heavily from Eleanor Lambert's College Art Association text. According to a "Partial List of Traveling Exhibitions for 1934-1935," in the Association's bulletin *Parnassus* (March 1934, p. 34), the show also was titled "The Art of Walt Disney—Mickey Mouse and the Silly Symphonies." For the Hagerstown, Md., stop, see "Talk on 'Mickey Mouse' Saturday," *Daily Mail*, p. 6.

Thus far, I have confirmed just eleven stops on the College Art tour beyond New York City: Buffalo, Wesleyan (Middletown, Conn.), Chicago, Manchester (N.H.), Chicago, Evansville, Milwaukee, Hagerstown, Portland, Toledo and Memphis. For the Buffalo show, see: "Mickey Mouse and Minnie Invade Staid Art Gallery," sec. 7, p. 5, and "Mickey Mouse Crashes Big Times," *Buffalo Times*; for the Middletown and Manchester venues: "Animated Cartoon Display," *Middletown Press*, p. A1, and "Among Disney Creations at Art Gallery," *Manchester Leader*, p. 24. Cynthia Van Ness, Director of Library and Archives at the Buffalo and Erie County Historical Society, took great pains to help document the October 1933 stop in Buffalo; Marilyn Masler, Associate Registrar, Brooks Museum of Art, kindly confirmed the Oct. 1934 exhibit in Memphis.

37. "Mickey Mouse's Friends Find Him in Portland Museum," *Newsweek*, p. 29. Michael D. Ryan, Research Assistant at the Toledo Museum of Art, generously supplied copies of the two letters from the College Art Association's Director of Traveling Exhibitions and Executive Secretary, Mrs. Audrey McMahon, to Miss Katherine McKinnon, secretary to the Assistant Director of the Toledo Museum (Mme. Georges-Henri Rivière), dated May 24, 1933 and Sept. 24, 1934. Mr. Ryan also provided a copy from the exhibition files in the museum's archives of a fascinating document, dated Oct. 1, 1934, listing ninety-eight objects shown in Toledo that were shipped to the next stop, the Brooks Memorial Art Gallery in Memphis. The list includes summary names for some of the art, such as "Minnie Horns in," "Yoo-Hoo Mickey," "A Ringer for Mickey," "Mickey Impersonates Maurice," and "Trader Mickey."

38. "Art Institute Reception Will Be Held Today," *Chicago Tribune*, p. 1; see also: "'Who Is It?' Is Question at Art Reception," *Chicago Tribune*, p. 25. The "Fleming museum," named in the first of these two *Chicago Tribune* stories, refers to the Robert Hull Fleming Museum at the University of Vermont, which opened in 1931.

39. United Press, "Mickey Mouse, Big Bad Wolf Reach Walls of Art Museum," *Cleveland Press*, p. 14; repr. in its entirety (as it is in this book), but with additional contextual information, in Apgar, *A Mickey Mouse Reader*, pp. 76-77).

40. *Columbus Dispatch*, Dec. 16, 1933 (editorial), cited in Hillier, "Introduction," *Mickey Mouse Memorabilia*, p. 22.

41. Klir Beck was affected along with 1,700 other artists across the country, when the Public Works of Art Project was discontinued; see: "Headless Statues, Murals Half-Done Will Mark Passing of PWAP," *Washington Post*, p. 15, and "Four Medals Given For American Art," *New York Times*, p. 17.

42. For the statuette of Mickey riding a tortoise, see "Brazilians Bring Gift For Disney," *New York Sun*, p. 23, which concluded by stating:

> There was no official explanation of the turtle, but there are so many turtles in Brazil that they manage to creep into every aspect of the national life. It is the national animal of Brazil and was included in the design as a symbol of the friendly relations existing between Brazil and the United States, probably.

See also, in the twice-monthly Brazilian magazine *Cinearte*: "'Cinearte' em Hollywood faz passar ás mãos de Walt Disney o bronze de Camondongo Mickey," p. 26, "Marcondes Junior em Hollywood," pp. 14-15, and "'Cinearte' em Hollywood faz a approximação des 'touristes' brasileiros e Walt Disney," p. 21. For "Hellenistic artists' particular fascination with children" in sculpture, see J. J. Pollitt, *Art in the Hellenistic Age*, pp. 127-129. The *Cinearte* references were kindly shared with me by Celbi Pegoraro.

43. "Harsche Is Awarded Medal of American Art Dealers," *Chicago Tribune*, p. 17, and Alva Johnston, "Mickey Mouse," pp. 12-13 (repr. in Apgar, *A Mickey Mouse Reader*). Johnston's article, in substantially revised form, was published in *Reader's Digest*, Aug. 1934, pp. 106-109. Robert Harsche, mentioned in the *Chicago Tribune* headline, and honored along with Walt by the Art Dealers Association, was director of the Art Institute of Chicago which just five months earlier had hosted an exbition of Disney production art.

44. This Associated Press wire story ("Cartoons Invade Chicago," *Washington Post*, p. 11) appeared in a number of other newspapers on or about Dec. 13-14, 1934, including: the *Portsmouth Times* (Ohio), *Madison Courier* (Ind.), and *Lockport Union-Sun Journal* (N.Y.), all from clippings in the archives of the Art Institute, Chicago.

45. The Leicester Galleries booklet, *Walt Disney and His Animated Cartoons*, contains three brief texts, "Biographical Note," "How Walt Disney Works," "The Technicolor Process," and a summary listing of the objects on display. For news reports on the show, see: "Mickey Mouse on Exhibition," *Listener*, p. 337, "Art of Mr. Disney: Film Cartoons in the Making," *London Times*, p. 10, also ads on that same page and in the *London Times* on other dates until it closed on Mar. 2, 1935. For Irving Wallace's flip comment on the show, see Wallace, "Mickey Mouse and How He Grew," *Collier's*, p. 36 (also p. 174 in *A Mickey Mouse Reader*, where the entire article is reprinted).

The Courtauld Institute library has copies of *Walt Disney and His Animated Cartoons*, plus an eight-page booklet bearing the same name published for the Harris Museum and Art Gallery and *Walt Disney's Animated Cartoons*, also eight pages long, published for the City of Manchester Art Gallery. The latter two items are both virtually identical to the Leicester Galleries booklet. For the Belfast venue, which opened Oct. 14, 1935, see: *Walt Disney and his Animated Cartoons*, a four-page flyer with all of the same content. I am grateful to Mr. Donal Fenlon, Assistant Librarian, Royal Society of Antiquaries of Ireland, Dublin, for providing a photocopy of this publication in the Society's collection, and to my brother, Keith Apgar, for obtaining copies of the booklets at the Courtauld Institute library.

46. Didier Ghez, "Ruthie Tompson," *Walt's People*, vol. 11, p. 24 ("Walt was very generous"). A Disney cel set-up from the 1938 short *Mother Goose To Hollywood* was inscribed to Clark Gable by Walt; see: catalogue of Christie's sale #1681, New York, June 22, 2006, *Film and Entertainment Including a Collection of Andy Warhol Memorabilia*, lot 90 (hammer price: $16,800). One early pre-Courvoisier Disney set-up, from the 1933 color Silly Symphony *Lullaby Land*, was sold by Philip Weiss Auctions, Feb. 15, 2015 (lot 365, hammer price $1,000). This multi-cel set-up (5½ x 7 in., sight) had been in the estate of Hal Sloane, a publicity man at United Artists in New York during the time UA was distributing the Disney cartoons.

On Courvoisier's marketing of Disney production art (set-ups and, occasionally, drawings), see Munsey, *Disneyana*, p. 189; on *Ferdinand the Bull*: Smith, *Disney A to Z* (2006), p. 252. To call such art "originals," incidentally, is slightly misleading, even if each item was marketed with a certificate of authenticity from the studio. Often, as Bruce Hamilton pointed out, the characters were trimmed from their celluloid sheets and glued onto backings. The backings were almost never production backgrounds from films for which the cels were made; in some cases they were no more than pieces of fabric or wood veneer. "Rarely," in Hamilton's words, did the items handled by

Courvoisier fully "simulate what appeared on the screen." But such issues seem not to have troubled his clientele. See Hamilton, "Disney in Context," in Bruce D. Kurtz, *Keith Haring, Andy Warhol, and Walt Disney*, pp. 25-26.

47. Walt and Roy were copied on Courvoisier's letter to Kay Kamen (Munsey, *Disneyana*, p. 186); for the Disneys' arrangement with Courvoisier, see also: "World-Wide Disney," *Magazine of Art*, p. 46, and "Dopey, Grumpy & Co.," *Art Digest*, p. 14.

48. For the 1936 MoMA show, see: "Modern Museum a Psychopathic Ward as Surrealism Has Its Day," *Art Digest*, pp. 5-6; Keith L. Eggener, "'Amusing Lack of Logic': Surrealism and Popular Entertainment," *American Art*, pp. 40-41, 43, 45 (n. 18).

For Disney, MoMA and Iris Barry, see: Barry, "Film Comments," *Bulletin of the Museum of Modern Art*, p. 3 (on *Three Little Pigs*); "The 'Vamp' and Mickey Mouse Join the Museum of Modern Art Film Library," Press Release #46; "Some Early Sound Films," p. 10; Barry, "Films," *Bulletin of the Museum of Modern Art*, p. 12; "Founding of the Film Library," *Bulletin of the Museum of Modern Art*, pp. 7-8; and Bill Mikulak, "Mickey Meets Mondrian," *Cinema Journal*, pp. 56, 61-62, 64-68, 72 (n. 58-61); MoMA Archives, General L [mf 39; 419].

On Erwin Panofsky, his article on film, and his lecture at the Met see: Panofsky, "On Movies," *Bulletin of the Department of Art and Archaeology of Princeton University*, June 1936, pp. 5-15; Thomas Y. Levin, "Iconology at the Movies: Panofsky's Film Theory," *The Yale Journal of Criticism*, pp. 27-28 (and endnotes 2, 5, 8-9). Panofsky also mentioned Mickey in a revised version of his Princeton article, published in Paris in February 1937, "Style and Medium in the Motion Pictures," *Transition*, p. 127.

49. Barry, "Program for 1938," *Bulletin of the Museum of Modern Art*, p. 2.

50. Regarding Dalí's card to Breton, see Fèlix Fanés, "Film as Metaphor," in Matthew Gale, ed., *Dali & Film*, pp. 43, 51, n. 31 (in the original French, Dalí wrote: "Je suis à Hollywood et j'ai contacté les trois surréalistes américains: Harpo Marx, Disney et Cecil B. Demille. Je crois bien les avoir suffisamment intoxiqué et j'espère que les possibilités du surréalisme se feront réalité ici."). For Disney's response to Huxley in *Time*, see "Mouse & Man," p. 21; for three later variants on the Huxley quote: Frank S. Nugent, "Disney Is Now Art—But He Wonders," p. 5; J. P. McEvoy, "Walt Disney Goes to War," *This Week*, p. 8; "Mickey Mouse First Named 'Mortimer'," *Irish Times*, p. 9.

51. Murrell, *History of American Graphic Humor*, vol. II, p. 258; "World-Wide Disney," *Magazine of Art*, p. 46 (Courvoisier); "Grim Disney," *Time*, p. 42. For more on Courvoisier's distribution of *Snow White* art for sale in galleries, see: "Dopey, Grumpy & Co.," *Art Digest*, p. 14.

52. For the vultures set-up at the Met, see: "Disney Joins the Masters in Metropolitan; Museum to Show 'Snow White' Watercolor," *New York Times*, p. 21, and Nugent, "Disney Is Now Art," p. 5. An almost identical piece, formerly in the Stephen H. Ison Collection, is reproduced in Martin Krause and Linda Witkowski, *Walt Disney's Snow White and the Seven Dwarfs: An Art in Its Making*, p. 142.

Ward Kimball was identified as early as 1987 as the man who animated the vultures in the film (Bob Hoover, "'Snow White' as Young as Ever," *Pittsburgh Post-Gazette*, p. 3). For a discussion of the three sequences in which the vultures appear, including Walt assigning Kimball to animate the birds, and for production credits on those sequences (sequence nos. 10B, 13A, 14J), see J. B. Kaufman, *The Fairest One of All: The Making of Walt Disney's Snow White and the Seven Dwarfs*, pp. 198, 292-294. The Kimball set-up at the Metropolitan Museum of Art is from sequence 14J in the film.

53. "Asked whether Mr. Disney was represented in any other museums, the Julien Levy Gallery, 15 East Fifty-seventh Street, reported that the Vassar art collection included another of the water-colors from the Disney studio" ("Disney Joins the Masters," *New York Times*, p. 21). The Vassar "watercolor," a cel

set-up from *Snow White*, representing an owl, from the sequence of the princess fleeing into the forest, entered Vassar's collection in 1938 (inv. no. 1938.9). An accession note states: "From the Walt Disney production of *Snow White*, 1937." Patricia Phagan, Curator of Prints and Drawings at Vassar's Frances Lehman Loeb Art Center, kindly supplied this information. A cel set-up formerly in the Ison Collection, "okayed for camera and stamped 'August 19, 1937'," also depicting the owl, is from the same sequence as the Vassar *Owl* (Krause and Witkowski, *Walt Disney's Snow White and the Seven Dwarfs: An Art in Its Making*, p. 74, illus.). For more on Levy's sale of art from *Snow White*, see: "Here and There in the Galleries," *Art News*, p. 14.

For Courvoisier's list of institutions that had acquired Disney production art by the fall of 1940, see Munsey, *Disneyana*, p. 190. In 1938, the Cleveland Museum was given five cel set-ups from *Snow White*, representing the Seven Dwarfs, Dopey, raccoons, Sleepy playing a flute, and a group of deer and birds (accession nos. 1938.369 through 1938.373). The Toledo Museum of Art has four cel set-ups from *Snow White*, purchased from the Albert Roullier Art Galleries, Chicago, also in 1938 (accession nos. 1938.37 through 1938.40); again, my thanks to Michael Ryan for this information. A set-up representing Doc, Bashful, Sneezy, Happy, and Dopey, from *Snow White* (inv. x1943-10), presented to the Princeton University Art Museum in 1943 by one of its faculty, Frank Jewett Mather, Jr., might have come from the Sessler Galleries in nearby Philadelphia. The Yale University Art Gallery has a cel of Jiminy Cricket (inv. no. 1949.46), a bequest in 1949 of another academic, retired Wellesley professor Elizabeth Manwaring, who might have acquired the piece in 1938 or 1939. My thanks to Elisabeth Hodermarsky, Associate Curator of Prints, Drawings, and Photographs, for information on this cel and a second object in Yale's collection, a standing figure of Happy (inv. 1967.95.7).

Regarding sales of Disney art by the Sessler Galleries in Philadelphia, the *Philadelphia Record*, Oct. 4, 1938 (from Munsey, *Disneyana*, p. 188), reported:

They took down the immortal picture of Whistler's "Mother" from its time-honored spot on the walls of the Charles Sessler Galleries … yesterday, and in its place they hung a portrait of—DOPEY! Down came the Rembrandts, the Durers and the works of other old masters. And up went Grumpy, being doused in the watering trough, a scene showing Sneezy and Dopey dancing with Snow White, the turtle rolling down the steps and other now famous scenes from Walt Disney's "Snow White and the Seven Dwarfs."

It was the opening of the first showing and sale of original watercolors used in the Disney production, which started simultaneously in fifteen cities in the United States. And the children who tried to get a glimpse of the Disney exhibition were crowded out by the grownups, collectors and museum scouts, who bought nearly 200 of the 275 pictures in the first few hours after the showing began.…"The highest priced pictures were sold first," Sessler said. Most of them were bought by well known art connoisseurs in Philadelphia, who pledged Sessler to anonymity. Others were purchased by the Metropolitan Museum of New York and by Mrs. H. P. Whitney's Museum of Modern Art.

The collectors also placed orders for originals from Disney's forthcoming productions, "Ferdinand the Bull" and Pinocchio." The most popular celluloids were those of the heroine Snow White, while those of the animals were second. Happy's picture was greatest in demand in the dwarf sequences, with Dopey running a close second.

For the Albert Roullier Galleries, see Eleanor Jewett, "'Snow White' Water Colors Are Exquisite," *Chicago Tribune*, p. 17, and Jewett, "Galleries Here Exhibit Disney Water Colors," *Chicago Tribune*, p. F4; for the London and Washington, D.C. exhibitions, see the catalogue published for the Leicester Galleries,

Original Paintings on Celluloid By Walt Disney and His Collaborators for the Film Snow White and the Seven Dwarfs, and "Phillips Gallery Gives Walt Disney Exhibition," *Washington Post*, p. TS6. For a cel set-up from *Pinocchio* handled by Julien Levy around 1940, see Bruce J. Altshuler, "Avant-Garde Impresario," *Art in America*, p. 55 (illus.).

54. Letter to Blake-More Godwin, Director of the Toledo Museum of Art, May 6, 1940, from Hugh M. Dunbar, Albert Roullier Galleries, Chicago; "Consignment of Disney Originals to the Toledo Museum of Art from Albert Roullier Art Galleries," Sept. 25, 1940 (both in the Toledo Museum of Art archives).

55. Los Angeles County Museum, *Retrospective Exhibition*, p. 6 (the primary or sole author of the catalogue was, presumably, Roland J. McKinney, the museum's director. For the text cited here, see "Walt Disney Show," *Weekly News Letter*, pp. 1-2. In 1946, McKinney left the Museum, having been hired by Disney to scout "the country for top artist talent" to work at the studio (Arthur Millier, "Masters of Mickey Mouse and Limp Team Up," *Los Angeles Times*, April 7, 1946, p. B4).

56. "Disney Museumized," *Art Digest*, p. 11.

57. "Art and Artists. Record in Visitors To Galleries," *San Bernardino Sun* (clipping in the archives of the Los Angeles County Museum). After the exhibition closed, on Dec. 30, it was slated to visit the University Gallery in Minneapolis (a co-sponsor) and art museums in Cleveland, Cincinnati, Detroit, Worcester (Mass.), St. Louis, and Chicago, for a third visit to the Art Institute. I have found no record of the exhibition reaching any of these venues except Worcester ("Walt Disney Retrospective Exhibition," *Worcester Art Museum News Bulletin and Calendar*, vol. 7, p. 1). For the planned itinerary, see the *San Bernardino Sun* article, plus: Los Angeles County Museum, *Weekly News Letter*, p. 2; "Mickey Mouse, Pals Will Go 'Highbrow,'" *Los Angeles Mesa News* (clipping in the archives of the L.A. County Museum); "Disney Saga in Museum Exhibition," *Los Angeles Herald and Express* (L.A.C.M. archives).

58. For the star on the Walk of Fame, see Jeff Figler, "Major Milestones in Mickey Mouse History," *San Diego Union-Tribune*, p. D15. The MoMA film retrospective ran from Nov. 18 to Dec. 17, 1978; the Library of Congress show, from Nov. 21, 1978 to Jan. 30, 1979. For the Au Printemps department store event, see the undated mimeograph or xerox flyer, *Mickey fête ses 50 ans au Printemps*, prepared by the store's Printemps public relations office (probably Oct. 1978). The roughly 300-piece collection of toys and other Mickeyana owned by Honoré Bostel were to be auctioned at the Au Printemps' flagship Paris store, Dec. 14, 1978, by the Commissseurs-Priseurs Guy Loudmer and Hervé Poulain. The store and Maîtres Loudmer and Poulain published a seven-page booklet about the collection (*Antiquités Mickey*), with brief texts by Bostel and French journalist Pierre Tchernia, "Mickey, mon ami." The Musée des Arts Décoratifs in Paris has a copy of the booklet.

59. Seldes, *The 7 Lively Arts*, pp. 313, 349; for the Boston Pops official website, see: www.bso.org/itemB/detail.jhtml?id=600005&area=pop.

60. Seldes, *The 7 Lively Arts*, p. 240; "The New Order of Critical Values—In Which Ten of the Modern Critics of America Are Allowed to Substitute New Laurels For Old," *Vanity Fair*, pp. 40-61. Carpenter's ballet-pantomime premiered Jan. 20, 1922; his program note for the performance, "The Krazy Kat Ballet," was published as an appendix in Seldes's book (pp. 377-379). See also the online description of the John Alden Carpenter Collection in the Music Division of the Library of Congress (findingaids.loc.gov).

61. Barrier, *The Animated Man*, p. 2.

62. Leslie, *Hollywood Flatlands*, p. v.

63. Theodore F. Wolff, "John Steuart Curry: A Critical Assessment," in *John Steuart Curry*, p. 81 (on Pollock as "abstract expressionism's original golden boy").

64. Henry Allen, "'Fantasia': Hip, Hippo Hooray!" *Washington Post*, p. G1.

1. Disney to Don Graham, "Inter-Office Communication," pp. 1-3. On-site life classes at the Hyperion studio were a reprise of a lapsed effort by Walt to improve the skills of his artists dating back to 1929, when he would drive some of his men to the Chouinard School in downtown Los Angeles, and bring them home afterward (Barrier, *Hollywood Cartoons*, pp. 82-84).

2. On Albert Hurter, see: Hurter, *He Drew As He Pleased*; Krause and Witkowski, *Walt Disney's Snow White and the Seven Dwarfs: An Art in Its Making*, p. 26; John Canemaker, *Before the Animation Begins: The Art and Lives of Disney Inspirational Sketch Artists*, pp. 8-25; Allan, *Walt Disney and Europe*, pp. 29-31, 34 (n. 21); Pierre Lambert, "Biographies," 301-302. For Horváth, see: Canemaker, *Before the Animation Begins*, 26-37; Allan, *Walt Disney and Europe*, 47-49, 58; Lambert, "Biographies," in *Once Upon a Time Walt Disney*, p. 301. For Gustaf Tenggren: Krause and Witkowski, *Walt Disney's Snow White*, p. 27; Canemaker, *Before the Animation Begins*, pp. 38-47; Allan, *Walt Disney and Europe*, pp. 47-48, 51, 64 (n. 18), 78-81, 85-86, 90 (n. 17, 18); Lambert, "Biographies," p. 311.

3. Charles Harrison, "Mondrian in London," *Studio International*, p. 286; Els Hoek, "Mondrian in Disneyland," *Art in America*, pp. 136-140, 142; Sophie Bowness, "Letters to Ben Nicholson and Barbara Hepworth," *Burlington Magazine*, p. 786 (Mondrian to Barbara Hepworth, Mar. 26, 1940); Harry Cooper, "Mondrian, Hegel, Boogie," *October*, p. 119; Simon Grant, "Hello from 'Sleepy'," *Tate Etc.*, pp. 112-115.

4. See Culhane, *Disney's Fantasia*, for photos of Benton and Wood at the Disney studio (p. 23), and Balanchine and Stravinsky with Walt (pp. 23, 168). For Low's comments at Grosvenor House, see "The Genius of Walt Disney: 'World of Fun and Happiness'," *London Times*, I; for his comparison of Walt to Leonardo: Low, "Leonardo da Disney," p. 18 (Low used similar language in his *Autobiography*, pp. 213-214).

5. Crowther, "Fantasia," *New York Times*, p. 28; Greene's comment, which he called "something sad about Walt Disney," came in a radio talk he made for the BBC Spanish Service, Aug. 14, 1941 (Greene, *Graham Greene Film Reader*, p. 520).

6. Russell Lynes, *Lively Audience: A Social History of the Visual and Performing Arts in America, 1890-1950*, p. 292; Otis Ferguson, "Both Fantasy and Fancy," *New Republic*, p. 724.

7. I. J. Belmont, "Painter of Music Criticizes 'Fantasia'," *Art News*, p. 11; Christopher La Farge, "Disney and the Art Form," *Theatre Arts*, pp. 679-680.

8. Max Horkheimer and Theodor Adorno, *Dialektik der Aufklärung: philosophische Fragmente*, first published in 1972 in English as *Dialectic of Enlightenment*; the quotes given here (from the 1986 edition in English, p. 138) appear in Leslie, *Hollywood Flatlands*, pp. 170-171. Adorno apparently played a role in Walter Benjamin's decision to eliminate a section on Mickey in his most famous work, *The Work of Art in the Age of Mechanical Reproduction*, when it was published, in French, in 1936 (North, *Machine-Age Comedy*, p. 58; Hansen, "Of Mice and Ducks: Benjamin and Adorno on Disney," pp. 28-29, 32, 34; Hansen, *Cinema and Experience*, pp. 163-167).

9. Gombrich, "The Vogue of Abstract Art," p. 149; first published as "The Tyranny of Abstract Art," April 1958.

10. For Benton's "rough outline" for a Davy Crockett musical, see the email from Dave Smith to Michael Barrier, Oct. 25, 2005 (Barrier, *The Animated Man*, p. 368, n. 47). A fleeting glimpse of one of Dali's images for *Destino* was presented in *Fantasia 2000*.

On Disney, Dali, and *Destino*, see (in chronological order): Alfred Frankenstein, "Something of a Jump from Burbank to Pasadena," *San Francisco Chronicle*, "This World" section, p. 8; Millier, "Masters of Mickey Mouse and Limp Team Up," *Los Angeles Times*, pp. B1, B4; Daniel Abadie, et al., *Salvador Dali rétrospective*, pp. 349-351; Robert Descharnes, *Salvador Dali: The Work, The Man*, pp. 289, 309-311; Eggener, "'Amusing Lack of Logic'," pp. 43, 45 (n. 32); Charles Solomon, *The Disney That Never Was: The Stories and Art*

from *Five Decades of Unproduced Animation*, pp. 187-189; Solomon, "A Surreal But True Match; Dali and Disney? It Really Happened, Though 'Destino's' Finish Comes Decades Later," *Los Angeles Times*, pp. E1, E4; Gabler, *Walt Disney*, pp. 414-416, 422, 493-494; Barrier, *The Animated Man*, p. 249; Fèlix Fanés, "Destino," in *Dali & Film*, pp. 186-195; Solomon, "Dali and Disney," in *Once Upon a Time Walt Disney* pp. 238-249; Smith, *Disney A to Z* (2008), pp. 153, 166-167; Korkis, *The Vault of Walt*, pp. 133-142; David A Bossert, *Dali & Disney: Destino: The Story, Artwork, and Friendship Behind the Legendary Film*.

11. *You Can't Take It With You*, prod. and dir. by Frank Capra, Sony Pictures, DVD.

12. Madoff, "Creative Chaos," *Time*, p. 97.

13. Hughes, "Disney: Mousebrow to Highbrow," *Time*, p. 91.

14. Hughes, *The Shock of the New*, p. 341.

15. For Schwitters's collage, *For Käte*, see Varnedoe and Gopnik, *High & Low*, pp. 184, 185.

16. All ten BUNK collages are in the Tate Gallery, London. On Paolozzi's Minnie and Mickey Mouse collages, and his connections with the Independent Group (I.G.) in England, see: Lawson, "Bunk," pp. 19-29; Jonathan Fineberg, *Art Since 1940: Strategies of Being*, pp. 236-239; Holly Crawford, *Attached to the Mouse: Disney and Contemporary Art*, pp. 76-77. The Henry Ford quote is from an interview in the *Chicago Tribune*, May 25, 1916. A humorous highlight of the film *Meet the People* is the performance of "Der Fuehrer's Face" by Spike Jones and His City Slickers, the big-band equivalent, in their day, of madcap cartoon characters like Donald Duck and Bugs Bunny (*Meet the People*, prod. E.Y. Harburg, dir. Charles Reisner, MGM, DVD).

17. Varnedoe and Gopnik, *High & Low: Modern Art and Popular Culture*, p. 319.

18. Crawford, *Attached to the Mouse*, p. 195; David Britt, *Modern Art: Impressionism to Post-Modernism*, p. 310 (for the Lichtenstein quote); Bonzo Dog Doo Dah Band, "Mickey's Son and Daughter," on the *Gorilla 33* rpm album (Liberty Records), October 1967 (reissued as part of a four-disc CD set, *The Bonzo Dog Band / Four Bonzo Dog Originals*, 1996, EMI). For *Look Mickey*, see also Varnedoe and Gopnik, *High & Low*, pp. 196, 199; and for more on Lichtenstein and Disney: *Crawford, Attached to the Mouse*, pp. 80-89.

19. Dan Cameron, et al., *Peter Saul*, p. 14 (for the phrase "errant breed of Pop" applied to Saul's work). For more on Saul see Crawford, *Attached to the Mouse*, p. 94). For Robert Hughes's description of Oldenburg as "the thinking person's" Disney, see Hughes, *Shock of the New*, p. 356.

As noted by Crawford in *Attached to the Mouse* (p. 91), Oldenburg "was provided studio space on the back lot of Disneyland in 1968." He "had been matched with Disney by Maurice Tuchman as part of" a program sponsored by the L.A. County Museum called "Experiments: Art and Technology," though nothing tangible resulted from the pairing. In "Disney: Mousebrow to Highbrow" (p. 91), Hughes said that Oldenburg "had himself worked at Disneyland." That comment has been interpreted to mean that he worked for the Disney company. But Crawford reported in her book (pp. 91-92) that she confirmed with Oldenburg personally that he was never employed by Disney. See also Tuchman, *Art and Technology: Report on the Art & Technology Program of the Los Angeles County Museum of Art, 1967-1971*, p. 19.

20. See Claes Oldenburg, *Multiples in Retrospect*, p. 108. Oldenburg's *Geometric Mouse*, a 14 x 14 in. ink wash drawing on paper, was sold in 1972 for $2,000 by Sotheby, Parke-Bernet Galleries, Los Angeles; see Munsey, *Disneyana*, p. 322 (illus.). For the Mouse Museum, see Oldenburg, *The Mouse Museum, The Ray Gun Wing: Two Collections/Two Buildings* (1977) and Coosje Van Bruggen, *Claes Oldenburg: Mouse Museum/Ray Gun Wing* (1979).

21. Varnedoe and Gopnik, "Comics," in *High & Low*, p. 212.

22. For the various large-scale *Geometric Mouse* installations, see, among other references: Barbara Haskell, *Claes Oldenburg: Object Into Monument*, pp. 108-111, and Oldenburg, *Multiples in Retrospect*, p. 114.

23. Coosje Van Bruggen, "The Haunted House: Ghosting,"

in Oldenburg and Van Bruggen, *A Bottle of Notes and Some Voyages*, p. 193.

24. *Interview* in Martin Friedman and Claes Oldenburg, *Oldenburg: Six Themes*, p. 25.

25. Dave Hickey, "Andy's Enterprise: Nothing Special," in Bruce D. Kurtz, ed., *Haring, Warhol, Disney*, p. 88; Schickel, *The Disney Version*, p. 361. For more on Warhol, Mickey, and Disney: Crawford, *Attached to the Mouse*, pp. 97-98.

26. Susan Sontag, "Notes on 'Camp'," in Sontag, *Against Interpretation*, p. 291, n. 54.

27. For Warhol saying that Disney would draw him as a duck, see Trevor J. Fairbrother, "Warhol Meets Sargent," *Arts Magazine*, p. 70; for Warhol's "empire-building ambitions," see Bruce D. Kurtz, "Keith Haring, Andy Warhol, and Walt Disney," in Kurtz, *Haring, Warhol, Disney*, p. 14. As early as 1934, columnist Sidney Skolsky referred to Walt's operation as "his Mickey Mouse factory" (Skolsky, "The Gossipel Truth," *Chicago Tribune*, p. 20).

28. Kurtz, "Haring, Warhol, and Disney," p. 13 (quoting from Drenger, "Art and Life," p. 46).

29. Hickey, "Andy's Enterprise: Nothing Special," p. 91; Alan Cumming and Andy Warhol, *Andy Warhol: Men*, p. 5 (for the John Warhola citation).

30. Culhane, "A Mouse for All Seasons," p. 50.

31. For Birza, see: Jonathan Turner, "Changing Colors (The Netherlands)," *Art in America*, p. 83.

32. Foulkes voiced his hostility to consumerism in an interview in 1997, as part of an oral history project for the Smithsonian Institution; see Archives of American Art, online at: www.aaa.si.edu/collections/oralhistories/transcripts/foulke97.htm.

33. Keith Roberts, "Current and Forthcoming Exhibitions," *Burlington Magazine*, p. 690 (on Sandle); Richard Morrison, "War Insights," *London Times*, p. 21 (John Keane).

34. Updike, "The Mystery of Mickey Mouse," p. 236 (in *A Mickey Mouse Reader*).

35. Kurtz, "Haring, Warhol, and Disney," p. 7 (Warhol and Disney, Haring's heroes); Barry Blinderman, "Keith Haring's Subterranean Signatures," *Arts Magazine*, p. 185.

36. Archives of American Art, Smithsonian Institution (Foulkes interview), for his relationship with Ward Kimball; Marilu Knode, *Llyn Foulkes*, pp. 62-65 (for Foulkes's paintings); Michael Duncan, "Better Mouse Trap," *Art in America*, pp. 84-85 ("national soullessness").

37. Archives of American Art (Foulkes interview).

38. Idem., and Duncan, "Better Mouse Trap," p. 86.

39. On Pensato, see: Barry Schwabsky, "Joyce Pensato," *Artforum*, p. 100; Crawford, *Attached to the Mouse*, pp. 12-13, 41-42, 162-163; for Oppenheim: "Disney v. Oppenheim," *Art in America*, p. 25; Robin Cembalest, "The Mouse that Roared," *Art News*, p. 35; Crawford, *Attached to the Mouse*, pp. 2, 166.

40. See: www.personal.psu.edu/users/j/t/jtl157 (personal web page, accessed fall 2003).

41. *The Collection of the King of Pop / Michael Jackson / Memorabilia from the Life & Career of Michael Jackson*, session VII, cat. 5, p. 25 (no. 1114) and p. 46 (no. 1137); Yoe, *The Art of Mickey Mouse*, n.p. (Jackson's drawing appears about twenty pages into the book, which was published in 1991, but the drawing is signed and dated "1998," perhaps as a joking predictor of Mickey's future persona); Leigh Purves, Nadia Brooks, Amy Watts Michael, "Jacko: a Man or a Mouse?," *London Daily Star*, n.p.

42. See "Re/Righting History: Counternarratives in African-American Art," posted in March 1999 by the Katonah (N.Y.) Museum of Art, at the website of the non-profit Traditional Fine Arts Organization (www.tfaoi.com/newsm1/n1m131.htm). Another example of Mickey Mouse being used as an artistic emblem of racism is a work from 1988 in the collection of the di Rosa Preserve (Napa, Calif.) by the Mexican-born California artist (and art studio professor at Stanford), Enrique Chagoya, in which a colossal gloved hand is seen poised to knock a young Chicana "out of the picture" with a flick of the finger. The title of the drawing, *When Paradise Arrived*, implies that there is no room for her and "her kind" in the Disneyfied American Dream. See Stephanie Barron, et al., *Made in*

California: Art, Image, and Identity, 1900-2000, pp. 248, 249, 289.

43. Updike, "The Mystery of Mickey Mouse," p. 236 (*A Mickey Mouse Reader*).

44. Howard L. and Judith Rose Sacks, *Way Up North in Dixie*, p. 158. A "suggestive link between Disney's mouse and minstrel music" by Hans Nathan, in Nathan's book, *Dan Emmett and Rise of Early Negro Minstrelsy*, is the Sacks's pretext for their take on Mickey as the progeny of black-face minstrel performers.

45. "Is Mickey Mouse African American?" at the website *Africana* (Gateway to the Black World), (www.africana.com/research/blackfacts/bl_fact_199.asp); undated (accessed Nov. 23, 2003).

46. Dave Kehr, "Fishnets, Race and Religion," *New York Times*, p. E11 (on *Star Spangled to Death*); Updike, "The Mystery of Mickey Mouse," pp. 236-237 (*A Mickey Mouse Reader*); Arnold Rampersad, quoted in Michael Powell, "The American Wanderer, in All His Stripes," *New York Times*, p. WK1.

47. For Otto Künzli, see William Zimmer, "Swiss Artist's Symbol of America," *New York Times*, p. CN24; for Peter Saul's *I Paint Faster Than Jackson Pollock*, see the review of the Artcurial show "Mickey dans tous ses états" by Olivier Delcroix, "Mickey, l'ange et la bête," *Le Figaro* (online only: www.lefigaro.fr/culture/20060814.WWW000000278_mickey_l_ange_et_la_bete.html).

On Wayne Thiebaud and his images of Mickey and Goofy in his art, see: Yoe, *Art of Mickey Mouse*, n.p. (23rd illus. into the actual album); Michael Kimmelman, "A Little Weirdness Can Help an Artist," *New York Times*, pp. C1, C25; Kimmelman, "Art in Review," *New York Times*, p. C23; Steven A. Nash, Adam Gopnik, *Wayne Thiebaud*; Stephen Kinzer, "Wayne Thiebaud," p. F5; Regina Schrambling, "Wayne Thiebaud," *New York Times*, p. F1; Kimmelman, "Wayne Thiebaud," *New York Times*, pp. E2, E31.

48. The Knickerbocker stuffed toy Mickey in *How the West Was Won* appears in a second painting by the late Robert Anderson, *Startling Stories* (1999), from his eight-piece series, "Angels & Outlaws," in which a third painting, *Mickey & the Princess* (2002), features a different toy Mouse. The Knickerbocker Mickey was in Anderson's personal collection (email from the artist July 7, 2009). For an image of *How the West Was Won* see: fineartamerica.com/featured/how-the-west-was-won-robert-anderson.html.

9: EMBLEM OF THE AMERICAN SPIRIT

1. Robert Hughes, "A Farewell to the Future That Was," *Time*, pp. 52-53.

2. Scott E. Casper, "Going Dutch," on-line review of Edmund Morris's *Dutch: A Memoir of Ronald Reagan* ("first postmodern President"). Grossman's comment appears in a sidebar to Steven Heller's article "Drawn and Quartered" in *Mother Jones*, p. 37, where the drawing *Ronald Rodent* may have been first published, in 1996.

3. Updike, "The Mystery of Mickey Mouse," *Art & Antiques*, p. 236 (*A Mickey Mouse Reader*).

4. Jim Hoberman, "Kurtzman's Hysterical Materialism," in *Masters of American Comics*, p. 274 ("superbly scurrilous"); for a reprint of the "Mickey Rodent" parody, see: Grant and Geissman, *Mad About the Fifties*, n.p.; see also Maria Reidelbach, *Completely Mad*, p. 29. For the story behind Wally Wood's "Disneyland Memorial Orgy," and its aftermath, plus *Realist* publisher Paul Krassner's take on Disney and artistic censorship, see Krassner, *Who's to Say What's Obscene?* pp. 56-63. For more on the controversy spawned by Wood's drawing, see: "Disney Fetish," *Time*, p. 16; Bob Levin, *Pirates and the Mouse*, p. 79;, and "The Disneyland Memorial Orgy," Wikipedia.com.

5. For Roth and Rat Fink, see: Martin, "Edward Roth," p. B6, and "Ed 'Big Daddy' Roth Dies," p. B7. For Stanley Miller: Maria Alicia Gaura, "Sonoma Artist Claims 'Monsters, Inc.' a Rip-off: Suit Says Eyeball Character Mike Was Based on His Own Creation," *San Francisco Chronicle*, p. A15; Stanley Mouse [Stanley Miller], *Freehand*, p. 72.

6. James Michener, "Revolution in Middle-Class Values," *New York Times Magazine*, p. 87, and Michener, *America vs. America*, p. 30. It is also possible that Michener's association of Mickey with America's involvement in the war in Vietnam inspired the one-minute, 16 mm. non-Disney animation, *Mickey Mouse in Vietnam*, made around 1969 by Lee Savage and Milton Glaser, in which, as John Grant has noted, "cartoon Mickey is depicted as a US soldier who is ferried out to Vietnam. As soon as he gets there he is shot dead—and that is the end of the short." See Grant, *Encyclopedia of Walt Disney's Animated Characters*, p. 31, and Steven Heller, "A Push Pin Miscellany," in Seymour Chwast, ed., *The Push Pin Graphic: A Quarter Century of Innovative Design and Illustration*, p. 241.

7. David Kunzle, "Introduction," in Dorfman and Mattelart, *How To Read Donald Duck*, p. 10. The text was first published in Spanish as *Para leer al Pato Donald* (Valparaiso, Chile, 1971).

8. Dorfman and Mattelart, *How To Read Donald Duck*, pp. 95, 99.

9. Ibid., p. 91.

10. Schickel, letter to the editor, *Playboy*, p. 12; George Carlin on *Real Time with Bill Maher*, HBO, Sept. 9, 2005 (www.youtube.com/watch?v=VOWe4-KXqMM).

11. Michener, "Revolution in Middle-Class Values," p. 90, and Michener, *America vs. America*, pp. 49-50.

12. On Gustav Hasford's life and work, see: www.gustavhasford.com.

13. Hasford, *The Short-Timers*, pp. 24-25.

14. Ibid., pp. 59, 82, 127, 154, and Michael Herr, *Kubrick*, pp. 4, 14, 40 (for Herr, Hasford, and *Full Metal Jacket*). For Hasford's borrowed epigraph, see Herr, *Dispatches*, p. 229.

15. *Full Metal Jacket*, prod. Jan Harlan, dir. Stanley Kubrick, Warner Home Video, DVD.

16. *The Shining*, prod. and dir. Stanley Kubrick, Warner Home Video, DVD. Former Mouseketeer Doreen Tracey, who subsequently served as a technical advisor to Francis Ford Coppola's movie *Apocalypse Now*, shared her memory of the incident with the *New York Times*: I sang a Rolling Stone[s] song to the G.I.'s in Vietnam, and the guys in the audience sang back: "M-I-C . . . K-E-Y . . . M-O-U-S-E!" (Aljean Harmetz, "30 Mousekeeter Alumni in Reunion," *New York Times*, p. C25).

17. "Life On Mars" appeared on the album *Hunky Dory* (EMD/Virgin), released December 1971; "Steel and Glass," *Walls and Bridges* (Capitol B00004ZLBV), released Sept. 26, 1974; "Mickey Mouse Is Dead" appeared on the album *The Day the Country Died* (Buurg Records), released 1983. John Lennon was quite the Disney fan. His tune, "Do You Want to Know a Secret?" (1963), was inspired by a line from the wishing well scene in *Snow White*. On a BBC radio program (recorded June 1, 1963), after the host did an impersonation of actor James Mason, Lennon gleefully asked: "Can you do Mickey Mouse?" A decade later, while married to May Pang, the couple took John's son Julian to Disney World, where, at the Polynesian Village Hotel, on Dec. 29, 1974, Lennon, the last of the Beatles to do so, signed the document legally dissolving the group. For the radio show repartee, see: Walter Everett, *The Beatles as Musicians: The Quarry Men Through Rubber Soul*, p. 151; *The Beatles, Live At The BBC* (Capitol B000007MVD), disc 1, track 13, June 5, 2001; originally released Dec. 1, 1994; and, for the Disney World incident, Pang, *Instamatic Karma*, pp. 101, 131. For bringing all this information to my attention I am grateful to Albert J. Oneto III.

18. *Yellow Submarine*, prod. Al Brodax, dir. George Dunning, MGM/UA, DVD; *Up in Smoke*, prod., Lou Adler, dir., Lou Adler and Tommy Chong, Paramount, DVD; *The Meaning of Life*, prod. John Goldstone, dir. Terry Jones, Universal Studios Home Entertainment, DVD; *Apocalyse Now*, prod., Kim Aubry and Francis Ford Coppola, dir. Francis Ford Coppola, Paramount, DVD .

19. For the "Mickey Mouse" Mozart production, see Anna Kisselgoff, "More of Mozart, With Minnie and Mickey," *New York Times*, p. 11. It must also be said that during Michael Eisner's tenure as Disney CEO from 1984 to 2005, as he dramatically grew the company via aggressive marketing, setting up shop on Broadway, scooping up other studios, production firms, and the ABC and ESPN television networks, hostility to Disney intensified. Mickey almost always embodied that elevated corporate profile, as illustrated by Bob Grossman's *Newsweek* cover from 1994 [289]. In the 1990s the Mouse also became the symbol of a controversial extension of intellectual and artistic copyright protection, from the life of the author plus fifty years to life plus seventy. In 1998 by President Bill Clinton signed into law a bill sponsored by Republican Congressman Sonny Bono, formerly of the Sonny and Cher pop duo—despite opposition from the *New York Times* and other critics (see, for example, Gary Clement's illustration titled "One Day in THE PUBLIC DOMAIN," for Steve Zeitlin's *Times* article "Strangling Culture With a Copyright Law," p. A15).

20. Vonnegut's remarks appeared on the internet website *In These Times*, Mar. 6, 2003 (at inthesetimes.com, and Vonnegut's own site, www.vonnegut.com/times1.asp).

21. For another instance of the expression *petits miquets*, see the title of the book by Yves Frémion, *Les Nouveaux Petits-miquets* (Paris, 1982). For "les Clubs Mickey," see Bernard Gresser, "Le sport sur la plage. Une facette de l'identité institutionnelle: la naissance des clubs 'Mickey'," in Serge Fauché, et al., *Sport et identités*, pp. 247-256. For Goofy as the mascot for the French Olympic tennis team: John Grant, *Encyclopedia of Walt Disney's Animated Characters*, p. 50. In an email (Aug. 23, 2010), Dave Smith wrote that "We only know Walt smoked Gitanes in his later years" ("Disney Archivist Dave Smith!" *All Ears*, online interview).

22. Brown, *Angels & Demons*, p. 114.

23. Brown, *The Da Vinci Code*, pp. 261-262.

24. Henninger, "Wonder Land: Holy Sepulcre! 60 Million Buy 'The Da Vinci Code'," *Wall Street Journal*, p. A10.

25. Alan Jolis, "Matisse, Picasso, Disney, and Paloma," *Art News*, p. 122; Charles R. Cross, *Heavier Than Heaven: a Biography of Kurt Cobain*, pp. 11-12, 17. The expression "cultural unconscious" was apparently coined by the French-born child psychologist and marketing consultant, Dr. Clotaire Rapaille; see Jack Hitt, "Does the Smell of Coffee Brewing Remind You of Your Mother?" *New York Times Magazine*, p. 73.

26. Mary Martin Niepold, "Mickey Is the Newest Hook Look," *Philadelphia Inquirer*, p. L1; Nina Hyde, "M-I-C-K-E-Y—Why? Because We Like Him," *Washington Post*, p. H3; Crane, "Mickey & Co.," press release; Beverly Gilmore, "Mickey Mouse Goes to College," Mickey Mouse Goes to College," *Staten Island Advance*, p. B1. I am grateful to Kathy Chow for the insights and materials she shared with me with respect to her former colleague, Max Raab, and the launching of Mickey & Co.

27. See: Smith, *Disney A to Z* (2006), p. 181, Jesse Hiestand, "Forever Young: Mickey Turns 75," *Hollywood Reporter*, p. 4 ("522 Disney Store outlets …"), and "Disney Store" at Wikipedia. At one point there were twenty-four Disney stores in France, however, in July 2009 it was announced that the number would be reduced to just four; see Mathilde Visseyrias, "Disney prêt à fermer neuf magasins en France," *Le Figaro*, p. 27.

28. Verrier, "M-I-C-K-E-Y: He's the Leader of the Brand," *Los Angeles Times*, p. A1 (and pp. 304-305, 307, in Apgar, *A Mickey Mouse Reader*, where the entire article is reprinted).

29. Regarding retro Mickey T-shirts, Aniston, and Lavigne, see Verrier, "M-I-C-K-E-Y," p. A1 (and *A Mickey Mouse Reader*, p. 307). For Kravitz in a Mickey tee: Frank Ahrens, "Disney Presents Mickey Mouse, Again: Media Giant Pushes to Make Cartoon Rodent Hip," *Washington Post*, p. E1 (and p. 309 in *A Mickey Mouse Reader*, where the article is reprinted).

30. For the Glendale celebration, and Michael Eisner, see Ahrens, "Disney Presents Mickey Mouse," p. E1 (and *A Mickey Mouse Reader*, p. 308); for Drew Carey as emcee, see Hiestand, "Forever Young," p. 4.

31. Joe Adamson, *Bugs Bunny: Fifty Years and Only One Grey Hare*, pp. 12, 15; Smith, *Disney A to Z* (2006), p. 443; *Mickey's Christmas Carol*, prod., Burny Mattinson, dir., Burny Mattinson, Walt Disney Studios Home Entertainment, DVD.

32. *Prince and the Pauper*, prod., Dan Rounds, dir., George Scribner, Walt Disney Home Video, DVD.

33. "Mickey Mouse," *200 Greatest Pop Culture Icons*, p. 104; "100 Icons of the Century," *Variety*, p. 23.

34. Verrier, "M-I-C-K-E-Y: He's the Leader of the Brand," p. A1 (stamps, "MouseWorks"), Ahrens, "Disney Presents Mickey Mouse," p. E1 (Disney stamps), and *A Mickey Mouse Reader*, pp. 304, 306, and 310, respectively.

35. Jefferson acquired the bust of Voltaire and a humorous print of Voltaire in bed, chatting with visitors, while serving as American envoy to the French court, 1784-1789; see: Susan R. Stein, *Worlds of Thomas Jefferson*, pp. 177, 217, and *Voltaire and Jefferson*, prod. Dennis Powers, Patrick Ryan, Voltaire Society of America/Films For the Humanities and Sciences, 2001. On Voltaire's iconic visual persona over the centuries, see G. Apgar, "'Sage comme une image': trois siècles d'iconographie voltairienne," *Nouvelles de l'estampe*, pp. 4-44 (for the print owned by Jefferson: p. 40, n. 28).

36. Boorstin, *The Image*, pp. 57, 60.

37. Ibid., pp. 48, 61.

38. Schneider, *That's All Folks!*, p. 172.

39. Updike, "The Mystery of Mickey Mouse" (*A Mickey Mouse Reader*, p. 235).

40. Neal Gabler, "Obama: Star of His Own Movie," *Los Angeles Times*, p. A19; Barrier, *Hollywood Cartoons*, p. 183.

41. Gabler, "Obama: Star of His Own Movie," p. A19; Robert Sklar, "The Making of Cultural Myths: Walt Disney and Frank Capra," *Boston Globe*, p. 200.

42. Brockway, "The Masks of Mickey Mouse," *Journal of Popular Culture*, p. 32; the quote ("most primitive, archaic level of the human mind"), mistakenly attributed by Brockway to another scholar, Edward Whitmont, is, in fact, from Harold Schechter, *The New Gods: Psyche and Symbol in Popular Art*, p. 62.

43. Hiaasen, *Team Rodent: How Disney Devours the World*, p. 12.

44. For the Spike Lee quote, see Agence France-Presse, "Hollywood, Not Nukes, Gives US Dominance: Lee," ABC News, Aug. 18, 2008. In February 2004, a student at the Edinburgh College of Art raised Mickey to new negative metaphorical heights and in so doing, unsurprisingly, caused a row when he exhibited a "soft sculpture" called *Mickey's Taliban Adventures*, which represented the Mouse "flying an airplane toward flaming, crying World Trade Center towers" (Associated Press, "Scottish Art Student Depicts Mickey Mouse Flying Toward Flaming World Trade Center," Feb. 20, 2004).

45. Hutchinson, "Mickey's Mockers 'Pure Evil': Disney's Daughter Rips Hamas Over Toon Terror," *New York Daily News*, p. 3 (repr. in Apgar, *A Mickey Mouse Reader*, pp. 348-349); and, for Tom Dooley: Grant, *Encyclopedia of Walt Disney's Animated Characters*, p. 31, and Culhane, "A Mouse for All Seasons," p. 50.

46. Eisner, "It's a Small World After All," *New Perspectives Quarterly*, pp. 40, 42. Eisner's article was based on a conversation with Nathan Gardels, editor of *New Perspectives Quarterly*. The same article, slightly reformatted, was reprinted as "Planetized Entertainment" in both *New Perspectives Quarterly* (fall 1995) and in a book edited by Gardels, *The Changing Global Order* (1997).

47. "Peter," "Rostropovich Redux," *Semisimple*, Apr. 17, 2006 (formerly: feed://www.blogger.com/feeds/3014257/posts/default? start-index=26&max-results=25).

48. Bart Barnes, "Charismatic Conductor Brought Prestige to National Symphony, *Washington Post*, p. A9.

49. Benz, "Noted With Wonder," *Washington Post*, p. F2. The article was published more than two years after the author's sojourn in Havana; I am grateful to Mr. Benz for providing the date of the visit (by email, March 26, 2008).

50. Hughes, "Philip Pearlstein," *Nothing If Not Critical*, p. 288 (first published as "A Roomful of Naked Strangers" in *Time*, Aug. 22, 1983, p. 62).

51. Kimmelman, "Real Flesh, Not Perfect or Prurient," *New York Times*, pp. E33, E41.

52. Updike, "The Mystery of Mickey Mouse" (*A Mickey

Mouse Reader, p. 235).

53. For a news story on *Epic Mickey*, see Alex Pham and Dawn C. Chmielewski, "Edgier Side of Mickey: Disney Tweaks Its Signature Rodent in an Ambitious New Video Game," *Los Angeles Times*, pp. D1, D20.
54. Fineman, "The Most Famous Farm Couple in the World," *Slate*, June 8, 2005 (slate.msn.com/id/2120494).
55. Schickel, *The Disney Version*, pp. 360-361; Neal Gabler cited Disney as a person who could "help us understand America itself," during a panel discussion, Apr. 28, 2007, at the Los Angeles Times Book Festival. The event was broadcast on C-SPAN 2 ("Book TV") and can be viewed on YouTube (www.youtube.com/watch?v=SRbVXtma9il).
56. Adams, *The Epic of America*, pp. vii-viii.
57. Jack Hitt, "Does the Smell of Coffee Brewing Remind You of Your Mother?" *New York Times Magazine*, p. 74 (Rapaille); Lord, "An American in Washington," *The American Spectator Online*.
58. Cullen, *The American Dream: A Short History of an Idea that Shaped a Nation*, pp. 5, 7; Hopper delivered his line in a 30-second Ameriprise TV commercial, "American Dream," which ran from approximately the fall of 2007 into 2008 (formerly: www.ameriprise.com/amp/global/about-ameriprise/commercials.asp).
59. Burke, *The Works of Edmund Burke*, vol. 2, pp. 32, 48; "Honest Questions with Jeff Foxworthy," *Glenn Beck show*, CNN, Mar. 21, 2008 (edition.cnn.com/TRANSCRIPTS/0803/21/gb.01.html).
60. Charles A. and Mary R. Beard, *The American Spirit, a Study of the Idea of Civilization in the United States*, p. v; Feild, *The Art of Walt Disney*, p. 283 (for Disney on "culture"); Danto, "Of Time and the Artist," *New York Times Magazine* ("Book Review"), p. 32.
61. Danto, "Freckles for the Ages," *New York Times*, p. 12.
62. Kimmelman, "Renaissance for a 'Lightweight'," *New York Times*, p. AR2.
63. Joel S. Sugarman and Judith H. Richter, letter to the editor, and David Hockney, letter to the editor, both in the *New York Times*, p. AR2.
64. Biel, *American Gothic*, p. 168; Updike, "How to Love America," *New Yorker*, p. 25 ("America is a vast conspiracy to make you happy.").
65. Hillier, "Introduction" to *Disney's Mickey Mouse Memorabilia*, p. 18.
66. Bradbury, "Walt Disney, the Man Who Invented a Better Mouse," *Los Angeles Times*, p. U3; Forster, "Happy Ending," *New Statesman*, p. 442 (wherein Forster described a poignant visit at the start of World War II to the front gate of Voltaire's château, closed at the time to the public); Buckley, untitled, in Solomon, et al., "America Celebrates Mickey's 60th Birthday," *People Weekly*, p. 6 ("best pleasures are innocent").
67. Crowther, "Dream Merchant," *New York Times*, p. 40.

BIBLIOGRAPHY

WALT DISNEY: PRINCIPAL REFERENCES AND RESOURCES

The Adventures of Oswald the Lucky Rabbit. Produced by Charles Mintz. Directed by Walt Disney. 3 hr. 54 min., Walt Disney Video, 2007, DVD ("Walt Disney Treasures"), 2-disc set.

Alexander, Jack. "The Amazing Story of Walt Disney." *Saturday Evening Post*, Oct. 31, 1953, pp. 4-25, 80, 84-86, 90, 92; Nov. 7, 1953, 26-27, 99-100.

Alice in Wonderland: 60th Anniversary Edition. Produced by Walt Disney. Directed by Clyde Geronimi, Wilfred Jackson, Hamilton Luske and Walt Disney, inter al. 1 hr. 15 min. (feature film only), Walt Disney Video, 2011, DVD, 2-disc set.

Alice in Wonderland: The Masterpiece Edition. Produced by Walt Disney. Directed by Bill Justice, Charles A. Nichols, Clyde Geronimi, Dick Rickard, Hamilton Luske and Walt Disney, inter al. 3 hr. 30 min., Walt Disney Video, 2004, DVD, 2-disc set.

Alice in Wonderland: Special Un-Anniversary Edition. Produced by Walt Disney. Directed by Clyde Geronimi, Wilfred Jackson, Hamilton Luske and Walt Disney, inter al. 3 hr. 4 min., Walt Disney Video, 2010, DVD, 2-disc set.

Allan, Robin. "Walt Disney and Europe." *Visual Resources: An International Journal of Documentation*, vol. 14, no. 3, January 1999, pp. 275-295.
———. *Walt Disney and Europe: European Influences on the Animated Feature Films of Walt Disney* (London and Bloomington, Ind., 1999).

Barrier, Michael. *The Animated Man: A Life of Walt Disney* (Los Angeles and London, 2007).
———. *Building a Better Mouse: Fifty Years of Animation*. Exhibition catalogue, Library of Congress, Washington, D.C., Nov. 21, 1978—Jan. 30, 1979 (Washington, D.C., 1978).
———. "Building a Better Mouse: Fifty Years of Animation." *Funnyworld: The World of Film Animation and Comic Art*, no. 20, summer 1979, pp. 6-22.
———, Milton Gray, and Bill Spicer. "An Interview with Carl Stalling." *Funnyworld: The World of Film Animation and Comic Art*, no. 13, spring 1971, pp. 21-27; repr. in Goldmark, et al., *The Cartoon Music Book* (Chicago, 2002), pp. 37-60.

Baxter, John. *Disney During World War II: How the Walt Disney Studio Contributed to Victory in the War* (New York, 2014).

Bessy, Maurice. *Walt Disney* (Paris, 1970).

Boré-Verrier, Nicole. See Jean Laury

Braggiotti, Mary. "Mickey Mouse's Dearest Friend." *New York Post*, June 30, 1944, p. 17.

Bradbury, Ray. "Walt Disney, the Man Who Invented a Better Mouse." *Los Angeles Times*, Nov. 14, 1976, p. U3 (review of *Walt Disney: An American Original*, by Bob Thomas).

Buckley Jr., William F. Untitled commentary on Walt Disney World, in Solomon, et al., "America Celebrates Mickey's 60th Birthday." Special advertising section, *People Weekly*, Nov. 7, 1988, n.p. (sixth of a 32-page insert).

Brian Burnes, Robert W. Butler, and Dan Viets, Dan. *Walt Disney's Missouri: The Roots of a Creative Genius* (Kansas City, Mo., 2002).

Canemaker, John. *Before the Animation Begins: The Art and Lives of Disney Inspirational Sketch Artists* (New York, 1996).
———. *Treasures of Disney Animation Art* (New York, 1992).
———. *Walt Disney's Nine Old Men and the Art of Animation* (New York, 2001).

Charlot, Jean. "But Is It Art? A Disney Disquisition." *American Scholar*, summer 1939, pp. 261-271.

Churchill, Douglas W. "Disney's Philosophy: His Creatures of the Screen, He Says, Are Simply Laughing at Our Human Weaknesses." *New York Times Magazine*, Mar. 6, 1938, pp. 9, 23.
———. "Walt Disney Sighs for More Whirls." *New York Times*, Jan. 9, 1938, p. X5.

Cline, Rebecca. "The Adventure of a Lifetime." *Disney twenty-three*, spring 2011, pp. 30-35.

Cohen, Harold W. "An Appreciation of the Disney Works." *Pittsburgh Post-Gazette*, Nov. 15, 1930, p. 13.

Crawford, Holly. *Attached to the Mouse: Disney and Contemporary Art* (Lanham, Md., 2006).
———. "Disney and Pop Art." In Girveau, et al., *Once Upon a Time Walt Disney* (Munich, 2007), pp. 252-264.

Crowther, Bosley. "The Dream Merchant." *New York Times*, Dec. 16, 1966, p. 40.

Culhane, John. "The Old Disney Magic." *New York Times Magazine*, Aug. 1, 1976, pp. 10-11, 32-34, 36.
———. *Walt Disney's Fantasia* (New York, 1983).

Davidson, Bill. "The Fantastic Walt Disney." *Saturday Evening Post*, Nov. 7, 1964, pp. 10-11, 66-74.

Disney, Edna and Roy. "Europe Trip—1935," 1-15; typed transcript of hand-written journal, recorded primarily by Edna (copies at the Walt Disney Archives, Burbank, and the Walt Disney Family Museum, San Francisco).

Disney, Edward. *A Story of Disney: Some Myths Exploded* (Bristol, England, 1997).

Disney, Elias. "Biography of the Disney Family in Canada." Unidentified Huron County, Ontario, newspaper, 1957; repr. by Leon C. Cantelon, a cousin on Walt's paternal grandmother's side, from a copy provided by Walt; according to Bob Thomas, Elias wrote the essay in 1939; see Thomas, *Building a Company* (New York, 1988), p. 8. The text was reproduced online by Michael Barrier, Sept. 23, 2008, www.michaelbarrier.com/Essays/Elias%20Disney/DisneyFamilyInCanada.html.

Disney, Lillian, and Isabella Taves. "I Live With a Genius—A Conversation With Mrs. Walt Disney." *McCall's*, Feb. 1953, pp. 38-40, 103-104, 106-107; excerpt repr. in Apgar, *Mickey Mouse Reader*, pp. 178-180.

Disney, Roy O. "Unforgettable Walt Disney." *Reader's Digest*, February 1969, pp. 212-218.

Disney, Walt. "Growing Pains." *Journal of the Society of Motion Picture Engineers*, vol. 36, no. 1, January 1941, pp. 30-40; repr. as "Growing Pains," in *American Cinematographer*, March 1941, pp. 106-107, 139-142.
———. "Inter-Office Communication." [Guidelines for training animators; addressed to Donald Graham.] Dec. 23, 1935, 8-page memo, unpaginated, typed and unsigned; collection of Michael Sporn, Michael Sporn Animation, Inc., New York, posted online July 20, 2005, www.michaelspornanimation.com/splog.
———. "The Marceline I Knew." *Marceline* (Mo.) *News*, Sept. 2, 1938, p. 1; repr. as "Walt Disney Recalls Some Pleasant Childhood Memories." *Marceline News*, Oct. 13, 1960, n.p. [section 3, 18th page].
———. "'Mickey Mouse': How He Was Born." *Windsor Magazine*, October 1931, pp. 641-645; repr. in Apgar, *A Mickey Mouse Reader*, pp. 37-42.
———. "Our American Culture." Radio speech transcript, Mar. 1, 1942. The Walt Disney Archives, Burbank.

"Disney Archivist Dave Smith!" *All Ears*, Apr. 8, 2003, no. 185 (online only).

"Disney Museumized." *Art Digest*, Dec. 15, 1940, p. 11.

Disney Rarities: Celebrated Shorts: 1920s-1960s. Produced by Walt Disney. Directed by Walt Disney, Clyde Geronimi, David Hand, Hamilton Luske, Robert Florey, Wilfred Jackson. 5 hr. 26 min., Walt Disney Video, 2005, DVD ("Walt Disney Treasures"), 2-disc set.

Disneyland USA ("Walt Disney Treasures"), Disney DVD, 2001.

Doherty, Thomas. "The Wonderful World of Disney Studies." *The Chronicle Review*, July 21, 2006, vol. 52, no. 46, p. B10.

Dorfman, Ariel, and Armand Mattelart. *How To Read Donald Duck: Imperialist Ideology in the Disney Comic*. Intro. and trans. by David Kunzle (New York, 1975; originally published in Spanish as *Para leer al Pato Donald*, Valparaiso, Chile, 1971).

Eliot, Marc. *Walt Disney: Hollywood's Dark Prince* (New York, 1993).

Epstein, Edward J. "Walt Disney: the Genius of the New System (1901-1966)." In Epstein, *The Big Picture* (New York, 2005), p. 29-35.

Fanning, Jim. *The Disney Poster Book: The Animated Film Classics From Mickey Mouse to Aladdin* (New York, 1993).

Feild, Robert D. *The Art of Walt Disney* (New York and London, 1942; London, 1944).

Finch, Christopher. *The Art of Walt Disney: From Mickey Mouse to the Magic Kingdoms* (New York, 1973; 1st rev. ed., 1995; 2nd rev. ed., London and New York, 2004).

——. "Disney, Walt(er Elias)." In *The Dictionary of Art* (London, 1996), vol. 9, pp. 10-11.

——. *Walt Disney's America* (New York, 1978).

Fishwick, Marshall. "Aesop in Hollywood: The Man and the Mouse." *Saturday Review*, July 10, 1954, pp. 7-9, 38-40.

Gabler, Neal. *Walt Disney: The Triumph of the American Imagination* (New York, 2006).

——. "Walt: Man or Mouse?" *London Sunday Telegraph*, Jan. 14, 2007, in the Sunday arts magazine, *Seven*, pp. 6-9.

Gartley, Lynn. See Elizabeth Leebron and Lynn Gartley

"Le Gala Mickey-Mouse . . ." (five-piece photo spread). *Le Figaro*, June 28, 1935, p. 6.

Ghez, Didier. *Disney's Grand Tour: Walt and Roy's European Vacation Summer 1935* (Orlando, Fla.: 2013).

——, ed. *Walt's People: Talking Disney with the Artists Who Knew Him*, 15 vols., ongoing (Philadelphia, 2005-2013; Orlando, Fla., 2013-).

Girveau, Bruno, et al. *Il était une fois Walt Disney: Aux sources de l'art des studios Disney*. Exhibition catalogue: Galeries Nationales du Grand Palais, Paris, Sept. 16, 2006—Jan. 18, 2007 (Paris, 2006); for the English- and German-language editions, see the entries immediately following.

——. *Once Upon a Time Walt Disney: The Sources of Inspiration for the Disney Studios*. Exhibition catalogue: Musée des Beaux-Arts, Montreal, Mar. 8, 2007—June 24, 2007 (Munich, Berlin, London and New York, 2007).

——. *Walt Disneys wunderbare Welt und ihre Wurzeln in der europäischen Kunst*. Exhibition catalogue: Kunsthalle der Hypo-Kulturstiftung, Sept. 19, 2008—Jan. 25, 2009 (Munich, 2008).

G. M. K. [probably Grace M. Keeffe]. "Personalities—Here and There" (column). *Psychology: Health, Happiness, Success* (New York), November 1933, pp. 24-25.

Grafly, Dorothy [unsigned]. "An Artist of Our Time: Walter E. Disney, 1901—." *Philadelphia Public Ledger*, Oct. 23, 1932, p. 12; repr. in Apgar, *Mickey Mouse Reader*, pp. 358-60.

—— [unsigned]. "Disney Has Debut In Art Circles: His Cartoons Given First Recognition by Art Body." *Philadelphia Public Ledger*, Oct. 23, 1932, p. 12.

Grant, Jack. "He's Mickey Mouse's Voice and Master." *Movie Classic*, November 1933, pp. 30, 75-76, 80.

Grant, John. *Encyclopedia of Walt Disney's Animated Characters* (New York, 1987).

Green, Amy Boothe, and Howard E. Green. *Remembering Walt: Favorite Memories of Walt Disney* (New York, 1999).

Griffin, Sean. *Tinker Belles and Evil Queens: The Walt Disney Company from the Inside Out* (New York, 2000).

The Hand Behind the Mouse: The Ub Iwerks Story. Produced and directed by Leslie Iwerks. 1 hr. 30 min., Walt Disney Video, 2001, VHS; also, as bonus material, on disc two of *The Adventures of Oswald the Lucky Rabbit*, 2007, DVD.

Hanhardt, John G. "Disney Animations and Animators." 6-page program for the Disney exhibition at the Whitney Musem of American Art, June 24—Sept. 6, 1981, unpaginated.

Hayes, R. M. *A Walt Disney Filmography, 1937-1972* (Jefferson, N.C., 2000).

Heide, Robert, and John Gilman. *Disneyana: Classic Collectibles 1928-1958* (New York, 1995; New York, 2002, softcover).

Hiaasen, Carl. *Team Rodent: How Disney Devours the World* (New York, 1998).

Holliss, Richard, and Brian Sibley. *The Disney Studio Story* (New York and London, 1988).

"Hollywood's Dizzy Ways Haven't Harmed Disney; Except for His Clothes, He Remains Quiet and Unassuming, Still Has Same Wife and Only Recently Acquired Six-Room Home and Expanded Studios." *Hartford Courant*, May 18, 1941, p. A8.

Hughes, Robert. "Disney: Mousebrow to Highbrow." *Time*, Oct. 15, 1973, pp. 88-91.

Iwerks, Leslie, and John Kenworthy. *The Hand Behind the Mouse: An Intimate Biography of the Man Walt Disney Called "The Greatest Animator in the World"* (New York, 2001).

Il était une fois Walt Disney: Aux sources de l'art des Studios Disney. Produced by Agathe Berman. Directed by Samuel Doux. 1 hr. 50 min., RMN/Walt Disney Company/Films d'Ici/Arte France, 2006, DVD.

Jackson, Kathy Merlock. *Walt Disney: A Bio-Bibliography* (Westport, Conn., 1993).

——, ed. *Walt Disney: Conversations* (Jackson, Miss., 2006).

Jamison, Jack. "He Gave Us Mickey." *Liberty*, Jan. 14, 1933, pp. 52-54; repr. in Apgar, *Mickey Mouse Reader*, pp. 61-65.

Johnston, Ollie. See Frank Thomas and Ollie Johnston.

Kaufman, J. B. See Russell Merritt and J. B. Kaufman

Kimball, Ward. "The Wonderful World of Walt Disney." In Walter Wagner, ed., *You Must Remember This* (New York, 1975), pp. 264-282.

Korkis, Jim. "History of the Partners Statue: Part One," Oct. 26, 2011, and "Part Two," Nov. 2, 2011 (www.mouseplanet.com/9766/The_History_of_the_Partners_Statue_Part_One) and (www.mouseplanet.com/9773/The_History_of_the_Partners_Statue_Part_Two)

—— [under the pen name "Wade Sampson"]. "The Myth of Mickey Rooney & Mickey Mouse." May 26, 2004 (www.jimhillmedia.com/main/index.htm).

——, with foreword by Diane Disney Miller. *The Revised Vault of Walt: Includes Five New Unofficial, Unauthorized, Uncensored Disney Stories Never Told* (Orlando, Fla., 2012).

——, with foreword by Diane Disney Miller. *The Vault of Walt: Unofficial, Unauthorized, Uncensored Disney Stories Never Told* (Lexington, Ky., 2010).

——, with foreword by Floyd Norman. *Who's Afraid of The Song of the South?* (Orlando, Fla., 2012).

Kozlenko, William. "The Animated Cartoon and Walt Disney." *New Theatre*, August 1936, pp. 16-18, 27; repr. in Lewis Jacobs, ed., *The Emergence of Film Art: The Evolution and Development of the Motion Picture as an Art, From 1900 to the Present* (New York, 1969; 2nd ed., New York, London and Toronto, 1969), pp. 246-253.

Krause, Martin, and Linda Witkowski. *Walt Disney's Snow White and the Seven Dwarfs: An Art in Its Making* (New York, 1994).

Kurtz, Bruce D., ed. *Haring, Warhol, Disney* (Munich, 1992).

——. "Keith Haring, Andy Warhol, and Walt Disney." In Kurtz, ed., *Haring, Warhol, Disney* (1992), pp. 13-22.

La Farge, Christopher. "Walt Disney and the Art Form." *Theatre Arts*, September 1941, pp. 673-680.

Lambert, Pierre. "Biographies." In Girveau, et al., *Once Upon a Time Walt Disney* (Munich, 2007), pp. 294-315.

Laury, Jean (Nicole Boré-Verrier). "Le Cinéma." *Le Figaro*, June 28, 1935, p. 8.

——. "Mickey Mouse au Gaumont Palace," *Le Figaro*, June 28, 1935, p. 1; repr. in Apgar, *Mickey Mouse Reader*, p. 364, and in translation as "Mickey Mouse at the Gaumont-Palace," pp. 126-127.

——. "Mickey-Mouse et les Silly Symphonies," *Le Figaro*, June 23, 1935, p. 8.

——. "La Vie Aventureuse de Walt Disney," *Le Figaro*, June 23, 1935, p. 8.

Leebron, Elizabeth, and Lynn Gartley. *Walt Disney: A Guide to References and Resources* (Boston, 1979).

Lesjak, David. *In the Service of the Red Cross: Walt Disney's Early Adventures 1918-1919* (forthcoming: Orlando, Fla., 2015).

——. *Service with Character: The Disney Studios and World War II* (Orlando, Fla., 2014).

Levin, Bob. *The Pirates and the Mouse: Disney's War Against the Counterculture* (Seattle, 2003).

Low, David. "Leonardo da Disney." *New Republic*, Jan. 5, 1942, pp. 16-18.

Mandry, Michel, and Carlo Marcello. "Et tout a commencé par une souris! . . ." ("quatrième partie"). *Le Journal de Mickey*, no. 1391, May 1979, pp. 26-27. This was the last installment in a four-part comic-book style series that ran in consecutive issues (nos. 1388-1391) of *Le Journal de Mickey* from February through May 1979 (the same fourth installment was reprinted in *Journal de Mickey* album n° 83).

Maltin, Leonard. *The Disney Films* (New York, 1973; 2nd ed., 1984; 3rd ed., 1995, 4th ed., 2000).

——. "Making Drawings Move." Review of *Disney Animation: The Illusion of Life* by Frank Thomas and Ollie Johnston). *New York Times Book Review*, Nov. 29, 1981, pp. 11, 37.

Marcello, Carlo. See Michel Mandry and Carlo Marcello

Martin, Pete, and Diane Disney Miller. "My Dad, Walt Disney," a series of eight articles published in 1956-1957 as "By Diane Disney Miller as told to Pete Miller" in the *Saturday Evening Post*:
"My Dad, Walt Disney," Nov. 17, 1956, pp. 25-27, 130, 132-134.
"Hard Times in Kansas City," Nov. 24, 1956, pp. 26-27, 75, 78.
"The Coming of the Mouse," Dec. 1, 1956, pp. 28-29, 67 70-71, 75.
"When the Animals Began to Talk," Dec. 8, 1956, pp. 38-39, 79-80, 82, 85.
"Suddenly He Was a Genius," Dec. 15, 1956, pp. 36-37, 97-98, 100.
"Disney's Folly," Dec. 22, 1956, pp. 24, 80-82.
"Mickey Mouse Becomes a Secret Weapon," Dec. 29, 1956, p. 24. 73-75.
"Small Boy's Dream Come True," Jan. 5, 1957, pp. 24, 80-82.

——. *The Story of Walt Disney* (New York, 1957); also credited as written by "Diane Disney Miller as told to Pete Martin." Published in paperback as *The Story of Walt Disney: A Fabulous Rags-to-Riches Saga* (New York, 1959); repr. with that title by Disney Editions (New York, 2005), with endnotes by Dave Smith, correcting minor editorial errors in the original text.

——. *Walt Disney: An Intimate Biography by His Daughter Diane Disney Miller as Told to Pete Martin* (London, 1958); British edition of *The Story of Walt Disney*. The French edition, *L'Histoire de Walt Disney*, was published in Paris in 1960.

Martin, Quinn. "How Animated Cartoons Are Made: Art and Science, in Complicated Studio Teamwork, Draw and Photograph 7,000 Movie-Talkie Musical Figures in Three Weeks for 600-Foot Reel of Silly Symphonies." *New York World*, Sept. 28, 1930, *Sunday World* Magazine color gravure feature section, pp. 8-9, 14.

Mattelart, Armand. See Ariel Dorfman and Armand Mattelart

McBride, Henry. "Walt Disney, the Artist." *New York Sun*, May 6, 1933; repr. in McBride (Daniel Catton Rich, ed.), *The Flow of Art: Essays and Criticisms* (New Haven, 1997), pp. 306-308.

McCord, David Frederick. "Is Walt Disney a Menace to Our Children?" *Photoplay*, April 1934, pp. 30-31, 92, 103.

McEvoy, J. P. "Walt Disney Goes to War." *This Week*, July 5, 1942, pp. 8-10. *This Week* was a Sunday magazine insert for newspapers.

McKinney, Roland J. [unsigned]. *Retrospective Exhibition of the Walt Disney Medium*. Exhibition catalogue: Los Angeles County Museum, Nov. 29, 1940—Dec. 30, 1940 (Racine, Wisc., Nov. 29, 1940), 22-page unpaginated booklet.

Meek, Clifton. "A Tribute to the Late Walt Disney." *Norwalk* (Conn.) *Hour*, Feb. 23, 1967, p. 23.

Merritt, Russell, and J. B. Kaufman. *Walt in Wonderland: The Silent Films of Walt Disney* (Baltimore, 1993).

——. *Walt Disney's Silly Symphonies: A Companion to the Classic Cartoon Series* (Gemona, Italy, 2006).

Millier, Arthur. "Walter in Wonderland." *Los Angeles Times Sunday Magazine*, Dec. 4, 1938, pp. 3, 14, 20-21.

——. "Masters of Mickey Mouse and Limp Team Up." *Los Angeles Times*, Apr. 7, 1946, pp. B1, B4.

Miller, Diane Disney. See Pete Martin and Diane Disney Miller

Mosley, Leonard. *Disney's World* (New York, 1985; London, 1986, as *The Real Walt Disney: A Biography*).

"Mouse & Man." *Time*, Dec. 27, 1937, pp. 19-21.

"The Mouse That Walt Built and That Built Walt." *Time*, Dec. 27, 1954, p. 45.

Munsey, Cecil. *Disneyana: Walt Disney Collectibles* (New York, 1974).

Neuman, Robert, ed. *Visual Resources: An International Journal of Documentation*, vol. 14, no. 3, January 1999 (special issue on Disney, "Art History Goes to the

Magic Kingdom").

Nugent, Frank S. "Disney Is Now Art—But He Wonders." *New York Times Magazine*, Feb. 26, 1939, pp. 4-5.

Pham, Alex, and Dawn C. Chmielewski, "An Edgier Side of Mickey: Disney Tweaks Its Signature Rodent in an Ambitious New Video Game." *Los Angeles Times*, Nov. 21, 2010, pp. D1, D20.

Pringle, Henry. "Mickey Mouse's Father." *McCall's*, August 1932, pp. 7, 28.

Rawls, Walton. *Disney Dons Dogtags: The Best of Disney Military Insignia From World War II* (New York, 1992).

Richard, Paul. "Under Walt's Spell: Disney Is No Mickey Mouse Figure in the World of Art." *Washington Post*, Jan. 11, 2009, pp. M6-M7.

RKO Pictures. "Biographical Sketch of Walt Disney." Circa spring 1937.

Rothstein, Edward. "Exploring the Man Behind the Animation." *New York Times*, Oct. 1, 2009, pp. C1, C5.

Seldes, Gilbert. "Disney and Others." *New Republic*, June 8, 1932, pp. 101-102; repr. in Jacobs, *Introduction to the Art of the Movies*, pp. 170-173.

——. "Mickey-Mouse Maker." *New Yorker*, Dec. 19, 1931, pp. 23-27; repr. in Apgar, *Mickey Mouse Reader*, pp. 43-50.

——. "No Art, Mr. Disney?" *Esquire*, September 1937, pp. 91, 171-172.

Schickel, Richard. *The Disney Version: The Life, Times, Art and Commerce of Walt Disney* (New York, 1968; 2nd, rev. ed., New York, 1985, with new 63-page "Epilogue: Disney Without Walt"; 3rd ed., Chicago, 1997); all editions follow the same pagination as the original text of the book.

——. "Walt Disney: Myth and Reality." *American Heritage*, April 1968, pp. 94-95 (sidebar within Schickel's piece, "Bringing Forth the Mouse").

Schroeder, Russell, ed., with introduction by Diane Disney Miller. *Walt Disney: His Life in Pictures* (New York, 1996; New York, 2009).

Shale, Richard. *Donald Duck Joins Up: The Walt Disney Company During World War II* (Ann Arbor, Mich., 1982).

Sherwood, Lydia E. "The Eternal Road Company." *Vogue*, June 15, 1937, pp. 40-41, 87.

Sibley, Brian. *See* Richard Holliss and Brian Sibley

"A Silver Anniversary for Walt and Mickey." *Life*, Nov. 2, 1953, pp. 82-90.

Sklar, Robert. "The Disney Magic: The Life and Work of Animation's Restless King Are Well Sketched in New Biography." *Boston Globe*, Nov. 12, 2006, p. D6.

Smith, David R. *Disney A to Z: The Official Encyclopedia* (New York, 1996; 2nd ed., 1998; 3rd ed., 2006).

——. "Disney Before Burbank: The Kingswell and Hyperion Studios." *Funnyworld: The World of Film Animation and Comic Art*, no. 20, summer 1979, pp. 32-38.

——. "Up to Date in Kansas City But Walt Disney Had Not Yet Gone as Far as He Could Go." *Funnyworld: The World of Film Animation and Comic Art*, no. 19, fall 1978, pp. 22-34.

—— and Steven B. Clark. *Disney: The First 100 Years* (New York, 1999).

Smoodin, Eric, ed. *Disney Discourse: Producing the Magic Kingdom* (New York and London, 1994).

Solomon, Charles. "Dali and Disney." In Girveau, et al., *Once Upon a Time Walt Disney* (Munich, 2007), pp. 238-249.

——. "A Surreal But True Match; Dali and Disney? It Really Happened, Though 'Destino's' Finish Comes Decades Later." *Los Angeles Times*, Nov. 5, 2003, pp. E1, E4 (Calendar section).

——. *The Disney That Never Was: The Stories and Art from Five Decades of Unproduced Animation* (New York, 1995).

Stajano, Francesco. "Disney Comics From Italy," *NAFS(k)uriren*, 1999, 46-48, www.cl.cam.ac.uk/~fms27/papers/1999-Stajano-disney.pdf, 64.233.169.104/search?q=cache:dvkvLwZz0fYJ:www.cl.cam.ac.uk/~fms27/papers/1999-Stajano-disney.pdf+%22francesco+De+Giacomo%22&hl=it&ct=clnk&cd=16&gl=it.

Susanin, Timothy S. *Walt Before Mickey: Disney's Early Years, 1919-1928* (Jackson, Miss., 2011; softcover edition, 2014).

Taylor, Frank J. "What Has Disney Got That We Haven't?" *The Commentator*, October 1938, pp. 12-18.

Thomas, Bob. *Building a Company: Roy O. Disney and the Creation of an Entertainment Empire* (New York, 1998).

——. *Disney's Art of Animation: From Mickey Mouse to Beauty and the Beast* (New York, 1991).

——. *Walt Disney: An American Original* (New York, 1976).

Thomas, Frank, and Ollie Johnston. *Disney Animation: The Illusion of Life* (New York, 1981).

Thurber, James. "The 'Odyssey' of Disney," *The Nation*, Mar. 28, 1934, p. 363.

Tieman, Robert. *The Disney Keepsakes* (New York, 2005; London, 2005, as *The Disney Experience*).

——. *The Disney Treasures* (New York, 2003).

——. *Quintessential Disney* (New York, 2005).

Tildesley, Beatrice. "Disney's New Fantasies: Three Little Pigs May Outshine Mickey Mouse." *Australian Women's Weekly*, June 2, 1934, p. 20.

"Walt Disney . . ." *Film Daily*, June 7, 1925, p. 73.

"Walt Disney, 65, Dies on Coast; Founded an Empire on a Mouse," *New York Times*, Dec. 16, 1966, pp. 1, 40.

"Walt Disney: 5.XII.1901—15.XII.1966," *Der Spiegel*, Dec. 19, 1966, p. 106.

Walt Disney and His Animated Cartoons: Exhibition of His Original Working Drawings (London, 1935), 8-page booklet published by Ernest Brown & Phillips, Ltd., for exhibition at the Leicester Galleries, February 1935; copy at Courtauld Institute library, London (shelf mark Z5055 LON LEI).

Walt Disney and His Animated Cartoons: Exhibition of His Original Working Drawings (Preston, 1935), 8-page booklet for the Harris Museum and Art Gallery, Preston, Lancashire (May 20 to June 15, 1935); copy at Courtauld Institute library, London (shelf mark Z5056 PRE HAR).

Walt Disney and His Animated Cartoons: Exhibition of the Original Working Drawings (Belfast, 1935), 4-page booklet for City of Belfast Museum and Art Gallery, Northern Ireland, from Oct. 14, 1935; copy at Royal Society of Antiquaries of Ireland, Dublin (shelf mark L2GVII).

"Walt Disney and Hogarth." *Art Digest*, Oct. 1, 1934, p. 8.

"Walt Disney Recalls Some Pleasant Childhood Memories." *Marceline* (Missouri) *News*, Oct. 13, 1960, unpaginated. [section 3, 18th page]; repr. of Disney, "The Marceline I Knew," Sept. 2, 1938, p. 1.

"Walt Disney Show." *Weekly News Letter* [Los Angeles County Museum], Nov. 21, 1940, pp. 1-2.

Walt Disney's Animated Cartoons (Manchester, City of Manchester Art Gallery, 1935), eight-page booklet for exhibition at the City of Manchester Art Gallery, July 2—Aug. 19, 1935; copy at the Courtauld Institute library, London (shelf mark Z5056 MAN CIT).

Watts, Steven. *The Magic Kingdom: Walt Disney and the American Way of Life* (Boston and New York, 1997).

——. "Walt Disney: Art and Politics in the American Century." *Journal of American History*, June 1995, pp. 84-110.

Witkowski, Linda. *See* Martin Krause and Linda Witkowski

Wolters, Larry. "Fabulous Story." Feb. 9, 1953, Chicago Daily Tribune, p. B9.

WEBSITES

Chronology of the Disney Company: www.islandnet.com/~kpolsson/disnehis.

D23 | The Official Community for Disney Fans: d23.disney.go.com.

Disney.com—The Official Home Page For All Things Disney: home.disney.go.com/index.

Disney History (Didier Ghez): disneybooks.blogspot.com.

The Encyclopedia of Disney Animated Shorts (J. D. Weil): www.disneyshorts.org.

"Historical Footnotes" on *Plane Crazy*: www.disneyshorts.org/years/1928/planecrazy.html.

Jim Hill Media.com (Jim Hill): www.jimhillmedia.com.

Michael Barrier.com—Exploring the World of Animated Films and Comic Art (Michael Barrier): www.michaelbarrier.com.

MousePlanet (Jim Korkis): www.mouseplanet.com/index.php.

TagToonz (Mark Sonntag): msonntag.blogspot.com.

This Day in Disney History: thisdayindisneyhistory.homestead.com/index.html. thisdayindisneyhistory.homestead.com/Jan02.html and /May15.html.

Toons At War (David Lesjak, a.k.a., "Disney Dave"): toonsatwar.blogspot.com.

Vintage Disney Collectibles 1928-1945 (David Lesjak): vintagedisneymemorabilia.blogspot.com.

The Walt Disney Family Museum: disney.go.com/disneyatoz/familymuseum/index.html.

MICKEY MOUSE: KEY REFERENCES AND RESOURCES

Ahrens, Frank. "Disney Presents Mickey Mouse, Again: Media Giant Pushes to Make Cartoon Rodent Hip." *Washington Post*, July 26, 2003, p. E1; repr. in Apgar, *Mickey Mouse Reader*, pp. 308-311.

Andrae, Thomas. "In the Beginning: Ub Iwerks and the Birth of Mickey Mouse." In Gottfredson, *Walt Disney's Mickey Mouse*, vol. 1 (Seattle, 2011), pp. 222-226.

——. "Of Mouse and the Man: Floyd Gottfredson and the Mickey Mouse Continuities," in Hamilton, *Walt Disney's Mickey Mouse in Color* (1988), pp. 9-24; repr. in shorter, revised form, as "Of Mouse & Man: Floyd Gottfredson and the Mickey Mouse Continuities 1930-1931: The Early Years," in Gottfredson, *Walt Disney's Mickey Mouse* (Seattle, 2011), vol. 1, pp. 10-15.

Apgar, Garry. "The Meaning of Mickey Mouse." *Visual Resources: An International Journal of Documentation*, vol. 14, no. 3, January 1999, pp. 263-273; repr. in Apgar, *Mickey Mouse Reader*, pp. 274-287.

——. "Mickey Mouse at Seventy-Five." *Weekly Standard*, Nov. 24, 2003, pp. 31-34.

——, ed. *A Mickey Mouse Reader* (Jackson, Miss., 2014).

Bain, David, and Bruce Harris. *Mickey Mouse: Fifty Happy Years* (New York, 1977).

"Barn Dance 1929 / Draughtsman...Walt Disney, The." *The Film Society Programme*, Nov. 10, 1929, p. 130.

Barrier, Michael. "...And the Mystery Mouse," Sept. 30, 2009 (www.michaelbarrier.com/Home%20Page/WhatsNewArchivesSept09.htm#andthemysterymouse)

——. "Catching Up," Jan. 11, 2011 (www.michaelbarrier.com/Home%20Page/WhatsNewArchivesJan11.html).

——. "The Curious Case of Mortimer Mouse," Sept. 3, 2009 (www.michaelbarrier.com/Home%20Page/WhatsNewArchivesSept09.htm#curiouscase).

——. "Curiouser and Curiouser," Sept. 4, 2009 (www.michaelbarrier.com/Home%20Page/WhatsNewArchivesSept09.htm#curiouserandcuriouser).

——. "More on That Curious Case," Sept. 10, 2009 (www.michaelbarrier.com/Home%20Page/WhatsNewArchivesSept09.htm#moreonthatcuriouscase).

Beall, Harry Hammond. "Mad Moments of Mickey Mouse .." *Milwaukee Sentinel*, June 28, 1931, p. E5.

Beaujean, Stéphane. "La véritable histoire de Mickey Mouse: Une souris et des hommes." *BeauxArts* (special issue, "hors série": *Un siècle de BD américaine*), August 2010, pp. 14-19.

Benayoun, Robert. "La Souris qui a accouché d'une montagne." *Le Point*, Oct. 30, 1978, pp. 143-144.

Benjamin, Walter. "Zu Micky-Maus." In: Benjamin, *Gesammelte Schriften* (Frankfurt, 1972-1989), eds. Rolf Tiedemann and Hermann Schweppenhäuser, vol. VI (1985), pp. 144-145. In English as "Mickey Mouse," in *Walter Benjamin: Selected Writings, Volume 2, 1927-1934* (Cambridge, Mass., and London, 1999), eds. Marcus Bullock and Michael W. Jennings, trans. Rodney Livingstone, p. 346. Repr. in Apgar, *Mickey Mouse Reader*, pp. 20-21, in translation as "On Mickey Mouse," and in the orginal German, p. 360 ("Zu Micki Maus").

Block, Paul, and Karl Ritter, eds. *Micky Maus: Ein lustiges Filmbildbuch* (Berlin, 1931).

Bostel, Honoré and Pierre Tchernia. "Mickey, mon ami ..." In *Antiquités Mickey* (Paris, 1978), auction catalogue, Maîtres Loudmer-Poulain, n.p.

Bragdon, Claude. "Straws in the Wind: Mickey Mouse and What He Means." *Scribner's Magazine*, July 1934, pp. 40-43.

Brockway, Robert W. "The Masks of Mickey Mouse." *Journal of Popular Culture*, spring 1989, pp. 25-34; and, in a revised, extended version in Brockway, *Myth From the Ice Age to Mickey Mouse* (Albany, N.Y., 1993), pp. 119-145, 180-181. Repr. in Apgar, *Mickey Mouse Reader*, pp. 219-230.

Canemaker, John. "An American Icon Scampers In For a Makeover." *New York Times*, Aug. 6, 1995, pp. H9, H20; repr. in Apgar, *Mickey Mouse Reader*, pp. 261-266.

Capelli, Gaudenzio, et al. *Topolino 60 anni insieme*. Exhibition catalogue (Milan, 1993).

Carr, Harry. "The Only Unpaid Movie Star." *American Magazine*, March 1931, pp. 55-57, 122, 125; repr. in Apgar, *A Mickey Mouse Reader*, pp. 25-34.

Cary, Elisabeth Luther. "Mickey Mouse and the Comic Spirit: The Art of Making Laughter in One of Its Modern American Manifestations—The Comic Strip as an Art Medium." *New York Times*, May 7, 1933, p. X8.

Churchill, Douglas W. "Now Mickey Mouse Enters Art's Temple." *New York Times Magazine*, June 3, 1934, pp. 12-13, 21.

Culhane, John. "A Mouse for All Seasons." *Saturday Review*, Nov. 11, 1978, pp. 50-51; repr. in Apgar, *Mickey Mouse Reader*, pp. 195-199.

Darwent, Charles. "Hey Mickey, You're So Fine—Disney and his Draughtsmen." *The Independent*, Sept. 3, 2006, pp. 6-8.

Delcroix, Olivier. "Mickey, l'ange et la bête." *Le Figaro*, Aug. 14, 2006 (online only: www.lefigaro.fr/culture/20060814.WWWV000000278_mickey_l_ange_et_la_bete.html).

Disney, Walt. "The Cartoon's Contribution to Children," *Overland Monthly and Out West Magazine*, October 1933, p. 138.

——. "The Life Story of Mickey Mouse," *Windsor Magazine*, January 1934, pp. 259-263; repr. in Apgar, *Mickey Mouse Reader*, pp. 82-88.

——. "Mickey and 16 mm." *American Cinematographer*, March 1932, pp. 36-37.

——. "Mickey as Professor." *The Public Opinion Quarterly*, summer 1945, pp. 119-125.

——. "Mickey Mouse Is 5 Years Old." *Film Pictorial*, Sept. 30, 1933, p. 36.

——. "Mickey Mouse Présente." In Nancy Naumberg, ed., *Silence!, On Tourne* (Paris, 1938), pp. 267-284 (French edition of entry immediately below; trans. J. G. Auyriol).

——. "Mickey Mouse Presents." In Nancy Naumberg, ed., *We Make the Movies* (New York, 1937), pp. 253-272.

——. "Mickey Mouse Presents." *Theatre Arts Monthly*, no. 9, September 1938, p. 674.

——. "The Story of Mickey Mouse." 11-minute recording made by Disney, Oct. 13, 1947; on track 2 of a CD included in Tieman, *The Disney Treasures* (New York, 2003). Published in Jackson, *Walt Disney: A Bio-Bibliography*, pp. 118-121, as having been broadcast on the NBC radio series, *University of the Air*, 1948. In spring of 1948, a shorter version of this account appeared under Walt's name as "What Mickey Means To Me" (see below).

——. "What Mickey Means To Me." *Who's Who in Hollywood*, April-June 1948, pp. 50-51; repr. in Apgar, *Mickey Mouse Reader*, pp. 164-167.

"Dopey, Grumpy & Co." *Art Digest*, Sept. 1, 1938, p. 14.

"Europe's Highbrows Hail 'Mickey Mouse'." *Literary Digest*, Aug. 8, 1931, p. 19.

"The Evolution of Mickey Mouse." *Motion Picture Daily*, June 20, 1931, p. 7.

Figler, Jeff. "Major Milestones in Mickey Mouse History." *San Diego Union-Tribune*, July 15, 2007, p. D15.

Fishwick, Marshall. "Mickey, A Mouse of Influence Around the World." *Orlando Sentinel*, June 14, 1992, p. D3; repr. in Apgar, *Mickey Mouse Reader*, pp. 242-244.

Fleming, R. C. "The Saga of Michael Rodent." *Compressed Air Magazine*, July 1934, pp. 4463-4467.

Forrest, Mark. "The Film To-Day." *Saturday Review of Literature*, Oct. 10, 1931, p. 467.

Forster, E. M. "Mickey and Minnie." *The Spectator* (Jan. 19, 1934), 81-82; repr. in Forster, *Abinger Harvest* (London, 1936), pp. 50-54, and Apgar, *Mickey Mouse Reader*, pp. 89-92.

Franklin, Mortimer. "The Art of Mickey Mouse." *Screenland*, August 1933, pp. 26-27, 96.

Gilman, John. See Robert Heide, John Gilman, Monique Peterson, and Patrick White

Gottfredson, Floyd. *Walt Disney: Mickey Mouse* (New York, 1978).

—— *Walt Disney's Mickey Mouse: Color Sundays*. Eds. David Gerstein and Gary Groth. Volume 1 of 2 in

The Floyd Gottfredson Library (Seattle, 2013).

——. *Walt Disney's Mickey Mouse: Race to Death Valley*. Eds. David Gerstein and Gary Groth. Volume 1 of 6 in The Floyd Gottfredson Library (Seattle, 2011-2014).

Gould, Stephen Jay. "Mickey Mouse Meets Konrad Lorenz." *Natural History*, May 1979, pp. 30, 32, 34, 36. Repr. as "A Biological Homage to Mickey Mouse," in Gould, *The Panda's Thumb* (New York, 1980), pp. 95-107, and Apgar, *Mickey Mouse Reader*, pp. 207-214 (with two illustrations from the original article).

Green, Jesse. "Can Disney Build a Better Mickey Mouse?" *New York Times*, Apr. 18, 2004, section 2, ("Arts & Leisure"), pp. AR1, AR18-19; repr. in Apgar, *Mickey Mouse Reader*, pp. 312-319.

Gresser, Bernard. "Le sport sur la plage. Une facette de l'identité institutionnelle: la naissance des clubs 'Mickey'," in Serge Fauché, Jean-Paul Callède, Jean-Louis Gay-Lescot, Jean-Paul Laplagne, *Sport et identités* (Paris, 2000), pp. 247-256.

Guiver, Marian Petersen. "Charlotte Clark Dolls." *Tomart's Disneyana Update*, no. 2 (1994), pp. 10, 31.

Hall, Mordaunt. "The Screen." *New York Times*, Nov. 19, 1928, p. 16.

Hamilton, Bruce, ed. *Walt Disney's Mickey Mouse in Color* (New York, 1988).

Hamilton, Sara. "Mickey and Minnie." *Motion Picture*, May 1931, pp. 44-45, 100.

——. "The True Story of Mickey Mouse." *Movie Mirror*, December 1931, pp. 100-101, 122.

Harris, Bruce. See David Bain and Bruce Harris

Heide, Robert, John Gilman, Monique Peterson, and Patrick White. *Mickey Mouse: The Evolution, the Legend, the Phenomenon!* (New York, 2001).

Hiestand, Jesse. "Forever Young: Mickey Turns 75." *Hollywood Reporter*, July 24, 2003, p. 4.

Hillier, Bevis, and Bernard C. Shine. *Walt Disney's Mickey Mouse Memorabilia: The Vintage Years 1928-1938* (New York, 1986).

Holliss, Richard, and Brian Sibley. *Walt Disney's Mickey Mouse: His Life and Times* (New York, 1986).

Hyland, Dick. "Mickey Mouse: His Life and Art." *New Movie Magazine*, May 1930, pp. 36-37, 128-129.

Inge, M. Thomas. "Mickey Mouse." In Dennis R. Hall and Susan Grove Hall, eds., *American Icons: An Encyclopedia of the People, Places and Things That Have Shaped Our Culture* (Westport, Conn., and London, 2006), vol. 2, pp. 473-480. Repr. in Apgar, *Mickey Mouse Reader*, pp. 339-347.

Jackson, Kathy Merlock. "Mickey and the Tramp: Walt Disney's Debt to Charlie Chaplin." *Journal of American Culture*, December 2003, pp. 439-444.

Jamison, Barbara Berch. "Of Mouse and Man, or Mickey Reaches 25." *New York Times Magazine*, Sept. 13, 1953, pp. 26-27; repr. in Apgar, *Mickey Mouse Reader*, pp. 181-184.

Johnston, Alva. "Mickey Mouse." *Woman's Home Companion*, July 1934, pp. 12-13, 92-94; repr. in Apgar, *Mickey Mouse Reader*, pp. 105-115.

——. "Mickey Mouse," *Readers Digest*, July 1934, pp. 106-109.

Kakutani, Michiko. "This Mouse Once Roared." *New York Times Magazine*, Jan. 4, 1998, pp. 8, 10.

Kaufman, J. B. "The Shadow of the Mouse." *Film Comment*, vol. 28, no. 5, September 1992, 68-69, p. 71.

Korkis, Jim. *The Book of Mouse: A Celebration of Walt Disney's Mickey Mouse* (Orlando, Fla., 2013).

——. "Disney Goes to Macy's." In Korkis, *The Vault of Walt* (2010), pp. 397-404.

——. "Secrets of Steamboat Willie." *Hogan's Alley: The Magazine of the Cartoon Arts*, vol. 3, no. 4, September 2004, pp. 57-63; repr. in Apgar, *Mickey Mouse Reader*, pp. 320-338.

Lambert, Eleanor. *Notes on The Art of Mickey Mouse and his Creator Walt Disney* (New York, 1933); repr. in Apgar, *Mickey Mouse Reader*, pp. 66-71.

Lambert, Pierre. *Mickey* (Paris, 1998); trans. as *Mickey Mouse* (New York, 1998).

Land. "'Steamboat Willie'." *Variety*, Nov. 21, 1928, p. 13; repr. in Apgar, *Mickey Mouse Reader*, p. 6.

Laqua, Carsten. *Wie Micky Unter die Nazis Fiel: Walt Disney und Deutschland* (Reinbeck bei Hamburg, 1992).

Lawrance, Lowell. "Kansas City Mouse Best Known Creature in World," *Kansas City Journal Post*, Sept. 8, 1935, p. 4B.

——. "World's Most Popular Movie Star Is Only a Shadow." *Kansas City Journal Post*, Sept. 15, 1935, p. 4B.

Lawrence, Elizabeth A. "In the Mick of Time: Reflections on Disney's Ageless Mouse." *Journal of Popular Culture*, vol. 20, no. 2, 1986, 65-72.

Mann, Arthur. "Mickey Mouse's Financial Career." *Harper's*, May 1934, pp. 714-721; repr. in Apgar, *Mickey Mouse Reader*, pp. 93-104.

Mandry, Michel R., et al. *Happy Birthday Mickey! 50 ans d'histoire du Journal de Mickey* (Paris, 1984).

"Master Mickey Celebrates an Epochal Event." *Washington Post*, Sept. 29, 1935, p. SA3.

"The Mechanized Mouse." *Saturday Review of Literature*, Nov. 11, 1933, p. 252.

Mercurius. "The Preposterous Rodent." *The Architectural Review*, February 1930, p. 98.

Mickey fête ses 50 ans Au Printemps. Exhibition catalogue: Au Printemps department store, Paris, Nov. 9, 1978—Dec. 26, 1978 (Paris, 1978).

"Mickey Mouse." *200 Greatest Pop Culture Icons* (VH1/*People* magazine "Special Collection"), July 20, 2003, p. 104.

"Mickey Mouse First Named 'Mortimer'." *Irish Times*, Nov. 26, 1945, p. 9.

Mickey Mouse in Black and White: The Classic Collection. Produced by Walt Disney. Directed by Ub Iwerks, inter al. 4 hr., 16 min., Walt Disney Video, 2002, DVD ("Walt Disney Treasures"), 2-disc set.

Mickey Mouse in Black and White: Volume Two 1928-1935. Produced by Walt Disney. Directed by Walt Disney, Burt Gillett, inter al. 5 hr., 34 min., Walt Disney Video, 2004, DVD ("Walt Disney Treasures"), 2-disc set.

Mickey Mouse in Living Color: A Collection of Color Adventures. Produced by Walt Disney. Directed by Wilfred Jackson, Ben Sharpsteen, inter al. 3 hr., 37 min., Walt Disney Video, 2001, DVD ("Walt Disney Treasures"), 2-disc set.

Mickey Mouse in Living Color: Volume Two 1939-Today. Produced by Walt Disney. Directed by Chris Bailey, Bill Roberts, Riley Thomson, inter al. 5 hr., 45 min., Walt Disney Video, 2004, DVD ("Walt Disney Treasures"), 2-disc set.

"Mickey Mouse Makes the Britannica." *New York Times*, July 29, 1934, p. X2; repr. in Apgar, *Mickey Mouse Reader*, pp. 116-118.

"Mickey Mouse is 8 Years Old: Disney's Squeaky Star Played to 468,000,000 in 1935." *Literary Digest*, Oct. 3, 1936, pp. 18-19; repr. in Apgar, *Mickey Mouse Reader*, pp. 135-140.

"Mickey Mouse's Eighth Birthday: Celebration in London." *London Times*, Sept. 25, 1936, p. 12.

"Mickey Mouse's Fourth Birthday Finds Organization Worldwide: 50 to 60 Makers of Novelties Join in Exploitation Campaign." *Motion Picture Herald*, Oct. 1, 1932, pp. 42-43, 51.

"Mickey Mouse's Friends Find Him in Portland Museum." *Newsweek*, Sept. 15, 1934, p. 29.

Mickey: Une souris et des hommes." Special issue, *Les Nouvelles littéraires*, Nov. 3-9, 1978, pp. 1, 17-22.

Mikulak, Bill. "Mickey Meets Mondrian: Cartoons Enter the Museum of Modern Art." *Cinema Journal*, vol. 36, no. 3, spring 1997, pp. 56-72.

Millier, Arthur. "Disney's Artistry Explains Silly Symphony Popularity: Creator of Film Cartoons Has One Hand on Human Heart. Other Up Among the Stars." *Los Angeles Times*, Nov. 5, 1933, pt. II ("Features—Stage—Screen—Radio—Books—Music"), pp. 1-2.

Monahan, Kaspar. "Mickey Mouse, His Vanity Wounded, Declares War On This Column and Writes Reproving Letter." *Pittsburgh Post*, July 18, 1932, p. 11 ("The Show Stops" column).

Muller, Jerome K. *Mickey Mouse, 1928-1978: An Exhibition of Original Art and Memorabilia From Private Collections* (Santa Ana, Calif.: Bowers Museum, 1978).

Nugent, Frank S. "That Million-Dollar Mouse." *New York Times Magazine*, Sept. 21, 1947, pp. 4-5; repr. in Apgar, *Mickey Mouse Reader*, pp. 158-163.

"On This the Fourth Birthday of Mickey Mouse to Exhibitors of the World." Oct. 1, 1932 *Motion Picture Herald*, pp. 46-47 (two-page ad).

Ong, Walter J. "Mickey Mouse and Americanism." *America*, Oct. 4, 1941, pp. 719-720.

Peet, Creighton. "Miraculous Mickey," *Outlook and*

Independent, July 23, 1930, p. 472; repr. in Apgar, *Mickey Mouse Reader*, pp. 17-19.

Peterson, Monique. *See* Robert Heide, John Gilman, Monique Peterson, and Patrick White

"Profound Mouse." *Time*, May 15, 1933, pp. 37-38.

Ramsaye, Terry. "Mickey Mouse: He Stays on the Job." *Motion Picture Herald*, Oct. 1, 1932, p. 41; repr. in Apgar, *Mickey Mouse Reader*, pp. 56-57.

Reaves, Wendy Wick. *Celebrity Caricature in America* (New Haven and Washington, D.C., 1998).

"Regulated Rodent." *Time*, Feb. 16, 1931, p. 21; repr. in Apgar, *Mickey Mouse Reader*, pp. 22-24.

R. E. S. "The Art of Mickey Mouse." *Art News*, May 13, 1933, p. 6.

Ritter, Karl. *See* Paul Block and Karl Ritter

Rivera, Diego. "Mickey Mouse and American Art." *Contact: An American Quarterly Review*, February 1932, 37-39; a fair copy by Rivera hand-written on Barbizon Plaza hotel stationery, is in the collection of the Walt Disney Family Museum, San Francisco, Calif. Repr. in Apgar, *Mickey Mouse Reader*, pp. 53-55, and in the original Spanish, pp. 362-363.

Robbins, L.H. "Mickey Mouse Emerges as Economist." *New York Times Magazine*, Mar. 10, 1935, pp. 8, 22; repr. in Apgar, *Mickey Mouse Reader*, pp. 119-125.

Rosenthal, Jack. "Mickey Mousing" ("On Language"). *New York Times Magazine*, Aug. 2, 1992, pp. 10, 12.

Russell, Herbert. "L'Affaire Mickey Mouse." *New York Times Magazine*, Dec. 26, 1937, 4, 17; repr. in Apgar, *Mickey Mouse Reader*, pp. 141-145.

Safire, William. "Mickey Mouse," subsection in "Bespokesman" ("On Language" column), *New York Times Magazine*, Dec. 2, 1990, p. 26.

Santoli, Lorraine. *The Official Mickey Mouse Club Book* (New York, 1995).

Schickel, Richard. "Bringing Forth the Mouse." *American Heritage*, April 1968, pp. 24-29, 90-96.

Schroeder, Russell. *Walt Disney's Mickey Mouse: My Life in Pictures* (New York, 1997).

Seldes, Gilbert. "Mouse and News First, Triumphs of Talkies." *New York Evening Journal*, June 18, 1932, p. 16.

Sendak, Maurice. "Growing Up With Mickey." *TV Guide*, Nov. 11, 1978, pp. 16-18. Repr. in Apgar, *Mickey Mouse Reader*, pp. 191-194; and, in slightly revised form as "Walt Disney / 1," in Sendak, *Caldecott & Co.: Notes on Books & Pictures* (New York, 1988), pp. 107-110.

Service, T. O. "Service Talks." *Moving Picture World*, Dec. 1, 1928, pp. 58-59 (subhead: "Steamboat Willie," p. 59).

Solomon, Charles. "Mickey Mouse's Birth Was One of Desperation." *Los Angeles Times*, July 23, 1988, p. 10.

———, Annette Funicello, Bevis Hillier, William F. Buckley, et al. "America Celebrates Mickey's 60th Birthday." Unnumbered 32-page special advertising section in *People*, Nov. 7, 1988.

Steff, Thierry. *Bon Anniversaire, Mickey!* (Paris, 1998).

Storm, J. P., and Mario Dreßler. *Im Reiche der Micky Maus: Walt Disney in Deutschland 1927-1945* (Potsdam, 1991).

Thomas, Dan. "How They Make Animated Cartoons." *Ohio State Journal*, Mar. 8, 1931, Sunday magazine section, p. 4.

Tieman, Robert. *The Mickey Mouse Treasures* (New York, 2007); Paris: 2008, as *Le Monde de Mickey Mouse*.

Updike, John. "The Mystery of Mickey Mouse," *Art & Antiques* (November 1991), pp. 60-65, 98. An expanded version of this article served as the "Introduction" to Yoe and Morra-Yoe, *The Art of Mickey Mouse* (New York, 1992), repr. with four black-and-white illustrations, in Updike, *More Matter: Essays and Criticism* (New York, 1999), pp. 202-210, and, with no illustrations, in Apgar, *A Mickey Mouse Reader*, pp. 233-241. *Art and Antiques* article repr., text only, in Susan Sontag and Robert Atwan, eds., *The Best of American Essays* (New York, 1992), 306-313; and in Donald McQuade and Atwan, eds., *Popular Writing in America: The Interaction of Style and Audience*, 5th ed. (Oxford, 1993), pp. 347-351.

Verrier, Richard. "M-I-C-K-E-Y: He's the Leader of the Brand;" *Los Angeles Times*, July 23, 2003, p. A1; repr. in Apgar, *Mickey Mouse Reader*, pp. 303-307.

Wallace, Irving. "Mickey Mouse and How He Grew." *Collier's*, Apr. 9, 1949, pp. 20-21, 35-36; repr. in Apgar, *Mickey Mouse Reader*, pp. 168-177.

White, Patrick. *See* Robert Heide, John Gilman, Monique Peterson, and Patrick White

Wood, Cholly. "Mickey Mouse Is 7 Years Old Today." *Bridgeport Sunday Herald*, Sept. 25, 1935, feature section, p. 3; repr. in Apgar, *Mickey Mouse Reader*, pp. 128-129.

"World-Wide Disney." *Magazine of Art*, vol. 31, no. 9, September 1938, p. 46.

Yoe, Craig, and Janet Morra-Yoe. *The Art of Mickey Mouse* (New York, 1992).

WEBSITES

Art Institute of Chicago, Ryerson and Burnham Libraries, for digital scan of Eleanor Lambert, *Notes on The Art of Mickey Mouse*: www.artic.edu/sites/default/files/libraries/pubs/1934/AIC1934Disney_comb.pdf

This Day in Disney History: thisdayindisneyhistory.homestead.com/index.html thisdayindisneyhistory.homestead.com/Oct13.html (re. Mickey's star on Hollywood Boulevard, 1978)

Michigan State University Libraries, Special Collections Division: Reading Room Index to the Comic Art Collection ("Mickey Mouse") www.lib.msu.edu/comics/rri/mrri/mickea.htm

Wikipedia: en.wikipedia.org/wiki/Mickey_Mouse

OTHER REFERENCES AND RESOURCES

"40th Division. Troops Lack Equipment. Woes of 'Mickey Mouse Army'." *San Francisco Examiner*, Feb. 3, 1951, p. 1.

"50 Greatest Cartoon Characters of All Time." *TV Guide*, Aug. 3-9, 2002, pp. 14-33.

"100 Icons of the Century." *Variety* (supplement, vol. 400, no. 9), Oct. 17, 2005 (www.variety.com/index.asp?layout= variety100&content=jump2&jump=icon1ndex).

Abadie, Daniel, et al. *Salvador Dalí rétrospective*. Exhibition catalogue: Centre Pompidou, Paris, Dec. 18, 1979—Apr. 21, 1980 (Paris, 1980, rev. ed.).

"About Louis Grell," Louis Grell Foundation (www.louisgrell.com/about-2/about).

"Academy's Annual Awards This Week." *Motion Picture Herald*, Nov. 19, 1932, p. 19.

"Actors Mix with Cartoons." *Los Angeles Times*, July 6, 1924, p. B31.

Adams, Henry. *Thomas Hart Benton: An American Original* (New York, 1989).

Adams, James Truslow. *The Epic of America* (New York, 1931).

Adamakos, Peter. "Ub Iwerks." *Mindrot*, June 15, 1977, pp. 20-24.

Adamson, Joe. *Bugs Bunny: Fifty Years and Only One Grey Hare* (New York, 1990).

"Advertising and Publicity Representatives." *Motion Picture Almanac: Pictures and Personalities* (Chicago, 1929), vol. 38, p. 85 ("Beall, Harry Hammond").

Agence France-Presse, "Hollywood, Not Nukes, Gives US Dominance: Lee." ABC News, Aug. 18, 2008 (www.abc.net.au/news/stories/2008/08/18/2338272.htm?section=entertainment).

"Air Liner Crash in Azores Kills 48." *Los Angeles Times*, Oct. 29, 1949, pp. 1, 6.

Allan, Robin. "The Fairest Film of All: *Snow White Reassessed*." *The Animator*, vol. 21, Oct.-Dec. 1987, pp. 18-21.

Allen, Frederick Lewis. *Only Yesterday: An Informal History of the 1920s* (New York, 1931).

———. *Since Yesterday: the 1930s in America, September 3, 1929—September 3, 1939* (New York, 1940).

Allen, Henry. "'Fantasia': Hip, Hippo Hooray!" *Washington Post*, Sept. 30, 1990, p. G1.

Altshuler, Bruce J. "An Avant-Garde Impresario." *Art in America*, March 1999, pp. 52-55.

"American Dream." 30-second Ameriprise TV commercial with Dennis Hopper, which ran from about the fall of 2007 till spring 2008 (www.ameriprise.com/amp/global/about-ameriprise/commercials.asp).

"The American Mechanical Display in Paris." *London Times*, Aug. 22, 1878, p. 6.

"Among Disney Creations at Art Gallery." *Manchester Leader*, Dec. 19, 1933, p. 24.

Anderson, Oswald. "This New Wonder—Television." *Australian Women's Weekly*, Apr. 1, 1939, p. 14.

Andrews, Craig L. *Broken Toy: A Man's Dream, A Company's Mystery* (Bloomington, Ind., 2002).

"Animated Cartoon Display Show Huge Amount of Work It Involves." *Middletown* (Conn.) *Press*, Nov. 16, 1933, p. A1.

"Animated Cartoons For Christmas Week." *New York Times*, Dec. 13, 1933, p. 29.

Apgar, Garry. "Le Grand Charlie et le Petit Mickey." *Paris Metro*, Nov. 22, 1978, pp. 6-7; repr. in Apgar, *Mickey Mouse Reader*, pp. 204-206.

———. "'Sage comme une image': trois siècles d'iconographie voltairienne." *Nouvelles de l'estampe*, July 1994, pp. 4-44.

Armitage, Shelley. *Kewpies and Beyond: The World of Rose O'Neill* (Jackson, Miss., 2011).

Arnoux, Alexandre. "Ub Iwerks, Maître de ballet des dessins animés sonores." *Pour Vous*, May 15, 1930, pp. 8-9.

"Art and Artists. Record in Visitors To Galleries." *San Bernardino* (Calif.) *Sun*, Dec. 30, 1940.

"Art Institute Reception Will Be Held Today." *Chicago Tribune*, Dec. 14, 1933, p. 1.

"The Art of Mickey Mouse." *Bulletin of the Milwaukee Art Institute*, February 1934, p. 2.

"The Art of Mr. Walt Disney: An Experiment in Colour." *London Times*, July 31, 1933, p. 10.

"Art of Mr. Disney: Film Cartoons in the Making." *London Times*, Feb. 13, 1935, p. 10 (on the same page: an ad for the Leicester Galleries exhibition, *How Walt Disney Makes His Animated Cartoons*).

"Art of Walt Disney; Exhibition and Lectures." *Bulletin of the Fogg Art Museum*, March 1939, vol. 8, p. 58.

"Asbury Park Welcomes Carl Edouarde." *Musical Courier*, July 3, 1912 (from clipping file, Music Division, New York Public Library).

Associated Press. "48 Killed in Azores Crash as Plane for U.S. Hits Peak; Cerdan, Boxer, Is a Victim." *New York Times*, Oct. 29, 1949, pp. 1, 3.

———. "Cartoons Invade Chicago Institute of Art Exhibit." *Washington Post*, Dec. 14, 1934, p. 11.

———. "French Honor Disney's Work." *New York Times*, Jan. 9, 1936, p. 25.

———. "President Confers Valor Medal on Girl, 12; Also Gives a Mickey Mouse to Ohio Child." *New York Times*, Sept. 13, 1936, p. N12.

———. "Pershing Tells Final Plans For Quitting France: Will Advise Against Removal of Dead Americans." *Chicago Tribune*, Aug. 1, 1919, p. 3.

———. "Reich Acts to Curb Foreign Films." *New York Times*, July 5, 1930, p. 7.

———. "Scottish Art Student Depicts Mickey Mouse Flying Toward Flaming World Trade Center." Feb. 20, 2004 (ap.tbo.com/ap/breaking/MGAHY2DOWQD.html).

———. "Ub Iwerks Artist with Disney, Dead." *New York Times*, July 10, 1971, p. 26.

Atkinson, Brooks. "'Anything Goes' as Long as Victor Moore, Ethel Merman and William Gaxton Are Present." *New York Times*, Nov. 22, 1934, p. 26.

Atkinson, Rick. *The Long Gray Line: The American Journey of West Point's Class of 1966* (Boston, 1989).

Auth, Tony, et al. (introduction by Tom Brokaw). *The Gang of Eight* (Boston and London, 1985).

Babes in Toyland. Produced by Hal Roach. Directed by Gus Meins, Charley Rogers. 1 hr. 17 min., 1934, Good Times Video, DVD.

Baigell, Matthew. "Thomas Hart Benton and the Left." In Hurt and Dains, *Thomas Hart Benton: Artist, Writer and Intellectual* (St. Louis, 1989), pp. 1-33.

"The Banning of Mouse." *London Times*, Nov. 16, 1938, p. 15.

Barks, Carl. *Carl Barks: Conversations*. Ed. Donald Ault (Jackson, Miss., 2003).

———, writer and artist. "The Seven Cities of Cibola," *Walt Disney's Uncle Scrooge*, no. 7, Sept.-Nov. 1954 (n.p.).

Barnes, Bart. "Charismatic Conductor Brought Prestige to National Symphony." *Washington Post*, Apr. 28, 2007, pp. A1, A9.

"Barnum's Publicity Man Dies." *Los Angeles Times*, July 4, 1931, p. 3.

Barrier, Michael. *Hollywood Cartoons: American Animation In Its Golden Age* (New York and Oxford, 1999).

———. "More on Walt, Dolores, and Diego" ("From Barry Carr in Melbourne, Australia"), MichaelBarrier.com, July 7, 2008 (www.michaelbarrier.com/#moreonwaltanddolores).

———. "Walt and Dolores—and Diego," MichaelBarrier.

com, May 29, 2008 (www.michaelbarrier.
com/#waltanddolores).

Barron, Stephanie, Sheri Bernstein, Ilene Susan Fort, eds.
*Made in California: Art, Image, and Identity,
1900-2000*. Exhibition catalogue, Los Angeles
County Museum of Art (Berkeley, Los Angeles,
and London, 2000).

Barrus, Maxine. "Disney, Chaplin Top Movie Geniuses,
Wilder Declares." *Tulsa Tribune*, Mar. 14, 1936, p. 12.

Barry, Iris. "Film Comments." *Bulletin of the Museum of
Modern Art*, vol. 1, no. 3, Nov. 1, 1933, p. 3.

——. "Films." *Bulletin of the Museum of Modern Art*, vol.
5, nos. 4/5, April-May 1938, pp. 10-12.

——. "The Founding of the Film Library." *Bulletin of the
Museum of Modern Art*, vol. 3, no. 2, November 1935,
pp. 2-8.

——. "Program for 1938." *Bulletin of the Museum of
Modern Art*, vol. 5, no. 1, January 1938, pp. 10-12.

Beard, Charles A., and Mary R. Beard. *The American
Spirit, a Study of the Idea of Civilization in the United
States* (New York 1942).

The Beatles, Live At The BBC (Capitol B000007MVD),
two-disc set, released June 5, 2001.

Bell, Nelson B. "The New Week's Bills," *Washington Post*,
Jan. 7, 1929, p. 14.

Belmont, I.J. "Painter of Music Criticizes 'Fantasia'." *Art
News*, Dec. 15, 1940, p. 11.

Benayoun, Robert. *Le Dessin animé après Walt Disney*
(Paris, 1961).

Benjamin Jr., Ludy T., and William H. M. Bryant. "A History
of Popular Psychology Magazines in America." In
A Pictorial History of Psychology. Eds. Wolfgang G.
Bringmann, Helmut E. Lück, Rudolf Miller, and Charles
E. Early (Chicago, Berlin, London, inter al., 1993),
pp. 585-593.

Benjamin, Walter. "Erfahrung und Armut." In Benjamin,
Gesammelte Schriften, vol. II.I, pp. 218-219. In English,
as "Experience and Poverty," in *Walter Benjamin:
Selected Writings*, vol. 2. Eds. Marcus Bullock and
Michael W. Jennings. Trans Rodney Livingstone
(Cambridge and London, 1972-1989), p. 732.

——— *Gesammelte Schriften*, 7 vols. Eds. Rolf Tiedemann and
Hermann Schweppenhäuser (Frankfurt, 1972-1989).

——— *Walter Benjamin: Selected Writings*, 4 vols. Eds. Marcus
Bullock and Michael W. Jennings. Trans. Rodney
Livingstone (Cambridge and London, 1996-2003).

Benton, Thomas Hart. *An Artist in America*, 4th rev. ed.
(Columbia, Mo., and London, 1983.

——. "The Arts of Life in America." In *Arts of Life in
America: A Series of Murals by Thomas Benton*
(New York, 1932), pp. 4-13.

——. "John Curry." *University of Kansas City Review*,
winter 1946, pp. 87-90; repr. in Junker, *John Steuart
Curry: Inventing the Middle West*, pp. 74-76.

Benz, Stephen. "Noted With Wonder," *Washington Post*,
Nov. 19, 2000, p. F2.

Berg, A. Scott. *Lindbergh* (New York, 1998).

Bertensson, Sergei, and Jay Leyda. *Sergei Rachmaninoff:
A Lifetime in Music* (Bloomington, 2001).

Bessy, Maurice. "Un langage international: le dessin
animé," *Pour Vous*, Mar. 27, 1930, p. 11; excerpt repr.
in Apgar, *Mickey Mouse Reader*, in English (as "An
International Language: The Animated Cartoon"),
pp. 15-16, and in the original French, pp. 358-359.

"Le Bestiaire improbable de Nickó Rubinstein."
Libération, July 15, 1997.

Betjeman, John. "Settings, Costumes and Backgrounds."
In Davy and Dworkin, *Footnotes to the Film* (Oxford
and New York, 1937).

——. "Stars to See To-night," *Evening Standard*, Apr. 23,
1934, p. 9; sidebar to Betjeman's regular column,
"London After Dark," pp. 8-9, headlined "She Threw
Away Her First Big Chance."

Biel, Steven. *American Gothic: A Life of America's Most
Famous Painting* (New York, 2005).

The Big Broadcast of 1936. Produced by Benjamin Glazer.
Directed by Norman Taurog, 1 hr. 37 min.,
Paramount, 1936.

Blinderman, Barry. "Keith Haring's Subterranean Signatures."
Arts Magazine, September 1981, pp. 182-188.

Blitzstein, Madelin. "Illegal Laughs from Germany's
Bootlegged Anti-Nazi Humor," *Washington Post*,
Aug. 11, 1935, p. SM4.

Bogdanovich, Peter. *Who the Hell's in It? Portraits and
Conversations* (New York, 2004).

"Book Notes." *New York Times*, Feb. 6, 1932, p. 15.

Boorstin, Daniel J. *The Image: or, What Happened to the
American Dream* (New York, 1961); repr. as *The
Image: A Guide to Pseudo Events in America* (New
York, 1992).

Born to Dance. Produced by Jack Cummings. Directed
by Roy Del Ruth, 1 hr. 46 min., 1936, on *Classic
Musicals from the Dream Factory*, vol. 3, Warner Home
Video, DVD.

Bossert, David A. (Juan M. Sevillano, intro.). *Dali & Disney:
Destino: The Story, Artwork, and Friendship Behind
the Legendary Film* (New York, 2015).

Bowness, Sophie. "Letters to Ben Nicholson and
Barbara Hepworth," *Burlington Magazine*, Nov. 1990,
pp. 782-788.

Bradley, Elizabeth. *Knickerbocker: The Myth Behind New
York* (New Brunswick, 2009).

Brand, Oscar. *Every Inch A Sailor*. Elektra EKL 169/EKS 7169.

Braun, Emily. "Thomas Hart Benton & Progressive
Liberalism: An Interpretation of the New School
Murals." In Braun and Branchick, *Thomas Hart
Benton* (1985), pp. 11-37.

Braun, Emily, and Thomas Branchick. *Thomas Hart Benton:
The America Today Murals*. Catalogue for the
exhibition at the Williams College Museum of Art,
Feb. 2—Aug. 25, 1985 (Williamstowm, Mass., 1985).

"Brazilians Bring Gift For Disney." *New York Sun*, Aug. 30,
1934, p. 23 (a clipping of this article is in album *,C 14
CLIPPINGS- -1935 FOREIGN*, at the Walt Disney
Archives, Burbank).

Bringing Up Baby. Produced and directed by Howard
Hawks. 1 hr. 42 min., Turner Home Entertainment,
1938, DVD.

"British Crowd Mobs Disneys." *Los Angeles Times*,
June 13, 1935, p. 1.

Britt, David, ed. *Modern Art: Impressionism to Post-
Modernism* (Boston, Toronto, and London, 1974).

Broadway Melody of 1936. Produced by Jack Cummings.
Directed by Roy Del Bluth. 1 hr. 50 min., 1936, on
disc two of two-disc set, *Classic Musicals from the
Dream Factory*, vol. 3, Warner Home Video, DVD.

Brown, Dan. *Angels & Demons* (New York, 2000).

——. *The Da Vinci Code* (New York, 2003).

Buchanan, George. "Radio Phone Boards Ship." *New York
Daily Mirror*, Aug. 1, 1935, pp. 2, 7.

Burke, Edmund. *The Works of Edmund Burke* (Boston,
1839), 9 vols.

"C. B. Mintz, Producer of Films, Dead at 50." *New York
Times*, Dec. 31, 1939, p. 22.

"Calendar of Exhibitions in New York." *Art News*, Apr. 29,
1933, p. 13.

Cameron, Dan, et al. *Peter Saul*. Catalogue for the
exhibition at the Orange County Museum of Art,
Newport Beach, Calif., June 22, 2008—Sept. 21, 2008;
Pennsylvania Academy of Fine Arts, Philadelphia, Oct.
18, 2008—Jan. 4, 2009 (Ostfildern, Germany, 2008).

Canemaker, John. *Felix: The Twisted Tale of the World's
Most Famous Cat* (New York, 1991).

——. "The Kid From Hogan's Alley: How an Artist
Named R. F. Outcault and an Urchin Named Mickey
Dugan Invented the Comic Strip." *New York Times
Book Review*, Dec. 17, 1995, pp. 7, 10.

Capra, Frank. *The Name Above the Title: An
Autobiography* (New York, 1971).

"Carey Orr," *Chicago Tribune*, May 17, 1967, p. 20.

"Carl Edouarde of the Films Dies; First Musical Director at
the Strand, Pioneer Movie House, With Symphony
Orchestra. / Turned To Synchronizing Adapted Music
for One of Aesop's Fables as the First Screen Cartoon
with Sound," *New York Times*, Dec. 9, 1932, p. 28.

"Carl N. Werntz. Artist, Teacher: Founder of Chicago
Academy Dies in Mexico City at 70, Trained Noted
Cartoonists." *New York Times*, Oct. 28, 1944, p. 15.

"Carl M. Werntz, Arts Academy Founder, Dies." *Chicago
Tribune*, Oct. 28, 1944, p. 12.

Carlin, John, et al. *Masters of American Comics*. Catalogue
for the exhibition at the Hammer Museum and The
Museum of Contemporary Art, Los Angeles;
Milwaukee Art Museum; The Jewish Museum, New
York, and The Newark Museum (Los Angeles and
New Haven, 2005).

Carpenter, John Alden. "The Krazy Kat Ballet" (program
note), Jan. 20, 1922; in Seldes, *The 7 Lively Arts*, pp. 377-379.

Carry, Harry. "The Lancer." *Los Angeles Times*, Jan. 28,
1935, section II, p. 1.

*Cartoon & Comic Art Including Archival Material From
the International Museum of Cartoon Art*. Auction
catalogue (May 19, 2001): Guernsey's, New York
(New York, 2001).

"The Cartoon Film: Its Origin and History." *London
Times*, May 17, 1938, p. 14.

Casper, Scott E. "Going Dutch." *Common-place, the
Interactive Journal of Early American Life*, Sept. 2000
(www.common-place.org/vol-01/no-01/dutch/).

Cembalest, Robin. "The Mouse that Roared." *Art News*,
January 1993, p. 35.

"The Censor!" *New York Times*, Nov. 16, 1930, p. X5.

Chalmers, Sarah. "What a Mickey Mouse Way To Run a
Country." *London Daily Mail*, Nov. 10, 2000, pp. 1+.

Charlot, Jean. *Art from the Mayans to Disney* (New York
and London, 1939).

——. *Pictures and Picture Making: A Series of Lectures*
("published" in mimeograph form by the Disney
studio, 1938).

A Child Lover. "Movies Harmful to Kiddies Declared to
be Winked at by Church and Parents." *Atlantic City
Press*, Jan. 21, 1931, p. 9 (letter to the editor).

Chinitz, David E. *T. S. Eliot and the Cultural Divide*
(Chicago, 2003).

Church, Brooke Peters. "John Curry, Artist . . ." *The Town
Crier* (Westport, Conn.), July 8, 1937, pp. 10-11 (n.p.).

Churchill, Winston S. *The Second World War* (Boston,
1983), vol. 5 *(Closing the Ring)*.

"'Cinearte' em Hollywood faz a approximação des
'touristes' brasileiros e Walt Disney." *Cinearte*
(Rio de Janeiro), vol. 9, no. 403, Nov. 15, 1934,
p. 21 ("Supplemento").

"'Cinearte' em Hollywood faz passar ás mãos de Walt
Disney o bronze de Camondongo Mickey." *Cinearte*,
vol. 9, no. 399, Sept. 15, 1934, p. 26.

Clemons, Walter. "Killing Ground." *Newsweek*, Jan. 1,
1979, p. 60.

"Clifton Meek." *Bridgeport Post*, Aug. 1, 1973, p. 49.

Coleman, Barbara J. "Through the Years We'll All Be
Friends: The 'Mickey Mouse Club,' Consumerism, and
the Cultural Consensus." *Visual Resources: An
International Journal of Documentation*, vol. 14, no. 3,
January 1999, pp. 297-306; repr. in Apgar, *Mickey
Mouse Reader*, pp. 288-298.

*The Collection of the King of Pop / Michael Jackson /
Memorabilia from the Life & Career of Michael
Jackson*. Catalogue for cancelled auction, session VII,
catalogue 5 (Apr. 25, 2009): Julien's Auctions, Beverly
Hills, Calif. (West Hollywood, Calif., 2009).

Collins, Amy Fine. "The Lady, the List, the Legacy." *Vanity
Fair*, April 2004, pp. 260-275, 328-333.

Collins, Bradford R. "Modern Romance: Lichtenstein's
Comic Book Paintings." *American Art*, vol. 17, no. 2,
summer 2003, pp. 60-85.

Colony Theatre advertisements. *New York Times*, Nov.
18, 1928, p. IX5; Nov. 25, 1928, p. X6.

"Colony (Wired)." *Variety*, Nov. 21, 1928, p. 42.

"Comedy Relief." *Art Digest*, Nov. 1, 1932, p. 10.

"The Comic Strip." *Harvard Crimson*, June 9, 1925,
p. 2 (editorial).

Commander U.S. Naval Forces in Europe (Admiral
Harold Stark). *Administrative History of U.S. Naval
Forces in Europe, 1940-1946, vol. 5, The Invasion of
Normandy* (Washington, D.C., 1948).

Cons, Carl. "The Slanguage of Swing Terms the 'Cats'
Use." *Down Beat*, November 1935, 1.

Considine, Bob. "Mickey Mouse's Real Godfather."
World Journal Tribune (New York), Feb. 15, 1967, p. 33.

Cooper, Harry. "Mondrian, Hegel, Boogie." *October*, spring
1998, pp. 119-142.

Crafton, Donald. *Before Mickey: the Animated Film
1898-1928* (Cambridge, Mass., 1982).

Crane, Maurice A. "Miscellany (Vox Bop)." *American
Speech*, October 1958, vol. 33, no. 3, pp. 223-226;
excerpt repr. in Apgar, *Mickey Mouse Reader*, p. 185.

Crane, Melissa. "Mickey & Co. Sails Into South Street
Seaport." Press release, June 5, 1985 (one-page
typescript handout).

Craven, Thomas. *Cartoon Cavalcade* (New York, 1943).

Crazy in Alabama, Produced by Jim Dyer. Directed by Antonio Banderas. 1 hr. 51 min., Columbia Tristar, 1999, DVD.

"A Creative Confab." *Box Office*, July 27, 1935, p. 29.

Crisler, B.R. "Digest of an Indigestible Week." *New York Times*, Sept. 25, 1938, p. IX5.

———. "Film Gossip of the Week." *New York Times*, May 30, 1937, p. X7.

———. "Gossip, of Pictures and People." *New York Times*, July 3, 1938, p. 99.

Cross, Charles R. *Heavier Than Heaven: a Biography of Kurt Cobain* (New York, 2001).

Cross, Gary. *Kids' Stuff: Toys and the Changing World of American Childhood* (Cambridge, Mass., 1997).

Crowther, Bosley. "Fantasia." *New York Times*, Nov. 14, 1940, p. 28.

Cullen, Jim. *The American Dream: A Short History of an Idea That Shaped a Nation* (Oxford and New York, 2003).

"Current Exhibitions." *Philadelphia Public Ledger*, Oct. 26, 1932, p. 7.

Daly, Steve. "Mickey Mouse: The Mighty Mite." *Entertainment Weekly*, Nov. 8, 1996, p. 108.

"Danes Ban 'Mickey Mouse': Censor Calls the Film Creation of Disney Too Macabre." *New York Times*, Feb. 24, 1931, p. 11.

Danto, Arthur C. "Freckles for the Ages," *New York Times Book Review*, Sept. 28, 1985, p. BR12.

———. "Of Time and the Artist," *The Nation*, June 7, 1999, pp. 27-32.

"Day of Giving Finds Room For Traditions of All Kinds," *Los Angeles Times*, Nov. 24, 2000, p. A45.

De Bellis, Jack. *The John Updike Encyclopedia* (Westport, Conn., and London, 2000).

DeCordova, Richard. "The Mickey in Macy's Window: Childhood, Consumerism, and Disney Animation," in Smoodin, ed., *Disney Discourse: Producing the Magic Kingdom* (New York and London, 1994), pp. 203-213, 249-251. Repr. in Apgar, *Mickey Mouse Reader*, pp. 245-260.

Deighton, Len. *Goodbye, Mickey Mouse* (New York, 1982).

Dewey, John. *Art as Experience* (New York, 1934).

"Die verbotene Maus," in the *Lichtspiel Rundschau* supplement to the *Berliner Tageblatt*, July 13, 1930, p. 7.

"Der Micky-Maus-Skandal!!!" *Die Diktatur*, July 1931. Repr. in "Sie sehen Micky Mäuse tanzen ...," *Film-Kurier*, July 28, 1931, p. 1; and in English in Apgar, *Mickey Mouse Reader*, p. 35, and p. 361, in the original German.

Descharnes, Robert (Eleanor R. Morse, transl.). *Salvador Dalí: The Work, The Man* (New York, 1989).

Dickerman, Leah. *Diego Rivera: Murals for The Museum of Modern Art* (New York, 2011).

Dickstein, Morris. *Dancing in the Dark: A Cultural History of the Great Depression* (New York, 2009).

"Disney and Popular Culture Revealed Through Magazine Covers." *Collectors' Showcase*, September 1996, pp. 76-79.

"Disney Awarded Medal." *Motion Picture Herald*, July 6, 1935, p. 43.

"Disney Exhibit at Fogg Will Supplement 4 Feild Lectures: New Display of Original Animated Cartoon Material Collected By Field." *Harvard Crimson*, Feb. 15, 1939, p. 1.

"The Disney Fetish." *Time*, Aug. 9, 1971, p. 16.

"Disney Joins the Masters in Metropolitan; Museum to Show 'Snow White' Watercolor." *New York Times*, Jan. 24, 1939, p. 21.

"Disney Lauds Feild, Expresses Regrets for 'Harvard's Loss': Feild Met Creator of Snow White at Commencement Here Last Year." *Harvard Crimson*, Feb. 10, 1939, p. 1.

"Disney Saga in Museum Exhibition." *Los Angeles Herald and Express*, Nov. 29, 1940.

"Disney v. Oppenheim." *Art in America*, December 1992, p. 25.

Display ad, *Lewiston Daily Sun*, Dec. 19, 1925, p. 10 (for Hotel Knickerbocker).

"Dr. Brill Analyzes Walt Disney's Masterpieces," *Photoplay*, April 1934, p. 92.

Donovan, Mollie, ed. *Westport Schools Permanent Art Collection: Our Art Heritage, A Gift For The Future* (Westport, 1999).

"Dorothy Puder." *Napa Valley Register* (Calif.), Oct. 4, 2007, p. B2. www.napavalleyregister.com/ articles/2007/10/04/obituaries/obituaries/ doc4704837064ac6284377757.txt

Drenger, Daniel. "Art and Life: An Interview with Keith Haring." *Columbia Art Review*, spring 1988, pp. 44-53.

Duffus, R. L. "The Magic of the Disney Films: A Fascinating Book About the Group Art That Sprang from Mickey Mouse." *New York Times*, June 7, 1942, pp. BR1, BR17 (Book Review section).

Dunaway, Donald King. *Huxley in Hollywood* (New York, 1989).

Duncan, Michael. "A Better Mouse Trap." *Art in America*, January 1997, pp. 82-87.

Dundes, Alan, and Manuel R. Schonhorn. "Kansas University Slang: A New Generation?" *American Speech*, October 1963, vol. 38, no. 3, pp. 163-177.

Dykhuizen, George. *The Life and Mind of John Dewey* (Carbondale, Ill., and London, 1973).

Eco, Umberto. *Foucault's Pendulum*. Trans. William Weaver (New York, 1989). From the original, *Il pendolo di Foucault* (Milan, 1988).

"Ed 'Big Daddy' Roth Dies; Created Rat Fink, Visionary Car Designs." *Washington Post*, Apr. 7, 2001, p. B7.

Eggener, Keith L. "'An Amusing Lack of Logic': Surrealism and Popular Entertainment." *American Art*, autumn 1993, vol. 7, no. 5, pp. 31-45.

Eisenstein, Sergei. *Eisenstein on Disney*. Ed. Jay Leyda. (London, 1986).

———. "The Future of the Film." Interview with Mark Segal. *Close Up*, August 1930; repr. in: *Close Up* (Nendeln, Liechtenstein, 1969), vol. 7, pp. 143-144.

———. *Walt Disney* (Strasbourg, France, 1991).

Eisner, Michael. "It's a Small World After All." In *New Perspectives Quarterly*, vol. 8, no. 4, fall 1991, pp. 40-42. "Adapted from a conversation" with the editor, Nathan Gardels).

———. "Planetized Entertainment." *New Perspectives Quarterly*, vol. 12, no. 4, fall 1995, pp. 8-10 (reformatted version of the preceding text), also repr. in Gardels, ed., *The Changing Global Order* (1997).

"Eleven Notables Awarded Honorary Degrees By Yale at Exercises in Woolsey Hall." *New Haven Evening Register*, June 22, 1938, p. 13.

Eliot, Alexander (unsigned). "U.S. Scene." *Time*, Dec. 24, 1934, pp. 24-27.

Engel, Allison. "Spanish Style in the Hollywood Hills." *Renovation Style*, October 2000 ("Great American Homes" feature). www.homeportfolio.com/Get Inspired/GreatAmericanHomes/10.05.00/fulltext.jhtml

"The England of Hollywood: Work on Film of 'Cavalcade'," *London Times*, Oct. 19, 1932, p. 10.

Everett, Walter. *The Beatles as Musicians: The Quarry Men Through Rubber Soul* (New York, 2001).

Eyman, Scott. *Mary Pickford: America's Sweetheart* (New York, 1990).

Fairbrother, Trevor J. "Warhol Meets Sargent at the Whitney." *Arts Magazine*, February 1987, pp. 64-71.

Faith, William Robert. *Bob Hope: A Life in Comedy* (Cambridge, Mass., 2003).

Fanés, Fèlix. "Destino." In Gale, ed., *Dalí & Film* (New York, 2007), pp. 186-195.

———. "Film as Metaphor." In Gale, ed., *Dalí & Film* (New York, 2007), pp. 32-51.

"'Fantasia': Mr. Disney's New Full-Length Film." *London Times*, July 17, 1941, p. 6.

Ferguson, Otis. "Both Fantasy and Fancy," *New Republic*, Nov. 25, 1940, p. 724.

"A Film Character Invades the Latin Quarter" (Acme wire photo). *New York Herald Tribune*, Mar. 8, 1931, Gravure Section (section IX, pt. I), p. 5.

"Films in Home by Television." *Barrier Miner* (Broken Hill, New South Wales, Australia), Apr. 11, 1935, p. 7 (photo and caption).

Fineberg, Jonathan. *Art Since 1940: Strategies of Being* (New York, 1996).

Fineman, Mia. "The Most Famous Farm Couple in the World: Why *American Gothic* Still Fascinates." Slate, June 8, 2005 (online: slate.msn.com/id/2120494).

Forster, E. M. "Does Culture Matter?" In Forster, *Time and Tide* ("Notes on the Way" series), Nov. 16, 1935, pp. 1657-1658; repr. in Forster, *Two Cheers for Democracy* (London, 1951), pp. 100-105.

———. "Happy Ending." *New Statesman*, Nov. 2, 1940, p. 442; repr. as "Ferney" in Forster, *Two Cheers for Democracy* (London, 1951), pp. 348-351.

Foster, Joanna. "The Way Westport Was: John Curry's Murals." *Westport* (Conn.) *News*, Feb. 18, 1987, pp. 12-13.

Foulkes, Llyn, and Ross Simonini. "In the Studio: Llyn Foulkes." *Art in America*, October 2011, pp. 170-177.

———. "Protecting the Kids." Letter to the editor. *Los Angeles Times*, July 6, 1996, p. F6 ("Calendar" section).

"Four Medals Given For American Art," *New York Times*, May 9, 1934, p. 17.

Frankenstein, Alfred. "It is Something of a Jump From Burbank to Pasadena." *San Francisco Chronicle*, Feb. 24, 1946, "This World" section, p. 8.

Frémion, Yves. *Les Nouveaux Petits-miquets* (Paris, 1982).

Friedman, Martin, and Claes Oldenburg. *Oldenburg: Six Themes*, exhibition catalogue: Minneapolis, Walker Art Gallery (Minneapolis, 1975).

Full Metal Jacket. Jan Harlan, prod. Stanley Kubrick, dir. 1 hr. 56 min., 1987, Warner Home Video, DVD.

Gabler, Neal. *Life the Movie: How Entertainment Conquered Reality* (New York, 1998).

———. "Obama: Star of His Own Movie: His 'Celebrity' Comes From an Emotional Identity with Voters, Not From 'Rock Star' Hysteria." *Los Angeles Times*, Aug. 9, 2008, p. A19.

"Gain in Television Is Demonstrated." *New York Times*, July 31, 1935, p. 15.

Gale, Matthew, ed. *Dalí & Film*. Exhibition catalogue, Tate Modern, London, June 1—Sept. 9, 2007, and other venues (New York, 2007).

"Le Gala Mickey Mouse." *Le Figaro*, June 25 and 26, 1935 (two separate stories), both on page 1, and another piece, June 26, 1935, p. 5.

Gardels, Nathan, ed., *The Changing Global Order: World Leaders Reflect* (Malden, Mass., and Oxford, England, 1997).

Garwood, H. P. "Ridiculus Mus." Letter to the editor. *London Times*, Aug. 10, 1933, p. 11.

Gaura, Maria Alicia. "Sonoma Artist Claims 'Monsters, Inc.' a Rip-off: Suit Says Eyeball Character Mike Was Based on His Own Creation." *San Francisco Chronicle*, Nov. 9, 2002, p. A15.

Geissman, Grant, ed. *Mad About the Fifties* (New York, 1997).

"The Genius of Walt Disney: 'World of Fun and Happiness'." *London Times*, Dec. 4, 1935, p. 11.

Ghez, Didier. "The Man with the Golden Touch." *Disney twenty-three*, spring 2012 ("special issue"), 22-26.

———. "Ruthie Tompson." In Ghez, *Walt's People*, vol. 11, pp. 15-31.

Gilmore, Beverly. "Mickey Mouse Goes to College." *Staten Island Advance*, June 24, 1985, p. B1.

Glueck, Grace. "New York Sculptor Says Intrepid Put Art on Moon." *New York Times*, Nov. 22, 1969, p. 19.

"Goblin Music?" *Time*, Mar. 24, 1952, p. 44.

The Godfather II. Produced by Francis Ford Coppola, Gray Frederickson. Directed by Francis Ford Coppola. 3 hr. 20 min., Paramount, 1974, DVD.

"Gold Medals for Walt Disney." *New York Herald Tribune*, July 2, 1935, p. 12 (one of a number of short items under the heading, "News of the Screen").

Goldmark, Daniel, and Yuval Taylor, eds. *The Cartoon Music Book*. Foreword by Leonard Maltin (Chicago, 2002).

Goldstein, Richard. "Elmo R. Zumwalt Jr., Admiral Who Modernized the Navy, Is Dead at 79." *New York Times*, Jan. 3, 2000, p. A17.

Gombrich, Ernst. "The Tyranny of Abstract Art." *Atlantic Monthly*, April 1958, pp. 43-48; repr. as "The Vogue of Abstract Art." In Gombrich, *Meditations on a Hobby Horse: And Other Essays on the Theory of Art* (London, 1963), pp. 143-150, 172-173.

Gordon, Kate, "Pragmatism in Aesthetics." In George Stuart Fullerton, *Essays Philosophical and Psychological in Honor of William James* (New York, 1908), pp. 461-482.

Gracyk, Tim, Hoffmann, Frank. W. *Popular American Recording Pioneers: 1895-1925* (Binghampton, N.Y., 2000).

Grafly, Dorothy. "Animated Cartoon Gives the World An American Art: Slips Into Being Without Benefit of the Orthodox." *Philadelphia Public Ledger*, Oct. 23, 1932, p. 12.

———. "America's Youngest Art." *American Magazine*, July 1933, pp. 336-342.

Grainville, Patrick. "Mickey Monstre." *Les Nouvelles littéraires*, Nov. 3-9, 1978, p. 1.

Grant, Simon. "Hello from 'Sleepy'": Mondrian in London." *Tate Etc.*, no. 20, fall 2010, pp. 112-115.

Grauel, Thane. "Expert Restores Curry's Kings Highway $1 Million Frescos." *Westport* (Conn.) *Minuteman*, July 11, 1996, pp. 3, 10.

Gray, Christopher. "Beaux-Arts Facade and 'Old King Cole' in the Bar." New York Times, Feb. 16, 1997, p. R7 (real estate section).

Green, Abel [a.k.a., "Abel"]. "Colony (Wired)." Variety, Nov. 28, 1932, p. 38.

Green, Rayna. "The Mickey Mouse Kachina." American Art, vol. 5, nos. 1/2, winter-spring 1991, pp. 208-209.

Greene, Graham. "Follow the Fleet / The Peace Film." The Spectator, Apr. 24, 1936, p. 744.

———. The Graham Greene Film Reader: Reviews, Essays, Interviews & Film Stories. Ed. David Parkinson (New York, 1995).

"Great Calendar of U.S. and Canadian Exhibitions." Art Digest, Oct. 15, 1932, p. 25.

"Grim Disney." Time, Feb. 6, 1939, p. 42.

Grove, Grace. Who Was First? The True Story of the Man Who Really Created Micky ... (Grand Junction, Colo., 1985).

Gruelle, Johnny. "The Dwarfies," Good Housekeeping, April 1921, pp. 62-63, 166 (www.michaelbarrier.com/Home%20Page/Dwarfies.htm).

———. Johnny Mouse and the Wishing Stick (Indianapolis, 1922).

"H. L. Reichenbach, Press Agent, Dead." New York Times, July 4, 1931, p. 8.

Hall, Mordaunt. "The Outstanding Pictorial Features of 1933." New York Times, Dec. 31, 1933, p. IX5.

Hall, Patricia. Johnny Gruelle, Creator of Raggedy Ann and Andy (Gretna, La., 1993).

———. Raggedy Ann and More: Johnny Gruelle's Dolls and Merchandise (Gretna, La., 1998).

Handzo, Stephen. "A Narrative Glossary of Film Sound Technology." In Elisabeth Weis and John Belton, eds., Film Sound: Theory and Practice (New York, 1985), pp. 383-426.

Hansen, Miriam. Cinema and Experience: Siegfried Kracauer, Walter Benjamin and Theodor Adorno (Los Angeles, 2011).

———. "Of Mice and Ducks: Benjamin and Adorno on Disney." South Atlantic Quarterly (January 1993), pp. 27-61.

Harman, Fred. "New Tracks in Old Trails." True West, October 1968, pp. 10-11.

Harmetz, Aljean. "30 Mouseketeer Alumni in Reunion." New York Times, Oct. 30, 1980, p. C25.

Harrison, Charles. "Mondrian in London." Studio International, vol. 172, no. 884, December 1966, pp. 286-292 (introduction to set of six reminiscences).

"Harry H. Beall, Publicist, Found Dead in Home." Los Angeles Times, Oct. 3, 1952, p. 6.

"Harsche Is Awarded Medal of American Art Dealers." Chicago Tribune, May 9, 1934, p. 17.

Haskell, Barbara. Claes Oldenburg: Object Into Monument, exhibition catalogue: Pasadena Art Museum, Pasadcena, Calif. (Los Angeles, 1971).

Harthan, John. The History of the Illustrated Book: The Western Tradition (London, 1981).

Harvard Beats Yale 29-29. Produced and directed by Kevin Rafferty. 1 hr. 45 min., Kino International, 2008, DVD.

"Harvard Professors as Well as Students Are Guilty of Hissing, Claims University Theatre: 'Hissing Is a Disturbance and Must Be Kept Down,' Maintains the Theatre Manager." Harvard Crimson, Nov. 29, 1935, p. 1.

Hasford, Gustav. The Short-Timers (New York, 1979).

Havelock, Christine Mitchell. Hellenistic Art: The Art of the Classical World from the Death of Alexander the Great to the Battle of Actium (New York and London, rev. ed., 1981).

Hayes, Carol A. "Cartoon Producer Recalls Early Days." New York Times, Apr. 28, 1985, p. WC24 ("Westchester Weekly" section).

"Headless Statues, Murals Half-Done Will Mark Passing of PWAP." Washington Post, Apr. 23, 1934, p. 15.

Heer, Jeet, and Kent Worcester. A Comics Studies Reader (Jackson, Miss., 2009).

Heide, Robert, and John Gilman. Cartoon Collectibles: Fifty Years of Dime-Store Memorabilia (New York, 1984).

———. "The King of Character Merchandise: Kay Kamen, The Original Disney Salesman Merchandise: Kay Kamen, The Original Disney Salesman Extraordinaire." Collector's Showcase, September 1996, vol. 16, no. 6, pp. 18-20, 22, 28, 30.

"Helen Hayes Wins Film Academy Award." New York Times, Nov. 19, 1932, p. 20.

Heer, Jeet, and Kent Worcester, Arguing Comics Literary Masters on a Popular Medium (Jackson, Miss., 2004).

———. A Comics Studies Reader (Jackson, Miss., 2009).

Heller, Steven. "Drawn and Quartered." Mother Jones, Nov.-Dec. 1996, pp. 32-37.

———. "A Push Pin Miscellany." In Seymour Chwast, The Push Pin Graphic: A Quarter Century of Innovative Design and Illustration. Eds. Steven Heller and Martin Venezky (San Francisco, 2004), pp. 241-250.

Hendrickson, Robert. The Dictionary of Eponyms: Names That Became Words (New York, 1973), pp. 216-218 ("Mickey Mouse").

Henninger, Daniel. "Wonder Land: Holy Sepulcre! 60 Million Buy 'The Da Vinci Code'." Wall Street Journal, May 19, 2006, p. A10.

"Here and There in the Galleries." Art News, Oct. 1, 1938, p. 14.

Herr, Michael. Dispatches (New York, 2009; first ed., 1977).

———. Kubrick (New York, 2000).

Heymann, Curt L. "In Which He Answers a Few Questions On His Hollywood Expedition." New York Times, Jan. 12, 1936, p. IX4.

Hickey, Dave. "Andy's Enterprise: Nothing Special." In Bruce D. Kurtz, ed., Haring, Warhol, Disney (Munich, 1992), pp. 87-95.

Hill, Edwin C. "Mickey Mouse Goes to Hollywood—How Young Artist tamed His Models." Boston Evening American, Aug. 8, 1933, p. 26 ("Human Side of the News") ; repr. in Apgar, Mickey Mouse Reader, pp. 73-75.

Hiller, Harriet. "The Curry Frescoes: An Art Jewel in Westport's Crown," Westport (Conn.) Minuteman, Oct. 10, 1996, pp. 33-34.

Hitt, Jack. "Does the Smell of Coffee Brewing Remind You of Your Mother?" New York Times Magazine, May 7, 2000, pp. 71-74.

Hoberman, Jim. "Harvey Kurtzman's Hysterical Materialism." In John Carlin, et al., Masters of American Comics (Los Angeles and New Haven, 2005), pp. 266-277.

Hockney, David. Letter to the editor. New York Times, Nov. 21, 1999, p. AR2 ("Norman Rockwell: Looking and Wishing," Arts and Leisure section).

Hoek, Els. "Mondrian in Disneyland." Art in America, February 1989, pp. 136-140, 142.

Holden, Stephen. "Dances With Wolves" ("The Pop Life"). New York Times, Dec. 5, 1990, p. C20.

"Holiday Brings Turkey, Mouse." Washington Post, Nov. 24, 2000, A27.

Hollywood Auction 44: Saturday and Sunday May 14-15, 2011 at 11 a.m. PDT (Calabanas, Calif., 2011).

Hollywood Party. Produced by Lewis Lewyn, Harry Rapf. Directed by Richard Boleslawski, et al., 1 hr., 8 min., 1934, MGM.

"Honest Questions With Jeff Foxworthy." Glenn Beck show, CNN television network, Mar. 21, 2008 (edition.cnn.com/TRANSCRIPTS/0803/21/gb.01.html).

"Honor Where Due." Editorial. New York Times, June 13, 1938, p. 18.

Hoover, Bob. "'Snow White' as Young as Ever." Pittsburgh Post-Gazette, July 17, 1987, entertainment section, "Weekend," p. 3.

Horkheimer, Max, and Theodor W. Adorno. Dialektik der Aufklärung: philosophische Fragmente (Amsterdam, 1947); in English as Dialectic of Enlightenment, trans. John Cumming (New York, 1972; London 1973), and as Dialectic of Enlightenment, ed. Gunzelin Schmid Noerr, trans. Edmund Jephcott (Stanford, 2002).

Horyn, Cathy. "Still Groovy After All These Years." New York Times Magazine, Apr. 16, 2000, 94-100 (with sidebar by Marjorie Rosen, "Footnotes," 100).

"Hotel Purchased on West 45th St." New York Times, Oct. 28, 1944, p. 27.

Hughes, Robert. "A Farewell to the Future That Was." Time, Feb. 16, 1981, pp. 52-53.

———. Nothing If Not Critical: Selected Essays on Art and Artists (New York and London, 1990).

———. "A Roomful of Naked Strangers." Time, Aug. 23, 1983, p. 62.

———. The Shock of the New (New York, 1991).

Hurt, R. Douglas, and Mary K. Dains, eds. Thomas Hart Benton: Artist, Writer and Intellectual (St. Louis, 1989).

Hurter, Albert. He Drew As He Pleased (New York, 1948).

Hutchinson, Bill. "Mock of Mickey Is Pure Evil: Disney's Daughter Rips Hamas Over Monster Mouse." New York Daily News, May 9, 2007, p. 3; repr. in Apgar, Mickey Mouse Reader, pp. 348-349.

Hyde, Nina. "M-I-C-K-E-Y—Why? Because We Like Him." Washington Post, Mar. 10, 1985, p. H3.

Indiana Jones and the Last Crusade. Produced by George Lucas, et al. Directed by Steven Spielberg. 2 hr. 7 min., Paramount, 1989, DVD.

Inge, M. Thomas. Comics as Culture (Jackson, Miss., and London, 1990).

Iwerks, Ub. "Ub Iwerks (1901-1971): Interviewed by Bob Thomas around 1956," in Ghez, ed. Walt's People, vol. 10, pp. 42-45.

Jacobs, Diane. Christmas in July: The Life and Art of Preston Sturges (Los Angeles, 1992).

Jacobs, Lewis, ed. Introduction to the Art of the Movies (New York, 1960).

Jewell, Edward Alden. "American Murals on Display Here." New York Times, Feb. 5, 1935, p. 17.

———. "The Arts of Life in America Are Portrayed in Murals at the New Library at the Whitney Museum." New York Times, Dec. 6, 1932, p. 24.

———. "From Disney to Sheeler: A Week of Diverse Activities Includes Oils and Prints, Fantasy and Realism." New York Times, Dec. 8, 1940, p. 173 (Arts and Leisure section).

Jewett, Eleanor. "'Snow White' Water Colors Are Exquisite." Chicago Tribune, Sept. 28, 1938, p. 17.

———. "Galleries Here Exhibit Disney Water Colors." Chicago Tribune, Oct. 2, 1938, p. F4.

"John Alicoate Dead." New York Times, June 22, 1960, p. 35.

Johnson, Lady Bird. White House Diary (New York, 1970).

Jolis, Alan. "Matisse, Picasso, Disney, and Paloma." Art News, November 1996, p. 122.

Jones, Chuck. Chuck Amuck: The Life and Times of An Animated Cartoonist (New York, 1989).

Junker, Patricia, et al. John Steuart Curry: Inventing the Middle West. Exhibition catalogue: Elvehjem Museum of Art, University of Wisconsin-Madison; Fine Arts Museums of San Francisco; Nelson-Atkins Museum of Art, Kansas City (New York, 1998).

Kaufman, J. B. The Fairest One of All: The Making of Walt Disney's Snow White and the Seven Dwarfs (San Francisco, 2012).

Kehr, Dave. "Fishnets, Race and Religion." New York Times, May 21, 2004, p. E11.

Kendall, M. Sue. "Alien Corn: An Artist on the Middle Border." In Junker, et al., John Steuart Curry (1998), pp. 165-182.

The Killer. Produced by Tsui Hark. Directed by John Woo. 1 hr. 44 min., Criterion, 1989, DVD; the original made-in-Hong Kong version of The Killer was titled Dip Huet Seung Hung.

Kimball, Robert, ed. The Complete Lyrics of Cole Porter (New York, 1983).

Kimmelman, Michael. "Art in Review." New York Times, May 23, 1997, p. C23.

———. "A Little Weirdness Can Help an Artist." New York Times, Aug. 23, 1996, pp. C1, C25.

———. "Real Flesh, Not Perfect or Prurient." New York Times, May 24, 2002, pp. E33, E41.

———. "Renaissance for a 'Lightweight'." New York Times, Nov. 7, 1999, p. AR2 (Arts and Leisure section).

———. "Wayne Thiebaud: Wistful Joy in Soda-Fountain Dreams." New York Times, June 29, 2001, pp. E2, E31.

Kinzer, Stephen. "Wayne Thiebaud: Still Generating Art Rooted in Respect for Painting." New York Times, Jan. 2, 2001, p. F5.

Kisselgoff, Anna. "More of Mozart, With Minnie and Mickey." New York Times, Feb. 29, 1992, p. 11.

Knode, Marilu. Llyn Foulkes: Between a Rock and a Hard Place, exhibition catalogue: Laguna Art Museum, Laguna Beach, Calif. (Los Angeles, 1995).

Koszarski, Richard. Hollywood on the Hudson: Film and Television in New York from Griffith to Sarnoff (Piscataway, N.J., 2010).

Krassner, Paul. "The Disneyland Memorial Orgy." In Krassner, Who's to Say What's Obscene?: Politics, Culture & Comedy in America Today (San Francisco, 2009), pp. 56-63.

Kroc, Ray (with Robert Anderson). Grinding It Out: The Making of McDonald's (Chicago, 1977).

Kuntzman, Gersh. "New Bunny Stamp Bugs Collectors." *New York Post*, May 12, 1997, p. 4.

Kunzle, David. "Introduction to the English Edition." In Dorfman and Mattelart, *How To Read Donald Duck* (1975), pp. 11-21.

Kurtz, Bruce D. "The Radiant Child (Keith Haring)." In Kurtz, ed., *Haring, Warhol, Disney* (Munich, 1992), pp. 143-151.

Kurtzman, Harvey, and Bill Elder. "Mickey Rodent!" *Mad*, no. 19, January 1955, n.p.

Lady Killer. Produced by Henry Blanke. Directed by Roy Del Ruth. 1 hr. 16 min., 1933, on *Warner Gangsters Collection*, vol. 3, Warner Home Video, DVD.

Lamour, Philippe. "The New Art: Mickey Mouse; A Note on the Talking Film." *New Hope*, Sept. 15, 1934, p. 9.

Land. "Ben Bernie." *Variety*, Nov. 10, 1931, p. 58.

———. "Colony (Wired)." *Variety*, Nov. 11, 1931, p. 42.

Lasch, Christopher. *The Culture of Narcissism: American Life in an Age of Diminishing Expectations* (New York, 1979).

"Late Political Rumor Causes Sensation: Curry's Frescoes Receive Enthusiastic Comment Among Westport Artists: Famous Artist Finishing One of Two Frescoes." *Westporter-* (Westport, Conn.) *Herald*, Aug. 31, 1934, pp. 1, 5.

Lawson, Thomas. "Bunk: Eduardo Paolozzi and the Legacy of the Independent Group." In exhibition catalogue (New York: Institute for Contemporary Art, Clocktower Gallery), *Modern Dreams: The Rise and Fall of Pop* (Cambridge, Mass., and London, 1988), pp. 19-29.

"League of Nations Medal For Mr. Disney." *London Times*, June 18, 1935, p. 18.

"Lee Roy Gossett, Cartoonist, Is Dead." *The Chicago Evening Post Magazine of the Art World*, January 19 (or 26?), 1926, p. 15 (from the archives of the Palette and Chisel Club, Chicago).

Lehman, Christopher P. *The Colored Cartoon: Black Representation in American Animated Short Films, 1907-1954* (Amherst, Mass., 2007).

Lejeune, C. A. "Disney's Cartoons." In Lejeune, *Cinema: A Review of Thirty Years' Achievement* (London, 1931), 83-90.

Lenburg, Jeff. *The Encyclopedia of Animated Cartoons* (New York, 1992).

Leslie, Esther. *Hollywood Flatlands: Animation, Critical Theory and the Avant-Garde* (London and New York, 2002).

Levin, Thomas Y. "Iconology at the Movies: Panofsky's Film Theory," *The Yale Journal of Criticism* vol. 9, no. 1, 1996, pp. 27-55.

Lewis, Ryan C. "Much More Than Ragtime: The Musical Life of George Hamilton Green (1893-1970)." PhD diss., School of Music, University of South Carolina, 2009.

Lewis, Sinclair. *It Can't Happen Here* (Garden City, Long Island, 1935).

Leymarie, Jean, and John Updike. *Saul Steinberg: Fifty Works From the Collection of Sivia and Jeffrey Loria* (Verona, Italy, 1995).

Lo Duca, Joseph-Marie. *Le Dessin animé* (Paris, 1948).

Lord, Jeffrey. "An American in Washington." *American Spectator Online*, June 24, 2008 (spectator.org/archives/2008/06/24/an-american-in-washington).

Lorenz, Konrad. "Part and Parcel in Animal and Human Societies." in *Studies in Animal and Human Behavior* (Cambridge, Mass., 1971), vol. 2, pp. 115-195.

———. *Studies in Animal and Human Behavior* (Cambridge, Mass., 1970-1971), 2 vols.

"Lost Disney Cartoon Shows How Mickey Mouse Was Originally Oswald the Lucky Rabbit." *The Daily Telegraph*, Nov. 28, 2011 (online only: www.telegraph.co.uk/culture/tvandradio/8919889/Lost-Disney-cartoon-shows-how-Mickey-Mouse-was-originally-Oswald-the-Lucky-Rabbit.html).

Low, David. *Low's Autobiography* (New York, 1957).

Lynd, Robert S., and Helen Merrell Lynd. *Middletown: A Study in Modern American Culture* (New York, 1929; New York, 1957).

Lynes, Russell. *The Lively Audience: A Social History of the Visual and Performing Arts in America, 1890-1950* (New York, 1985).

Lynn, Kenneth S. *Charlie Chaplin and His Times* (New York, 1997).

M. Produced by Seymour Nebenzal. Directed by Fritz Lang. 1 hr. 50 min., Criterion, 1931, DVD.

MacDonald, W. A. "Yale Throng Pays Tweedsmuir Honor." *New York Times*, June 23, 1938, p. 25.

Madoff, Steven Henry. "Creative Chaos: Recalling the Past 50 Years of American Art—From the Spiritually Sublime to the Subversively Crude." *Time*, Nov. 22, 1999, pp. 97-98.

Mahony, Emma. "And Mickey Came Too." *London Times*, July 15, 2000, "The Times Week" section, p. 25.

Maland, Charles J. *Chaplin and American Culture* (Princeton, 1989).

Maltin, Leonard. "Cartoons and Music: Perfect Partners." In *The Score: The Society of Composers and Lyricists*, vol. 8, no. 2, summer 1993; repr. as the foreword to Daniel Goldmark, Yuval Taylor, eds., *The Cartoon Music Book* (Chicago, 2002), pp. ix-x.

———. *Of Mice and Magic: A History of American Animated Cartoons* (New York and London, 1987, rev. ed.; 1st ed., New York, 1980).

Mano, D. Keith. "A Real Mickey Mouse Operation." *Playboy*, December 1973, pp. 199, 322, 324, 326, 328-330, 332, 334, 336, 338.

Manvell, Roger, and John Huntley. *The Technique of Film Music* (New York, 1957).

"Marcondes Junior em Hollywood," *Cinearte* (Rio de Janeiro), vol. 9, no. 403, Nov. 15, 1934, pp. 14-15, 44.

"Margaret Winkler Mintz; Distributor of Animated Films." *Los Angeles Times*, June 24, 1990, p. 34.

Martin, Douglas. "Edward Roth, Master of Monster Cartoons, Dies at 69." *New York Times*, Apr. 7, 2001, p. B6.

Martin, [Maj.] J. R. *Report No. 147 / Historical Section Canadian Military Headquarters: Part 1: The Assault and Subsequent Operations of 3 Cdn Inf Div and 2 Cdn Armd Bde, 6-30 Jun 44* (Ottawa: Directorate of History, Department of National Defence, Dec. 3, 1945).

Mast, Gerald, ed. *Bringing Up Baby: Howard Hawks, Director* (New Brunswick, N.J., and London, 1988).

McBride, Henry. "Whitney Museum Decorations Still a Subject for Debate." *New York Sun*, Dec. 31, 1932, 22; repr. as "Thomas Hart Benton's Murals at the Whitney Museum," in McBride (Daniel Catton Rich, ed.), *The Flow of Art: Essays and Criticisms* (New Haven, 1997), pp. 295-297.

McDonnell, Patrick, Karen O'Connell, and Georgia Riley de Havenon. *Krazy Kat: the Comic Art of George Herriman* (New York, 1986).

McGuirk, Charles J. "Chaplinitis." *Motion Picture Magazine*, July 1915, 85-89, and August 1915, pp. 121-124.

McNeill, David. "Shifting Sands of Iwo Jima." *New Zealand Herald*, Dec. 31, 2005, p. B12 (originally in *The Independent*, Dec. 27, 2005, pp. 27-28).

McRae, Rick. "'What Is Hip?' and Other Inquiries in Jazz Slang Lexicography." *Notes*, second series, March 2001, vol. 57, no. 3, pp. 575-584.

Meet the People. Produced by E. Y. Harburg. Directed by Charles Reisner. 1 hr. 40 min., MGM, 1944, DVD.

Melvin, Michael J. *Minesweeper, The Role of the Motor Minesweeper in World War II* (Worcester, England, 1992).

Mencken, H. L. *The American Language* (New York, 1936, 4th ed.).

Mendieta, Ana. "Birthplace of a Magic Kingdom." *Chicago Sun-Times*, Dec. 4, 2001, p. 47.

Michener, James A. "The Revolution in Middle-Class Values." *New York Times Magazine*, Aug. 18, 1968, pp. 20-21, 85, 87-88, 90, 92-93, 99; published in book form as *America vs. America: the Revolution in Middle-Class Values* (see next entry).

———. *America vs. America: the Revolution in Middle-Class Values* (New York, 1969).

"Mickey Mouse." *Irish Times*, Oct. 1, 1935, p. 6.

"Mickey Mouse," in R. W. Burchfield, ed., *Supplement to the Oxford English Dictionary* (Oxford, 1987), p. 925.

"Mickey Mouse," *200 Greatest Pop Culture Icons* (VH1/People magazine "Special Collection," New York), July 20, 2003, p. 104.

"Mickey Mouse," *Variety*, Oct. 16, 2005.

"Mickey Mouse, A Friend To Families Around The World, Selected As Grand Marshal For The 2005 Tournament of Roses / The Magical Mouse is the Ideal Grand Marshal for the 2005 Rose Parade, Themed *Celebrate Family*" (press release for the Tournament of Roses), Nov. 16. 2005 (sev. prnewswire.com/entertainment/20041116).

"Mickey Mouse and Minnie Invade Staid Art Gallery."

Buffalo Courier Express, Oct. 1, 1933, section 7, p. 5.

"Mickey Mouse as a 'Revolutionary': A Yugoslav Ban." *London Times*, Dec. 3, 1937, p. 15.

"Mickey Mouse Crashes Big Times, Is Headliner in Albright Gallery." *Buffalo Times*, Oct. 1, 1933 (from clipping in the Walt Disney Archives, Burbank).

"Mickey Mouse Exhibit Will Be Shown Here." *Evansville* (Indiana) *Press*, Dec. 8, 1933, p. 9.

"Mickey Mouse Full-Fledged Producer." *Washington Post*, June 26, 1932, p. A1.

"Mickey Mouse Gets Schools' Backing." *New York Times*, July 16, 1937, p. 21.

"Mickey Mouse in Germany." *New York Times*, Dec. 12, 1931, p. 95.

"'Mickey Mouse' in Trouble: German Censorship." *London Times*, July 14, 1930, p. 12.

"Mickey Mouse Makes the Britannica." *New York Times*, July 29, 1934, p. X2.

"Mickey Mouse Matinee Attraction." *Irish Times*, Apr. 9, 1936, p. 4.

"Mickey Mouse on Exhibition." *Listener*, Feb. 20, 1935, p. 337.

"Mickey Mouse, Pals Will Go 'Highbrow'." *Los Angeles Mesa News*, Nov. 26, 1940.

"Mickey Mouse Reprieved: Exempt From Italian Ban." *London Times*, Nov. 19, 1938, p. 12.

"Mickey Mouse Saves Jersey Toy Concern; Carries It Back to Solvency on His Railway." *New York Times*, Jan. 22, 1935, p. 21.

"Mickey Mouse Scores In Virginia Tech Poll." *Washington Post*, Oct. 23, 1936, p. X13.

"Mickey Mouse Art Show Extended." *New York Morning Telegraph*, June 1, 1933, p. 2.

"'Mickey Mouse' Was Invasion Password." *Johannesburg Sunday Times*, June 11, 1944, p. 1; repr. in Apgar, *Mickey Mouse Reader*, pp. 156-157.

"Mickey Mouse: With Minnie's Aid, Saved Toy Firm." *New York Daily Mirror*, Jan. 22, 1935, p. 14.

"Mickey Mouse's Miraculous Movie Monkey-shines." *Literary Digest*, Aug. 9, 1930, pp. 36-37.

"Mickey Mouse's New Affiliation." *New York Times*, June 26, 1932, p. X3.

"Milestones." *Time*, Oct. 8, 1934, p. 40.

Miller, Stanley [a.k.a., Stanley Mouse]. *Freehand: The Art of Stanley Mouse*. Exhibition catalogue: San Francisco Museum of Modern Art; Detroit Institute of Art; Museum of Fine Arts, Boston; Smithsonian Institution, Washington, D.C.; Museum of Modern Art, New York; Oakland Museum; the Hermitage, Saint Petersburg, Russia (Berkeley, Calif., and Hong Kong, 1993).

Minific, James M. "American Comics Found Making Young Italians Sissies," *Washington Post*, Nov. 12, 1938, p. X1.

"Miss Rose O'Neill, Creator of Kewpie," *New York Times*, Apr. 7, 1944, pp. 19.

"Merchandising: The Mighty Mouse," *Time*, Oct. 25, 1948, pp. 96, 98.

"Modern Museum a Psychopathic Ward as Surrealism Has Its Day," *Art Digest*, Dec. 15, 1936, pp. 5-6.

Modern Times. Produced and directed by Charles Chaplin. 1 hr. 27 min., Warner Home Video, 1936, DVD.

Montagu, Ivor. *With Eisenstein in Hollywood: A Chapter of Autobiography by Ivor Montagu* (New York, 1969).

Morison, Samuel Eliot. *The Invasion of France and Germany 1944-1945* (Boston, 1957), vol. 5, in Morison, *History of United States Naval Operations in World War II*, 15 vols. (1947-1962).

Morrison, Richard. "War Insights From Artist Who Stayed at the Front." *London Times*, Apr. 26, 2003, p. 21.

Mossholder, Robert. "Alice Howell Recalls War Days in France With Walt Disney As Her Chauffeur." *Lincoln Sunday Journal and Star*, (Nebraska), May 13, 1934, p. CD-3.

"Motion Pictures." *Encyclopaedia Britannica* (Chicago, London, and Toronto, 1952), vol. 15, 879 and pl. xviii, facing p. 871.

"Movie of the Week: *Sullivan's Travels*: It Stamps Sturges an Ace Director," *Life*, Jan. 26, 1942, pp. 51-54.

"Mr. Walt Disney: Election to Art Workers Guild." *London Times*, Apr. 20, 1934, p. 12.

"Mr. Walt Disney Has Been Awarded a Diploma by the Academy of Fine Arts of Buenos Aires ..." (untitled news item). *London Times*, Oct. 14, 1933, p. 15.

Munson, Donald. "Westport Artist, John Stuart [sic] Curry, Wins Acclaim." *Bridgeport Post*, Nov. 4, 1934, p. 5.

Murrell, William H. *History of American Graphic Humor* (New York, 1933, 1938), 2 vols.

Muschamp, Herbert. "Playful, Even Goofy, but What Else? It's Disney." *New York Times*, Mar. 5, 1995, p. H34.

Nash, Steven A., and Adam Gopnik. *Wayne Thiebaud: A Paintings Retrospective*. Exhibition catalogue: Fine Arts Museums of San Francisco, June 10, 2000—Sept. 3, 2000 (New York, 2000).

Nater, Carl. "Interviewed by Dave Smith on October 7, 1972." In Ghez, *Walt's People* (2011), vol. 11, pp. 138-151.

"The Nation's Honor Roll for 1930." *The Nation*, Jan. 7, 1931, p. 8.

"A New Art in the Making." *Art News*, vol. 31, no. 15, Jan. 7, 1933, p. 221.

"New British Army Slang Less Colorful Than Old." *New York Times*, Apr. 6, 1941, p. 30; repr. in Apgar, *Mickey Mouse Reader*, p. 155.

"New Films in London." *London Times*, July 1934, p. 10.

"The New Order of Critical Values—In Which Ten of the Modern Critics of America Are Allowed to Substitute New Laurels For Old." *Vanity Fair*, April 1922, pp. 40-41.

Niepold, Mary Martin. "Mickey Is the Newest Hook Look." *Philadelphia Inquirer*, Dec. 9, 1985, p. L1.

Night Must Fall. Produced by Hunt Stromberg. Directed by Richard Thorpe. 1 hr. 56 min., MGM/UA Home Video, 1937, VHS.

Norman, Floyd. "Toon Tuesday: Getting a Head with Blaine Gibson." JimHillMedia.com, June 24, 2008 (jimhillmedia.com/blogs/floyd_norman/archive/2008/06/24/toon-tuesday-getting-a-head-in-the-game-with-blaine-gibson.aspx).

North, Michael. *Machine-Age Comedy* (Oxford and New York, 2009).

"Normandie Sails For A New Record; Eastbound Mark Due to Fall Under Ship's 28-Knot Pace—1,500 Persons Aboard." *New York Times*, June 8, 1935, p. 17.

"Notes." *Time*, Oct. 15, 1923, p. 16.

"November First Set as Tentative Date for Formal Unveiling of Curry Murals at Bedford Jr. High." *Westporter-Herald* (Conn.), Oct. 9, 1934, p. 1.

Nugent, Frank S. "The Music Hall Presents Walt Disney's Delightful Fantasy, 'Snow White and the Seven Dwarfs'—Other New Films at Capitol and Criterion." *New York Times* (Jan. 14, 1938), p. 21 ("The Screen in Review").

"Observations of The Day's Philosopher." *New Day* (New London, Conn), Dec. 8, 1933, p. 6.

"Ocean Travelers." *New York Times*, Aug. 1, 1935, p. 14.

Olmsted, Anna Wetherill. Letter to the editor, *Time*, May 29, 1933, p. 4.

Oldenburg, Claes. *The Mouse Museum, The Ray Gun Wing: Two Collections/Two Buildings*, exhibition catalogue: Museum of Contemporary Art, Chicago, and other venues (Chicago, 1977).

——. *Multiples in Retrospect 1964-1990* (New York, 1991).

"Origin of Mickey Mouse." *Athens Banner-Herald* (Georgia), Dec. 26, 1933, p. 4.

Original Paintings on Celluloid By Walt Disney and His Collaborators on the Film Snow White and the Seven Dwarfs, The. Exhibition catalogue, Leicester Galleries, Nov.-Dec. 1938 (London, 1938).

Orwell, George. *The Collected Essays, Journalism And Letters Of George Orwell*, 4 vols. Edited by Sonia Orwell and Ian Angus (New York, 1968).

O'Sullivan, Judith. *The Great American Comic Strip* (Boston, 1990).

"Outstanding in the Week's News." *Box Office*, Aug. 17, 1935, p. 11.

Pagel, David. "Smelling a 'Rat' in the Motives of Corporate America." *Los Angeles Times*, June 13, 1996, p. F8 ("Calendar" section).

Pang, May. *Instamatic Karma: Photographs of John Lennon* (New York, 2008).

Panofsky, Erwin. "On Movies." *Bulletin of the Department of Art and Archaeology of Princeton University*, June 1936, pp. 5-15.

——. "Style and Medium in the Moving Pictures." *Transition* (Paris), no. 26, February 1937, pp. 121-133.

Parramore, Lynn. *Reading the Sphinx: Ancient Egypt in Nineteenth Century Literary Culture* (New York, 2008).

"Partial List of Traveling Exhibitions for 1934-1935."

Parnassus, March 1934, vol. 6, no. 3, 34, 39.

"Patrick A. Powers, Film Official, Dead." *New York Times*, Aug. 1, 1948, p. 57.

Peary, Gerald, and Danny Peary, eds. *The American Animated Cartoon: A Critical Anthology* (New York, 1980).

Pegolotti, James A. *Deems Taylor: A Biography* (Boston, 2003).

"Le Père de 'Mickey Mouse' à Paris." *Le Figaro*, June 22 and 23 (two stories), 1935, both p. 1.

Perry, George, and Alan Aldridge. *The Penguin Book of Comics* (Harmondshire, England, 1967).

Peter. "Rostropovich Redux." *Semisimple*, Apr. 17, 2006 (feed/www.blogger.com/feeds/3014257/posts/default?start-index=26&max-results=25).

"Phillips Gallery Gives Walt Disney Exhibition." *Washington Post*, Nov. 6, 1938, p. TS6.

"Picking On Santa." *Boston Herald*, Nov. 20, 1933, p. 28.

Plaskin, Glenn. *Horowitz* (New York, 1983).

"Pollen Man." *The New Yorker*, Nov. 1, 1941, p. 14.

Pollitt, J. J. *Art in the Hellenistic Age* (Cambridge, England, and New York, 1986).

Popa, Christopher. "Blue Barron: 'The Music History of Yesterday and Today'." *The Big Band Library*, Feb. 2005 (www.bigbandlibrary.com/bluebarron.html).

Powell, Michael. "The American Wanderer, in All His Stripes." *New York Times*, Dec. 2, 2010, p. WK1.

"The Prince of Wales: Purchase of Goods Made By War-Disabled Men." *London Times*, Nov. 19, 1931, p. 15.

The Princess Comes Across. Produced by Arthur Hornblow, Jr. Directed by William K. Howard. 1 hr. 16 min., Universal, 1936, DVD.

"Prof. Feild Is Out; Harvard Stirred: Man Who Found Walt Disney's Mickey Mouse Was Art Not Reappointed to Faculty." *New York Times*, Feb. 8, 1939, p. 20.

"A Professor Abroad. Europe's 'Tramping Men'." *West Australian* (Perth), Jan. 11, 1934, p. 12.

Purves, Leigh, Nadia Brooks, and Amy Watts Michael. "Jacko: a Man or a Mouse?" *London Daily Star*, Oct. 15, 2005, p. 12.

"Quacky Doodles Hooks Up With Paramount." *Moving Picture World*, Feb. 17, 1917, p. 1050.

Ramsaye, Terry. *A Million and One Nights* (New York, 1926).

"The Real Beverly Hillbilly: With Buddy Ebsen, Actor, Painter, Author." Washingtonpost.com, Sept. 1, 2001 (discuss.washingtonpost.com/wp-srv/zforum/01/entertainment_ebsen090701.htm).

Real Time with Bill Maher, HBO (Home Box Office) weekly cable TV talk show, Sept. 9, 2005 (www.youtube.com/watch?v=VOWe4-KxqMM).

"Reichenbach's Year." *Variety*, Nov. 14, 1928, p. 10.

Reidelbach, Maria. *Completely Mad: A History of the Comic Book and Magazine* (Boston, Toronto and London, 1991).

Reports of the United States Commissioners to the Paris Universal Exposition, 1878 (Washington, D.C., 1880), 5 vols.

Richmond, Ray, and Antonia Coffman, eds. *The Simpsons: A Complete Guide to Our Favorite Family* (New York, 1997).

"Rivera Here, Ready for Painting Show." *New York Times*, Nov. 15, 1931, p. 31.

"Rivera on The Horizon: His Exhibition at Museum of Modern Art Opens This Week." *New York Times*, Dec. 20, 1931, p. X10.

Roberts, Keith. "Current and Forthcoming Exhibitions." *Burlington Magazine*, Oct. 1978, pp. 689-690.

Rooney, Mickey. *Life Is Too Short* (New York, 1991).

"Roosevelt Observes Franklin's Birthday." *New York Times*, Jan. 18, 1934, p. 15.

Rosenfeld, Paul. "Ex-Reading Room," *New Republic*, Apr. 12, 1933, pp. 245-246.

Rosenthal, Andrew. "Reagan Asserts Democrats Would Hinder U.S. Defense." *New York Times*, Sept. 7, 1988, p. A28.

Ross, Douglas T. "Origins of the APT Language for Automatically Programmed Tools." In Wexelblat, ed., *History of Programming Languages* (New York, 1981), pp. 279-367.

"Round the Shops: Clothes as Gifts." *London Times*, Dec. 13, 1934, p. 13.

Sabotage. Produced by Michael Balcon. Directed by Alfred Hitchcock. 1 hr. 16 min., MGM, 1937, DVD.

Sacks, Howard L., and Judith Rose Sacks. *Way Up North in Dixie: A Black Family's Claim to the Confederate Anthem* (Washington, D.C., 1993).

Sam de Vincent Collection of Illustrated American Sheet Music, National Museum of American History, Smithsonian Institution, Washington (#300, Series 7).

Sampson, Henry T. *That's Enough Folks: Black Images in Animated Cartoons, 1900-1960* (Lanham, Md., and London, 1988).

Saving Private Ryan. Produced by Ian Bryce. Directed by Steven Spielberg. 2 hr. 49 min., Universal/DreamWorks, 1998, DVD.

"Says Harvard Will Honor Disney." *New York Times*, June 9, 1938, p. 21.

Schechter, Harold, *The New Gods: Psyche and Symbol in Popular Art* (Bowling Green, Ohio, 1980).

Schickel, Richard. Letter to the editor, *Playboy*, March 1974, p. 12.

Schiller, Justin C., and Dennis M. V. David (Leonard S. Marcus, ed.). *Maurice Sendak: A Celebration of His Work*. Exhibition catalogue: Society of Illustrators, New York, June 11, 2013—Aug. 17, 2013 (New York, 2013).

Schmeckebier, Laurence E. *John Steuart Curry's Pageant of America* (New York, 1943).

Schmidt, Dana Adams. "Navy Will Allow Beer and Beards." *New York Times*, Nov. 13, 1970, p. 1, 11.

Schneider, Steve. *That's All Folks! The Art of Warners Bros. Animation* (New York, 1988).

Schneider, Walther. "Micky Maus ist geisteskrank," *Der Querschnitt*, October 1931, pp. 35-36.

Schlosser, Eric. *Fast Food Nation: The Dark Side of the All-American Meal* (Boston, 2001).

Schrambling, Regina. "Wayne Thiebaud: The Painter of Pies Knows the Real Thing, Too." *New York Times*, June 27, 2001, p. F1.

Schwabsky, Barry. "Joyce Pensato, Max Protetch Gallery," *Artforum*, October 1995, p. 100.

Scize, Pierre (Michel-Joseph Piot). "Le Cinéma." *Jazz: L'actualité intellectuelle*, no. 12, Dec. 15, 1929, pp. 547-548. Repr. in Apgar, *Mickey Mouse Reader*, pp. 12-14 in English, and, pp. 355-357, in the original French (also partially repr. in Bessy, *Walt Disney*, pp. 105-107).

"Screen Notes." *New York Times*, Sept. 28, 1935, p. 13.

Seldes, Gilbert. *The 7 Lively Arts* (New York, 1924) and in a facsimile edition (New York, 2001).

——. *The Movies and The Talkies* (Philadelphia and London, 1929; in the series, "An Hour With").

——. *The Movies Come from America* (New York, 1937).

——. "The 'Vulgar' Comic Strip," in Heer, Worcester, eds., *A Comics Studies Reader* (Oxford, Miss., 2009), pp. 46-52.

Sempé, Jean-Jacques. "La Vie atroce d'un humoriste." *Paris-Match*, March 31, 1962, pp. 113, 118, 122.

Shaw, Arnold. "The Vocabulary of Tin-Pan Alley Explained." *Notes*, second series, vol. 7, no. 1, December 1949, pp. 34, 42.

Shickel, Richard. Letter to the editor. *Playboy*, March 1974, p. 12.

Shikes, Ralph E. *The Indignant Eye: The Artist as Social Critic in Prints and Drawings from the Fifteenth Century to Picasso* (Boston, 1969).

The Shining, Producer and director, Stanley Kubrick. 2 hr. 22 min., 1980, Warner Home Video, DVD.

"Short of the Week." *Time*, Nov. 7, 1932, p. 40.

"Short Subjects." *Film Daily*, Aug. 7, 1927, p. 20.

"Sie sehen Micky Mäuse tanzen ..." *Film-Kurier*, July 28, 1931, p. 1; repr. in English in Apgar, *Mickey Mouse Reader*, as ""You Can See Mickey Mouse Dancing ...," pp. 35-36, and in the orginal German, p. 361.

Simon, George T. *The Big Bands* (New York, 1967; 1981, 4th ed.).

"Sketches Of Dead From U.S. in Crash." *New York Times*, Oct. 29, 1949, p. 3.

"Air Liner Crash in Azores Kills 48." *Los Angeles Times*, Oct. 29, 1949, pp. 1, 6.

Sklar, Robert. "The Making of Cultural Myths: Walt Disney and Frank Capra." In Sklar, *Movie-Made America: A Cultural History of American Movies* (New York, 1975), pp. 197-205.

Skolsky, Sidney. "The Gossipel Truth" ("Hollywood" column). *Chicago Tribune*, June 6, 1934, p. 20.

Slide, Anthony. *Inside the Hollywood Fan Magazine: A History of Star Makers, Fabricators, and Gossip Mongers* (Jackson, Miss., 2010).

Slosberg, Steven. "Uncasville's Brush With Fame." *The Day* (New London, Conn.), Sept. 20, 2001, "Entertainment This Week" section, p. 4.

Smith, David R. "Ub Iwerks, 1901-1971: A Quiet Man Who Left a Deep Mark on Animation." *Funnyworld: The World of Film Animation and Comic Art*, no. 14 (spring 1972), pp. 32-37, 47.

See also: Carl Nater, "Interviewed by Dave Smith on October 7, 1972"

Smith, Edward G. "St. Francis of the Silver Screen," *Progress Today*, January-March 1935, pp. 43-44.

Solomon, Charles. *Enchanted Drawings: The History of Animation* (New York, 1994, rev. ed.).

"Some Early Sound Films: An American Programme." *London Times*, May 12, 1936, p. 10.

Sontag, Susan. "Notes on 'Camp'." In Sontag, *Against Interpretation* (New York, 1964), pp. 275-292.

Sparks, Esther. "A Biographical Dictionary of Painters and Sculptors in Illinois, 1808-1945." PhD diss., Northwestern University, 1971, 2 vols.

Speigelman, Art. *Maus: A Survivor's Tale: II And Here My Troubles Began* (New York, 1991).

"Starred in Cartoons." *Los Angeles Times*, Feb. 3, 1924, p. C16.

Stashower, Daniel. *The Boy Genius and the Mogul: The Untold Story of Television* (New York, 2002).

Stein, Susan R. *The Worlds of Thomas Jefferson at Monticello* (New York, 1993).

Stout, Rex. *Fer-de-Lance* (New York, 1934).

Strauss, William, and Neil Howe. *Generations: The History of America's Future, 1584 to 2069* (New York, 1991).

Sturges, Preston. *Five Screenplays*, Brian Henderson, ed. (Los Angeles and Berkeley, 1986).

Sugarman, Joel S., and Judith Horowitz Richter. Letter to the editor. *New York Times*, Nov. 21, 1999, p. AR2 ("Norman Rockwell: Looking and Wishing," Arts and Leisure section).

Sullivan, Ed. "Broadway." *Washington Post*, Sept. 25, 1935, p. 10.

Sullivan's Travels. Produced by Buddy G. DeSylva. Directed by Preston Sturges. 1 hr. 30 min., Criterion, 1941, DVD.

"Switzers Toy Exhibition now open!" (advertisement), *Irish Times*, Nov. 17, 1930, p. 14.

"A Tale of Six." *Harvard Crimson*, Feb. 17, 1939, p. 2 (editorial probably written by Harry S. Hammond, Jr.); repr. in Apgar, *Mickey Mouse Reader*, pp. 149-150.

"Talk on 'Mickey Mouse' Saturday," *Daily Mail* (Hagerstown, Md.), May 11, 1934, p. 6.

Taylor, Deems. "And tomorrow...." *New York World*, Nov. 4, 1923.

——. *Selected Writings, Selected and Annotated by James Pegolotti* (New York, 2007).

"Teacher Disney." *Time*, Aug. 17, 1942, pp. 49-50.

"Television." *Time*, Mar. 16, 1936, pp. 76-81.

Telotte, J. P. *The Mouse Machine: Disney and Technology* (Champaign, Ill., 2008).

Testa, Vivien. "The Curry Frescoes." 3½–page, unpaginated typescript prepared in 1971 (copy available in a folder labeled "John Steuart Curry" at Westport, Conn. Public Library).

"'That Baboon Baby Dance' Traded for Modern Jazz Record as Concerted Attack on Evolutionary Theory Gets Under Way." *Harvard Crimson*, Nov. 5, 1929, p. 2.

"That Rodent Now Rates a Top Ranking," *Washington Post*, May 17, 1931, p. A4.

Thomas, Bob. *King Cohn: The Life and Times of Harry Cohen* (New York, 1967).

Thomas, Frank, and Ollie Johnston. *Disney Animation: The Illusion of Life* (New York, 1981).

Toland, John. "Living History." Remarks presented to the Tenth International Revisionist Conference, Oct. 1990, *Journal of Historical Review* (www.ihr.org/jhr/v11/v11p--5_Toland.html).

Toliver, Raymond F., and Trevor J. Constable. *Fighter General: The Life of Adolph Galland* (Zephyr Cove, Nevada, 1990).

"Tragedy, Comedy." *Survey Graphic*, February 1935, pp. 58-59.

Tuchman, Maurice. *Art and Technology: Report on the Art & Technology Program of the Los Angeles County Museum of Art, 1967-1971* (New York, 1971).

Turner, Jonathan. "Changing Colors (The Netherlands)." *Art in America*, December 1992, p. 83.

"Ub Iwerks Artist With Disney, Dead." *New York Times*, July 10, 1971, p. 26.

United Press. "Even Mickey Helps." *Piqua* (Ohio) *Daily Call*, June 8, 1944, p. 6.

——. "Mickey Does Bit." *Statesville* (North Carolina) *Daily Record*, June 8, 1944, p. 4.

——. "Mickey Mouse, Big Bad Wolf Reach Walls of Art Museum." *Cleveland Press*, Dec. 14, 1933, p. 14; repr. in Apgar, *Mickey Mouse Reader*, pp. 76-77.

——. "Mickey Mouse Has Invasion Role." *Los Angeles Times*, June 9, 1944, p. 6.

——. "'Mickey Mouse' Used as Invasion Password." *Charleston* (West Virginia) *Daily Mail*, June 8, 1944, p. 6.

——. "'Mickey Mouse,' the Password." *New York Herald Tribune*, June 8, 1944, p. 3.

——. "Yugoslavia Bans Mickey Mouse For Cartoon-Plot Against a King." *New York Herald Tribune*, Dec. 3, 1937, p. 1.

Updike, John. "How to Love America and Leave it at the Same Time." *New Yorker*, Aug. 19, 1972, p. 25.

——. "Introduction," pp. 5-7, in Saul Steinberg, Jean Leymarie, and Updike, *Saul Steinberg: Fifty Works From the Collection of Sivia and Jeffrey Loria*. Exhibition catalogue: Yale University Art Gallery, New Haven, Mar. 22, 1996—June 9, 1996 (New York, 1995).

"The 'Vamp' and Mickey Mouse Join the Museum of Modern Art Film Library." Press Release #46 from the Museum of Modern Art (New York), Dec. 3, 1935.

Van Bruggen, Coosje. *Claes Oldenburg: Mouse Museum/Ray Gun Wing*. Exhibition catalogue: Museum Ludwig, Cologne, Germany, 1979 (Amsterdam, 1979).

——. "The Haunted House: Ghosting." In Claes Oldenburg and Van Bruggen, *A Bottle of Notes and Some Voyages*, exhibition catalogue: Northern Centre for Contemporary Art, Sunderland; The Henry Moore Centre for the Study of Sculpture; Leeds City Art Galleries (Sunderland, 1988).

Varnedoe, Kirk, and Adam Gopnik. *High & Low: Modern Art and Popular Culture*. Exhibition catalogue: Museum of Modern Art, New York, Oct. 7, 1990—Jan. 15, 1991; Art Institute of Chicago, Feb. 20, 1991—May 12, 1991; Museum of Contemporary Art, Los Angeles. June 21, 1991—Sept. 15, 1991 (New York, 1990).

Veress, Laura-Louise. *Clear the Line: Hungary's Attempt to Leave the Axis During the Second World War* (Cleveland, 1995).

"Very Popular Art." *New York Times*, Dec. 16, 1933, p. 14 ("Topics of the Times").

Vest, Rob. "Otto Skorzeny: The Scar-Faced Commando." On Vest's homepage, Indiana University Southeast (homepages.ius.edu/RVEST/SkorzenyDr2.htm).

Vintage Animation Art, auction catalogue (Nov. 19, 1989): Christie's East, New York (New York, 1989).

Visseyrias, Mathilde. "Disney prêt à fermer neuf magasins en France: Il ne resterait que plus que quatre boutiques dans l'Hexagone, dont celle des Champs-Élysées." *Le Figaro*, July 22, 2009, p. 27.

Voltaire and Jefferson: The Sage of Ferney and the Man From Monticello, documentary produced by Dennis Powers and Patrick Ryan (Voltaire Society of America/Films For the Humanities and Sciences, 2001).

Vonnegut, Kurt. "Dear Mr. Vonnegut." *In These Times*, Feb. 28, 2003, at inthesetimes.com, and www.vonnegut.com/times1.asp.

"Vote for Mickey Mouse." *New York Times*, Apr. 1, 1933, p. 17.

Wagner, Walter, ed. *You Must Remember This* (New York, 1975).

"Walt Disney and His Children." *Vanity Fair*, October 1933, p. 26.

"Walt & the Professors." *Time*, June 8, 1942, p. 58.

"Walt Disney Hailed for His Music." *New York Evening Journal*, May 25, 1936, p. 13.

"Walt Disney Honored." *Edwardsville (Ill.) Intelligencer*, July 23, 1935, p. 7.

"Walt Disney, M.S., M.A." *Art Digest*, July 1, 1938, p. 17; repr. in Apgar, *Mickey Mouse Reader*, p. 146.

Walt Disney Presents Fantasia (New York, 1940), a 28-page program for *Fantasia* printed for Walt Disney Productions by the Western Printing and Lithographing Company.

"Walt Disney Retrospective Exhibition." *Worcester Art Museum News Bulletin and Calendar*, April 1942, no. 7, p. 1.

"The Walt Disney World Resort Will Host a Celebration Commemorating the Legacy of Walt Disney." *The Connecticut Traveler* (Connecticut Motor Club), August 2001, p. 15.

Warhol, Andy (Alan Cumming, foreword). *Andy Warhol Men* (San Francisco and London, 2004).

Wattenberg, Daniel. "Groucho Marx: The Hard Work of Making It Look Easy." *Weekly Standard*, May 15, 2000, pp. 31-35.

Werr nimmt denn schon die Liebe ernst. Produced by Curt Melnitz. Directed by Erich Engel. 1 hr. 31 min., Terra-Filmkunst, 1931 (released in the U.S. as *Who Takes Love Seriously*).

Westphal, Ruth, and Janet Blake Dominik, eds. *American Scene Painting: California 1930s and 1940s* (Irvine, Calif., 1991).

Wexelblat, Richard L., ed. *History of Programming Languages* (New York, 1981).

White, David Manning, ed. *Popular Culture* (New York, 1975).

White, Eric Walter. *Walking Shadows: An Essay on Lotte Reiniger's Silhouette Films* (London, 1931).

Whitfield, Eileen. *Pickford: The Woman Who Made Hollywood* (Lexington, Ky., 1997).

"Will Produce Animated Cartoons." *Film Daily*, June 19, 1922, p. 2.

"'Who Is It?' Is Question at Art Reception," *Chicago Tribune*, Dec. 15, 1933, p. 25.

Whyte, Gordon. "Carl Edouarde." *The Metronome*, February 1928, 27, 42-43.

Wise, Terry. *D-Day to Berlin: Armour Camouflage and Markings of the United States, British, and German Armies, June 1944 to May 1945* (London and New York, 1993).

Wodehouse, P. G. *The Luck of the Bodkins* (London, 1935).

——. "Life With Freddie," in Wodehouse, *Plum Pie* (London, 1966).

——. *Pearls, Girls and Monty Bodkin* (London, 1972).

Wolff, Theodore F. "John Steuart Curry: A Critical Assessment." In Junker, et al., *John Steuart Curry* (1998), pp. 77-88.

Worcester, Kent. See Jeet Heer and Kent Worcester

You Can't Take It With You. Produced and directed by Frank Capra. 2 hr. 6 min., Sony Pictures, 1938, DVD.

Zeitlin, Steve. "Strangling Culture With a Copyright Law." *New York Times*, Apr. 25, 1998, p. A15.

Zimmer, William. "Swiss Artist's Symbol of America." *New York Times*, May 17, 1992, CN24 (Connecticut section).

Zischka, Anton E. "Avec Ub Iwerks, père de Mickey Mouse." *Pour Vous*, Nov. 13, 1930, p. 2.

Zumwalt, Jr., Elmo R. "...on the Navy." *New York Times*, Dec. 3, 1977, p. 23; repr. in Apgar, *Mickey Mouse Reader*, pp. 186-187.

——. "Z-gram #57 (Elimination of Demeaning or Abrasive Regulations," Nov. 10, 1970 (www.history.navy.mil/faqs/faq93-57.htm).

WEBSITES

78-L-Digest, www.78online.com: www.78online.com/forum/read.php?f=3&l=2221&t=2221&v=t

Africana (Gateway to the Black World), www.africana.com: "Is Mickey Mouse African American?" undated (accessed Nov. 23, 2003; no longer searchable) www.africana.com/research/blackfacts/bl_fact_199.asp

Ambassador Archive, www.ambassadorarchive.net: www.ambassadorarchive.net/hotel.html

Archives of American Art, Smithsonian Institution, www.aaa.si.edu: www.aaa.si.edu/collections/oralhistories/transcripts/foulke97.htm (Paul Karlstrom's interview with Llyn Foulkes)

Bolerium Books, San Francisco, www.bolerium.com: www.bolerium.com/cgi-bin/bol48/102658.html

The Boston Pops, www.bso.org: www.bso.org/itemB/detail.jhtml?id=600005&area=pop

"Celebrity Caricature" (Smithsonian Institution), www.sil.si.edu/exhibitions/Celeb: www.sil.si.edu/exhibitions/Celeb/gallery08.htm

DisneyDave, "1st Disney character combat insignia." Toons At War, Nov. 25, 2007, toonsatwar.blogspot.com/search?q=1931

Harvard Crimson (the six articles cited herein are also available online): www.thecrimson.com/article.aspx?ref=429029 (June 9, 1925) www.thecrimson.com/article.aspx?ref=257922 (Nov. 5, 1929) www.thecrimson.com/article.aspx?ref=454350

(Nov. 29, 1935)
www.thecrimson.com/article.aspx?ref=460472
(Feb. 10, 1939).
www.thecrimson. com/article.aspx?ref=460537
(Feb. 15, 1939)
www.thecrimson.com/article.aspx?ref=460566
(Feb. 17, 1939).
International Movie Database: www.imbd.com
Jasmin Lucas (personal web page, accessed fall 2003),
 www.personal.psu.edu/users/j/t/jtl157
John Alden Carpenter Collection (Music Division,
 Library of Congress), findingaids.loc.gov
Lyrics World, ntl.matrix.com.br/pfilho/html/top40/1936.
 html ("Top Hits of 1936")
New Yorker online "Cartoon Bank," www.cartoonbank.com
Percussive Arts Society, www.pas.org:
 www.pas.org/Museum/Gerhardt/green.cfm
Royal Air Force: Battle of Britain Memorial Flight 50
 (1957-2007), www.bbmf.co.uk/bomber.html
SteynOnline, www.steynonline.com:
 www.steynonline.com/index2.cfm?edit_id=65
 ("Centenary Special: Dorothy Fields Song of the Day")
Tate Gallery, www.tate.org.uk:
 www.tate.org.uk/servlet/ViewWork?cgroupid=999
 999961&workid=11347&searchid=8344 (Eduardo
 Paolozzi)
Traditional Fine Arts Organization, www.tfaoi.com:
"Re/Righting History: Counternarratives in African-
 American Art," posted March 1999 by the Katonah
 Museum of Art, www.tfaoi.com/newsm1/n1m131.htm
Wikipedia, en.wikipedia.org:
 "Berliner Tageblatt"
 "Disney Store"
 "The Disneyland Memorial Orgy"
 "Jazz royalty"
 "The Performo Toy Company"
 "Harry Reichenbach"
 "September Morn"

INDEX

IMAGE CREDITS

All images courtesy of The Walt Disney Archives in Burbank, California, with the following exceptions:

Ad Vercruijsse: 220, 221
 220, 221: Courtesy of Ad Vercruijsse, www.aviator.nl

American Magazine: 64-65

Angelo State University: 14

AP Images: 231

Art Resource, NY: 49, 55, 234, 244, 254
 49: Image © The Metropolitan Museum of Art. Image source: Art Resource, NY.
 55: Gianni Dagli Orti / The Art Archive at Art Resource, NY
 244: Erich Lessing / Art Resource, NY
 254: Tate, London / Art Resource, NY

Artists' Rights Society: 11, 234, 254, 255, 258, 259, 264-267, 271
 11, 264, 265, 271, 323: © 2013 The Andy Warhol Foundation for the Visual Arts, Inc. / Artists Rights Society (ARS), New York
 234: © 2013 Banco de México Diego Rivera Frida Kahlo Museums Trust, Mexico, D.F. / Artists Rights Society (ARS), New York
 254, 258, 259: © 2013 Trustees of the Paolozzi Foundation, Licensed by DACS / Artists Rights Society (ARS), New York
 255: © Salvador Dalí, Fundació Gala-Salvador Dalí, Artists Rights Society (ARS), New York
 266: © 2013 Artists Rights Society (ARS) New York / PICTORIGHT, Amsterdam

Backstage Magazine: 321

Michael Barrier: 135, 235

Rev. Ed Bergen: 66

Mary Boone Gallery: 260, 280

Barrie Brewer Photography: 210, 232

Bridgeman Art Library: 51

The British Cartoon Archive: 143
 143: University of Kent, Canterbury, Great Britain. © Solo Syndication / Associated Newspapers Ltd.

The British Museum: 314

British Pathé: 184

Steve Brodner: 293

Conde Nast: 10, 17, 138, 178, 182, 222, 273

Corbis images: 5, 154, 171, 195, 206, 287, 306

María Elena Rico Covarrubias: 207, 209
 207, 209: Art © María Elena Rico Covarrubias.

Andreas Deja Collection: 53, 212

Dennis Books: 107, 166

Disney Animation Research Library: 217

Walt Disney Family Foundation: 19, 20, 22, 27, 69, 95, 100, 103-105, 108, 120, 147-148, 151-153, 156, 158-159, 194, 243, 313, 332

Serge Dutfoy: 322

Edison State College, Bob Rauschenberg Gallery: 15
 15: Photograph by Jade Dellinger. Courtesy of the Bob Rauschenberg Gallery, Edison State College, Ft. Myers, Florida

E.C. Publications: 12, 284
 12, 284: MAD #239 ™ and © E.C. Publications, Inc. Used with Permission.

S. M. Eisenstein Scientific-Memorial Cabinet: 146

Lawrence Faden: 307

Felix the Cat Productions: 38
 38: Permission to use image provided courtesy of Don Oriolo and FTCP, Inc. © 2014 and ™ Felix the Cat Productions, Inc.

Le Figaro: 196

Film Daily: 32, 92, 117, 137

Geppi Museum: 111, 118-119, 121

David Gerstein: 31, 198

Getty Images: 16

Didier Ghez: 189

Jean-Marie Grand: 8

Lewis Green, Jr: 134

Hake's Americana: 228

Keith Haring Studio: 263, 270

Heritage Auctions: 190

Billy Ireland Cartoon Library & Museum: 24, 106

Le Journal de Mickey: 291

King Features Syndicate: 56, 89, 109

Les Krims: 269

Leicester Galleries: 246

Matthew Levine: 4

Library of Congress: 61, 205, 230, 250, 283

Rico Lims: 303

Literary Digest: 68

Los Angeles Public Library Photo Collection: 149

Magnum Photos: 305

Laurent Melki: 7

Peter and Cheryl Merolo: 286

Metro Goldwyn Meyer: 173

Metropolitan Museum of Art, New York: 248

Motion Picture Herald: 136

Mouse Studios: 285

Moving Picture World: 37

Musée du Louvre: 55

Museum of Fine Arts, Boston: 294

National Gallery of Art: 262

National Portrait Gallery, Smithsonian Institution: 138, 179

Natural History magazine: 45, 48

The Newsweek / Daily Beast Company LLC: 289
 289: From Newsweek September 5 © 1994 The Newsweek/Daily Beast Company LLC. All rights reserved. Used by permission and protected by the Copyright Laws of the United States. The printing, copying, redistribution, or retransmission of this Content without express written permission is prohibited.

NFA Syndicate: 94

Oldenburg van Bruggen Studio: 261

Outlook & Independent: 60

Pantheon Books: 165
 165: "Book Cover," copyright © 1991 by Pantheon Books, a division of Random House LLC; from Maus II: And Here My Troubles Began by Art Spiegelman. Used by permission of Pantheon Books, an imprint of Knopf Doubleday Publishing Group, a division of Random House LLC. All rights reserved.

Paris-Match: 290, 292

Philip Pearlstein: 308. 309

Mike Peters: 145

Palm Springs Art Museum: 272

Pathé Exchange: 93

Portsmouth City Museum: 225

Private collections: 18, 23, 26, 33, 36, 75, 78, 80, 86, 96, 110, 164, 203, 233, 241, 242, 252, 276, 288, 311

Punch: 197

Michael Ramirez: 144
 144: By permission of Michael Ramirez and Creators Syndicate, Inc.

Reuters: 304

Rob Richards: 9, 151, 168

Robert Risko: 298

Norman Rockwell Family Agency: 320
 320: Printed by permission of the norman Rockwell Family Agency. Copyright © 1960 the Norman Rockwell Family Entities.

Franklin D. Roosevelt Presidential Library & Museum: 176

The Rosenbach Museum & Library: 59, 247

Roy Export SAS: 114, 116, 129, 204

Sacramento Railroad Museum: 183

Santa Barbara Museum of Art: 274

AFTERWORD AND ACKNOWLEDGMENTS

Mickey Mouse: Emblem of the American Spirit had its genesis in 1997 as a twenty-minute slide talk, "The Meaning of Mickey Mouse," in an all-Disney session at the annual convention of the College Art Association in New York. Robert Neuman, an art historian at Florida State University, who chaired the panel, subsequently invited me to write up the presentation for a special issue ("Art History Goes to the Magic Kingdom") he'd been asked to edit for the academic journal *Visual Resources*.

After "The Meaning of Mickey Mouse" appeared in print in 1999, I thought I could easily expand it into a relatively short, illustrated monograph. I pitched the idea to the Yale University Press, where it was accepted in principle, but hung fire for a number of years before—for reasons never fully clear to me—it got the axe. "The Meaning of Mickey Mouse" was followed in November 2003 by "Mickey at Seventy-Five," published in *The Weekly Standard* to mark Mickey's diamond jubilee. Those two articles were the collective germ that sprouted into the present volume.

In August 2011, during a visit to the Walt Disney Family Museum in San Francisco, after my rejection by Yale, I had the good fortune of being introduced to Diane Disney Miller by the museum's Director of Collections, Michael Labrie. I had a set of proposed illustrations for the project with me at the time, and after thumbing through them, Diane turned to Michael and said, "We have to publish this book." And so she did. Without ever telling me what I should write or which images I should choose. "It's your book," she said repeatedly. She also loved the subtitle, "Emblem of the American Spirit." Those words may strike some as banal or simplistic, but—like me—Diane felt that if any single figure embodies the American spirit, it is Mickey Mouse. She must have found his Americanness especially gratifying since Mickey was more closely bound up with the man she called "dad" than any other Disney character or endeavor.

Alas, in November 2013, well before this book went to press, Diane Miller, without whose unstinting support it would not have seen the light of day, passed away. My immense gratitude to her is thus mingled with a great sense of personal loss, and an acute awareness of how sorely she is missed by her husband Ron and the rest of the Miller family. Diane took with her a unique and encyclopedic font of knowledge about her father, the history of the Disney Company, and the people who once worked there. Happily, while she was alive she readily shared with scholars and writers like me the bounty of her knowledge.

Diane and I met and conferred several times between 2011 and the summer of 2013, and we often spoke on the phone and exchanged scores of e-mails. I soon realized that she bore many of Walt's traits. She was down-to-earth and yet visionary, dynamic, driven, and—when required—tough. She was the prime force behind the creation of the Walt Disney Family Foundation, the Walt Disney Family Foundation Press, and the Disney Family Museum. However, she wasn't just her father's daughter, Diane was her mother's daughter, too. She played a pivotal, principled role in ensuring that the Walt Disney Concert Hall in Los Angeles—funded originally, in large part, by Lillian Disney—got built as planned by Frank Gehry, the architect commissioned to design the structure.

In addition to Diane Miller, many individuals, in ways large and small, have been instrumental in helping make this book possible. I am deeply indebted to them all. Chief among them are Margaret Adamic and Maxine Hof at Disney Enterprises, Inc.; Mathew Apgar, Barbara and Keith K. Apgar; Michael Barrier; Ed Bartholomew, Senior Curator at the National Railway Museum, York, England; Kathie Bennewitz; Ludy T. Benjamin, Jr., Ed Bergen; Bill Berkson; Dennis Books; Joseph Bottom; Hervé Cabezas; Joe Campana; Fox Carney at the Walt Disney Animation Research Library, Glendale; Rebecca Cline and her staff at the Walt Disney Archives, Burbank, notably Michael Buckhoff, Kevin Martin Kern, Ed Ovalle, and Steven Vagnini; Roland De Wolk; Ken DellaPenta (indexer par excellence); Lewis Green, Jr.; Wendy Greenhouse; Richard Grell; cartoonists Robert Grossman, Mike Peters, and Michael Ramirez; Shaun O'L. Higgins; Elisabeth Hodermarsky, Associate Curator of Prints, Drawings, and Photographs, Yale University Art Gallery; Benjamin E. Keim; Naum Kleiman, Head of the Eisenstein Scientific-Memorial Cabinet in Moscow; Jim Korkis; Michael Labrie and his colleagues at the Walt Disney Family Museum, Brenda Litzinger and Mark Gibson; Pierre Lambert; David Lesjak; Howard and Paula Sigman Lowery; Peter Merolo; Michael O'Malley; Robert Neuman; John E. Pepper; Michael D. Ryan, Research Assistant at the Toledo Museum of Art; Bernard Shine; Dave Smith; Rog Sphar; Timothy Susanin; and Andrew Whitworth, Military History Curator, Portsmouth Museums & Records Service. Other persons who provided assistance on bibliographic or reference issues, notably librarians and museum curators, are cited in the appropriate endnotes.

As the manuscript progressed through various iterations, it was scrutinized by friends, family, fellow scholars, and Disney devotees, including Gunnar Andreassen, Tony Anselmo, Stephen M. Apgar, Michael Barrier, Rebecca Bedell, Didier Ghez, Dave Smith, Harry Stein, Priscilla Turner, and Steven Wander. It benefited as well from J. B. Kaufman's mastery of both early film and Disney history and David Gerstein's vast knowledge of cartoon art, Golden Age animation, and all things Disney—in particular, Mickey's multitudinous manifestations on film, in comic strips, comic books, and promotional materials. David was hugely helpful in identifying and locating sources for the illustrations. Without his expertise and input the book would have suffered greatly.

Finally, I am indebted to Ron Miller and the Walt Disney Family Foundation, who, along with Diane, helped bring this decade-and-a-half-long project to fruition, and to Roger Shaw, President and Publisher at Weldon Owen, and Mariah Bear, Associate Publisher, for their stalwart devotion to the complex, often-challenging task of making it happen materially.

The Weight

of Water

The Weight

of Water

ANITA SHREVE

DOUBLEDAY DIRECT LARGE PRINT EDITION

LITTLE, BROWN AND COMPANY

BOSTON NEW YORK TORONTO LONDON

This Large Print Edition, prepared especially for
Doubleday Direct, Inc., contains the complete
unabridged text of the original Publisher's Edition.

**This Large Print Book carries the
Seal of Approval of N.A.V.H.**

For my mother and my daughter

Author's Note

During the night of March 5, 1873, two women, Norwegian immigrants, were murdered on the Isles of Shoals, a group of islands ten miles off the New Hampshire coast. A third woman survived, hiding in a sea cave until dawn.

The passages of court testimony included in this work are taken verbatim from the transcript of *The State of Maine* v. *Louis H. F. Wagner.*

Apart from recorded historical fact, the names, characters, places, and incidents portrayed in this work are either the products of the author's imagination or, if real, are used fictitiously.

The matter of who killed Anethe and Karen Christensen was settled in a court of law, but has continued to be debated for more than a century.

The Weight

of Water

I have to let this story go. It is with me all the time now, a terrible weight.

I sit in the harbor and look across to Smuttynose. A pink light, a stain, makes its way across the island. I cut the engine of the small boat I have rented and put my fingers into the water, letting the shock of the cold swallow my hand. I move my hand through the seawater, and think how the ocean, this harbor, is a repository of secrets, its own elegy.

I was here before. A year ago. I took photographs of the island, of vegetation that had dug in against the weather: black sedge and bayberry and sheep sorrel and sea blite. The island is not barren, but it is sere and bleak. It is granite, and everywhere there are ragged reefs that cut. To have lived on Smuttynose would have required a particular tenacity, and I imagine the people then as dug in against the elements, their roots set into the cracks of the rocks like the plants that still survive.

The house in which the two women were murdered burned in 1885, but when I was here a year ago, I photographed the footprint of the house, the marked perimeter. I got into a boat and took pictures of the whitened ledges of Smuttynose and the black-backed gulls that swept and rose above the island in search of fish only they could see. When I was here before, there were yellow roses and blackberries.

When I was here before, something awful was being assembled, but I didn't know it then.

I take my hand from the water and let the drops fall upon the papers in the carton, dampened already at the edges from the slosh. The pink light turns to violet.

Sometimes I think that if it were possible to tell a story often enough to make the hurt ease up, to make the words slide down my arms and away from me like water, I would tell that story a thousand times.

It is my job to call out if I see a shape, a rocky ledge, an island. I stand at the bow and stare into the fog. Peering intently, I begin to see things that aren't really there. First tiny moving lights, then minutely subtle gradations of gray. Was that a shadow? Was that a shape? And then, so shockingly that for a few important seconds I cannot even speak, it is all there: Appledore and Londoners and Star and Smuttynose—rocks emerging from the mist. Smuttynose, all of a piece, flat with bleached ledges, forbidding, silent.

I call out. *Land,* I guess I say.

Sometimes, on the boat, I have a sense of claustrophobia, even when alone on the bowsprit. I have not anticipated this. We are four adults and one child forced to live agreeably together in a space no bigger than a small bedroom, and that space almost always damp. The sheets are damp, my underwear is damp. Rich, who has had

the boat for years, says this is always true of sailing. He gives me the impression that accepting the dampness, even taking a certain pleasure in it, is an indication of character.

Rich has brought a new woman with him whose name is Adaline.

Rich gives instructions. The sailboat is old, a Morgan 41, but well-tended, the teak newly varnished. Rich calls for the boat hook, shouts to Thomas to snag the buoy. Rich slows the engine, reverses it, guns it slightly, maneuvers the long, slim boat—this space that moves through water—alongside the mooring. Thomas leans over, catches the buoy. Adaline looks up from her book. It is our third day aboard the sloop: Hull, Marblehead, Annisquam, now the Isles of Shoals.

The Isles of Shoals, an archipelago, lie in the Atlantic, ten miles southeast off the New Hampshire coast at Portsmouth. The islands measure three and a half miles north and south by one and a half miles east and west. There are nine islands at high tide, eight at low; White and Seavey are connected. The largest island looked to its first residents like a fat pig wallowing in the sea, and hence the

name of Hog. Smuttynose, our destination, derived its name from a clump of seaweed on the nose of a rock extending into the ocean. It has always been an off-putting name, though the others read like poetry from a ship's log: "We passed today the islands of Star and Malaga and Seavey and Londoners; and navigated to our success the treacherous rock of Shag and Eastern and Babb's and Mingo."

In 1635, the Isles of Shoals were formally divided between the Massachusetts Bay Colony, which included Maine, and the territory subsequently to be known as New Hampshire. Duck, Hog, Malaga, Smuttynose, and Cedar went to Maine. Star, Londoners, White, and Seavey went to New Hampshire. The division has always held. In 1635, when the ordinance was first declared, nearly all of the residents of Star fled to Smuttynose, because it was still legal to drink in Maine.

From the guidebooks, I read startling facts: On the island of Star, in 1724, a woman named Betty Moody hid herself and her three children from Indians in a cavern. She crouched near to the ground and held one of the children, an infant girl, tightly to

her breast. Mrs. Moody meant to silence her baby to keep the child from giving away their location, but when the Indians had gone, she discovered that she had smothered the girl.

Rich looks like a wrestler: He is neatly muscled and compact. His head is shaved, and he has perfect teeth. I do not think he resembles Thomas at all—an odd, genetic quirk; there are ten years between them. Rich tickles Billie unmercifully, even on the Zodiac. She squeals as if she were being tortured, and then complains when he stops. Rich walks about the Morgan with athletic grace, and he gives the impression of a man for whom nothing has ever been compli- cated.

We have come only from Annisquam and arrive in the early morning. I watch Thomas bend over the stern to snag the mooring. His legs are pale with whorls of brown hair above the backs of his knees. Over his bath- ing suit, he has on a pink dress shirt, the cuffs rolled to the elbows. It is odd to see Thomas, my husband of fifteen years, en- gaged in chores upon this boat, a second mate to his younger brother. Without his pen or his books, Thomas seems disarmed, dis-

oriented by manual labor. As I watch him, I think, as I so often do, that my husband looks too tall for his surroundings. He seems to have to stoop, even while seated. His hair, cut longish, now nearly colorless, falls forward onto his forehead, and he pushes it away with a gesture I am fond of and have seen a thousand times. Despite his seniority, or perhaps because of it, I sometimes see that Thomas is unsettled by the presence of Rich and Adaline, as a father might be in the company of a grown son and a woman.

What does Adaline think when she observes Thomas? My husband is a poet of the first tier, already a kind of emeritus at the university, even though he is only forty-seven. Adaline is not a poet, but seems to have great admiration for Thomas's work. I wonder if she knew Thomas's verse before, or if she has learned it for the trip.

When there is time, I read about the islands. I carry pounds of paper in my camera bag—guidebooks, accounts of the murders, a trial transcript—materials from Research, who seem to think that I am writing the piece. When the murders occurred, in 1873, the newspapers wrote of the crime, and later

it was called in these same papers "the trial of the century." This is a familiar turn of phrase this summer as we witness a courtroom spectacle that has all but benumbed even the most avid observers. My editor thinks there is a link between the two events: a double murder with a blade, a famous trial, circumstantial evidence that hinges on tiny factual details. As for me, I think the similarities few, but a magazine will make of something what it can. I am paid to take the pictures.

My expense account is lavish, but Rich, who publishes technical journals, will not hear of money. I am glad that Thomas has thought of his younger brother and his boat: I would not like to be in such close quarters with a strange captain or a crew.

How long, I wonder, has Rich been seeing Adaline?

I read many accounts of the murders. I am struck most by the relativity of facts.

When I think about the murders, I try to picture what might have happened that night. I imagine there would have been a gale, and that the wind from the water would have battered against the glass. Sometimes, I can hear that wind and can see the

wooden house under the high cirrus of a full moon. Maren and Anethe would have lain on their backs on either side of the double bed—or could it have been that they were touching?—and in the next room, Karen would have called out suddenly with fright.

Or was it that the dog barked first?

Sometimes I imagine the murders to have been a thing of subtle grace and beauty, with slim arms raised in white nightgowns against the fright, white nightgowns against the snow, the rocks sharp and the gale billowing the thin linen like sheets on a line. I see an arm raised along a window, the moon etching smudges on the panes, and a woman calling to another and another, while below them, at the waterline, the waves slap fast and hard against the dory.

I love to watch my daughter move about the boat in her bathing suit, the fabric stretched and limp, riding high over her butt, her body plump and delicious, often salty if I lick her arm. At five, Billie is entranced by the sloop, a space with lots of cubbyholes and clever places to store the few toys she has been allowed to bring along. She sleeps in the quarter berth beside the companionway. Adaline and Rich are in the forward

cabin, the owner's prerogative. Thomas and I have less privacy, stowed amidships as we are, in the open, on a bed that is put away each morning to become a breakfast table.

Occasionally I find Billie's sandy footprints down below. Sand in the fridge. Does Rich mind? I think not. Billie's hair has lightened in the sun and curls continuously from the damp. More and more, I notice her enlarged pupils and the way they cause her eyes to appear nearly black. She has extravagantly long lashes that exaggerate every blink. The loss of her two top front teeth has widened her grin and produces a delicate lisp.

In the mornings, I can hear Adaline and Rich in the forward cabin: a rustle of cloth, a murmur, rhythmic movements. The sounds from Adaline are surprising—guttural and sometimes frantic. I begin to anticipate the sounds and to move away from them. I go above to the cockpit in my robe. I wonder if Billie would be afraid if she awoke—afraid that Adaline were being hurt.

I think that Evan, who was Anethe's husband, would have moved urgently toward the door on the morning after the murders, reports of the unthinkable pushing him forward in a kind of frenzy. The high cirrus

would have blown out by then, and the sun would have been on the rocks, beginning to melt the snow. Evan would have been the first man inside the door. He would have insisted.

In 1852, Nancy Underhill, a schoolteacher, was sitting on a ledge at Star when a wave washed her into the sea. Her body was found, a week later, at Cape Neddick, in Maine.

This morning, after we have tied up, Adaline stands in the cockpit, her hands at her waist, her eyes searching the shoreline of Smuttynose, as if something profound might reveal itself to her. When she speaks, she has a residue of an Irish accent, and her voice lends her an aura of authority I do not necessarily feel in myself. Her words rise and fall and dip some more, and then come back to where you can hear them—like soft church music, I often think, or like the melodious beat of water on the hull.

Adaline moves like a dancer, swaying for balance. In the mornings, when she comes up the ladder and emerges from the companionway, she seems to glide into the cockpit. She wears long skirts in thin cottons, with blouses that fall loosely around

her hips. She wears a gold cross at her throat, jewelry that is somewhat startling in a woman of her age and stature. The cross draws the eye to the hollow above her clavicle, a hollow that is smooth and tanned. It is as though she once wore the cross as a girl and simply forgot to take it off.

Adaline, Rich tells me, works for Bank of Boston, in an international division. She never talks about her job. I imagine her in suits, standing at gates in airports. She has scars on her wrists, slightly crooked vertical threads in smooth flesh, as though she once tried to trace her veins with a razor or a knife. She has an arresting mouth, with full curved lips of even dimensions, and barely any bow at all.

Sometimes I imagine I can see Maren Hontvedt at the end of her life. In the room in which she is sitting, the wallpaper is discolored but intact. She wears an eyelet cap to cover her hair. I note the languid drape of the shawl folding into her lap, the quiescent posture of her body. The floor is bare, wooden, and on the dresser is a basin of water. The light from the window falls upon her face and eyes. They are gray eyes, not

yet faded, and they retain an expression that others who knew her might recognize.

I think that she is dying and will be gone soon. There are thoughts and memories that she hoards and savors, holding them as one might a yellowed photograph of a child. The skin hangs from her face in folds, her skin a crushed velvet the color of dried hydrangeas. She was not beautiful as a young woman, but her face was handsome, and she was strong. The structure of her face is still as it was, and one can see the bones as one might be able to discern the outline of a chair covered by a loose cloth.

I wonder this: If you take a woman and push her to the edge, how will she behave?

After we moor the boat, Rich offers to take me over to Smuttynose in the Zodiac. Billie begs to go along. I shoot from the dinghy in a crouch, leaning against the side of the boat for balance. I use the Hasselblad and a telephoto with a polarizing lens. From time to time, I shout to Rich to cut the engine so that the vibrations will be lessened, or I gesture with my hand in such a way that he knows to push the throttle forward.

There are two houses on the island. One is a small, wooden-frame house called the

Haley house. It is not habitable, but is of historic note and has a great aesthetic purity. The other is a shack with rudimentary supplies for shipwrecked sailors.

Rich beaches the Zodiac expertly inside the crumbled breakwater of Smuttynose. The beach is tiny, narrow, blackened by dark stones and charred bits of wood. The air is sharp, and I understand why years ago sea air was prescribed as a tonic for the body. Billie removes her life jacket and sits cross-legged on the sand in a lavender T-shirt that doesn't quite cover her belly. Rich is tanned already, an even red-gold on his legs and arms and face. There is a line at his throat. We have left Thomas and Adaline on the Morgan.

In the winter months on the Isles of Shoals, the windows were never opened, nor were the children ever let outside, so that by March the air inside the houses was stale and putrid and old with smoke, and the children could hardly breathe.

Rich takes Billie by the hand and guides her past the breakwater so that he can help her search for mussels among the rocks and put them in her pail. I heft my camera bag onto my shoulder and head out toward the

end of Smuttynose. My plan is to turn around and frame a shot of the entire island. At my destination, the easternmost tip of the island, there is a rock shaped like a horse's fetlock. Inside the square-cut boulders is a sheltered space, a sea cave, that sloshes with water when the tide is high. It is slippery on the rocks, but after I have left my camera bag on a dry ledge and anchored it in a crevice so that the wind will not blow it away, I crawl like a crab to the sea cave and squat inside. On three sides of me are the shoals and roiling water, and straight out to the east nothing but Atlantic Ocean. Unlike the harbor and the place where we have landed, this side of the island is unprotected. There is lichen on the rock, and small flies lift in a frenzy whenever a wave crashes and sprays.

At the rock, which is known as Maren's Rock, I shut my eyes and try to imagine what it would be like to huddle in that cave all night in winter, in the dark, in the snow and freezing temperatures, with only my nightgown and a small black dog for warmth.

I crawl from the rock, scraping my shin in the process. I collect my camera bag, which

has not moved from its notch. I take a roll of color slide film, thirty-six shots of Maren's Rock. I walk the length of the island, the going slow in the thick, scratchy brush.

On January 14, 1813, fourteen shipwrecked Spanish sailors, driven to Smuttynose by a winter gale, tried to reach the light from a candle in an upstairs window of Captain Haley's cottage. They died in a blizzard not forty feet from their destination and are buried under boulders on the island. One man made it to the stone wall, but could go no further. Captain Haley discovered him the following morning. Six more bodies were found on January 17, five more on the twenty-first, and the final body was discovered "grappled up on Hog Island passage" on the twenty-seventh. According to the *Boston Gazette* on January 18, the vessel, named *Conception,* weighed between three and four hundred tons and was laden with salt. No one in America ever knew the dead sailors' names.

When I find Rich and Billie, they are sitting on the beach, their toes dug into the sand. I sit beside them, my knees raised, my arms folded around my legs. Billie gets up and

stares into her pail and begins to leap in stiff-legged jetés all around us.

"My fingers are *bleeding*," she announces proudly. "We pulled off a million of them. At least a million. Didn't we, Uncle Rich?"

"Absolutely. At least a million."

"When we get back to the boat, we're going to cook them up for supper." She bends over her pail again and studies it solemnly. Then she begins to drag the pail down to the water's edge.

"What is she doing?" Rich asks.

"I think she's giving the mussels something to drink."

He smiles. "I once read an account of a pilot who said the most beautiful sight he'd ever seen from the air was the Isles of Shoals." He runs his hand over his shaved head. His skull is perfectly shaped, without bumps or dents. I wonder if he worries about sunburn.

"Adaline seems very nice," I say.

"Yes, she is."

"She admires Thomas's work."

Rich looks away and tosses a pebble. His face is not delicate, in the way that Thomas's is. Rich has dark, thick eyebrows that nearly meet in the center. Sometimes I think

that he has Thomas's mouth, but he doesn't. Rich's is firmer, more pronounced in profile. "Childe Hassam painted here," he says. "Did you know that?"

"I wouldn't have thought that someone who worked for Citibank would know so much about poetry," I say.

"Actually, it's Bank of Boston." He tilts his head and looks at me. "I think poetry is something that's fairly universal, don't you? Enjoying it, I mean."

"I suppose."

"How is Thomas?"

"I don't know. I think he's convinced himself that each poet is given a finite number of words and that he's used up his allotment."

"I notice that he's drinking more," Rich says. Rich's legs are brown and covered with dark hair. Looking at his legs, I contemplate the trick of nature that has caused Thomas and Rich to receive what appear to be entirely separate sets of genes. I glance out toward the sloop, which floats four hundred feet from us in the harbor. The mast teeters in the chop.

"Adaline was married once," Rich says. "To a doctor. They had a child."

I turn to him. He must see surprise on my face.

"I think the girl must be three or four now. The father has her. They live in California."

"I didn't know."

"Adaline doesn't see the girl. She's chosen not to."

I am silent. I try to absorb this information, to put it together with the gold cross and the lilting voice.

"Adaline came over from Ireland for him," he says. "For the doctor."

He leans over and brushes a dried smear of muck from my calf. He smooths my leg with his fingertips. I am thinking that the calf is not a place that anyone touches much. I wonder if he shaves his head every day. What the top of his head would feel like.

"She's kind of detached," he says, withdrawing his fingers. "She doesn't stay with people long."

"How long have you two been together?"

"About five months. Actually, I think my tenure is almost up."

I think of saying to him that to judge by the sounds emanating from the forward cabin, I cannot agree.

In front of us, Billie lies down at the wa-

terline. Mostly, I think, to get sand in her hair. I tense and begin to rise. Rich puts a restraining hand on my wrist.

"She's OK. I've got my eye on her."

I relax a bit and sit back down.

"Did you want something more?" I ask. "From Adaline, I mean."

He shrugs.

"She's very beautiful," I say.

Rich nods. "I've always envied you," he says. "You and Thomas."

He puts his hand to his face to shade his eyes, and he squints in the direction of the boat.

"I don't see anyone in the cockpit," I say.

A few minutes later, I take a photograph of Rich and Billie and her pail of mussels. Rich is lying on the small piece of rough beach, his knees raised, dark circles inside the wide openings of his khaki shorts. The eye is drawn to those dark circles. His arms are spread at his sides in a posture of submission. His head has fallen into a depression in the sand, so that his body seems to end at his neck. Billie is standing over him, perfectly bent at the waist, her arms stretched out behind her for balance, like two tiny wings. She is talking to Rich or ask-

ing him a question. Rich seems vulnerable under her scrutiny. Beside Billie is her green plastic pail of mussels, perhaps enough to make an appetizer for two. Up behind them both is the Haley house, small and old, the trim neatly painted in a dull brick red.

When I look at the photographs, it is hard not to think: We had seventeen hours then, or twelve, or three.

Immediately after the photograph is taken, Rich sits up. He remembers, he tells Billie, that a pirate named Blackbeard once buried his treasure on the island. He gets up and searches through the scrub, examining this branch and that, until he has made two forked sticks. He sets off with Billie while I wait on the beach. After a time—fifteen minutes, twenty?—I hear a cry from Billie. She is calling to me. I get up to look and then walk over to where she and Rich are standing together, about two hundred feet from the beach. Billie and Rich are bent over a hole they have dug in the sand. In the hole is a treasure: five quarters, two dollar bills, a gold-colored toothpick, a chain with a single key attached, a bracelet made of copper wire, and a silver-colored ring. Rich pre-

tends to read the inscription under the band of the ring. "To E from E with undying love."

"What's 'E to E' mean?" Billie asks.

"Blackbeard's real name was Edward, which begins with *E*. And his wife's name was Esmerelda, which also begins with *E*."

Billie ponders this. Rich tells her that the silver ring belonged to Blackbeard's fifteenth wife, whom Blackbeard himself murdered. Billie is nearly levitating with excitement and fright.

The boundaries of the Hontvedt house—also known, before the murders, as simply "the red house"—have been marked with stakes. The boundaries delineate an area approximately twenty feet by thirty-six feet. In this small space were two apartments, separated by a doorless wall. The northwest side of the house had two front doors.

After the brief ride back, I step up onto the Morgan from the Zodiac, Rich catching my hand. Thomas and Adaline are sitting opposite one another, on canvas cushions in the cockpit, seawater dripping from their bodies and making puddles on the floor. They have been swimming, Adaline says, and Thomas seems mildly out of breath.

Adaline has her hands up behind her

head, wringing out her hair. Her bathing suit is red, two vibrant wisps of fire-engine red on glistening skin. Her stomach, a lovely, flat surface the color of toast, seems that of a young girl. Her thighs are long and wet and have drops of seawater among the light brown hairs.

She twists her hair and smiles at me. Her face is guileless when she smiles. I am trying to reconcile the image of her smile with the frantic, guttural sounds that emanate in the morning from the forward cabin.

I remember these moments not solely for themselves, but for the knowledge that beyond these memories lies an instant in time that cannot be erased. Each image a stepping stone taken in innocence or, if not in innocence, then in a kind of thoughtless oblivion.

Rich goes immediately to Adaline and puts a proprietary hand on the flat of her belly. He kisses her on the cheek. Billie, too, takes a step forward, drawn to beauty as any of us are. I see that Billie will find a reason to drape herself across those long legs. With effort, Thomas keeps his eyes on me and asks about our small trip. I am embarrassed for Thomas, for the extraordinary

whiteness of his skin, for his chest, which seems soft. I want to cover him with his blue shirt, which is lying in a puddle.

On March 5, 1873, approximately sixty people lived on all the islands composing the Shoals: the lighthouse keeper's family on White; workmen building a hotel on Star; two families—the Laightons and the Inger-bretsons—on Appledore (formerly known as Hog); and one family, the Hontvedts, on Smuttynose.

We run the Zodiac into Portsmouth. We are hungry and want lunch, and we don't have much in the way of provisions. We sit in a restaurant that has a porch and an awning. It seems as close to the water as one can get in Portsmouth, though I think there is not much to look at beyond the tugs and the fishing boats. A sharp gust of wind catches the awning and lifts it for a second so that the poles that anchor it come off the ground as well. The awning tears loose at one corner and spills its wind. The canvas flaps in the breeze.

"The heavens rent themselves," Thomas says.

Adaline looks up at him and smiles. *"Uncovered orbs and souls."*

Thomas seems surprised. *"Mullioned waters,"* he says.

"Beveled whispers."

"Shuttered grace."

"Shackled sunlight."

I think of Ping-Pong balls hit hard across a table.

Adaline pauses. *"Up-rushed sea,"* she says.

"Yes," Thomas answers quietly.

At the restaurant, Billie eats a grilled cheese sandwich, as she almost always does. She is hard to contain in a restaurant, an effervescence that wants to bubble up and pop out of the top of the bottle. I drink a beer called Smuttynose, which seems to be a brand that capitalizes upon the murders. After all, why not name a beer Appledore or Londoner's? The drink is oak colored and heavier than I am used to, and I think I become slightly drunk. I am not sure about this. The boat itself produces a kind of inebriation that stays with you for hours. Even when you step foot on land, you are still swaying, still feeling the thump of water against the hull.

I read in the guidebooks that America was

discovered at the Isles of Shoals, on Smut-
tynose, by vikings.

On Star Island, there is a cemetery known
as Beebe. In it are buried the three small
daughters of George Beebe who died sep-
arately and within a few days of each other
in 1863 of diphtheria.

At the restaurant I have a lobster roll. Tho-
mas has fried clams. There is a lull in the
conversation, as though the strain of the trip
into the harbor in the Zodiac has drained
everyone of words. Adaline eats a salad and
drinks a glass of water. I notice that her back
is straight while she eats. Rich, by contrast,
is easily slouched, his legs stretched in front
of him. He pushes his chair slightly closer to
Adaline's and begins idly to stroke her arm.

Captain Samuel Haley settled on Smut-
tynose several years before the American
Revolution. While he was building a seawall
to connect Malaga and Smuttynose, he
turned over a rock and discovered four bars
of silver. With this money, he completed the
breakwater and built the pier. The break-
water was destroyed in February 1978.

Edward Teach, also known as the pirate
Blackbeard, spent his honeymoon with his
fifteenth and last wife on the Isles of Shoals

in 1720. He is said to have buried his treasure on Smuttynose.

"Don't tear your napkin."

Thomas's voice is ragged, like the bits of paper on the table.

Adaline gently removes the wad from Billie's fist and picks up the debris around her plate.

"How did you get a name like Billie?" she asks.

"It's Willemina," Billie answers, the name spooling off her lips in a pleased and practiced way.

"I named her for my mother," I say, glancing at Thomas. He drains his wineglass and puts it on the table.

"My mom calls me Billie because Willemina is too old," she adds.

"Fashioned," I say.

"I think Willemina is a pretty name," Adaline says. Her hair is rolled at the sides and caught at the back with a clip. Billie stands on her chair and tilts her head to examine the rolls and the way they seamlessly fold into the nape of Adaline's neck.

Smuttynose is twenty-eight hundred feet east and west, and a thousand feet north and south. It consists of 27.1 acres, almost

all of which is rock. The elevation of the island is thirty feet.

Thomas is thin and stretched, and seems, physically, not to have enough leverage in life. I think that Thomas will probably be thin until he dies, stooped perhaps in the way some tall men become as they age. I know that it will be an elegant stoop. I am sure of that.

I wonder if Thomas is as sad as I am when he awakens in the mornings and hears Adaline and Rich in the forward cabin.

We are waiting for the check to come. Billie is standing next to me, coloring on a place mat. "Were you born in Ireland?" I ask Adaline.

"In the south of Ireland."

The waitress brings the check. Thomas and Rich reach for it, but Thomas, distractedly, lets Rich have it.

"This assignment you're on must be gruesome for you," says Adaline. She begins to massage the back of Billie's neck.

"I don't know," I say. "It seems so long ago. Actually, I wish I could get my hands on some old photographs."

"You seem to have a lot of material," Thomas says.

"It was foisted upon me," I say, wondering why my voice contains a defensive note. "Though I must confess I find the accounts of the murders intriguing."

Adaline reaches up and removes a gold hair clip from the back of her head. Her hair is multihued, a wood grain that curls slightly in the humidity, as does Billie's. On the boat, Adaline most often wears her hair rolled at the back of her head or at the nape of her neck in intricate knots and coils that can be loosened with a single pin. Today, when she removes the clip, her hair falls the length of her back, swaying with the fall. The settling of all that hair, the surprising abundance of hair springing from a knot no bigger than a peach, seems, at the time, like a trick, a sleight of hand, for our benefit.

I look over at Thomas. He is breathing slowly. His face, which normally has high color, has gone pale. He seems stunned by the simple fall of hair from a knot—as though the image itself, or the memories it evokes, were unwanted news.

I do not have many personal photographs of Thomas. There are dozens of other pictures of him, photos of a public nature: book-jacket portraits, for example, and formal

snapshots in magazines and newspapers. But in my own collection, Thomas has almost always managed to avert his eyes or to turn his head altogether, as if he did not want to be captured on any day at any place in time. I have, for instance, a picture of Thomas at a party at our apartment after Billie was born: Thomas is stooped slightly, speaking with a woman, another poet, who is also a friend. He has seen me coming with the camera, has dipped his head and has brought a glass up to his cheek, almost entirely obscuring his profile. In another photograph, Thomas is holding Billie on a bench in a park. Billie, perched on Thomas's knee, seems already aware of the camera and is smiling broadly and clasping her tiny fists together with delight at this new activity, at this strange face that her mother has put on— one with a moving and briefly flickering eye. Thomas, however, has bent his head into Billie's neck. Only his posture tells the viewer he is the father of the child.

For years I thought that Thomas avoided the camera because he has a scar that runs from the corner of his left eye to his chin— the result of a car accident when he was seventeen. It is not disfiguring, in the way

some scars can be, ruining a face so that you no longer want to look at it; instead, Thomas's scar seems to follow the planes of his face—as though a brush had made a quick stroke, a perfect curve. It is almost impossible not to want to touch that scar, to run a fingertip along its bumpy ridge. But it is not the scar that makes Thomas turn his face away from the camera; it is, I think, that he cannot bear to be examined too closely by a lens. Just as he is not able to meet his eyes for any length of time in a mirror.

I have one photograph of Thomas in which he is not turned away. I took it on the morning after we met. He is standing in front of his apartment building in Cambridge, and he has his hands in the pockets of his trousers. He has on a wrinkled white shirt with a button-down collar. Even in this picture, the viewer can see that Thomas wants to pull away, and that it is with the greatest of effort that he has kept his eyes focused on the camera. He looks ageless in the photograph, and it is only because I happen to know that he is thirty-two that I would not think he was forty-seven or twenty-five. In the picture, one can see that Thomas's hair, which is naturally thin and of no distinct

color, has recently been cut short. I took the picture about nine o'clock in the morning. He looks that morning like someone I have known a long time—possibly since childhood.

We met for the first time, appropriately, in a bar in Cambridge. I was twenty-four, and worked for a Boston paper, assigned recently to Local Sports. I was on my way home from a shoot in Somerville of a high school girls' basketball team, but I needed a bathroom and a pay phone.

I heard his voice before I saw his face. It was low and measured, authoritative and without noticeable accent.

When he finished the reading, he turned slightly to acknowledge a nod, and I could see Thomas's face then in the light. I was struck by his mouth—he had a loose and generous mouth, the only extravagance in a spare face. Later, when I was sitting with him, I saw that his eyes were set closely together, so that I did not think he was classically handsome. His irises, however, were navy and flecked with gold, and he had large pupils, dark circles that seemed to have no protection.

I went to the bar and ordered a Rolling

Rock. I was lightheaded and hollow-stomached from not having eaten anything. It seemed that every time I had thought of eating that day, I had been called to yet another assignment. I leaned against the bar and studied the menu. I was aware that Thomas was standing next to me.

"I liked your reading," I said.

He glanced briefly at me. "Thank you," he said quickly, in the way of a man who has no skill with compliments.

"The poem you read. It was very strong."

His eyes flickered over my face. "It's old work," he said.

The barman brought my Rolling Rock, and I paid for the beer. Thomas picked up his glass, leaving a wet circle on the highly varnished surface of the bar. He took a long swallow and set the glass back down.

"This is a reading?" I asked.

"Tuesday night. Poet's night."

"I didn't know."

"You're not alone."

I tried to signal to the barman, so that I could order a snack.

"Thomas Janes," he said, holding out his hand. I noticed the fingers, long and strong and pale.

He must have seen the confusion on my face.

He smiled. "No, you've never heard of me," he said.

"I don't know poetry very well," I said lamely.

"No apologies."

He had on a white shirt and a complicated cable-knit sweater. Dress slacks. Gray. A pair of boots. I told him my name and that I was a photographer for the *Globe.*

"How did you become a photographer?"

"I saw a show of AP photos once. I left the show and went out and bought a camera."

"The baby falling from the third-story window."

"Something like that."

"And you've been taking pictures ever since."

"It helped to put me through school."

"You've seen a lot of terrible things."

"Some. But I've seen wonderful things, too. I once caught the moment that a father lay down on the ice and pulled his son from a fish hole. You can see the clasped arms of the boy and the man, and the two faces with their eyes locked."

"Where was this?"

"In Woburn."

"It sounds familiar. Could I have seen it?"

"Possibly. The *Globe* bought it."

He nodded slowly and took a long swallow of his drink. "Actually, it's much the same, what you and I are doing," he said.

"And what would that be?"

"Trying to stop time."

The barman beckoned to Thomas, and he walked to a small platform at one end of the room. He leaned on a podium. The audience, to my surprise, grew quiet. There was not even the chink of glasses. Thomas pulled a piece of paper from the pocket of his trousers and said he wanted to read something he had written just that day. There were words that stayed with me: *Wainscot* and *redolent* and *core-stung.*

Later there were a great many glasses on the table, mugs of cut glass that refracted the dregs. There seemed to be endless circles of liquid oak. I thought that nearly half the people in the bar had come to the table to buy Thomas a drink. Thomas drank too much. I could see that even then. He stood and swayed a bit and held the table. I touched him on the elbow. He had no

shame in his drunkenness. He asked me if I would help him get to his car. Already I knew that I would have to drive him home.

A sink with a rusty stain leaned along one wall. A small bed that sagged and was covered with a beige blanket stood in the center. Thomas lay on his back on the bed, which was too short for him. I removed his boots and sat on a chair by the desk. Thomas's feet were white and smooth. His stomach was concave and made a slight hollow under his belt. One of the legs of his trousers had ridden up to expose an inch of skin above his sock. I thought he was the most beautiful man I had ever seen.

When I knew that he was asleep, I slipped a hand into his trouser pocket and removed the folded piece of paper. I took it to the window, where there was a slit in the curtain. I read the poem in the street light.

After a time, I put a finger to the skin at his shin. I traced the scar on his face, and he twitched in his sleep. I put my palm on the place where his belly dipped. The heat of his skin through his shirt surprised me, as though he were running a temperature, as though the inner mechanisms of his body burned inefficiently.

I slipped into the bed and lay beside him. He turned onto his side, facing me. It was dark in the room, but I could see his face. I could feel his breath on my skin.

"You brought me home," he said.

"Yes."

"I don't remember."

"No, I know you don't."

"I drink too much."

"I know." I brought my hand up, as though I might touch him, but I didn't. I laid my hand between our faces.

"Where are you from?" he asked me.

"Indiana."

"A farm girl."

"Yes."

"Seriously?"

"I've been in Boston since I was seventeen."

"School."

"And after."

"The after sounds interesting."

"Not very."

"You don't miss Indiana?"

"Some. My parents are dead. I miss them more."

"How did they die?"

"Cancer. They were older. My mother was

forty-eight when I was born. Why are you asking me these questions?"

"You're a woman in my bed. You're an attractive woman in my bed. Why did you stay here tonight?"

"I was worried about you," I said. "What about your parents?"

"They live in Hull. I grew up in Hull. I have a brother."

"How did you get this?" I reached up and touched the scar on his face.

He flinched, and he turned onto his back, away from me.

"I'm sorry," I said.

"No, it's all right. It's just"

"You don't have to tell me. It's none of my business."

"No." He brought an arm up and covered his eyes. He was so still for so long that I thought he had fallen asleep.

I shifted slightly in the bed with the intention of getting up and leaving. Thomas, feeling the shift, quickly lifted his arm from his eyes and looked at me. He grabbed my arm. "Don't go," he said.

When he rolled toward me, he unfastened one button of my shirt, as though by that gesture he would prevent me from leaving.

He kissed the bare space he had made. "Are you with anyone?"

"No," I said. I put my fingers on his face, but I was careful not to touch the scar.

He unfastened all the buttons. He opened my shirt and laid the white cloth against my arms. He kissed me from my neck to my stomach. Dry lips. Light kisses. He rolled me away from him, pulling my shirt down below my shoulders. He lay behind me, encircling me, pressing his palms into my stomach. My arms were pinned beneath his, and I felt his breath on the nape of my neck. He pushed himself hard against my thigh. I bent my head slightly forward, letting go, letting this happen to me, to us, and I felt his body stretch with mine. I felt his tongue at the top of my spine.

Sometime later that night, I was awakened by a ragged moan. Thomas, naked, was sitting at the edge of the bed, the heels of his hands digging angrily into his eye sockets. I tried to pull his hands away before he injured himself. He fell back onto the bed. I turned on a light.

"What is it?" I asked. "What's wrong?"

"It's nothing," he whispered. "It'll pass."

His jaw was clenched, and his face had

gone a sickly white. It couldn't simply be a hangover, I thought. He must be ill.

He raised his head off the pillow and looked at me. He seemed not to be able to see me. There was something wrong with his right eye. "This will pass," he said. "It's just a headache."

"What can I do for you?" I asked.

"Don't go," he whispered. "Promise me you won't go." He reached for my hand, catching my wrist. He gripped me so tightly, he raised welts on my skin.

I prepared him an ice pack in the tiny kitchen of his apartment and lay down next to him. I, too, was naked. It's possible I slept while he waited out the pain. Some hours later, he rolled over, facing me, and took my hand. He placed my fingers on the scar. His color had returned, and I could see that the headache was gone. I traced the long bumpy curve on his face, as I was meant to do.

"There's something I want to tell you," he said.

In the morning, after our long night together, after the migraine, the first of dozens I would eventually witness, I persuaded him to get up and take me out to breakfast. I

made him pose for a photograph at the front door of the apartment house. At the diner, he told me more about the scar, but the language, I could hear, had already changed, the telling of it was different. I could see that he was composing images, searching for words. I left him with a promise to return in the late afternoon. When I came back, Thomas had still not showered or changed his clothes, and there was an unmistakable exhilaration about him, a flush on his face.

"I love you," he said, getting up from the desk.

"You couldn't possibly," I said, alarmed. I looked over to the desk. I saw white-lined papers covered with black ink. Thomas's fingers were stained, and there was ink on his shirt.

"Oh but I do," he said.

"You've been working," I said, going to him. He embraced me, and I inhaled in his shirt what had become, in twenty-four hours, a familiar scent.

"It's the beginning of something," he said into my hair.

In the restaurant in Portsmouth, Thomas turns slightly and sees that I am watching him.

He reaches across the table. "Jean, do you want a walk?" he asks. "We'll go up to the bookstore. Maybe we'll find some old photographs of Smuttynose."

"Yes, that's right," says Adaline. "You and Thomas go off for a bit on your own. Rich and I will take care of Billie."

Rich stands. My daughter's face is serious, as if she were trying to look older than she is—perhaps eight or nine. I watch her smooth her T-shirt over her shorts.

"Fat repose," Thomas says. He speaks distinctly, but there is, in his voice, which is somewhat louder than it was, the barest suggestion of excitement.

At the next table, a couple turns to look at us.

Adaline reaches around for a sweater she has left on the back of the chair. *"Spaded breasts,"* she says.

She stands up, but Thomas cannot leave it there.

"Twice-bloated oaths on lovers' breath."

Adaline looks at Thomas, then at me. *"The hour confesses,"* she says quietly. *"And leaves him spinning."*

Thomas and I walk up Ceres Street to the center of the town. Thomas seems anxious

and distracted. We pass boutiques, a micro-brewery, a home-furnishings store. In a storefront window, I see my reflection, and it occurs to me there are no mirrors on the boat. I am surprised to see a woman who looks older than I think she ought to. Her mouth is pressed into a narrow line, as if she were trying to remember something impor-tant. Her shoulders are hunched, or perhaps that is simply the way she is standing, with her hands in the pockets of her jeans. She has on a faded navy sweatshirt, and she has a camera bag on her arm. She might be a tourist. She wears her hair short, hastily pushed back behind her ears. On the top of her hair, which is an indeterminate and faded chestnut, there is a thin weave of dew. She wears dark glasses, and I cannot see her eyes.

I am not, on the afternoon we walk up Ceres Street, or even on the evening I first meet Thomas, a beautiful woman. I was never a pretty girl. As my mother once said, in a moment of honesty that I used to resent but now appreciate, my individual features were each lovely or passable in themselves, but somehow the parts had never formed an absolutely coherent whole. There is some-

thing mildly disturbing, I know, in the length
of my face, the width of my brow. It is not
an unpleasant face, but it is not a face that
strangers turn to, have to see. As Thomas's
is, for instance. Or Adaline's.

Thomas and I do not touch as we walk up
Ceres Street. "She seems a pleasant per-
son," I say.

"Yes, she does."

"Billie likes her."

"And Rich."

"He's good with kids."

"Excellent."

"She has a beautiful voice. It's interesting
that she wears a cross."

"Her daughter gave it to her."

At the top of the street, Thomas pauses
for a moment and says, "We could go
back." I misunderstand him and say, looking
at my watch, "We've only been gone ten
minutes."

But he means, *We could go home.*

There are tourists on the street, people
peering into shop windows. We reach the
center of town, the market square, a church,
a tiny mall with benches. We round the cor-
ner and come upon the facade of a tall, brick
building. The windows are long and arched,

multipaned. There is a discreet card in the window.

"That was an interesting game you were playing with Adaline," I say, studying the card for a moment.

"Not really," says Thomas. He leans in toward the window and squints at the sign.

"THE PORTSMOUTH ATHENAEUM," he reads. "READING ROOM OPEN TO THE PUBLIC." He examines the hours listed. He seems to study the card a long time, as though he were having trouble understanding it.

"Who was the poet?" I ask.

"Fallon Pearse."

I look down at my sandals, which are spotted with drops of oil from cooking in the kitchen at home. My jeans have stretched and wrinkled at the tops of my thighs.

"If any place would have archival photographs, this would be it," he says.

"What about Billie?" I ask. We both know, as Rich and Adaline do not, that even a half hour with Billie can be exhausting. All those questions, all that curiosity.

Thomas stands back and scans the building's height. "I'll go back and find Adaline," he says. "I'll give her a hand with Billie. You

see if they've got what you need, and we'll meet back here in, say, an hour?"

Underneath my feet, the ground seems to roll slowly up and away as it sometimes does in children's cartoons.

"Whatever you think," I say.

Thomas peers into the front window as if he might recognize something beyond the drapes. With a casualness and tenderness I suddenly mistrust, he bends and kisses me on the cheek.

Some weeks after Thomas and I met each other in the bar in Cambridge, we parked my car by the waterfront in Boston and walked up a hill toward an expensive restaurant. Perhaps we were celebrating an anniversary—one month together. From the harbor, fog spilled into the street and around our feet. I had on high heels, Italian shoes that made me nearly as tall as Thomas. Behind me, I could hear a foghorn, the soothing hiss of tires on wet streets. It was raining lightly, and it seemed as though we would never make it up the hill to the restaurant, that we were walking as slowly as the fog was moving.

Thomas pressed in on my side. We had been at two bars, and his arm was slung

around my shoulder rather more passionately than gracefully.

"You have a birthmark on the small of your back, just to the right of center," he said.

My heels clicked satisfyingly on the sidewalk. "If I have a birthmark," I said, "it's one I've never seen."

"It's shaped like New Jersey," he said.

I looked at him and laughed.

"Marry me," he said.

I pushed him away, as you would a drunk. "You're crazy," I said.

"I love you," he said. "I've loved you since the night I found you in my bed."

"How could you marry a woman who reminded you of New Jersey?"

"You know I've never worked better."

I thought about his working, the dozens of pages, the continuously stained fingers.

"It's all your doing," he said.

"You're wrong," I said. "You were ready to write these poems."

"You let me forgive myself. You gave this to me."

"No I didn't."

Thomas had on a blazer, his only jacket, a navy so dark it was nearly black. His white

shirt seemed luminescent under the street
lamp, and my eye was drawn to the place
where his shirt met his belt buckle. I knew
that if I put the flat of my hand there, the
fabric of the shirt would be warm to the
touch.

"I've only known you for a month," I said.

"We've been together every day. We've
slept together every night."

"Is that enough?"

"Yes."

I knew that he was right. I put the flat of
my hand against his white shirt at the belt
buckle. The shirt was warm.

"You're drunk," I said.

"I'm serious," he said.

He pressed toward me, backing me insis-
tently into an alleyway. Perhaps I made a
small and ineffectual protest. In the alley,
the tarmac shone from the wet. I was aware
of a couple, not so very unlike myself and
Thomas, walking arm in arm, just past the
narrow opening of the alley. They glanced
in at us with frightened faces as they
passed. Thomas leaned all of his weight
against me, and put his tongue inside my
ear. The gesture made me shiver, and I
turned my head. He put his mouth then on

the side of my neck, licking the skin in long strokes, and suddenly I knew that in that posture he would come—deliberately—to show me that he had become helpless before me, that I was an alchemist. He would make of this an offering of the incontinence of his love. Or was it, I couldn't help but wonder, simply the abundance of his gratitude?

I am trying to remember. I am trying hard to remember what it felt like to feel love.

I enter the building with the tall, arched windows and shut the door behind me. I follow signs upstairs to the library. I knock on an unprepossessing metal door and then open it. The room before me is calm. It has thick ivory paint on the walls, and heavy wooden bookshelves. The feeling of serenity emanates from the windows.

There are two library tables and a desk where the librarian sits. He nods at me as I walk toward him. I am not sure what to say.

"Can I help you with something?" he asks. He is a small man with thinning brown hair and wire glasses. He wears a plaid sport shirt with short, crisp sleeves that stick out from his shoulders like moth's wings.

"I saw the sign out front. I'm looking for

material on the murders that took place out at the Isles of Shoals in 1873."

"Smuttynose."

"Yes."

"Well . . . we have the archives."

"The archives?"

"The Isles of Shoals archives," he explains. "They were sent over from the Portsmouth Library, oh, a while ago. They're a mess, though. There's a great deal of material, and not much of it has been cataloged, I'm sorry to say. I could let you see some of it, if you want. We don't lend out materials here."

"That would be—"

"You'd have to pick an area. A subject."

"Old photographs," I say. "If there are any. Of people, of the island. And personal accounts of the time."

"That would be mostly in diaries and letters," he says. "Those that have come back to us."

"Yes. Letters then. And photographs."

"Have a seat over there at the table, and I'll see what I can do. We're very excited to have the archives, but as you can see, we're a bit short-staffed."

I have then an image of Thomas with Ad-

aline and Billie. Each has a vanilla ice-cream cone. The three of them are licking the cones, trying to control the drips.

Thomas said, "I'll go find Adaline." He did not say, "I'll go find Adaline and Billie," or "Adaline and Rich."

The librarian returns with several books and folders of papers. I thank him and pick up one of the books. It is an old and worn volume, the brown silk binding of which has cracked. The pages are yellowed at the edges, and a few are loose. Images swim in front of me, making an array of new covers on the book. I shut my eyes and put the book to my forehead.

I look at an old geography of the Isles of Shoals. I read two guidebooks printed in the early half of the century. I take notes. I open another book and begin to riffle the pages. It is a book of recipes, *The Appledore Cookbook,* published in 1873. The recipes intrigue me: Quaking Pudding, Hash Made from Calf's Head and Pluck, Whitpot Pudding, Hop Yeast. What is pluck? I wonder.

From the folders the library has given me, papers slide out onto the table, and I can see there is no order to them. Some papers are official documents from the town, li-

censes and such, while others are clearly bills of sale. Still other papers seem to be letters written on a stationery so fragile I am almost afraid to touch them. I look at the letters to decipher the old-fashioned penmanship, and with dismay I realize that the words are foreign. I see the dates: April 17, 1873; November 4, 1868; December 24, 1856; January 5, 1867.

There are a few photographs in the folders. One is a portrait of a family of seven. In the photograph, the father, who has a beard and a full head of hair, is wearing a waistcoat and a thick suit, like a captain of a ship might have. His wife, who has on a black dress with a white lace collar and lots of tiny white buttons, is quite plump and has her hair pulled severely back off her head. Everyone in the photograph, including the five children, appears grim and bug-eyed. This is because the photographer has had to keep the shutter open for at least a minute, during which time no one is allowed to blink. It is easier to maintain a serious expression for sixty seconds than it is a smile.

In one of the folders, various documents seem interspersed with students' papers and what look to be, to judge from the titles,

sermons. There is also a faded, flesh-colored box, a box expensive writing paper might once have come in. Inside the box are pages of writing—spidery writing in brown ink. The penmanship is ornate, almost impossible to make out, even if the words were in English, which they are not. The paper is pink at the edges, slightly stained in one corner. A water stain, I think. Or perhaps even a burn. It smells of mildew. I stare at the flowery writing, which when looked at as a whole makes a lovely, calligraphic design, and as I lift the pages out of the box, I discover that a second set of papers, paper-clipped together, is at the bottom of the box. These pages are written in pencil, on white-lined paper, and bear many erasure marks, which have been written over. They also bear one purple date stamp and several notations: *Rec'd September 4, 1939, St. Olaf's College Library. Rec'd 14.2.40, Oslo, forwarded Marit Gullestad. Rec'd April 7, 1942, Portsmouth Library, Portsmouth, New Hampshire.*

I look at the first set of papers and the second. I note the date at the beginning of each document. I study the signature at the end of the foreign papers and compare it to

the printed name at the end of those written in English.

Maren Christensen Hontvedt.

I read two pages of the penciled translation and set it on my lap. I look at the date stamp and the notations, which seem to tell a story of their own: the discovery of a document written in Norwegian; an attempt to have a translation made by someone at St. Olaf's College; the forwarding of that document to a translator in Oslo; the war intervening; the document and its translation belatedly sent to America and then relegated to a long-neglected folder in the Portsmouth Library. I take a deep breath and close my eyes.

Maren Hontvedt. The woman who survived the murders.

Maren Hontvedt's Document

TRANSLATED FROM THE NORWEGIAN
BY MARIT GULLESTAD

19 September 1899, Laurvig

If it so please the Lord, I shall, with my soul and heart and sound mind, write the true and actual tale of that incident which continues to haunt my humble footsteps, even in this country of my birth, far from those forbidding, granite islands on which a most unforgivable crime was committed against the persons whom I loved most dearly in all the world. I write this document, not in defense of myself, for what defense have those who still live, and may breathe and eat and partake of the Lord's blessings, against those who have been so cruelly struck down and in such a way as I can hardly bear to recall?

There is no defense, and I have no desire to put forth such. Though I must add here that I have found it a constant and continuous trial all these twenty-six years to have been, even by the most unscrupulous manner of persons, implicated in any small way in the horrors of 5 March 1873. These horrors have followed me across the ocean to my beloved Laurvig, which, before I returned a broken and barren woman, was untainted with any scandal, and was, for me, the pure and wondrous landscape of my most treasured childhood memories with my dear family, and which is where I will shortly die. And so I mean with these pages, written in my own hand, while there are some few wits remaining in my decrepit and weakening body, that the truth shall be known. I leave instructions for this document to be sent after my death into the care of John Hontvedt, who was once my husband and still remains so in the eyes of the Lord, and who resides at Sagamore Street in the town of Portsmouth in the state of New Hampshire in America.

The reader will need sometimes to forgive me in this self-imposed trial, for I find I am thinking, upon occasion, of strange and faraway occurrences, and am not altogether in

control of my faculties and language, the for-
mer as a consequence of being fifty-two
years of age and unwell, and the latter ow-
ing to my having completed my last years of
schooling in an interrupted manner.

I am impatient to write of the events of 5
March 1873 (though I would not visit again
that night for anything save the Lord's ad-
monition), but I fear that the occurrences of
which I must speak will be incomprehensible
to anyone who has not understood what
went before. By that I mean not only my own
girlhood and womanhood, but also the life of
the emigrant to the country of America, in
particular the Norwegian emigrant, and most
particularly still, the Norwegian emigrant
who makes his living by putting his nets into
the sea. More is known about those persons
who left Norway in the middle of this century
because the Norwegian land, even with all
its plentiful fjords and fantastical forests,
was, in many inhospitable parts of this coun-
try, unyielding to the ever-increasing popu-
lation. Such dearth of land, at that time,
refused to permit many households even a
modest living in the farming of oats, barley,
mangecorn and potatoes. It was these per-
sons who left all they had behind, and who

set intrepidly out to sea, and who did not stop on the Atlantic shores, but went instead directly inland to the state of New York, and hence from there into the prairie heartland of the United States of America. These are the emigrants of our Norway who were raised as farmers in the provinces of Stavanger and Bergen and Nedenes, and then abandoned all that they had held dear to begin life anew near the Lake of Michigan, and in the states of Minnesota and Wisconsin and in other states. The life of these emigrants was, I believe and am sorry to have to write, not always as they had imagined it to be, and I have read some of the letters from these wretched persons and have heard of the terrible hardships they had to bear, including, for some, the worst trial of all, the death of those they loved most, including children.

As I have not ever had children, I have been spared this most unthinkable of all losses.

In our village, which was Laurvig, and which was well coasted and had a lovely aspect out to the Laurvigsfjord and to the Skaggerak from many vantage points, some families who made their livings from the sea

had gone to America before us. These persons were called "sloopfolk," as they had sailed in sloops in voyages of one to three months, during which some unfortunates perished, and some new life was born. John and I, who had been married but the year, had heard of such folk, though we did not have the acquaintance of any of these persons intimately, until that day in the seventh month of 1867, when a cousin of John's whose name was Torwad Holde, and who is since deceased, set sail for new fishing grounds near to the city of Gloucester, off the coast of the state of Massachusetts in America, fishing grounds that were said to hold forth promise of great riches to any and all who would set their nets there. I must add at this point that I did not believe in such fanciful and hollow promises, and would never have left Laurvig, had not John been, I shall have to say it, *seduced* by the letters of his cousin, Torwad, in particular one letter that I no longer have in my possession but remember in my heart as a consequence of having had to read this letter over and over again to my husband who had not had any schooling because of the necessity of having had to go to sea since the age of

eight. I reproduce that letter here as faithfully as I can.

20 September 1867, the Isles of Shoals

My Dear Cousin,
You will be surprised to hear from me in a place different from that where I last wrote to you. I have moved north from the city of Gloucester. Axel Nordahl, who you may remember visited us last year, came to Gloucester to tell myself and Erling Hansen of the fishing settlement of which he was a part at a place called the Isles of Shoals. This is a small grouping of islands nine miles east of Portsmouth, New Hampshire, which is not far north of Gloucester. I am now residing with Nordahl and his good family on the island of Appledore, and I can report that he has a trawler here, and that he has found a bounty of fish such as I have never seen before in any waters. Indeed, I do not think there are any waters on earth that are so plentiful as these in which he has set his nets. A man can put his hand into this sea and fetch up, with his hand only, more fish than his boat might bear. I am firmly of a mind to remain here through the winter with Nor-

dahl and then burden his family no more as I will build my own cottage on the island of Smutty-Nose, which has a strange name and which is also sometimes known as Haley's Island. When spring comes I will have saved enough dollars from my work with Nordahl to begin such a project. This is a better life, Hontvedt, than that which exists in Laurvig, or in Gloucester, where I was lodged with fifty other fishermen of the fleet and where my wages did not exceed one dollar a day.

I beg of you, John, to share this bounty with me. I beg of you to bring your brother, Matthew, who may be as pleased as I am to fish in these fertile waters. I have selected on this island called Smutty-Nose a house for you to lease. It is a good house, strongly built to withstand the Atlantic storms, and I might have taken up residence there myself if I had already had a family. In the spring, if the Lord permits me to find a wife, I shall move from Appledore so that we may all be a family in the Lord's sight.

If you come, as I am hoping, you must go by coastal ferry to Stavanger, and thence to Shields, England. There you will take the rail to Liverpool where you will join

a great flood of emigrants who will take passage with you on a packet to Quebec, where ships are landing now, preferring to avoid the higher tariffs charged in Boston and New York. For your voyage, you will want fruit wine to alter the taste of the poor water, and dried fish. Grind some coffee and put it in a box. You will also want to bake the flatbrød and pack it in the round tubs you have seen down at the docks, and also cure some cheese. If you have a wife and she is with child, then come before it is her time, as infants do not well survive the journey. Seven perished on my own passage, owing to the diphtheria croup which was a contagion on board. I will tell you in truth, Hontvedt, that the sanitary conditions aboard these ships are very poor, and it is too bad, but on my journey I was well disposed to prayer and to thinking of the voyage as a deliverance. I was seasick all but the last two days, and though I arrived in America very gaunt and thin, and remained so in Gloucester, now I am fat again, thanks to the cooking of Nordahl's wife, Adda, who feeds me good porridge and potato cakes with all the fresh fish you can imagine.

When you are here, we may together

purchase a trawler in the town of Ports-
mouth. Send me news and greet all my
friends there, my mother, and all soskend.

Your cousin and servant unto death, Tor-
wad Holde

May God forgive me, but I confess that I
have truly hated the words of Torwad
Holde's letter and even the man himself,
and I do so wish that this cursed letter had
never come into our house. It was an evil
missive indeed that stole my husband's
common sense, that took us from our home-
land, and that eventuated in that terrible
night of 5 March. Would that this letter, with
its stories I could not credit, this letter that
bore with its envelope strange and fright-
ening stamps, this letter with its tales so
magical I knew they must be lies, been
dropped into the Atlantic Ocean during its
transit from America to Norway.

But I digress. Even with the distance of
thirty-one years, it is possible for me to be-
come overwrought, knowing as I do what
came later, what was to follow, and how this
letter led us to our doom. Yet even in a state
of distress, I must admit to understanding

that a mere piece of paper can not be the instrument of one's undoing. In John, my husband, there was a yearning for adventure, for more than was his lot in Laurvig, desires I did not share with him, so content was I to be still near my family. And also, I must confess, there had been that summer, in the Skaggerak and even in the Kristiania-fjord, a fish plague that had greatly lessened the number of mackerel available to the fisher-folk, and though not a consequence of this, but rather as a result of the importation of fish from Denmark, a simultaneous lowering of the price of herring in Kristiania, which caused my husband, in a more practical manner, to look toward new fishing grounds.

But bringing up a living fish with one's bare hands? Who could be such a blasphemer as to put forth such lies against the laws of nature?

"I will not go to America," I said to Evan on the landing at Laurvig on 10 March 1868.

I believe I spoke in a quavering voice, for I was nearly overcome by a tumult of emotions, chief among them an acute distress at having to leave my brother, Evan Christensen, behind, and not knowing if I would see

him or my beloved Norway ever again. The smell of fish from the barrels on the landing was all around us, and we could as well distinguish the salted pork in wooden cases. We had had to step cautiously to the landing, as all about us the rod iron lay for loading onto the ship, and to my eye, this disarray seemed to have been made by a large hand, that is to say by the hand of God, Who had strewn about the pier these long and rusty spokes. I believe that I have so well remembered the sight of this cargo because I did not want to look up that day at the vessel which would carry me away from my home.

I must say that even today I remain quite certain that souls which take root in a particular geography cannot be successfully transplanted. I believe that these roots, these tiny fibrous filaments, will almost inevitably dry and wither in the new soil, or will send the plant into sudden and irretrievable shock.

Evan and I came to a stopping place amidst the terrible noise and chaos. All about us were sons taking leave of their mothers, sisters parting from sisters, husbands from young wives. Is there any other

place on earth so filled with sweet torment as that of a ship's landing? For a time, Evan and myself stood together in silence. The water from the bay hurt my eyes, and a gust came upon us and billowed my skirt which had become muddied at the hem on the walk to the landing. I beat my fists against the silk, which was a walnut and was cinched becomingly at the waist, until Evan, who was considerably taller than myself, stayed my hands with his own.

"Hush, Maren, calm yourself," he said to me.

I took my breath in, and was near to crying, and might have but for the example of my brother who was steadfast and of great character and who would not show, for all the earth, the intense emotions that were at riot in his breast. My dress, I have neglected to say, was my wedding dress and had a lovely collar of tatting that my sister, Karen, had made for me. And I should mention as well that Karen had not come to the landing to say her farewells as she had been feeling poorly that morning.

The gusts, such as the one that had whipped up my skirt, turned severe, spiriting caps away and pushing back the wide brims

of the bonnets on the women. I could hear the halyards of the sloops slapping hard against their masts, and though the day was fair, that is to say though the sky was a deep and vivid navy, I thought the gusts might presage a gale and that I would be granted a reprieve of an hour or a day, as the captain, I was certain, would not set sail in such a blow. In this, however, I was mistaken, for John, my husband, who had been searching for me, raised his face and beckoned me toward the ship. I saw, even at a distance, that relief softened his squint, and I know that he had been afraid I might not come to the landing at all. Our passage had been paid already—sixty dollars—but I had, for just a moment, the lovely and calming image of two berths, two flat and tiered berths, sailing empty without us.

Evan, beside me, sensing that the fury had left my arms, released my hands. But though my wretchedness had momentarily abandoned me, my sorrow had not.

"You must go with John," he said to me. "He is your husband."

I pause now as if for breath. It is very difficult for me to write, even three decades

later, of my family, who was so cruelly treated by fate.

In our family, Karen was born first and was some twelve years older than myself. She was, it must be said, a plain woman with a melancholy aspect, which I have always understood is sometimes appealing to men, as they do not wish a wife who is so beautiful or lively that she causes in her husband a constant worry, and our Karen was strong, an obedient daughter, and a skilled seamstress as well.

I see us now sitting at my father's table in the simple but clean room that was our living room and dining room and kitchen and where also Karen and I slept behind a curtain, and where we had a stove that gave off a great deal of heat and always made us comfortable (although sometimes, in the winter, the milk froze in the cupboard), and I am struck once again by how extraordinarily different I was from my sister, for whom I had a fond, though I must confess not passionate, regard. Karen had dun eyes that seldom seemed to change their color. She had had the misfortune, from a young age, to have fawn-colored hair, a dull brown that was not tinged with golden highlights

nor ever warmed by the sun, and I remember that every day she fixed it in exactly the same manner, which is to say pulled severely behind her ears, with a fringe at her forehead, and rolled and fastened at the back of her head. I am not certain I ever saw Karen with her hair free and loose except for those occasions when I happened to observe her make herself ready for bed. Normally, Karen, who had great difficulty sleeping, was late to bed and early to rise, and I came to think of her as keeping a kind of watch over our household. Karen did have, however, an excellent figure, and was broad in her shoulders and erect in her posture. She was a tall woman, some five inches taller than myself. I was, if not diminutive, then small in my proportions. Like Karen, I too had broad shoulders, but perhaps a less plain face than hers when I was twenty. I did not possess, however, her obedience, nor her excellence as a seamstress. Though I would say otherwise at the time, I took a foolish pride in this when I was a girl, preferring the world of nature and imagination to that of cloth and needle, and I know that in my heart I set myself up as the more fortunate of us two, and I believed at the

time that if ever I should have a husband, he would be a man who would be drawn to a woman not solely for her domestic skills, which has always seemed to be the measure of a woman, but also for her conversation.

In our family there was only the one other child besides Karen and me, Evan, my brother, who was two years older than myself, and so it happened that we were raised as one, so close were we in age, and so far from Karen. At that time, there were many deprivations visited upon the fisher-folk. Because of the shortness of the fishing season near to our home, our father, in order to feed his family, had sometimes to leave us for months at a time during the winter, to fish not by himself in his skiff, which he preferred and which better suited his independent nature, but rather to join the fishing fleets that sailed along the west coast and further north after the cod and the herring. When our situation was very bad, or it had been a particularly harsh winter, my mother and sometimes my sister had to hire themselves out for washing and for cooking in the boardinghouse for sailors on the Storgata in Laurvig.

But I must here dispel the image of the Christensen family in rude circumstances, hungry and in poverty, for in truth, though we had little in the way of material goods in my early childhood years, we had our religion, which was a comfort, and our schooling, when we could make our way along the coast road into Laurvig, and we had family ties for which in all my years on this earth I have never found a replacement.

The cottage in which we lived was humble but of a very pleasing aspect. It was of wood, painted white, and with a red-tiled roof, as was the custom. It had a small porch with a railing in the front, and one window, to the south, that was made of colored glass. In the rear of our home was a small shed for storing nets and barrels, and in front there was a narrow beach where our father, when we were younger, kept his skiffs.

How many times I have had in my mind the image of leaving Laurvig, and seeing from the harbor, along the coast road, our own cottage and others like it, one and a half stories tall, with such a profusion of blossoms in the gardens around them. This area in Norway, which is in the southeastern

part of the country, facing to Sweden and Denmark, has a mild climate and good soil for orchards and other plants such as myrtle and fuchsia, which were in abundance then and are now. We had peaches from a tree in our garden, and though there were months at a time when I had only the one woolen dress and only one pair of woolen socks, we had fruit to eat and fresh or dried fish and the foods that flour and water go together to make, such as porridge and pancakes and lefse.

I possess so very many wonderful memories of those days of my extreme youth that sometimes they are more real to me than the events of last year or even of yesterday. A child who may grow to adulthood with the sea and the forest and the orchards at hand may count himself a very lucky child indeed.

Before we had reached the age when we were allowed to go to school, Evan and I had occasion to spend a great deal of time together, and I believe that because of this we each understood that in some indefinable manner our souls, and hence our paths, were to be inextricably linked, and perhaps I knew already that whatever fate might befall the one would surely befall the other.

And as regards the outside world, that is to say the world of nature (and the people and spirits and animals who inhabited that tangible world), each of us was for the other a filter. I remember with a clarity that would seem to be extraordinary after so many years (these events having occurred at such a young age) talking with Evan all the long days and into the nights (for is not a day actually longer when one is a child, time being of an illusory and deceptive nature?) as if we were indeed interpreting for each other and for ourselves the mysterious secrets and truths of life itself.

We were bathed together in a copper tub that was brought out once a week and set upon a stand in the kitchen near to the stove. My father bathed first, and then my mother, and then Karen, and lastly, Evan and me together. Evan and I were fearful of our father's nakedness and respectful of our mother's modesty, and so we busied ourselves in another room during the times when our parents used the copper tub. But no such restraints had yet descended upon us as regards our sister, Karen, who would have been, when I was five, seventeen, and who possessed most of the attributes of a

grown woman, attributes that both fright-
ened and amazed me, although I cannot say
it was with any reverence for her person that
Evan and I often peeked behind the curtain
and made rude sounds and in this way tor-
tured our sister, who would scream at us
from the tub and, more often than not, end
the evening in tears. And thus I suppose I
shall have to admit here that Evan and my-
self, while not cruel or mischievous by na-
ture or necessarily to anyone else in our
company, were sometimes moved to tor-
ment and tease our sister, because it was,
I think, so easy to do and at the same time
so enormously, if unforgivably, rewarding.

When our turn for the bath had come, we
would have clean water that had been
heated by our mother in great pots and then
poured into the copper tub, and my brother
and myself, who until a late age had no
shame between us, would remove our cloth-
ing and play in the hot soapy water as if in
a pool in the woods, and I remember the
candlelight and warmth of this ritual with a
fondness that remains with me today.

Each morning of the school year, when
we were younger and not needed to be
hired out, Evan and I rode together in the

wagon of our nearest neighbor, Torjen Helgessen, who went every day into Laurvig to bring his milk and produce to market, and home again each afternoon after the dinner hour. The school day was five hours long, and we had the customary subjects of religion, Bible History, catechism, reading, writing, arithmetic and singing. We had as our texts Pontoppidan's Explanation, Vogt's Bible History and Jensen's Reader. The school was a modern one in many of its aspects. It had two large rooms, one above the other, each filled with wooden desks and a chalkboard that ran the length of one wall. Girls were in the lower room and boys in the upper. Unruly behavior was not allowed, and the students of Laurvig School received the stick when necessary. My brother had it twice, once for throwing chalk erasers at another student, and once for being rude to Mr. Hjorth, a Pietist and thus an extremely strict and sometimes irritating man, who later died during an Atlantic crossing as a result of the dysentery aboard.

In the springtime, when it was light early in the morning, and this was a pearly light that is not known in America, an oyster light that lasts for hours before the sun is actually

up, and so has about it a diffuse and magical quality, Evan and I would wake at daybreak and walk the distance into Laurvig to the school.

✓ I can hardly describe to you the joy of those early morning walks together, and is it not true that in our extreme youth we possess the capacity to see more clearly and absorb more intensely the beauty that lies all before us, and so much more so than in our later youth or in our adulthood, when we have been apprised of sin and its stain and our eyes have become dulled, and we cannot see with the same purity, or love so well?

The coast road hugged at times the very edge of the cliffs and overlooked the Bay, so that on a fine day, to the east of us, there would be the harbor, with its occasional schooners and ferries, and beyond it the sea twitching so blindingly we were almost forced to turn our eyes away.

As we walked, Evan would be wearing his trousers and a shirt without a collar and his jacket and his cap. He wore stockings that Karen or my mother had knit, wonderful stockings in a variety of intricate patterns, and he carried his books and dinner sack,

and sometimes also mine, in a leather strap which had been fashioned from a horse's rein. I myself, though just a girl, wore the heavy dresses of the day, that is to say those of domestic and homespun manufacture, and it was always a pleasure in the late spring when our mother allowed me to change the wool dress for a calico that was lighter in weight and in color and made me feel as though I had just bathed after a long and oppressive confinement. At that time, I wore my hair loose along my back, with the sides pulled into a topknot. I may say here that my hair was of a lovely color in my youth, a light and soft brown that picked up the sun in summer, and was sometimes, by August, golden near the front, and I had fine, clear eyes of a light gray color. As I have mentioned, I was not a tall girl, but I did have a good carriage and figure, and though I was never a great beauty, not like Anethe, I trust I was pleasant to look upon, and perhaps even pretty for several years in my late youth, before the true responsibilities of my journey on earth began and altered, as it does in so many women, the character of the face.

I recall one morning when Evan and my-

self would have been eight and six years of age respectively. We had gone perhaps three quarters of the way to town when my brother quite suddenly put down his books and dinner sack and threw off his jacket and cap as well, and in his shirt and short pants raised his arms and leapt up to seize a branch of an apple tree that had just come fully into bloom, and I suspect that it was the prospect of losing himself in all that white froth of blossoms that propelled Evan higher and higher so that in seconds he was calling to me from the very apex of the tree. *Hallo, Maren, can you see me?* For reasons I cannot accurately describe, I could not bear to be left behind on the ground, and so it was with a frenzy of determination that I tried to repeat Evan's acrobatics and make a similar climb to the height of the fruit tree. I discovered, however, that I was encumbered by the skirts of my dress, which were weighing me down and would not permit me to grab hold of the tree limbs with my legs in a shimmying fashion, such as I had just witnessed Evan performing. It was, then, with a gesture of irritation and perhaps anger at my sex, that I stripped myself of my frock, along that most travelled of public roads into Laur-

vig, stripped myself down to my under-
clothes, which consisted of a sleeveless
woolen vest and a pair of unadorned home-
spun bloomers, and thus was able in a mat-
ter of minutes to join my brother at the top
of the tree, which gave a long view of the
coastline, and which, when I had reached
Evan, filled me with a sense of freedom and
accomplishment that was not often repeated
in my girlhood. I remember that he smiled at
me and said, "Well done," and that shortly
after I had reached Evan's perch, I leaned
forward in my careless ebullience to see
north along the Laurvigsfjord, and, in doing
so, lost my balance and nearly fell out of the
tree, and almost certainly would have done
had not Evan grabbed hold of my wrist and
righted me. And I recall that he did not re-
move his hand, but rather stayed with me in
that position, his hand upon my wrist, for a
few minutes more, as we could not bear to
disturb that sensation of peace and com-
pleteness that had come over us, and so it
happened that we were both late for school
on that day and were chastised by having to
remain after school for five days in a row, a
detention neither of us minded or com-
plained about as I think we both felt the stric-

ture to be pale reprimand for the thrilling loveliness of the crime. Of course, we had been fortunate that all the time we had been in the tree no farmer had come along the road and seen my frock in the dirt, a shocking sight in itself, and which doubtless would have resulted in our capture and quite likely a more severe punishment of a different nature.

At school, Evan was well liked, but though he did join in the games, he did not take extra pains to become popular in the manner of some boys of the town. He was not a boy, or ever a man, who was filled with anger or resentments as some are, and if a wrong was done to him, he needed only to correct it, not exact a punishment for the crime. (Though I am sorry to say that Evan was eventually to learn, as were we all, that there was no righting of the ultimate wrong that was done to him.) In this way, I do not think I have measured up to him in character, for I have often felt myself in the sway of intense emotions that are sinful in their origin, including those of anger and hatred.

Evan was always substantially taller than myself, and for a time was the tallest boy in the Laurvig school. Although he had slightly

crooked teeth in the front, he developed a handsome face that I believe resembled our father's, though, of course, I never saw my father as a younger man, and by the time I was old enough for such impressions to register, my father's cheeks were sunken and there were many wrinkles on his face, this as a consequence of the weathering that occurred at sea and was a feature of most fishermen of that time.

When our schooling was finished for the year, we often had the long days together, and this was the very greatest of joys, for the light stayed with us until nearly midnight in the midsummer.

I see us now as if I were looking upon my own self. In the woods, just west of where our home was situated, there was a little-visited and strange geographic phenomenon known as Hakon's Inlet, a pool of seawater that was nearly black as a consequence of both its extraordinary depth and of the sheer black rock that formed the edges of the pool and rose straight up to a height of thirty feet on all sides, so that this pool was, with the exception of a narrow fissure through which seawater flowed, a tall, dark cylinder. It was said to be twenty fath-

oms deep, and along its walls were thin ledges that one, with some practice, could navigate to reach the water and thus swim, or fish, or even lower a boat and paddle about. Yellow stone crop grew in the fissure, and it was altogether a most magical place.

At this pool, on a June morning, I see a small girl of eight years of age, who is standing on a ledge, holding her dress above the water, revealing her knees and not caring much, as there had not yet been between herself and her brother any loss of innocence, nor indeed any need for false modesty on the part of either, and beyond her, perched upon a nearby shelf of rock, with a rudimentary fishing pole in his hands, her brother, Evan. He is smiling at her because she has been teasing him in a pleasant manner about the fact that he has grown so tall that his pants rise a good inch above his ankles. He is, upon his rock, the embodiment of all that Norwegian parents might wish in their boys, a tall and strong youth, with the thin pale hair that we have come in this country to favor so, and eyes the color of water. Presently, the boy puts down his fishing pole and takes from his sack a small dark object that he quickly flings out over the

water, and which reveals itself to be a net of the finest threads, intricately woven, a gauze, more like, or a web of gossamer, catching the light of the sun's rays that hover and seem to stop just above the surface of the pool. The girl, intrigued, makes her way to the ledge on which the boy is standing and sees that the net is large and comments upon this, whereupon the boy tells her that he has made it deep so that it will sink low into the pool and bring up from its depths all manner of sea creatures. The girl watches with fascination as the boy, who has had a not inconsequential amount of experience with fishing nets, and who has fashioned the present one from threads from his mother's sewing cabinet, expertly spreads the net over the surface of the black water and allows it, with its weighted sinks, to lower itself until only the bobbers at the four corners are visible. Then, with a deft movement of his body, and indicating that the girl should follow him, he hops from ledge to ledge, dragging the gathering net behind him. After a time, he lets the bobbers float closer to the wall of the pool, where he then snags them and slowly brings up the net. He hauls his catch up onto the ledge on which the pair

are standing and opens it for their inspection. In the net are wriggling bits and sacs of color the girl has never seen before. Many of these sea creatures have lovely iridescent colorings, but some appear to her grotesque in texture, like mollusks without their shells. Some are translucent shapes that reveal working innards; others are heaving gills flecked with gold or round fat fish with bulging eyes or simple dark slivers the color of lead. Some of the fish the girl recognizes: a sea bass, a codfish, several mackerel.

But the girl is frightened by the grotesque display, and is fearful that the boy has perhaps trespassed in the unnatural world, and has brought up from the black pool living things not meant to be seen or to see the light of day, and, indeed, some small peacock-blue gelatinous spheres begin to pop and perish there upon the ledge.

"Maren, do you see?" the boy asks excitedly, pointing to this fish and to that one, but the girl is both attracted and repulsed by the catch, wanting to tear her head away, yet not able to, when suddenly the boy picks up the four corners of the net and upends the catch into the water, not realizing that the girl's foot is on a part of the net, whereupon

the gossamer tears and catches on the girl's bare ankle, and with one swooping movement, she plunges into the water, believing that she might kick the net away whenever she wants to, and then discovers in a panic (that even now I can taste at the back of my throat) that both feet have become entangled in the threads and the skirt of her dress has become weighted with water. In addition, in her fright, she is surrounded by the sealife that had been in the net, some of which swims away, and some of which floats near to her face. She flails with her arms and tries to swim, but cannot find a suitable ledge to hang on to. And Evan, who sees that his sister is in great distress, jumps into the water after her, caring little for his own safety, but greatly concerned for hers. I can hear my voice that is filled with the utmost terror, calling out *Help!,* and then again, *Help!,* and Evan's voice, not yet broken and matured, a melodious voice that was most welcome at the Christmas Hymns each year, calling out, *I'll get you, Maren.* I remember now the strength of his hand under my chin, holding my mouth above the water so that I could breathe, while he splashed about most terribly and took in a

great deal of water himself, and was as pan-
icked as I, though he would never say so
later. It was only by the greatest good for-
tune that we drifted, in this agitated state,
across the pool, to a ledge a meter above
the water and that Evan, by the grace of
God and by a strength not commonly known
to children of that age, grasped that ledge
with his free hand and thus saved us both.

I remember that we lay upon the rocky
shelf, clasped in each other's arms, for a
long time afterward, and it was only after
many minutes in such a position that I was
able to stop shivering.

I think now upon that day and imagine an-
other fate. A fisherman coming upon the in-
let and seeing two children, locked together
in embrace, floating just below the surface
of the black water, forever free, forever
peaceful, and I wonder now if that might not
have been a more desirable end for both of
us.

In our cottage by the sea, our mother had
hung gay curtains of a red-checked cloth,
and on our table, there was always, in sea-
son, a small glass milk pitcher of flowers that
had come from the garden that surrounded
the cottage, and for many years after our

mother had died, I could not look at a vessel of flowers on a table without thinking of her. I am troubled now that I have primarily indistinct memories of my mother, whom I loved, but who was drawn in her aspect and often so tired as to be unwell. She was, like myself, a small woman who had a great many physical tasks to attend to, and who was not, I believe, of a sufficient fortitude to withstand these burdens. Also I believe that whatever love she did not reserve for her husband, she felt for her son, and in this she could not help herself.

In the evenings, I might be sent to bed while my mother spoke in low tones to Evan. About these talks, Evan would only say that they were often stories or homilies about virtues of character and defects of same, and that our mother had shown herself to be not religious in her beliefs, which at that time surprised me, as Evan and I and also Karen were required to spend almost all of Sunday in our church.

As to why I was excluded from these talks, my mother must have felt that either my character had already been formed and therefore such homilies were unnecessary, or that these talks in the night would be lost

on a girl who would, by nature and by custom, submit herself to her husband's beliefs and character when she married. I am pleased to say that though marriage often constrained my actions, my character and my beliefs, both of which were molded by influences far stronger than the fisherman who became my husband, remained intact and unchallenged for the duration of my years with John Hontvedt. I will add, however, that an unfortunate result of these private talks between my mother and my brother was that I was hard-pressed to disbelieve the notion that of the two of us, Evan was the more greatly loved, and in some way I could not articulate or account for, the more deserving of this love, and thus my own affection for my brother was not compromised but rather enhanced by this exclusionary affection of which I so desperately wanted to be a part.

My mother sat by the table in the evenings when her presence was not required in town, and sewed or made bread for the next day. When I remember her in this way, I see her as in the thrall of a quiet sorrow, not the dreary if not altogether sour melancholy that Karen was sometimes possessed of, but

rather a weight upon her spirit that she bore uncomplainingly and in an unobtrusive manner. Perhaps she was not ever really well and simply never told us this. When our father was home, he would sit near to her, mending his nets or just silently smoking his pipe, and though they seldom spoke, I would sometimes catch him regarding her with admiration, although I don't believe the possibility of romantic love between our mother and our father ever consciously occurred to me until I had occasion to witness our father's demeanor after our mother had died.

When I was thirteen years of age, and Evan just fifteen, our mother perished, giving birth to a stillborn child who was buried with her. It was in the worst winter month of 1860, and the environs of Laurvig, and indeed the entire coast region, had been buried with the snows of that year. On the day that my mother perished, there was, in the early hours of the morning, when she had just begun her labor, a wild blizzard of snow so thick it was impossible to see out the windows. My father, who had not been present for the births of his other three children, as he had been at sea during those occasions,

did not feel qualified to attend to such an event, and therefore hastened, even in the terrible storm, to fetch the midwife who lived between our cottage and the town, and might be reached if the sleigh, belonging to our neighbor, Mr. Helgessen, could be fetched and could make the passage. Karen, who might have been able to help our mother, was residing that night at the boarding house for sailors, where it was thought she should stay during the storm. Thus myself and Evan, who were too young to help in this matter, except insofar as we could put ice on our mother's brow, wipe her head and arms when it was necessary, and hold her hand when she would let us, stood beside her listening to her terrible cries. I had had until that moment no experience of childbirth, and I had never seen such torment in any individual. I remember that in the candlelight Evan stood shivering with fear in his nightshirt, believing that our mother's agony was a certain sign that she would die. He began to cry out most awfully, although he wished that he would not, and I became distraught at the sight of Evan's crying, since he had always been a strong and undemonstrative boy, and I believe now

that I was more distressed at the sound of his weeping, at least momentarily, than I was at the unspeakable rhythmic cries from our mother, and that I may have left my mother's side to tend to him, holding him with thin arms that barely reached around him, kissing his tear-ruined face to soothe him, to stop his shivering, so that when, startled by the sudden silence, I looked back at our mother, I saw that she was gone. A large pool of blood had soaked the bedclothes from her stomach to her knees, and I dared not lift the sheets for fear of what lay beneath them. I think that possibly I may have closed her eyes. My father could not reach the midwife and was forced to turn back. When he finally returned to our house, nearly dead himself, the event was finished.

I remember his hoarse shout when he entered the cottage and saw what lay before him. I remember also that I had not the strength to leave Evan, and that I could not go out into the living room to console my father. When finally our father came into our bedroom, with his face blasted by the sight of his beloved wife taken from him in such a violent manner, he found Evan and myself in our bed, holding each other for comfort.

I would not for all the world speak of such gruesome matters except that I have always wondered if I might not have attended to my mother in some better way and thus perhaps have saved her. And I have wondered as well if my memories of this terrible night, or my actions, have been the cause of my barren state in my own womanhood, as if I had been punished by God for not allowing the birth of my sibling.

I remained, for some months after this event, in an agitated state of mind. Indeed, I grew worse and was overtaken by a mysterious malady. I do not remember all of this time very well, but I was told about it often enough by Karen, who was, during those long and dark days, in despair over our mother's death and my illness. Unable to sleep at night, or if I did sleep, subject to the most excruciatingly horrible dreams, and without any medicines that might be a remedy to me, I became weakened and then ill, and from there slipped into a fever that appeared to all around me to have a psychic rather than physical origin. At least that was the opinion of the doctor who was fetched more than once from Laurvig, and who was at a loss to describe the root cause of my

symptoms. I recall that for a time I could not move either my legs or my arms, and it was thought that I might have caught the meningitis, even though there were no other reported cases in our area that season. Because I was so incapacitated, I could not feed myself. Karen, having more than her share to do about the house as a result of my being bedridden, left this chore to Evan, who nursed me uncomplainingly, and I believe that he was in a kind of torment himself, owing to the events that had occurred on the night that our mother had died.

There were entire days when I could not speak and had to be held up in a half-sitting position just to take a sip of Farris water, which was thought to be therapeutic. I was moved for the duration of my illness to my father's bed near to the stove in the living room, while my father took up residence in the room that I had shared with Evan. My brother made a vigil at my bedside. I believe he sat there not speaking for much of the time, but he may have read to me from the folk tales as well. During this time Evan did not attend school.

I was not always lucid during my illness, but there is one incident I remember with

absolute clarity, and which has remained with me in all its wonder and complexity.

I had just awakened from a dream-like state one morning some months into the illness. Karen was outside in the garden, and there were daffodils in a pitcher on the table. It must have been late April or early May following my mother's death. Previously, when I had awakened and was emerging from one of my dreams, I had felt frightened, for the feelings of the illness would flood into me and I would be visited by the strangest waking visions, which seemed very real to me at the time, and were all against the tenets of God. But that morning, though I was again beset with such visions, I did not feel fear, but rather a kind of all-encompassing forgiveness, not only of those around me, but of myself. Thus it happened that in the first seconds of consciousness that morning, I impulsively reached for Evan's hand. He was sitting in a wooden chair, his back very straight, his face solemn. Perhaps he himself had been far away when I awakened, or possibly he had been yearning to go outside on that fine day himself. When I put my hand on his, he flinched, for we had not willfully touched since the night that our mother

had perished. In truth, I would have to say that he looked stricken when I first touched him, though I believe that this was a consequence of his worry over my health and his surprise at my awakening.

I remember that he had on a blue shirt that Karen had recently washed and ironed. His hair, which had been combed for the morning, had become even paler over the past year and accentuated the watery blue of his eyes.

His hand did not move in mine, and I did not let him go.

"Maren, are you well?" he asked.

I thought for a moment and then answered, "I feel very well indeed."

He shook his head as though throwing off some unbidden thought, and then looked down at our hands.

"Maren, we must do something," he said.

"Do something?"

"Speak to someone. I don't know . . . I have tried to think."

"I don't know what you mean," I said to him.

Evan appeared to be irritated by this admission.

"But you must do," he said. "I know you

do." He looked up quickly and allowed his eyes to meet mine.

I believe that wordlessly, in those few moments, we spoke of many things. His hand grew hot under mine, or perhaps it was simply my own fever, and, just as I could not pull away, neither could he, and for some minutes, perhaps even for many minutes, we remained in that state, and if it is possible to say, in a few moments, even without words, all that has to be said between two individuals, this was done on that day.

After a time (I cannot accurately say how long this occurrence took place), I sat up, and in a strange manner, yet one which on that day seemed as natural to me as a kiss upon a baby's cheek, I put my lips to the inside of his wrist, which was turned upward to me. I remained in that position, in a state of neither beginning nor ending a kiss, until that moment when we heard a sound at the door and looked up to see that our sister, Karen, had come in from the garden.

I remember the bewildered look that came upon her face, a look of surprise and darkening all at once, so that she frightened me, and a sound escaped my throat, and Evan, leaving me, stood up. Karen said to me, al-

though I think not to Evan, *What is it that you do?* To which question I could no more have made an answer than I could have explained to her the mystery of the sacraments. Evan left the room, and I do not believe that he spoke. Karen came to me and hovered over my bed, examining me, her hair pulled tightly back off her head, her dress with its shell buttons rising to her throat, and I remember thinking to myself that though the wondrous forgiveness I had so recently felt encompassed everyone around me, I did not really like Karen much, and I felt a pity for her I had not consciously realized before. I believe I closed my eyes then and drifted back into that state from which I had only a short time earlier emerged.

Not long after that incident, I recovered my health. Never was anyone so glad to greet the lustrous mornings of that spring, though I was quickly advised by Karen that my childhood was now over and that I would have to assume the responsibilities and demeanor of a young woman. Around that time, perhaps even immediately after my illness, it was decided that I would remain sleeping with Karen in the kitchen behind

the curtain, and that our father would permanently take up the bed I had shared with Evan. This was because I had reached, during my illness, the age of fourteen, and that while I had been sick there had been certain changes in my body, which I will not speak of here, which made it necessary for me to move out of a room that Evan slept in.

Our mother having died, and our father out at sea for most of the hours in his day, I was put under the care of our sister, who was dutiful in her watch, but who I do not think was ever suited for the job. Sensing something, I know not what, a reluctance on her part perhaps, I was sometimes a torment to her, and I have often, in the years that have since passed, wished that I might have had her forgiveness for this. To her constrictions I gave protest, thus causing her to put me under her discipline until such time as I did not have so much freedom as before.

I would not like to attribute the loss of my liberty, my uncompromised happiness, to the coming of my womanhood, and I believe it is merely a coincidence of timing, but I was, nevertheless, plagued with extremely severe monthly pains, which may have had,

at their root, the more probable cause of my barrenness.

I must stop now, for these memories are disturbing me, and my eyes are hurting.

When I look at photographs of Billie, I can
see that she is there—her whole self, the
force of her—from the very beginning. Her
infant face is intricately formed—solemn, yet
willing to be pleased. Her baby hair is thick
and black, which accentuates the navy of
her eyes. Even then she has extraordinarily
long lashes that charm me to the bottom of
my soul and stop passersby on the street.
Our friends congratulate me for having pro-
duced such a beguiling creature, but in-
wardly I protest. Was I not merely a
custodian—a fat, white cocoon?

In the first several weeks after Billie's
birth, Thomas and Billie and I inhabited a
blur of deepening concentric circles. At the
perimeter was Thomas, who sometimes
spun off into the world of students and the
university. He bought groceries, wrote at
odd hours, and looked upon his daughter as
a mystifying and glorious interruption of an
ordered life. He carried Billie around in the

crook of his arm and talked to her continuously. He introduced her to the world: "This is a chair; this is my table at the diner." He took her—zipped into the front of his leather jacket, her cheek resting against his chest or her head bobbing beneath his chin—on his daily walks through the streets of the city. He seemed, for a time, a less extraordinary man, less preoccupied, more like the cliché of a new father. This perception was reassuring to me, and I think to Thomas as well. He discovered in himself a nurturing streak that was comforting to him, one that he couldn't damage and from which he couldn't distance himself with images and words. For a time, after Billie was born, Thomas drank less. He believed, briefly, in the future. His best work was behind him, but he didn't know that then.

In the middle circle were the three of us, each hovering near the other. We lived, as we had since Thomas and I were married, in the top half of a large, brown-stained, nineteenth-century house on a back street in Cambridge. Henry James once lived next door and e. e. cummings across the street. The neighborhood, thought Thomas, had

suitable resonance. I put Billie in a room that used to be my office, and the only pictures I took then were of Billie. Sometimes I slept; sometimes Thomas slept; Billie slept a lot. Thomas and I came together in sudden, bewildered clutches. We ate at odd hours, and we watched late-night television programs we had never seen before. We were a protoplasmic mass that was becoming a family.

And in the center circle—dark and dreamlike—was the nest of Billie and myself. I lay on the bed, and I folded my daughter into me like bedclothes. I stood at the window overlooking the back garden and watched her study her hands. I stretched out on the floor and placed my daughter on my stomach and examined her new bright eyes. Her presence was so intensely vivid to me, so all-consuming, that I could not imagine who she would be the next day. I couldn't even remember what she had looked like the day before. Her immediate being pushed out all the other realities, blotted out other pictures. In the end, the only images I would retain of Billie's babyhood were the ones that were in the photographs.

At the Athenaeum, I put the papers back into the flesh-colored box and set it on the library table. I fold my hands on top of it. The librarian has left the room. I am wondering how the material can have been allowed to remain in such a chaotic state. I don't believe the Athenaeum even knows what it has. I suppose I am thinking that I will simply take the document and its translation and then bring them back the following week after I have photocopied them. No one will ever know. Not so very different, I am thinking, from borrowing a book from a lending library.

I put the loose letters, photographs, sermons, and official documents back into the folder and eye it, trying to judge how it looks without the box. I put the three books I have been given on top of the folder to camouflage the loss. I study the pile.

I cannot do it.

I put the box back inside the folder and stand up. *Goodbye,* I say, and then, just as I am leaving, in a somewhat louder voice, *Thanks.* I open the metal door and walk evenly down the stairs.

When I emerge from the Athenaeum,

Thomas is not on the sidewalk. I wait ten minutes, then another five.

I walk across the street and stand in a doorway. Twenty minutes elapse, and I begin to wonder if I heard Thomas correctly.

I see them coming from the corner. Thomas and Adaline have Billie between them. They count *one, two, three,* and lift Billie high into the air with their arms, like a rope bridge catching a gust of wind. Billie giggles with the airborne thrill and asks them to do it again—and again. I can see Billie's small brown legs inside her shorts, her feet kicking the air for height. People on the sidewalk move to one side to let them pass. So intent are Thomas and Adaline on their game that they walk by the Athenaeum and don't even see it.

Adaline lets go of Billie's hand. Thomas checks his watch. Adaline scoops Billie up into one arm, and hefts her onto her hip, as I have done a thousand times. Thomas says something to Adaline, and she tilts her head back and laughs soundlessly. Billie pats her hair.

Moving fast, I cross the street before they can turn around. I reenter the Athenaeum

and take the stairs two at a time. When I open the door to the reading room, I see that my neat stack of books and folders is exactly as I have left it. The librarian hasn't yet returned. I walk over to the long library table and remove the box from the folder. I put it under my arm.

I nearly slap the door into Thomas, who is looking up at the tall building, trying to ascertain whether he is in the correct place. Billie has climbed down from Adaline's hip, but is still holding her hand.

"Sorry," I say quickly. "I hope you weren't waiting long."

"How'd it go?" he asks. He puts his hands in his pockets.

"Fine," I say, bending to give Billie a kiss. "How about you?"

"We had a good time," Adaline says. She seems slightly flushed. "We found a park with swings, and we had an ice-cream cone." She looks down at Billie as if for confirmation.

"Where's Rich?" I ask.

"He's buying lobsters for supper," Thomas says quickly, again glancing at his watch. "We're supposed to meet him. Right

now, as a matter of fact. What's that you've got there?"

"This?" I say, holding out the box. "Just something they lent me at the Athenaeum."

"Useful?"

"I hope so."

We walk four abreast along the sidewalk. I am aware of a settling of spirits, a lessening of exuberance. Adaline is quiet. She holds Billie's hand. That seems odd to me, as if she were unwilling to relinquish the tiny hand, even in my presence.

Rich is standing on the sidewalk and cradling two large paper bags. His eyes are hidden behind dark glasses.

We set off for the dock. The sky is clear, but the breeze is strong.

Rich and Adaline go ahead to prepare the Zodiac and to get the life jacket for Billie. I stand beside my daughter. Her hair whips across her face, and she tries unsuccessfully to hold it with her hands.

Thomas is staring into the harbor.

Thomas, I say.

Billie was six weeks old when she began to cough. I was bathing her in preparation for an appointment with the pediatrician, when I observed her—as I had not been

able to when she was dressed—engaged in an awful kind of struggle. Her abdomen deflated at every pull for air, like an oxygen bladder on a pilot's mask. I picked Billie up and took her into Thomas's study. He glanced up at me, surprised at this rare intrusion. He had his glasses on, and his fingers were stained with navy ink. In front of him were white lined pages with unintelligible words on them.

"Look at this," I said, laying Billie on top of the desk.

Together we watched the alarming phenomenon of the inflating and deflating chest.

"Shit," Thomas said. "Did you call the doctor?"

"I called because of the cough. I have an appointment at ten-thirty."

"I'm calling 911."

"You think—?"

"She can't breathe," said Thomas.

The ambulance driver would not let me travel with Billie. Too much equipment was needed; too much attention. They were working on her even as they closed the door. I thought: What if she dies, and I'm not there?

We followed in our car, Thomas cursing

and gesturing at anyone who attempted to cut us off. I had never seen him so angry. The ambulance stopped at the emergency ward of the hospital in which Billie had been born.

"Jesus Christ," said Thomas. "We just got out of here."

In the emergency room, Billie was stripped naked and put into a metal coverless box that later Thomas and I would agree looked like a coffin. Of course, Billie was freezing, and she began to howl. I begged the attending physician to let me pick her up and nurse her to calm her. Surely the crying couldn't be good for the coughing and the breathing? But the young doctor told me that I was now a danger to my daughter, that I could no longer nurse her, that she had to be fed intravenously and pumped with antibiotics. He spoke to me as though I had been given an important assignment and had blown it.

Billie was hooked up to dozens of tubes and wires. She cried until she couldn't catch her breath. I couldn't bear her suffering one second longer, and when the doctor left to see to someone else, I picked her up, wrapping the folds of my quilted jacket around

her, not feeding her, but holding her to my breast. Immediately, she stopped crying and rooted around for my nipple. Thomas looked at us with an expression of tenderness and fear I had never seen on his face before.

Billie had pneumonia. For hours, Thomas and I stood beside a plastic box that had become Billie's bed, studying the bank of monitors that controlled and recorded her breathing, her food intake, her heart rate, her blood pressure, her blood gases, and her antibiotics. There was no other universe except this plastic box, and Thomas and I marveled at the other parents in the intensive care unit who returned from forays into the outside world with McDonald's cartons and boxes from Pizza Hut.

"How can they eat?" said Thomas.

That night, Thomas was told that he had a phone call, and he left the room. I stood beside the plastic box and rhythmically recited the Lord's Prayer over and over, even though I am not a religious woman. I found the words soothing. I convinced myself that the words themselves would hold Billie to me, that as long as I kept reciting the prayer, Billie would not die. That the words themselves were a talisman, a charm.

When Thomas came back into the room, I turned automatically to him to ask him who called. His face was haggard—thin and papery around his eyes. He blinked, as though he were emerging from a movie theater into the bright sun.

He named a prize any poet in America might covet. It was for *The Magdalene Poems,* a series of fifty-six poems it had taken my husband eight years to write. We both sat down in orange plastic chairs next to the plastic box. I put my hand on his. I thought immediately of terrible contracts. How could we have been given this wonderful piece of news and have Billie survive as well?

"I can't digest this," Thomas said.

"No."

"We'll celebrate some other time."

"Thomas, if I could be, I'd be thrilled. I will be thrilled."

"I've always worried that you thought I was with you because of the poems. That I was using you. As a kind of muse."

"Not now, Thomas."

"In the beginning."

"Maybe, for a while, in the beginning."

"It's not true."

I shook my head in confusion. "How can

this possibly matter?" I asked with the irritation that comes of not wanting to think about anything except the thing that is frightening you.

"It doesn't matter," he said. "It doesn't matter."

But of course it did matter. It did matter.

I learned that night that love is never as ferocious as when you think it is going to leave you. We are not always allowed this knowledge, and so our love sometimes becomes retrospective. But that night Thomas and I believed that our daughter was going to die. As we listened to the beeps and buzzes and hums and clicks of the machines surrounding her, we held hands, unable to touch her. We scrutinized her eyelids and eyelashes, her elbows and her fat calves. We shared a stunning cache of memories, culled in only six weeks. In some ways, we knew our daughter better that night than we ever would again.

Billie recovered in a week and was sent home. She grew and flourished. Eventually we reached the day when she was able to irritate us, when we were able to speak sharply to her. Eventually we reached the day when I was able to leave her and go out

to take photographs. Thomas wrote poems and threw them away. He taught classes and gave numerous readings and talked to reporters and began to wonder if the words were running out on him. He drank more heavily. In the mornings, I would sometimes find him in the kitchen in a chair, his elbow resting on the counter. Next to him would be an empty bottle of wine. "This has nothing to do with you," he would say to me, putting a hand on the skirt of my robe. "I love you. This is not your fault."

I have sometimes thought that there are moments when you can see it all—and if not the future, then all that has gone before. They say this is true of the dying—that one can see a life—that the brain can perceive in an instant, or at most a few seconds, all that has gone before. Beginning at birth and ending with the moment of total knowledge so that the moment itself becomes a kind of infinite mirror, reflecting the life again and again and again.

I imagine that moment would be felt as a small billowy shock through the body, the *whoomph* of touching a frayed cord. Not fatal in itself, perhaps, but a surprise, a jolt.

And that is how it comes to me on the

dock. I can see the years that Thomas and I have had together, the fragility of that life. The creation of a marriage, of a family, not because it has been ordained or is meant to be, but because we have simply made it happen. We have done this thing, and then that thing, and then that thing, and I have come to think of our years together as a tightly knotted fisherman's net; not perfectly made perhaps, but so well knit I would have said it could never have been unraveled.

During the hours that pass between our return from Portsmouth and dinner, we each go our separate ways. Adaline shuts the door and reads Celia Thaxter in the forward cabin; Thomas dozes in the cockpit while Billie kneels beside him, coloring; Rich retreats into the engine compartment to fix the bilge pump; and I sit on Billie's berth with guidebooks and notes and the transcript spread all around me. I open the flesh-colored box and examine the penciled translation. I know that I will read it soon, but I am not quite ready. I feel furtive in the narrow berth, and vaguely ashamed of myself.

I tell myself that the reason for my theft is simple: I want to know how it was, to find the one underlying detail that will make it all

sensible. I want to understand the random act, the consequences of a second's brief abandonment. I am thinking not so much of the actions of a single night as I am of the aftermath of years—and of what there would be to remember.

In the guidebooks, I read that history has only one story to tell about John Hontvedt, Maren's husband, at Smuttynose, apart from all the events attending the murders on March 5, 1873. On a frigid day in 1870, three years before the murders and two years after Hontvedt arrived in America, John left Smuttynose for fishing grounds northwest of the island. We are told it was a particularly filthy day, ice forming on mustaches and oilskins, on lines, and even on the deck of Hontvedt's schooner, which remains nameless. John stood on the slippery shingle of the small beach at Smuttynose, the sleet assaulting him from a slanting angle, trying to decide whether or not to row out to the schooner. We can only guess at what finally compelled Hontvedt to go to sea on such a day, among the worst the Atlantic had to offer that year. Was it poverty? Or hunger? Expensive bait that might rot if it wasn't used? An awful kind of restlessness?

After setting sail and losing sight of Smut-
tynose, John was surprised by a gale that
blew up, creating heavy seas and blizzard
conditions. The snow became so thick on
the sea as the hours wore on that John
could not have seen much beyond the boat
itself. Perhaps realizing his mistake, John
did try then to turn back toward Smuttynose,
but the swells were so high and the visibility
so poor that he could make no headway. He
was instead forced to drift in an aimless pat-
tern in a darkish, white blindness. The dan-
ger of being swamped or of the schooner
being gouged open on unseen rocks and
ledges was very real.

A number of the islanders, chief among
them a man named Ephraim Downs, who
lived on Smuttynose himself, and who would
later live with his family in the Hontvedt
house after the murders (the landlord refus-
ing to clean away the bloodstains, he said,
because he could get more money from
souvenir hunters than he could from a
higher rent), thought John mad for having
set out that day at all, and watched for him
to return. When it became apparent that
Hontvedt's schooner must be lost, Downs
set out in his own larger ship, aptly named

the *White Rover,* to search for the disabled or stranded boat. Downs and his crew scanned the sea for hours until they themselves lost their bearings in the storm. After several hours, they finally caught sight of the smaller boat with Hontvedt aboard. Looping across fourteen-foot swells, Downs managed to collect the stranded seaman. After John was safely aboard the *White Rover,* Hontvedt's schooner drifted away and was never seen again.

For many hours, the *White Rover* rode the waves, the men aboard her becoming frozen and covered with ice until they could no longer move. When the boat finally beached herself—and history doesn't tell us where—the crew, who were able to use neither their legs nor their arms properly, hitched themselves over the prow of the boat and tumbled onto the sand. Several of the men from the *White Rover* had frozen their feet through and later had to have them amputated. John Hontvedt appears to have survived intact.

"Mommy, will you take me swimming?"

Billie tugs at my sleeve and rolls her head back and forth in the crook of my arm. I set my book down and lift her onto my lap. A

small bit of crayon wrapping is stuck to her bottom lip, and I pick it off. She smells of shellfish and of sunblock.

"I don't know, Jean," calls Thomas from the cockpit. "It's awfully deep out there. I said she had to ask you. I don't especially want to go in again myself."

"She'll be all right if she wears her life jacket," says Rich, emerging from the engine compartment. "Anyway, *I* need a swim. I'm disgusting. If we both take her, she'll be OK."

"Please, Mom."

I look at Rich, whose hands are covered with grease, and then I look at Billie. "Sure," I say. "Why not?"

I am able to get over the side of the boat, but I am pretty sure they will never get me back in. Rich has left the swim ladder, which was being repaired, in his van at the dock. Billie cannonballs into the water and bobs straight up, her hair covering her face. I swim close to my daughter, never more than an arm's length away, while Billie flails her arms, barely keeping her mouth above water. The water is, at first, shockingly cold, but after a few minutes I begin to get used to it. From the waterline, the prow of the sailboat

seems massive—that of an ocean liner. In the distance, without my glasses, the islands are indistinct shapes of gray and brown.

I give Billie a shove toward Rich, and she "swims" between her uncle and myself—a wriggly fish with no fear. Her mouth fills with seawater. She swallows it and she seems surprised by the taste. She begs Rich for a ride on his back, and when they swim near to me, Billie slides off and clutches me around my neck. Rich's leg is momentarily slippery against my own, and I grab onto his shoulder to keep from going under.

"Careful, Billie," I say, loosening her grip around my neck. "I don't have a life jacket on like you. You'll sink me."

From the bowsprit, Thomas watches us. He has a glass in his hand. I see him turn away and smile. He says something I cannot hear—it must be to Adaline.

When I let go of Rich, he dives deep into the water. He comes up about thirty feet away from me and begins to swim hard, his arms beating a rhythm to his kick. Billie and I paddle around each other until I see that she is tiring. Thomas reaches down, and between us we are able to get Billie easily back into the boat. As I anticipated, how-

ever, I am not strong enough to haul myself up and over, and there is an embarrassing and awkward pulling on arms and legs before I am able finally to flop into the cockpit. Billie wraps herself in a towel and sits, shivering, next to Adaline. When I stand up and put my glasses on, I see that Rich has swum all the way to Smuttynose and is sitting on the beach.

The Isles of Shoals derives its name not from the shoals surrounding the islands, but rather from the Old English word for *school.* As in schools of fish.

During the American Revolution, the Isles of Shoals were evacuated. Because the Shoalers had been trading with the British, the colonial leaders of New Hampshire and Maine ordered all residents off the islands. On January 5, 1776, eighty houses were dismantled, shipped to the mainland, and reconstructed all along the coast, from Massachusetts to Maine. A number of these houses are still standing.

"Loss. Abandonment. Castration. Chauvinism . . ."

"But think of Tom Moore, the charm."

"Melancholy. It's all melancholic," says Thomas. "Kavanaugh, Frost, MacNeice."

"You're forgetting Yeats. The celebration of the human imagination, the magician."

"Donnelly. Hyde Donnelly. Do you know him? *Gray light thieving, mother's grief / Steals by hedgerows—*"

"You're indicting an entire race," Adaline says lightly.

Thomas takes a long sip of scotch.

A thick, peasanty scent of fish and garlic spreads and settles over the cockpit where Adaline and Thomas and I are sitting. Rich is holding a plate of mussels he has just steamed.

"*I* picked them," Billie says, weaving through Rich's legs. She is trying to retain her pride in the mussels, though I sense she has been somewhat defeated in her attempts actually to like them. Just moments ago, going below to fetch the papers I took from the Athenaeum, I saw the partly chewed remains of a mussel stuffed inside a crumpled napkin. Billie has on clothes she particularly likes—a blue T-shirt with Pocahontas on the front and matching shorts—and I know she regards this small gathering as something of a party. As does Thomas. Billie has brought a sandwich bag of Cheerios, so that she can nibble with us. She

comes and snuggles beside me, screwing her head up and inside my arm. Thomas and Adaline sit across from me. Within seconds, I know, Billie will ask me for a Coke.

"Sons are leaving," says Thomas.

Rich sets the mussels on a makeshift table in the center of the cockpit, perches himself on the cabin roof, and dangles his legs over the opening. The air around us seems cleansed. Smuttynose is sharply etched and brushed with a thin wash of gold from a low sun. From the sloop, the gulls above the island are dark check marks in the blue dust. I am thinking that it is, possibly, the most beautiful night of the summer.

I have a photograph of the five of us in the cockpit of the Morgan the evening Rich makes the mussels and Thomas breaks the glass. I take the picture while the light is still orange; and, as a result, all of us look unreasonably tanned and healthy. In the photograph, Billie is sitting on Rich's lap and has just reached over to touch a gold wrist cuff that Adaline has put on a few minutes earlier. Rich is smiling straight at the camera, an open-mouthed smile that shows a lot of teeth, which look salmon-colored in the light. Beside him, Adaline has shaken out her hair

so that the camera has caught her with her chin slightly raised. She has on a black sundress with thin straps and a long skirt; her cross gives off a glint of sunlight. The low sun is shining almost painfully into everyone's eyes, which is why Thomas is squinting and has a hand raised to his brow. The only part of his face that is clearly identifiable is his mouth and jawline. As for me, I have engaged the timer so that I have time to insert myself into the picture. I am sitting beside Thomas, but am slightly tilted, as though I am straining to be part of the composition. I have smiled, but my eyes are, at that instant, closed in a blink. Thomas has attempted to put his free arm around me, but the camera has caught him with it raised and crooked in the air.

"How exactly did you get the scar?" Adaline is asking.

"We really need to feed Billie," I say, talking as much to myself as to anyone. It has been an exhausting day, and I haven't thought about Billie's dinner at all. I know that Rich has bought lobsters for the rest of us, but Billie will not eat a lobster.

"Mommy, can I have a Coke?"

"In a car accident," Thomas says. "When

I was a kid. The driver was drunk." Rich looks up quickly at Thomas, but Thomas turns his head away.

"Not now, Sweetie. It's almost time for supper."

"We have some tunafish," says Rich. "I'll make her a sandwich."

"You've done enough," I say. "The least I can do is make a sandwich." I start to get up.

"I don't want tunafish," Billie says. "I want a lobster."

"Billie, I don't think . . ." I start to say, but Rich stops me with a small shake of his head.

"Why don't you give the lobster a try?" he asks Billie. "And if you don't like it, we can make the sandwich then."

She closes her mouth and nods. I can see that she is slightly worried now that she has won her small contest. I doubt she really wants a lobster.

"Where are you from?" Adaline asks me. As she crosses her legs, a slit in the skirt of her black dress falls open, revealing a long, suntanned calf. Thomas looks down at Adaline's leg, and then away. I am wearing jeans and a sweatshirt. Thomas has a fresh

shirt on, a blue shirt with a thin yellow stripe, and he has shaved.

"Indiana, originally," I say. "My parents are dead. I was born late, when my mother was forty-eight."

"Mommy, what do seagulls eat?"

"Fish, I think," I say to Billie. "They dive in the ocean for fish. If you watch them closely, I'll bet you can see them." Self-consciously, I look toward Smuttynose, at the gulls that loop in the air over the ragged shoreline.

"And you do this?" Adaline asks, gesturing with her hands to include the boat, the island, the harbor.

"When I can," I say.

"But, Mom, where do they sleep?"

"That's a good question," I say, turning to Thomas for help.

"Damned if I know," Thomas says.

"They must sleep on rocks," Adaline offers. "They put their heads under their wings, I think."

"Have you ever seen a seagull sleep?" Billie asks her.

Adaline purses her lips. "I must have done," she says. "But I can't think where."

"On the back of a garbage barge in the

middle of Boston Harbor," Rich calls out from the galley.

"The rats of the sea," mutters Thomas.

Billie snuggles deeper into the cavity of my arm and chest and speaks into my rib cage. "Adaline is beautiful," she says shyly, not quite certain it is all right to say such a thing aloud.

"I know she is," I say, looking directly at Adaline, who meets my eyes.

"I love you, Mommy," Billie says.

"I love you, too," I say.

Early reports of the murders were hastily written and full of inaccuracies. The first bulletin from the *Boston Post* read as follows: "Two Girls Murdered on Smutty Nose Island, Isles of Shoals. Particulars of the Horrible Butchery—Escape of the Assassin and Subsequent Arrest in Boston—The Murderer's Object for Committing the Deed—Attempt to Kill a Third Person—Miraculous Escape of His Intended Victim—Terrible Sufferings from the Cold—Appalling Spectacle at the Home of the Murdered Females, Etc., Etc.—[SPECIAL DISPATCH TO THE BOSTON POST] Portsmouth, N.H., March 6. Our citizens were horror-struck soon after noon to-day, when a fisherman named

Huntress, whose home is at the Isles of Shoals, by landing his boat at Newcastle, and taking them thence to this city, hastened to inform our police that murder most foul had been done at the Shoals."

According to the same report, a "rough young man named Lewis Wagner" was seen walking down to the wharf the previous night with an ax in hand. The next morning at seven o'clock, while Wagner and "Huntress" were "having breakfast together" in Portsmouth, Wagner told the unfortunate Huntress (who had not yet returned home and did not know of the murders) that something was going to happen to him (Lewis Wagner). Anetta Lawson and Cornelia Christenson were the victims. A third woman, Mrs. Huntress, had escaped. Portsmouth City Marshall Johnson was already on his way to Boston to try to apprehend the fugitive murderer, who had, earlier in the day, been seen boarding a train for Boston.

I go below to help Rich in the galley. He has a lobster pot on a burner on the stove, another on a hibachi on the stern. He is heating bread in the oven, and he has made a salad.

I begin to lay out the table. Rich and I

move awkwardly about the cramped space, trying not to bump into each other or reach for the same utensil simultaneously. Through the companionway, I can see Billie lying faceup on the cushion I have vacated. She seems to be studying her fingers with great intensity. Across from her, framed in the rectangle, are Thomas's legs in their trousers, and his hand reaching for the bottle he has set by his right foot. The boat moves rhythmically, and through the west-facing portholes, watery reflections flicker on the bulkheads. I am searching for lobster crackers and picks in the silverware drawer when I hear three achingly familiar words: *Wainscot, redolent, core-stung.*

Adaline's voice is deep and melodious, respectful, forming words and vowels—perfect vowels. She knows the poem well. By heart.

I strain so that I can see Thomas's face. He is looking down at his knees. He doesn't move.

I remember the bar, the way Thomas read the poem. I remember standing at a window and reading it in the streetlight while Thomas slept.

"Thomas," I call. The edge in my voice is audible, even to me.

Billie sits up and leans on her elbows. She seems slightly puzzled. Adaline stops reciting.

Adaline's wrists are lightly crossed at her knee. In one long-fingered hand, she holds a wineglass. I am surprised suddenly to realize that this is the first time I have seen her drinking.

"Thomas, I need you," I repeat, and turn away.

I busy myself in the silverware drawer. He puts his head inside the companionway.

"What is it?" he asks.

"I can't find the nutcrackers, and I don't know what you've done with the wine we're having for dinner." My annoyance—a weaseling, sour note—is unmistakable.

"I've got the wine right here," Rich says quietly next to me. He opens the tiny refrigerator door for me to see.

But it is too late. Thomas has already turned and walked away. He stands, looking out over the water. He holds his glass in one hand; the other he has in the pocket of his trousers. Adaline has twisted her body around, so that she, too, is gazing out over the water, but away from Thomas.

Rich goes above to put the corn into the

pot on the hibachi. I see Thomas move aside and hold the lid for Rich. After Rich has dumped the ears into the steaming kettle, he wipes his hands on a dishtowel, and then bends and pours himself a glass of wine from another bottle on the cockpit floor. Thomas and Rich, their backs to me, speak a few words to each other, like husbands who have gone to stand by the grill in the backyard. I lean against the lip of the counter in the galley and sip my wine with concentration.

Billie looks at her father, then at me. She rolls over onto her stomach and puts her hands to the sides of her face, as if she were peering at something very tiny on the cushion. Rich turns around and gestures to Adaline to move over a bit. He sits next to her and rests his fingers on her thigh. He slips them in under the slit of her skirt, under the black cloth.

Thomas, who has made a half turn at that moment and is about to speak, sees Rich touch Adaline. He stands as if transfixed, as if not knowing where to put his body. He takes an awkward step forward. He hits Adaline's wineglass, which she has set down on the floor. The glass falls and shatters.

"Jesus," Thomas says.

Louis Wagner was arrested at eight-thirty on the night after the murders at the home of an acquaintance in Boston by both Portsmouth and Boston police. Wagner seemed stunned by the accusation of the murders and swore that he had not been on Smuttynose since November of the previous year. He said he could not have done such a thing because the Hontvedt women had been good to him. He had heard the train whistle at nine o'clock that morning, and, since he was down on his luck in Portsmouth, he thought it might be a good thing to try Boston.

News that the police were bringing Wagner back to Portsmouth on the ten o'clock train on Friday morning swept through the town, and the train route was lined with angry, screaming mobs. Fearing for their prisoner, the police had the train stopped a quarter mile short of the station to take Wagner off, but the crowd spotted him anyway and began to pelt the prisoner—and the police—with stones and ice chunks. They called out "Lynch him" and "String him up." The Marines were summoned, and the police drew their guns. Wagner spent the night

in the Portsmouth jail, but was transferred the next day to Saco, Maine, since Smutty-nose is technically not in New Hampshire, but in Maine. Again police were confronted with thousands of demonstrators who once more tried to stone Wagner, who was wounded in the head. One of the men in the mob was Ephraim Downs, the fisherman who had once saved John Hontvedt's life.

The prisoner was arraigned at the South Berwick jail and then kept in the Portland jail. He was transported to Alfred, Maine, when the trial of *The State of Maine* v. *Louis H. F. Wagner* opened on June 16, 1873. Louis Wagner stood accused of delivering ten mortal wounds with an ax to the head of "Anethe M. Christenson" and thereby caus-ing her instant death.

After Rich and I clean up the broken glass, he lifts the lobsters from the pot, and we all sit down at the dining table to eat. Thomas, who has drunk even more than he usually does, struggles clumsily with his lob-ster, spraying bits of white chitin around the table. Billie, as anticipated, loses her appe-tite for lobster when she watches me crack the shells and extract with a pick the spot-ted, pink meat. Adaline does not dip her

meat with her fingers into melted butter as do the rest of us, but rather soaks it in a bowl of hot broth and eats it from a fork. She works her way methodically through the bright red carapace, missing not a piece of edible flesh.

Thomas goes above to the deck when he cuts his thumb on a claw. After a time, Rich, who may feel that Thomas needs company, also goes above. Billie, too, leaves us, happy to turn her back on the pile of claws and red detritus that is forming in a stainless steel bowl and is becoming vaguely repulsive. Across the table, I watch with fascination as Adaline pulls tiny bits of meat I'd have overlooked from the body of the lobster. I watch her suck and chew, one by one, each of the lobster's spindly legs, kneading the thin shells with her teeth.

"Did you grow up on a farm?" she asks. "Were your parents farmers?"

"Yes, as a matter of fact, they were," I say. "Where in Ireland did you grow up?"

"Cork," she says. "It's in the south."

"And then you went to university."

"Yes," she says. "Billie is wonderful. You're very lucky to have her."

"Thank you. I do feel lucky to have her. How did you end up in Boston?"

"I was with someone," she says. "When I was in London. He worked in Boston, and I came over to be with him. I've always liked Boston."

"How did you come to know so much about Thomas's poetry?" I ask.

She seems surprised at the question.

"I think I've always read Thomas," she says. "Even at Dublin, I thought he was extraordinary. I suppose, after the prize, everyone reads Thomas now, don't they? That's what a prize does, I should think. It makes everyone read you, surely."

"You've memorized his work."

"Oh, not really."

There is an accusing tone to my voice that seems to put her on the defensive.

"The thing about Thomas is that I think he wants to be read aloud," she says. "One almost has to, to fully understand."

"You know he killed a girl," I say.

Adaline slowly removes a lobster leg from her mouth, holds it between her thumb and finger as she rests her hands on the edge of the table. The blue-checked oilcloth is

dotted with bits of flesh and yellow drips of butter that have congealed.

"Thomas killed a girl," she repeats, as though the sentence doesn't scan.

I take a sip of wine. I tear a piece of garlic bread from the loaf. I try to control my hands, which are trembling. I believe I am more shocked at what I have just said than she is. By the way I have said it. By the words I have used.

"I don't understand," she says.

She puts the spindly leg on her plate and wipes her fingers on the napkin in her lap. She holds the crumpled napkin in one hand.

"The car accident," I explain. "Thomas was driving."

She still seems not to understand.

"There was a girl with him. In the car. Thomas went off the road, caught his rear wheel in a ditch, and flipped the car."

Adaline reaches up and, with her finger, absently picks at a piece of lobster between her teeth. I look down and notice I have a spill of lobster water on my jeans.

"How old was she?"

"The same age as he was, seventeen."

"He was drunk?"

"Yes," I say.

I wait.

I see it then, the moment of recognition. I can see her processing the information, reciting lines to herself, suddenly understanding them. Her eyes move to the stove and then back to me.

"*The Magdalene Poems,*" she says quietly.

I nod. "But her name wasn't Magdalene. It was Linda."

Adaline flinches slightly at the word *Linda,* as though the commonness of the girl's name makes it real.

"He loved her," she says.

"Yes," I answer. "Very much. I don't think he's really ever gotten over it. In a way, all of his poems are about the accident, even when they seem not to be."

"But he married you," she says.

"So he did," I say.

Adaline puts her napkin on the table and stands up. She walks a few steps to the doorway of the forward cabin. She has her back to me, her arms crossed over her chest.

Rich bends his head into the cabin. "Jean, you should come out here," he calls. "The light is perfect."

He stops. Adaline is still standing in the doorway with her back to me. She doesn't turn around. Rich glances at me.

"What's up?" he asks.

I uncross my legs under the table. "Not much," I say.

I fold my hands in my lap, stunned by my betrayal. In all the years that I have been with Thomas, I have never told a single person. Nor, to my knowledge, has he. Despite our fears when he won the prize, no one discovered this fact about Thomas's youth, as the records were well sealed. Now, however, I know that Adaline will tell others. She won't be able to keep this information to herself.

I can't have done this, I am thinking.

"Rich, leave this," I say quickly, gesturing toward the mess on the table. "I want to go up. With Thomas. With the light still good. I'll do the dishes later." I push away from the table. Rich comes down the ladder and stands a moment with his hands over his head, holding on to the hatch. He seems puzzled.

Behind me, Adaline goes into the forward cabin. She shuts the door.

The Honorable R. P. Tapley of Saco,

Maine, was the lawyer for the defense of Louis H. F. Wagner. George C. Yeaton, Esq. was the county attorney. The Honorable William G. Barrows was the presiding judge. The members of the jury were Isaac Easton of North Berwick, George A. Twambly of Shapleigh, Ivory C. Hatch of Wells, Horace Piper of Newfield, Levi G. Hanson of Biddeford, Nahum Tarbox of Biddeford, Benajah Hall of North Berwick, Charles Whitney of Biddeford, William Bean of Limington, Robert Littlefield of Kennebunk, Isaac Libbey of Parsonfield, and Calvin Stevens of Wells.

Although all of the jury, the lawyers, and the judge were white men of early American—that is to say, English—stock, neither the accused nor the victim, nor the woman who survived, nor even most of the witnesses, was an American citizen.

In the cockpit, Thomas comes to sit beside me. Billie leans against Thomas's legs. My hands begin to shake. I feel an urge to bend forward, to put my head between my knees.

The three of us watch the sun set over Newcastle and Portsmouth, watch the coral light move evenly across Appledore and

Star, leaving in its wake a colorless tableau. From below, Rich switches on the running lights.

I want to tell Thomas that I have done something terrible, that I don't know why I did it except that I couldn't, for just that moment, bear Adaline's certainty that she knew Thomas well—perhaps, in a way, even better than myself.

On Star, windows are illuminated, and people walk through pools of deep yellow light.

"You're trembling," Thomas says.

The Magdalene Poems are an examination of the life of a seventeen-year-old girl in the last four seconds of her life, written in the voice of a seventeen-year-old boy who was clearly her lover and who was with her when she died. The poems speak to the unfulfilled promise of love, to the absolute inevitability of that promise remaining unfulfilled. The reader is allowed to imagine the girl as a middle-aged woman married to the man who was the boy, as an elderly widow, and as a promiscuous sixteen-year-old. The girl, whose name is Magdalene, is— as seen from the eyes of the boy—extraordinarily beautiful. She has the long slender

body of a dancer, abundant multihued hair that winds into intricate coils at the nape of her neck, and full curved lips of even dimensions with barely any bow at all.

According to the State of Maine, on March 5, 1873, six people lived in the one-and-one-half-story red cottage on Smuttynose, and there were no other inhabitants on the entire island that winter. John and Maren Hontvedt had come in 1868. Karen, Maren's sister, and Matthew, John's brother, had each come separately in 1871. Karen almost immediately entered service at the Laighton's Hotel on Appledore Island, while Matthew joined John on the *Clara Bella,* the latter's fishing schooner. Evan, Maren's brother, and his wife, Anethe, had arrived on the island in October of 1872, five months before the murders.

At daybreak on March 5, Matthew, Evan, and John left Smuttynose and sailed northeast in the schooner to draw their trawls. The Ingerbretson men from Appledore joined them in their own schooner. The plan for the day was to fish in the morning, return for lunch, and then head for Portsmouth to sell their catch and purchase bait. But just before noon, an unexpected and swift-rising

wind prevented them from making an easy sail home to Smuttynose. Because they knew they had to have bait, they called over to Emil Ingerbretson and asked him to stop at the island and tell the women that they would not be home until evening. The three women—Maren, Karen, and Anethe—cooked a stew and made bread for the men in preparation for their return after dark.

Louis Wagner, standing at Rollins Wharf in Portsmouth, watched the *Clara Bella* come into the dock. Wagner, who was wearing that day two sweaters, a white dress shirt, and overalls, helped John and Matthew and Evan tie up their boat. Louis told the men that the bait they wanted, which was coming by train from Boston, would be delayed and wouldn't be in until nearly midnight. Louis then asked John for money for something to eat, and John laughed and said that none of the men had brought any money because they had thought they would go home first, and that they would have to eat on credit with Mrs. Johnson, to whose house the bait was to be delivered. Wagner then asked John if he had had any luck with his fishing, and John answered that he had been able to save up six hun-

dred dollars. The three men of Smuttynose said goodbye to Louis, leaving him on the dock, while they went to fetch their dinner.

Baiting the trawls was a time-consuming and slimy business. Each of a thousand hooks had to have its piece of baitfish, a stinking sliver of herring that would have come in barrels from Boston by train, and did in fact arrive much later than expected in Portsmouth that night, preventing the men from returning to Smuttynose at all. Each individual hook had to be separated from the tangle, baited, then coiled into a tub so that the lot could be thrown overboard when the schooner, the next day, had made it to the fishing grounds. To bait the trawls took three men six hours. When the work was finished, it was not uncommon for one or more of the men to have stabbed himself with fishhooks.

Louis Wagner had emigrated from Prussia to the United States seven years earlier. He was twenty-eight years old and was described by those who knew him as being tall and extremely strong, light-haired, and having "steel blue" eyes. Other descriptions of him depict his eyes as soft and mild. Many women thought him handsome. He had worked at the Isles of Shoals off and

on, loading and unloading goods, and with John Hontvedt on the *Clara Bella* for two months, September to November of 1872. For seven months of that year (from April to November), Wagner had boarded with the Hontvedts, but he had been crippled much of the time with rheumatism. After leaving the Hontvedts, he signed on as a hand with the *Addison Gilbert,* which subsequently sank, leaving Wagner once again without a job. Just prior to the murders, he had been wandering in and among the boarding-houses, wharves, docks, and taverns of Portsmouth, looking for work. He is quoted as having said, to four different men, on four different occasions, "This won't do anymore. I am bound to have money in three months' time if I have to murder for it." While in Portsmouth, he resided at a boardinghouse for men that belonged to Matthew Johnson and his wife. He owed his landlord money.

According to the prosecution, at seven-thirty on the evening of March 5, Louis Wagner stole a dory, owned by James Burke, that had been left at the end of Pickering Street. Just that day, Burke had replaced the dory's thole pins with new, expensive ones. Wagner intended to row out to the

Isles of Shoals, steal the six hundred dollars that John had spoken of, and to row immediately back. This would be a twenty-five-mile row, which, even in the best of circumstances, would be extremely taxing for any man. That day it was high tide at six P.M., low at midnight. There was a three-quarters moon, which set at one A.M. On a favorable tide, it took one hour and forty minutes to row from Pickering Street to the mouth of the Piscataqua River (which flowed through Portsmouth), and one hour and fifteen minutes to row from there to Smutty-nose. This is a round-trip, in favorable conditions, of just under six hours. If a man tired, or encountered any obstacles, or if he did not have completely favorable conditions, the row to and from the Isles of Shoals could take as long as nine or ten hours.

County Attorney Yeaton reconstructed Wagner's plan as follows: Maren would be asleep in the southwest bedroom, and Anethe would be upstairs. Wagner would fasten the door that linked Maren's bedroom to the kitchen by sliding a slat from a lobster trap through the latch. Since the money would be in the kitchen in a trunk, he felt there would be no difficulty. Wagner mistakenly as-

sumed that Karen would still be on Apple-
dore. He brought no murder weapon with
him.

Wagner, who had the current with him,
moved quickly down the river and past
Portsmouth. When he reached the Shoals,
he circled the island silently to see if, by
some chance, the *Clara Bella* had returned.
When he was certain there were no men on
the island, he rowed himself into Haley's
Cove. This was at approximately eleven P.M.
He waited until all of the lights in the houses
on Appledore and Star had been extin-
guished.

When the islands were dark, he walked in
his rubber boots up to the front door of the
cottage, where an ax leaned against the
stone step. He entered the kitchen and fas-
tened the door to the bedroom.

The dog, Ringe, began to bark.

Louis turned abruptly. A woman rose from
her bed in the darkness and called out,
"John, is that you?"

I take Billie below to get her ready for bed.
She still finds the head a novelty, particularly
the complicated flushing of the toilet. She
brushes her teeth and then puts on her pa-
jamas. I settle her into her berth and sit next

to her. She has asked for a story, so I read her a picture-book tale of a mother and her daughter gathering blueberries in Maine. Billie lies in a state of rapt attention and holds in her arms a threadbare cocker spaniel she has had since birth.

"Let's say our things," I say, when I have finished the book.

When Billie was a toddler, she learned to talk, as most children do, by repeating what I said to her. As it has happened, this particular bit of repetition, a bedtime litany, has lasted for years.

"Lovely girl," I say.

"Lovely Mom."

"Sleep well."

"Sleep well."

"See you in the morning."

"See you in the morning."

"Don't let the bedbugs bite."

"Don't let the bedbugs bite."

"Sweet dreams."

"Sweet dreams."

"Love you."

"Love you."

"Goodnight."

"Goodnight."

I put my lips against her cheek. She

reaches up her arms, letting go of the dog, and hugs me tightly.

"I love you, Mom," she says.

That night, on the damp mattress that serves as a bed, Thomas and I lie facing each other, just a few inches apart. There is enough light so that I can just make out his face. His hair has fallen forward onto his brow, and his eyes seem expressionless— simple dark pools. I have on a nightshirt, a white nightshirt with pink cotton piping. Thomas is still wearing the blue shirt with the thin yellow stripes, and his undershorts.

He reaches up and traces the outline of my mouth with his finger. He grazes my shoulder with the back of his hand. I move slightly toward him. He puts his arm around my waist.

We have a way of making love now, a language of our own, this movement, then that movement, signals, long-practiced, that differ only slightly each time from the times before. His hand sliding on my thigh, my hand reaching down between his legs, a small adjustment to free himself, my palm under his shirt. That night, he slides over me, so that my face is lightly smothered between his chest and his arm.

I freeze.

It is in the cloth, faint but unmistakable, a foreign scent. Not sea air, or lobster, or a sweaty child.

It takes only seconds for a message to pass between two people who have made love a thousand times, two thousand times.

He rolls away from me and lies on his back, his eyes staring at the bulkhead.

I cannot speak. Slowly, I take the air into my lungs and let it out.

Eventually, I become aware of the small twitches in Thomas's body—an arm, a knee—that tell me that he has fallen asleep.

To get a landscape photograph at night, you need a tripod and decent moonlight. Sometime after midnight, when everyone is asleep on the boat, I take the Zodiac over to Smuttynose. I use the paddle, because I do not want to wake Thomas or Rich with the motor. In the distance, the island is out-lined by the moon, which casts a long cone of light onto the water. I beach the Zodiac at the place where Louis Wagner left his dory and retrace the steps he would have taken to the house. I stand in the foundation of the house and replay the murders in my mind. I look out over the harbor and try to

imagine a life on the island, at night, in the quiet, and with the constant wind. I take two rolls of Velvia 220, seventy-two shots of Smuttynose in the dark.

21 September 1899

I have been thinking this morning upon the subjects of storytelling and truth, and how it is with the utmost trust that we receive the tales of those who would give them to us.

Not long after our mother had died, and I had recovered from my illness, Karen became, as I have said, the mistress of the house, and Evan and I were sent out to work, me to a neighboring farm, and Evan to sea. This was not such an unusual occurrence, not in that area and in that time.

Our father, having grown older and grieving for the loss of his wife, was going to sea fewer days than he had before and not for long journeys as he had done in the past. Thus he did not have a surplus of fish to sell or to dry. All around us at this time, there were other families in failing circumstances, some far worse off than we were, families in

which the father had drowned, and the mother and the eldest son had the responsibility of feeding many young children, and also families whose livelihoods had been reduced by the economic troubles of the region and, indeed, of the entire country at that time, and there were many indigent and homeless persons as a result. By contrast, I remember very few occasions when our family actually had no food in the pantry, although I do recall at least one and perhaps two winters when I had only one dress and one pair of socks to see me through to spring, and we could not get wool to spin to make another pair.

The decision to send Evan out to work was, I believe, an easy one for my father, since Evan was a tall and strong boy of sixteen, and there were many youths of the same age in the environs of Laurvig who had been working for some time. It was thought that Evan would make a better wage as a hired mate to someone else than he might by selling the herring and the cod he would catch with my father; but because there was very little fishing work in Laurvig Bay in those years, Evan had to go to Tons-

berg, which was twenty kilometers north of Laurvig. There he was told about a man named John Hontvedt, who was looking for a mate and who lived in a house with six other fishermen, one of them his brother, Matthew. From that day forward, which was 12 October 1860, until such time as Evan and John entered into partnership, Evan worked with John Hontvedt on his fishing sloop, the *Malla Fladen,* and lived in that house for six days a week.

As for myself, I stayed one more year at school, and then was hired out to the Johannsen farm. This was a grave time in my father's life, and I believe the decision to send his youngest child out to work was a wrenching one for him to make. Karen could no longer go to the boarding house as she was needed at home, and since I was only fourteen and my father did not think it suitable for me to work in similar circumstances, he inquired about work for me elsewhere, where the conditions might be more gentle. As it happened, it was Karen who was advised of the position with Knud Johannsen, who was a recent widower himself, and she urged my father to send me there.

Knud Johannsen's dairy farm lay six kilometers back from the sea, an uphill climb on my way to work in the morning and, of course, a downhill slope in the evening, which was just as well, since I usually was so very tired then that I needed gravity to propel me forward to our cottage. My hours at the Johannsen farm were long and difficult, but generally, not unpleasant. During the time of my employ at that household, which lasted two years and eight months, Evan and I did not have many opportunities to see each other, and almost never alone, and this was a sorrow to me. Because of Evan's hard work and prosperity, however, our family's fortunes did gradually increase, so that I was allowed to discontinue my work for Mr. Johannsen and re-enroll in school, where I stayed for one year and seven months, entering a course of preparation for further study, though sadly I was not ever to go on to university. It was my good fortune, while in school, however, to put my whole heart and mind into my studies and thus command the attention of Professor Neils Jessen, the headmaster, who then took upon himself the bettering of my language skills so that I subsequently found

pleasure in the study of rhetoric and com-
position. I trust that while I was lacking in
certain rudimentary prerequisites for this
challenging task at hand, I acquitted myself
passably well, as Professor Jessen spent
many hours with me after school in hopes
that I might be the first female student from
the Laurvig School to attend the university
in Kristiania.

As it happened, however, I was not able
to go on to university, owing to a lack of suf-
ficient funds, even though my brother regu-
larly sent to us large portions of his wages,
and so I applied for and was given a position
as clerk at the Fritzoe ironworks, which I
held for two years. And then, in the winter
of 1865, John Hontvedt and his brother,
Matthew, moved to Laurvig, and shortly after
that, the direction of my life changed quite
dramatically.

A house in the Jorgine Road had become
vacant and was to be leased at a low price,
and Evan had spoken highly of the area to
John these several years. Because of his
hard work and cleverness, John Hontvedt
had done well for himself in the fishing trade,
and with him Evan had earned enough

money to put some by. The two men, with
Matthew Hontvedt, thus entered into a part-
nership aboard a sloop which they pur-
chased and which was called the *Agnes C.
Nedland.*

John Hontvedt was not a particularly tall
man, not when compared to our father and
to Evan, both of whom were well over six
feet, but John gave the impression of
strength and of size nevertheless. He had
brown hair of a cinnamon tint that he wore
thick and long, combed across his brow, and
he had as well eyes that hinted at a gentle-
ness of spirit. They were hazel, I believe, or
possibly gray, I cannot remember now. His
face was not narrow, as was Evan's, but
rather square in shape, and he had a hand-
some jaw. I suspect he had been thin as a
boy, but as a man, his body, like his face,
had filled out. His chest was round and
formed like a fish barrel. He had no fat on
him at that time.

Hontvedt had a habit of standing with his
hands hooked around his belt, and of hitch-
ing his trousers sometimes when he spoke.
When he sat, he crossed his legs at the
knees, as some women do, but he was

never feminine in any other of his gestures. Occasionally, when he was tense or anxious, he would hold his elbow with one hand, and swing the free arm in an exaggerated manner, an odd gesture, I always thought, and one I came to think of as belonging exclusively to John. He had lost one finger of his left hand as a consequence of having severed it in a winch.

I believe our father was, at the time I met John Hontvedt, apprehensive for his two daughters. Certainly this was true as concerns his responsibilities toward Karen, who, at thirty-three, had lost her youth and seemed destined to remain a maid. It was a shame upon a father, then as now, if he could not marry off his daughters, and I shudder to think of all the young women who have been so unsuitably given away, only to live out lives of utter misery simply to assuage the public strain of their fathers.

I will not accuse our father of such base desires, however, for, in truth, I do not think this was so, but I believe that he was, after having watched his eldest daughter turn herself into a spinster, anxious to see me well

married. Also, I must add here that my father had not recently met a man in these parts who was of so good a fisherstock and who had prospered so well as John. And I believe my father had reason to be grateful to John Hontvedt for his having taken on our Evan, and in that way gradually changing the fortunes of our family.

One evening, after Hontvedt had been to our table for dinner, he suggested that he and I go out walking together.

I had not actually wanted to go walking at all, and certainly not with John Hontvedt, but I did not see how I could refuse such a request, particularly as it had been made in front of my father. It was a mild night in early October, with long shadows that caused the landscape to take on a heightened clarity. We walked in the direction of the coast road, toward town, John with his hands in the pockets of his trousers, mine folded at my waist, as was proper for a young woman then. John took up the burden of the conversation, talking, as I recall, with great ease and volubility, although I cannot remember anything of what he said. I confess it was often this way between us, as I frequently

allowed my thoughts to wander whilst he spoke, and, oddly enough, he seldom seemed to notice these absences of mine. That evening, when after a time I did begin to attend to what he was saying, I noticed that we were quite far from the cottage. We were standing on a headland that looked out over Laurvigsfjord. The ground was covered with gorse that had gone aflame with the setting sun, and the blue of the water below us had reached that deep solid sapphirine that comes only late in the evenings. We were admiring this view, and perhaps John was addressing me, when I noticed that he had moved closer to me than was strictly comfortable. Nearly as soon as I had this observation, he put his hand lightly at the back of my waist. This was a gesture that could not be misunderstood. It was, I believe I am correct in saying, a somewhat posses-sive gesture, and I was then in no doubt as to its intent. I think I may have moved slightly away from him, but John, who was dogged in his pursuits, moved along with me, so that he had no need to remove his hand. As we stood there, I recall that his fin-gers began to inch even further, so that he

was able to circle my waist. I thought that if I did not speak to him at that moment he might take my passivity as an invitation for further intimacies, which I did not want, so I moved abruptly away from him then.

"Maren," he said, "there are things about which I must speak to you."

"I am feeling quite tired, John. I think we should go back to the cottage."

"You know," said John, "that I have given some thought to emigrating to America. I have been much impressed with reports of the American customs and views, particularly the idea that there is no class distinction. That a man pays only a little tax on the land he actually owns, and is not filling the pockets of the idle, who do no work at all."

"But would you leave all that you know behind and go to a country in which if you do not have money you must remain where you are on the coast?" I asked. "I have heard tales of the large sums that are necessary to travel to the interior, and even there the land is already being twice-sold so that the original owners reap enormous profits, and cheap land can no longer be had by newly arrived immigrants. I have also heard

that commodities are very expensive there. A barrel of salt costs nearly fifty orts! And coffee is forty skillings a pound!"

"Since I would want to remain on the coast," he answered, "I do not see the worry about having money to travel inland. But I do understand your point, Maren. One must have a stake with which to begin a new life, for a house and supplies and transportation and so on."

"Would you truly settle there, on the coast of America?" I asked.

"I might if I had found a wife," John answered.

At the word *wife,* John looked at me, and my eyes turned toward his, even before I had understood the suggestion in his declaration. It was the first time such a thought had clearly presented itself to me, and I confess I was at first quite shocked.

"I'm sorry, Maren," he said. "You seem distressed, and this was not at all my intention. Indeed, my intention was quite the opposite. In all my days on earth, I have never met a sweeter woman than you, Maren."

"Really, John, I am feeling quite faint."

"Whether I should go to America or remain in Norway, I am of an age now, and

happily of sufficient means, that I may think of taking a wife. I trust that I may be worthy enough in my character to ask . . ."

I have never appreciated women who resort to histrionics or who show themselves to be so delicate in their constitutions that they cannot withstand the intense images that words may sometimes conjure forth, but I must acknowledge that at that moment, standing on the headland, I was so sorely exercised in my futile attempts to convince my companion to cease his conversation and escort me back to the cottage that I was tempted to feign a swoon and collapse in the gorse at his feet. Instead, however, I spoke to John rather sharply. "I insist that we return or I shall be ill, John," I said, and in this way I was able, for a time, to stave off what seemed to me to be an inevitable request.

It was only the next day that my father himself broached the subject. Evan had gone off to bed, and Karen was visiting the privy in the back, so that my father and I were alone. He wished, he said, to see me settled with a family. He did not want me to be dependent upon himself, as he did not think he had many years left. I cried out at this declaration, not only because I did not

like to think upon my father's death, but also because I was cross at having twice in one week the necessity to fend off the prospect of marrying John Hontvedt. My father, brushing aside my protests with his hand, spoke of John's character, his healthy financial situation, and, finally, though I thought his priorities misplaced, of Hontvedt's apparent affection for me, which might, in time, he said, develop into a deep and lasting love. I was greatly vexed by having to think upon these matters, but I hasten to tell you that in Norway at that time, it was seldom the place of a young daughter to criticize her father, and so it was that I had to hear my father out at length on the subject of my eventual marriage. Dutifully, I said that I was grateful for his concerns, but that it was too soon in my life to take such a large and grave step, and that it would only be with the utmost care and consideration that I would do so.

I thought the matter at an end, or at least held in abeyance for a time, when, due to an impulsive gesture on my part, which I was later deeply to regret, I myself caused the subject to be brought up again, and finally resolved.

It was some four weeks later, in mid-November, and the weather was quite bitterly cold, but in the late afternoons a strange and wondrous phenomenon would occur on the bay. Because the water was considerably warmer than the air above it, great swirls of mist would rise from the sea, like steam lifting from a bath. These swirls, due to the light and angle of the sun at that time of year, would take on a lovely salmon color that was breathtaking to behold. So it was that the bay, which was normally thick with fisher-traffic in and out of the harbor, had that Sunday an entirely magical quality that I do not believe was reproduced anywhere else on earth. It was a natural occurrence that Evan and myself had sometimes observed on our journeys as children along the coast road, and it had never failed to halt our progress as we stood in rapt worship of such a simple, yet magnificent, accident of nature. That afternoon, I asked Evan if he would like to accompany me out to the cliffs, where we might better observe the bay. I thought this would be a good opportunity for Evan and myself to speak with each other apart from the others, which we rarely had occasion to do. Evan was at first reluctant,

since I believe that he was particularly exhausted from his arduous week (for a fisherman's work is invariably made more difficult in cold temperatures), but I persisted in my invitation, and I daresay I talked him into it.

We walked for some distance without speaking. My brother seemed rather preoccupied that afternoon, and I was somewhat at a loss as to how to begin our conversation. As Evan walked beside me, I could not help myself from making a close observation of him. Already it was apparent that, at the age of twenty-two, the sun and the sea had begun to take their toll, as he had tiny lines around his eyes and mouth and on his forehead. His brow seemed to have knit itself together in a permanent manner, and I thought this the result of a constant squint on the water. His skin was weathered, with that texture seamen get that resembles nothing so much as fine paper. The blisters and rope burns on his hands had long since turned to calluses, but I could see the scars of many hook tears on his fingers. Additionally, I observed that Evan had attained, during his absence, his full growth, and I may say here that he towered over me. He was

not, as I may have mentioned earlier, built broad in the shoulders, as John was, but rather was sinewy in his structure, though he gave off the appearance of great strength. I think that partly this was due as well to his character, which was extremely reserved and not given to much foolishness.

After a time, we passed a few pleasantries between us, but spoke of nothing that might be of a difficult nature, at least not immediately. I had dressed that day in my heavy woolen cloak, and my face was wrapped in a long scarf of a fine pale blue, the wool of which I had sent for from Kristiania.

"Do you remember," I asked when we had reached the cliffs and were gazing out at the bay, from which rose what appeared to be a miasmic wall of coral and rose and pink, "all the walks we used to take along this very coast road?"

He looked surprised for a minute, and then he said, "Yes, I do, Maren."

"And the day you climbed the tree, and I took off all my clothes and went up after you?"

"It seems so long ago."

"And how you saved me at Hakon's In-let?"

"You would have saved yourself."

"No, I'd have drowned. I'm sure of it."

"It wasn't a very safe place to play," he said. "If I saw children there now, I'd chase them off."

"We never thought about safety."

"No, we didn't."

"Those were such good times," I said.

Evan was silent for a moment. I assumed that he was, like myself, contenting himself with the fond memories of our childhood, when suddenly a great sigh erupted from him, and he turned himself away from me.

"Evan, what is it?" I asked.

He didn't answer me. I was about to ask him again what the matter was, but I was silenced by the sight of tears that had, at that moment, sprung to his eyes. He shook his head violently, so that his hair swung about. Indeed, he was shaking his head in the rough manner of men who wish literally to throw out of their heads the thoughts that lodge there. I was so frightened and ap-palled by this sudden show of emotion and of intense hatred toward himself that I fear I cried out in the most desperate way and

flung myself to my knees, for I have never been able to bear signs of grief or of sorrow on the face of my brother—and indeed, these signs triggered in me memories of the night our mother perished, a night on which Evan, and thus myself, had nearly lost our senses.

When next I was aware of my brother, he was tugging on my sleeve and trying to get me to stand up.

"Don't be so dramatic, Maren," he said curtly. "You'll freeze to death." He brushed tiny pebbles from my cloak.

And then, without any further words between us, Evan began to walk along the coast path south in the direction of the cottage. It was apparent, from his gait, that he did not intend I should follow him.

I had never been abandoned by Evan in so horrid a manner, and although I did soon recover myself and think how distraught my brother must have been to have wept in front of me and how truly sorry I was for his troubled nature, I felt bereft there on the cliffs and also, I must say, quite angry.

I walked home with a furious step and, at a critical juncture in the road, I took a turn that I have forever regretted. At the Jorgine

Road, I walked east, toward John Hont-vedt's cottage.

My legs and hands were trembling as I climbed the porch steps of Hontvedt's house, from the earlier disturbances on the cliffs or simply the inappropriateness of my visit I cannot say, but as you may imagine, John Hontvedt was exceedingly surprised to see me. After his initial shock, however, he could not hide his pleasure.

I allowed John Hontvedt to make me a cup of tea and to serve this to me in his front parlor, along with biscuits that he had pur-chased in town. He had not fully dressed, and had no collar on, and in his haste to prepare the tea, did not put one on. Perhaps it was only the absence of the collar and the sight of his braces, but I felt as though the entire encounter were an improper one. In-deed, I could not easily have explained my presence in John Hontvedt's house to any-one were someone to come upon us. What was I doing unchaperoned in a single man's living quarters on a Sunday afternoon? Pos-sibly it was in an effort to answer that query, even to myself, that I spoke to John.

"Do you remember that on our walk of

several weeks ago you were speaking of
some matters?" I asked.

He put down his mug of tea. "Yes, I do."
I believe I had surprised Hontvedt in the act
of trimming his beard, as it had an odd, mis-
shapen appearance.

"And I insisted that you stop speaking of
them?" I asked.

"Yes."

"I have thought about the matters which
you brought up, and it seems to me that
these are subjects we might at some later
date continue to discuss. That is, we may
explore them further."

"Oh, Maren—"

"This is not to say at all that I find the idea
acceptable at the moment. I am merely stat-
ing that I will allow further discussion."

"You cannot imagine—"

"You understand, of course, that it is re-
ally too soon for me to think of leaving my
father's house. . . ."

To my horror, John Hontvedt left his seat
altogether and placed himself at my feet. I
made a motion with my hands to make him
rise, but he seized both of my hands in his.

"Maren, I shall not disappoint you!" he

cried. "I shall make you the happiest woman in all of Norway."

"No, John, you have misunderstood. . . ."

He reached forward to embrace me. I believe he underestimated his strength and his ardor, for when he put his arms around me, he nearly squeezed the breath out of my body. In the next minute, he was covering my face and my hands with kisses and had leaned his entire torso onto my lap. I tried to stand up, but could not move in this embrace. I became frightened then, frightened of being overtaken by someone stronger than myself, and also quite hollow with the first sensations of a decision so wrong as to threaten to poison my entire soul.

"John!" I cried out. "Please stop!"

John then stood up, and he said that he would walk me to the cottage. I protested, as I did not want Karen or my father to see Hontvedt in such an excited state, nor did I want this excitement to carry over into any possible conversation between Father and John.

"I shall make you very happy, Maren," he said.

"Thank you," I said, although I sincerely doubted that he could do this.

And thus it was that John Hontvedt and myself came to be engaged.

Hontvedt and I were married on 22 December 1867, just after the winter solstice. I wore the walnut silk I have mentioned in these pages, as well as a fringed bonnet with braided ties that fastened behind the ears and under the chin. Professor Jessen, who remained my friend, lent Hontvedt and myself his house in Laurvig for a small wedding party after the ceremony at Laurvig Church. I confess I was not so gay on this occasion as I might have been, as I was somewhat fearful of the heavy responsibilities that lay before me as the wife of John Hontvedt, and also because my brother, Evan, did not come to my wedding, owing to the fact that he was home ill with a bronchial infection, and this was a distress both to John and myself.

After the reception, at which John drank a good deal of aquavit, which Professor Jessen had been kind enough to provide for us, I was forced to leave the others, as was my duty, and to go away with John, to his house, where we were to spend our first night together. I should say here that our initial occasion as man and wife was not en-

tirely successful, owing in part to John's state of inebriation, which I had reason, in the event, to be grateful for, and also to some confusion, when John cried out, although there was only, I am relieved to say, myself to hear, that I had deceived him. Since I had not given any thought to these technicalities, nor had I been properly educated in that aspect of marriage, having only Karen, who, of course, cannot have had any experience herself, to instruct me, I was alarmed by John's cries, but fortunately, as I have indicated, the drink then overwhelmed him, and though I anticipated some discussion on this subject the next morning, it was never again raised, and I am not certain to this day if John Hontvedt ever retained any consciousness of the particular occurrences of our wedding night, his memory having been expunged, so to speak, by the aquavit.

Torwad Holde's hateful letter came to us shortly after the wedding. All that long winter, in the darkness, newly married, I was engaged in numerous preparations for the Atlantic crossing. John wanted to set sail in the early spring as it would allow us several months of mild weather during which to es-

tablish ourselves in a fishing community, find lodgings and lay by enough food to see us through the following winter.

Though I had no inclination myself to take this voyage, I knew the value of having stores, as I had read many America letters which attested to the necessity of bringing one's own provisions, and in sufficient quantity, on the crossings. Sometimes Karen assisted me in this work, but not often, as I was no longer living in my father's house. All that long winter, in the darkness, newly married, I made clothes for John and myself of wool, and of colored gingham when I could come by it. John built for us barrels and chests, into which I put salted fish, herring, sour milk, beer, rye rusks, whey cheese, peas, cereal, potatoes and sugar. In other chests, I packed tallow candles, soap, a frying pan, a coffee burner, kettles, a flatiron, a tin funnel with matches, many linens and so on. Indeed, I believe I so occupied myself in the preparations for our journey that I was able to put from my mind, until those last moments on the dock with Evan, the nearly unthinkable fact of the voyage itself, which would mean my departure from Norway forever. To this end, I had not

made any farewells, either to my family or to my few friends, believing that to do so might weaken whatever small resolve I had in regards to my duty, which was to accompany my husband on this sojourn.

Our sailing vessel, which was sloop-rigged, contained, belowdecks, forty bunks, each of which was to be sleeping quarters, as well as storage, for two persons. So that John and I, for thirty-nine days, shared a narrow pallet with many of our provisions, and owing to the fact that I dared not remove my outer garments in that crowded room, and also to the dreadful pitching and rolling of that ship, I hardly slept at all during those interminable nights. Instead I lay in the blackness of that hold listening to various persons praying and crying and being sick, with no hope of release until North America was reached, or the ship sank, and there were nights of such wretchedness that, God forgive me, I sometimes wished for the latter.

We were not treated badly by the crew, as I have heard was the case on some Atlantic crossings, particularly aboard those vessels that were owned by the English, but water was strictly rationed, and so much so

that it was a trial to most of us to manage on just one quart a day, although John and I did have the beer to drink when our thirst was almost intolerable. I had the seasickness from the second day out, and I may say here that I believe there is no physical torment, which then permits recovery, greater than the seasickness, which causes one to feel ill at one's very soul. So wretched was this affliction that I was unable to eat, and might have grown seriously ill as a consequence of this. I must, however, despite the misery of those days, count myself among the lucky, for there were those on board who contracted the ship's fever and the cholera, and it is a wonder of God that these dreadful contagions did not spread to us all. During the fourth week of our voyage, which was the worst in regards to illness on board, there were many burials at sea, the most trying of which was the burial of a small boy, who had contracted the ship's fever, which is also called typhus, and who was so thin at the time of his death that, though he had boarded the ship fat enough, he had to be buried with sand in his casket, so that the poor child might sink to the depths, and not stay afloat behind the ship,

which would truly have been an unendurable torment to the mother, who was already in despair. I believe this was the lowest moment of our journey, and that there was not one person on board, who was still conscious and sensible, who was not sorely affected by this tragedy.

I am told that on the voyage, those who were not ill engaged in knitting and sewing, and some playing of the flute and violin, and I think that John, as he remained in robust health the entire trip, may have participated in the music-making and singing that sometimes spontaneously erupted out of the tedium of the crossing. We lost fourteen persons to illness during the journey, and one woman from Stavern gave birth to twins. I have always thought this a grotesquely unacceptable ratio of deaths to births, and had I paid more attention to the stories of fatal diseases on board these ships, I might have been able to persuade John Hontvedt not to make the crossing at all. But this is idle speculation, as we did make the journey, did reach Quebec, where we were quarantined for two days, and did travel further south to the town of Portland in the state of Maine, and thence to Ports-

mouth in the state of New Hampshire, where we were met by Torwad Holde, who took us, in his schooner, to the island of Smutty Nose, where I was to reside for five years.

In having undertaken to write this document, I find I must, unhappily, revisit moments of the past, which, like the Atlantic Crossing, are dispiriting to recall. And as I am in ill health at the time of this writing, it is a twice-difficult task I have set for myself. But I believe that it is only with great perseverance that one is able to discover for oneself, and therefore set before another, a complete and truthful story.

I had been forewarned that we would be living on an island, but I do not think that anyone could adequately have prepared me for the nature of that particular island, or, indeed, of the entire archipelago, which was called the Isles of Shoals and lay 18 kilometers east of the American coast, north of Gloucester. As it was a hazy day on our first trip from Portsmouth to the islands, we did not spy the Shoals altogether until we were nearly upon them, and when we did, I became faint with disbelief. Never had I seen such a sad and desolate place! Lumps of rock that had barely managed to rise above

the water line, the islands seemed to me then, and did so always after that day, an uninhabitable location for any human being. There was not one tree and only the most austere of empty, wooden-frame dwellings. Smutty Nose, in particular, looked so shallow and barren that I turned to John and implored him, "This is not it! Surely this is not it!"

John, who was, at that moment, struggling to conquer his own considerable shock, was unable to answer me. Though Torwad Holde, who was, the reader may recall, the author of the infamous letter that had brought us to America (and to whom I was perhaps not as cordial as I might have been), yelled out with some enthusiasm, "Yes, Mrs. Hontvedt, these are the Isles of Shoals. Are they not wonderful?"

After we had made anchor in the tiny harbor, and I, trembling, had been helped onto the island of Smutty Nose, I felt a deep sinking as well as the beginnings of fear in my breast. How could I live on this inhospitable ledge in the middle of the Atlantic Ocean, with nothing around me but seawater, with the nearest shore not even within sight that day? How could I accept that this was the

place where I should spend the rest of my life, and upon which shortly I was to be abandoned by all human company, with the exception of John Hontvedt? I clung to my husband, which I was not in the habit of doing, and begged him, I am ashamed to say, right in the presence of Torwad Holde, to take us back to Portsmouth instantly, where we might at least find a house that was settled on the soil, and where there might be about us flowers and fruit trees such as we had known in Laurvig. John, embarrassed for me and disentangling himself from my embrace, went to help Torwad Holde carry our provisions into the cottage that stood on that island with the forlorn look of a child who has been abandoned or not ever loved. Although it was spring, there were no inhabitants in any of the other buildings on the island, and there were no blossoms in the crevices of the rocks. The soil, when I bent down to feel it, was not even three inches deep. What beautiful thing could possibly grow in such a wasteland? Around me I could hear no human sounds, apart from the grunts and sighs of John and Torwad Holde as they went to and fro with their burdens. There was, however, the steady irritating

whine of the wind, for it was a cold day in early May, not at all spring-like. I walked slowly eastward, as if in a trance, as if, having committed no crime, I had been sentenced to a life in exile in the bleakest of penal colonies. I gazed out to the horizon line, imagining that my beloved Norway lay in my line of sight. We seemed to have travelled half the earth! And for what purpose?

After a time, when I could bear it, I entered the wooden-frame house that would be my home for five years. It was sided with clapboards, and was of an entirely unadorned style I was not familiar with. It had, I imagine, originally been built for at least two families, as there were two separate dwellings within the one, each with its own front door on the northwestern side of the house. The house had been painted a dull red, and there were no shutters on the windows. A single chimney, such as might accommodate a stove, had been put into the house. Inside of each apartment, there were three small rooms downstairs and one small room up a short stairway. The stove was put into the largest room of the first apartment, and henceforth we used that room as our kitchen and living room, and, in winter, as our bed-

room as well. As it was then 9 May, however, John put our bed in the southwestern corner of that apartment. I believe that the previous tenants, doubtless a fisher-family such as we, had been in rather poor financial circumstances, as the walls were papered with newsprint that had yellowed, and, in some places, torn. No curtains hung on the windows, and there was no evidence of any painting or of any effort to make a cheerful abode. The entire interior was bleak, and, if I may say so, quite gloomy, as there was, in the kitchen, only one small window at the end of the room. As the house held the smell of mildew as well, I thought it could not have been occupied for some time.

John brought a chair into the house, and I sat on it. He touched me on the shoulder, but did not speak, and then he went out again.

I sat, in an attitude of prayer, with my hands folded in my lap, though I could not pray, as I thought then that God had abandoned me. I knew that I would not be able to leave the island, that our arrival at this place was irrevocable, as was my marriage to Hontvedt, and I had, I remember, to bite

my cheek to keep from breaking into tears that once started might continue forever.

But perhaps God did not abandon me after all on that day, for as I sat there, paralyzed with the weakest of sins, which is despair, I believe it was God's hand that caused me then to realize that I must somehow survive my ordeal so that I would one day be reunited with my brother. I stood up and walked to the window and looked out over the rock. I vowed then to keep as still and as silent as possible so that the strong emotions that threatened to consume me might come under my control, in much the same way that a drowning man, clinging to a life raft, will know that he cannot afford to wail or cry out or beat his breast, and that it is only with the utmost reserve and care and patience that he will be able to remain afloat until he is saved. It would not do, I also knew, to bemoan constantly my great loss to my husband, for John would quickly tire of that lament, and would feel, in addition, a personal sorrow that would inhibit his own ability to embrace the life he had chosen. I turned away from the window and examined again the interior of the cottage. I would make a home here, I told myself. I would not look eastward again.

In Africa, when I was on assignment there, some Masai whom I met thought that if I took a photograph of them, and if I went away with that photograph, I would have stolen their soul. I have sometimes wondered if this can be done with a place, and when I look now at the pictures of Smuttynose, I ask myself if I have captured the soul of the island. For I believe that Smuttynose has a soul, distinct from that of Appledore or Londoner's, or any other place on earth. That soul is, of course, composed of the stories we have attached to a particular piece of geography, as well as of the cumulative moments of those who have lived on and visited the small island. And I believe the soul of Smuttynose is also to be found in its rock and tufted vetch, its beggar's-ticks and pilewort, its cinquefoil brought from Norway. It lives as well in the petrels that float on the air and the skate that beach themselves—white

and slimy and bloated—on the island's dark beach.

In 1846, Thomas Laighton built a hotel on Smuttynose known as the Mid-Ocean House. This hotel was a thin, wooden-frame, clapboard structure, not much bigger than a simple house. It was built on pilings and had a wraparound porch on three sides. Over the tin roof of the porch hung a hand-painted sign from a third-story window. The sign was imperfectly lettered and read, simply, MID-OCEAN HOUSE.

From photos of the hotel, there is little evidence of landscaping around the building; sand and rock and seagrass border the pilings under the porch. But history tells us that the hotel, in its heyday, boasted a garden, several fruit trees, and a bowling green. Nathaniel Hawthorne, Henry David Thoreau, Edward Everett Hale, and Richard Henry Dana were guests at the Mid-Ocean. In one archival photograph, three unidentified people are relaxing on the porch. One man is wearing a suit with a white straw hat; a woman has on a high-necked, long-sleeved black dress, with a black silk bonnet, a costume that seems better suited for a Victorian funeral than for a holiday on Smuttynose. A

second woman, who appears to be stout, and who has her hair rolled at the back, has on a white blouse, a long black skirt, and over it an apron. One imagines her to have been the cook. The Mid-Ocean House burned in 1911. In March of 1873, the hotel was unoccupied because the season didn't begin until June.

I wonder now: Did Maren ever go to the Mid-Ocean Hotel? Might John, on a pleasant summer evening, have walked his wife the hundred yards, across the rocks with the wildflowers snagged and blowing, to the hotel porch, and had a cup of tea and a piece of American cake—a bowl of quaking pudding? Whitpot? Would they have sat, straight-backed, in the old woven rockers, damp and loosened already from the sea air, and looked out to a view they knew already by heart? Might this view—this panorama of rocky islands and spray and some pleasure boats coming now from the mainland—have looked different to them than it did from the windows of the red house? Did Maren wear a dress brought from Norway, and were they, as they sat on the wooden porch in the slight breeze from the water,

objects of curiosity? Their shoes, their speech, their not-perfect manners giving them away? Might they have sat beside Childe Hassam at his easel or Celia Thaxter with her notebook and passed a pleasantry, a nod, a slight bow? Might John once have reached over to the armrest of his wife's chair and touched her hand? Did he love her?

Or was the hotel a building they could not enter except as servants—John, in his oilskins, bringing lobsters to the cook? Maren, in her homespun, her boots and hands cracked, washing linens, sweeping floorboards? Did they, in their turn, regard the guests as curiosities, American rich who provided Shoalers with extra monies in the summer season? Pale natives who were often seasick out from Portsmouth?

I like to think of Hawthorne on Smuttynose, taking the sea air, as had been prescribed. Would he have come by steamer from Boston, have brought a boater and a white suit for the sun? Would he have been inspired by the desolation of the Shoals, tempted to bathe in the extraordinarily deep waters that separated Smuttynose from Ap-

pledore or Star? Might he have been invigorated by the conversation of the intellectuals and artists Celia Thaxter had gathered around her—Charles Dickens and John Greenleaf Whittier, William Morris Hunt, a kind of colony, a salon. Did he eat the blueberry grunt, the fish soup, the pluck that was put before him? And who put it there? Is it possible that a Norwegian immigrant hovered over him? Did this woman ask a question of Nathaniel Hawthorne, a pleasant question, having no idea who he was, another guest is all, in her charming but broken English? *Tings. Togedder. Brotter.*

It is almost impossible now, looking across to Smuttynose, to imagine Hawthorne on that island. There is no trace of the Mid-Ocean Hotel. It has passed into recorded memory, historical fact, with no life except in sentences and on photographic emulsion. If all the sentences and photographs about the hotel were to be swept into the sea that surrounds Smuttynose, the Mid-Ocean—Hawthorne's stay there, an immigrant's abbreviated pleasantries—would cease to exist.

No one can know a story's precise reality.

On October 2, 1867, a boxing match was held at Smuttynose. Because gambling was illegal in the 1860s, isolated locations, without much interference from the police, were in demand. The Isles of Shoals, and Smuttynose in particular, appeared to be ideal for this purpose. Two fighters went at it for an hour and a half in the front yard of the Charles Johnson house, previously known as "the red house," and subsequently to be known as the Hontvedt house. The spectators came by boat. Another fight was planned, but was canceled when bad weather prevented any observers from reaching the island and made the contestants seasick.

At dawn on the morning of the second day at the Isles of Shoals, I am awakened by unwanted and familiar sounds. I slip out of the bed, with its damp-roughened sheets, and begin to make a pot of coffee in the galley. When I run the water, I cannot hear the movements in the forward cabin. I am waiting for the coffee to drip through the filter, my arms crossed over my chest, a sense of wet seeping through my socks, when I reach

up and pop open the hatch for just a sliver of fresh air. I see immediately that the sky is a darkened red, as though there has been a fire on the shore. I open the hatch fully and climb up through the companionway in my robe. A band of smoky crimson arches over all the islands, a north-south ribbon that seems to stretch from Portland all the way to Boston. The red is deep in the center, becoming dustier toward the edges. Beneath the swath of red, gulls catch the light of the slanted sun and seem momentarily imbued with a glow of color all their own. I am somewhat concerned—the way you are when nature goes off her routines—yet I want to go below, to wake Billie, to show her this phenomenon of sunlight on water particles in the air. But Billie is already there, behind me.

"I've cut my foot, Mommy" is what she says.

I turn in the cockpit. Her face is sticky and puffed with sleep, her mouth beginning to twist with the first messages of pain. She has on her summer baseball pajamas, shorts and a T-shirt—*Red Sox,* they say. Her feet are white and tiny and bare, and

from her right foot the blood is spreading. She moves slightly toward me and makes a smudge on the white abraded surface of the cockpit floor. A small stray shard from last night's broken glass must have fallen below the ladder of the companionway. My opening the hatch this morning has woken Billie, who then walked into the small triangle under the ladder to retrieve one of Blackbeard's treasures, the key chain.

I go below to get towels and hydrogen peroxide and bandages from the first-aid kit, and after I have washed and dressed the cut and am holding Billie in my arms, I look up and realize there is no trace, nothing left at all, of the red band in the sky.

Rich comes up onto the deck, puts his hands to his waist, and examines the color and texture of the sky, which is not altogether clear, not as it was the day before. To the east, just below the morning sun, a thin layer of cloud sits on the horizon like an unraveling roll of discolored cotton wool. Rich, who looks mildly concerned, goes below to listen to the radio. When he returns to the deck, he brings with him a mug of coffee. He sits opposite Billie and me in the cockpit.

"How did it happen?"

"She cut it on a piece of glass."

"She's all right?"

"I think so. The bleeding seems to have stopped."

"NOAA says there's a cold front coming through later today. But NOAA is not to be entirely trusted."

Rich moves his head so that he can see beyond me. There is a gentle chop, but the harbor still seems well protected. Across the way, there is activity aboard a ketch anchored near us. Rich nods at a woman in a white polo shirt and khaki shorts.

"Looks like they're leaving," he says.

"So soon? They just got in last night."

A sudden breeze blows the skirt of my robe open, and I fold it closed over my knees. I do not really like to be seen in the morning. I have a sense of not being entirely covered, not yet protected. Rich has on a clean white T-shirt and a faded navy-blue bathing suit. He is barefoot and has recently showered. The top of his head is wet, and he doesn't have a beard. I wonder where Adaline is.

"I don't know," he says, speculating out loud about the storm. "It isn't clear how bad

it will be, or even if it will definitely be here by tonight."

I shift Billie on my lap. I look over toward Smuttynose. Rich must see the hesitation on my face.

"You need to go over to the island again," he says.

"I should."

"I'll take you."

"I can take myself," I say quickly. "I did it last night."

This surprises him.

"After everyone was asleep. I wanted night shots."

Rich studies me over the rim of his coffee. "You should have woken me," he says. "It isn't safe to go off like that by yourself. At night, especially."

"Was it scary, Mommy?"

"No. Actually, it was very beautiful. The moon was out and was so bright I could see my way without a flashlight."

Rich is silent. I pick up my own mug from the deck. The coffee is cold. Billie sits up suddenly, jogging my arm. The coffee spills onto the sleeve of my white robe.

"Mommy, can I go over with you tonight?

To the island when it's dark? Maybe there will be ghosts there."

"Not tonight," says Rich. "No one's going over there tonight. We may be having a storm later. It wouldn't be safe."

"Oh," she says, dropping her shoulders in disappointment.

"I've got landscape shots from the water," I say, tallying up my meager inventory. "And night shots, and I've done Maren's Rock. But I need shots from the island itself, looking out to Appledore and Star, and to the east, out to sea. And also some detail shots."

"Like what?"

"Scrub pine. Rose hips. A window of the Haley house, the footprint of the Hontvedt house. I should have done this yesterday when I had the chance. I'm sorry."

"It's all right," he says. "We have time."

"Me too!" says Billie excitedly.

Rich shakes his head. "You stay here with your dad and Adaline." He reaches over and pulls my daughter from my lap. He whirls her around and tickles her at her waist. She begins to laugh with that unique helplessness that borders on hysteria. She tries to wriggle away from his grasp and screams to me to

help her. "Mommy, save me! Save me!" But when Rich suddenly stops, she turns to him with an appreciative sigh and folds herself into his lap.

"Whew," she says. "That was a good tickle."

George E. Ingerbretson, a Norwegian immigrant who lived at Hog Island Point on Appledore Island, was called to the stand. He, like many who were summoned, spoke in a halting and imperfect English that was not always easy to transcribe. He was asked by the county attorney what he observed between seven and eight o'clock on the morning of March 6, 1873. He replied that he had two small boys and that they had come into his house and said, "They are halooing over to Smutty Nose." He was then asked what he saw when he got to the island.

"I saw one bloody axe; it was lying on a stone in front of the door, John Hontvet's kitchen door. The handle was broken. I went around the house. I saw a piece knocked off the window. Then I stopped. I saw John was coming. I did not look into the window. I only saw the bloody axe and blood around."

After John Hontvedt arrived, along with

several other men, Ingerbretson went inside
the house.

"Evan Christensen went just ahead of me;
he opened the door. Evan is the husband of
Anethe."

"Who else went with you at that time?"
Yeaton asked.

"John Hontvet and Louis Nelson and
James Lee, no one else. John's brother,
Matthew, was with us. I do not know
whether he went into the house or not."

"State what you saw."

"It was Anethe, lying on her back, head to
the door. It looked to me as though she was
hauled into the house by the feet. I saw the
marks."

"Of what?"

"From the south-east corner of the house
into the door."

"Traces of what?"

"Of blood."

"Was there any other body there?"

"Yes. Then we went out and went into an-
other room in the northward side, north-east
of the house. We came in and there was
some blood around, and in the bed-room we
found another dead body."

"Whose body was that?"

"That was Karen Christensen."

"Did you notice any wounds upon the body of Anethe?"

"Yes; there are some scars on the head."

"What part of the head were they?"

"In the ear most, just about the right ear. She had some scar in her face there."

"Scar on top of the head?"

"We did not look much after that time."

Yeaton then asked Ingerbretson some questions about the well that belonged to the house and its distance from the house, and whether he had disturbed any of the bodies. Ingerbretson said that he had not. Yeaton asked the fisherman if he had seen any tracks, and Ingerbretson said no, he had not seen any tracks. Before Yeaton dismissed the witness, he asked if, when he had arrived on Smuttynose that morning, there was any living person on that island.

"Yes," the fisherman replied.

"Who was it?"

"Mrs. Hontvet and a little dog."

"State condition in which you found her."

"In an overbad condition. She was in her night-dress crying and halooing, and blood all over her clothes, Mrs. Hontvet's clothes. I got her into the boat."

"Do you know whether her feet were frozen?"

"Yes. I searched her feet right off and they were stiff. I carried her over to my house."

Before a shoot, I will prepare the cameras—check my film and the batteries, clean the lenses—and I begin these tasks in the cockpit. Billie has gone below to wake Thomas. I can hear them talking and laughing, playing on the bed, although the wind, with its constant white noise, steals their words.

Adaline emerges from the companionway. She smiles and says, "Good morning." Her legs are bare, and she is holding a towel around her, as if she had just stepped from the shower, although she is not wet. Her hair is spread all along her back in knots and tangles. I can see a small bit of red beneath the towel, so I know that she has on her bathing suit, and I wonder for a moment why she has the towel around her. How strange we women are in the mornings, I am thinking, this modesty, this not wanting to be seen. Adaline turns her back to me and puts her foot up on the cockpit bench, inspecting her toes.

"I hear Billie got a cut," she says.

"Yes. She did."

"Bad?"

"Not too."

"I'm going for a swim."

She lets the towel drop to the cockpit floor. She keeps her back to me, and I notice things I have not before. The plate-shallow curve of her inner thigh. The elongated waist. The patch of hair she has missed just above the inside of her right knee. I think about what her skin would feel like. This is painful curiosity. She steps up to the back of the stern, positions herself for a dive. She skims the water like a gull.

She does not come up sputtering or exclaiming from the cold, as I might have done, but rather spins in a lovely barrel roll and swims with an economy of strokes, her feet barely moving at all. I see wisps of red amid the chop. She swims for about ten minutes, away from the boat and back. When she is done, she climbs up over the stern with ease, refusing my outstretched hand. She sits opposite me in the cockpit and picks up the towel to dry herself. She is slightly winded, which is somehow reassuring.

"You kept your maiden name," she says.

"Jean Janes had an infelicitous ring to it," I explain.

I notice that the water beads up on her skin.

"It wasn't for professional reasons then?"

"Not exactly."

She sets the towel down beside her and begins to brush out her hair.

"Did I hear Rich say there might be a storm?" she asks.

"We may have to leave before this afternoon." The thought of leaving the harbor fills me with swift, sharp regret, as if I had left something significant unfinished.

"Where are we going?"

"I don't know. Portsmouth possibly. Or Annisquam."

She bends her head to her knees, letting her hair fall forward to the floor. She brushes upward from the nape of her neck. She throws her head back and begins to brush from the sides of her face. In my camera bag is a Polaroid camera I use in test shots. Often, when I have a scene I like, I take a Polaroid first, so that I can examine the composition and the light and make adjustments if necessary before shooting the real thing. I take the Polaroid out of my camera bag

and aim it at Adaline. I quickly snap a picture. She blinks at the click. I rip the film out and hold it in my hand, waiting for the image to appear. In the photograph, Adaline is holding a brush to her head. Her hair, which has dried in the sun, has streaked itself a light blond, or perhaps it is a photographic deception. Her skin looks dark by contrast, deeply tanned. I hold the picture out to her.

She takes it in her hand and examines it.

"A mere negative of my former self," she says and smiles.

In Haley's Cove, a pier supported a long warehouse and fish processing plant. The men of Smuttynose invented the process of drying fish called dunning. Large vessels would tie up inside the pier to load and off-load goods and fish, which were then stored in the building known as the Long House. The area that comprises the pier, the Long House, Captain Haley's House, and the footprint of the Hontvedt cottage is not much bigger than a modest suburban backyard.

Dunfish sold for three or four times the price of regularly prepared fish. So many fish were harvested by Shoalers that in 1822

the national price of fish was quoted not from Boston but from the Isles of Shoals.

When Thomas comes up the ladder, he brings with him the smell of bacon and pancakes.

"Billie and I made breakfast," he says. "Adaline's setting the table."

I am rereading one of the guidebooks to see if I have overlooked a landmark, an artifact that I should not miss when I go across to Smuttynose to finish the shoot. In my lap is Maren Hontvedt's document and its translation, as well as a thin pamphlet, one of the accounts of the murders.

"What's that?" he asks. A conciliatory gesture. Interest in my work.

"This?" I ask, holding up the guidebook.

"No, that."

I lay my hand on the papers with the brown ink, as if protecting them. "It's the thing I got from the Athenaeum."

"Really. Can I see it?"

Without looking precisely at him, I hand the papers to Thomas. I can feel the color and the heat coming into the back of my neck.

"It's not in English," he says.

"There's a translation."

"This is an original document," he says with some surprise. "I'm amazed they let you have it."

There is a silence.

"They didn't," I say. I push my hair behind my ears.

"They didn't," he repeats.

"I knew they wouldn't give it to me, so I took it. I'll give it back."

"What is it?"

"It's a memoir. By Maren Hontvedt."

"Who is?"

"The woman who survived the murders."

"It's dated 1899."

"I know."

He hands the papers back to me, and I look up at him for the first time. His hair has been combed off his forehead with his fingers and lies in thinning rows, an already harvested crop. His eyes are bloodshot, and his skin, in the harsh, flat light, looks blotchy.

"You don't need this stuff for your assignment," he says.

"No."

He is about to turn and go back down to the galley, but he hesitates a moment on the steps. "What's going on with you?" he asks.

I shade my brow with my hand. "What's going on with you?" I ask.

At the Shoals, men have always fished for haddock and for hake, for porgies and for shad. In 1614, Captain John Smith first mapped the islands and called them Smythe's Isles, and he wrote that they were "a heape together."

Halyards slap against the mast, an insistent beat we can hear at the double bed–cum–dining table in the center of the cabin. Thomas and Billie have made pancakes— kidney shaped, oil glistened, and piled high upon a white platter. There is also bacon, which Adaline declines. She chooses toast and orange juice instead. I watch her, nearly naked, lift her mug of decaffeinated coffee to her lips and blow across the rim. I am not sure that I could now sit at a breakfast table in my bathing suit, though I must have done so as a younger woman.

Are we, as we age, I wonder, repaid for all our thoughtless gestures?

Billie, next to me, still has on her Red Sox pajamas. She smells of sleep. She is proud of her misshapen pancakes, and eats six of them. I think it is the one certain way to get

Billie—any child?—to eat a meal. Have her cook it herself.

I have on my robe. Rich his bathing suit. Thomas the shirt he slept in. Is it our dishabille that creates the tension—a tension so pronounced I find it hard to swallow? Rich wears the weather report on his face, and we seem excessively focused on the food and on Billie, in the manner of adults who have not found an easy entrée into the conversation. Or who are suddenly wary of conversation: "These are wonderful, Billie. I can see the bear now." "What kind of coffee is this? It has an almond flavor." "I love bacon. Honestly, is there anything better on a camping trip than a bacon sandwich?"

Sometimes I watch the way that Thomas watches me. And if he catches me at this, he slips his eyes away so gracefully that I am not sure he has seen me. Is this simply the familiarity of bodies? I wonder. I no longer know with any certainty what he is thinking.

"Do you keep a journal?" Adaline asks Thomas.

I am surprised by the question. Will she dare a reprise of Pearse?

Thomas shakes his head. "Who has so

many words that he can afford to spend them on letters and journals?" he asks.

Rich nods. "Tom's a terrible letter writer."

I haven't heard the nickname in years.

"His literary executor will have it easy," Rich adds. "There won't be anything there."

"Except the work," I say quietly. "There's a lot of the work."

"A lot of false starts," says Thomas. "Especially lately."

I look over at Thomas, and I wonder if what I see is the same face I knew fifteen years ago. Does it seem the same to me? Is the skin the same? Or is the expression now so different than it was then that the muscles have become realigned, the face itself unrecognizable?

"Is it definite that man did it?"

Adaline's question startles all of us. It takes me a second to catch up. "Louis Wagner?" I ask.

"Do they know for sure?"

"Some think yes," I answer slowly, "and some think no. At the time, Wagner protested his innocence. But the crime created a tremendous amount of hysteria. There were riots and lynch mobs, and they had to hurry the trial."

Adaline nods.

"Even now, there are doubts," I add. "He hadn't much of a motive for the murders themselves, for example, and that row from Portsmouth to Smuttynose would have been brutal. He'd have had to row almost thirty miles in the dark. And it was the first week in March."

"It doesn't seem possible," says Rich. "I couldn't do it. I'm not even sure I could do it on a flat surface."

"Also, I've read parts of the trial transcript," I say, "and I can't figure out why the prosecution didn't do a better job. Maren Hontvedt's clothes were blood-soaked, but the defense didn't really pursue this. And the coroner was very careless with the murder weapon—they let the sea spray wash off all the fingerprints and blood on the journey back to Portsmouth."

"Surely, they had fingerprinting techniques then," says Rich.

"On the other hand," I say, "Wagner seems to have no alibi for that night, and the next morning he's reported to have told people he committed murder."

"Jean doesn't always get to pick her as-

signments," Thomas says. He sounds apologetic.

"A crime of passion," says Rich.

"A crime of passion?" Adaline narrows her eyes. "In the end, a crime of passion is just sordid, isn't it? At heart. We think a crime of passion has a morality all its own—people have thought so for years. History is full of judgments that forgive crimes of passion. But it doesn't have a morality, not really. It's pure selfishness. Simply having what you want."

"I think it's the knife that makes it seem like a crime of passion," says Thomas. "It was a knife, wasn't it?"

"An ax."

"Same thing. It's the intimacy. With a gun, you can kill a person at a distance. But with a knife, you have to touch the victim—more than touch. Manhandle. Subdue. It would seem to require, at least for the several seconds it takes to complete the deed, a sustained frenzy or passion."

"Or a lucrative contract," says Rich.

"But even then," argues Thomas, "there would have to be something in the act—the handling of the victim, the feel of the knife

against the flesh—that attracted the killer to that particular method."

"Thomas," I say, nodding at Billie.

"Mommy, take a picture of the pancakes," she says. "Before they're all gone?"

I reach behind me into my camera bag and bring out the Polaroid. I shoot the platter with the pancakes that are left, and then rip the film out and give it to Billie to hold. She's a pro at this, and holds the corner casually.

"The Masai," I say idly, "believe that if you take a photograph of a person, you have stolen his soul. You have to pay them for the picture."

"The soul is for sale then?" asks Adaline.

"Oh, I think the Masai are shrewder than that."

"See, Adaline? Look!" Billie stands on the bench to hand Adaline the Polaroid. As she does, she cracks her head on the sharp corner of an overhanging cabinet. The color leaves Billie's face, and her mouth falls open, but I can see that in this company my daughter is determined not to cry.

I reach over and fold her into me. The photograph flutters onto the table. She presses her face into my chest, and I feel her breath through the opening of my robe.

Adaline picks up the Polaroid. "Lovely picture, Billie," she says.

I kiss Billie's forehead, and she pulls away from me, turning in her seat, trying bravely to smile. Adaline hands the picture to Billie.

"Very game," says Adaline to me.

"Thanks."

"I envy you."

I look quickly up at her and catch her eyes. Does she mean Billie? Or does she mean having my daughter with me? Or does she mean Billie and Thomas—the whole package?

"Sometimes I imagine I have caught a likeness of a person's soul," I say carefully. "Occasionally, you can see it. Or what you imagine is the true character of that person. But of course, it's only a likeness, and that likeness is only an image, on the paper."

"But you can fool with images," she says. "Didn't I read that somewhere? Can't you change the image?"

"You can now," I say. "You can do it almost flawlessly with computers."

"So you could, theoretically, create another character, another soul."

"This is assuming that you believed the

camera could capture the soul in the first place," I say.

"This is assuming that you believed in the soul at all," says Thomas. "That what you saw was not simply an arrangement of organic particles."

"But surely you believe in the soul," Adaline says quickly, almost defensively. "You of all people."

Thomas is silent.

"It's in the poems," she says.

I have a series of photographs of Billie and Thomas together, taken shortly after we have eaten the pancakes. I have dressed and am getting my gear together in preparation for the boat ride over to Smuttynose. I take out the Hasselblad, which I have loaded with black-and-white. I do four quick shots—click, click, click, click—of Thomas and Billie, who have lingered at the table. In the first, Billie is standing on the padded bench, inspecting Thomas's teeth, counting them, I think. In the second, she has bent her body so that she is butting her head into Thomas's stomach; Thomas, too, is slightly bent, and has wrapped his arms over her back. In the third picture, they both have their elbows propped upon the table and are

facing each other, talking. The conversation must be serious; you can see that in the tilt of Billie's head, the pursing of her mouth. In the fourth picture, Thomas has one hand tucked inside the open collar of his shirt, scratching his shoulder. He is facing me, but he won't look at me or at the camera. Billie has turned her head away from Thomas, as though someone has just called to her from the forward cabin.

The head sea is apparent the moment we round the breakwater. Small waves hit the Zodiac and send their spray into and over the inflatable boat. With one hand on the tiller, Rich tosses me a poncho, which I use to protect my camera bags from the salt water. When I look up again, I find I can hardly see for the spray. My face and hair and glasses are soaked, as in a rain, and foolishly, I have worn shorts, so that my legs are wet and cold and covered with goosebumps.

Rich turns the Zodiac around. He has wanted to observe the ocean on the unprotected side of the island, and he has seen enough. He maneuvers back into the harbor and puts the Zodiac up onto the narrow dark beach of Smuttynose, a beach I left only the night before. I dry my glasses on the inside

of my sweatshirt and inspect my camera bags for any signs of wet.

"How do you want to work this?" he asks as he is tying up the boat. His T-shirt has turned a translucent peach. "You want me to go with you and hold things? Or do you want me to wait here?"

"Wait here," I say. "Sit in the sun and get dry. Rich, I'm really sorry about this. You must be freezing."

"I'm fine," he says. "I've been wet before. You do what you have to do." He smiles. "I know this is hard to believe," he says, "but I'm actually having a good time. The truth is"—he gestures to indicate the expanse of the ocean and seems to laugh at himself— "I usually have to go to a lot of trouble to be able to do this on my days off."

"I'll try not to be long. Thirty, forty minutes at the most. And if you do get cold," I say, "give a shout, and we'll get out of here. This isn't worth getting sick over."

I bend to collect my camera bags. When I stand up, Rich is wrestling with his wet T-shirt. He takes it off and wipes the top of his head with it, and then squeezes it out. I watch him walk over to a rock that is in the sun, or what is left of the sun, and lay the

T-shirt carefully out to dry. When I was in Africa, I observed the women there drying their clothes in a similar manner—by laying them flat on top of long grasses over a wide field, so that often you would come upon a landscape of bright cloth. Rich glances over at me. Perhaps because he has almost no hair on his head, the thick dark chest hair that spreads across his breast draws the eye. I turn around and walk to the interior of Smuttynose.

The defense waived its right to cross-examine Ingerbretson, at which point the prosecution then called Evan Christensen to the stand. Christensen was asked to identify himself and to talk about his relationship to Smuttynose.

"In March last, I lived at the Shoals, Smutty Nose, in John Hontvet's family; I had lived there about five months. Anethe Christensen was my wife. I was born in Norway. Anethe was born in Norway. I came to this country with her after I married her."

Yeaton asked Christensen what he was doing the day of the murders. Christensen answered: "During the night my wife was killed I was in Portsmouth. I arrived at Portsmouth about four o'clock the night before."

"Who was with you when you arrived at Portsmouth about four o'clock that night?"

"John Hontvet and Matthew Hontvet. I was at work for John in the fishing business."

"Was anyone else with you that night?"

"No, sir."

"Where did you spend the night at Portsmouth?"

"I was on board till twelve o'clock; after that went up to Johnson's house and baited trolls."

"Baited trolls the rest of the night?"

"Yes, till six or seven o'clock in the morning. John Hontvet was with me when I baited trolls."

"When did you first hear of this matter at Smutty Nose?"

"Heard it from Appledore Island."

"Where were you then?"

"On board Hontvet's schooner."

"Who were with you at that time?"

"Matthew Hontvet and John Hontvet; it was between eight and nine o'clock in the morning."

"Did you go ashore?"

"Yes; got a boat and went ashore on Appledore Island."

"Where did you go from Appledore Island?"

"I went first up to Ingerbretson's house. After I left there I went to Smutty Nose. When I got to Smutty Nose, I went right up to the house and right in."

"What did you see there?"

"I saw my wife lying on the floor."

"Dead or alive?"

"Dead."

"What did you do?"

"Went right back out again."

The light is flat and muffled, colors indistinct. Thin, dull cloud has slipped over the sun, still rising in the east. I am annoyed with myself for having wasted too much time the day before shooting Maren's Rock. I walk to the spot where the Hontvedt house once stood. The air has a chill in it, or perhaps it is only that I am chilled because my sweatshirt and shorts are wet. I am grateful that Rich knew not to bring Billie.

I stand in the footprint of the house, surveying its markers. There is little here that will make an outstanding photograph; its purpose will be merely documentary. Unless, that is, I can convey the foundation's claustrophobia.

I know that it is always true that the dimensions of a house, seen from above, will look deceptively small. Space appears to increase in size with walls and furniture and windows. Yet even so, I am having difficulty imagining six grown men and women— Maren, John, Evan, Anethe, Matthew, and, for seven months, Louis Wagner—living in a space not much bigger than the single room Thomas had in Cambridge when I met him. All those passions, I think, on such a small piece of land.

I find what I think must have been one of the two front doors of the house and stand at its threshold, looking out toward Appledore, as Maren must have done a thousand times in the five years she lived on the island. I take my cameras and lenses from their separate pouches, check the light meter, and shoot a series of black-and-white stills to make a panorama of that view. Directly west of me is Gosport Harbor and, beyond that, ten miles of water to the New Hampshire coast. To my north is Appledore; to my south is Star. Behind me, that is to say east of me, is the Atlantic. I back away from the threshold and stand in the foundation's center. Beneath me, the floor of that

old house has long given way to thistle and wood sage. I find a small patch of bare ground and sit down. Above me, the clouds are growing oilier, as though a film were being washed across the sky. My sweatshirt sticks to my back, and I shiver.

I dig under the brush to feel the dirt. I bring the soil up and massage it with my fingers. In the place where I am sitting, two women died. One was young, one was not. One was beautiful, the other not. I imagine I can hear Maren's voice.

22 September 1899

The morning after we arrived on the island of Smutty Nose, John went off with a man named Ingerbretson to Portsmouth to secure more provisions and also to see about a schooner that might be for sale. In order to make a living on Smutty Nose, around which we were told was an abundance of mackerel, cod, flounder, haddock, and menhaden, John would have to have his own boat plus full gear for fishing. This would be a great expense, and would largely exhaust John's savings, but it was clear to him that no profit, nor even a livelihood, could be earned without such expenditures.

While John was gone, I stripped the walls of the yellowed and ugly newsprint, rolling the papers into logs and burning them on the stove for warmth. At first, the house was colder than it had been, but I knew that

shortly John would begin to build wooden walls, behind which he would place goat's tick for insulation. I also found a roll of blue gingham in my stores, which I hastily fashioned into curtains. When these efforts were completed, I examined our remaining provisions for foodstuffs that might make a meal, as I knew that John would be hungry when he returned. All that day I busied myself so that I did not have time for any thoughts about people or a home left behind. I have found, in the course of my adult life, that the best cure for melancholy is industry, and it was only when John and I were imprisoned in the cottage for long weeks at a time during the winter months that I fell victim to that malady and could not control myself or my thoughts and words, so that I was a worry not only to John Hontvedt but also to myself. That day, however, my first day on the island of Smutty Nose, was one of determined busyness, and when my husband returned from his sail into Portsmouth, I saw that the changes I had made had pleased him, and he had a smile upon his face, which, for the first time since we had left Norway, re-

placed the concern that he nearly always had for my well-being.

Our daily life on Smutty Nose was, for the most part, unremarkable in many of its aspects. John and I would wake early, and I would immediately remake the fire that had gone out during the night. John, who would have baited his trawls the evening before, would gather his oil pants and underclothes from the hooks that were in the kitchen, and once dressed would sit down at the table on which I would put in front of him large bowls of porridge and of coffee. We did not speak much, unless there was some unusual piece of information that needed to be imparted, or unless I was in need of some provisions, which I would inform John about. Early on, we had lost the habit of speech with each other, as I think must happen with other husbands and wives who dare not speak for fear of asking the wrong question, or of revealing a festering hurt or a love for another person which might be ruinous to the partnership they had formed.

John would then go down to the beach and from there row out in his dory to his schooner. On good drying days, when he had left the harbor, I would wash the clothes

and lay them out on the rocks in the sun. I would bake the flatbrød and prepare the mid-day meal. I would have the task of cleaning the fish John had caught for drying or eating. I made clothes from bolts of cloth I had brought with me or John had managed in Portsmouth. I spun wool with a spinning wheel John had bought in Portsmouth, and knit various articles of clothing for both myself and for John. When I had finished these chores, and if the day were clear, I would go outside with the dog John had given me, which I had named Ringe, and walk the perimeter of the island, throwing sticks for Ringe into the water so that he might fetch them back to me. In time, John built me a hen coop and purchased in Portsmouth four hens, which were good layers, providing me with fresh eggs.

When John arrived in the evenings, I would take from him his soiled oil clothes and undergarments, and he would have a wash at the sink. I would have prepared a light meal for him. By then, he would have put on dry underclothes, and would sit near to the fire. We had both taken up the habit of smoking a pipe, as it soothed us to do so.

John's face was weathering, and he was growing many lines in his skin.

Sometime during the evening, usually when I was sitting near to the fire as well, he would put a hand on my knee, and that would be a signal to me that he wished me to join him in bed. Regardless of the cold, he would remove his garments altogether, and I believe that I saw my husband in a state of undress every night of our married life, as he always lit the candle on the table by our bed. As for me, I would have preferred that our marital relations be conducted in the dark, but John would not have this. I usually kept on my nightdress, or if it were very cold, all my garments. Except for one or two occasions when I was bathing, I am not sure John Hontvedt ever saw me in my natural condition. I had, after a time, lost my physical revulsion toward my husband, and tolerated these nightly relations well enough, but I cannot say there was ever any pleasure in the event—particularly so as it became more and more obvious to me that there was something wrong with me that was preventing me from conceiving a child.

Though our daily life on Smutty Nose was one of habit and routine, I would not be correctly portraying life on the Isles of Shoals if I omitted to say that the winters there were exceedingly harsh. Of that seasonal desolation, I can barely write. I am not certain that it is possible to convey the despair that descends upon one who has been subjected to the ceaseless cold and wet, with storms out of the northeast that on occasion smashed fishing boats upon the rocks and washed away the houses of the Shoalers, causing many to die at sea and on land, and imprisoning those who survived in dark and cheerless rooms for so many days on end that it was a wonder we did not all lose our minds. It has been said that the fishermen who lived on those islands at that time were possessed of an extraordinary courage, but I think that this courage, if we would call it so, is merely the instinct to fasten one's body onto a stationary object and hold on, and have as well the luck not to have one's roof blown into the ocean. I remember weeks when John could not go to sea, nor could anyone come across to Smutty Nose, and when the weather was so dangerous

that we two sat for hours huddled by the stove in the kitchen, into which we had moved our bed, and the windows and door of which we had sealed from the elements. We had no words to speak to each other, and everything around us was silent except for the wind that would not stop and made the house shudder. Also, the air inside the room became quite poisonous due to the smoke of the stove and of our pipes, and I recall that I almost always had the headache.

Many fisher-families experience lives of isolation, but ours was made all the greater because of the unique geographical properties of an island in the North Atlantic Ocean, which properties then convey themselves to the soul. There was no day, for example, that the foremost element in one's life was not the weather. There might be clear days with heavy seas, cloudy days with light seas, hazy days when one could not see the mainland, days of fog so dense that I could not find the well, nor make my way accurately to the beach, days of such ferocious storms and winds that entire houses were washed in an instant into the

sea, and one could not leave one's dwelling for fear of meeting a similar fate, and days upon days of a noxious wind that made the panes of glass beat against their wooden frames and never ceased its whistle in and around the cottage. So important was the state of the elements that every morning one thought of nothing else except of how to survive what God and nature had brought forth, or, on the rare days of clear skies and no wind, of warm sun and exhilarating air, of how thankful one was for such a heady reprieve.

Because of the necessity for John to go out to sea seven days a week in season, and the equally strong necessity to remain shut in for so many weeks at a time in winter, we did not have many friends or even acquaintances on those islands. To be sure, the Ingerbretsons had befriended us, and it was with this family that we celebrated 17 May and Christmas Eve, sharing together the fattigmann, which, if I may say so, achieved a delicate and crispy texture in my hands, even with my crude implements, and also the lutefisk, a fish which was soaked in lye for several days and then

poached to a delicate texture. But as the In-gerbretsons resided on Appledore and not on Smutty Nose, I had little occasion to spend time with the women in these house-holds as I might have done were there no water barriers between us. In this way, I was often alone on the island for long stretches at a time.

At this point in my tale, I must hasten to explain to the reader that life on Smutty Nose was not entirely bereft of pleasant mo-ments. As even the barest tree on the darkest hour in winter has a beauty all its own, I eventually came to see that Smutty Nose was not without its own peculiar charms, particularly on those days when the weather would be fine, that is to say, sharp and tingling, with silver glints in the granite, every crevice visible, the water all around us a vivid aquamarine. On those occasions, which in my mind are relatively few in num-ber, I might sit upon a ledge and read one of the books I had been lent in Portsmouth, or I might walk about the island playing with my dog, or I might pick some of the wild growth that survived in the rocks and make a bouquet of sorts for my table.

In the five years I was on Smutty Nose, I ventured into Portsmouth four times. I had, at first, a great deal of trouble with the English language, and sometimes it was a trial to make myself understood or to comprehend what was being said to me. I have observed that such a lack of facility with a language tends to make others think of one as not very intelligent and certainly not very well educated. And this used to be a great annoyance to me, as I could converse quite well, and even, I may say, fluently and with some style, in my native tongue, but I was rendered nearly imbecilic when required to express my needs in English.

And here I must say a further word about the American inability to pronounce any Norwegian at all, even, or especially, Norwegian names that were not familiar to them. So that many of the immigrants were forced to change the spelling of their names to make them more easily understood. Thus John, over time, changed his surname to Hontvet, omitting the combination of the *dt,* which Americans found queer in the writing of it and nearly impossible to enunciate correctly. And I also acquiesced to the entering of myself on the church roll at Gosport as

Mary S. Hontvet, rather than as Maren, as the Pastor wrote it that way initially, and it was some time before I discovered the mistake. In addition, I observed that after the events of 5 March 1873, the spelling of Evan's name was changed to Ivan in the American newspapers.

Putting aside the language difficulties, I did grow to have some fondness for Portsmouth. To go from the silence of Smutty Nose to the agitation and bustle of Portsmouth was always unsettling, but I could not help but be intrigued by the dresses and bonnets on the women, which I would keep in my mind when I returned to the island. We would visit the pharmacy for tonics and nostrums, and the public market for provisions, and there were always many curious sights in that city, though I confess I was appalled at the lack of cleanliness on the streets, and by the condition of the streets themselves, as they were not graded and were full of ruts and mud and so on. At that time, the main industry of Portsmouth was its ship yard, and always in the background, there was the din of the ironworks. In addition, there were many sailors on the streets, as the Port attracted ships of various nationalities. On

three of my trips into Portsmouth, we spent the night with the Johnson family, Norwegians who had come before us, and with them engaged in lively conversation through the night, which was always a joy for me, as there was seldom any conversation of any duration on the island. On these occasions, I was especially pleased to receive news from Norway, and even once from the area near Laurvig, since the Norwegian families in Portsmouth were the recipients of many letters in America. More often than not, these letters were read aloud at table, and discussed at length. We always went to Portsmouth in the summer, owing to the fact that John did not like to take the risk of ferrying me during the winters and chance hitting one of the numerous ice floes that would sometimes block the passage between the mainland and the Shoals.

I did, in that time, receive three letters from Karen telling of our father (and full of vague complaints about her health and the housework), but, curiously, with few mentions of Evan, who himself did not write to us until the second year of my stay at Smutty Nose, and then to tell us of our father's death from old age. In March of 1871,

we had a fourth letter from Karen, saying she would join us in America in May.

Karen's letter was a great surprise to John and me. We could not imagine what motivation my sister had for leaving Norway, as she had been quite parsimonious in her letter regarding her reasons for emigrating. She wrote only that as our father had died, she was no longer obliged to stay in that house.

To prepare for my sister's arrival, John purchased a bed in Portsmouth and put it in the upstairs bedroom. I made curtains for that room, and sewed a quilt, which was of a star pattern and took all the scraps I had from my provisions. As I did not have much time in which to finish it, I worked on the quilt all the long days and into the nights until my fingers were numb at their tips, but when the quilt was done, I was glad of the result, for the room now had a cheer which had been entirely absent before.

I remember well the morning of 4 May, when I stood on the beach at Smutty Nose and watched John bring my sister to the island in the dory. He had gone into Portsmouth the day before to wait for the arrival of Karen's ship, and I had seen them coming

across from Portsmouth in John's schooner. It was a clear day but exceedingly cold, and I confess that I was apprehensive about Karen's arrival. Though it may strike the reader as odd, I was not eager to change the habits that John and I had shared for three years, nor to admit another person, or, in particular, my sister, about whom I felt somewhat ambivalent.

As Karen drew closer, I examined her appearance. Though I knew she was thirty-seven, she seemed a much older woman than when I had left her, even somewhat stooped. Her face had narrowed, and her hair had gone gray in the front, and her lips, which had thinned, had turned themselves down at the corners. She was wearing a black silk dress with a flat bodice and with high buttons to the collar, around which was a ruffle of fawn lace. She had on, I could see, her best boots, which were revealed to me as she fussed with her skirts upon emerging from the skiff.

Perhaps I should say a word here about my own appearance. I was not in the habit of wearing my best dresses on the island, as I had learned early on that the silk and the cotton were poor protection against the

wind and sea air. Therefore, I had taken to wearing only the most tightly woven home-spun cloth, and over that, at all times, various shawls that I had knit myself. Also I kept a woolen cap upon my head to protect myself from the fevers that so decimated the island population in the winter and even in the early spring. And, in addition, if it were very windy, I would wear a woolen muffler about my neck. I had not lost my figure altogether, but I had grown somewhat more plump in my stay on the island, which greatly pleased my husband. When I did not have to wear my woolen cap, I preferred to roll my hair on the sides and in the back, and keep some fringe in the front. The only distressing aspect of my appearance, I will say here, was that my face, as a consequence of the island sun and rain and storms, was weathering somewhat like John's, and I had lost the good complexion of my girlhood. I was twenty-five at the time.

Karen stepped from the dory and clasped her hands to her bosom. She looked wildly about her, doubtless stunned, as I had been, by the appearance of her new home. I went closer to Karen and kissed her, but she stood frozen in the sand, and her

cheeks were dry and chilly. I told her that she was welcome, and she said stonily that she would never have come to such a place had she not been obliged to endure the greatest shame that ever can befall a woman. I was intensely curious as to the nature of this shame, and asked her there on the beach, but she waved me off and said that she was in need of coffee and bread, as she had been horribly sick on the boat and had not yet fully recovered.

I took her into the house, while John carried her trunk and spinning wheel and the mahogany sewing cabinet that had belonged to my mother. Karen went directly to the table and sat down and removed her bonnet and heaved a great sigh. I could see that in addition to graying, her hair was thinning at the sides and at the top, and this I attributed to the shock of having had our father die, as any death of a loved one may cause the bereaved to age suddenly.

I put on the table a bowl of coffee and a meal which I had prepared in advance. Before she ate, however, she studied the room.

"I was not given to understand from your letters, Maren, that you and John were in

such unfortunate circumstances," she said with a distinct tone of disappointment.

"We have managed," I said. "John has made the walls tight and the room as warm as he can."

"But Maren!" she exclaimed. "To have no good furniture, or wallpaper, or pictures on the walls. . . ."

"It wasn't possible to bring such things on the boat," I said, "and we have had no money yet for luxuries."

She scowled. "Your curtains are hastily made," she observed. "America, I see, has not cured your bad habits. I have always said that nothing which will be done well can be done in haste. Dear Sister, they are not even lined."

I remained silent. I did not wish to quarrel with Karen so soon after her arrival.

"And you have not oiled your floorcloth. And what a curious pattern. I have never seen anything quite like it. What is this I have before me?" She had taken something up in her fork, and now put it down again and studied it.

"It is called dunfish, but it is cod," I said.

"Cod!" she exclaimed. "But it is the color of mahogany!"

"Yes," I said. "The people here have the most ingenious way of preserving and drying fish for shipping elsewhere. It is called dunning and keeps—"

"I cannot eat this," she said, pushing away the plate. "My appetite is still not keen. Do you have any honey for the bread? I might be able to get the bread down if you have honey."

"I do not," I said.

"But I see that you have grown fat nevertheless," she said, examining me intently.

I was silent and uncomfortable with such a compliment. Karen sighed again and took a sip from her bowl of coffee. Immediately she screwed up her mouth in pain, and put her hand to the side of her face.

"What is it?" I asked.

"The toothache," she said. "I have been plagued with holes in my teeth for these several years now, and have had no good dentistry for them."

"We must take you into Portsmouth," I said.

"And will you have the money for the dentist," she asked sharply, "if you have no money for wallpaper? When I was at home, I had money from Evan, though there were

no decent dentists to be found near Laurvig, I am sorry to say."

Across the table from her, I picked up my own bowl and took a sip of the coffee. "And how is our brother?" I asked.

Karen lifted up her head and fastened her eyes upon mine, and as she did so I began to color and to curse myself for this weakness in my constitution. "He did not write to you?" Karen asked sweetly.

"We have had the one letter," I said. My forehead was now hot and wet. I stood and went to the stove.

"One letter? In all this time? I am quite surprised. I have always thought our brother bore you a special affection. But I suppose our Evan was never one for dwelling much in the past. . . ."

"I expect that Evan has been too busy to write," I said quickly, wishing now to put an end to the subject.

"But not too busy to be a comfort to me, you will be glad to hear," said Karen.

"A comfort?" I asked.

"Oh, most decidedly so." She opened her mouth and rubbed a back tooth. As she did, I could see that many of her teeth were blackened and rotted, and (I hope I will not

offend the sensibilities of the reader by revealing this) I could as well detect a terrible smell emanating from that orifice. "Full of the most stimulating conversation in the evenings," she went on. "Do you know that we went together to Kristiania by train over the Easter holiday last year? It was tremendously exciting, Maren. Evan took me to the theater and to supper and we stayed at a hotel. And he spent one afternoon at the University, and spoke to some of the professors there quite seriously of admitting himself to a course of study."

"Evan did?"

"Oh, yes. He has prospered wonderfully and has been able to put some money by. And I do think that now I am gone, he will go to Kristiania, at least for a term, to see how he fares. And doubtless he will meet there some young woman who will turn his head. It's time he settled down, our Evan. Don't you think so, Maren?"

I tried to calm my hands by stirring the soup that was on the stove. "You don't think that Evan will come to America too?" I asked as casually as I could.

"America!" Karen exclaimed. "Whyever for? A man who prospers so well in his own

country and has no need to escape will never think of emigrating to another country. No, Maren, I should think not. It was of course difficult for me to have to leave him. . . ."

"Why exactly did you leave?" I asked, turning to her sharply. I was feeling quite cross with Karen at this point.

"We may talk about that at some other time."

Karen turned her head away, and appeared once again to be examining the cottage. "You cannot keep your windows clean?"

"The sea spray," I said. "It is continual."

"At home, I like to use the vinegar."

"I would like to know what has brought you here," I said, interrupting her. "Of course, you are entirely welcome, whatever the reasons, but I do think John and I have a right to know. I hope it is not some dread illness."

"No, nothing like that."

Karen stood up and walked to the window. She folded her arms across her breast and appeared to contemplate the northwest view for some time. Then, with a sigh of, I believe, resignation, she began to tell her

story. There had been a man in Laurvig by
the name of Knut Eng, she said, who was a
widower of fifty-four years, who had courted
Karen for seven months with the implicit
promise of an engagement not long in the
future as they were neither of them young,
and then suddenly, after a particularly silly
quarrel between them, had broken off their
relations, and there was no longer any talk
of marriage. So abrupt and shaming was
this cessation of his affections, and so wide-
spread the gossip surrounding the affair,
that Karen found she could no longer walk
with any confidence into town or attend
services at our church. Thus the thought of
voyaging to America to join John and myself
suddenly became appealing to her.

I felt sorry for her loss, though I could not
help but think that Karen had most likely
done her part to alienate her suitor. Nor was
it altogether flattering to know that my sister
had come to us only because she was em-
barrassed to have been spurned. But as it
was our custom to welcome all visitors, and
particularly those who were family, I tried to
make her comfortable and showed her to
the upstairs bedroom so that she might have
privacy. She found the room uncheerful, and

had the poor manners to say so, and, in addition, appeared not to see the star quilt at all. But I forgave her, as she was still in a state of irritation and tiredness owing to her sea-journey.

"What was the nature of the quarrel?" I asked her when she was settled and sitting on the bed.

"I had observed that he was growing more and more stout as the months progressed," she said, "and one afternoon I told him so."

"Oh," I said. I confess I had then to suppress a smile, and I turned away from my sister so that she could not see this effort. "I am sorry that this has happened to you," I said. "I trust you will be able to put all your sadness behind you now that you are in a new world."

"And do you suppose," she asked, "that there is any life for Karen Christensen here on this dreadful island?"

"I am sure there must be," I said.

"Then you, Maren, are possessed of an optimism I cannot share."

And with that, she made a fluttering motion with her hand, a motion I knew well, which dismissed me from her bedroom.

For a time, Karen was my companion during the days when John was at sea, though I cannot say that this was an easy or comfortable companionship, as Karen had grown sorry for herself, and as a result, had become somewhat tedious and dull. She would sit at her spinning wheel and sing the very saddest of tunes, whilst I went about my domestic chores in her presence. I did not like constantly to ask for information about Evan, as Karen had a curious way of regarding me when I did, which always made the blood come into my face, and so I would sometimes have to sit for hours in her company to catch one casual word of my brother, which she gave only sparingly. Sometimes I believe she deliberately withheld information about Evan, and at other times I could see that she was pleased to reveal a confidence I hadn't shared with my brother. These are harsh things to say about one's sibling, but I believe them to be true. When one night I could bear it no longer, and I blurted out to her that I believed in my heart that Evan would eventually join John and me in America, she laughed for a long time and said that Evan had barely mentioned my name in the three years I had

been apart from him, and it was her opinion that though one remains attached to a family member forever, he had quite forgotten me.

I was so enraged by this utterance, which she knew wounded me deeply, I went to my room and did not emerge that day or the next day, and finally was persuaded to come into the kitchen by John, who declared that he would not tolerate discord in his house and that my sister and I must make peace between us. In truth, I was embarrassed and eager to put the entire incident, which had not shown me in my best light, behind me.

Karen and I did not have many quarrels like this, however, as she left Smutty Nose within the month. It shortly became apparent that my sister must have money for her teeth, and since there was not work on Smutty Nose, and since I did not really need any help in my domestic routine, nor did we have any extra funds to spare for her, John rowed her across to Appledore, where she was interviewed and hired as a servant to Eliza Laighton, and installed for the summer in a garret room in the hotel the Laighton family occupied and managed. In the winter, she was a personal servant to Eliza.

We were to see Karen at regular intervals

during the next two years, primarily on Sundays, when John would take the dory to collect her on her afternoon off so that she might have a meal with us. I did not notice that domestic service improved her disposition much. Indeed, I would say that as the months passed, she seemed to sink further into melancholy, and it was a wonder to me how she was able to maintain her position there at all.

Despite Karen's departure, John and I were almost never to be alone again on the island, as Matthew, John's brother, came to us soon after Karen had gone into service. Matthew was quiet and undemanding and used the northeast apartment for his sleeping quarters. He was a great help to John on the boat. And on 12 April 1872, John brought home a man to board with us, as my husband needed extra monies in order to save up for a new fishing boat. This man was called Louis Wagner.

I think now, in retrospect, I was struck most by Louis Wagner's eyes, which were a metallic blue, and were as well quite canny, and it was difficult to ignore them or to turn one's head away from them, or, indeed, even to feel comfortable in their gaze. Wag-

ner, who was an immigrant from Prussia and had about him an arrogance that I have always associated with Prussians, was large and strongly built. He had coarse hair of a sort that lightens in the elements, so that it was sometimes difficult to say whether he was fair-haired or brown-haired, but his beard was most striking, a vivid copper color under any circumstances, and shiny copper in the sun. Louis's skin was extraordinarily white, which I found surprising in a man of the sea, and his English was poor. But I will confess that he had the most contagious of smiles and quite excellent teeth, and that when he was in good humor and sat at table and told his stories, he had a kind of charm that was sometimes a relief from the silence of Matthew and John.

Louis was lodged in the northeast apartment with Matthew. In the beginning, when Louis was a mate on John's boat, I hardly saw our new boarder, as Louis ate his meals quickly and then repaired almost immediately to his bed, owing to the fatigue the long hours caused in him. But shortly after he had arrived, Mr. Wagner got the rheumatism, which he said had plagued him chronically nearly all his adult life, and he was

rendered so crippled by this ailment that he was forced to stay behind and take to his bed, and in this way I got to know Louis rather better than I might have.

✓ I had not really ever had the experience of nursing another to health, and at first I found the duties awkward and uncomfortable. As Louis could not in the beginning rise from his bed without considerable pain, I was compelled to bring him in his meals, collect his tray when he was done, and clean his room.

One morning, after Louis had been confined to his bed for several weeks, I was surprised in my lounge by a knocking at the outer door. When I opened it, Louis was standing on the stoop in a state of some disarray, his shirttails outside of his trousers and his collar missing, but still it was the first time he had been upright in many days, and I was glad to see this. I begged him to come in and sit down at the table, while I prepared some hot coffee for him.

He made his way limpingly to the chair and sat upon it with a great sigh. When he had been well, I had observed him hoisting the dory from the water as if it were a child's plaything; now he seemed barely capable of

lifting his arm from the table. He had lost considerable weight, and his hair was disheveled and in need of a wash. Despite his appearance, however, he seemed that day pleased with himself, and he smiled when I brought to him the bowl of coffee.

"I am in debt to you for your kindness," he said after he had taken a swallow.

"It's nothing," I said to him in English, as I always did, since neither of us could speak the other's language. "We hope only to make you well again."

"And that I will be, if I remain in your hands."

"We are all concerned for your health," I said. "My husband and his brother."

"But you are the nurse. I am a great burden to you."

"Oh, no," I said, hastening to assure him that he was welcome. But he shook his head.

"In this country, I have been nothing but a burden. I've had no luck and have not made my mark. I owe money to everyone, and I see no real prospects of a job."

"You have work with my husband," I pointed out.

"But I'm not working now, am I? I'm sick. I can't even pay my rent to you."

"Don't be thinking of that now. You should be thinking of getting well," I said.

"Yes?" he asked, suddenly brightening. "Do you think you will make me well, Mrs. Hontvedt?"

"I will try . . . ," I said, somewhat embarrassed. "But you are hungry. Let me feed you now."

"Yes, Mrs. Hontvedt. Please feed me."

I turned to him as he said this, and he was smiling, and I thought for a moment he might be mocking me, but then I dismissed the notion. I had been waiting for the soup to come to the boil when he had knocked, and now I stirred it and poured some into a bowl. I had in addition the flatbrød that I had baked earlier in the day. The soup was a fish chowder and had, if I may say so, a wonderful aroma, so much so, in fact, that I was compelled to pour myself a bowl.

Louis sipped from his bowl with an inelegant sucking sound, and I thought that he had probably not ever been much on manners. I observed, as he drank, that his copper beard badly needed trimming, and that while I had been fairly diligent with his laun-

dry, his lying in bed so many hours of the day had stained his shirt around the neck and under the arms. I was thinking that perhaps, if I could find some proper cloth, I would make him a new shirt while he was recovering.

"You are a good cook," he said, looking up from the soup.

"Thank you," I said, "but fish soup is easy, is it not?"

"I can't cook myself," he said. He put his spoon down. "You are lonely here?"

To my surprise, I blushed. I was so rarely ever asked questions of a personal nature.

"No," I said. "I have my dog, Ringe."

"Your dog," he said, observing me. "Is he enough?"

"Well, I have my husband . . ."

"But he is gone all the day."

"And I have work. There is always a great deal to do here. You have seen this."

"Too much work makes for a dull life," he said, and again smiled to reveal his teeth. He brushed his hair, which had grown long and somewhat greasy and overhung his forehead, with his fingers. "Do you have a pipe?" he asked.

I was, for the moment, confused by this

request. I didn't know whether John would like me to share his tobacco with this boarder, but I didn't quite know how to refuse Louis Wagner.

"My husband sometimes smokes in the evenings," I said.

Louis tilted his head at me. "But he is not here during the day, is he?"

"There are pipes," I said uncertainly.

Louis simply smiled at me and waited.

After a time, uncomfortable under his scrutiny, I went to the box where John kept the pipes, handed one to Louis, and watched as he filled it with tobacco. Outside it was a fair day, with a calm sea. The sun highlighted the salt on the windows so that it looked like ice crystals.

I had never smoked a pipe without my husband, and never at such an early hour in the morning, but I confess that as I sat there observing Louis, my own yearning for a smoke grew, so that after a time, I got out my own pipe and, as Louis had just done, filled it with tobacco. I suppose I had been quite nervous altogether, for the first long draw on my pipe tasted wonderfully marvelous and calmed my hands.

Louis seemed amused that I was smoking

with him. "In Prussia," he said, "women do not smoke."

"I am a married woman," I said. "My husband has taught me to smoke."

"And what other things has your husband taught you?" Louis asked quickly with a smile.

I hasten to say that I did not like this rejoinder and so did not answer him, but Louis seemed determined to tease me out of my somber demeanor, and so said to me, "You look too young to be a married woman."

"Then you have seen not too many married women," I said.

"I don't have enough money for a proper woman."

I colored at my understanding of the possible meaning of this utterance and turned my head away.

"John Hontvedt is very lucky to have such a beautiful wife," he said, persisting in this inappropriate speech.

"You are being silly," I said, "and I will not listen to such talk."

"But it's true," he said. "I've been looking at the women in this country for eleven years, and none are so beautiful as you."

I am ashamed to admit, so many years

later, that at that moment I was at least par-
tially flattered by this talk. I knew that Louis
Wagner was flirting with me, and that it was
improper for him to do so, but though I could
scold him, I could not quite bring myself to
banish him from my apartment. After all, I
told myself, he meant no harm. And to be
truthful, I had never in my life had a man call
me beautiful. I don't believe that my hus-
band ever said such a thing. I don't think, in
fact, that he ever even called me pretty. I
was not thinking at the time that any of these
attentions were in any way dangerous.

"I have made some konfektkake," I said,
wishing to change the subject. "Can I give
you a piece?"

"What is the konfektkake?" he asked.

"It's a Norwegian sweet," I said. "I think
you will like it."

I put before our boarder a plate of choc-
olate cake. Louis damped his pipe and laid
it on the table. After he had taken his first
bite of cake, I could see immediately that he
had a great liking for it, and he ate steadily
until nearly all of it was gone. I was thinking
that I had ought to eat the remaining two
pieces, as I would not be able to explain to
my husband that evening what had hap-

pened to the rest, and so I did. Louis wiped the icing from his mouth with the sleeve of his shirt.

"I think that you are seducing me with all this smoke and konfektkake," he said, grinning and pronouncing the Norwegian badly.

I was shocked by his words. I stood up. "You must go now," I said quickly.

"Oh, but Mrs. Hontvedt, do not send me away. We are having such a nice time. And I am only teasing you. I can see you have not been teased much lately. Am I correct?"

"Please go now," I repeated.

He got up slowly from his chair, but in doing so, arranged himself so that he was standing even closer to me than he had been before. I did not like actually to back away from him, and besides, I would have had to press against the stove, which I could not do for fear of burning myself, and so it was that he reached out and put his fingers to my cheek, very gently, and to my everlasting shame, unbidden tears sprang quite suddenly to my eyes, tears so numerous that I was unable to hide them.

"Mrs. Hontvedt," he said in an astonished voice.

I reached up and tore his hand away from

my cheek. There was no reply I could have made to him that even I myself could have understood, and as I did not think that he would leave the room, I grabbed my cloak from the hook and ran from the cottage altogether.

Once begun, the tears would not stop, and so I walked nearly blindly to the end of the island and put my hands into fists and shook them angrily at the sea.

I did not tell my husband of Louis Wagner's visit to me, as, in truth, there was not much to tell, but John shortly could see for himself that his boarder was improving in strength. I never did, after that first morning, invite Wagner into my apartment when I was alone, but I saw him often enough, as I continued to nurse him, and then later, morning and evening, when he took his meals with us. Indeed, after he was fully recovered, Wagner took to sitting by the stove in the evenings, so that there would be Wagner and myself and John and Matthew, and sometimes the men would talk, but most often, they would smoke in silence. I am happy to report that I never again lost my composure with Louis Wagner, although I must say he continued to place me under

his scrutiny, and if he no longer dared to tease me with words, I did think, from time to time, that he mocked me with his eyes.

There was only one other occasion when I was seriously to wonder at Louis Wagner's intentions and, indeed, his sanity. On a late summer afternoon, while Louis was still recuperating, I heard through the wall that separated our apartment from his room the most dreadful banging about and muttering, and I suddenly became extremely frightened.

"Louis?" I called, and then again, "Louis?"

But I had no reply, and still the commotion in the next room continued. Quite concerned, I ran outside the house and looked in at the window of our boarder's room, which, I am sorry to say, I had not yet adorned with curtains. There I saw a most astounding sight. Louis Wagner, in a fit of uncommon distress, was thrashing and flailing about, upturning objects on the shelf, creating a chaos with the bedclothes, and all the time expressing a terrible rage on his face and in a series of unintelligible sounds. I was too terrified to call to him lest he turn his fury on me, but I was also apprehensive

for his own well-being. And then, seemingly as suddenly as he had begun, Louis Wagner stopped his wild behavior and flopped himself back upon his bed and began that sort of hysterical laughing that is accompanied by tears, and after a time, he threw his arm across his eyes, and I think he fell asleep. Reassured that his fit, whatever its origin, had ended, I went back to my kitchen and pondered this unusual and unnatural outburst.

Gradually, as I have said, Louis Wagner recovered his health and was able to return to work for John. Several times, after Louis was up and about, John went, as accustomed, to fetch Karen from Appledore, and on these occasions, which were always on Sunday afternoons, Louis would be dressed in his best shirt, and I must say, that when his hair was washed and combed, he made a rather fine appearance. Karen, perhaps thinking that Wagner might be a possible suitor, was considerably warmer with him than she was with me, and I observed that her melancholy seemed to leave her altogether. She made some effort to fix her face, but this effort was largely unsuccessful in the way that trying to reshape a molded bit

of rubber will be a futile enterprise, as the elasticity of the rubber itself will cause the object immediately to resume its original shape. One time Karen actually said to me that she thought Louis Wagner a handsome man and that he seemed to be favoring her with some attention, but as I had actually been there on every occasion they had been together, and had observed Wagner's demeanor toward my sister, which was cordial, but not overly so, I privately thought that Karen must be in the thrall of those peculiar fantasies that visit spinsters in their desperation.

On one such Sunday afternoon as I am describing, Karen came into our house with John. It was, I believe, early in September, and the weather was mild, but quite dreary, as the sun hadn't broken through the cloud in several days. Everything on the island that day was covered with a fine mist, and I fancied I could see the dew on John's hair as well when he brought my sister to us.

But my attention was most drawn to the expression on Karen's face, which seemed a mixture of secret confidence and of pleasure, and was so fixed upon me that I could not turn away from her. She came directly

toward me and smiled, and I was quite at a loss as to what she meant to convey to me, and when I asked her outright what seemed to be pleasing her so, she said only that I must be patient, and that perhaps I would find out in good time. Her withholding of her secret made me, I confess, cross with her, and I vowed to put my sister and her machinations out of my mind, but so determined was Karen to whet my curiosity that it was nearly impossible to turn away from her or to avoid her glance. She then proceeded to preside, in her rather silly fashion, over the entire Sunday dinner, speaking of the personages who had been to visit Celia Thaxter, who was Eliza Laighton's sister and a poetess of some repute, of the work on the Jacob Poor Hotel, and of a small altercation she herself had had with her employer, and, in short, speaking of nearly everything but the one thing she wished me to know.

As I am not possessed of extraordinary reserves of patience, and as she meant to keep me guessing an entire week more by not revealing anything else that afternoon, I found that I could not hold my tongue when she was preparing to leave and was putting on her cloak.

"Tell me what your secret is, Karen, or I shall die of curiosity," I said, knowing that this was precisely the begging sentence my sister had wanted to hear from me.

"Oh, it is nothing, Maren," she said airily. "Simply that I have had a letter from Evan."

"Evan," I said, catching my breath. "And did you bring this letter with you?"

"I am so sorry, Maren, but I have forgotten it, and have left it back in my room."

"Then tell me what Evan has written to you."

She looked at me and smiled in a condescending manner. "Only that he is coming in October."

"Evan?"

"He is sailing in two weeks and will be here toward the middle of the month. He says he wishes to stay with you and John, here on Smutty Nose, for a time until he can settle himself."

Evan! Coming to America! I confess I must have betrayed my excitement by clutching John by the arm. "Do you hear Karen?" I asked. "Evan will be coming. And in only a month's time." I bent and picked up my dog, Ringe, who, having sensed a

mood of enthusiasm in the room, was leaping about wildly.

I may truly say here that the next weeks were the most pleasant I ever had on Smutty Nose. Even Karen I was able to tolerate with some equanimity, though, irritatingly, she forgot each week to bring Evan's letter to me. I doubt I have ever been as industrious as I was in those early autumn days, scrubbing the upstairs bedroom clean, making curtains and a floorcloth, and as the time grew closer for Evan's arrival, baking many of the delicacies I knew he loved in Norway and probably thought never to have again: the rommegot, the krumcake, and the skillingsbolle. John, I believe, was quite happy to see me so content and purposeful, and I think he did not mind at all that soon we would have another mouth to feed. If the thought of my brother's arrival could cause such happiness in his wife, a happiness that was infectious and conveyed itself to all, so that there was on Smutty Nose an atmosphere of the greatest gaiety and anticipation, then my husband would accept its cause gladly. Even the weather seemed to cooperate, bestowing upon us a succession of clear days with a lively but manageable

sea, so that just to walk outside that cottage and breathe in the air seemed nearly intoxicating.

Because I had taken on so many projects and had so little time in which to accomplish them, I was quite beside myself on the last day of all, and most eager to finish the floorcloth for the room that we had made up for him, so that while I might have been watching all day from the window for the first sight of Evan in the schooner and then on the dory, I was instead on my knees. Thus it was that I did not even know of my brother's arrival on Smutty Nose until I heard my husband halloo from the beach.

Actually, it was quite an evil day, with a gale from the northeast sweeping across the island so that one had to bend nearly double to make any progress. Nevertheless, I ran from the cottage down to the beach. I saw a knot of people, and in this knot, a glint of silvery-blond hair.

"Evan!" I cried, running to greet him. I went directly to my brother, seeing his face clearly in what was otherwise a blur of persons and of landscape, and with my arms caught him round the neck. I bent his head down toward me and pressed his face to my

own. Evan raised an arm and shouted loudly, "Halloo to America!" and everyone about us laughed. I saw that John was standing just behind Evan, and that John was smiling broadly, as I believe he truly loved me and was glad of my good fortune.

And so it was that in the midst of these giddy salutations, my arms still clutched to my brother, I slowly turned my head and my eyes rested upon an unfamiliar face. It was the face of a woman, quite a beautiful woman, clear of complexion and green-eyed. Her hair was thick and not the silvery blond of my brother, but a color that seemed warmed by the sun, and I remember thinking how odd it was that she had not worn it pinned up upon her head, particularly as it was blowing in a wild manner all about her person, so that she, from time to time, had to clutch at it in order to see anything at all. Her face was lovely, and her skin shone, even in the dull light of the cloud. Gradually my brother loosened himself from my embrace and introduced me.

"This is Anethe," he said. "This is my wife, Anethe."

I sit in the foundation of the house an unreasonably long time, using up the precious minutes I have left in which to finish the assignment. When I stand up, my legs are stiff, and I am still shivering badly. I cannot take off my wet sweatshirt, since I have no other clothes with me, and I don't think there are any in the Zodiac. I gather my cameras together and begin to shoot, in the flat light, the detail shots I have described to Rich. I move methodically about the island, hunching into the wind when I am not actually shooting. I take pictures of the graves of the Spanish sailors, the ground on which the Mid-Ocean Hotel once stood, the door of the Haley house. I use six rolls of Velvia 220. I shoot with a tripod and a macro lens. I don't know exactly how much time elapses, but I am anticipating Rich's impatience when I round the island and return to the beach. So I am surprised when he isn't there.

I sit down on the sand and try to shield

my legs with my arms. When that proves unsatisfactory, I roll over onto my stomach. The sand, I discover, has held the sun's warmth, and it feels good against my bare legs, even through the cotton of my shorts and sweatshirt. I take off my glasses and set them aside. Like a small sea creature, I try to burrow deeper into the sand, shielding my face with the sides of my hands. I find that by doing this, and by breathing evenly, I can almost control the shivering.

I do not hear Rich as he approaches. The first indication I have that he is near me is a thin trickle of sand, as from a sand timer, from my ankle to my knee and along the back of my thigh. First one leg, and then another.

When I do not turn over or respond, I feel the slight pressure of fingers on my back. He kneels in the sand beside me.

"Are you all right?"

"No."

"You're soaked."

I don't answer.

"What's wrong?" he asks.

I have sand on my forehead. I turn my head slightly, away from him. I can see the

oily wet on the small dark rocks of the beach, a crab at eye level scurrying along the crusty surface and then disappearing into a hole. There is a constant susurrus of the wind, fainter on the ground, but ceaseless still. I think that if I had to live on the island, I would go mad from the wind.

Rich begins to rub my back to warm me, to stop the shivering. "Let me get you into the dinghy. And onto the boat. You need a hot shower."

"I can't move."

"I'll help."

"I don't want to move."

I am thinking that this is true. I do not ever want to move again. I do not want to go back to the boat, to look at the faces of Thomas and Adaline, to wonder what they have been doing, or not doing, what has been said between them. What lines of poetry might have been quoted. Or not quoted. I know that Billie is on the boat, and that because of her I will have to go back, will shortly want to go back. I will have to participate in the sail to Portsmouth or to Annisquam or find a way to survive another night in the harbor. I understand that I will have to be a participant

on this cruise—a cruise for which I am responsible. I know that I will have to repack the cameras, finish the log, go home and develop the film, and hope that I have something to send into the magazine. I know that I will have to return to our house in Cambridge, that Thomas and I will go on in our marriage, as we have, in our way, and that I will continue to love him.

At this moment, it doesn't seem possible that I am capable of any of it.

I want only to dig into the sand, to feel the sand around me for warmth, to be left alone.

"You're crying," Rich says.

"No, I'm not."

I sit up and wipe my nose on the sleeve of my sweatshirt. The entire front of my body is coated with a thin layer of sand. There is sand in my hair, on my upper lip. I wrap my arms around my legs as tightly as I can. Without my glasses I cannot see the sloop or anyone on it. Even the Zodiac, only twenty feet away, is an orange blur. A shape I take to be a gull swoops down upon the beach and lurches along the pebbles. There is comfort in not being able to see the shapes of things, the details.

I bury my face in my knees. I lick my upper lip with my tongue and bring the sand into my mouth. Rich puts his hand at the back of my neck, the way you do with a child when the child is being sick to her stomach. His hand is warm.

It seems to me that we remain in that position, neither of us speaking or moving, for an unreasonably long time.

Finally I sit back and look at my brother-in-law. I can see him clearly, but not much beyond. He seems puzzled, as though he is not entirely sure what is going to happen next.

"Do you remember the wedding?" I ask.

He removes his hand from my neck with what I sense as a complicated mixture of regret and relief. "Of course I remember the wedding."

"You were only twenty-two."

"You were only twenty-four."

"You wouldn't wear a suit, and you had a ponytail. You wouldn't kiss me after the wedding, and I thought it was because you were cross that you'd been asked to wear a suit."

"You had on a black dress. I remember

thinking it was a great thing to wear to your own wedding. You had no jewelry. He didn't give you a ring."

"He didn't believe in that sort of thing," I say.

"Still."

"You and I went swimming that morning."

"With Dad. Thomas stayed home and worked. On his wedding day."

"It's his way. . . ."

"I know, I know."

"I thought at the time that Thomas was making an extraordinary commitment in marrying me. That it was almost brutally hard for him to do."

"My parents were thrilled."

"Thrilled?"

"That he'd got you. You were so solid."

"Thank you."

"No, I mean you were rooted, grounded. They were tremendously relieved he had found you."

"I wasn't going to cause him any trouble."

"You weren't going to let him cause trouble to himself."

"No one can prevent that."

"You've tried."

"Thomas isn't doing well," I say.

"You're not doing well."

"We're not doing well."

I shake my head and stretch my legs out in front of me. "Rich, I swear I think marriage is the most mysterious covenant in the universe. I'm convinced that no two are alike. More than that, I'm convinced that no marriage is like it was just the day before. Time is the significant dimension—even more significant than love. You can't ask a person what his marriage is like because it will be a different marriage tomorrow. We go in waves."

"You and Thomas."

"We have periods when I think our coming together was a kind of accident, that we're wedded because of a string of facts. And then, maybe the next day, or even that night, Thomas and I will be so close I won't be able to remember the words to a fight we had two hours earlier. The fact of the fight, the concept of an accident, will be gone—it won't even seem plausible. You called him Tom."

"Earlier. I did. I don't know why."

I look up toward the sloop I cannot see.

My horizon of beach and rocks and water is a dull watercolor blur.

"What do you think is going on out there?" I ask.

Rich turns away from me. "Jean, don't do this to yourself."

"Is it that obvious?"

"It's painful to watch."

I stand up abruptly and walk away from the water. I walk fast, meaning to shake Rich, to shake them all. I want refuge—from the cold, from the island, most of all from the sight of the sloop in the harbor. I walk toward the Hontvedt house. From where I have so recently come.

But Rich is right behind me. He follows me over the rocks, through the thick brush. When I stop, he stands beside me.

"This is where the women were murdered," I say quickly.

"Jean."

"It's so small. They lived here in the winter. I don't know how they did it. I look at this island, and I try to imagine it. The confinement, the claustrophobia. I keep trying to imagine the murders."

"Listen—"

"There aren't even any trees here. Did

you know that until recently children who were raised on the island never saw a tree or a car until they were teenagers?"

"Jean, stop."

"I love Thomas."

"I know you do."

"But it's been hard."

"He makes you worry."

I look at Rich, surprised at this insight. "Yes, he does. He makes me worry. Why did you shave your hair?"

He smiles and rubs his head.

"Do you love Adaline?" I ask.

Rich looks out toward the boat. I think that he, too, is wondering.

"It's a sexual thing?" I ask.

He tilts his head, considering. "She's very attractive," he says. "But it's a bit more than that. She's . . . Intriguing."

"And we're not intriguing," I say. "We're just good."

"We're not that good," he says, and he smiles. He has perfect teeth.

I put my hand on his arm.

He is stunned. I can feel that, the small jolt through the body. But he does not pull away.

"Jean," he says.

I lean forward and put my mouth on the skin of his arm. Did I misread the trickle of sand on the backs of my legs?

When I look up, I can see that Rich is bewildered. I realize this is the first time I have ever seen him lose his composure.

"Why?" he asks.

I study him. I shake my head. *Deliberately,* I could say. Or, *To do it before Thomas does it to me.* Or, *Before I have absolute proof he has done it to me.* Or, simply, *Because I want this, and it's wrong.*

Without touching me with his hands, he bends to kiss me. The kiss is frightening— both foreign and familiar.

I lift my sweatshirt up over my head. Oddly, I am no longer cold, and I have long since stopped shivering.

I can hear his breathing, controlled breathing, as if he had been running.

I feel the top of his head, that smooth map.

He kisses my neck. Around us, gulls and crabs swoop and scurry in confusion, alarmed by this disturbance in the natural order of the universe. I taste his shoulder. I put my teeth there lightly.

He holds me at my waist, and I can feel his hands trembling.

"I can't do this," he says into the side of my head. "I want to." He traces a circle on my back. "I want to," he repeats, "but I can't."

And as suddenly as it opened, a door shuts. For good. I lean my head against his chest and sigh.

"I don't know what came over me," I say.

He holds me tightly. "Shhhh," he says.

We stand in that posture, the clouds moving fast overhead. There is, I think, an intimacy between us, an intimacy I will not know again. A perfect, terrible intimacy— without guilt, without worry, without a future.

Calvin L. Hayes, a member of the coroner's jury who participated in the inquest held over the bodies of Anethe Christensen and Karen Christensen, took the stand for the prosecution and explained in some detail what he had observed: "We arrived on the island between eight and half-past eight P.M. We landed and proceeded to the house formerly occupied by John C. Hontvet. Upon entering the house there is first a small entry from which opens a kitchen. When we entered the kitchen we found the furniture

strewn all over the floor, the clock lying on the lounge face down; clock was not going. I did not look at the face of the clock; it fell evidently from a small bracket just over the lounge in the corner. The body of Anethe Christensen lay in the middle of the kitchen floor, the head towards the door through which we entered. Around the throat was tied a scarf or shawl, some colored woolen garment, and over the body some article of clothing was thrown loosely. The head was, as you might say, all battered to pieces, covered with wounds, and in the vicinity of the right ear two or three cuts broke through the skull so that the brains could be seen running through them. There was a bed-room opening from the kitchen; in that was a bed and trunk, the trunk opened, the contents scattered over the floor. The body of Anethe was placed upon a board upon a table, and an examination made by the physicians who were present. We then proceeded to the other part of the house. The arrangement of the other end of the house was similar to the end into which we first went. We went into an entry, from there into a room that corresponded to the kitchen, out of which another bed-room opened. In that bed-room, face

down, we found the body of Karen Christen-sen. The windowsill of the first bed-room I spoke of was broken off, window in the south-west end of house. The body of Karen Christensen had a white handkerchief knot-ted tightly around the neck, tied at the back of the neck, so tightly that the tongue was protruding from the mouth. Upon the inside of the sill of the window on the south-west end of the house, was a mark as though made with the pole of an axe, and on the outside of the window-sill, the part that was broken off, there was another mark as though made with some round instrument, as the handle of an axe. The head of Karen Christensen was covered with wounds, but not so bad as the first one. Only one I think broke the skull. I found an axe there."

Hayes produced the murder weapon.

He continued: "I took the axe from the is-land. It has been in my custody since. I found the axe lying by the side of the first door we entered; it does not now resemble its condition then at all; it was besmeared with blood and covered with matter entirely. In coming from the island the sea was very rough, and the spray washed nearly all the blood off."

After Calvin Hayes testified, Dr. John W. Parsons, the physician who performed the autopsy of Anethe, took the stand.

"The examination was made on March 8," he began, "in the city of Portsmouth, at the rooms of the undertakers, Gerrish & Adams. I found upon examination one flesh wound upon the right side of the forehead upon the upper part. The left ear was cut through nearly separating it from the head, and this wound extending down behind the ear an inch or two; flesh wound merely. There was a flesh wound on the left side of the head just above and in front of the ear, under which there was a compound fracture of the skull. There was a flesh wound in front of the right ear, and another almost separating the right ear from the head, and extending down behind it. There were two flesh wounds upon the upper part of the right side of the head, above the ear. There was a small flesh wound upon the left side of the head above the large wound spoken of. There were a few other minor scratches, and wounds about the scalp, but that is all worthy of notice."

Dr. Parsons then stated that, in his opinion, a very heavy instrument had to have

made the blows, and that, yes, it could have been an ax.

Rich makes me put my sweatshirt on and leads me back down to the beach. I notice that he is careful to let go of my hand at the exact point the sloop comes into view. We search in the sand for my glasses, and I clean them off. I retrieve my camera bag and lift it onto my shoulder. The sky has darkened and casts a dispiriting light.

"I've never been unfaithful," I say.

Rich scrutinizes my face. "I'd be very surprised to hear you had been."

"Thank you for—"

"Don't," he says sharply. "I'm not sure you understand. Back there I wanted to. Believe me, I wanted to. I've been angry with Thomas for a long time. Angry at his carelessness. Angry at the way he takes you for granted. But it's more than that. I've"—he searches for the word—"admired you since the day I first met you."

"Admired?" I ask, smiling.

"I don't dare use any other words," he says. "Not now."

"It's all right," I say with a small laugh. "Feel free. I can take it."

Rich crosses his arms over his chest and

gazes out over the expanse of Smuttynose. I think I see, in Rich's profile, something of Thomas. The long space between the upper lip and the nose. The slant of the brow.

"Rich," I say, touching his arm lightly. "I'm only kidding."

His face, when he turns back to me, seems momentarily defeated. Sad.

"I think you're beautiful," he says.

Fat drops of rain begin to fall around us, making saucer shapes in the sand. Rich looks down at his feet, then wipes the top of his head.

"The rain is coming," he says. "We'd better go."

Early in the trial, Maren Hontvedt, the only eyewitness to the murders, took the stand. She gave her name as Mary S. Hontvet, using the name and spelling she had adopted in America. She said that she was the wife of John C. Hontvet and was the sister of Karen Christensen. Evan Christensen, she stated, was her brother.

Yeaton began to question her.

"How long before this matter at Smutty Nose did you live there?" Yeaton asked.

"Five years," Maren answered. "I was at home day before the murder."

"Was your husband there that day?"

"He left in the morning, about day-light with my brother, and his brother. Evan is husband of Anethe."

"After he had left that morning, when did you next see your husband?"

"I saw him the next morning after, cannot tell, but about ten o'clock."

"At nine o'clock that night, who were present at your house before you went to bed?"

"I, Karen, and Anethe. There were no other persons upon that island at that time."

"What time did you go to bed that night?"

"Ten o'clock. I slept in the western part of the house in the bedroom. I and Anethe slept together that night."

"About ten o'clock you went to bed."

"About ten. Karen stayed there that night; she slept on a lounge in the kitchen. The lounge upon which Karen slept was in the easterly corner of the kitchen, corner standing up that way, and my bed-room that way." Maren pointed with her hands for the benefit of the court.

Yeaton then asked her how the door between the kitchen and the bedroom had been left that night.

"Left open," Maren said.

"How were the curtains?"

"I did not haul them down, it was a pleasant night, so I left them open."

"I speak now of the curtains to the kitchen."

"Yes."

"How was the outside door to that part of the house, fastened or not?"

"No, sir, it was not fastened. The lock was broke for some time, broke last summer and we did not fix it, it was unfastened. Karen was undressed, bed made; we made a bed up."

"Was there a clock in that room?"

"Yes, clock standing right over the lounge in the corner."

"If you were disturbed that night or awoke, state the first thing that awoke you, so far as you know, what took place."

There was an objection here by Tapley for the defense, and some talk among the lawyers and the court. Finally, Maren was allowed to answer.

" 'John scared me, John scared me,' she says."

"Are you able to determine in any way about what time during the night that was?"

"We woke up. I know about his going and striking her with a chair."

"About what time was it?"

"The clock has fallen down in the lounge, and stopped at seven minutes past one."

"After you heard Karen cry out, John scared me, what next took place?"

"John killed me, John killed me, she halooed out a good many times. When he commenced striking her with a chair she halooed out, John killed me, John killed me."

"What did you do?"

"As soon as I heard her haloo out, John killed me, I jumped up out of bed, and tried to open my bed-room door. I tried to get it open but could not, it was fastened."

"Go on."

"He kept on striking her there, and I tried to get the door open, but I could not, the door was fastened. She fell down on the floor underneath the table, then the door was left open for me to go in."

"What next?"

"When I got the door open I looked out and saw a fellow standing right alongside of the window. I saw it was a great tall man. He grabbed a chair with both hands, a chair

standing alongside of him. I hurried up to take Karen, my sister, and held one hand on to the door, and took her with my other arm, and carried her in as quick as I could. When I was standing there, he struck me twice, and I held on to the door. I told my sister Karen to hold on to the door, when I opened the window and we were trying to get out."

"Which window was that?"

"My bed-room window, and she said no, I can't do it, I am too tired. She laid on the floor with her knees, and hanging her arms upon the bed. I told Anethe to come up and open the window, and to run out and to take some clothes on her, to run and hide herself away."

"Where was Anethe when you told her that?"

"In my bed-room."

"Well."

"She opened the window."

"Who opened the window?"

"Anethe opened the window, and left the window open and run out. I told her to run out."

"Where did she run out?"

"Out of the window, jumped out of the window."

"Go on."

"I told her to run, and she said I can't run. I said you haloo, might somebody hear from the other islands. She said, I cannot haloo. When I was standing there at the door, he was trying to get in three times, knocked at the door three times when I was standing at the door."

"What door?"

"My bed-room door. When he found he could not get in that way, he went outside, and Anethe saw him on the corner of the house. She next halooed, Louis, Louis, Louis, a good many times, and I jumped to the window and looked out, and when he got a little further I saw him out the window, and he stopped a moment out there."

"How far from the window was he when he stopped?"

"He was not far from the window; he could have laid his elbow right that way on the window." Maren then illustrated this gesture for the court.

Yeaton asked: "Who was that man?"

"Louis Wagner."

"Go on. What else took place?"

"And he turned around again, and when Anethe saw him coming from the corner of

the house, back again with a big axe, she halooed out, Louis, Louis, again, good many times she halooed out, Louis, till he struck her. He struck her with a great big axe."

"Did you see that part of her person the blow took effect?"

"He hit her on the head. He struck her once, and she fell down. After she fell down, he struck her twice."

"Well."

"And back he went on the corner again, and I jumped out, and told my sister to come, but she said, I am so tired I can't go."

"Which sister was that?"

"Karen. I told Karen to come; she said, I am so tired I can't."

"You jumped out where?"

"Out through my bed-room window, and I ran down to the hen-house where I had my hens, and opened the door and thought of hiding away in the cellar. I saw the little dog coming, and I was afraid to hide away there because he would look around, and I was afraid the dog would bark, and out I went again. I thought I would run down to the landing-place, and see if he had dory there, and I would take the dory and draw to some island. I looked down the dock, but I did not

find any boat there, so I went around. I got a little ways out from the house, and I saw he had a light in the house."

"Go on, and state what you saw or heard."

"He had hauled the window curtains down too. I did not haul them down, but he had them hauled down before I got into the kitchen. I forgot to state that. I went down on the island, ran a little ways, and heard my sister haloo again. I heard her so plain I thought she was outside of the house. I ran to find rocks to hid myself away underneath the rocks on the island."

"How long did you remain there among the rocks?"

"The moon was most down, and I staid till after sunrise, about half an hour after sunrise."

"What relation are you to Anethe and Karen?"

"Anethe married my brother, and Karen was my own sister."

Beyond the harbor, the sky blackens and hangs in sheets. The sun, which is still in the southeast, lights up all the boats in the harbor and the buildings on Star with a luminescence against the backdrop that is

breathtaking. We can actually see the front moving.

The rain hits Rich's face and washes over his brow, his eyes, his mouth. Drops hang on the tip of his nose and then fall in rivulets down his chin. He has to narrow his eyes into slits, and, as he holds the tiller, I wonder how he can see at all. The T-shirt he has so recently dried drags on his chest from the weight of the water.

I sit with my feet anchoring the poncho over the cameras. I have taken my glasses off, and I am trying to shield my eyes with my hands. All at once, there is a green wall beside us, the hull of the boat. Rich touches my knee. I shake my head.

A figure looms above us, and a hand reaches down.

"Give me the cameras first," Thomas shouts. "I'll take them in."

23 September 1899

When I finally understood, on the beach, that Evan had brought a wife with him to America, I was at such a loss for words that I was unable to express anything further there on the shore, and it wasn't until some time afterwards that I had the strength to make a proper greeting to the woman, who, I must say, was possessed of such an astonishing beauty it was an effort to draw one's eyes away from her. It was a beauty the chief components of which are vibrant youth as well as lovely aesthetic form, and I could not help but observe, even in those first few moments, that my brother was most infatuated with his new bride, and that he was, except for perhaps three or four occasions in his childhood, more ebullient than I had ever seen him. He had worn that day a leather jerkin and cap, over which he had his yellow oilskin jacket, and he stood with

an umbrella close to the young woman like a man servant who does not want one foul drop of rain to fall upon his mistress, with the obvious difference being that Evan was the mistress's husband and was unable to refrain from putting his hands on her in one way or another nearly all the time they remained on the beach and in my kitchen that afternoon. I had the distinct impression that Evan believed that if he did not stay near to his wife she might suddenly vanish.

Anethe was tall for a woman, perhaps only a hand's length shorter than our Evan, and after she removed her cloak in our entryway, I saw that she had an admirable figure, that is to say, she was slim-waisted but not flat-chested, and her figure was most fetchingly shown to advantage in a prettily made, high-necked, lace blouse. She had fine Nordic features (high cheekbones, clear skin, and dusty gray-green eyes with pale eyelashes), altogether an open and guileless face nearly always set in a pleasing attitude. In fact, I doubt I have ever known anyone who smiled as much as that young woman, so much so that I began to wonder if her mouth mustn't hurt from the effort, and

I can hardly ever remember seeing Anethe's face in repose, except for a few occasions when she was sleeping. If her comeliness was of the sort that is lacking in enigma and mystery, qualities which I believe are necessary for true classical beauty, her mien suggested an uncommon light and, even more, a sunny disposition I have seen only in young girls. Of course, Anethe was considerably more than a girl when she came to us, being already twenty-four, but she seemed innocent, if not altogether naive. In Laurvig, she had been the youngest daughter of a shipwright and had been watched over keenly by this father, who, I was told, was loath to let her go, even at an age when young women are in serious danger of becoming spinsters if they do not marry. Also, I thought that Anethe's father must have instilled in his daughter a passionate desire to please, since her entire being, her face, her posture and her words, seemed dedicated to this effort.

My brother's wife had as well, I must add here, a remarkable head of hair, and I can attest to the fact that when she took out her combs and unbraided her plaits, this hair

reached all the way to the back of her calves.

With Evan close to her side, Anethe, smiling all the while, recounted for us (with myself translating into English for our boarder, so that, in essence, for me, these tales were somewhat tediously twice-told) the particulars of their marriage vows, of their wedding trip to Kristiania, and of the crossing itself, which the newlyweds seemed to have weathered in fine fashion. In fact, so great was their enthusiasm for this adventure to America, though I trust they would have retained a desire for any sojourn so long as it allowed them to be together, that they often interrupted each other or spoke simultaneously or finished the other's sentences, a practice that began to wear upon me as the afternoon progressed, in the same way that one might come to be irritated by the overworked and frequent repetition of a once-charming trait in a young child. Also, I think it is not necessary to say that I was extremely vexed at my sister, Karen, who was not present that afternoon, but who had deliberately withheld important information from me, for what reasons I cannot think,

except to cause me the most acute humili-
ation. At times, sitting there in my lounge,
next to the stove, serving Evan and Anethe
and Louis Wagner and John and Matthew
the sweets I had made expressly for this oc-
casion, thinking to please with delicacies
from our Norway my brother, who, I am
sorry to report, ate almost nothing that day,
and observing Louis Wagner, who was, from
a distance I suspect he would have
breached in an instant if he thought he had
so much as a chance, practically as en-
tranced by Anethe's melodious voice and
lustrous skin as was her husband, I was
nearly overtaken by a rage so powerful at
my sister I felt myself quiver in my very soul
and had immediately to ask the Lord for for-
giveness for the terrible thoughts against her
person I was entertaining. I knew that
shortly she would come to my house, as she
did on most Sundays and certainly would
this coming Sunday since it would be her
first visit in America with Evan and his new
wife, and I thought that I would speak to her
most severely about the malign game she
had played with me, and of its conse-
quences. If I had been able to, without re-

vealing my innermost feelings and casting some shame upon myself, I would have banished Karen altogether from Smutty Nose, or at least until such a time as she might confess her wicked machinations. Altogether, it was an afternoon of mixed emotions, and more mixed still when Evan and Anethe repaired to their sleeping quarters above the lounge. They went up to their bedroom to lay down their trunks and to change their clothes, and, ostensibly, to rest, but it was quite shamefully apparent, from the sounds emanating from that room just above my head, that resting was the furthest thing from their minds, and so difficult was it to sit there below them listening to the noise of their relations in the presence of my husband, his brother and our boarder, all of whom pretended to hear nothing and to take great interest in the cake which I had cut and served to them, that though it was an evil day outside, I put on my cloak and left that house, and had I had anywhere else on earth to go, I can assure you that I would have done so.

On Sunday, when Karen came, I said no word about my surprise at Evan's marriage,

as I did not want to give my sister the satisfaction of seeing in me the very emotion she had apparently taken such pains to elicit. Indeed, I was most gracious during that particular Sunday dinner, and I like to think I confounded our Karen by openly rejoicing in Anethe's arrival to our islands, and in pointing out to Karen the comely attributes and domestic skills of the young wife, and if Karen studied me oddly and tried several times to ensnare me in my own trickery by coaxing Anethe or Evan to tell of moments the two had shared in Norway during their courtship, I trust that a certain smugness, with which Karen had entered our house that day, began to fade and dissipate as the afternoon wore on. Of course, I had had to tell some untruths, as Anethe was a most appalling seamstress and cook and was almost entirely lacking in any knowledge of housewifery whatsoever. And I think it is probably not incorrect to say that young women with beauty are seldom possessed of great domestic ability, primarily because this quality is often unnecessary in order to attract eligible men into marriage. I often wonder how many of these men, in the sec-

ond or third month of their wedded life, confronted with disorder in the household and weeks of ill-prepared meals, begin to speculate about the brilliance of their choice. Our Evan, of course, was spared this disillusionment, as I remained in charge of the housekeeping and of the meals, and suffered Anethe as but a poor assistant, more in need of instruction than of praise.

For five months on that island, I lived with Evan and Anethe, and with my husband and his brother and, for part of that time, our boarder as well. In October and early November, when the men would leave for the day, Anethe would come down to the stove in her nightdress, and after she had had her bowl of coffee, she would dress and share the chores with me, but oddly I felt lonelier with her there than I had without her, and there were many days that I wished her gone or never come, and I felt badly about this, as there was nothing offensive in Anethe's disposition or in her person, certainly nothing that warranted such a desire. She was given to storytelling and even sometimes to teasing, and for hours at a stretch, while we spun or sewed or cooked, she

would talk of Evan, all the while laughing, joking, and sharing the little intimate secrets that women sometimes tell each other, although I have never felt compelled to do so. I heard many times and could relate to you now the smallest details of their courtship and of their wedding, and of the long walks they took along the coast road and in the forest. Occasionally Anethe would attempt to glean from me anecdotes from my own time with Evan, but I was not so generous and could spare no stories, as they were still close to my bosom, and moreover, my poor narratives would have lacked lustre in the telling, as it was understood that in Evan's life Anethe had taken precedence, and so how could anything I relate be but a poor second cousin to the more legitimate? When the men came in the late afternoon, Anethe would run down to the cove to find Evan, and the two would play with each other as they stumbled up the path to the house. Even in the snow she did this.

It wasn't until the fourth week after Evan and Anethe had come to us that I found myself in a room alone with my brother. John and Matthew and Louis had gone into Ports-

mouth for provisions, but Evan had stayed behind to mend some nets. He could speak no English, and I think he was reluctant to make himself uncomfortable in that way in that city. Anethe, I recall, was still upstairs in her room. She was not an early riser and had no need to be except to bid her husband farewell in the mornings, for it was usually myself who rose before daybreak and fired up the stove and made the meal for the men, and gave them whatever clothes they might need. On this particular morning, however, Evan, too, had risen late, and had not yet had his breakfast. I was pleased to prepare it for him, although he protested and said he did not deserve it as he had been unforgivably lazy. He said this in a good-natured manner, and it was understood that he was joking. This was, as you may imagine, an altogether new side of my brother I was seeing, for before this time, he had nearly always been a pensive and thoughtful man. I began to think that his marriage had altered his very chemistry, or had, in some way, brought forth joy and hope from where they had lain buried inside him all those years.

Evan took off his jacket, as he had been down to the cove to see the men off, and he sat at the table. He was wearing a blue cotton shirt without a collar, and had exchanged that day his overalls for a pair of woolen trousers with suspenders. Over the last several years, his body had filled out some, so that I was most impressed with the length and breadth of his back, which seemed strong. Also his face, which before had shown the beginnings of the sunken cheeks which was certainly a family trait if not a national one, had filled out as well. These changes combined to give an impression of contentment and of a man who now daydreamed when once he had brooded. His hair, I noticed, had grown long in the back, and I wondered if I should offer to cut it, or if this task belonged now to Anethe. Indeed, it was difficult to know just exactly what the nature of the attachment between Evan and myself was, apart from our history, and though I wished to discuss in some oblique manner this question, I was content, for the moment, simply to be serving my brother at table.

I set before him a plate of bread and geitost, and sat down with him.

"Do you think John will be long in Portsmouth?" I asked.

"The tide is favorable, and the wind as well. They must have bait and set the trawls, and fill out the list you have given them, but I think they will be home before dark. And anyway, there is a moon tonight, so there is no danger either way."

"Why didn't you go with them? Isn't Portsmouth vastly more interesting than this poor island?"

He laughed. "This poor island has everything I need and ever wanted," he said. "My wife is here." He took a mouthful of biscuit. "And my sister," he added with a nod. "And I do not need the distraction of the city at the moment. I am content to sit here and mend the nets and think about my good fortune instead."

"You and Anethe are settling in well then?"

"Yes, Maren, you have seen this."

"She is very agreeable," I said. "And she is pleasant to look upon. But she has a lot to learn about keeping a house. I suppose she will learn that here."

"She can't fail with such a good teacher,"

Evan said, stabbing his spoon in my direction. I winced, for I thought sometimes that his new jocularity was overbearing and not really suited to him, however happy he had become.

"Maren, you have turned yourself into a first-rate cook," he said. "If I do not watch myself, I will grow fat from your cooking."

"You are already fat from your happiness," I said to him.

He laughed a kind of self-congratulatory laugh. "That is overweight I would not mind carrying," he said, "but you are growing fat as well, and with luck you may grow fatter still." I think my brother may actually have winked at me.

I got up at once and went to the stove.

"I mean that you will one day give us all some good news," he said amiably.

Still I said nothing.

"Maren, what is it?" he asked. "Have I said something wrong?"

I struggled for a moment over the wisdom of answering my brother, but I had waited for so long to speak with him, and I did not see when I would easily have another opportunity.

"I cannot have a child," I said, turning, and looking at him steadily.

He looked away toward the south window, through which one could see across the harbor and over to Star. I did not know if he was simply taken aback, or if he was chastising himself for so carelessly bringing up a painful subject. I saw, when he turned his head, that the silver-blond hair was thinning at the crown. He looked up. "Are you sure of this, Maren? Have you been to a doctor?"

"I have no need of doctors. Four years have been proof enough. And, truth to tell, I am not so surprised. It is something I have suspected all my life, or at least since . . ."

I hesitated.

"Since our mother died," I said quietly.

Evan put down his spoon, and brought his hand up to the lower half of his face.

"You remember," I said.

He did not answer me.

"You remember," I said, in a slightly more distinct voice.

"I remember," he replied.

"And I have thought," I said quickly, "that my illness after that time and the simultaneous onset of my womanhood . . ."

He began to rub the underside of his chin with his forefinger.

"That is to say, the beginning of my monthly curse . . ."

He suddenly took his napkin from his lap and put it on the table. "These are not matters of which we should speak, Maren," he said, interrupting me. "I am sorry to have brought up such a private subject. It is entirely my fault. But I do want to say to you that there can be no possible cause and effect between the events of that time and the state of your"—he hesitated at the word—"womb. This is a subject for doctors and for your husband at the very least. Also, I think that sometimes such difficulties may result from a state of mind as well as a state of bodily health."

"Are you saying I am barren because I have wished it so?" I asked sharply, for I was more than a little piqued at this glib remark on a matter he can have known so very little about.

"No, no, Maren," he said hastily. "No, no, I have no authority to say such things. It's just that I . . ." He paused. "Your marriage to John is a happy one?"

"We have managed," I said.

"I mean," he said, with a small, awkward flutter of his hand, "in the matter of a child . . ."

"Do you mean, does my husband put his seed into me with regularity?" I asked, shocking him, for he colored instantly and darkly.

He stood up in a state of confusion, and I was immediately remorseful and angry with myself for causing him this discomfort. I went to him and put my arms about his neck. He separated my hands from behind his neck and held my arms by their wrists, and I leaned against his chest.

My eyes filled with tears. Perhaps it was the proximity of his familiar body and the smell of him that allowed me to weep. "You have gone on," I cried. "You have gone on, but I . . . I cannot go on, and sometimes I think I will go mad."

His smell was in the fabric of his shirt. I pressed my face into the cloth and inhaled deeply. It was a wonderful smell, the smell of ironed cotton and a man's sweat.

He pulled my wrists down so that they were at my side. Anethe came into the room. Evan let go of me. She was still in her nightdress, and her hair was braided in a

single plait down her back. She was sleepy still, and her eyes were half closed. "Good morning, Maren," she said pleasantly, seemingly oblivious to her husband's posture or the tears on my cheeks, and I thought, not for the first time, that Anethe must be short-sighted, and I then recalled several other times in the past few weeks when I had seen her squinting.

Anethe went to her husband and coiled herself into his embrace so that though she was facing me, his arms were wrapped around her. Evan, unwilling to look at me any longer, bent his head into her hair.

I could not speak, and for a moment, I could not move. I felt raw, as though my flesh had torn, as though a wild dog had taken me in his teeth, sunk his teeth into me, and had pulled and tugged until the flesh and gristle had come away from the bone.

"I must go," Evan said quickly to Anethe, giving her one last quick embrace about the shoulders. "I must collect the nets."

And without a glance in my direction, he took his jacket from the chair and left the room. I knew then that Evan would take great pains never to be left alone in a room again with me.

I turned around and brought my fists close in to my breast. I squeezed my eyes shut and tried to contain the rage and longing within me so that no unwanted sound would slip through my lips. I heard Anethe walk her husband to the door. Evan would take the nets, I knew, to Louis Wagner's room to mend them, even though it was colder in there. When I heard Anethe come back to where I was standing, I made myself relax my eyelids and put my hands on the back of a chair. I was trembling.

"Maren," Anethe said behind me, reaching up to tuck a stray lock of hair into my bun. The touch sent a shiver through my back and down my legs. "I am hopelessly naughty for sleeping so late, but do you think you could forgive me and let me have some of the sausage and cheese from yesterday's dinner for my breakfast?"

I stepped away from her and, with methodical movements, long practiced, long rehearsed, went to the stove, and slowly lifted the kettle up and slowly set it down again upon the fire.

For six weeks during the period that Evan and Anethe lived with John and me, Louis Wagner was with us, and for most of this

time he was well and working on the *Clara Bella.* But one day, when the men were still going out, Louis remained behind. He was, he said, experiencing a sudden return of the rheumatism. I know now, of course, that this was a ruse, and I am sorry to have to report here that the inappropriate attraction Louis felt for Anethe had not abated with time, but rather had intensified. And this was due, in part, to the fact that Anethe had taken pity on Louis, fearing for his poverty and loneliness and his inability to get a wife, and had shown him some mild affection in the way of people who are so content with their lot that they have happiness in excess of their needs and thus can share the bounty with others. I believe that Louis, not having had this form of attention, and certainly not from such a lady as Anethe, mistook the young woman's kindness for flirtation and sought to make the most of that advantage. So it happened that on the day that he pretended ill and I had gone to see if he would sit up to take some porridge, he asked me if I would send Anethe forthwith into his chamber in order that she might read to him, and thus divert his attention from his "sore joints." I did see, in Anethe's face, the small-

est hesitation when I suggested this, as she had never attended to a man other than her husband in the privacy of his room, and had never nursed the sick, but I imagine that she thought that if I was so willing to be alone with Louis there could be no harm in it. She took a book out of the front door of our kitchen and into the apartment in which Louis was lying.

I do not believe she was in his room for more than ten minutes before I heard a small exclamation, a sound that a woman will make when she is suddenly surprised, and then a muffled but distinctly distressed cry. As there was no noise from Louis, the first thought I had was that the man had fallen out of his bed. I had been on my knees with a dustpan, cleaning the ashes from the stove, and was halfway to my feet when there was a loud thump as though a shoulder had hit the wall that separated Louis's apartment from the kitchen of our own. There was a second bump and then another unintelligible word. I set down the dustpan on the table, wiped my hands on a cloth and called to Anethe through the wall. Before I could wonder at a lack of response, however, I heard the door of Louis's apart-

ment open, and presently Anethe was in our kitchen.

One plait to the side of Anethe's head had pulled loose from its knot and was hanging in a long U at her shoulder. On the bodice of her blouse, a starched, white garment with narrow smocked sleeves, was a dirty smudge, as though a hand had ground itself in. The top button of her collar was missing. She was breathless and held her hand to her waist.

"Louis," she said, and put her other hand to the wall to steady herself.

The color had quite left Anethe's face, and I saw that her beauty was truly in her coloring and animation, for without both she looked gaunt and anemic. I confess I was riveted by the contrast of the dirty smudge on the white breast of her blouse, and I suppose because I am not at all a demonstrative person I found it difficult to speak some comfort to her. It was as though any word I might say to her would sound false and thus be worse than no word at all, and for some reason I cannot now articulate, I was in an odd state of paralysis. And though it shames me deeply, I must confess that I think I might actually have begun to smile in that awful

inappropriate way one does when one hears terribly bad news, and the smile just seems automatically, without will, to come to one's lips. I reproach myself greatly for this behavior, of course, and think how easy it might have been to go to my sister-in-law and put my arms around her and console her, or at least help to put behind her the absurd and almost laughable advances of the man next door, but as I say, I was frozen to the spot and able only to utter her name.

"Anethe," I said.

Whereupon the blood left her head altogether, and she fell down in a wondrous sort of collapse that I am sorry to say struck me as somewhat comical in nature, the knees buckling, the arms fluttering out sideways as if she would try to fly, and it was only once she was on the ground that I was able to unlock my limbs and move toward her and raise her head up and in that way help her back to consciousness.

When I had her in her bed, and she had nearly recovered her color, we spoke finally about Louis and about the fearful rage that this incident might provoke in Evan, and it was decided then and there between us that I would not tell my brother, but rather would

suggest to my husband that there had been some disappearances of beer and honey and candles in the household for which I could not account, and that without raising a fuss I thought it might be wise to terminate our boarder's lease.

Unfortunately, however, I was not present at Louis Wagner's dismissal and, as a consequence, John did not quite heed or remember my precise advice, and said to Louis that because I had missed certain household items it might be better for Louis to look elsewhere for lodgings. Louis denied these charges vigorously and demanded to see me, but John, of course believing his wife and not his boarder, stood firm and told Louis that he would be leaving the next day. The following morning, as Louis was preparing to board Emil Ingerbretson's schooner for the passage into Portsmouth, I remained in the kitchen, as I did not want an unpleasant confrontation, but just before sailing Louis came up from the cove and sought me out. I heard a noise and turned to see him standing in the open door. He did not speak a word, but merely stared at me with a look so fixed and knowing I grew warm and uncomfortable under his gaze.

"Louis," I began, but could not go on, although the expression on his face seemed to dare me to speak. Truthfully, I could think of nothing I could say to him that would not make the situation worse. He smiled slowly at me then and closed the door.

Thus it was that Louis Wagner left Smutty Nose.

I think about the weight of water, its scientific properties. A cubic foot of water weighs 62.4 pounds. Seawater is 3.5 percent heavier than freshwater; that is, for every 1,000 pounds of seawater, 35 of those will be salt. The weight of water causes pressure to increase with depth. The pressure one mile down into the ocean is 2,300 pounds per square inch.

What moment was it that I might have altered? What point in time was it that I might have moved one way instead of another, had one thought instead of another? When I think about what happened on the boat, and it was a time that was so brief—how long? four minutes? eight? certainly not even ten—the events unfold with excruciating lethargy. In the beginning, I will need to see the scene repeatedly. I will hunt for details I have missed before, savor tiny nuances. I will want to be left alone in a dark room so that I will not be interrupted. But

after a time, I will not be able to stop the loop. And each time the loop plays itself, I will see I have a chance, a choice.

Thomas pulls me by the arms up onto the deck. He tries to wipe the rain from his eyes with his sleeve. "Where have you been?" he asks.

"Where's Billie?"

"Down below."

"It was my last chance to get any pictures."

"Christ."

"We started back the minute it began to rain." My voice sounds strained and thin, even to myself.

"The wind came up half an hour ago," Thomas says accusingly. "The other boat has already left. I don't know what's going on."

"Billie's all right?"

Thomas combs his hair off his forehead with the fingers of both hands. "I can't get her to put her life jacket on."

"And Adaline?" I ask.

He massages the bridge of his nose. "She's lying down," he says.

Rich hoists himself onto the deck from the

dinghy. I notice that Thomas does not extend a hand to his brother. Rich drags the dinghy line to the stern.

"Tom," Rich calls, again using the boyhood nickname. "Take this line."

Thomas makes his way to the stern, and takes the rope from Rich, and it is then that I notice that Thomas is shaking. Rich sees it, too.

"Go inside," Rich says to Thomas quietly. "Put on dry clothes and a sweater. The foulweather gear is under the bunks in the forward cabin. You, too," he adds, looking at me quickly and then away. He ties the line in his hand to a cleat. "I'll go down and listen to what NOAA has to say. How long ago did the other boat leave?"

"About fifteen minutes," Thomas answers.

"Did she say where she was headed?"

"Little Harbor."

As if in answer to Rich's doubts, the Morgan shudders deep in her hull from the hard bang of a wave. I can feel the stern skid sideways in the water, like a car on ice. The rain is dark, and I can barely make out the shape of the islands around us. The sea is lead colored, dull but boisterous.

I go below to find Billie huddled in her berth. She has her face turned away. I touch her on the shoulder, and she snaps her head around, as though she were raw all over.

I lie down beside her. Gently, I rub her shoulder and her arm. "Daddy was right," I say softly. "You have to put your life jacket on. It's a law, Billie, and there isn't anything we can do about it."

Invoking parental helplessness before a higher authority has usually worked with Billie, as when I tell her that the police will stop me if she doesn't put on her seat belt in a car. The door to the forward cabin is shut. Thomas knocks and enters simultaneously, a gesture that catches my breath. I can see a slim form lying on the left side of the V berth. A head rises. Thomas shuts the door.

My sneakers make squelching sounds on the teak floor grate. I kick them off, and they thwack against a galley cabinet. I strip off my sweatshirt and shorts and underwear and pull from my duffel bag a pair of jeans and a cotton sweater. Billie, hearing the un-expected bumps of the sneakers, rolls over

in her berth and looks up at her naked and shivering mother.

"Can't I wear an orange one?" she asks.

"No, those are for adults. Only yours will fit you." I peer down at the life vest, with its Sesame Street motif, on the table.

Thomas opens the door of the forward cabin. I am struggling awkwardly with jeans on wet skin. Rich swings down from the deck. Instinctively, I turn my back.

Thomas drops a muddle of navy and yellow foul-weather gear onto the teak table. "There's a small one here," he says and holds it up. "I think it will fit Billie."

"Oh, Daddy, can I have it?" Billie asks, holding out her arms.

I wrestle with my sweater. I bend to Thomas's duffel bag and take out a dry shirt, a sweater, and a pair of khakis. I hold them out to him. I look at Thomas's face, which has gone white and looks old.

At the trial, Mr. Yeaton for the prosecution asked "Mary S. Hontvet" how long she had known Louis Wagner. She answered that he had boarded with her for seven months the previous year, beginning in the spring.

"When did he leave, get through boarding with you?" Mr. Yeaton asked.

"He went into Portsmouth about November," Maren answered.

"What room did he occupy in your house?"

"He had the easterly end of the house, he had a big room there."

"Where did he keep his clothes?"

"He kept his clothes in a little bed-room there hanging up. He had oil skin hanging up in my entry, when he had been out fishing, he took his oil skin off and hung it up in the entry, entry coming into my kitchen."

"Entry in your part?"

"Yes."

Mr. Yeaton then asked what was in Louis Wagner's room.

Maren answered: "He had his bed there, and one big trunk, which belonged to my sister Karen."

"Do you know what was in that trunk?"

"She had clothes, some she wore in the winter time, and she put them in the trunk in the summer, and summer clothes she did not use she put in the trunk, and she had a feather-bed that she had at the time she came over in the steamer."

"Was that in the trunk?"

"Yes, the bed was in the trunk, the big chest."

"While he boarded with you, was Karen a member of the family?"

"She came out visiting me some days."

"Did she sleep there?"

"No, sir."

Mr. Yeaton then asked Maren whether she knew if Karen had a piece of silver money. Maren answered that yes, she had seen the piece of silver money in October or November, and that Karen had said she had gotten the money from boarders at Appledore, and that it was kept in her purse. Mr. Tapley then asked her if she knew if Karen kept anything else in that purse or if Maren had seen Karen on the day of the murders put something in the purse.

"Yes," Maren answered.

"What was it?"

"A button, white button-like."

"Have you any articles of clothing, with similar buttons upon?"

"Yes, have got some."

"Where was the button taken from, if you know?"

"From my sewing basket."

"State what was done with the button, how did it come there."

"She took the sewing basket and looked for a button, and took a button there and handed it to Karen."

"Who took it from the basket?"

"Anethe, and handed it to Karen, and Karen put it in her purse."

"Have you any buttons similar to that?"

"Yes, have them with me."

Maren then produced the buttons.

"Where did you get these buttons?" Mr. Yeaton asked.

"Got them in my sewing basket, found one in the basket and two in my box that I have always kept in my sewing basket. I have a nightdress with similar buttons upon it."

Maren produced the nightdress, and the Court said to Mr. Yeaton that it did not see how the buttons and the nightdress were relevant.

"We will connect them hereafter and offer them again," Yeaton answered.

Rich stands at the chart table, a microphone uncoiled and in his hand. Staticky sounds—a man's even, unemotional voice—drone from the radio over the quarter berth,

but I cannot understand what the man is saying. Rich seems to, however, and I watch as he bends closer to the charts, sweeping one away onto the floor altogether and examining another. I am looking for a sweater for Billie.

Rich puts the microphone back into its holder and makes markings on a chart with a ruler and a pencil. "We've got a front coming in faster than they thought," he says with his back to Thomas and me. "They're reporting gusts of up to fifty miles an hour. Thunderstorms and lightning as well." A wave hits the sailboat side-to and floods the deck. Seawater sprays into the cabin through the open companionway. Rich reaches up with one hand and snaps the hatch shut.

"The wind alone could put us up on the rocks," he says. "I'm going to motor in towards Little Harbor, the same as the other boat, but even if we get caught out in the open, we'll be better off than we'd be here. There's not enough swinging room." He turns and looks from Thomas to me and back to Thomas, and seems to be making lists in his mind. He is still in his wet T-shirt and shorts, though this is a different Rich

from the one I saw earlier, organized and in charge. Alarmed, but not panicked.

"Thomas, I need you to put sail ties on the main. Jean, I want you to heat some soup and hot coffee and put it into thermoses, and put dry matches, bread, toilet paper, socks, and so on—you decide—into Ziploc bags. We need to lock down everything in the cabin—drawers, your cameras, the binoculars, anything in the galley that could shift. There are cargo straps in that drawer over there if you need them. Get Adaline to help you. We want all the hatches tightly closed." Rich turns around to the chart table. "And you'll need these."

He opens the slanted desk top and pulls out a vial of pills, which he tosses to Thomas. "Seasickness pills," he says. "Each of you take one—even you, Thomas—and give a half of one to Billie. It could be a little uncomfortable today. And Thomas, there are diving masks under the cushions in the cockpit. Those are sometimes useful in the rain for visibility. Where *is* Adaline?"

Thomas gestures toward the forward cabin.

"She's sick?"

Thomas nods.

I look at my daughter, struggling with the jacket of the foul-weather gear. I open a drawer to retrieve the plastic bags. Beside the drawer, the stove is swinging. I realize that it is not the stove that is swinging, but rather the sloop itself. Seeing this, I feel, for the first time, an almost instantaneous queasiness. Is seasickness in the mind? I wonder. Or have I simply been too busy to notice it before?

Rich goes to the forward cabin and leaves the door open. Adaline is still lying motionless on the berth; she has thrown her arm across her eyes. I watch Rich peel off his wet clothes. How casual we are being with our nakedness, I think.

Rich dresses quickly in jeans and a sweatshirt. I can hear his voice, murmuring to Adaline, but I cannot hear the precise words. I want to know the precise words. He comes out and pulls on a pair of foul-weather pants and a jacket. He slips his feet back into his wet boat shoes. I can see that he is still thinking about the storm, making mental lists, but when he walks past me to go up on deck, he stops at the bottom of the ladder and looks at me.

It is strange enough that just a half hour

before I was willing—no, trying—to make love with my brother-in-law. But it seems almost impossibly strange with my daughter in the berth and my husband at the sink. I feel an odd dissonance, a vibration, as though my foot had hit a loose board, set something in motion.

Thomas turns just then from the faucet, where he has been pouring water into a paper cup. In one hand, he holds the cup; in the other, a pill. I believe he is about to say to me, "Drink this," when he sees his brother's face, and then before I can pull away, my own.

Thomas's eyes move briefly from Rich's face to mine. Rich glances away, over toward the radio. I can see images forming in Thomas's mind. He still holds the cup of water with his hand. The other hand with the pill floats in front of me.

"What?" he asks then, almost inaudibly, as if he cannot formulate a whole question. I take the pill and the cup of water. I shake my head quickly, back and forth, small motions.

I hand the cup to Thomas. Rich goes immediately up to the cockpit. Billie calls to

me: "Mommy, help me, please. I can't do the snaps."

With the exception of Maren Hontvedt's testimony as an eyewitness to the murders, the prosecution's case was based on circumstantial evidence and a lack of an alibi. It had been a bloody murder, and blood was found on clothing (left in the privy behind his landlady's house) belonging to Louis Wagner. Mrs. Johnson, the landlady in question, identified a shirt as belonging to Wagner by the buttonhole she had once mended. Money had been stolen from the Hontvedt house, and the next morning Wagner had enough money to go to Boston and to buy a suit of clothes. Any man who made the row to Smuttynose and back would have put a lot of wear and tear on a dory; the brand new thole pins in James Burke's dory were worn down. Wagner had talked to John Hontvedt and knew that the women would be alone on Smuttynose. In the weeks prior to the murders, Wagner had said repeatedly that he would have money if he had to murder for it. Wagner could not produce a single witness who had seen him in the city of Portsmouth from seven P.M. on the night of the murders until after seven o'clock the

next morning. His landlady testified that Wagner did not sleep in his room that night.

The chief bit of evidence for the prosecution, however, was the white button that was found in Wagner's pocket when he was arrested. The button, the prosecution claimed, had been stolen, along with several coins, from a pocketbook belonging to Karen Christensen the night of the murders. The button matched those of Mary S. Hontvet's nightdress—the one she produced in court.

I slip Maren Hontvedt's document and its translation into a plastic bag and seal it. Into other plastic bags, I put my film and my cameras, my log, Thomas's notebooks, other books, and the provisions Rich has asked for. Rich and Thomas are above; Billie is beside me. I keep her close, throwing my arm in front of her or behind her like a railroad barrier whenever I feel the boat tip or catch a gust of wind. Rich and Thomas have unfastened the boat from the mooring and have turned on the motor. I can hear the cough and kick of the engine, and then a reassuring hum. We leave the Isles of Shoals and head for open water.

"Mommy, is Adaline coming to live with us?"

Billie and I are folding charts and sliding them into Ziploc bags. My daughter likes running her fingers along the seal, the satisfaction of feeling it snap shut.

I crouch down in front of her and sit back on my heels.

"She's not coming to live with us," I say. It is meant to be an answer, but it sounds like a question.

"Oh," Billie says. She looks down at the floor. I notice that water is sloshing over the teak planking.

"Why do you ask?" I put my finger under her chin and lift it just a fraction. There is a note that isn't entirely parental in my voice, and I think she must hear it. She sticks her tongue out the gap made by her two missing front teeth and stares up at the ceiling.

"I forget," she says.

"*Billie.*"

"Um." She stretches her arms high above her head. Her toes are pointed inward. "Well . . . ," she says, drawing out the words. "I think Daddy said."

"Said what?"

She flaps her arms at her sides. "I don't know, do I?"

Shockingly, tears appear at the lower lids of her eyes.

"Billie, what's the matter?" I pull her to me and hold her close. I can feel the oilskin, the damp curl of her hair, the plumpness of her legs.

"Why is the boat moving around like this?" she asks. "It doesn't feel good."

Louis Wagner's defense consisted primarily of attempts to answer prosecution questions in order to convince the jury of a reasonable doubt. Why were his hands blistered and the knuckles bruised the day after the murders? He had helped a man lay crates on a fish cart. Where had he been all night? He had had a glass of ale, then had baited nine hundred hooks for a fisherman whose name he didn't know and who could not be produced at the trial. After that, he had two more mugs of ale and then began to feel poorly. He was sick to his stomach in the street and fell down near a pump. He went back to the Johnsons' at three o'clock to go to sleep, but went in the back door instead of the front, and did not go up to his bed, but slept in the lounge. Later in the

morning, he decided to have his beard shaved, then heard the train whistle and thought to go to Boston. There he bought a new suit of clothes and went to stay at his old boardinghouse in North Street, a place he had lived at several times before. How did he happen to have blood on articles of clothing that he had on the night of the murders? It was fish blood, he said, and also he had stabbed himself with a fish-net needle several days earlier. How did he come by the money to go to Boston and to buy a suit of clothes? He had earned twelve dollars earlier in the week baiting trawls for a fisherman, whose name he did not remember, and the night of the murders had earned a further dollar.

Wagner took the stand in his own defense. Mr. Tapley, counsel for the defense, asked Louis Wagner what had happened to him when he was arrested in Boston.

"When I was standing in the door of the boarding master where I boarded five years," Wagner answered, "he came along, shook hands with me and said, halloo, where did you come from. Before I had time to answer him, policeman stepped along to the door. He dropped me by the arm. I ask

them what they want. They answered me they want me. I asked him what for. I told him to let me go up-stairs and put my boots on. They answered me the slippers are good enough. They then dragged me along the streets and asked me how long I had been in Boston. I was so scared I understand they asked me how long I had been in Boston altogether. I answered him five days, making a mistake to say five years."

"Did you intend to say five years?"

"Yes, sir. Then they asked me if I could read the English newspapers. I told them no. Well, he says, if you could you would have seen what was in it. You would have been in New York at this time."

"Would what?"

"I would have been in New York at this time if I knowed what was in the newspapers. I asked him what was in the newspapers. He asked me if I was not on the Isle of Shoals and killed two women; I answered him that I had not done such a thing. He brought me into station-house, Number One. I found there a man named Johnson, city marshal at Portsmouth."

Mr. Tapley then asked him what hap-

pened to him when he was brought to the station house.

Wagner said that City Marshall Johnson had asked him the whereabouts of the tall hat he was supposed to have worn the night before on the Isles of Shoals.

Wagner continued. "I told him I had not been on the Isle of Shoals; had not wore no tall hat in my life. He says the woman on the Isle of Shoals has seen you with a tall hat that night. I asked him what woman. He told me Mrs. Hontvet. He told me that he had the whiskers, that was shaved off my face, in his pocket, that it was shaved off in Portsmouth by such a barber. I told him to show me them whiskers. He told me that he had found the baker where I had been that night and bought bread; that I told the baker that I was going to the Isle of Shoals that night. I asked him to put me before the baker, or put the baker before me that said so. He answered that I soon would see him. When the new clothes was taken from my body I was taken into another room. The city marshal Johnson stripped me bare naked; asked me where I changed them underclothes. I told him that I had them underclothes on my body nearly eight days. He

says you changed them this morning when you went to Boston; he says there was no gentleman in the city of Boston could wear underclothes for eight days so clean as them was. I told him I was poor, but I was a gentleman and I could wear clean under-clothes just as well as any gentleman in the city of Boston. After my underclothes was overhauled they was put on me and I was brought into the cell; stayed in the cell until the next morning; when I was taken out again from two policemen, and dragged along the street."

"Do you mean from two men?"

"They took me along the street; walked me along the street."

"What do you mean by dragged?"

"They dragged me on my hands; took me into some kind of a house; don't know what it was. I was put on a seat; was kept about ten minutes; all the people had to look at me; was taken then away out of that house where they took my picture; and was brought again to station-house."

"After that, what took place?"

"After that I was closed up again. After a spell I was taken out and brought to the de-pot. When they took me down to the depot,

I asked them where they were going to put me to. They answered me, they were sending me back to Portsmouth, asked me if I did not like to go there. I told them yes."

"Who asked you that?"

"The policeman who took me down there."

"Do you know his name?"

"Yes, one that was here."

"Go on."

"Well, I was brought to Portsmouth. I came to Portsmouth, the street was crowded with peoples, and was hallooing, 'Kill him, kill him.' I was put into station-house. I was closed in about three-quarters of an hour when Mr. Hontvet came there. . . . Mr. Hontvet came to side door and said, Oh! damn you murderer. I said, Johnny, you are mistaken. He says, damn you, you kill my wife's sister and her brother's wife. I told John, I hope you will find the right man who done it. He says, I got him. He says, hanging is too good for you, and hell is too good for you. He says I ought to be cut to pieces and put on to fish-hooks. I told him, that the net that he had spread out for me to drop in he might drop in himself. He says, where is that tall hat that you had on that night when

you was on the Shoals. I told him I had no tall hat. He says, what have you been doing with the fish that you bought last night from the schooner, or was going to buy. I told him that I had not bought any fish, and was not out of Portsmouth that night. He told me that the dory was seen that night, between twelve and two o'clock, going on board a vessel that was lying at anchor on Smutty Nose Island."

"What do you mean by dory?"

"Dory pulled on board that schooner and asked that skipper if he had any fish to sell."

"Did he say where the schooner was?"

"Yes, he said that she was lying at anchor on Smutty Nose Island. He said that this dory was seen crossing over to the westward of the island and had hailed another vessel there. I then told him, Johnny, better look after that man that has been pulling that night in the dory. Then he and his brother-in-law answered me, that I was the man. His brother-in-law told Mr. Hontvet to ask me if I could not get the money without killing the vimen."

"Who do you mean by brother-in-law?"

"Evan Christensen. I told him that I never tried to steal money, but if I was a thief I

thought I could get money without killing people. He says, you stole thirteen dollars. He says, you took ten-dollar bill out of that pocket-book."

"Who said that?"

"Mr. Hontvet. His brother, Mattheas Hontvet, showed me another pocket-book and said I stole out five dollars out of that. I told him that he was mistaken. They then left me, and some more people was coming to see me."

Blood evidence was introduced into the trial. Horace Chase, a physician who resided at 22 Newbury Street in Boston, testified that he had made a study of the analysis of blood and had examined the blood found on Louis Wagner's clothing. Dr. Chase explained that the red corpuscles of fish blood differ in shape from those of human or mammalian blood. Moreover, he said, it was possible to distinguish human blood from horse blood because of the size of the blood corpuscles. "The average blood corpuscle of man measures 1-3200 of an inch; that is, 3200 laid down in a line would cover one side of a square inch; it would take about 4600 of the corpuscles of a

horse; the difference is quite perceptible," he said.

Various articles of clothing had been taken to Dr. Chase in Boston for blood analysis by Mr. Yeaton of the prosecution— overalls, a jacket, and a shirt. Dr. Chase testified that he found human blood on the overalls, human blood on the shirt, and simply mammalian blood on the jacket. During cross-examination, Dr. Chase said that he had not made more than "two or three" blood analysis examinations in criminal cases.

The defense introduced its own blood expert. James F. Babcock, a professor of chemistry at the Massachusetts College of Pharmacy in Boston, testified that it was not possible to distinguish with absolute certainty human blood from other mammalian blood, and that it was not possible to say, after blood had dried on an article of clothing, how old the stain was or whether it had appeared before or after another stain. Nor were there any tests available to determine whether the blood was male or female. Mr. Babcock said that he had examined blood stains in "several" capital cases.

The defense then called Asa Bourne, a

fisherman, who testified that he and his sons had been out fishing on the night of the murders, and that the wind was so strong they could not make any headway against it. In his opinion, said Bourne, Wagner could not have rowed to the islands and back.

Dr. John D. Parsons, the physician who had examined the body of Anethe at the undertaker's room at Gerrish & Adams, was recalled to the stand by the defense. He was asked whether or not it was reasonable to suppose that the wounds upon Anethe, from their appearance, were made by a person not very muscular. He replied, "I think the flesh wounds might have been made by a person of not great muscular force."

Finally, the defense made an attempt to dismiss the entire case. In the state of Maine, at that time, a person could not be convicted of murder in the first degree of another person if the victim was not accurately named and that name not accurately spelled in the indictment. When Evan Christensen first testified, he said, "Anethe Christensen was my wife." The indictment, however, reports the victim as Anethe M. Christenson, with the slightly different spelling and the

middle initial. Evan was recalled to the stand, whereupon Tapley questioned him.

"What time of day did you say that you went down to that house where your wife was dead?"

No response.

"What time was it?"

No response.

"Do you understand me?"

No response.

"What time of the clock was it, after you heard of your wife's death, that you went to the house the first time, the first morning after the murder?"

No response.

"Did you go inside?"

"Yes, sir."

"Did you go around in the different rooms?"

"I went into other rooms."

"Didn't you find a good deal of blood in those rooms?"

"Yes, sir."

"On the floor?"

"Yes, sir."

"Were you asked, since you were here day before yesterday, what your wife's name was?"

No response.

"Did anybody ask you before you came in this morning what your wife's name was? Didn't somebody ask you?"

No response.

"When did anybody say anything to you about your wife's name since day before yesterday, do you understand?"

No response.

"Are you a Norwegian?"

No response.

"You do not understand, do you?"

"No, sir."

"Did you speak with any one about your wife?"

No response.

"Did you tell anybody your wife's name, before you came here this morning?"

No response.

"What is Karen's full name?"

"Karen Alma Christensen."

"Was your wife's name Matea Annette?"

"Anetha Matea Christensen."

"Was she not sometimes called Matea Annette?"

No response.

"Do you understand my question?"

No response.

"When were you married?"

No response.

"When did you marry your wife?"

No response.

Tapley finally gave up this odd appeal, and the court declared that Anethe M. Christenson, as written, was the victim in the case.

Billie is doubled over at the waist, as if she will be sick. She coughs several times. Her skin has gone a shadowy white, and there is perspiration on her forehead. She cries. She does not understand what is happening to her. "Mom," she says. "Mom."

The boat catches a gust, and it feels as though we have been hit by a train. We heel over, and I bang my head hard on the chart table. I hear the crash of dishes in the cabinets. A thermos on the counter slides the length of the Formica counter and topples onto its plastic cap. I kneel on the teak planking and hold Billie as best I can. I fight a sense of panic.

"Rich," I call up the ladder. I wait for an answer. I call again. "There's water on the floor," I shout.

It is hard to hear his response. Before the storm, the sounds from the water were

soothing. The gentle slap of waves upon the hull. But now there is a kind of churning roar that is not just the engine. It is as though the ocean has become more difficult to slice through, as though the sea were causing resistance. Above this noise, I hear Rich call to Thomas, but I cannot make out the words.

Thomas slides down the ladder. He is soaked despite his slicker. He seems not to have the metal clasps fastened correctly. He sees me with Billie, with Billie bent over and crying. "What's wrong?" he asks.

"I think she's seasick."

He squats down beside us.

"She's frightened," I say. "She doesn't understand."

"Did you give her the half pill?"

"Yes. But it was probably too late."

Thomas reaches for a dishtowel and uses it to wipe Billie's forehead. Then he blots his own face. He is breathing hard, and there is an angry swelling to one side of his cheekbone.

"What happened?" I ask, pointing to the bump.

"It's rough out there," he says. He flips off the hood of the slicker, wipes the top of his head. His hair is mussed in an odd kind of

sculpture that would make Billie laugh if she felt better.

He puts his hand down to the teak planking to balance himself. He is still breathing hard. Trying to catch his breath. Our faces aren't a foot apart. I think, looking at him, He's frightened, too.

Thomas yells up the companionway. "There's water over the teak, Rich. I can't tell how much."

We can hear Rich's voice, but again I cannot make out the words. Thomas stands up and leans against the ladder. "OK," he says in answer to something Rich has asked.

I watch Thomas take a tool from a galley drawer and then remove a cushion from the dinette. In the bulkhead is a socket. Thomas puts the metal tool into the socket and begins to ratchet it back and forth. He is awkwardly bent on the bench, and the table is in his way. I have hardly ever seen Thomas perform manual labor before.

"It's the bilge," Thomas says to me. "Rich says the electric is gone."

Thomas works intensely, silently, as if he wishes to exhaust himself.

I hear another sound then, or rather it is the cessation of sound.

"Shit," I hear Rich say loudly.

He comes down the ladder. He lifts a diving mask off his face, and I can see the crazy 8 the rubber has made. The skin around the 8 looks red and raw. "We've lost the engine," he says quickly. He looks at Billie. "What's wrong?" he asks.

"She's seasick," I say.

He sighs heavily and rubs his left eye with his finger. "Can you take the wheel for a minute?" he asks me. "I have to go into the engine compartment."

I look at Billie, who is lost in the isolation of her misery. She has her hands neatly folded at her stomach. "I could put her in with Adaline," I say. I know that Rich would not ask for help unless he really needed it.

"Get her settled," he says, "and come on up, and I'll show you what to do. The sooner the better."

I take Billie to the forward cabin and open the door. The berths make an upside-down V that joins in the middle, so that they form a partial double bed. Below this arrangement, there are large drawers, and to the end of each leg of the V, a hanging locker. Adaline is lying on her side in the berth to my left. She has a hand to her forehead.

She glances up as I enter and raises her head an inch.

I hold Billie on my hip. I do not want to give my daughter up. I do not want her to be with Adaline. Billie retches again.

"She hasn't thrown up yet," I say, "but she feels awful. Rich needs me to take the wheel for a minute. Thomas is right here if you need him."

"I'm sorry, Jean," she says.

I turn to Billie. "I have to help Uncle Rich for a minute," I say. "Adaline is going to take care of you. You're going to be all right." Billie has stopped crying, as if she were too sick to expend even the effort to weep.

"Seasickness is awful," I say to Adaline. "Rich and Thomas pride themselves on never getting sick. It's supposed to be in the genes. I guess Billie didn't get them."

"It's one of the first things he told me about himself when I met him," says Adaline.

"Rich," I say, wiping the sweat off Billie's brow.

"No, Thomas."

I feel it then. A billowing in of the available air.

"When did you meet Thomas?" I ask as casually as I can.

There are moments in your life when you know that the sentence that will come next will change your life forever, although you realize, even as you are anticipating this sentence, that your life has already changed. Changed some time ago, and you simply didn't know it.

I can see a momentary confusion in Adaline's face.

"Five months ago?" she says, trying for an offhand manner. "Actually, it was Thomas who introduced me to Rich."

A shout makes its way from the cockpit to the forward cabin.

"Jean!" Rich yells. "I need you!"

"Put Billie down here with me," Adaline says quickly. "She'll be fine."

I think about Thomas's suggestion that we use Rich's boat.

I set Billie beside Adaline, between Adaline and the bulkhead, and as I do, the boat slides again. Billie whacks her head against the wall. "Ow," she says.

I am thinking I just want it to be all over.

I could not have anticipated what it is like above deck, how sheltered we have been

below. I did not know that a storm could be so dark, that water could appear to be so black.

There is almost no visibility. Rich takes my arm and turns me around to face the stern and yells into the side of my hood. "This is simple," he shouts. "Keep the seas behind you just like they are now. Whatever you have to do. I'm running with a piece of sail, but don't bother about that right now. The main thing is that we don't want the boat to put its side to the waves. OK?"

"Rich, when did you meet Adaline?"

"What?" He leans closer to me to hear.

"When did you meet Adaline?" I shout.

He shakes his head.

I turn away from him. "How high are those waves?" I ask, pointing.

"High," he says. "You don't want to know. OK, now, take the wheel."

I turn and put my hands on wooden spokes at ten and two o'clock. Immediately the wheel spins out of my control, flapping against the palms of my hands.

"You have to hang on, Jean."

"I can't do this," I say.

"Yes, you can."

I take hold of the wheel again and brace

my legs against the cockpit floor. The rain bites my cheeks and eyelids.

"Here, put this on," he says.

He bends toward me with a diving mask, and in the small shelter of our hoods I realize we do not have to shout. "Rich, where did you meet Adaline?" I ask.

He looks confused. "The Poets and Prose dinner," he says. "I thought you knew that. Thomas was there. You couldn't go."

"I couldn't get a babysitter. Why was Adaline there?"

"Bank of Boston was a sponsor. She went as a representative."

Rich slips my hood from my hair, and I think it must be that gesture, the odd tenderness of that gesture, or perhaps it is the fitting of the mask, as you might do for a child, but he bends and kisses my wet mouth. Once, quickly. There is a sudden hard ache inside me.

He lowers the mask onto my face. When I have adjusted it and opened my eyes, he already has his back to me and is headed for the cabin.

I think it will be impossible to do as Rich has asked. I cannot control the wheel without using both hands, so I have to steer with

my neck craned to see behind the stern. The boat falls into a trough, and I think the wall of water will spill upon me and swamp the boat. The swell crests at the top, then pushes the boat along with a forward zip. The boat zigzags in my inexpert hands. Several times, I mistake the direction I should turn the wheel, and overcorrect. I do not see how I will be able to keep the waves behind me. My hands become stiff with the wet and cold. The wheel shakes, and I put all my weight into my hands to keep it from spinning away from me. Less than an hour earlier I was on the beach at Smuttynose.

A wave breaks over the railing to my left. The water sloshes into the cockpit, rises to my ankles, and quickly drains away. The water is a shock on the ankles, like ice. The boat, I see, is turning into the swells. I fight the wheel, and then, oddly, there is no resistance at all, just a spinning as if in air. To my right, lightning rises from the water. Then we are lost again in a trough, and I am once more struggling with the steering apparatus. Rich has been gone only a minute, two minutes. There is another lightning skewer, closer this time, and I begin to have a new worry.

The jib snaps hard near the bow. It collapses and snaps again. I turn the wheel so as to head into the wind. The jib grows taut and steadies.

Adaline emerges from the forward hatch.

I rub the surface of the diving mask with my sleeve. The wheel gives, and I take hold of it again. I am not sure what I am seeing. There is the smoky blur of the Plexiglas hatch rising. I take the diving mask off and feel for my glasses in the pocket of my oilskin. There is a half inch of water in the pocket. I put the glasses on, and it is as though I am looking through a prism. Objects bend and waver.

Adaline sits on the rim of the hatch and lifts her face to the sky, as if she were in a shower. The rain darkens and flattens her hair almost at once. She slips out of the hatch entirely and closes it. She slides off the cabin roof and onto the deck. She holds herself upright with a hand on a metal stay. She comes to the rail and peers out. I yell to her.

She has on a white blouse and a long dark skirt that soaks through immediately. I cannot see her face, but I can see the out-

line of her breasts and legs. I yell again. She doesn't have a life vest on.

I shout down to Rich, but he doesn't hear me. Even Thomas cannot hear with all the roar.

What is she doing out there? Is she crazy?

I feel then an anger, a sudden and irrational fury, for her carelessness, this drama. I do not want this woman to have entered our lives, to have touched Thomas or Billie, to have drawn them to her, to have distracted them. I do not want this woman to be up on deck. And most of all, I do not want to have to go to her. Instead, I want to shake her for her foolishness, for the theatrical way she carries herself, for her gold cross.

I let the wheel go, bend forward at the waist, and clutch at a stay. The wind flattens the oilskin against my body. I reach for a winch, the handholds in the teak railing. I pull myself forward. She is perhaps fifteen feet from me. My hood snaps off my head.

Adaline leans over the teak rail. Her hair falls in sheets, then blows upward from her head. I see then that she is sick.

I am three, four feet from where she is huddled at the railing. I shout her name.

The boat turns itself into the swells and heels. Adaline straightens and looks at me, an expression of surprise on her face. The jib swings hard, and makes a sharp report, like a shot. She holds out her hand. It seems to float in the air, suspended between the two of us.

I have since thought a great deal about one time when I shut a car door, gave it a push, and in the split second before it closed, I saw that Billie's fingers were in the door, and it seemed to me in the bubble of time that it took for the door to complete its swing that I might have stopped the momentum, and that I had a chance, a choice.

In Alfred, Maine, the jury took less than an hour to reach a verdict of murder in the first degree. Wagner was sentenced to be hanged. He was then taken to the state prison at Thomaston to await execution.

The hanging at Thomaston was a particularly grisly affair and is said to have almost single-handedly brought about the abolition of the death penalty in Maine. An hour before Wagner and another murderer, a man named True Gordon, who had killed three members of his brother's family with an ax, were to be hanged, Gordon attempted sui-

cide by cutting his femoral artery and then stabbing himself in the chest with a shoemaker's knife. Gordon was bleeding out and unconscious, and the warden of Thomaston was presented with a ghastly decision: Should they hang a man who was going to die anyway before the afternoon was out? The warrant prevailed, and Wagner and Gordon were brought to an abandoned lime quarry, where the gallows had been set up. Gordon had to be held upright for the noose to be put on. Wagner stood on his own and protested his innocence. He proclaimed, "God is good. He cannot let an innocent man suffer."

At noon on June 25, 1873, Louis Wagner and True Gordon were hanged.

Adaline goes over like a young girl who has been surprised from behind by a bullying boy and pushed from the diving board, arms and legs beginning to flail before she hits the water.

The ocean closes neatly over her head. I try to keep my eye fixed on the place where she has gone in, but the surface of the water—its landscape, its geography—twitches and shifts so that what has been there before is not there a moment later.

The sea heaves and spills itself and sends the boat side-to sliding down a trough. Water cascades onto the deck, pinning my legs against the railing. Adaline breaks the surface twenty yards from the place I expected her to be. I shout her name. I can see that she is struggling. Rich comes above to see what has happened to the boat. He takes the wheel immediately.

"Jean!" he shouts. "Get away from the railing. What's going on?"

"Adaline's overboard," I shout back, but the wind is against me, and all he can make out is my lips moving soundlessly.

"What?"

"Adaline!" I yell as loudly as I can and point.

Thomas comes above just then. He has put on a black knit cap, but his oilskins are off. Rich shouts the word *Adaline* to Thomas and gestures toward the life ring. Thomas takes hold of the life ring and pulls himself toward me.

There are thundering voices then, the spooling out of a line, a life ring missed and bobbing in a trough. There is a flash of white, like a handkerchief flung upon the water. There are frantic and sharp commands,

and Thomas then goes over. Rich, at the wheel, stands in a semi-crouch, like a wrestler, from the strain of trying to keep the boat upright.

I think then: If I had put out my hand, might Adaline have grabbed it? Did I put out my hand, I wonder, or did a split second of anger, of righteousness, keep my hand at my side?

I also think about this: If I hadn't shouted to Adaline just then, she would not have stood up, and the sail would have passed over her.

When Rich hauls Adaline over the stern, her skirt and underwear are missing. What he brings up doesn't seem like a person we have known, but rather a body we might study. Rich bends over Adaline and hammers at her chest, and then puts his mouth to hers again and again. In the corner of the stern, against the railing, Thomas stands doubled over from the effort to rescue Adaline and to pull himself back into the boat. He wheezes and coughs for breath.

And it isn't me, it isn't even me, it is Rich—angry, frustrated, exhausted, breathless—who lifts his head from Adaline's chest, and calls out: "Where's Billie?"

25 September 1899

I now encounter my most difficult task of all, which is that of confronting the events of 5 March 1873, and committing them to paper, to this document, to stand as a true account made by a witness, one who was there, who saw, and who survived to tell the tale. Sometimes I cry to myself, here in the silence of my cottage, with only the candles to light my hand and the ink and the paper, that I cannot write about that day, I cannot. It is not that I do not remember the details of the events, for I do, too vividly, the colors sharp and garish, the sounds heightened and abrasive, as in a dream, a terrible dream that one has over and over again and cannot escape no matter how old one grows or how many years pass.

It was a day of blue sky and bright sun and harsh reflections from the snow and sea

and ice crystals on the rocks that hurt the eye whenever one's gaze passed across the window panes or when I went outside to the well or to the hen house. It was a day of dry, unpleasant winds that whipped the hair into the face and made the skin feel like paper. The men had left the house early in the morning to draw their trawls, which they had set the day before, and John had said to me as he was leaving that they would be back midday to collect Karen and to have a meal before they set out for Portsmouth to sell the catch and purchase bait. I had some errands I wished him to perform, and I spoke to him about these, and it is possible I may have handed him a list on that day, I do not remember. Evan stumbled down the stairs, unshaven, his hair mussed, and grabbed a roll on the table for his breakfast. I urged him to stay a moment and have some coffee, as it would be raw and frigid in the boat, but he waved me off and collected his jacket and his oilskins from the entryway. Matthew was already down at the boat, making it ready, as he did nearly every morning. Indeed, I hardly ever saw Matthew, as he seemed to be on a clock different from the rest of us,

rising at least an hour before me, and retiring to his bed as soon as it was dark. Karen, I remember, was in the lounge that morning, and she said to John that she would be dressed and ready to go with him after the dinner meal, and John nodded to her, and I could barely look at her, since she had had all her teeth removed, and her face had a terrible sunken appearance, as one sometimes sees on the dead. Karen, who had been with us since the end of January, had been fired from her job with the Laightons when she had said one day that she would not sweep out or make the beds in a certain room belonging to four male boarders. I suspect that Eliza Laighton had been wanting to let Karen go for some time, since Karen could now speak a rudimentary English and therefore could make her complaints and opinions known, as she had not been able to do when she first arrived. As you may imagine, I was somewhat ambivalent about Karen's presence. Since Evan's arrival, we had not been overly cordial with one another, and, in addition, there were many of us under that roof, under that half-roof I should say, since we all lived in the south-

west apartment, so as to be nearer to the heat source during the long winter.

Indeed, I can barely write about that dreadful winter when we were all closed in together for so many weeks in January and February. In the kitchen most hours of the day, there would be myself and John, Evan and Anethe, Matthew of course, and then Karen, and for days on end we would not be able to leave the house or to bathe properly so that there was a constant stale and foul odor in that room, a smell composed of shut-in human beings as well as the stink of fish that was on the oilskins and in the very floor-boards themselves, and that no matter how hard I scrubbed with the brush was never able entirely to remove. Even Anethe, I noticed in the last weeks of February, had begun to lose her freshness, and I did observe that her hair, unwashed for so many days, took on a darker and more oily appearance and that her color, too, seemed to have faded in the winter.

It was a severe trial to keep one's temper in that fetid atmosphere. Only Evan seemed to have any enthusiasm for his lot, being content simply to remain in Anethe's pres-

ence, though I did notice signs of strain in Anethe herself, and if ever a marriage was put to the test, it was on that island, during those winters, when small tics or habits could become nearly unbearable, and the worst in a person was almost certain to emerge. John used the hours to mend nets and repair trawls, and Matthew was his partner in this work. Matthew would often hum or sing tunes from Norway, and I do remember this as a pleasant diversion. Evan had taken on the building of a wardrobe for Anethe as a project, so that the room was filled not only with nets and hooks into which one had to be careful not to become entangled, but also with wood shavings and sawdust and nails and various sharp implements with which Evan worked. I took refuge in routine, and I will say here that more than once in my life the repetition of chores has been my salvation. Of the six of us, I was the one who went outdoors the most often, to collect wood or water or eggs from the coop. It was understood that I would keep the house in order, and I have observed that while fishermen do take seasonal rests from their labors, their womenfolk do not, and do not

even when the men are too weak from old age to draw a trawl and must retire from their labors. An aging wife can never retire from her work, for if she did, how would the family, or what was left of it, eat?

Karen, during this time, attended to her sewing and her spinning, and I was just as happy not to have her in my way or in constant attendance. In the beginning of Karen's stay, Anethe set out to please this sister of Evan's, rolling the wool that Karen had spun, feigning enthusiasm for the skill of embroidery and offering to braid Karen's hair, but it was not long before I noticed that even Anethe, who previously seemed to have nearly inexhaustible reserves of selflessness, began to tire of Karen's constant querulous whine and started to see as well that pleasing Karen was in itself a futile endeavor. There are some people who simply will not be pleased. After a time, I noticed that Anethe asked me more and more often for chores of her own to perform. I had more than a few to spare, and I took pity upon her, as enforced idleness in such a claustrophobic setting will almost certainly begin to erode joy, if not one's character altogether.

As for me, I had not thought about joy much, and sometimes I felt my character, if not my very soul, to be in jeopardy. I had not prayed since the day that Evan spoke harshly to me in the kitchen, as I no longer had anything compelling to pray for. Not his arrival, not his love, not even his kindness or presence. For though he was in that room all the days, though we were seldom more than a few feet from each other, it was as though we were on separate continents, for he would not acknowledge me or speak to me unless it was absolutely necessary, and even at those times, I wished that he had not had need to speak to me at all, for the indifference of his tone chilled my blood and made me colder than I had been before. It was a tone utterly devoid of warmth or for-giveness, a tone that seeks to keep another being at bay, at a distance. Once, in our bed at night, John asked me why it was that Evan and I seemed not to enjoy each other's company as much as we used to, and I an-swered him that there was nothing in it, only that Evan was preoccupied and blind to everyone except Anethe.

Since the first day of March, the men had

been going out to sea again, and there was something of a sense of relief in this, not only because we had all survived the gruelling weeks of the hard winter, but also because now there would be some breathing room. The men, in particular, were cheered by occupation, and I suppose I was a bit more relaxed not to have so many underfoot. My work did not seem to lighten much, however, since there were the same number of meals to prepare and increased washing now that the men would come back fouled with fish goory in the afternoons.

On the morning of 5 March, I remember that Karen painstakingly dressed in her city clothes, a silver-gray dress with peacock-blue trim, and a bonnet to match, and that once outfitted in this manner, she sat straight-backed in a chair, her hands folded in her lap, and did not move much for hours. I believe she thought that being in city clothes prevented her from taking up a domestic occupation, even one so benign as sewing. It was extremely annoying to me to observe her that day, so stiff and grim, her mouth folded in upon itself, arrested in a state of anticipation, and I know that at least

once I was unable to prevent my irritation from slipping out, and that I said to her that it was ludicrous to sit there in my kitchen with her hat on, when the men would not return for hours yet, but she did not respond to me and set her mouth all the tighter. Anethe, by contrast, seemed excessively buoyant that morning, and it was as though the two of us, Anethe and myself, were performing some sort of odd dance around a stationary object. Anethe had a gesture of running the backs of her hands upwards along the sides of her neck and face and gracefully bringing them together at the top of her head and then spreading her arms wide, actually quite a lovely, sensuous movement, and she did this several times that day, and I thought it could not just be that she was glad the men were out of the kitchen, for, in truth, I think she was ambivalent about not being with Evan, and so I asked her, more in jest really, what secret it was that was making her so happy on that day, and she stunned me by replying, "Oh, Maren, I had not thought to tell anyone. I have not even told my husband."

Of course, I knew right away what she

meant, and it hit me with so much force that I sat down that instant as though I had been pushed.

Anethe put her hand to her mouth. "Maren, you look shocked. I should not have said—"

I waved my hand. "No, no . . ."

"Oh, Maren, are you not pleased?"

"How can you be sure?" I asked.

"I am late two months. January and February."

"Perhaps it is the cold," I said. It was an absurd thing to say. I could not collect my thoughts and felt dizzy.

"Do you think I should tell him tonight? Oh, Maren, I am amazed at myself that I have kept it from him all this time. Indeed, it is surprising that he himself did not notice, although I think that men—"

"No, do not tell him," I said. "It is too soon. It is bad luck to speak of this so early on. There are so many women who lose their babies before three months. No, no, I am quite sure. We will keep this to ourselves for now." And then I collected myself a bit. "But, my dear, I am happy for you. Our little family will grow bigger now, as it should do."

And then Karen said from the table, "Where will you keep it?" and Anethe, I think somewhat taken aback by the use of the word *it* rather than *the child,* composed herself and looked steadily at her sister-in-law. "I will keep our baby with myself and Evan in our bedroom," she said.

And Karen did not say anything more at that time.

"It is why you have been looking pale," I said, suddenly comprehending the truth of what Anethe was saying. As I looked at her, I had no doubt now that she was pregnant.

"I have felt a bit faint from time to time," she said, "and sometimes there is a bad taste in the back of my mouth, a metallic taste, as if I had sucked on a nail."

"I cannot say," I said, standing up and spreading my hands along my apron skirt. "I have never had the experience."

And Anethe, silenced by the implications of that statement, picked up the broom by the table and began to sweep the floor.

The coroner missed this fact about Anethe in his examination of her body, and I did not like to tell Evan, as I thought it would make his agony all the more unendurable.

About two o'clock of that afternoon, I heard a loud hallooing from the water and looked through the window and saw Emil Ingerbretson waving to me from his schooner just off the cove, and so I ran outside quickly, thinking that perhaps there had been an accident, and I managed to make out, though the wind kept carrying off the words, that John had decided to go straight in to Portsmouth, as he could not beat against the wind. When I had got the message, I waved back to Emil, and he went off in his boat. Once inside, I told the other two women, and Anethe looked immediately disappointed, and I saw that she had meant to tell Evan that day of her news, despite my admonition not to. Karen was quite vexed, and said so, and asked now what would she do all dressed up with her city clothes on, and I replied that I had been asking myself that question all morning. She sighed dramatically, and went to a chair against the wall in the kitchen and lay back upon it.

"They will be back tonight," I said to Anethe. "Let's have a portion of the stew now, as I am hungry, and you must eat regular meals, and we will save the larger share for

the men when they return. I have packed them no food, so unless they feed them-selves in Portsmouth, they will be starved when they return."

I asked Karen if she would take some din-ner with us, and she then asked me how she would eat a stew with no teeth, and I replied, with some exasperation, as we had had this exchange nearly every day since she had had her teeth removed, that she could sip the broth and gum the bread, and she said in a tired voice that she would eat later and turned her head to the side. I looked up to see that Anethe was gazing at me with a not unkind expression, and I trust that she was nearly as weary of my sister's complaints as I was.

We ate our meal, and I found some rubber boots in the entryway and put them on and went to the well and saw that the water had frozen over and so I went into the hen house to look for the axe, and found it lying by a barrel, and brought it to the well and heaved it up with all my strength and broke the ice with one great crack. I had been used to this chore, since the water often froze over on that island, even when the temperature of

the air was not at freezing level, and this was due to the wind. I fetched up three buckets of water and took them one by one into the house and poured them into pans, and when I was done I brought the axe up to the house and laid it by the front door, so that in the morning, I would not have to go to the hen house to get it.

Dusk came early, as it was still not the equinox, and when it was thoroughly dark, and I noticed, as one will notice not the continuous sound of voices in the room but rather the cessation of those voices, that the wind had quieted, I turned to Anethe and said, "So that is that. The men will not be back this night."

She had a puzzled look on her face. "How can you be sure?" she asked.

"The wind has died," I said. "Unless they are right at the entrance to the harbor, their sails will not fill, and if they have not yet left Portsmouth, John will not go out at all."

"But we have never been alone at night before," Anethe said.

"Let us wait another half hour before we are sure," I said.

The moon was in its ascendancy, which had a lovely effect on the harbor and on the

snow, outlining in a beautifully stark manner
the Haley House and the Mid-Ocean Hotel,
both vacant at that time. I went about the
lounge lighting candles and the oil lamp.
When a half hour had elapsed, I said to Ane-
the, "What harm can possibly come to us on
this island? Who on these neighboring is-
lands would want to hurt us? And anyway,
it is not so bad that the men have not come.
Without them, our chores will be lighter."

Anethe went to the window to listen for the
sound of oars. Karen got up from her chair
and walked to the stove and began to spoon
broth and soft potatoes into a bowl. I took
off my kerchief and stretched my arms.

Anethe wondered aloud where the men
would stop to eat. Karen said she thought it
likely they would go to a hotel and have a
night for themselves. I disagreed and said I
thought they would go to Ira Thaxter's on
Broad Street, for they would have to beg a
meal from a friend, until they sold the catch,
the proceeds of which were to have gone
for provisions. Karen pointed out to me that
Ringe hadn't been fed yet, and I rose from
the table and put some stew into his dish.
All in all, I was quite amazed that Karen had
not muttered something about the men

having failed to take her into Portsmouth, but I imagine that even Karen could tire of her own complaints.

While Anethe washed the pots and dishes, nearly scalding her hand from the kettle water, Karen and I struggled with a mattress that we dragged downstairs to lay in the kitchen for her. Anethe asked if she could sleep in my bed to keep from being cold and lonely without Evan that night, and though I was slightly discomfited by the thought of a woman in my bed, and Anethe at that, I did reason that her body would provide some warmth, as John's did, and besides, I did not like to refuse such a personal request. After stoking up the fire for warmth, I believe that the three of us then took off our outer garments and put on our night-dresses, even Karen, who had thought to stay in her city clothes so that she would not have to dress again in the morning, but in the end was persuaded to remove them so as not to muss them unduly. And then, just as I was about to extinguish the lights, Karen took out from the cupboard bread and milk and soft cheese, and said that she was still hungry, and I will not weary the reader with the silly quarrel that ensued, although I

had reason to be annoyed with her as we had just cleaned up the kitchen, and finally I said to Karen that if she would eat at this time, she could tidy up after herself and would she please extinguish the light.

Sometimes it is as though I have been transported in my entirety back to that night, for I can feel, as if I were again lying in that bed, the soft forgiveness of the feather mattress and the heavy weight of the many quilts under which Anethe and I lay. It was always startling, as the room grew colder, to experience the contrast in temperatures between one's face, which was exposed to the frigid air, and one's body, which was encased in goose down. We had both been still for some time, and I had seen, through the slit underneath the bedroom door, that the light had been put out, which meant that Karen had finally gone to bed. I was lying flat on my back with my arms at my sides, looking up at the ceiling, which I could make out only dimly in the moonlight. Anethe lay facing me, curled into a comma, holding the covers close up to her chin. I had worn a nightcap, but Anethe had not, and I suppose this was because she had a natural cap in the abundance of her hair. I had thought she

was asleep, but I turned my head quickly
toward her and back again and saw that she
was staring at me, and I felt a sudden stiff-
ening all through me, a response no doubt
to the awkwardness of lying in my bed with
a woman, and this woman my brother's wife.

"Maren," she whispered, "are you still
awake?"

She knew that I was. I whispered, "Yes."

"I feel restless and cannot sleep," she
said, "although all day I have felt as though
I would sleep on my feet."

"You are not yourself," I said.

"I suppose." She shifted in the bed, bring-
ing her face a little closer to my own.

"Do you think the men are all right? You
don't think anything could have happened to
them?"

I had thought once or twice, briefly, not
liking to linger on the thought, that perhaps
John and Evan had met with an accident
on the way to Portsmouth, although that
seemed unlikely to me, and, in any event,
hours had passed since Emil had come with
the message, and if some ill had befallen the
men, I thought that we would have heard
already.

"I believe they are safe in Portsmouth.

Perhaps in a tavern even as we speak," I said. "Not minding at all their fate."

"Oh," she said quickly, "I think my Evan would mind. He would not like to sleep without me."

My Evan.

She reached out a hand from the covers and began to stroke my cheek with her fingers. "Oh, Maren," she said, "you are so watchful over us all."

I did not know what she meant by that. My breath was suddenly tight in my chest from the touch of her fingers. I wanted to throw her hand off and turn my back to her, but I was rigid with embarrassment. I was glad that it was dark, for I knew that I must be highly colored in my face. To be truthful, her touch was tender, as a mother might stroke a child, but I could not appreciate this kindness just then. Anethe began to smooth my forehead, to run her fingers through the hair just underneath my cap.

"Anethe," I whispered, meaning to tell her to stop.

She moved her body closer, and wrapped her hands around my arm, laying her forehead on my shoulder.

"Do you and John?" she asked, in a sort of muffled voice. "Is it the same?"

"Is what the same?" I asked.

"Do you not miss him at this moment? All the attentions?"

"The attentions," I repeated.

She looked up at me. "Sometimes it is so hard for me to sit in the kitchen until it is proper to go up to bed. Do you know?" and she moved herself still closer to me so that her length was all against my own. "Oooh," she said. "Your feet are freezing. Here, let me warm them," and she began, with the smooth sole of her foot, to massage the top of my own. "Do you know," she said again, "I have never told anyone this, and I hope you will not be shocked, but Evan and I were lovers before we were married. Do you think that was very wrong? Were you and John?"

I did not know what to say to her or which question to answer first, as I was distracted by the movement of her foot, which had begun to travel up and down the shin of my right leg.

"I no longer know what is right or wrong anymore," I said.

Her body was a great deal warmer than my own, and this warmth was not unpleas-

ant, though I remained stiff with discomfort, as I had never been physically close with anyone except my brother Evan and my husband. I had certainly never been physically close with a female, and the sensation was an odd one. But, as will happen with a child who is in need of comfort and who gradually relaxes his limbs in the continuous embrace of the mother, I began to be calmed by Anethe, and to experience this peace as pleasurable, and, briefly to allow myself to breathe a bit more regularly. I cannot explain this to the reader. It is, I think, a decision the body makes before the heart or the head, the sort of decision I had known with John, when, without any mental participation, my body had seemed to respond in the proper ways to his advances. In truth, as Anethe laid her head on my chest and began to stroke the skin of my throat, I felt myself wanting to turn ever so slightly toward my brother's wife and to put my arm around her, and perhaps, in this way, return something of the affection and tenderness she was showing to me.

"Do you do it every night?" she asked, and I heard then a kind of schoolgirlish embarrassment in her own voice.

"Yes," I whispered, and I was shocked at my own admission. I wanted to add that it was not my doing, not my doing at all, but she giggled then, now very much like a girl, and said, to my surprise, "Turn over."

I hesitated, but she gently pushed my shoulder, and persisted with this urging, so that finally I did as I was told, putting my back to her, and not understanding what this was for. She lifted herself up onto her elbow and said, close to my ear, "Take up your nightgown."

I could not move.

"I want to rub your back," she explained, "and I cannot do it properly through the cloth." She pushed the covers down and began slightly to tug at the skirt of my nightgown with her hand, and I, though somewhat fearful of the consequences, began to wrestle with the gown and to pull the hem up to my shoulders. I held the bunched cloth to my bosom as I had done once at the doctor's office in Portsmouth when I had had the pleurisy. But shortly I felt the warmth of being attended to, and I surrendered myself to this attention.

Anethe began then to stroke my skin with an exquisite lightness and delicacy, from the

top of my spine to my waist, from one side of my back to the other, all around in the most delightful swirls, so that I was immediately, without any reservations, put into a swoon of such all-encompassing proportions that I could not, in those moments, for any reason, have denied myself this touch. It was a sensation I had not experienced in many years. Indeed, I cannot remember, ever in my adult life, being the recipient of such pleasure, so much so that had she stopped before I had had my fill, I would have begged her to continue, would have promised her anything if only she would again touch my skin with her silken fingers. But she did not stop for some time, and I remember having the thought, during that experience, that she must be a very generous lover, and then realizing, when I was nearly in a dream state myself, that her hand had trailed off and that she had fallen asleep, for she began to snore lightly. And hearing her asleep, and not wishing to wake her, and also not wanting the trance I had fallen into to be broken, I did not move or cover myself, but drifted into a deep sleep while the moon set, for I remember being confused and struggling for sense when I

heard my dog, Ringe, barking through the wall.

What a swimming up is there from the bath of a sensuous dream to the conscious world, from a dream one struggles desperately not to abandon to the frigid shock of a startled voice in the darkness. Ringe barked with loud, sudden yips. I raised my arms up from the bed before I was even fully awake. I thought that Karen was stumbling about in an attempt to go to the privy, and that she had woken Ringe, who normally slept with me. I was about to call out to her with some irritation to be quiet and go back to bed and to send my dog into the bedroom, when I heard her say, in the clearest possible voice, "My God, what have you done?"

It was all so much simpler, so much simpler, than I said.

I sat up in my bed and saw that my sister was standing at the open door of the bedroom and that to my great embarrassment, the bedclothes were still at the foot of the bed, and that most of my naked body was exposed. I hastily pulled the cloth of my nightdress down to my feet.

I can remember the awful surprise in Karen's face, and, even now, the horror of

her mouth folded in upon itself, sputtering words to me in a voice that had become more metallic, more grating with the years, and the way the words issued from that black hole of a mouth.

"First our Evan and now Anethe!" she shouted. "How can you have done this? How can you have done this to such a sweet and innocent woman?"

"No, Karen . . . ," I said.

But my sister, in an instant, had progressed from shock to moral righteousness. "You are shameless and have always been so," she went on in that terrible voice, "and I shall tell our Evan and John also when they return, and you will be banished from this household as I should have done to you many years ago, when I knew from the very beginning you were an unnatural creature."

"Karen, stop," I said. "You don't know what you say."

"Oh, but I do know what I say! You have borne an unnatural love for our brother since your childhood, and he has fought to be free of you, and now that he is married, you have thought to have him by having his wife, and I have caught you out in the most heinous of sins, Maren, the most heinous of sins."

Beside me, Anethe struggled to waken. She lifted herself up upon one elbow and looked from me to Karen. "What is it?" she asked groggily.

Karen shook her head furiously back and forth, back and forth. "I have never loved you, Maren, I have never loved you. I have not even liked you, and that is the truth. And I think it is true also that our Evan has found you selfish and self-dramatic, and that he grew so tired of you he was glad when you went away. And now you are grown old, Maren, old and fat, and I see that your own husband does not really love, nor does he trust you, for you would do anything to get what you want, and now, rebuffed, you have committed the worst possible of sins, a sin of corruption, and have chosen to steal your brother's wife, and seduce her in the most shameful manner."

No one can say with any certainty, unless he has lived through such an experience, how he will react when rage overtakes the body and the mind. The anger is so swift and so piercing, an attack of all the senses, like a sudden bite on the hand, that I am not surprised that grown men may commit acts they forever regret. I sat, in a stiffened pos-

ture on the bed, seconds passing before I could move, listening to the outrageous litany against me which I knew that Anethe was being forced to hear as well, and the beating of my heart against my breastbone became so insistent and so loud that I knew I must silence Karen or surely I would die.

I pushed myself from my bed, and Karen, observing me, and coward that she was and always had been, backed away from me and into the kitchen. At first she put her hand to her mouth, as if she might actually be frightened, but then she took her hand away and began to sneer at me most scornfully.

"Look at you in your silly nightdress," she said, "grown fat and ugly in your middle age. Do you imagine you can scare me?" She turned her back to me, perhaps to further show her scorn by dismissing me. She bent over her trunk and opened it, and took up a great armful of linens. Or perhaps she was looking for something. I have never known.

I put my hands on the back of a chair and gripped that chairback so hard my knuckles whitened.

Karen staggered two or three steps under the blows from the chair and, twisting

around, turned towards me, held out her arms and dropped the linens on the floor. I am not sure if she did this in entreaty or if she meant only to protect herself. A small exclamation escaped me, as I stood there with the chair in my hands.

Karen stumbled into my bedroom and fell upon the floor, weakly scrabbling against the painted wood like a strange and grotesque insect. I think that Anethe may have gotten out of the bed and taken a step backwards toward the wall. If she spoke, I do not remember what she said. The weight of the wood caused the chair to swing from my arms so that it fell upon the bed. I took hold of Karen's feet and began to pull her back into the kitchen, as I did not want this sordid quarrel to sully Anethe. The skirt of Karen's nightgown raised itself up to her waist, and I remember being quite appalled at the white of her scrawny legs.

I write now of a moment in time that cannot be retrieved, that took me to a place from which there was never any hope of return. It all seemed at the time to happen very quickly, somewhere within a white rage in my head. To retell these events is exceedingly painful for me now, and I will doubtless

horrify the reader, but because my desire is to unburden myself and to seek forgiveness before I pass on, I must, I fear, ask the reader's patience just a moment longer.

When Karen was across the threshold, I moved to the door, shut it and put a slat through the latch so that there would be only myself and my sister in the kitchen. I think that Karen may have struggled to stand upright, and then fallen or been thrown against the door, for there was a small shudder against the wood, and it must have been then that Anethe, on the other side of the door, pushed our bed against it. I heard Karen cry out my name.

I would not have harmed Anethe. I would not. But I heard, through the wall, the sound of the window being opened. Anethe would have run to the beach. Anethe would have called for help, alerted someone on Appledore or Star, and that person would have rowed across the harbor and come up to the house and found myself and Karen. And then what would I have done? And where could I go? For Karen, possibly, was dying already.

In truth, the axe was for Karen.

But when I picked up the axe on the front

stoop, I found I was growing increasingly concerned about Anethe. Therefore I did not return just then to the kitchen, but stepped into the entryway and put on the rubber boots, and went outside again and kept moving, around to the side of the house, where the window was. I remember that Ringe was barking loudly at my feet, and I think that Karen was crying. I don't believe that Anethe ever said a word.

She was standing just outside the window, her feet in the snow up to the hem of her nightgown. I was thinking that her feet must be frozen. Her mouth was open, and she was looking at me, and as I say, no sound emerged from her. She held a hand out to me, one hand, as though reaching across a wide divide, as though asking for me, so that I, too, might lay my hand over that great expanse and help her to safety. And as I stood there, gazing upon her fingers, looking at the fearful expression in my brother's wife's face, I remembered the tenderness of her touch of just hours ago, and so I did extend my hand, but I did not reach her. She did not move, and neither then could I.

It is a vision I have long tried to erase, the

axe in the air. Also as well the sight of blood soaking the nightgown and the snow.

On more than one occasion, I have waited for the sunrise. The sky lightens just a shade, promising an easy dawn, but then one waits interminably for the first real shadows, the first real light.

I had to leave the boots back at the house, in keeping with the first and hasty suggestions of a story, and as a consequence, I had cut my feet on the ice. I could no longer feel them, however, as they had gone numb during the night. I held my dog, Ringe, for warmth, and I think that if I had not done so, I would have frozen entirely.

During those awful hours in the sea cave, I wept and cried out and battered my head back against the rock until it bled. I bit my hand and my arm. I huddled in my hiding place and wished that the rising tide might come in to my cave and wash me out to sea. I relived every moment of the horrors that had occurred that night, including the worst moments of all, which were those of cold, calculated thought and of arranging facts to suit the story I must invent. I could not bear the sight of Karen's body, and so I dragged her into the northeast apartment and left her

in the bedroom. And also, just before I fled the house, I found I did not like to think of Anethe in the snow, and so I hauled her inside the cottage.

I have discovered in my life that it is not always for us to know the nature of God, or why He may bring, in one night, pleasure and death and rage and tenderness, all intermingled, so that one can barely distinguish one from the other, and it is all that one can do to hang onto sanity. I believe that in the darkest hour, God may restore faith and offer salvation. Toward dawn, in that cave, I began to pray for the first time since Evan had spoken harshly to me. These were prayers that sprang from tears shed in the blackest moment of my wretchedness. I prayed for the souls of Karen and Anethe, and for Evan, who would walk up the path to the cottage in a few hours, wondering why his bride did not greet him at the cove, and again for Evan, who would be bewildered by the cluster of men who stood about the doorstep, and once more for Evan, who would stagger away from that cottage and that island and never return again.

And also I prayed for myself, who had al-

ready lost Evan to his fathomless grief. For myself, who would be inexplicably alive when John saw the bodies of Karen and Anethe. For myself, who did not understand the visions God had given me.

When the sun rose, I crawled from the rock cave, so stiff I could barely move. The carpenters on Star Island, working on the hotel, dismissed me as I waved my skirt. Around the shore I limped on frozen feet until I saw the Ingerbretson children playing on Malaga. The children heard my cries and went to fetch their father. In a moment, Emil ran to his dory and paddled over to where I was standing on the shore of Smutty Nose. My eyes were swollen, my feet bloody, my nightgown and hair dishevelled, and, in this manner, I fell into Emil's arms and wept.

At the Ingerbretsons', I was laid upon a bed. A story came out, in bits and pieces, the pieces not necessarily in their correct order, the tale as broken as my spirit. And it was not until later that day, when I heard the story told to another in that room, that I understood for the first time all that I had said, and from that moment on, this was the precise story I held to.

I kept to my lurid story that day and the

next, and throughout the trial, but there was a moment, that first morning, as I lay on a bed in the Ingerbretson house, and was speaking to John and was in the midst of my story, that my husband, who had been holding his head in his hands in a state of awful anguish, looked up at me and took his hands away from his face, and I knew he had then the first of his doubts.

And what shall I say of my meeting with Evan, who, shortly after John left, stumbled into the room, having been blasted by the scene at Smutty Nose, and who looked once at me, not even seeing me, not even knowing I was there in that room with him, and who turned and flung his arm hard against the wall, so hard he broke his bones, and who howled the most piteous wail I have ever heard from any human being?

The white button that was found in Louis Wagner's pocket was an ordinary button, quite common, and only I knew, apart from Louis, although how could he admit to the manner in which he had come by it without showing that he was capable of an attack on a woman and thus aiding in his own conviction, that the button had come loose from Anethe's blouse on the day that he had

feigned illness and had made advances to her in his bedroom. Following the discovery of the button, which was widely reported, I removed the buttons from the blouse, which I subsequently destroyed, and put them on my nightgown.

I often think of the uncommon love I bore my brother and of how my life was shaped by this devotion, and also of John's patience and of his withdrawal from me, and of the beauty and the tenderness of my brother's wife. And I think also of the gathering net Evan threw into the water, and how he let it sink, and how he drew it up again, and how it showed to us the iridescent and the dark, the lustrous and the grotesque.

Last night, lying awake with the pain, I could take no nourishment except water, and I understand that this is a sign of the end, and to be truthful, I cannot mind, as the pain is greater than the ability of the girl who attends to me to mollify it with the medicine. It is in my womb, as I always knew it would be, knew it from the time I lay ill with the paralysis and my womanhood began. Or perhaps I knew it from the night my mother died, knew that I, too, would one day perish from something that would be delivered from

the womb, knew that one day my blood, too, would soak the sheets, as it did that night, so long ago, that night of my mother's death, when Evan and I lay together in the bed, and occasionally I am addled and confused and think myself a young woman again and that my monthly time has come, and then I remember, each time with a shock that leaves me breathless, that I am not young but am old, and that I am dying.

In a few weeks, we will have a new century, but I will not be here to see it.

I am glad that I have finished with my story, for my hand is weak and unsteady, and the events I have had to write about are grim and hideous and without any redemption, and I ask the Lord now, as I have for so many years, Why was the punishment so stern and unyielding? Why was the suffering so great?

The girl comes early in the morning and opens the curtains for me, and once again, as I did each day as a child, I look out onto Laurvig Bay, the bay constantly changing, each morning different from the one before or indeed any morning that has ever come before that. When the girl arrives, I am always in need of the medicine, and after she

has given it to me, I watch from the chair as she changes the filthy sheets, and goes about the cottage, tidying up, making the thin soup that until recently I was able to drink, speaking to me occasionally, not happy with her lot, but not selfish either. And in this way, she very much reminds me of myself when I was at the Johannsen farm, though in this case, she will have to watch me die, will have to sit beside me in this room and watch the life leave me, unless she is fortunate enough to have me go in the night, and I hope, for her sake, that it will be an easy passage, without drama and without agony.

26 September 1899, Maren Christensen Hontvedt.

I sit in the small boat in the harbor and watch the light begin to fade on Smuttynose. I hold in my hand papers from the cardboard carton.

Not long ago, I had lunch with Adaline in a restaurant in Boston. I hadn't been in a restaurant since the previous summer, and I was at first disoriented by the space—the tall ceilings, the intricately carved moldings, the mauve banquettes. On each table was a marble vase filled with peonies. Adaline was waiting for me, a glass of wine by her right hand. She had cut her hair and wore it in a sleek flip. I could see more clearly now how it might be that she was an officer with Bank of Boston. She was wearing a black suit with a gray silk shell, but she still had on the cross.

Our conversation was difficult and strained. She asked me how I was, and I had trouble finding suitable words to answer her. She spoke briefly about her job. She

told me she was getting married. I asked to whom, and she said it was to someone at the bank. I wished her well.

"Have you seen Thomas?" I asked her.

"Yes. I go down there . . . well, less now."

She meant Hull, Thomas's family home, where he lived with Rich, who looked after him.

"He's writing?"

"No, not that any of us can see. Rich is gone a lot. But he says that Thomas just sits at the desk, or walks along the beach."

I was privately amazed that Thomas could bear to look at water.

"He blames himself," said Adaline.

"I blame myself."

"It was an accident."

"No, it wasn't."

"He's drinking."

"I imagine."

"You haven't seen him since . . . ?"

She was unable to say the words. To define the event.

"Since the accident," I said for her. "We were together afterwards. It was excruciating. I suppose I will eventually go down to see him. In time."

"Sometimes a couple, after a tragedy, they find comfort in each other."

"I don't think that would be the case with me and Thomas," I said carefully.

During the hours following the discovery that Billie was missing, Thomas and I had said words to each other that could never be taken back, could never be forgotten. In the space of time it takes for a wave to wash over a boat deck, a once tightly knotted fisherman's net had frayed and come unraveled. I could not now imagine taking on the burden of Thomas's anguish as well as my own. I simply didn't have the strength.

"You're all right, then?" she asked. "In your place?"

"The apartment? Yes. As fine as can be."

"You're working?"

"Some."

"You know," she said, "I've always been concerned . . ." She fingered the gold cross. "Well, it doesn't seem very important now. But I've always been concerned you thought Thomas and I . . ."

"Were having an affair. No, I know you weren't. Thomas told me."

"He held me once in the cockpit when I was telling him about my daughter."

"I know. He told me that, too." I picked up a heavy silver spoon and set it down. All around me were animated women and men in suits.

"And there's another thing," she said. "Thomas indicated that you thought . . . well, Billie must have misheard a casual invitation from Thomas to me. Billie somehow thought I might be coming to live with you."

I nodded. "You were lucky," I said. "Not having a life vest."

She looked away.

"Why did you leave her?" I asked suddenly, and perhaps there was an edge of anger in my voice.

I hadn't planned to ask this of Adaline. I had promised myself I wouldn't.

Her eyes filled. "Oh, Jean, I've gone over and over this, a thousand times. I didn't want to be sick in front of Billie. I wanted fresh air. I'd been looking through the hatch all morning. I didn't think. I just opened it. I just assumed she wouldn't be able to reach it."

"I don't think she went out the hatch," I said.

Adaline blew her nose. I ordered a glass of wine. But already I knew that I would not be there long enough to drink it.

"She was a wonderful girl," I said to Adaline.

I think often of the weight of water, of the carelessness of adults.

Billie's body has never been found. Her life jacket, with its Sesame Street motif, washed up at Cape Neddick in Maine. It is my theory that Billie had the life jacket on, but not securely. That would have been like Billie, unclipping the jacket to readjust it, to wear it slightly differently, backwards possibly, so that she could satisfy herself that some part of her independence had not been lost. It is my theory that Billie came up the companionway looking for me or for Adaline to help her refasten the waist buckle. I tell myself that my daughter was surprised by the wave. That it took her fast, before thoughts or fear could form. I have convinced myself of this. But then I wonder: Might she have called out *Mom,* and then *Mom?* The wind was against her, and I wouldn't have heard her cry.

I did not return Maren Hontvedt's document or its translation to the Athenaeum. I did not send in the pictures from the photo shoot, and my editor never asked for them.

This is what I have read about John Hont-

vedt and Evan Christensen. John Hontvedt
moved to a house on Sagamore Street in
Portsmouth. He remarried and had a daugh-
ter named Honora. In 1877, Evan Christen-
sen married Valborg Moss at St. John, New
Brunswick, where he had gone from Ports-
mouth, and where he worked as a carpenter
and cabinetmaker. After his marriage, the
couple moved to Boston. They had five chil-
dren, two of whom died in infancy.

I think about the accommodations Evan
Christensen would have had to make to
marry another woman. What did he do with
his memories?

Anethe and Karen Christensen are buried
side by side in Portsmouth.

I sometimes think about Maren Hontvedt
and why she wrote her document. It was ex-
piative, surely, but I don't believe she was
seeking absolution. I think it was the weight
of her story that compelled her—a weight
she could no longer bear.

I slide the handful of papers into the wa-
ter. I watch them bob and float upon the wa-
ter's twitching surface, and I think they look
like sodden trash tossed overboard by an
inconsiderate sailor. Before morning, before
they are found, the papers will have disin-

tegrated, and the water will have blurred the ink.

I think about the hurt that stories cannot ease, not with a thousand tellings.

Acknowledgments

I could not have written this book without the aid of the various guidebooks to the Isles of Shoals as well as the several published accounts of the Smuttynose murders, in particular *Murder at Smuttynose and Other Murders* by Edmund Pearson (1938), *Moonlight Murder at Smuttynose* by Lyman Rutledge (1958), *The Isles of Shoals: A Visual History* by John Bardwell (1989), *The Isles of Shoals in Lore and Legend* by Lyman Rutledge (1976), "A Memorable Murder" by Celia Thaxter (1875), *A Stern and Lovely Scene: A Visual History of the Isles of Shoals* by the Art Galleries at the University of New Hampshire (1978), *Sprays of Salt* by John Downs (1944), and, of course, my much thumbed copy of *Ten Miles Out: Guide Book to the Isles of Shoals* by the Isles of Shoals Unitarian Association (1972). To these authors and to others who have written about this wonderful and mysterious archipelago, I am indebted.

I am also extremely grateful to my editor, Mi-

chael Pietsch, and my agent, Ginger Barber, for their incisive comments and advice.

Finally, I am most grateful to John Osborn for his tireless research and emotional intelligence.